The Lure of the Great West

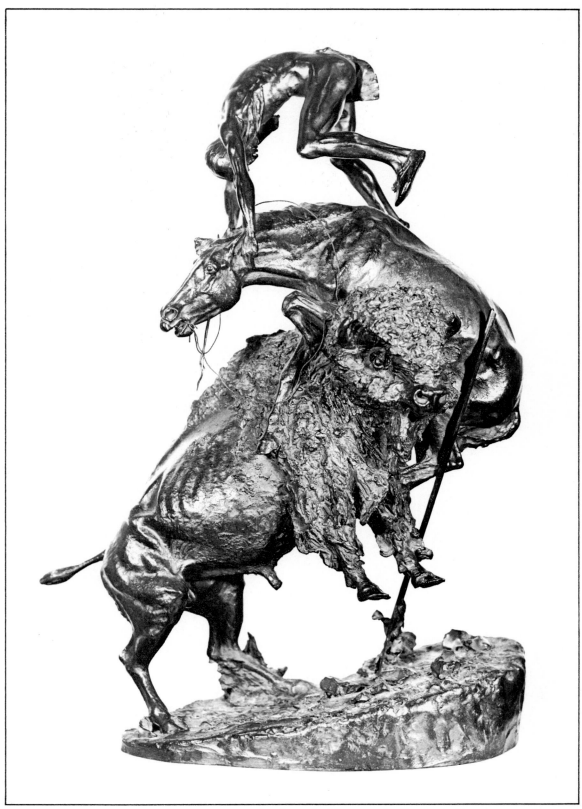

An Episode of the Buffalo Hunt, n.d., Frederic Remington, bronze.
Thomas Gilcrease Institute of American History and Art, Tulsa.

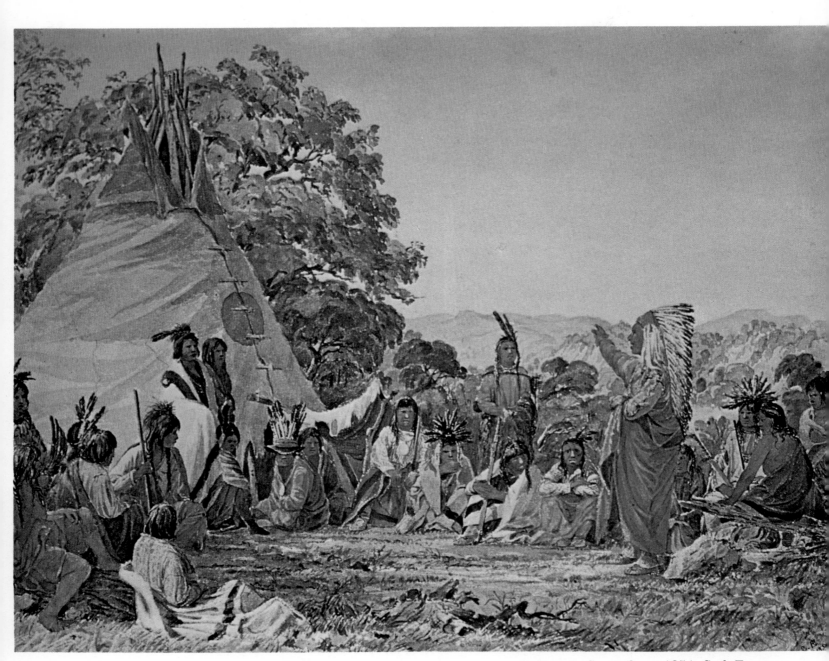

Indians in Council, ca. 1851, Seth Eastman.
10-3/4 x 8-1/4 in., watercolor.
James Jerome Hill Reference Library, St. Paul.

THE LURE OF THE GREAT WEST

BY FRANK GETLEIN
and the Editors of Country Beautiful

COUNTRY BEAUTIFUL
Waukesha, Wisconsin

For Bill and Karl, the reluctant cowboys

COUNTRY BEAUTIFUL: *Publisher and Editorial Director:* Michael P. Dineen; *Executive Editor:* Robert L. Polley; *Senior Editors:* Kenneth L. Schmitz; James H. Robb; *Art Director:* Buford Nixon; *House Editor:* D'Arlyn Marks; *Associate Editors:* John M. Nuhn, Kay Kundinger; *Editorial Assistant:* Nancy Backes; *Production Manager;* Donna Griesemer; *Editorial Secretary:* Jane Boyd; *Administration:* Brett E. Gries, Bruce Schneider; *Administrative Secretary:* Kathleen M. Stoner.

Country Beautiful Corporation is a wholly owned subsidiary of Flick-Reedy Corporation: *President:* Frank Flick; *Vice President and General Manager:* Michael P. Dineen; *Treasurer and Secretary:* August Caamano.

ACKNOWLEDGEMENTS

The author and editors wish to thank all the museums and collectors represented herein for their cooperation and suggestions.

Braves Leaving the Reservation, by R. C. Woodville, from the *Illustrated London News,* January 17, 1891, and *Prospecting for Gold in British Columbia: A Portage,* by R. C. Woodville, from the *Illustrated London News,* January 16, 1897. From Paul Hogarth, *Artists on Horseback* (New York, Watson-Guptill, 1973). Reproduced by permission of the author and publisher.

CONTENTS

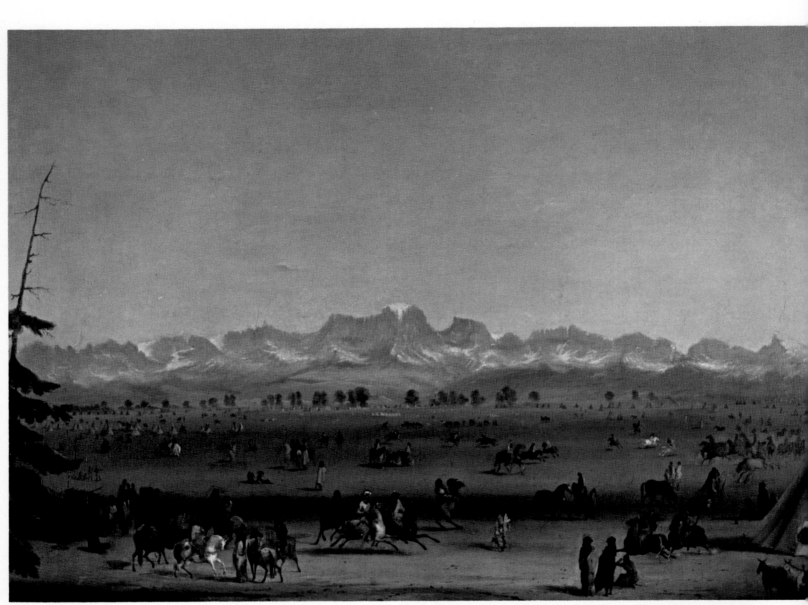

Fur Trappers Rendezvous, ca. 1840, Alfred Jacob Miller.

INTRODUCTION

Nothing in American art history is more difficult to understand than the low repute paintings and sculpture on Western subjects have endured through most of the years that America has had an art history. On the face of it, Western art should have been a particular pride to the American art community. The history paintings, as they were called, that showed both great events in history and sacred events from scripture, dealt in materials that European artists had dealt in since the earliest Middle Ages. American landscape, when it came into widespread existence around 1825, was following and enlarging a European tradition already almost two centuries old in France and the Lowlands. American portraiture was taken wholesale from the studios of London, as is eloquently testified by a certain confusion of nationality surviving until this day over Benjamin West and John Singleton Copley. Like landscape, still-life painting in America took its origins in seventeenth-century Holland, as well as in Renaissance Italy and even in late Roman painting, both fresco and mosaic.

The single, outstanding, new and original form of art that America brought into existence was Western painting and sculpture, for the very good reason that the way of life shown in Western art had never existed anywhere else. That being so, the reasonable person would have

expected Western art to be the very acme and pinnacle of American art in the eyes of the art public and the art professionals of studio, museums and publications.

Nothing of the sort happened. On the contrary, Western art has been treated, until quite recently, as a kind of side-show, a minor, branch development not really worthy of serious attention. Indeed, in surveys of American art from colonial days to the present, Western art has more often been ignored altogether than included as an authentic part of the story. Frederic Remington and Charles Russell have been dismissed as painters of cowboys and Indians, rather as Buffalo Bill's Wild West Show might be dismissed in a history of American theater.

(Oddly enough, Buffalo Bill was indirectly responsible for the one towering exception to the rule of isolation and quarantine imposed upon Western art by Eastern art establishments. This was Gertrude Vanderbilt Whitney, herself a sculptor of considerable talent but more important as a creative patron of American art in the twentieth century. She bought pictures, she employed artists, she exhibited their works and badgered museums and collectors to acquire them. Her supreme contribution was the founding of the Whitney Museum of American Art in New York, which has been by far the most important single institution in fostering the appreciation of American art of both past and present. Gertrude Whitney also founded one of the three or four most important institutions devoted to Western painting and sculpture, the Whitney Gallery of Western Art. It is said that her interest in the West began when, as a child brought to the circus, Buffalo Bill seated her in front of him on his horse and gave her a ride around the ring. Appropriately, the Gallery is located in Cody, Wyoming.)

If hard to understand, that indifference to Western art is easy enough to explain. In the early days, of course, the Eastern art establishment wanted nothing so much as to be like Europe and especially England. Hence, the very originality of Western art counted against it. Artists of the Eastern seaboard were spending years of their student lives, when they could afford it, in London, Rome, Paris, Düsseldorf and Munich to find out what art was supposed to be and to practice it accordingly. In none of those cities or their classes and studios or their museums, did they see pictures of American Indians, or of cowboys or of the Rocky Mountains. Western art, far from being a point of pride for national achievement, was a slight embarrassment to several generations of artists and art officials determined to prove they could be as cultured as the Europeans and in the same way.

In the twentieth century, the rules of the game changed, but the change was such that it still left Western art more often off the playing field entirely than competing in the struggle for acceptance. As abstract art was first imported from Europe and duly copied and was then succeeded by that form of native non-objectivity loosely called Abstract Expressionism, it was discovered that one of the worst things a painting or sculpture could have was a subject. What art was all about was various abstract considerations, such as composition, color relations, texture, linear development, volumes, form, space relations and others.

Since, if there was one thing all Western art had in common, it was not only subjects but the importance of subjects, once again Western art was found to be out of bounds and beneath serious consideration.

The subject of subjects is mildly complicated, more complicated than it is believed to be either by those who think subject matter is the only thing that counts in art or those who think, equally naively, that subject matter is the only thing that does not count.

Of course there are other considerations beside subject matter in judging whether a picture or a statue is worthwhile. Of course things other than subject matter engage the eye, the mind, the kinetic sense, the tactile sense, the sense of wholeness and interrelatedness of parts. Of course there can be successful and communicating works of art which appear to have no subject at all except, perhaps, basic plane geometry or such indeterminable things as the artist's struggle with his means of expression.

Granted all that, it remains true that modern painting and sculpture were begun and for a long time maintained by a series of commissions by lords spiritual and temporal in central Italy. It is also true that no Renaissance duke, prince, abbott or abbess, cardinal or pope ever dreamt of asking anyone from Giotto to Michelangelo to whip up a little of that old space-composition or some more of those tactile values. No, the great patrons who, in their way, created modern art, asked their artists to paint the Virgin, the Saints, the events of the Old and New Testaments, or their Uncle Luigi being welcomed into heaven by St. Peter and the angels. The space composition and the tactile values were explored and exploited in the first instance to reinforce the subject matter of the paintings and sculptures.

So the two things go together, matter and method, and subject is indeed part of the work of art if the work has a subject. The contemporary American painter Jack Levine, certainly not to be accused of being soft on religion, put it this way: "The Madonna's more important than the apple, every time."

Happily, we seem to have passed beyond all those considerations. Avant-garde art wore itself out sometime around 1960 and since then has returned to subject matter. Thus Western painting and sculpture, an art profoundly involved with its subject matter, became at last admissible as American art in any form at all. We have all benefited from the change.

The country as a whole has benefited most. Western art chronicles a great period and the classic struggle in the history of America—that of the Anglo-Americans against the Indians, against sheer space, against assorted foreign governments with claims on part of the American territory, against one another and, finally, against the weakness within. The results have been varied, but there is no questions that the West ranks with the Civil War—in some ways outranks that rebellion—as the epic place, the epic events, the epic people, of the United States.

Every country needs such materials of epic, and the recognition of that need may be seen in the never flagging popular market for those materials in the dime novel, the Wild West show, the Western movie and the Western television program.

The paintings and sculpture of the West have brought that theme up to a level on which our highest faculties of reflection and contemplation may be engaged—as is clear in the pages that follow.

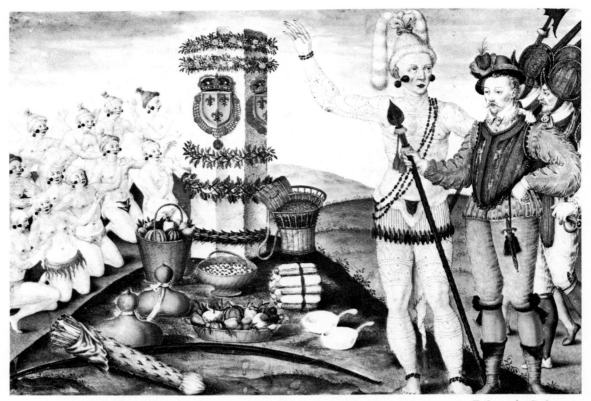

The Indian Chief Athore and the French Leader Laudonnière at Ribaut's Column, 1564, Jacques Le Moyne de Morgues. 10-1/4 x 7 in., gouache on vellum. James Hazen Hyde Bequest, Prints Division, New York Public Library, Astor, Lenox and Tilden Foundations. Le Moyne's is one of the earliest impressions of the New World and its noble savages.

THE LURE OF THE WEST

"Go West, young man," said Horace Greeley, a confirmed Easterner, and thousands did, but that was already halfway through the nineteenth century. The westering drive that brought Europeans and especially the people from the British Isles into the coastal lands that were to become the original thirteen United States began a good two centuries earlier at Plymouth, Massachusetts, and Jamestown, Virginia. A century before those two settlements, Cortez undertook the still astonishing conquest of Mexico, an event which, although outside the United States, was to have profound, decisive effects on the nature of the life that eventually came into being in our Western states.

The keenest appreciation of the West by those who remain in or return to the East goes back before Greeley. The key saying, almost the charter, of the whole westering enterprise was written by Bishop Berkeley, the philosopher, who tried to found a school for American Indians and failed but who did spend three or four years as far west from Britain as Newport, Rhode Island, almost half a century before the American Revolution. His poem was called, in the manner of his day, "On the Prospect of Planting Arts and Learning in America," and in the sixth stanza he wrote the immortal line: "Westward the course of empire takes its way."

For Bishop Berkeley, Newport was already about as far West as one would care to go. He knew, of course, that there were lands beyond the Appalachians, but the very shore of the New World was already the mystical West with its promise, at once encouraging and discouraging in Berkeley's words, "Time's noblest offspring is the last."

That mixture of nobility and finality marks many a European lofty thought about the New World, especially in Berkeley's century, the eighteenth. It was the century of the Ancient Regime which carried a sense of its own impending death—fair enough, for die it did. With the peculiar but universal tendency of groups to confuse their own destiny with that of mankind, or at any rate with the highest potentialities of mankind, the dying classicists and borning romantics of the Ancient Regime saw the possibilities of a new, primitive and noble society coming into brief existence in the New World as a kind of end-game, a coda, an afterpiece, an epigraph even, to their own long history of growth and decay.

Not surprisingly, the settlers themselves in the New World took no such attitude of dying fall; they did not regard themselves as the end of all things, but as a beginning. That spirit is admirably caught in Emanuel Leutze's painting in illustration of Bishop Berkeley's single greatest line, *Westward the Course of Empire Takes Its Way.* The fact that the painting was commissioned for and still adorns the Capitol of the United States is itself a commentary with several meanings on the lure of the West for the American society. It says immediately that

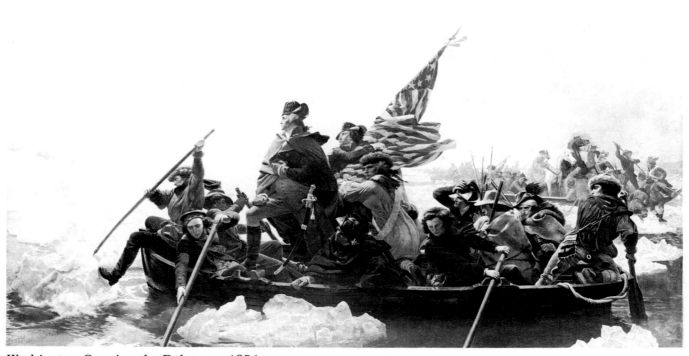

Washington Crossing the Delaware, 1851,
Emanuel Leutze. 149 x 225 in., oil.
The Metropolitan Museum of Art, gift of John S. Kennedy.

the Congress, too, shared the somewhat mystical belief in the West and even the belief in itself as the embodiment of that belief in an open future in the West. Leutze himself was not an American. He was a German despite several crucial residences in the New World. Moreover his most famous picture—one of the most famous in all art concerned with America—was painted by Leutze not in obvious reference to its American subject but rather in reference to its primarily German audience.

The painting, of course, is *Washington Crossing the Delaware.* That image of the Revolutionary commander, standing in his boat and staring out at the approaching hostile shore in one of his most daring and successful maneuvers, is so long familiar as part of the American heritage of patriotic piety, that we take it for granted it was painted for the purposes it has so long been put to. But no: Leutze at the time was once again a patriotic German. The great continental Revolution of 1848 had failed everywhere and nowhere more completely than in Germany. Leutze, as a German with considerable American experience, painted his *Washington Crossing the Delaware* not so much as a patriotic icon for the Americans as a sign of hope and an exhortation to perseverence in adversity to his fellow-German liberals after the defeat of 1848.

Think of Washington, he was saying in effect: like him, if we Germans keep the faith and labor on, regardless of the appearance of defeat, we too shall finally find liberty and union. The fact that to this day the Germans have not found liberty and union is hardly the fault of either Washington or Leutze. At any rate, the picture was barely completed before it began to become famous in America. Although ruined by fire, it lived on in hundreds of engravings distributed here and was reborn in a copy made by Leutze and now in the collection of the Metropolitan Museum of Art, New York, but usually exhibited in a special building erected for the purpose at the site of Washington's crossing of the Delaware.

With this substantial reputation as a patriotic American painter, it was not surprising that Congress commissioned Leutze to decorate its walls with *Westward the Course of Empire Takes Its Way.* Leutze approached the assignment with Germanic thoroughness. Although the Civil War had begun, he journeyed to America, visiting old friends in service around Washington and going West to sketch details and absorb the general feeling that would permeate the mural.

The finished picture centers on a moment of climax in the long trek westward. Up from the right-hand side of the picture a band of pioneers and settlers with covered wagons had reached the top of a notch through a mountain chain. The mountains themselves take the sunlight and tower above everything, gradually fading back into mist in the distance. Like Moses at the entrance to the Promised Land, the actual toilers seem almost unaware of the plains spreading before them beyond the crest of the pass. The wagon train continues its steady ascent in two main streams, one in the right foreground, one parallel and more distant. Echoing the lofty summits in their upflung arms, two of the pioneers have mounted a table rock in the background. One is just gaining the summit as the other, on his feet, waves his hat in the air at the prospect before them. Closer to us, at the actual center of the composition, a rawhide-clad pioneer, complete with fur bonnet, shelters a pioneer mother and child with one arm while the other points the way toward the West, toward the future. To the right, two other figures repeat the essential gesture of hailing the new fair land beyond the mountain walls.

It is an heroic group, quite conscious, at least among its leaders, of its own heroism and of the historically crucial moment. If there is any doubt on this point, the viewer has but to consult the painted borders of the picture, with eagle holding the title scroll above, the sides as rich in floral medallions as any gilt-edge stock certificate, the base containing portraits of the pioneer and the legislator on either side of a broad view of a

9

water inlet in the mountain wilderness. Yet, it may be doubted that the actual westering folk were any more conscious of their historicity in going West than were the Americans at large conscious of their role as the final act in history's drama in Bishop Berkeley's verse. Like much, perhaps most, art of the style practiced by Leutze, his Congressional mural portrays the inner meaning of a moment, or of a series of events as if that meaning were entirely clear to the people involved in it even while it was taking place.

Leutze himself seems to have been played out in his historical vein by the effort he put into *Westward*. He was, for example, specifically invited to enter a competition sponsored by the Pennsylvania legislature for a similar heroic work shortly after the crucial Battle of Gettysburg decided the failure of the South's supreme effort in the Civil War, and he declined. By the end of the decade he was dead, in Washington. But his influence survived him and not only as the creator of the most enduring image of the Revolution. During his years as a master in Düsseldorf, Germany, he welcomed into his studio a whole generation of American painters, including painters of the West, and helped many of them develop the skills and perhaps even something of the vision needed to come to grips with the people and the scenes of that new world that lay beyond the American coastal mountains, the West.

Much less well known than Leutze's Congressional mural, but in its own way even more significant as an example of the European eye viewing the American West, or at least an aspect of America that came eventually to be principally associated with the West, is a watercolor by a French artist and explorer, Jacques Le Moyne de Morgues, painted almost three hundred years earlier. The title is descriptive, *The Indian Chief Athore and the French Leader Laudonnière at Ribaut's Column*. Member of an abortive French effort to establish a colony in Florida in the sixteenth century, Le Moyne was one of the few to escape when the Spanish, whose claim to Florida went back to Ponce de Leon and his search for the fountain of youth, fell upon the French and killed most of them. The artist survived the attack and made his way to England, where engravings made from his drawings proved immediately popular and provided Europeans with an early image of life in the New World.

The present illustration is of the single original work by Le Moyne known to be still in existence. It qualifies its author as an artist of lightness and precision. Le Moyne later specialized in the flowers and fruits of England and his gifts in that direction are already well-established in the fruits of the field that his pink Indians have brought to offer the French leader at the site of a column left by a predecessor. It may be doubted if anything except the fruits and vegetables and the uniforms of the French soldiers is depicted with total accuracy. At any rate, it is easy to see how Le Moyne's pictures helped create the enduring European impression of the New World as a land inhabited by noble savages living in a world more or less as the Europeans imagined Eden to have been before the fall of Adam and Eve.

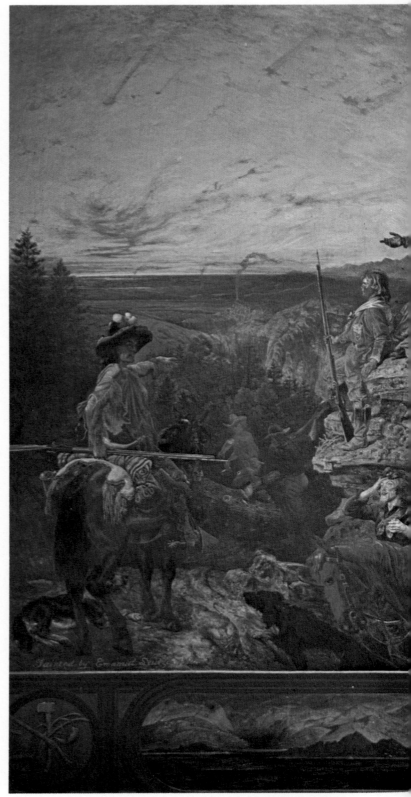

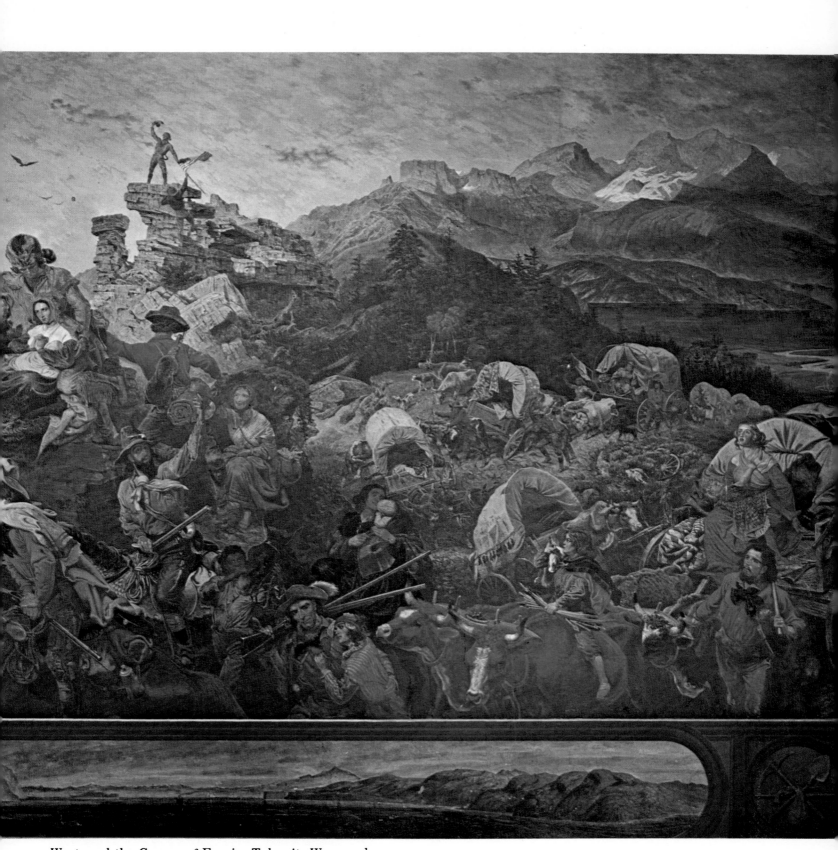

Westward the Course of Empire Takes its Way, n. d.,
Emanuel Leutze. 30 x 40 in., oil.
House of Representatives, Washington, D.C.
Leutze's painting symbolizes the westering
enterprise that began with the discovery of the New World.

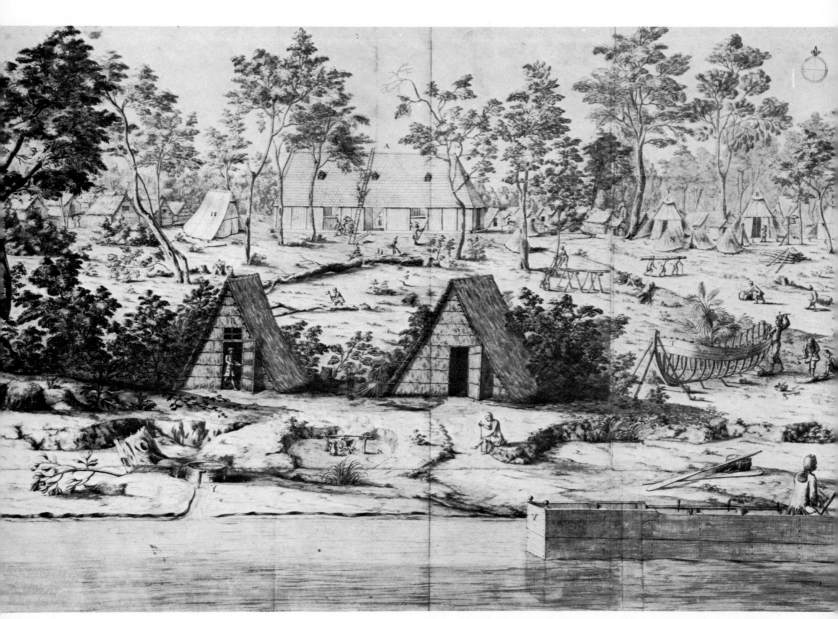

View of the Camp of Mr. Law's Concession at New Biloxi,
Coast of Louisiana, ca. 1720, Jean-Baptiste Michel Le Bouteux.
37-1/2 x 20-3/4 in., ink and brown wash.
Courtesy, The Newberry Library, Ayer Collection.

THE ORIGINAL INHABITANTS

It is, of course, absurd, even insulting, to speak of the "discovery" of America as an event that took place in 1492, and of the exploration and settling of the American West as a series of subsequent events that took place from the middle of the sixteenth century to almost the beginning of the twentieth century. We do not know when America was "discovered," but it was assuredly some thousands of years before A.D. 1492. It was so long ago and at such a primitive state of the discoverers' own social development—as well as that of all other societies then existing—that no records have survived. In all probability, the "discoverers" were unaware that there was any discovery involved. Wandering peoples from northeast Asia, most likely, they crossed a land bridge between the two continents, probably not along the chain of Aleutian Islands stretching out from Alaska toward Siberia, but across the much narrower passage to the north, now marked by the Diomede Islands. Hunting and fishing peoples, driven by the impulses that still move the surviving nomadic peoples, these Asiatics drifted south, spreading out, no doubt, as generation succeeded generation, making their way, some of them, across the Isthmus of Panama and into South America. Datable remains have established that they were settled close to the southernmost point of South America almost ten thousand years ago.

While this view of the origins of the American peoples is today the one most widely held by scholars, there are others, and it may easily be that several, perhaps all, are correct. Instead of using the land bridge postulated in the north, the original inhabitants may have come across the Pacific in canoes or on rafts, using the Humboldt current. They may, conceivably, have come from Africa, even from ancient Egypt, as is the view of Thor Heyerdahl, the

A Land Tort(oise) which the Savages esteeme
above all other Torts, 1590, John White.
5-2/3 x 7-3/4 in., watercolor and pencil.
The British Museum.

voyager, who has attempted to duplicate such a hypothetical trip. At any rate, the originals were well settled in to both North and South America thousands of years before Columbus dropped anchor off Hispaniola.

Just as what became the high civilization of the Europeans began on and around the Mediterranean Sea—Sumer, Assyria, Babylonia, Egypt, Greece and Rome—so in the New World, the high civilizations, the culture of the cities, came into being at roughly the same remove from the equator and also in roughly the same proximity to an enclosed sea, the Caribbean. The successive cultures of Mexico and Guatemala and the unrelated, or distantly related chain of cultures in Peru—of which the best-known, the Inca, was only the last before the Spanish Conquest—created cities, streets, stone buildings, temples and great pyramids, highways, canals and calendars. The people knew how to work precious metals and to weave intricate designs in reeds and feathers as well as cloth. Peruvian textiles still survive which are close to two thousand years old. Only a little of that high Indian civilization penetrated north to the area that eventually came within the boundaries of the United States, and that little tended naturally to be provincial.

In general the Indians of the land that became our country were more primitive than the Maya, the Aztecs and the Incas. They were still hunting cultures, like the very first we know about in humanity's stay on earth. They had weapons which were little different from those of our earliest ancestors: spears or lances, bows and arrows, clubs and rocks for throwing. Game was also captured in traps, fish in nets or at temporary dams constructed for the purpose. Hunting was augmented by some scattered primitive agriculture and by the gathering of roots, nuts and berries in season. Typically, food was "found" or captured rather than cultivated. Since arrowheads, clubheads and cutting edges of all kinds were made of stone, the Indians can accurately be described as constituting a Stone Age culture.

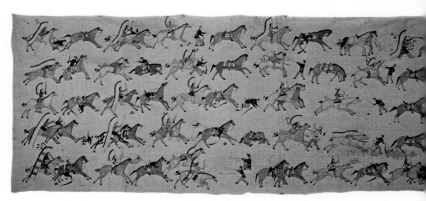

Sioux or Cheyenne Pictograph, Little Big Horn Battle, Montana, late 19th century, 35 x 85 in., painted muslin. National Museum of Natural History, Smithsonian Institution, bequest of Victor J. Evans. Keeping record of important tribal events, such as this, was both a practical and contemplative art.

Right: Wild Turkey, 1825, John James Audubon. 38-3/4 x 26 in., watercolor. Courtesy, New-York Historical Society, New York.

Grand Boeuf du Nouveau d'Anemar en Amerique, n. d., Charles Bécard de Granville. 14 x 9-1/2 in., pen and ink drawing. Thomas Gilcrease Institute of American History and Art, Tulsa.

Right: Capitaine de la Nation Illinois, n. d., Charles Bécard de Granville. 14 x 9-1/2 in., pen and ink drawing. Thomas Gilcrease Institute of American History and Art, Tulsa.

14

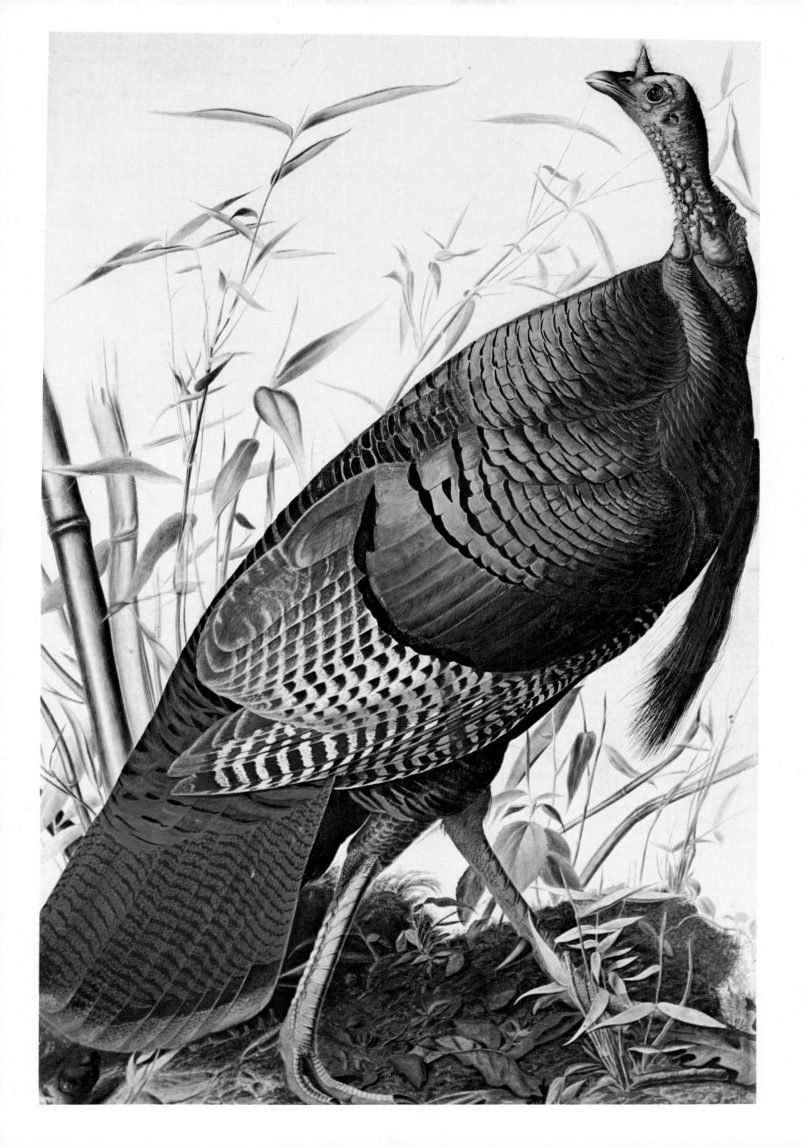

In the broadest of terms, the American Indians who lived within the borders of what was to become the continental United States could be divided into four geographic-anthropological groupings. The Woodland Indians were the first encountered by the English-speaking settlers in Massachusetts and Virginia as well as elsewhere along the coastal plain. These are the people who taught the Puritans how to cultivate corn, whose princess, Pocahantas, saved Captain John Smith from death and, later became an adornment of Queen Elizabeth's court, and whose great chief, Hiawatha, was the subject of one of the first conscious efforts at epic poetry in the young Republic. These are also the Indians celebrated in James Fenimore Cooper's *Leatherstocking Tales*, intimately familiar with the ways of forest and stream, endowed with the vision of the eagle, the swiftness of the deer, the strength of the bear. Pushed back and off their hunting grounds by the English-speaking settlers, they were able to enjoy, in contrast, mutually profitable trading relationships with the French, and therefore entered into alliance with them against the English in what we call the French and Indian War, which settled, thirteen years before the American Revolution, that the English-speaking culture would be the dominant one in the heart of the North American continent. That war ended the ambitions of the French for continental domination, restricting them, eventually, to the single province of Quebec.

It also ended, or rather recognized the ending of, the Woodland Indians' survival as independent peoples within the expanding Anglo-American ascendency. The Indians could trade with the French as equal partners to transactions; they could join with the Spanish in creating a new culture in a score of countries south of the Rio Grande. But confronted with the Anglo-Americans and their drive to make a new nation of their own, based on, but independent of, the English nation, the Indians could only fight and fall back, overwhelmed by superior numbers and a technology vastly superior for purposes of war and conquest. The Woodland peoples fell back, through the Appalachians, and became new members of the great and complex culture of Indian peoples between the mountain ranges. What the Woodland Indians learned first about the Anglo-Americans, their Western brothers would learn slowly, agonizedly and at sometimes mortal cost to the life of the tribes.

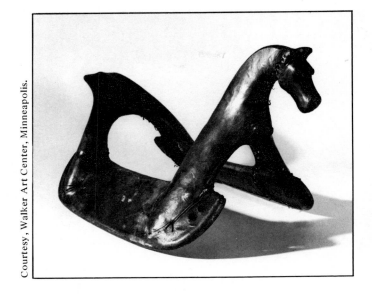

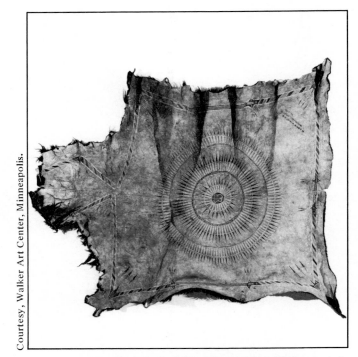

Top: **Man's Saddle, Menomini (Wisconsin).**
20 x 13-1/2 x 22-1/2 in., leather over wood, brass tacks.
American Museum of Natural History,
collected by W. Jones.

Above: **Buffalo Robe, Sioux (Central Plains).**
93-1/2 x 74 in., painted hide, sunburst design.
Museum of Primitive Art.

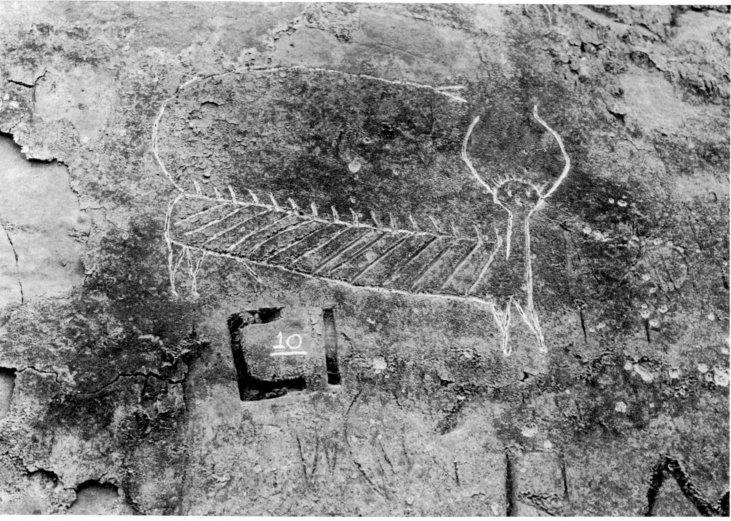

Photo courtesy of the Nebraska State Historical Society.

Incised Winnebago Drawing of Medicine Animal, n. d.,
Anonymous Indians. 36 x 26 in., chalk on sandstone.

Photo courtesy Museum of Northern Arizona, by Marc Gaede.

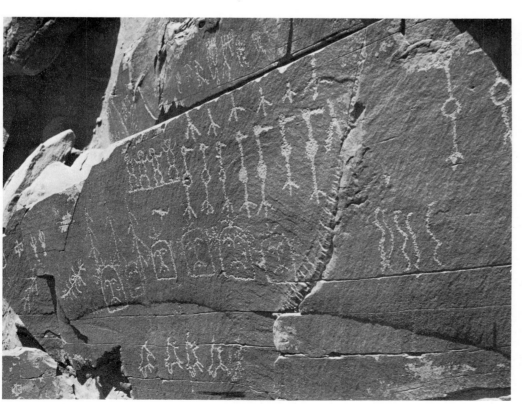

Pecked Hopi Clan Symbols,
Anonymous Indians, chalked.
Willow Springs, Arizona.

At the opposite side of the continent were the Coastal Indians and along what was to become the border with Mexico, the Southwest Indians, who tended to be more agriculturally advanced than any of the other tribes and who seem to have begun as branches from the high Indian civilizations of Mexico. Like the Aztecs and the Maya, the Pueblo Indians built stone dwellings. Others in the area built adobe houses of dried mud. Life centered around the harvest rather than around the hunt and was more settled, less nomadic than that of most of the American tribes.

The great central group of tribes left until last in this broad accounting are those of the Plains Indians, by far the most important in the history of the West. The modern American consciousness, shaped by, among other forces, popular adventure fiction from the dime novel to the home screen, with the movies an enormous force between those two, hears the word Indian and thinks of the Plains tribes. These were the Indians who attacked the wagon trains, who fought the United States Cavalry and often —as at Little Big Horn—outfought them. These were the Indians of the war path, the war dance and the war paint. They were also the Indians of the rifle and gunpowder, obtained from the whites, and of the horse, the Indian pony.

Those two items, the gun and the horse, made the Plains Indians a very different kind of people from any Indians who had lived in the New World since the race

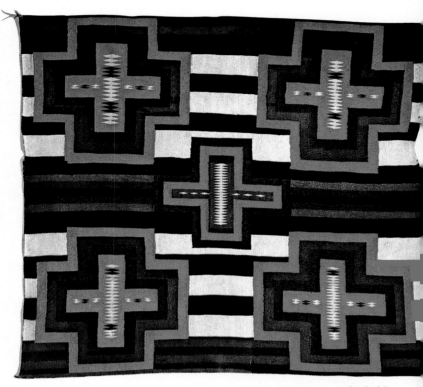

Chief Pattern Navaho Blanket, Third Phase, 1890-95,
23-3/4 x 56-1/2 in., wool.
Millicent A. Rogers Memorial Museum, Taos, New Mexico.

Sioux Pictograph of Little Big Horn Battle, late 19th century,
Kicking Bear, 68-1/2 x 34-7/8 in., painted muslin.
Cranbrook Institute of Science, Bloomfield Hills, Michigan.
The figures on this record include Sitting Bull, Crazy Horse,
Kicking Bear, Rabbit Stands Up and General George Custer.

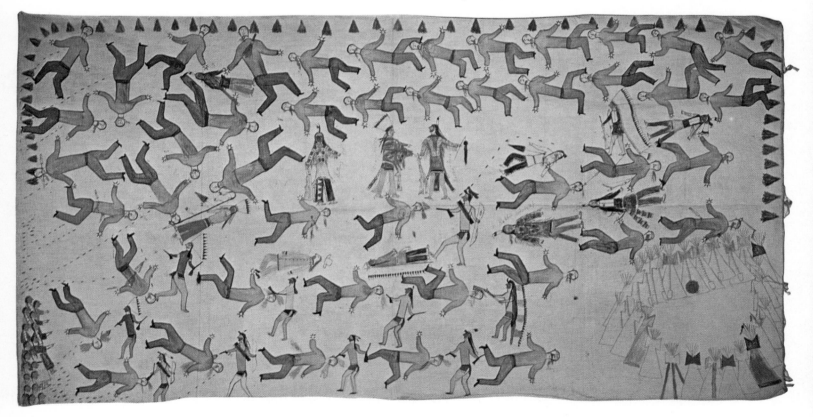

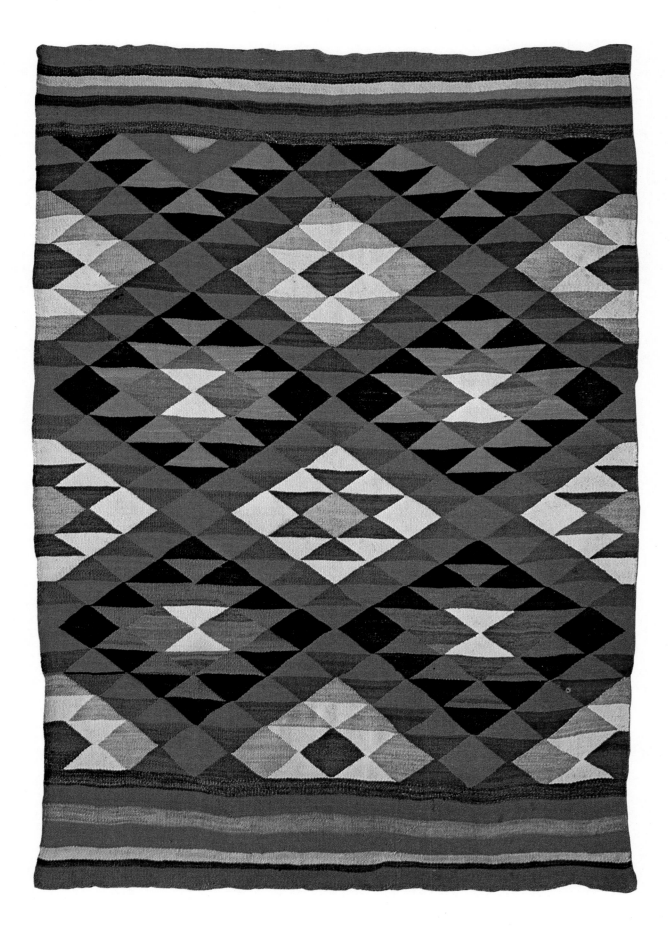

Eye-Dazzler Navaho Blanket, 1880-90,
84-1/4 x 59-1/4 in., wool.
Collection of Anthony Berlant, Santa Monica.

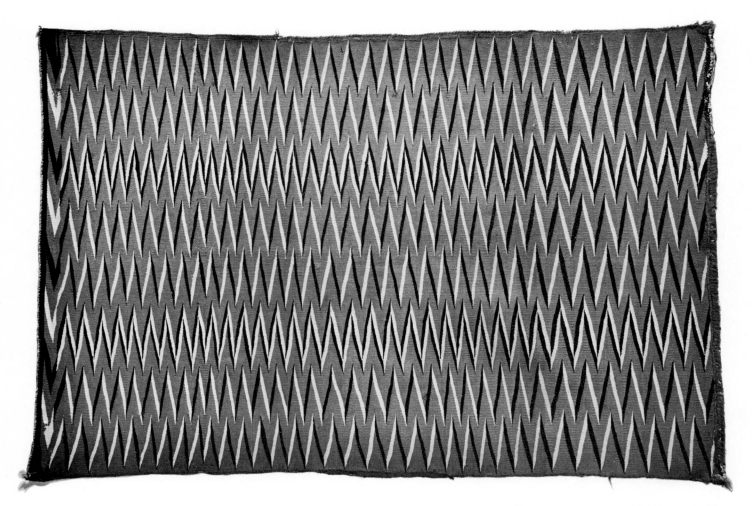

Above: **Child's Blanket, Vibrating Zig-zag, 1870-80,**
Navaho Blanket. 53 x 23-1/2 in., wool.
Heard Museum, Phoenix.

Right: **Pictorial Style, Horses, 1880-90,**
Navaho Blanket. 84 x 51-1/2 in., wool.
Taylor Museum, Colorado Springs Fine Arts Center.

came over from Asia and began filtering south from Alaska. The horse extended the range of the Indian warrior and hunter enormously, and the Plains Indians rapidly became the most extraordinary horsemen since the Huns and Mongols. The gun, on the other hand, propelled the Plains Indians violently from their Stone Age lives into the Age of Machines. The two things together enabled the Plains Indians to hold off the fate that had already overtaken the Woodland Indians and the more highly cultivated Indians of Mexico and Peru With artillery more or less irrelevant to the long wars for the plains, the situation was a man-to-man, horse-to-horse, rifle-to-rifle confrontation. The Plains Indians were more than a man-to-man match for the whites from the east. Their marksmanship was at least as good and often better, and their riding was unmatched and unbeatable. Vastly outnumbered, they nevertheless held off the inevitable for the better part of a century and in the process created an essential and major part of the legend of the West.

Like the arts of all primitive people, Indian art was not art at all in the modern European-American sense of the

product of separate human activity made for contemplation in itself. Modern white people keep art quite distinct from most of the activities of their lives, certainly distinct from those vital activities with which they earn their living and equally distinct, usually, from those activities through which they worship God or consider the nature of the universe. For the Indians, all of these things were conceived as aspects of the same thing and were practiced as a single, on-going life. Art was not separate from other activities and it certainly never existed as a thing in itself worthy of abstracted contemplation. Art was called upon to decorate the costume and the shelter—also the face and body of the warrior and the hide of the warrior's horse. Art entered into religious experiences of all kinds, and religious practices were closely associated with the success of the hunt. The sand painting of the Southwest Indians was similar in purpose to the fresco painting in late medieval cathedrals; the images on shields, the selected animal parts fastened to a headdress were similar in function to the stylized animals found on the shields of ancient European nobility.

20

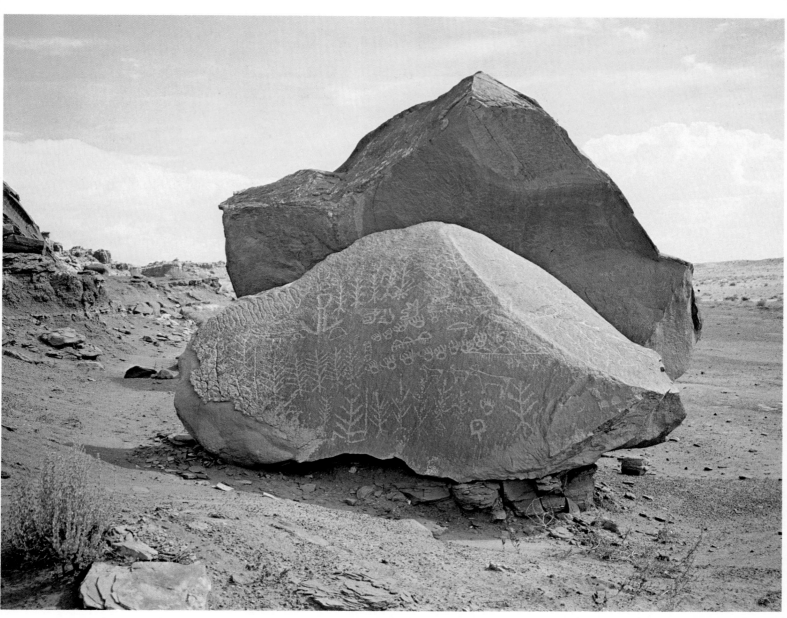

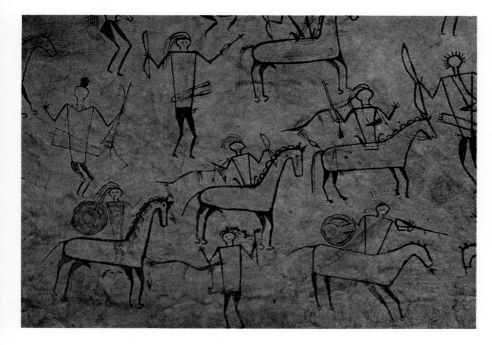

Pecked Hopi Clan Symbols,
Anonymous Indians, chalked.
Willow Springs, Arizona.

Left: **Buffalo Robe, Ojibwa**
(Great Lakes, Eastern Woodlands),
late 19th century, 81 x 72-1/4 in.,
painted hide. Peabody Museum of Archaeology
and Ethnology, Harvard University, gift of
Mr. William Barbour. The Woodlands Indians'
finest art was hide painting, and this is a rare
example of the dozen or so known such robes.

IMAGES OF INDIANS: TWO VIEWS

John Vanderlyn
(1775—1852)

Edward Hicks
(1780—1849)

The Peaceable Kingdom, ca. 1830-40,
Edward Hicks. 17-1/4 x 23-1/4 in., oil.
Abby Aldrich Rockefeller Folk Art Collection, Williamsburg.
Painting was another form of preaching for the itinerant Quaker
minister Hicks, and pictures of the blessed state of peace,
prophesized by Isaiah, combined with William Penn's "Great
Treaty with the Indians," were his favorite message.

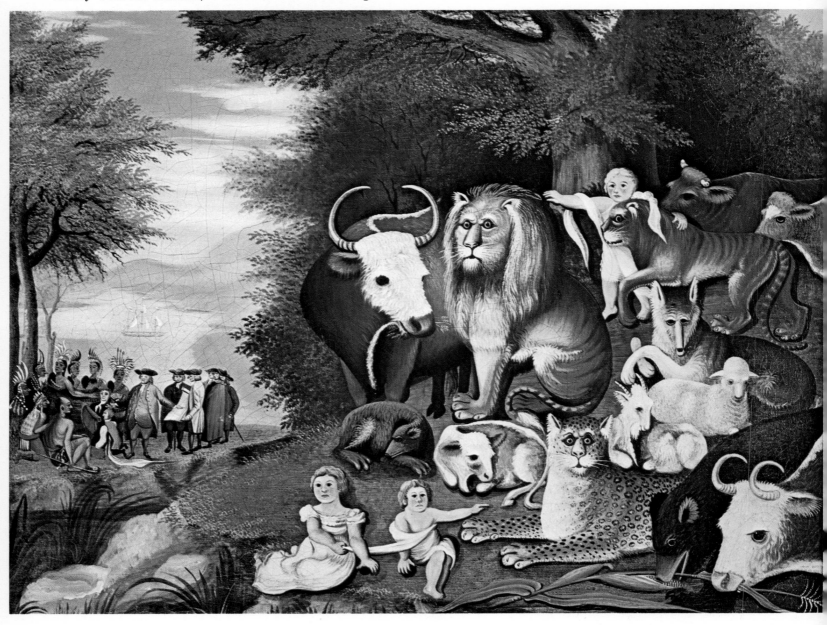

It would be hard to find two men in the entire history of American art who, passing their lives through the same decades, were more unlike in every particular than were Vanderlyn and Hicks. Nowhere are their differences more striking than in the two opposing images of the Indians these two artists gave to their countrymen and women, images which accurately reflected the exaggerated and opposite views of the American natives that many citizens of the young Republic managed to hold simultaneously, despite their mutual contradiction.

Hicks was an itinerant Quaker preacher, a deeply religious man, who came to art by way of sign painting and carriage painting, trades he practiced to support himself as he moved about the Pennsylvania small towns in which he preached the gospel as it revealed itself to him from the Bible and from a lifetime of meditation on its meaning. He was entirely self-taught and not especially well-taught. He was a primitive painter, probably America's best, certainly, until Grandma Moses, America's best-known. Painting was simply a natural expression for him, another form of preaching. He did do what might be called "portraits" of family farms in the countryside he traversed, but more often he stuck to one of two themes and occasionally combined the two into the same picture.

The great scriptural theme that preoccupied Edward Hicks was the blessed state prophesied by Isaiah: "The wolf also shall dwell with the lamb, and the leopard shall lie down with the kid; and the calf and the young lion and the fatling together; and a little child shall lead them.

"And the cow and the bear shall feed; their young ones shall lie down together: and the lion shall eat straw like the ox.

"And the suckling child shall play on the hole of the asp, and the weaned child shall put his hand on the cockatrice' den."

This vision of the prophet so entranced Hicks that he painted it again and again. His second theme he obviously regarded as a kind of modern, historical event that embodied the spirit of Isaiah's prophecy. This was the signing of the treaty by William Penn with the Indians. The great Quaker actually made two treaties with the Indians, one in 1683, another in 1700, and managed to gain and keep the affections of the Indians throughout his life. The first internationally celebrated American painter, Benjamin West, made an imaginative picture of the signing of the treaty. This image, known to Hicks through the prints of it, which were numerous in Pennsylvania, became for him as forceful an element in his artistic imagination as the prophecy of Isaiah. Quite often he combined the "Peaceable Kingdom" theme with that of Penn's "Great Treaty with the Indians" in a single picture, sometimes, too, throwing in for good measure a famous natural wonder of the New World, seen in another print, most especially the Natural Bridge in Virginia, which may well have had for Hicks some religious significance, all religion being, in a sense, the building of bridges between humanity and deity.

In the version illustrated, however, it is not the Natural Bridge but a fanciful version of the shore at Philadelphia or New Castle. It is fanciful because of the mountains, a fine scenic addition to any harbor but one singularly out of place along the lower reaches of the Delaware River. In the background is Penn's ship; in the middle ground is the famous scene itself, copied from Benjamin West, with Penn looking much as he has for so long on the oatmeal box; in the foreground in Hick's favorite, "The Peaceable Kingdom," after Isaiah.

Like most primitive painters, Hicks was totally literal even in his imaginative works. The cast of characters follows Isaiah's verses to the smallest detail. The wolf and the lamb are one pair, in the middle right; the leopard and the kid are indeed lying down together, as are, in the upper right of the group, the calf, the young lion and the fatling, this trio being led by a young child. In the lower right corner, the cow and the bear are feeding and toward the center their young ones are lying down together. Above these young, the ox seems to be instructing the docile lion in the eating of straw, while below them the suckling child and the weaned child are respectively engaged with the hole of the asp and the den of the cockatrice, the latter being another snake, mythical in origin, said to live by eating the eggs of the asp.

This theme of Isaiah's, of natural enemies becoming friendly associates, is both the history and the myth of William Penn's colony. He got the land from the English crown in the first place because of a debt owed his father, a great English admiral. But Penn, like his neighbor to the south, Lord Baltimore of Maryland, differed from most of the English colonizers in prescribing freedom of religion rather than an imposed, or established religion, supported by the state and forced by state power upon all citizens. Penn and Baltimore were both moved by the fact that their own religions were decided minorities in England, Baltimore being a Roman Catholic, but both made decisive contributions to what became the American tradition of religious tolerance, the separation of church and state, and the legal equality of all religions, a totally new set of ideas in European history.

In addition to establishing a state of affairs in which the religious lion of the established English church would lie down peacefully with the religious lamb of Quakerism —rather than attempt the suppression which marked the early history of the sect in England—Penn also applied the same general principle to his relations with the Indians who lived on the land he came to claim. Despite his royal charter, he took it as his natural obligation to make terms with the inhabitants. He did so and he abided by those terms, in stark contrast to the overwhelming majority of arrangements between European settlers and the native Americans.

Hicks thus saw, as have many others before and since, the realization in America of visions of a promised land made in the Bible. Amity with the Indians was an inescapable part of such a fulfillment, and while Hicks would certainly put the stress in that relationship upon the opportunity given the Indians to hear the word of God, his picture at least leaves open the possibility of the Europeans gaining something from their friendship with the Indians as well. This, too, is part of the early tradition of relations between whites and Indians, appearing both in Virginia and in Massachusetts, with the Indian gifts of tobacco and corn to the struggling colonists. In our own time it has come to be appreciated that the Indians lived on far more intelligent and sympathetic terms with the American land than the European immigrants have ever managed to do, another gift from the redmen to the whites.

Vanderlyn was different from Hicks in every way.

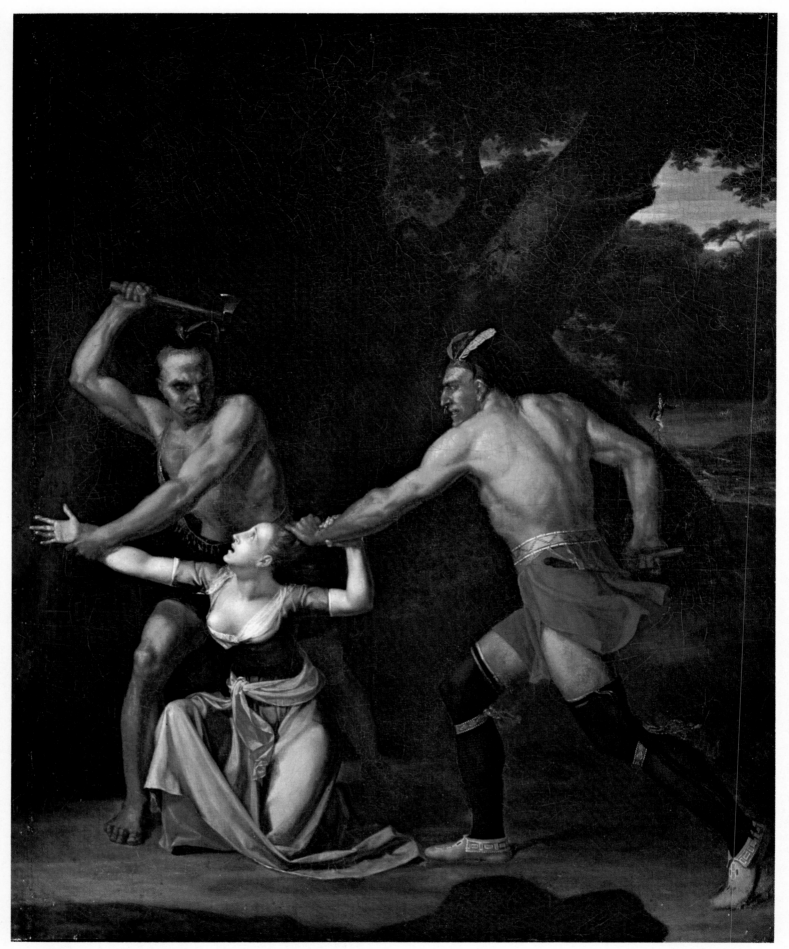

The Death of Jane McCrea, 1804, John Vanderlyn.
32 x 26-1/2 in., oil. Wadsworth Atheneum, Hartford, Connecticut.
Vanderlyn's Neo-Classical view of America's Indians portrays
them as expressions of the savage, uncontrolled side of nature which white
Americans found in the New World and also in themselves.

Member of a Dutch family of painters who had been practicing their craft of portraiture along the Hudson for several generations, Vanderlyn became the most accomplished, most ambitious and most famous member of the clan. By his own ambitions he was, no doubt, a failure, but he moved easily and naturally, by birth and education, in a world of art Hicks hardly knew existed. To say that Vanderlyn was infinitely more sophisticated than Hicks in his general apprehension of the world as in his professional preparation and practice is an inadequate statement, since Hicks did not even know what sophistication was in those fields.

The painting members of his family were what were called, in colonial America, "limners," and were roughly equivalent in the hierarchy of art to the itinerant photographer of a couple of generations ago who came to town and worked his way from house to house making photos of children, sometimes accompanied by a pony on which to pose them. Vanderlyn changed all that abruptly. Born on the eve of the Revolution, he grew up with the new American idea that there were no limits—certainly no inherited limits—as to what an American might make of himself. What Vanderlyn wanted to make of himself was an artist, a full-fledged, well-trained, well-paid, natural aristocrat in the republic of letters and arts.

Loaded with natural talent for an ease in draftsmanship that Hicks never attained, Vanderlyn early caught the attention of the man who became the most important politician in his native New York, Aaron Burr, founder of Tammany Hall, vice-president of the United States, and very largely the author and inventor of American urban politics as it has been practiced ever since. With Burr's patronage, Vanderlyn went to Paris—the first American painter to study there—and, through patient mastery of the fashionable mode of Neo-Classicism introduced by Jacques-Louis David, achieved reputation. Napoleon, inspecting an exhibition, approved a classical theme painted by Vanderlyn and ordered the jurors to give the American the gold medal. Vanderlyn's reputation was made and he enjoyed good fortune in Paris.

But the painter was an American and wanted to live his professional life in his native land. On returning, he enjoyed no such good fortune as he had in Paris. His best painting, a Neoclassical nude, scandalized his fellow-Americans. With the backing of a group of admirers, he erected in New York a circular building to house his three-hundred-and-sixty-degree painting of the gardens of Versailles, but this, too, proved a failure. He obtained a Congressional commission to paint the landing of Columbus for the new Capitol building in Washington, but the commission, largely executed by his assistants in Paris, became a hopeless bog of quibbles over costs. His basic problem seemed to be that, educated in Paris and Rome, he expected New York and Washington to have the same sort of natural acceptance of art that those two ancient cities have. The young Republic had no such acceptance, and most of Vanderlyn's years in America were composed of frustration and irritation.

While still in Paris, in 1804, Vanderlyn painted *The Death of Jane McCrae,* the subject of which had died at the hands of the Indians. This lady lived at Fort Edward, near Troy, New York, and her death, in an odd way, proved to be a decisive factor in one phase of the American Revolution, though she is little remembered today.

In 1777, when the war between England and the American colonies had been going on for a year, General John Burgoyne, who was also moderately successful as a London playwright, led an invasion of the colonies from Canada. He took Ticonderoga and proceeded South. The plan was for Burgoyne to link up with Lord Howe, coming north up the Hudson from New York. When the link-up would be made, obviously, New England would be cut off from the rest of the rebellious colonies and mopping up could begin north and south as it suited the English commanders.

From Ticonderoga, Burgoyne, known as "Gentleman Johnny," presumably because of his theatrical connections, marched south and took Fort Edward, a vital point in the strategy. In the process, however, Jane McCrae was killed, under circumstances that have never been completely cleared up. She was scalped by Indians in alliance with Burgoyne, but the Indians claimed she had already been killed by a stray musket ball in the battle for Ford Edward. Burgoyne, living up to his nickname, was horrified at the death of the woman, and furiously reprimanded the Indians. The result of that was that the Indian allies left the alliance, feeling unjustly used by the British commander. On the other hand, large numbers of colonists in the area, hitherto more or less neutral, were aroused by the news of Jane McCrae's death and flocked to the standard of the United States. The result of these two turns in Burgoyne's fortune was his surrender at Saratoga, a major event in the survival of the new nation. Burgoyne continued to be haunted by the dead Miss McCrae. Returned to England, he found himself under attack by both sides in Parliament, on the one hand for the surrender at Saratoga, on the other for his use of uncivilized and barbarous Indians.

Out of this semi-legend, Vanderlyn made a perfect Neo-Classical myth. The golden light falls upon the forest folk who, from their faces and their dress, seem to be some sort of sub-Romans rather than American Indians. There is a nice compositional use of the arms of victim and murderers and in the distance may be seen Jane McCrae's fiancé hastening—too late—to her rescue.

There are the two poles of the early American sentiment about the Indians. In *The Peaceable Kingdom,* the Indians not only represent the object of Penn's turning from the customary European exploitation of the "under-developed" people of the world; they also represent some of the primal paradise that Hicks saw in Isaiah's prophecy. In Vanderlyn's Neo-Classical rendering of *The Death of Jane McCrae,* the two Indians are the savage, brutish, almost beastial expression of the malevolence of nature, the force of the thunder storm or the earthquake.

Taking these two pictures together and realizing that they do accurately express the extremely mixed feelings of the new Americans toward the old ones, it is not too fanciful to imagine that both images of Indians are also projections by the immigrant Europeans of aspects of their own spiritual reality they are all too conscious of. Under the Puritan morality that came to dominate in the new Republic, the white Americans were on the one hand concerned to keep in check their own savagery, while on the other they yearned toward an imagined pre-lapsarian paradise, where equity and perfect justice governed all relationships. The Indian, a little too conveniently, came to represent both these opposing forces within the white American out to capture a continent while dreaming of perfect peace.

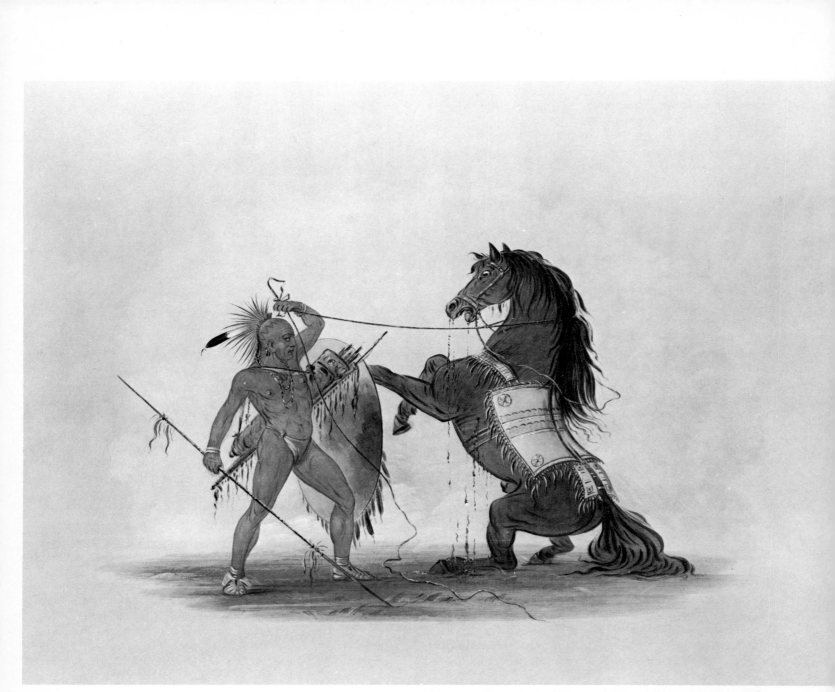

A Pawnee Warrior Sacrificing His Favorite Horse, ca. 1870,
George Catlin. 18-1/2 x 24-1/2 in., oil on cardboard.
National Gallery of Art, gift of Paul Mellon.

FIRST CHAMPION OF THE INDIANS

George Catlin
(1796—1872)

One of the mysteries that strikes anyone interested in the painting and sculpture of the American West is simply why it took so long to get started. Most, not all, of the seaboard states had grand, if somewhat vague, claims to Western lands; the claims, indeed, were one of the great difficulties blocking for a while the union of the states. Citizens of those states had ventured West when the thirteen were still colonies; their venturings and consequent collisions with French-Indian trade interests were the principal cause of the French and Indian War, which began in 1754. Yet an authentic art of the American West did not begin until the 1830's, more than half a century after the new Republic declared its independence.

The most obvious reasons are probably the correct ones. From the point of view of painters in the new nation, although they had thrown off the British yoke, they still largely regarded themselves as British artists. The self-

Pigeon's Egg Head, 1832, George Catlin. 27-3/4 x 23 in., oil.
Courtesy, National Collection of Fine Arts, Smithsonian Institution.

View in the Big Bend of the Upper Missouri, 1832,
George Catlin, 11-1/8 x 14-3/8 in., oil.
Courtesy, National Collection of Fine Arts, Smithsonian Institution.
From 1830 to 1836 Catlin roamed the Western territories
owned by the States and the still-trusting Plains Indians.

taught itinerant portrait painters, the so-called "limners," of the seventeenth century and early eighteenth century had been replaced, by the time of the Revolution, by a growing group of extremely competent artists, most of them portrait painters but some of them with ambitions for the "higher" form of history painting, by which was meant both the painting of historical events and the painting of events in the Bible. But that first generation of American great artists were all firmly oriented toward England as to the artistic motherland. The oldest of them, Benjamin West, moved to London well before the Revolution and his studio there became the training ground for numerous Americans before, during and after the Revolution. The finest American painter of the end of the colonial period was John Singleton Copley, who, due to the influence of his Tory father-in-law, went to England on the eve of the Revolution and became an established English artist. Gilbert Stuart, probably the best known artist of the period, also spent long years in England before coming home to settle down as the painter of portraits of George Washington for every patriot who wanted one. Thus, besides being oriented toward England,

back across the Atlantic instead of over the mountains and across the plains, the art of the late colonial and early republican periods was strongly biased in favor of elegant portraits of the urban rich on the one hand and, on the other, of grand pictures of historical or Biblical events. No market existed for either of these commodities away from the string of cities and great plantations along the Eastern coast.

In addition, from the very first settlements onward, the American wilderness had been regarded by most Americans as a place of danger. Sudden death lurked everywhere for the new Americans of the seventeenth century, from the strange, savage Indians, from the wild beasts, from snakes and insects, even from poisonous plants, to say nothing of natural catastrophes of all sorts. The wilderness was there not to be admired but to be subjected, to be made into an extension of civilization and cultivation. It was only when that attitude had changed profoundly that American painters were able to

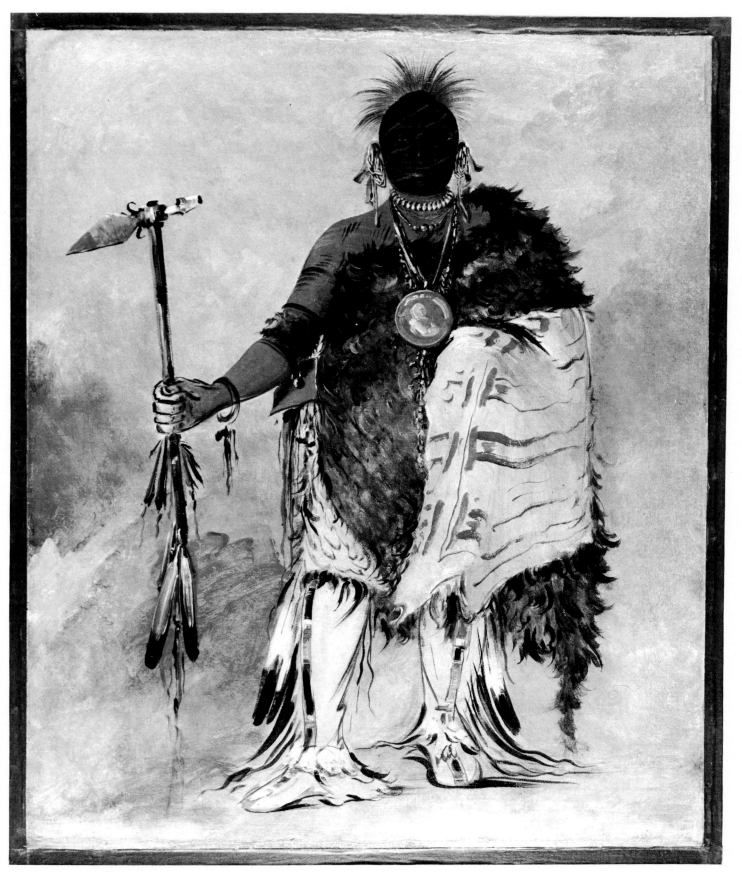

Om-pa-ton-ga, The Big Elk, Chief of the Omahas, 1833, George Catlin.
Courtesy, National Collection of Fine Arts, Smithsonian Institution.

tackle the greatest natural subject ever presented to a nation's artists, the American West.

That attitude did change and change almost abruptly in the third decade of the nineteenth century. The Romantic Revolution of Europe, which made possible the success of Byron, Shelley, Keats and Wordsworth, arrived in America, a little late, to be sure, in the form of the nature poems of William Cullen Bryant, the Noble Savage novels of James Fenimore Cooper and a whole new and immensely popular approach to the art of painting. This was named for its first locale of subjects, the Hudson River School.

The Hudson River painters at once manifested and furthered a total change in the American attitude toward the wilderness. Instead of the menace it was formerly thought to be, it now became a place of romantic, even mystical, appeal. Poets and painters alike based their work on a kind of homemade bosky pantheism, in the light of which God was more accessible in the unpeopled glens of the forests and in the sparkling waters of mountain streams then He could possibly be in the crowded streets of the city. Starting in 1825, Thomas Cole and Asher Durand were the first of a long and distinguished list of nineteenth-century American painters concerned with the American wilderness, at first in the gentle slopes and almost toylike peaks and pinnacles of the Catskills, but before long in the rugged grandeur of the Rocky Mountains. Inevitably, this change in attitude toward the wilderness as a subject for art produced a corresponding change of attitude toward the West.

Of the first four artists to paint the West on any substantial scale, George Catlin deserves to be first on several counts. He was the oldest, for one thing, being roughly a dozen years older than the other three, Alfred Jacob Miller, Karl Bodmer and Seth Eastman. He was also by far the most faithful to his chosen theme. He lived a long life and he devoted all of it, unstintingly, to the American West and particularly the American Indian of the West, once he made his original determination to do so. Finally, he was the only one of the four to take the West as his subject entirely on his own inspiration. The other three were hired hands for the Western expeditions of other people, including the United States Government, which was Eastman's employer for half a century. Catlin went West on his own volition, following his own dream and joining or dropping out of expeditions strictly in furtherance of his own aims.

His aims were ambitious and well they might be, for they were formulated following an experience that, in its intensity of feeling at the time and in its enduring effects on the subject's life, can only be likened to a religous conversion. At that moment of revelation on the streets of Philadelphia, George Catlin was gripped by a force outside himself just as was St. Paul on the road to Damascus.

Catlin had, to be sure, prepared himself for some such revelation. He was looking for it when it happened, but he certainly had no idea of whence it would come or what it would do to his life.

Born in Wilkes-Barre, Pennsylvania, Catlin had in the very place of his birth some of the elements of the West and particularly of his own preoccupation, the Indian. The city, on the Susquehanna River in the Wyoming

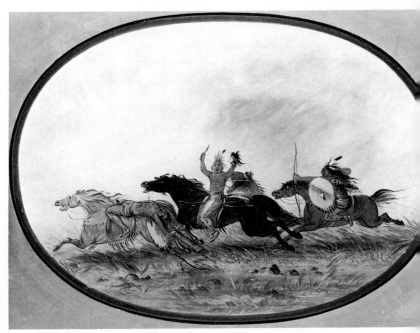

The Scalper Scalped — Cheyennes and Pawnees, ca. 1870, George Catlin. 18-1/2 x 24-1/2 in., oil on cardboard. National Gallery of Art, gift of Paul Mellon.

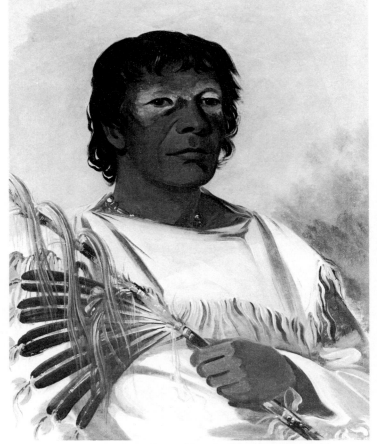

Wah-pe-kee-suck, the White Cloud, "Prophet" and Counselor to Black Hawk, 1832, George Catlin. 29 x 24 in., oil. Courtesy, National Collection of Fine Arts, Smithsonian Institution.

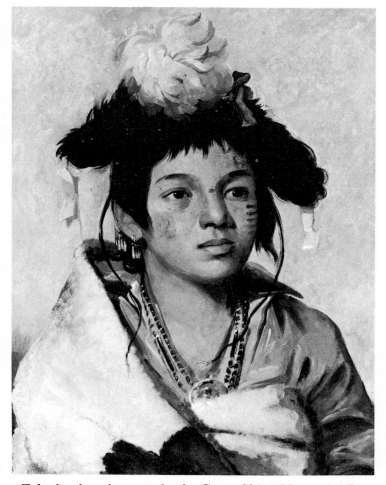

Teha-kauks-o-ko-maugh, the Great Chief, Menomini Boy, 1836, George Catlin. 21-1/8 x 16-7/16 in., oil. Courtesy, National Collection of Fine Arts, Smithsonian Institution.

Valley, was settled in 1769 as part of a land grant operation working out of Connecticut. Wilkes-Barre may not seem very far west, but it was so from the point of view of Connecticut. The early history of the city also illustrates the tangled claims of the several colonies which persisted when they became states. Connecticut claimed that its parallel northern and southern borders extended legally in a narrow swath all the way to the Western Ocean, wherever that might turn out to be. This obviously included Wilkes-Barre, which was named, in what may be the only such deviation from the established pattern of settlements named for reigning monarchs, supporting aristocrats or the actual pioneer leaders themselves, for two members of the British Parliament who were staunch advocates of the American cause in the continuing debates on the subject in the years immediately before the Revolution. In 1776, a fort was built on the site as a defense against the Indians of the area. Between then and the year of Catlin's birth, Wilkes-Barre was twice destroyed by fire at the hands of Indians and British rangers and in a small war between Pennsylvanians and Connecticut Yankees. The conflicting claims between the two states were not settled until after the Revolution only a few years before Catlin's birth.

Catlin at first thought he would be a lawyer and, under the free and easy ways of the bar at the time, actually succeeded in practicing law for a couple of years. He had a talent for drawing, however, and taught himself to paint by studying the pictures in private Philadelphia collections as well as in the Peale Museum, the nation's first natural history museum, which originally occupied space in Independence Hall. By the mid-1820's, he had given up law altogether and was supporting himself and his wife successfully by painting portraits. He developed a special flair for miniature portraits on ivory, then very popular. At the same time, however, he consciously declared, upon setting himself up as an artist, that he was determined to find some great theme that would make his art a worthy practice for him. This rather grand declaration links Catlin with his eighteenth-century origins, but the manner in which his aspiration embodied itself was strictly of the new epoch, of the democratic age and of the suddenly discovered American frontier.

Standing in the street in Philadelphia one day, shortly after his election to membership in the Pennsylvania Academy in 1824, the young Catlin noticed a delegation of Indians from the Far West passing through town on their way to conduct treaty negotiations in Washington. The painter was struck by the majesty of their bearing, the fineness of their vision, the nobility of their carriage. He wrote of that moment as follows:

"In silent and stoic dignity these lords of the forest strutted about the city for a few days, wrapped in their pictured robes, with their brows plumed with the quills of the war-eagle, attracting the gaze and admiration of all who beheld them. After this, they took their departure for Washington City, and I was left to reflect and regret, which I did long and deeply, until I came to the following deductions and conclusions.

"Black and blue cloth and civilization are destined, not only to veil, but to obliterate the grace and beauty of Nature. Man, in the simplicity and loftiness of his nature, unrestrained and unfettered by the disguises of art, is surely the most beautiful model for the painter—and the country from which he hails is unquestionably the best study or school of the arts in the world; such I am sure, from the models I have seen, is the wilderness of North America. . . . The history and customs of such a people, preserved by pictorial illustrations, are themes worthy of the lifetime of one man, and nothing short of the loss of my life shall prevent me from visiting their country, and of becoming their historian."

The statement is interesting for several reasons, not the least being that Catlin actually did devote "the lifetime of one man" to "becoming their historian." But the first sentence shows that Catlin, undoubtedly in common with most other Philadelphians and indeed most other seaboard Americans at the time, thought of Indians in the familiar, Woodland sense, the forest pedestrians who go padding through the trails of James Fenimore Cooper's upstate New York Indian country. He had at that time, obviously, no idea of the vast differences he was to discover and document among the Plains Indians, then at the very peak of their power, the fullest development of their "grace and beauty of Nature." The third point of interest is that Catlin was already aware that the Indians, in their primal state, were doomed by contact with the whites: "Black and blue cloth and civilization were destined, not

(continued on page 36)

33

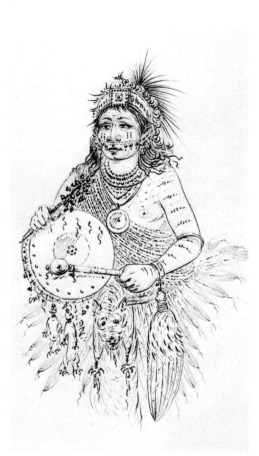

Sioux Medicine Man,
after 1850, George Catlin.
14 x 10 in., blue ink and pencil.
Courtesy, The Newberry Library,
Ayer Collection.

The Bull Dance, Mandan O-kee-pa, n. d.,
George Catlin. 22-5/8 x 27-5/8 in., oil.
Courtesy, National Collection
of Fine Arts, Smithsonian Institution.

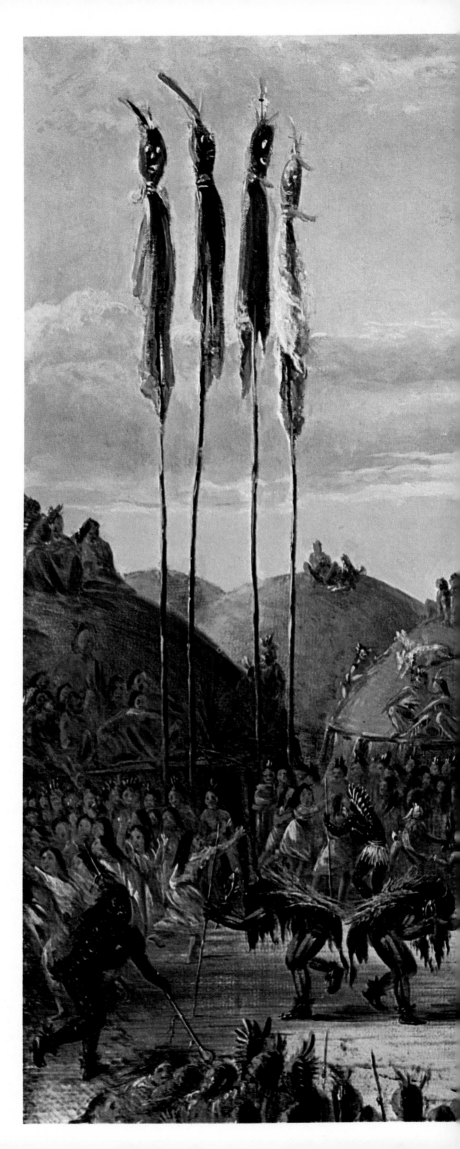

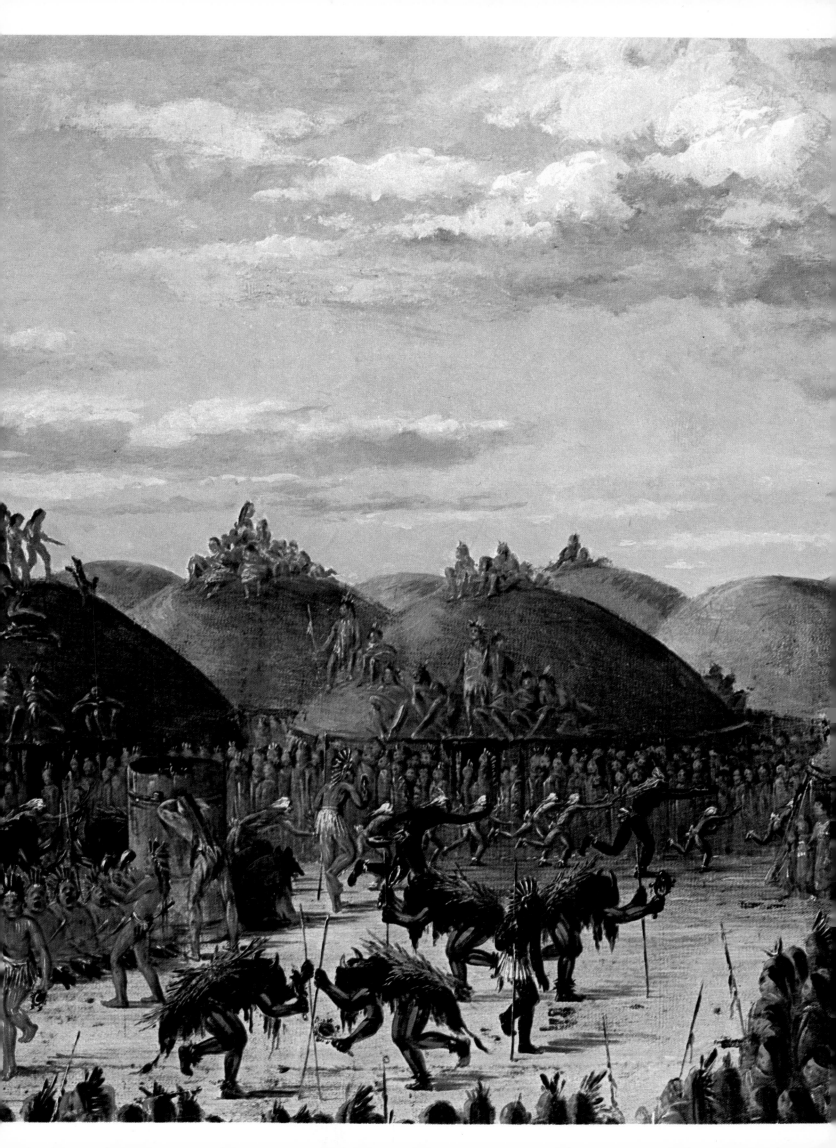

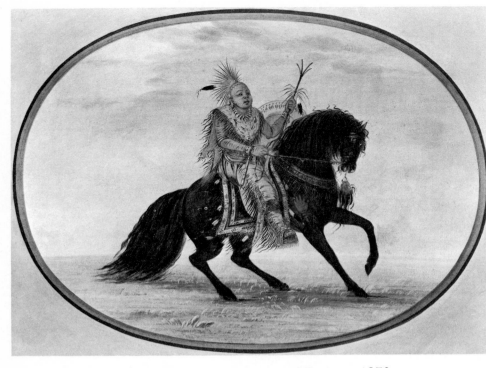

The Running Fox on a Fine Horse — Sauk and Fox, ca. 1870, George Catlin. 18-1/2 x 24-1/2 in., oil on cardboard. National Gallery of Art, gift of Paul Mellon.

only to veil, but to obliterate" the natural dignity and power he so admired on the streets of Philadelphia.

The young Republic was then, as it was to continue to be for decades in the future, involved in treaty negotiations with the Indian tribes, or Nations, as we called them in order to conform with European usage. That, after all, was the mission to Washington of the very Indians Catlin was so struck with. Treaty arrangements always imply that both parties recognize the independent, sovereign existence of each other. Treaties imply, too, that such mutual existence is, to some extent at least, mutually guaranteed, short of the claims of an actual alliance. The United States Government, apparently in good faith, professed to believe it was dealing with sovereign nations, the integrity of which it respected. Catlin's prophecy is almost as if he foresaw what Indian spokesman have called "The Trail of Broken Treaties." At any rate, the young painter was keenly aware that the Indians' natural state was nearing its end, its submergence in "black and blue cloth." That awareness sharpened his determination to get there as soon as he could and to record what he saw for those who would live after it had ceased to be.

For all that sharpening of determination, Catlin did not drop everything and rush pell-mell to the wilderness. He continued painting in his accustomed manner and two years later, in 1826, was gratified to be elected to the recently organized National Academy of Design in New York City. At that time, his double status as an Academician of both Pennsylvania and the National was a decided, almost measurable, business asset for an artist, somewhere between union membership in the construction trades and membership in the local bar association or

Chippewa Sage, after 1850, George Catlin. 14 x 10 in., blue ink and pencil. Courtesy, The Newberry Library, Ayer Collection.

medical society today. No force of law was invoked, as it is for unions and the legal and medical professional groups, but the picture buying public expected higher priced artists to be recognized, as Catlin now was, by their peers. Thus certified, the Philadelphian began taking trips to the Indian reservations already established in western New York state. These journeys of exploration and sketching were in some degree rehearsals for Catlin's great travels through the West, but he could not but have been impressed—or depressed—by the change in status, in bearing, in spirit, between the proud and sovereign envoys he had seen en route to deal with the United States Government as with an equal, and the kept, or tame, Indians of the new reservations.

Four years later, in 1830, all his preparations were complete and Catlin launched out from Philadelphia, from his solidly successful career as a portrait artist in a society with a lively market for portraits, from his wife, and into the wilderness. Even then, however, Catlin moved with prudence and circumspection. From Philadelphia he traveled to St. Louis, where he presented himself to General William Clark, the famous explorer and co-leader of the Lewis and Clark Expedition to the Pacific in 1803-1806, commissioned by President Thomas Jefferson.

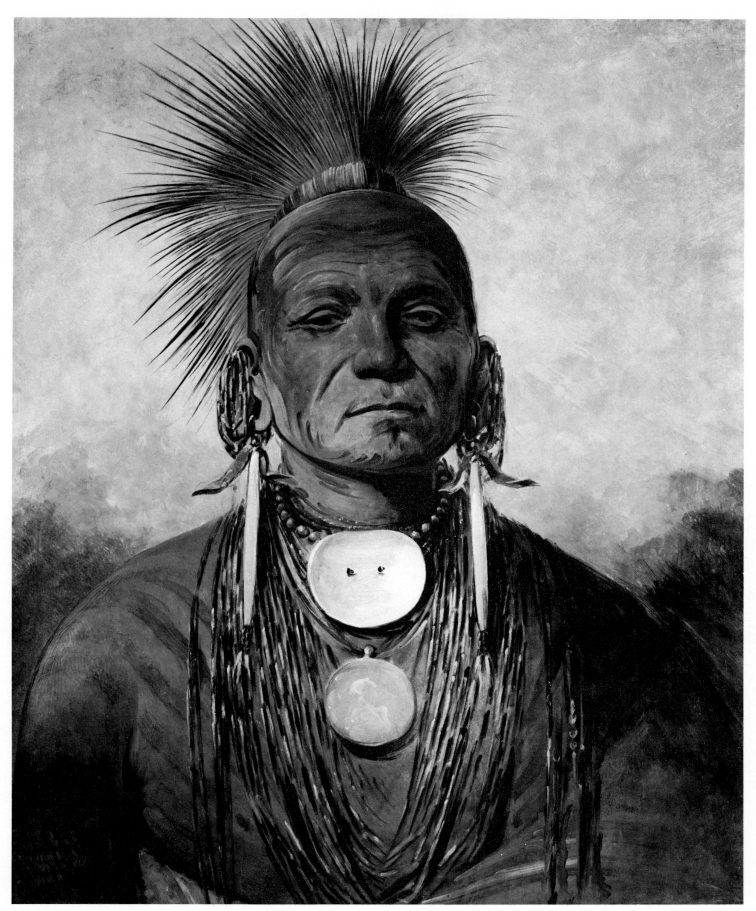

See-non-ty-a, an Iowa Medicine Man, ca. 1870,
George Catlin. 28 x 22-7/8 in., oil.
National Gallery of Art, gift of Paul Mellon.

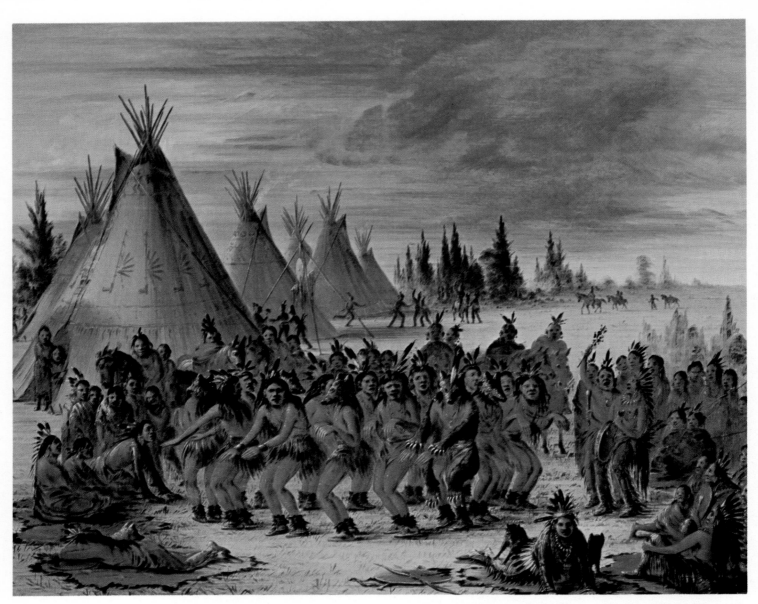

Sioux Bear Dance, 1847, George Catlin. 25 x 32 in., oil.
Thomas Gilcrease Institute of American History and Art, Tulsa.
Though Catlin did not intend sensationalism, his paintings of Indian
dances are wonderfully strange, for he emphasized what he felt was
the key to their character — mystery and supernaturalism.

St. Louis was then the jumping-off point for the West, but the city was also extremely interesting in itself as a kind of prophecy of the mixture of peoples the West itself would become. Originally French, named for the French king who led a Crusade, the city, by the time Catlin got there, had been heavily inhabited by Virginians, including General Clark, and by Germans, whose influence to this day is stronger in St. Louis than that of the original French. Clark, after his extraordinary journey to the Pacific and back, had settled in to life in St. Louis in the post of governor of the Missouri Territory. After Missouri became a state, Clark became regional commissioner of Indian Affairs, the ideal officer for Catlin, with his stated intentions, to report to and work with. For a couple of months, Catlin geared himself up to his grand design by painting portraits of Indian delegations who came to St. Louis to negotiate with Clark. Then, in July of 1830, he traveled with General Clark to Prairie du Chien (Wisconsin) on a diplomatic mission to the Indians. Later that year, he voyaged up the lower Missouri to observe and paint the Kansas tribe. His career with the Indians had fairly begun.

In terms of active service, it was a short career, but it was intensely pursued and it was followed by the rest of Catlin's life in service to the cause of recognition for the Indians not only of their virtues but of their very existence. It is true that Catlin's advocacy of the Indians was always intimately tied up with his advocacy of various forms of government subsidy for himself, but his logic was impeccable: he was indeed the only artist around who was making or, later, had made, the record of the original inhabitants of the American continent. Government subsidy to him, on the pattern now universally accepted in agriculture and weaponry, was clearly a boon to society, anthropology, foreign relations (the Indians being foreigners), natural history and, not least, to art. Meanwhile, there was the work on which Catlin's claim, never granted, for government support, rested. From 1830 to 1836, he roamed the territories of the expanding Republic and the still largely unsuspicious Plains Indians. He did not come, for the most part, with military company, or indeed with any company. He mastered the Indian art of

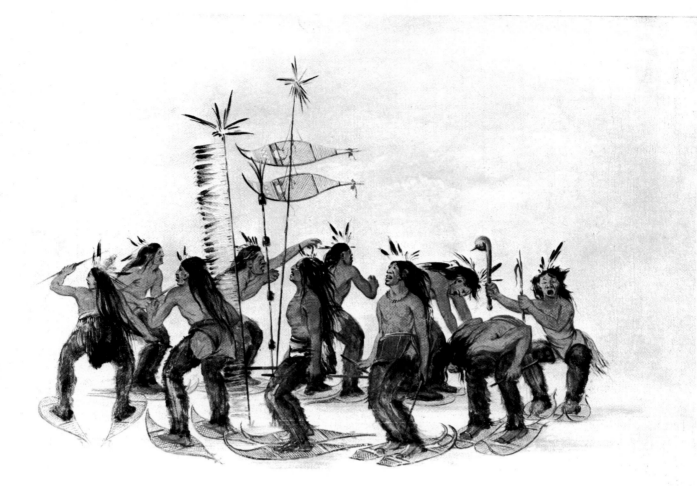

Snowshoe Dance at First Snowfall, 1835,
George Catlin. 19-1/2 x 27 in., oil.
Courtesy, National Collection of Fine Arts,
Smithsonian Institution.

canoeing and traveled by water whenever he could. He rode, of course, as all people of his time did. Between horseback and birchbark vessel he covered vast tracts of the territories.

Following his initial trips of 1830, he traveled as follows: in 1832, with the expedition led by Major John Dougherty, he went up the Platte River, a major tributary of the Missouri, which winds through Nebraska, Colorado and Wyoming. In 1832, spring, he headed up the Missouri itself as far as Fort Union on the steamboat *Yellowstone*, run by John Jacob Astor's fur trading company, and returned downriver alone in a canoe. In 1833 he may or may not have visited the Great Salt Lake of Utah. (The chronology is confused.) But that summer and autumn he was back in Cincinnati exhibiting for the first time his paintings of Indians and Indian life to a relatively settled, non-frontier community. In 1834, he advanced to Fort Gibson, from where with a detachment of Dragoons, he set out for Comanche territory up the Red River. The following year, he spent time up the river with the Chippewas. In 1836, with time running out on his Western stay, he exhibited some Indian portraits in Buffalo. During the good months, he went to the Sacred Pipestone Quarries, making a subsidiary voyage to Rock Island, Illinois, where the Sauk and Fox Indians were making treaty agreements with Colonel Dodge. That winter, Catlin retreated as far east as Albany, where he passed the bad weather completing his paintings begun in the field and making others from his numerous sketches. As things turned out, 1836 was the last year Catlin spent actually living with, painting and recording the way of the Indians. On the basis of those half dozen years, from 1830 to 1836, he was to live for most of the second half of his life completing pictures of which he had made sketches, making copies of pictures made on the spot, writing books and articles, and, above all, creating and exhibiting his "Indian Museum" in the United States and Europe.

Catlin was also, inadvertently, a generation ahead of the French and later the American painters who made a particular virtue out of painting in the open air the subjects as they saw them. The traditional method of the landscape artist was to observe a natural scene closely, to sketch it in charcoal or crayon on the spot, writing in color notes, and then return to his studio to lay out his landscape composition on a stretched canvas, block in the main forms and complete the painting according to his own studio methods, including, usually, a final coat or two of varnish, sometimes applied after the painting was hung in an exhibition, from which we get the term "vernissage," or literally "varnishing," meaning a private party for friends of the artist during which he applied the last, transparent coat of varnish.

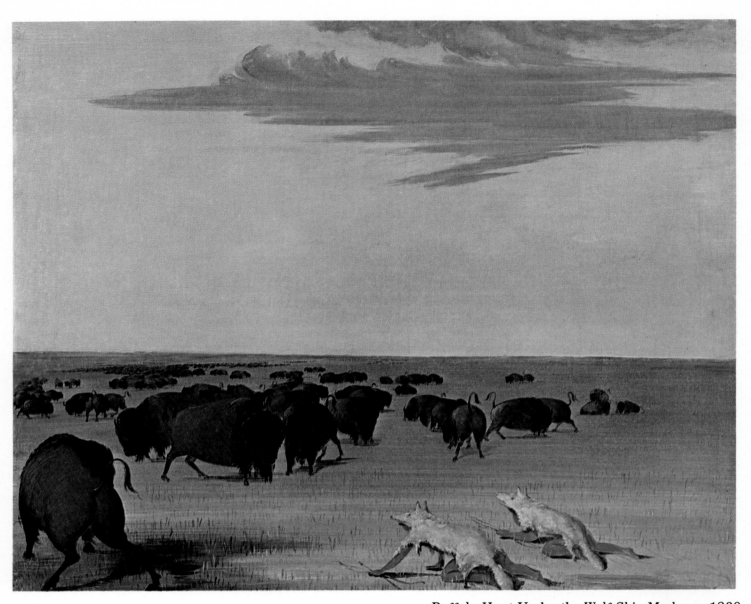

Buffalo Hunt Under the Wolf-Skin Mask, ca. 1830,
George Catlin. 22-5/8 x 27-5/8 in., oil.
Courtesy, National Collection of Fine Arts, Smithsonian Institution.
Warriors disguised themselves under wolf skins in order both to
surprise the buffalo and to prepare themselves almost religiously
with wolflike stealth, courage, speed and accuracy in the hunt.

The French Impressionists and to some extent their immediate predecessors, the Barbizon painters, changed all that. They began, in the 1860's and continuing for more than half a century, setting up their easels right out there in the meadows, on the beaches, along the Seine, in their own gardens, and painting the scenes before them in the natural light. This was a profound revolution in artistic practice, which had always assumed that the even, clear, cool, north light of the studio was the best, even the only, light to paint by. Catlin, simply because he had no choice, began painting in the open air a full generation, some thirty years, before the French Impressionists discovered the method.

His intention, of course, was not as artistically sophisticated as theirs, nor were his means as artistically pure. Painting not only in camps on the plains and along the rivers but also while drifting downstream in a canoe and even, according to his own account, occasionally on horseback, Catlin devised a number of necessary economies to make his unique methods possible. For one thing, he severely limited his palette, that is, the number

of colors he had to work with. The studio artist, or even the open-air artist of later in the century working in such thoroughly civilized and accessible outdoor places as the "forest" at Barbizon, for centuries a royal park, had the range of his colors and shades of colors limited only by the state of the art of color making, which had already progressed beyond the earth and vegetable colors of tradition to the beginnings of the chemistry which gives today's painter a virtual infinity of choice.

Moreover, just as the fashionable and therefore busy portrait painters of the East Coast and of England often shortened their labors by starting with canvases primed with a coat of flesh tones, so Catlin, in observing the untamed landscape he was passing through, devised a method of pre-painting his surfaces with an abstract, undifferentiated blue above for the sky, an abstract, undifferentiated green below for the grassy plains, with the horizon line customarily a little hazy. In painting an actual scene, he would not only add the figures of the Indians in action or the animals he saw, but also cloud formations above and specific topographical features below. In the

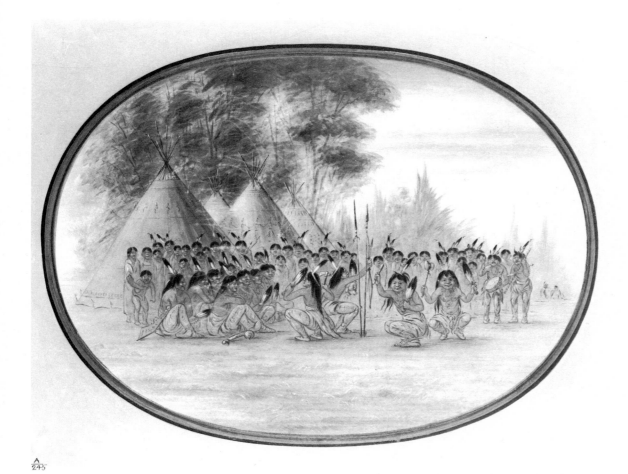

Eagle Dance — Choctaw, ca. 1870, George Catlin.
18-1/2 x 24-1/2 in., oil on cardboard.
National Gallery of Art, gift of Paul Mellon.

view of most painters and probably all art teachers, this is no way to capture the true feeling of a stretch of landscape or indeed of anything else. Yet we do have a feeling of overwhelming authenticity in looking at an early Catlin Indian picture, such as *Buffalo Hunt Under the Wolf-Skin Mask.*

The high, somewhat chilly sky, broken by the scattered clouds which are now blue themselves, though Catlin certainly painted them white, and green grassy plain give a sense of the immense distances confronted by the painter and by all easterners venturing West in those early years. The open space is not hostile, exactly, but it is certainly not welcoming or friendly. Catlin very carefully created the feeling of great distance not only by the diminishing size of the grazing buffalo—the most distant ones are merely a thin, brown line just below the horizon —but also by a definite but subtle progression in the greens of the grass. The grass itself is hardly rendered at all; there are merely a few vertical sprouts between the Indian hunters and the nearest buffalo, down in the left-hand corner of the picture. But he had seen and was careful to report visually that the grass close to the eye is actually a greenish yellow, that it only becomes full green at a distance, becoming deeper the farther away it is from the eye.

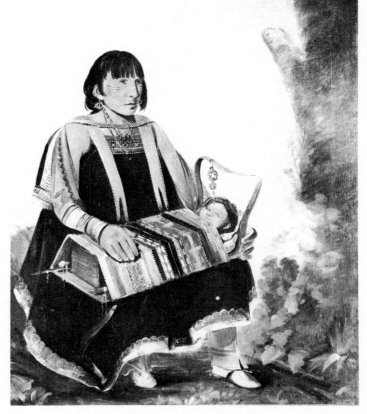

Ojibway (Chippewa) Woman and Baby, 1834,
George Catlin. 29 x 24 in., oil.
Courtesy, National Collection of Fine Arts,
Smithsonian Institution.

41

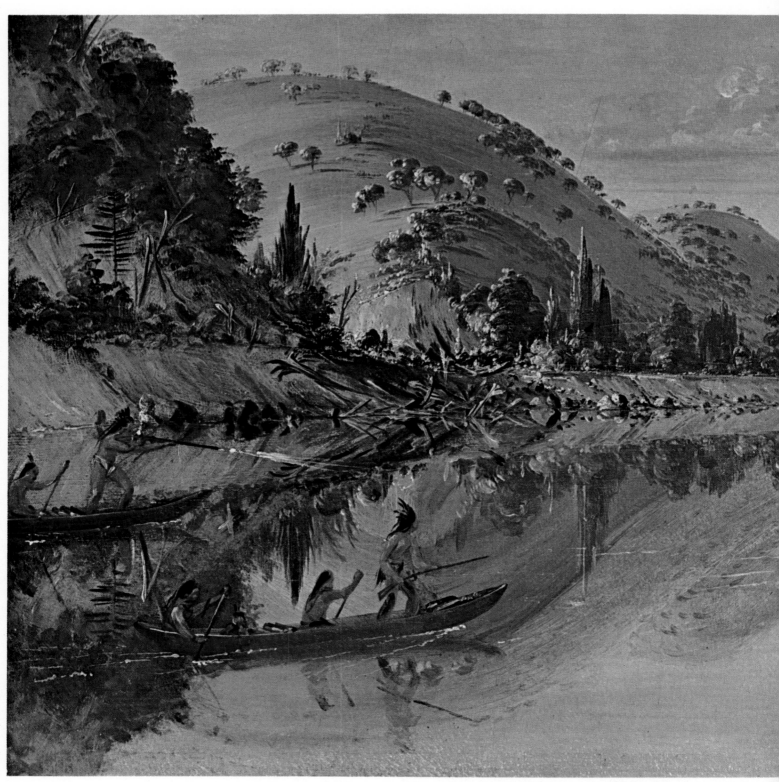

Sioux Indians Pursuing a Stag in Their Canoes, 1836,
George Catlin. 19-1/2 x 27-5/8 in., oil.
Courtesy, National Collection of Fine Arts, Smithsonian Institution.
The large, triangular forms of Catlin's composition — also the form
of an arrow — point off to the right, to where the stag is fleeing,
to the infinity and freedom, perhaps, of the West.

The method of hunting the buffalo here depicted was an ancient one and was passing out just as Catlin was moving in to Indian country. The warriors, naked save for the breech-clout and the covering of wolf skins, approach the herd on hands and knees armed only with the traditional bow and arrow. As the horse became available to the Plains Indians, the method of buffalo hunting changed radically; the coming of the horse, in fact, changed every aspect of Indian life. The horse, Spanish in origin in the American West, gone wild and

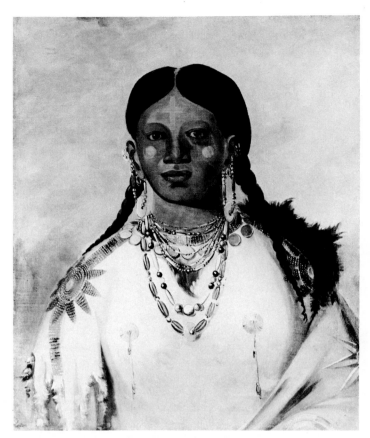

Tis-se-woo-ha-tis, She Who Bathes Her Knees, Wife of a Cheyenne Chief, 1834, George Catlin. 29 x 24 in., oil. Courtesy, National Collection of Fine Arts, Smithsonian Institution.

grown smaller into the typical Indian "pony," began entering the territory that became the United States by the beginning of the seventeenth century, coming up through Texas and Oklahoma and being found east to the Mississippi by the end of that century. By the time of the American Revolution, this liberated and mutated Spanish horse lived and bred in wild herds from Canada to the Gulf of Mexico, from the eastern slopes of the Rockies to the great river.

Once the Indians had horses, buffalo hunting became the most exciting, demanding and psychologically as well as nutritionally rewarding species of classic hunt ever known to mankind. Typically, a tribe would set out to insure its entire supply of meat for the winter in a single, prolonged assault on the herd in autumn, after the summer's grazing had fattened the buffalo and the bulls were still moving with the herd. The hunt was a community activity based on both individual prowess in riding sharply into a racing herd and shooting the leaders and on driving the entire herd to its destruction off the edge of a cliff or into an elaborately constructed pitfall.

The bow-and-arrow hunters crawling toward the herd on their hands and knees in Catlin's painting were wearing the wolf skins not only for the obvious tactical advantage of disguise-surprise but also for psychological and religious reasons. Unquestionably, in the very beginning of the relationship between the Plains Indians and the great herds, the hunters noted that the wolves were superb buffalo hunters, racing with the herd, or getting upwind and approaching unobserved, then springing to the back of the beast and going for the throat and death. Since the wolf could be the sacred animal, or totem, of a tribe, a family or an individual, wearing the wolf skin in the hunt could be basically a religious observance. Somewhere between religion and practical psychology, the warrior thus accoutered might expect that the valued characteristics of the wolf as buffalo hunter—stealth, courage, speed, accuracy and endurance—might enter into him as a result of wearing the predator's skin.

Another hunting scene painted six years later, at the end of Catlin's stay among the Indians, shows at once the

improvement in the painter's basic approach to the land-scape of the plains, in this case the hills, and his highly developed sympathy of movement and poise with the people of the Plains. *Sioux Indians Pursuing a Stag in Their Canoes*, 1836, is in every way a superior picture to the *Buffalo Hunt* of 1830 or thereabouts. The terrain has dictated the impossibility of Catlin's device of pre-painted sky and grass, blue and green. The perfect, moundlike hills, to be found along both the Missouri and the Upper Mississippi, create a semi-enclosed space in contrast to the infinite, open space of the earlier picture. The hills and the flat stretch along the bank of the river are painted with great attention to the feeling, if not the detail, of the foliage. The hunt is taking place either early or late in the day, as we see from the lengthened shadows of the trees upon the grass and from the special brightness of the sunny side of all the foliage. The hills are reflected in the water, but not perfectly, only roughly, with a loss of precision that is normal except in the most still waters. It is almost as if the reflection represented Catlin's earlier, rough-and-ready, blocking out, sketching-in methods, while the real ensemble of trees, hills and embankment represented his skill at its highest development.

Against this superbly painted setting, two canoes of Indians are seen in pursuit of the swimming stag. Each vessel has two men working the paddles—the sternmost paddler in the upper canoe is cut off by the edge of the picture, but he has to be there or the single paddler would be more to the stern himself—and one rifleman standing erect. The rifleman in the farther canoe is just firing, the one in the nearer canoe is awaiting a good shot at the quarry. The bent knees of both riflemen indicate the sharpened skill required to stand and fire in the bow of a canoe, a skill appreciated by anyone who has so much as attempted to change positions in the classic Indian craft.

In terms of composition and the inner meaning of composition, the picture is one of the most interesting in Catlin's entire work. There is still a center line, the equivalent of the horizon in the earlier picture. This equatorial line is that of the river bank. Due to adjust-ments toward the left, the upper line of the bank goes almost straight across the painting, equally distant from top and bottom at both left and right. The actual water line, however, curves considerably to make a diagonal rising from low on the left to high on the right. This implies a curve in the river, but it also implies a good deal more than that. The green hills of reality and of reflection are above and below a more yellowish embankment, above and below the water line. Toward the right, the direction in which the stag is swimming and the Indians are pursuing, that embankment grows ever paler, becom-ing a kind of dirtied white at the right-hand edge of the picture. Toward the left, on the contrary, that band becomes darker and darker, ending in a red-brown solid form broken by the light picked up by tree stumps along the water's edge. Of the two boats, one is actually poised against this red-brown embankment which, in fact, echoes the skin coloring of the Indians themselves. The other boat is out from the camouflage-identity union with the embankment: It and its passengers stand out clearly against the reflected greens.

All of this adds up to several things. In the first place, there is a kind of symbolism of the bow-and-arrow sur-viving in the basic forms of the picture even though the

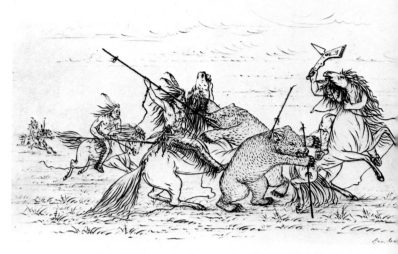

Indians Attacking Grizzly Bears, n.d., George Catlin. New York Historical Society, New York.

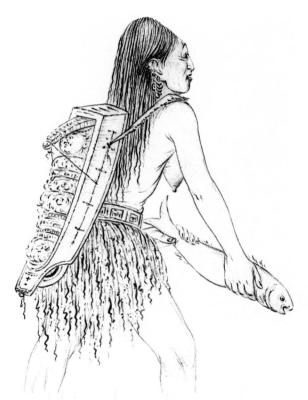

Flathead Woman, after 1850, George Catlin. 14 x 10 in., blue ink and pencil. Courtesy, The Newberry Library, Ayer Collection.

Indians portrayed are using the white man's rifle in their traditional hunt by water. The arching hills describe a double bow form; the progression from left to right of the embankment from the large red-brown dirt area to the thin and elongated yellow-green to yellow-white area is a rough representation of the arrow from feathers to the pointed head. Thus, in Catlin's late view of the hunt, the ancient ways survive in the modern methods.

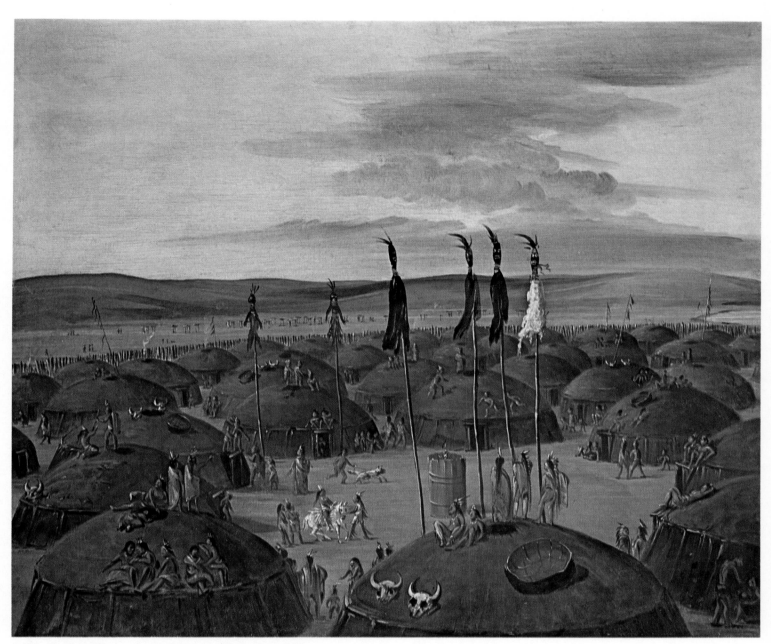

A Bird's-Eye View of the Mandan Village, 1832,
George Catlin. 19-1/2 x 27-5/8 in., oil.
Courtesy, National Collection of Fine Arts,
Smithsonian Institution.
Catlin's affection for his Indian subjects and their way
of life is clear in this intimate view of a Mandan village
settled among peaceful green hills.

Again, the whole direction of the hunt is toward a kind of infinity considerably more directed and specific than the generalized infinity of the horizon in the earlier picture. Here, the hills, the water, the swimming stag and the two canoes all point in one direction, left to right and toward a kind of contained infinity: Down the river, the subconscious message of the composition tells us, is freedom, is open country, is infinity. This, of course, was Catlin's whole message to his fellow urbanites back along the Eastern seaboard: There is a fresh, glorious world out there in the West; we immigrants from the East are going to destroy it; the process has already begun and is irreversible. But look while you can at the image of that world of freedom and infinity which we will so shortly measure and contain and thus destroy.

That feeling is still only implicit in *A Bird's-Eye View of the Mandan Village,* painted by Catlin in 1832. The Mandans lived west of the Upper Mississippi on the northern Great Plains. Catlin gained acceptance there, as he did with all the tribes he encountered, by his open, direct honesty, his simple statement of purpose, his obvious lack of guile or of any perceptible purpose beyond his statement. The Mandans, like the other Indians he traveled among, were intrigued by his talent, thinking the creation of painted likenesses akin to magic, and won over by his simplicity and sympathy. Catlin shows the characteristic wood frame, mud surface houses of the Mandan people, their tribal emblems high in the air on poles, the palisades of cut logs around the village and the rich, varied rooftop life, complete with buffalo skulls, grain-drying devices, sunbathing, conversations, amorous dalliance and even games of tag. The implied infinity of the landscape is present, but its terrors, perhaps even its opportunities, have been successfully held at bay by the rugged palisade fence around the village.

Evidence of Catlin's total acceptance by the Indian tribes he moved among is plentiful in the pictures themselves, especially those depicting secret rites and ceremonies hardly even heard of by other white men, let alone witnessed and recorded.

Self-Torture in the Mandan Okipa Ceremony is such a painting. Catlin's quiet, matter-of-fact composition, based on the sturdy construction of the lodge, provides a telling contrast to the grisly spectacle of the two braves suspended by thongs piercing their skin. The warriors of the tribe and the chief and the medicine man sit and chant in their full ceremonial paint. The shields of the warriors are hung around the wall while the two suspended braves, who seem to have passed into unconsciousness, have their own shields and lances attached to their arms, their arms and legs being pierced by darts. Catlin was no anthropologist, but he was an accurate observer. The ceremony he witnessed in this picture was one of many forms of endurance testing undergone by the Plains Indians in the process of gaining acceptance as full-fledged, adult, hunting and fighting members of the tribe. In other ceremonies and other tribes, young braves would isolate themselves in high or desert places, or stand unmoving from dawn to dusk.

The endurance element of such feats is obvious, although the white mind at first shrinks from the idea. The Indian warrior led a hard, often painful life in intimate relation to the earth and the weather. He was often at war with neighboring tribes, and in Catlin's time there were already intimations of the long and all but genocidal wars the whites were preparing to make against the Indians for the rest of the century. The aspiring warrior himself wanted nothing so much as to prove his ability to endure—and more than that to acquire that ability. The initiation ceremonies involving what Catlin called self-torture at once provided an exercise in endurance and demonstration of its attainment. Like the individual warrior, the tribe itself, as a community, had a vital stake in the fine tuning, as it were, of the young brave's abilities to endure pain and to survive bodily injury.

But there was usually, perhaps always, another aspect to such tests of endurance and it was at least as important as the "certification" process that seems so apparent. This came from the fact that "self-torture" provided Indians with a means, rigorous but effective, of achieving the experience of communion with a felt presence of some spiritual being. This presence has been conventionally described in white literature as the "Great Spirit" and as analagous to God in the Judaeo-Christian tradition, but the analogy is somewhat misleading. The spirit in question was more often the spirit of the tribe, sometimes in the form of its totem animal or bird. In trance induced by "self-torture," as in trance induced by fasting, by standing motionless, by solitude, the Indian might hope to experience the presence of "the other," the spirit of the tribe, and thus, in some mystical way, heighten his identification with the tribe, become a member of the tribe as the arms and legs are members of the body.

Thanks to Catlin's closely observant eye and accurate hand, we have a reliable record of an Indian art form that is rare and getting rarer, the *Ornamented Buffalo Robe,* which is actually a pictograph representing fighting men and including both firearms and horses.

Self-Torture in the Mandan Okipa Ceremony, 1832,
George Catlin. 23 x 28 in., oil.
The University Museum, University of Pennsylvania.
Catlin's honesty granted him acceptance among the Indians he
visited, whereby he saw sacred rites rarely open to other whites.

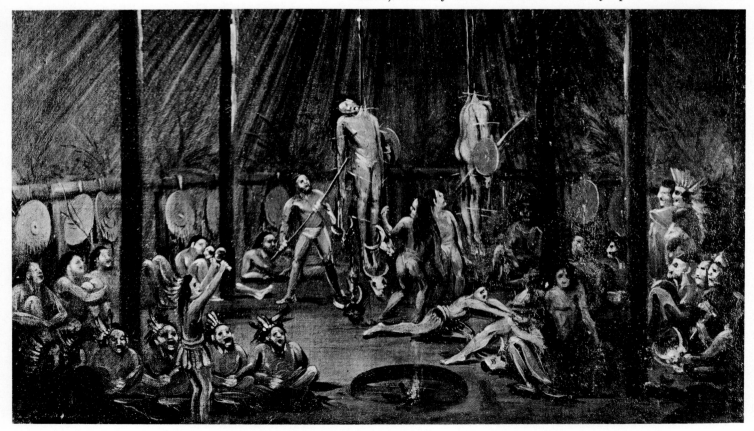

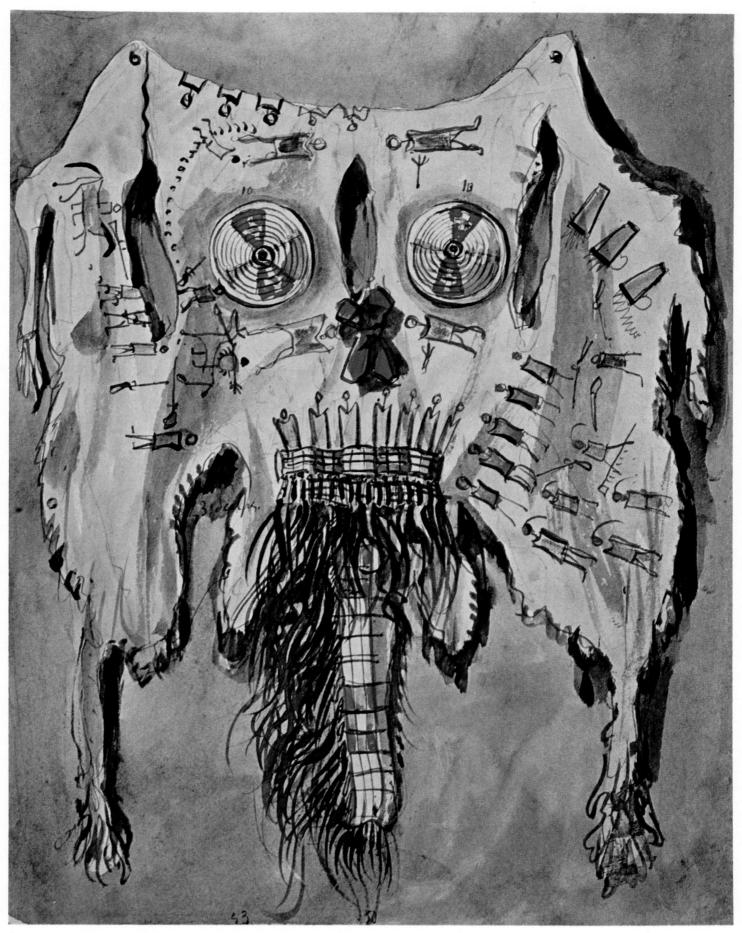

Ornamented Buffalo Robe, n. d., George Catlin. 9 x 7 in., watercolor.
Thomas Gilcrease Institute of American History and Art, Tulsa.
Catlin's record of Indian hide art is valuable when so
many of the original such paintings are lost.

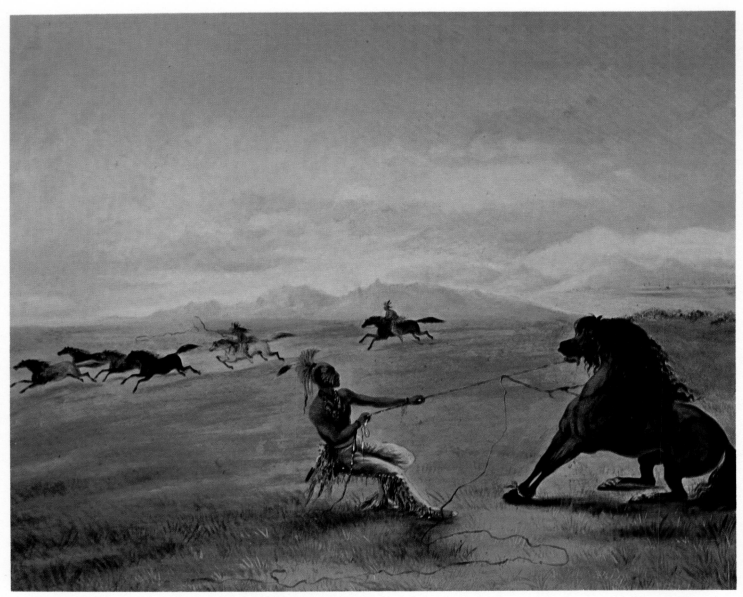

Catching Wild Horses, n. d., George Catlin. 12 x 16 in., oil.
Thomas Gilcrease Institute of American History and Art, Tulsa.
The American Indians' horsemanship was outstanding
among the horse cultures of the world.

In *Catching Wild Horses,* Catlin recorded one of the great changes that came into Indian life with the arrival of the Europeans. The horse quite probably existed in some early evolutionary form in America before man existed anywhere, but if so it had long vanished as an extinct species by the time human beings came to the Americas. Although the modern horse originated in north central Asia, it did not accompany its human fellow-Asiatics across the land bridge to Alaska and southward. While the first Americans were making that journey, the horse spread through China, then westward across Asia into Europe, through the Middle East and across North Africa. It came to America with almost all the European rival national settlements, but for the American Indian it came preeminently with the Spanish.

When Spain discovered, conquered and settled its possessions in the New World, the mother country was still very largely a society shaped by its long Moorish occupation. The Iberian peninsula was a colony of Islam for longer than it has been completely independent even

today. Granada, the last of the Mohammedan Spanish kingdoms, was liberated only in January of 1492, nine months before Christopher Columbus planted the cross and the Spanish flag on the beach of Hispaniola. Spain's Moorish heritage had profound effects on the entire culture of the peninsula and of all New Spain in the Western Hemisphere. But the one that concerns us here is the legacy of the horse.

As nomadic peoples, the Arabs who spread Islam from the Pacific to the Atlantic were among the best horsemen of history and the Spanish inherited a great deal of the Arabian understanding of and reliance upon the horse. The conquest of the great cultures and the numerous people of the Aztec and Inca civilizations was possible in great part because the Spanish were a people on horseback. They imported the horse to their colonies as naturally as the English brought self-government to theirs. Horses being horses and the country being so vast, with most of it beyond the reach of Spanish law, a certain number of the Spanish horses escaped regularly, were never recaptured by their owners and in a century or so formed new breeds, tending to be smaller than the Arabian-Spanish ancestors. The Plains Indians, area by

area, tribe by tribe, became mounted warriors and hunters over a period of almost two hundred years, from the last decades of the sixteenth century to about the time of the American Revolution. Through the capture of wild horses, through inter-tribal raiding and eventually through breeding and raising—an astonishing process to have been discovered by a people wholly unused to horses in the past—the Plains Indians became a horse culture as thoroughly as the nomadic Arabs were.

Catlin here records a vital moment in that long, historic, process, a moment, of course, that was repeated many times by almost all the tribes of the Plains. In the background two already mounted Indians pursue a small herd of wild horses, the rider out in front casting a lariat at his prey. In the foreground, a dismounted Indian has roped a horse and is getting it under control. The running horses have a lovely fluid grace. The captured steed, forelegs bound just above the hooves, conveys the powerful, almost panicky resistance of any wild animal to capture. The Indian working his ropes is a sensitively observed combination of caution and prudent determination. He is prepared to duck, to dodge, even to retreat a bit if necessary; but he is also prepared to work the horse until it is his servant and companion, ready to be ridden and to give its great speed to his human master.

The picture is one of Catlin's best color compositions. The rich gold browns of the prairie grass are subtly varied as if by sunlight shafting down between clouds. In the distance, the pearly mountain ranges change to lavender beneath the dramatic shifts of light and shadow in the cloudy sky.

In 1836, Catlin made his last solitary expedition into the West, visiting the Sacred Pipestone quarries and witnessing, on a sidetrip to Rock Island in the Mississippi, the signing of the United States treaties with the Sauk and Fox tribes. In that same year, he put on display in Buffalo—either as a kind of out-of-town opening or simply as a means of getting some badly needed cash—Catlin's Indian Gallery, consisting of the pictures he had made throughout the Plains during the past seven years. Moving on to Albany, he finished paintings half done while he was traveling and made some new ones from his voluminous

sketches. He then exhibited his pictures successfully in Albany and in Troy.

But George Catlin had grander aims than to be the successful proprietor of an itinerant exhibition of Indian art. Deriving his ideas from the Peale Museum in Philadelphia, he proposed nothing less than a national, government supported gallery of his Indian art, so that Americans could see the country and the people beyond the mountains, and so that an enduring record would exist of a way of life already, he keenly realized, heading toward extinction.

In the session of Congress of 1837-38, he managed to get a bill introduced to purchase his pictures for the nation and establish in Washington the "Catlin Collection of Indian Portraits and Curiosities." The bill was tabled. Catlin never gave up hope that his paintings would become part of the American heritage preserved and exhibited by the government.

In the meantime, however, he made his living, at times a very decent one, out of traveling about with the paintings as he had once traveled about to make them. He held very successful exhibitions in New York and in Washington. In the early 1840's, he took the show to London, where he was well received. While in London Catlin seems to have invented that enduring element of American show business, the Wild West show, actually using those words and augmenting the paintings with real live Indians and with "living pictures" created by actors taking up poses. In Paris he duplicated his London success, becoming a small sensation and attracting serious attention from the art community, at that time just beginning, rather timidly, to move toward the open-air style of painting Catlin had started practicing fifteen years earlier. He also received a royal commission. Louis-Philippe, the last king of France, hired the American painter of the wilderness to paint twenty-nine scenes from the life of René Robert Cavelier, Sieur de La Salle, who, operating out of Montreal, had traversed much of Catlin's Indian country more than a century and a half earlier, exploring the Great Lakes, following the Mississippi to its mouth in the Gulf of Mexico and establishing the French claim to a vast American empire finally liquidated with Jefferson's Louisiana Purchase. Fortunately for Catlin, he finished the picture cycle and received his payment in 1847. The following year Louis-Philippe was overthrown, the Second Republic was established and the "bourgeois king" ended his days in an English retreat provided him by Queen Victoria.

All in all, the Paris years were probably the high point of Catlin's career, in terms of public acceptance and seeming success, although certainly the years on the Plains were his best from every other point of view. After that, despite steady publication of books about the Indians, his reputation sank slowly but steadily. He continued in vain to petition Congress to buy his paintings and establish his gallery. For twenty years of declining fortunes and popularity, he drifted around Europe and South America, attempting, in the Andes, to repeat his success on the North American Great Plains, also in vain.

Depressed by public indifference to him, to his art and to his Indians, Catlin went into bankruptcy and died, a broken man, in 1872, having painted nothing of the ori-

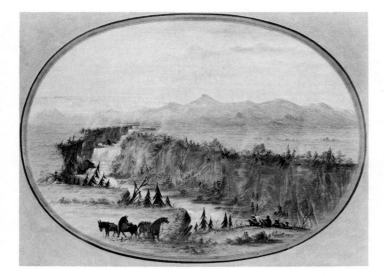

Falls of the Snake River, ca. 1870, George Catlin.
18-1/2 x 24-1/2 in., oil on cardboard.
National Gallery of Art, gift of Paul Mellon.

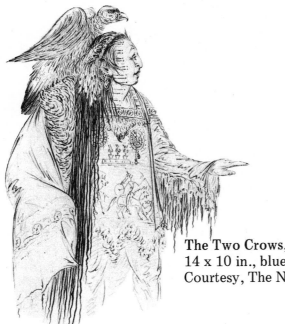

ginality and talent of his Plains pictures for two decades. From the bankruptcy, his "Indian Gallery" of paintings, almost intact and complete, became the property of a Philadelphia boilermaker, at whose death they were found, ignored and in shameful condition, stashed away in the basement of his factory. Seven years after his death, Catlin achieved vindication of a sort. His pictures were at last acquired by the United States government and lodged in the Smithsonian Institution, a center of learning and scientific inquiry that did not yet exist when Catlin had made his first proposals to Congress.

The Two Crows, after 1850, George Catlin.
14 x 10 in., blue ink and pencil.
Courtesy, The Newberry Library, Ayer Collection.

Buffalo Hunt on Snowshoes, n. d., George Catlin. 25 x 32 in., oil.
Thomas Gilcrease Institute of American History and Art, Tulsa.
This buffalo hunting scene has a timeless air, for the Indians
hunt as they did long before the white invasion, without gun or horse.

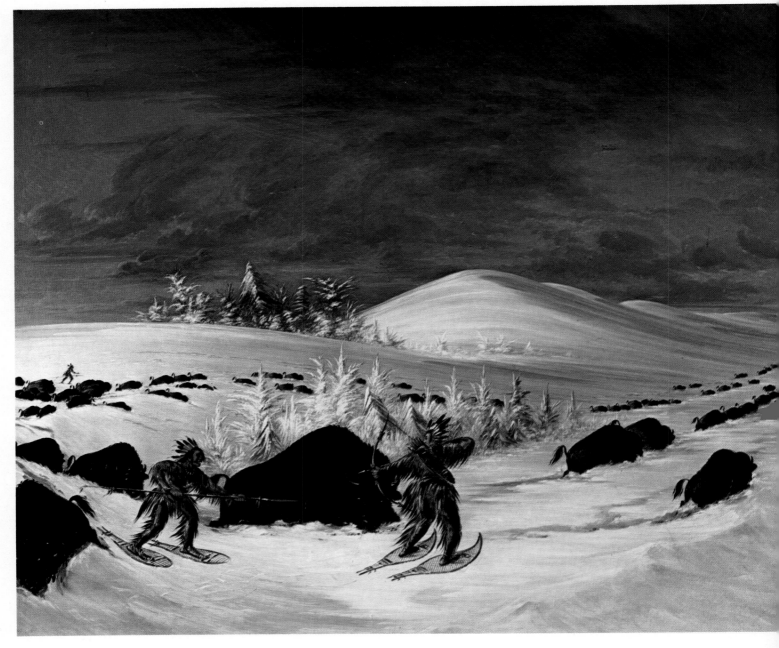

A more important vindication, however, had already taken place in Paris while Catlin himself was undoubtedly more concerned with the popular success of his "Museum," as he was then calling it, and with the prospect of his royal commission. The thing that led to his decline in reputation following the first brilliant successes was a widespread opinion that he was not really a very good artist, that while his subjects had an obvious, immediate interest, the paintings as paintings did not repay repeated viewing. Catlin suffered from this opinion throughout his last two scratchy decades. It followed him into bankruptcy, which indeed it brought about, and survived his death. Standard works on American art do not quite leave him out, but they often give the impression that he ought to be left out, that he is important ethnologically, not artistically. At the Smithsonian itself, for that matter, his paintings, until fairly recently, were held by the Ethnological Department, not one of the several art museums.

Yet, at the height of his popularity, the most important art critic of the nineteenth century looked at his work and found it good. As it happened, the critic, Charles Baudelaire, was also aware of the beginning of the conventional view that Catlin was not a very good artist and dealt with it in his review of the Paris Salon of 1846. His remarks are worth quoting at length in establishing some of the merits of Catlin and some of the obstacles against which he struggled.

"When M. Catlin came to Paris," wrote Baudelaire, "with his Museum and his Ioways, the word went round that he was a good fellow who could neither paint nor draw, and that if he had produced some tolerable studies, it was thanks only to his courage and his patience. Was this an innocent trick of M. Catlin's, or a blunder on the part of the journalists? For today it is established that M. Catlin can paint and draw very well indeed. These two portraits (*Little Wolf* and *Buffalo Grease*) would be enough to prove it to me, if I could not call to mind many other specimens equally fine. I had been particularly struck by the transparency and lightness of his skies.

"M. Catlin has captured the proud, free character and the noble expression of these splendid fellows in a masterly way; the structure of their heads is wonderfully well understood. With their fine attitudes and their ease of movement, these savages make antique sculpture comprehensible. Turning to his colour, I find in it an element of mystery which delights me more than I can say. Red, the colour of blood, the colour of life, flowed so abundantly in his gloomy Museum that it was like an intoxication; and the landscapes—wooded mountains, vast savannahs, deserted rivers—were monotonously, eternally green. Once again I find Red (so inscrutable and dense a colour, and harder to penetrate than a serpent's eye)—and Green (the colour of Nature, calm, gay and smiling)—singing their melodic antiphon in the very faces of these two heroes.—There is no doubt that all their tatooings and pigmentation had been done in accordance with the harmonious modes of nature.

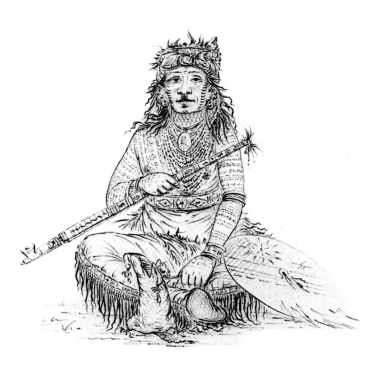

The Stone with Horns, after 1850, George Catlin. 14 x 10 in., blue ink and pencil.
Courtesy, The Newberry Library, Ayer Collection.

"I believe that what has led the public and the journalists into error with regard to M. Catlin is the fact that his painting has nothing to do with the *brash* style, to which all our young men have so accustomed us that it has become the *classic* style of our time."

A dozen years later Baudelaire's perceptive criticism of Edgar Allan Poe established a place in international literature for an American poet ignored, even despised, in his native land. It is instructive that he thought so highly of George Catlin.

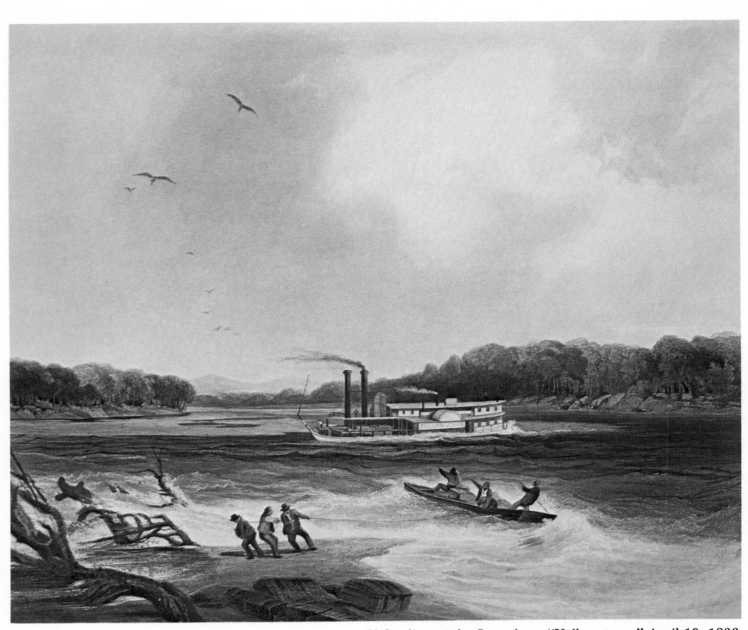

Unloading of the Steamboat "Yellowstone," April 19, 1833,
Karl Bodmer. 8-1/4 x 13-1/4 in., watercolor.
Joslyn Art Museum, Northern Natural Gas Company Collection, Omaha.
The steamboat proved to be one of the first intrusions of
mechanical power that conquered and transformed the West.

ILLUSTRATOR TO THE PRINCE

Karl Bodmer
(1809—1893)

Karl Bodmer was the only one of all the Western artists to have something of a distinguished career in European art. Catlin, of course, was highly praised in London and Paris, but no one, not even his greatest admirer, Baudelaire, ever thought of him as part of the continuity of continental art. Bodmer *was* part of that continuity and to this day occupies a recognized if now minor place in the standard art history of the French nineteenth century.

He came to the American West at the very beginning of his career. A Swiss native, he studied in Paris and there became acquainted with a German princeling of one of

the myriad tiny independent states that prompted the jesting definition, "Germany is a geographical expression." Like other members of the European ruling class following the shock of the French Revolution and the Napoleonic conquests, Prince Maximilian of Wied-Neuwied was determined to contribute usefully to mankind, specifically by adding to the sum of human knowledge. An amateur explorer and botanist, he organized a scientific expedition to the American West and hired the youthful Bodmer to come along as illustrator. It was perhaps typical not so much of Maximilian as of European assumptions about America that he took it

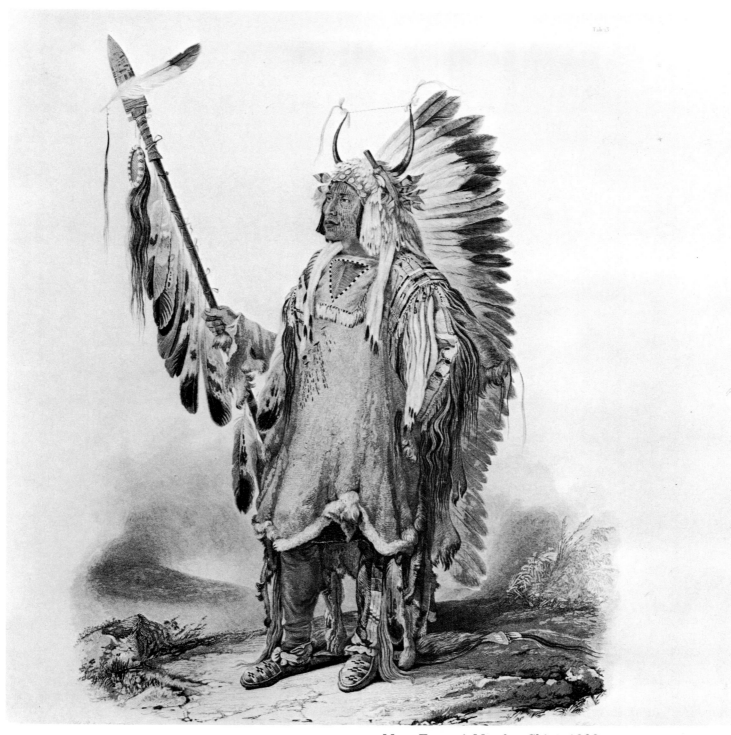

Mato-Tope, A Mandan Chief, 1839,
Karl Bodmer. 19-3/8 x 14 in., aquatint.
Joslyn Art Museum,
Northern Natural Gas Company Collection, Omaha.

for granted that if he wanted a competent artist as a member of the party, he would have to bring his own from Europe.

On an auspicious date, July 4, 1832, the expedition arrived in this country, landing in Boston and possibly mistaking the parades and fireworks as a sign of welcome to the New World. The prince was in no crashing hurry to get into the West and Bodmer was able to explore the East Coast to some extent. He made trips to Providence, New York and Philadelphia, where he visited the Peale Museum that was the scene, half a dozen years earlier, of Catlin's view of the Indian delegation whose grace and dignity inspired him with the ambition to paint the story of the Indian peoples. He talked with Titian Peale and traveled into the Alleghenies.

Out of prudent fear of a cholera epidemic then raging along the land routes, Maximilian led his expedition down the Ohio River to the Mississippi, retreating to Indiana for the winter. During the winter, Bodmer went alone down that great highway of the continent, the Mississippi, to visit New Orleans. In the spring, the group continued down river to St. Louis, where Bodmer had the opportunity to look at a collection of Indian portraits that Catlin had left with a nephew of General Clark when he was visiting there three years earlier. As if following in Catlin's path, Maximilian's expedition took the steamboat *Yellowstone* up the Missouri River, as Catlin had just a year earlier, and Bodmer made sketches of much of the same country, customs and people that Catlin had.

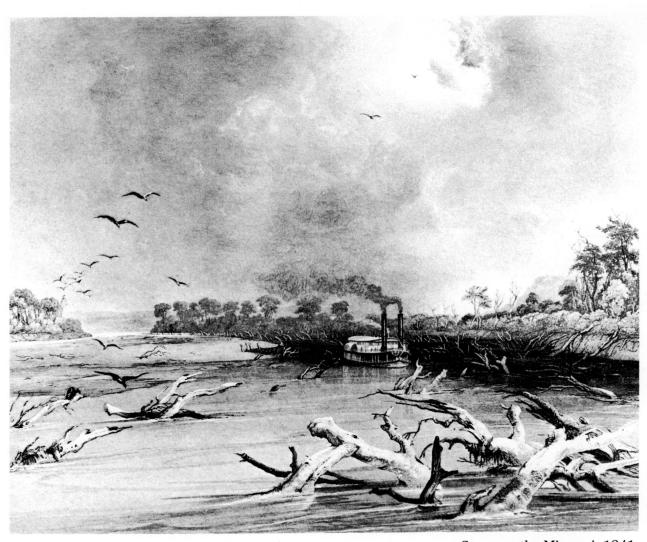

The prince's party was in sharp contrast to Catlin's lonely travels in every way. Most importantly, perhaps, Maximilian essentially led a tour of United States forts in the area, which already formed a network of surveillance and protection against the Indians. The second winter was passed at Fort Clark, named for the explorer and commander of the district. Back in St. Louis in the spring, Bodmer once more inspected Catlin's Indian paintings, now with increased understanding due to his own experiences in the intervening months. Going up the Ohio River, as they had come down to begin their exploration, the expedition members sailed from New York, Bodmer with them. He had been in the West, in Indian country, about a year and a half. He never returned.

Back in Europe, executing his contract with Maximilian, Bodmer began working with some extraordinarily gifted print houses to make the color reproductions of his drawings to illustrate Maximillian's major work on the expedition's fruits, *Travels in the Interior of North America, 1832—1834.* At the same time, he got started on his own work as a European painter, entering exhibitions with some success. In 1839 Maximilian's book was published with Bodmer's illustrations and the same year the artist was naturalized as a citizen of France.

A decade later, Bodmer settled in Barbizon, a small town some thirty miles from Paris on the edge of the forest of Fountainebleau. This was not just a move to the coun- try. At Barbizon at that time were gathering a new school of nature painters, led by Théodore Rousseau and Jean-François Millet. Millet exercised a profound influence on Vincent Van Gogh among others and he also did on Bodmer. While most of the Barbizon artists concentrated on forest scenes and the light on the leaves, in a manner that led directly to Impressionism, Millet was more concerned with the lives of the peasants who worked the land. Three of his pictures became, at one time, probably the best-known and best-loved paintings in the world, hanging in reproductions in hundreds of thousands of living rooms on both sides of the Atlantic. These were *The Gleaners, The Sower* and *The Angelus.* At the time of their execution and first presentation to the world, in the 1850's, they were immediately seen as revolutionary pictures, for they presented a peasant life of hard work and small rewards, in contrast to the cheerful, happy peasants who occasionally turned up in pictures by the painters of the Academy, the oligarchical group that ruled French art with an iron hand and sternly disapproved of the Barbizon painters as it would, later, of the Impressionists.

Working in this stimulating and congenial atmosphere, Bodmer progressed in reputation as a minor member of

a dissident sect of painting. Only once, as far as we know, did he look back to what by now must have seemed almost the dream of his youthful wanderings through the wilderness of a savage world across the ocean. He succeeded in arousing Millet's interest in collaborating on a series of paintings of the Indians. The subject was naturally one to arouse the sympathy of Millet and the fact that he knew nothing at all about Indians was hardly an objection in a society in which artists for centuries had been painting the gods and goddesses, nymphs and satyrs, of an antique world that never existed at all. Unfortunately, the Indian painting scheme failed of realization. The moment passed and Bodmer continued his ways, painting, illustrating an occasional book, including one by Maximilian on snakes and an edition of Jean de La Fontaine's animal stories. At sixty-seven he was made a Chevalier of the Legion of Honor and at eighty-four he died in his beloved Barbizon,

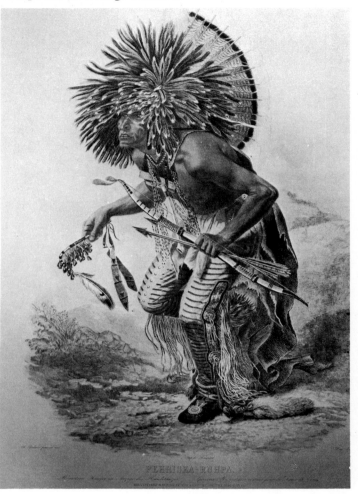

Pehriska-Ruhpa, Moennitarri Warrior,
in the Costume of the Dog Danse, 1841,
Karl Bodmer. 20 x 14-1/2 in., aquatint from a watercolor.
Joslyn Art Museum,
Northern Natural Gas Company Collection, Omaha.
Bodmer's precise details of anatomy and costume please the eye, though a sense of felt reality is dim compared to George Catlin's.

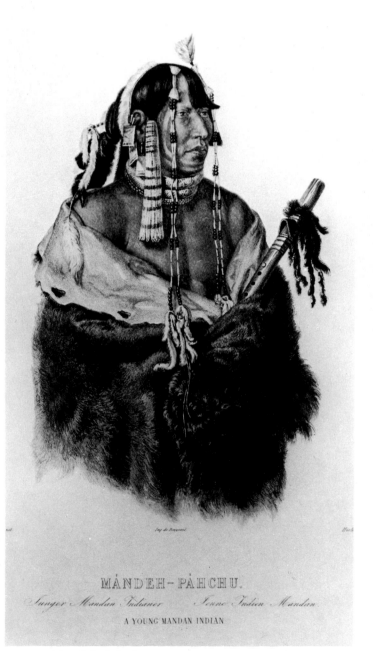

Mandeh-Pahchu, A Young Mandan Indian, 1840,
Karl Bodmer, 13 x 9-3/4 in., aquatint.
Joslyn Art Museum,
Northern Natural Gas Company Collection, Omaha.

loyal member of a school once too advanced for recognition but by then, 1893, already eclipsed and passed by, first by Impressionism and then by Post-Impressionism.

Pehriska-Ruhpa, Moennitarri Warrior in the Costume of the Dog Danse is a fair sample of the finished work Bodmer produced for Maximilian's book on the Interior of North America. The color lithography is exquisitely done, in contrast to much of the work in that medium at that time. The plate was published in three languages, German first in honor of Maximilian's origin but the French execution commemorated in the spelling of "dance." The polyglot nature of the enterprise is perhaps also responsible for both the name of the warrior here recorded and that of his tribe. "Moennitarri" appears in none of the standard maps of tribal territories in the regions traversed by Bodmer and Maximilian. The name could conceivably be a corruption of Menomini or Potawatomi. It is clear at a glance that Bodmer knows a great deal more about human anatomy than George Catlin ever learned for all his studies. We feel the tension of the muscles in the left forearm as the hand is tight on the bow and arrows; we feel the corresponding relaxation of the

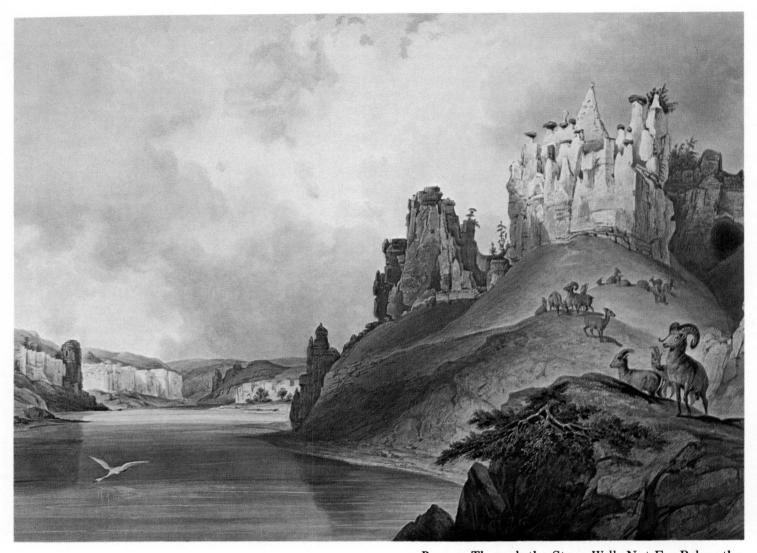

Passage Through the Stone Walls Not Far Below the
Mouth of the Marias River on the Missouri, Summer 1833,
Karl Bodmer. 9-7/8 x 16—3/4 in., watercolor. Joslyn Art Museum,
Northern Natural Gas Company Collection, Omaha.
Bodmer gave the look of long-imposed order on this Missouri
River scene, almost as if the rock formations were castles
overlooking a tamed European river.

grip of the right hand on the lighter, more decorative
dance object. We are very much aware of the weight of
the Indian on his left foot and of the moment of balance
in his dance. We are also aware that the costume is very
accurately portrayed in its details, the fur and feather.
There is nice diminution of the surrounding rocks and
scrub bushes, of the sunlit mountain in the background
and of the cloudy sky, all subordinated to the dancing
figure of "Pehriska-Ruhpa."

Yet, all these details are so well ordered, so profession-
ally ordered, into the overall composition, that we begin
to doubt, at least a little. We begin to regard the dancing
man as a performer expertly got up for the occasion per-
forming well-rehearsed movement, while the clouds and
mountains become a painted backdrop. The artistic per-
formance is decidedly better than anything Catlin ever
did, but there is much less sense of reality felt,
experienced, passionately cared about. Like Christopher
Isherwood a century later, Bodmer might have boasted,

"I am a camera," but Catlin was more than a camera.
He was a man who cared.

Bodmer's actual watercolors, on which the prints were
based, are typically not so well finished as the prints.
They did not, after all, have the collaborative services of
the finest lithographic craftsmen in the world. But partly
for that very reason, they came closer to the living, im-
mediate reality we know in Catlin, with the advantage of
Bodmer's superior talent and training in draftsmanship.

*Unloading of the Steamboat "Yellowstone," April 19,
1833,* exhibits that happy combination. The picture is a
solid but subtle composition, with the essential oval form
of the steamboat set in a flat oval frame composed of the
trees along the bank of the island, the wooded hills in the
distance, the larger tree on the near bank to the right and,
closing the ring, the odd brushes and derelict logs stuck
in the mud of the near shore. The steamboat itself is the

56

brightest area in the picture, thus ensuring attention to what is important. Although, like its more elaborate successors later in the century along the Missouri, the Mississippi and the Ohio, the *Yellowstone* was a shallow draft vessel, it was not shallow enough to get closer to such shores as these, and the unloading was done by rafts poled from ship to shore. In a very few years, as the settling of the West proceeded, stopping places along the river system would put forth jetties, piers, docks and quays for the river queens sailing majestically from Cincinnati to New Orleans. Except for the rifle itself, which the Indians speedily made their own, the steamboat also represented the first intrusion of machinery and mechanical power into the Stone Age wilderness of the Great Plains. It was the machines, finally, that conquered and transformed the West, the railroads bringing undreamed of speed in transport and incidentally laying straight iron lines across the fluid world of Indian life, the reapers and combines organizing the earth itself on a scale never heard of before and rendering Indian life as it had been hereafter impossible.

Passage Through the Stone Walls Not Far Below the Mouth of the Marias River on the Missouri, Summer 1833,

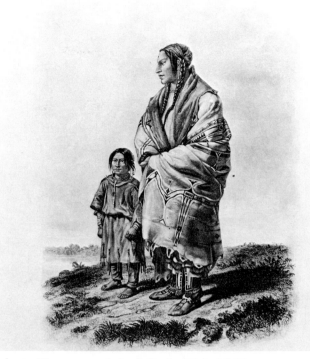

Dakota Woman and Assiniboin Girl, 1841, Karl Bodmer. 19-3/8 x 14-1/4 in., aquatint. Joslyn Art Museum, Northern Natural Gas Company Collection, Omaha.

Interior of the Hut of a Mandan Chief (Near Fort Clark), 1841, Karl Bodmer. 16-7/8 x 11-3/8 in., aquatint. Joslyn Art Museum, Northern Natural Gas Company Collection, Omaha. Bodmer's gifted hand detailed the structures and contents of many Indian constructions on the northern Plains.

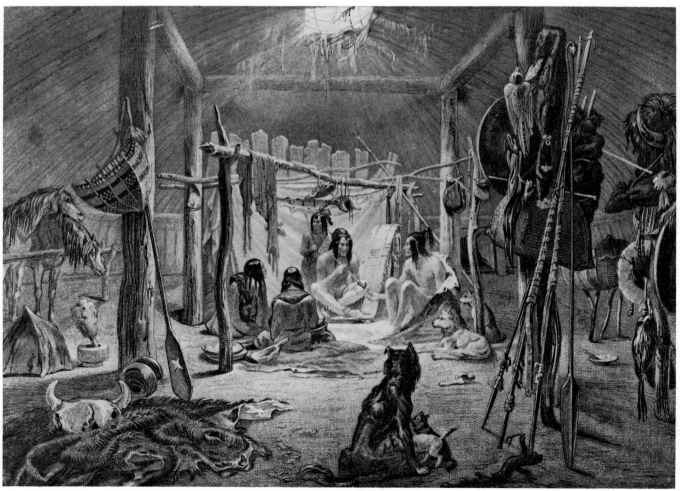

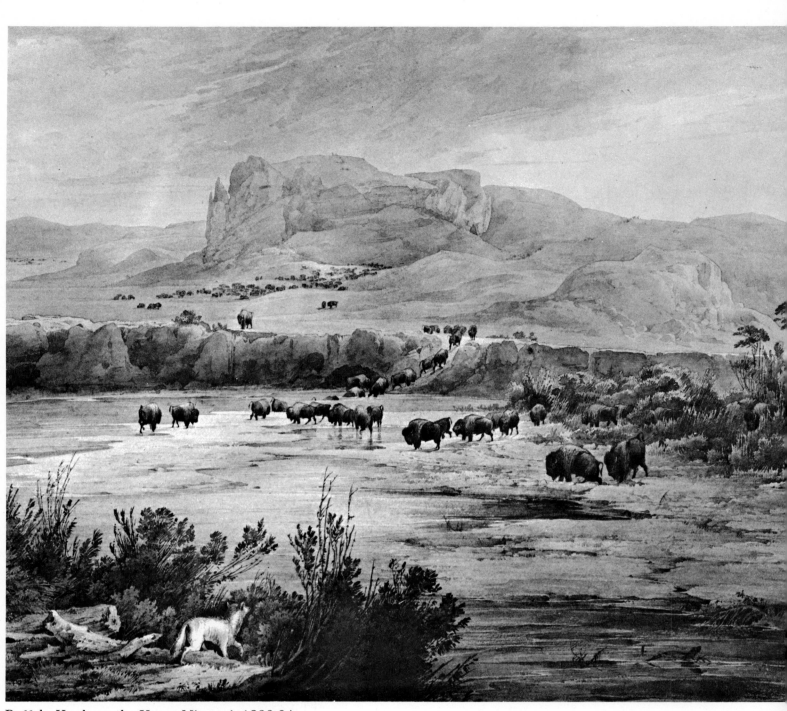

Buffalo Herds on the Upper Missouri, 1833-34,
Karl Bodmer. 9-5/8 x 12-1/4 in., watercolor.
Joslyn Art Museum,
Northern Natural Gas Company Collection, Omaha.

records one of the still fascinating views the traveler on the Missouri may encounter. Again, Bodmer skillfully manipulated light and shade upon the water so as to increase the feeling of the broad expanses of river between the towering rocks. Almost automatically Bodmer included the smaller bluff with its closely observed vegetation in the lower right for the same purpose, in a way that never occurred to Catlin. But once more there is about the whole an air of imposed order, as if the rugged rock formations were castles overlooking the long inhabited Rhine.

In *Forest Scene With Indian Tree Burial, Near Fort Union, 1833,* Bodmer actually painted a view very similar to those his friends and mentors at Barbizon would be painting in Fountainebleau Forest twenty years later—except, of course, for the central object, the tree burial platform with its wrapped and amuletted body. In style, therefore in vision, the foliage relates both to the French eighteenth-century bosky scenes of painters like François Boucher and Jean Honoré Fragonard, without the amorous dalliance they invariably placed within them, and at the same time to those of the Barbizon painters, presented for themselves alone.

Fort Union was well up the Missouri, near the border between the present-day states of Montana and North

Forest Scene With Indian Tree Burial, Near Fort Union, (Tomb of Assiniboin Indians in Trees), 1833, Karl Bodmer. 12-1/2 x 10 in., aquatint. Joslyn Art Museum, Omaha. Bodmer's professional training as a draftsman aided the precise depictions he made of the New World's inhabitants and their customs.

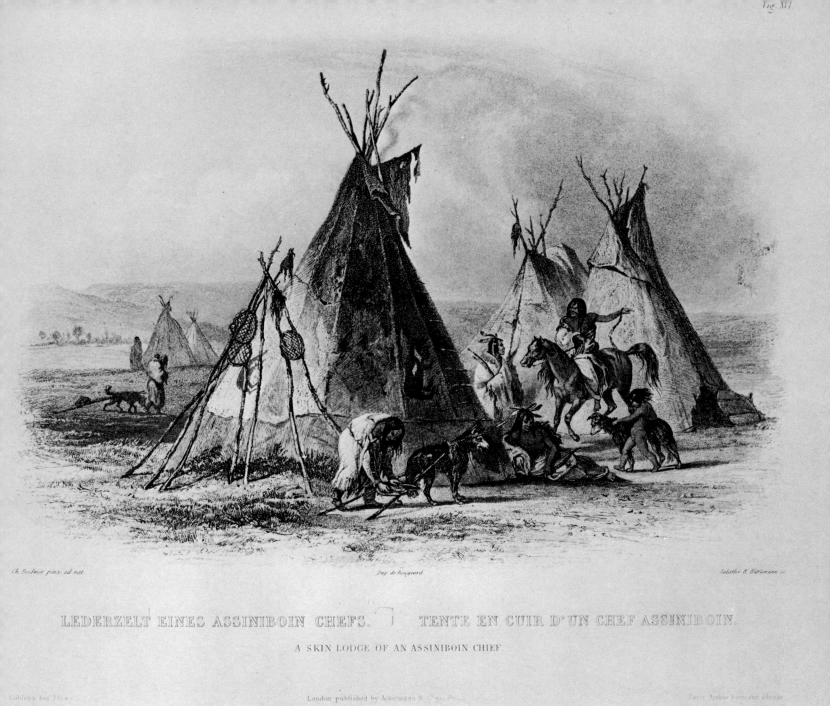

Fig. XVI

LEDERZELT EINES ASSINIBOIN CHEFS. TENTE EN CUIR D'UN CHEF ASSINIBOIN.

A SKIN LODGE OF AN ASSINIBOIN CHIEF.

London published by Ackermann & C.

A Skin Lodge of an Assiniboin Chief, n. d.,
Karl Bodmer. 9-3/8 x 13-1/16 in., aquatint.
Joslyn Art Museum,
Northern Natural Gas Company Collection, Omaha.

Dakota at the confluence of the Missouri and Yellowstone Rivers. The tribe involved could have been the Blackfoot, by far the most numerous in the region, or the Crow, Mandan or Hidatsa. Bodmer's picture actually combines two separate but related forms of burial among the Plains Indians, tree burial and platform burial. Earth burial, so common everywhere else in the world, was almost never practiced among the Indians, apparently because it was felt that the weight of the earth on top of the body would prevent the liberated spirit of the dead person from returning to its aerial origins. Tree or platform burial at once raised the body toward that destination and protected it from animals. The dead warrior was

painted in the markings of his tribe and dressed in ceremonial attire. He was then wrapped in buffalo hides which had been softened by water. Layer after layer of such robes ensured that no air could penetrate. Then, accompanied by weapons, provisions, tools, pipe and tobacco, he was placed upon the raised platform or lashed in the crotch of a tree. In both cases, the ground around the tree trunk or the supporting poles of the platform were surrounded with brambles designed to keep animals from disturbing the corpse.

The Indians had great reverence for the dead, despite their normal, primitive fear of ghosts. The highest form of burial, reserved for great chiefs or other tribal person-

ages, was lodge burial, in which the dead man, dressed, decorated and wrapped as in the other forms, was laid out within his own lodge, which was then sealed shut. After that, the entire tribe moved to a new location, so that their former site became the property of the dead chief by virtue of his having died there.

Bodmer made a most valuable contribution to our knowledge by his work for Prince Maximillian. He remains fascinating and a little puzzling to Americans as a skilled professional who took a long look at the New World and returned to the old with, apparently, no regrets.

Camp of the Gros Ventres of the Prairies, 1841,
Karl Bodmer. 10-1/16 x 12-1/4 in., aquatint.
Joslyn Art Museum,
Northern Natural Gas Company Collection, Omaha.

Mih-tutta-hangkusch, a Mandan Village, 1841,
Karl Bodmer. 17-1/2 x 21-7/8 in., aquatint.
Joslyn Art Museum,
Northern Natural Gas Company Collection, Omaha.

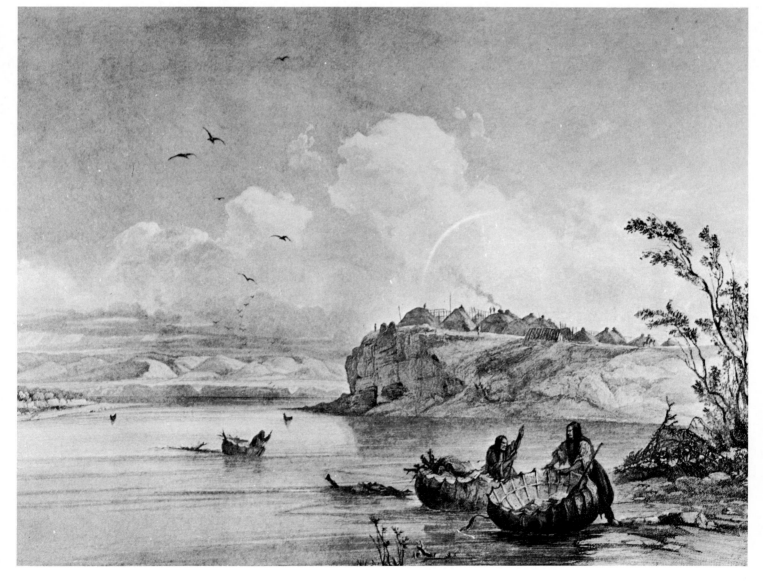

Scene at Rendezvous, n.d., Alfred Jacob Miller. 9 x 15-1/2 in., watercolor.
Walters Art Gallery, Baltimore.

YOUNG MAN
ON A WESTERN HOLIDAY

Alfred Jacob Miller
(1810—1874)

Presents for the Snake Indians, 1837,
Alfred Jacob Miller. 11-1/4 x 9-7/16 in., watercolor.
Walters Art Gallery, Baltimore.

Like Catlin, Miller was a native American, but like Bodmer he had received a sound, European training in his art before he set out to the West. Like Bodmer and unlike Catlin, Miller went West not out of any passionate determination to paint the country and the people but as a hired hand, specifically a hired painting hand. Like both of them, Miller's Western period was a brief time in a long and busy life, but it is the work from that time that has earned him his place in the history of American art.

Son of a Baltimore grocer, Miller studied in his native city with Thomas Sully, one of the most successful and sought after portrait artists in the young Republic, and it is possible he also studied under one or more of the painting Peale family, who had by now opened a museum in Baltimore like their original one in Philadelphia. At twenty-three he went to Paris and enrolled in the École des Beaux-Arts. The following year, he moved to Rome, where he studied the Old Masters in that city's numerous collections, painted in the campagna, the malarial countryside around Rome, and worked also in the English Life School in the city. By the end of that year he was back in Baltimore, where he set himself up as a portrait painter and tried his hand at the still relatively new print medium of lithography.

Whether from a youthful desire to see new places or whether in the hope of finding better prospects farther away from the expert competition in portraiture along the East Coast, Miller in 1837 moved to New Orleans, like Baltimore a port and the scene of an heroic moment in the War of 1812, but in most other ways a totally different atmosphere and society, in some ways no doubt recalling to Miller his recent student days in Paris. One day, Miller recorded in his journal, a stranger with a military air entered his studio on Chartres Street and, with only a nod to the artist, began examining the paintings on the walls, speaking only once, to communicate his admiration of a large, romantically lighted view of Baltimore Miller had painted, and then departing as abruptly as he had arrived.

A few days later the stranger called again and this time was friendlier. He was, he said, Captain William Drummond Stewart of the British Army and a Scot, as his name implied. He had served with Wellington both in the Peninsular Campaign against Napoleon and at the Battle of Waterloo. Heir to extensive lands in Scotland, he had

made several trips to the West and wished to take one more before being forced, as seemed likely, to assume his hereditary duties in Perth, Scotland. He found Miller's painting satisfactory in every way and invited the artist to accompany him, for a fee, to make sketches along the way and, later, to transform these sketches into oil paintings for his Highland castle.

With appropriate prudence, Miller called on the British consul in New Orleans, from whom he learned that Stewart was indeed the heir to the substantial Scottish estates of Murthly, that he had been making these trips into the American West for several years now and that Miller would be well advised to accept his offer and join the journey. Miller did so.

As a result, Miller penetrated farther into the wilderness than had any artist before him. He was the first artist to paint Indian life along the Oregon Trail and the first and last of any substance to witness the famous annual "rendezvous"—which Miller accurately nicknamed a "saturnalia"—of the fur trappers of the West.

Shoshone Indian and Pet Horse, ca. 1845, Alfred Jacob Miller. 20 x 26 in., oil. The Peale Museum Collection, Baltimore.

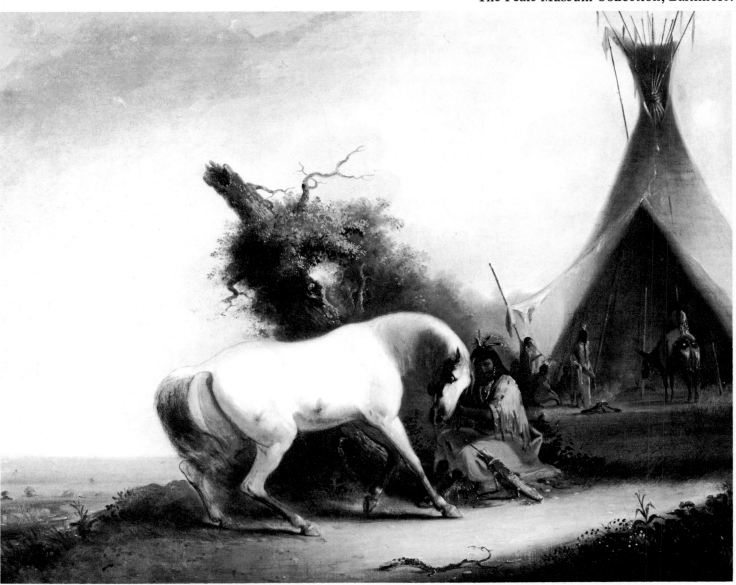

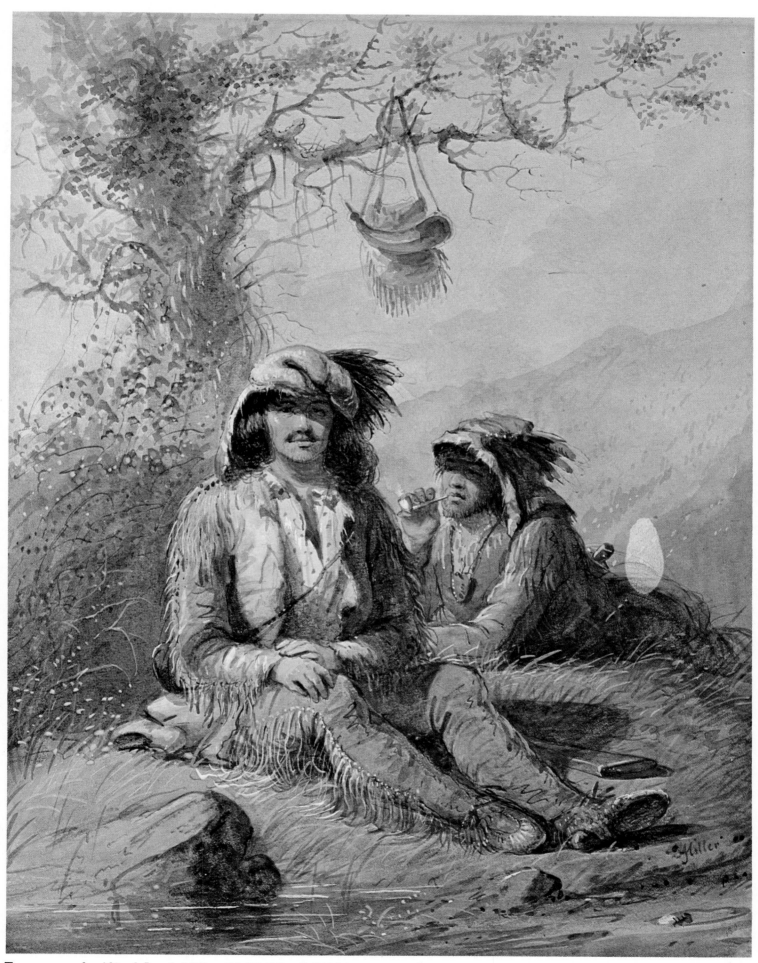

Trappers, n.d., Alfred Jacob Miller. 11-15/16 x 9-7/16 in., watercolor.
Walters Art Gallery, Baltimore.

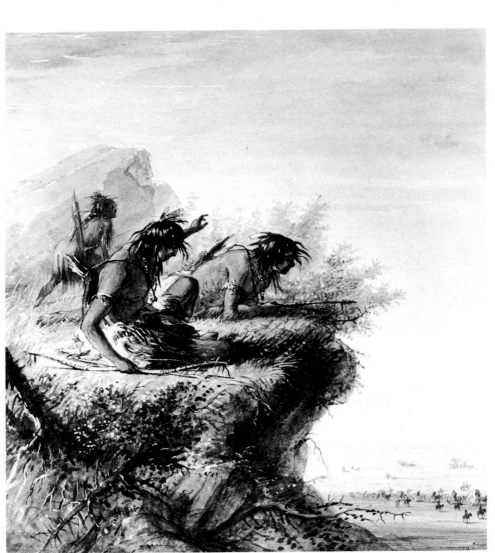

Pawnee Indians Watching the Caravan, 1837,
Alfred Jacob Miller. 10-7/16 x 9-7/16 in., watercolor.
Walters Art Gallery, Baltimore.

Right: **Arapahos**, n.d., Alfred Jacob Miller.
8-15/16 x 12-3/16 in., watercolor.
Walters Art Gallery, Baltimore.

To achieve these goals, Stewart joined his party of ten men and two covered wagons to the annual expedition to the trappers' rendezvous of the American Fur Company, organized by John Jacob Astor. The Stewart band not only joined the caravan to the rendezvous, but, because of his military background and relatively extensive experience among the tribes of the Plains and the Rockies, Captain Stewart was offered—and accepted—the command of the entire expedition.

For the young East Coast painter transported into the wilderness, this increase of authority of his employer was not an unmixed blessing. In a later recollection, Miller wrote, "He was the military martinet & rigidly exacted from me all the duties of the camp.—said I had been spoiled at home:—he insisted among other things that I should catch my horse of a morning (they are let loose at daybreak & stroll off half a mile by the time breakfast is over & all ready for a start on our journey), so that I had to run a considerable distance in moccasins with the additional difficulty of securing when I came up with him. I now reflected how easy it was for a Leader here at the head of a band of men to become a capricious tyrant, where there were no laws to restrict him:—As a great favor he let me buy out my guard at night—& also pay a trapper to set up my tent."

Anyone familiar with life in the wilderness or at sea or in military service will recognize at once, as Miller did not, the classic conflict between the desirability of individual

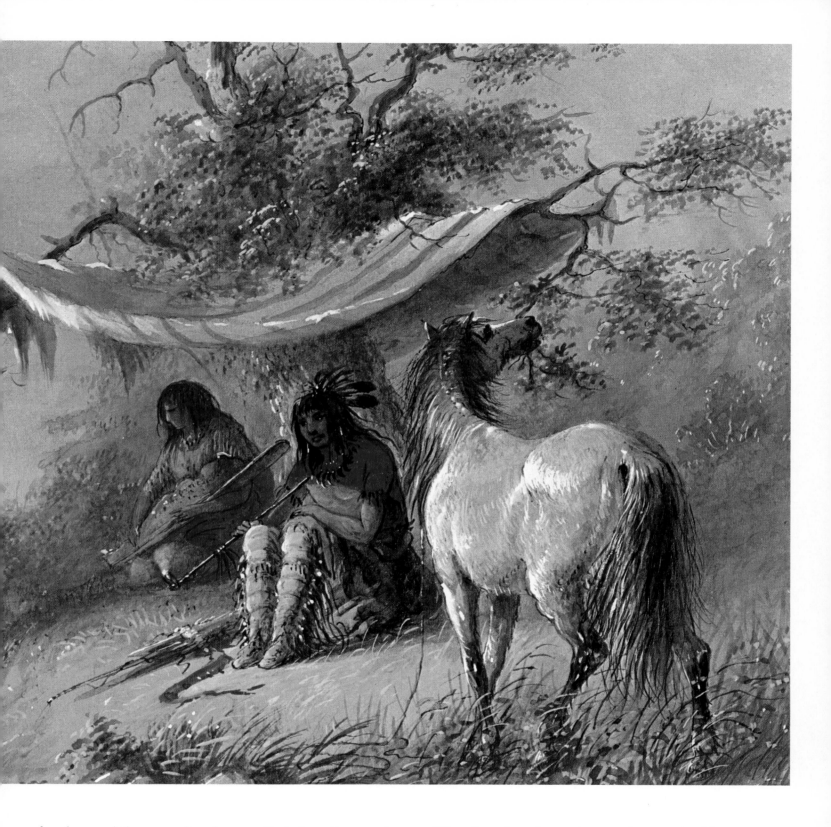

freedom and the necessity of group discipline. On top of that basic human conflict undoubtedly rested a fundamental misunderstanding between the two as to just what Miller's role was. For the painter, he was preeminently an artist, with all the rights and privileges of that profession, including that of maintaining a little distance between himself and the ordinary, daily duties of life for the sake of higher things. For the captain, in contrast, the painter was another member of the company, a specialized and valuable one, a talented and appreciated one, but basically a member of the troop, subject to its discipline and potentially dangerous to himself and the others insofar as he removed himself from that discipline. Another memory of Miller's reveals another aspect of their differences:

"Our Captain, who took great interest in this matter, (i.e., Miller's sketching), came up to me one day while so engaged, & said 'you should sketch this and that thing' and so on. 'Well!' I answered (possibly with a slight asperity), 'if I had half a dozen pair of hands, it should have been done!' "

On another occasion, as Miller was sketching near Independence Rock, "being completely absorbed, about half an hour transpired when suddenly I found my head violently forced down and held in such a manner that it was impossible to turn right or left. An impression ran immediately through my mind that this was an Indian and that I was lost. In five minutes, however, the hands were removed. It was our Commander. He said: 'Let this be a

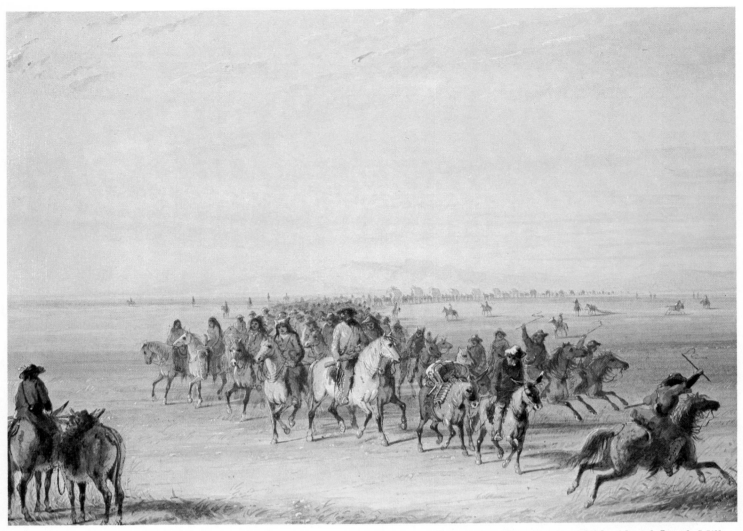

Caravan en Route, ca. 1859, Alfred Jacob Miller.
12 x 16-7/8 in., watercolor. Walters Art Gallery, Baltimore.
Miller's fellow travelers in Captain Stewart's band were depicted as a great horde that seemingly filled the plain, though the actual number was about 100 men.

warning to you or else on some fine day you will be among the missing.' "

The conflict was never resolved; neither man ever fully understood the other, although, obviously, some sort of *modus vivendi* was reached and maintained. A few years later, while a visitor in Stewart's Scottish castle painting Western murals, Miller recorded his gratification that Stewart, by then a baronet, was a completely gracious host with no hint of his exacting conduct in the West. Thus the painter seemed to dismiss his employer's style in the wilderness as some sort of personal aberration, happily cured by his return to his native Scotland.

Prince Maximilian, being German, had a full scientific purpose for his expedition up the Missouri to the Yellowstone, a purpose accurately reflected in Bodmer's careful renderings of what he saw. Captain Stewart, participant in the first and last of the great romantic wars of history, the Napoleonic campaigns, and a native of the Scottish highlands in the age of Sir Walter Scott, had neither the need nor the desire for any such scientific scaffolding for his travels in the American West. He rode west because the West was there, because it was inhabited by exotic, dangerous and fascinating natives, because it boasted some of the most spectacular scenery in the world, because it was totally removed from the

cribbed and cabined confinements of civilization. You can find his spirit in the heroes of Scott's Waverly Novels and perhaps a more realistic appraisal of that spirit in Stendhal's accounts of the sense of personal liberation that mysteriously flowed in the wake of Napoleon's conquests. It was the Romantic Age. Stewart obviously regarded himself as a Romantic hero of some kind and for his purposes on his last trip West—that very notion has a romantic ring to it—he found the perfect artist-explorer in Alfred Jacob Miller, who had already removed himself to romantic Paris and Italy and, at home, to romantic New Orleans, and who, moreover, had found in Paris that the contemporary painter he most admired was Eugène Delacroix, the leader of the Romantic Movement in art. The circle is completed by the fact that in 1832, the year before Miller's arrival in Paris and enrollment at the Beaux-Arts, Delacroix had accompanied a French government expedition to the Sultan of Morocco as official artist to the Count de Mornay, leader of the expedition.

Miller was thus relieved of any need for close scientific accuracy and, on the contrary, was encouraged to follow his natural bent and pursue the larger image, the

Romantic view of the West. He thus became the first painter of the mood, the attitude, which has prevailed about the West of America ever since in painting, sculpture, narrative fiction, drama, movies and television. We cannot really say that he set that attitude and others followed, for he had no followers. In those early days in the West, every artist, like every man, was for himself. Nothing that might be reasonably called a "school" of Western painting developed for half a century or more after Miller left the West. Nevertheless, he was the first American artist to respond to and embody in his work the Romantic attitude toward the West that has endured.

The sheer scope of the enterprise is captured by Miller in his sketch of *Caravan en Route.* There is a pardonable exaggeration. The expedition comprised perhaps a hundred men—Miller noted, "a heterogeneous mass of people from all sections, free and company trappers, traders, half-breeds and Indians"—but the artist has easily implied three times that number in the great horde of riders followed by the long wagon train. Impressive as the horde is, seeming to swell out toward the front as if to fill up the plain, it is nevertheless also seen as a scattered crowd of tiny individuals against the vastness of the land, the looming heights of the background mountains and the immeasurable expanse of the sky above. Miller

Crossing the Kansas, ca. 1859, Alfred Jacob Miller.
8-5/8 x 13-7/16 in., watercolor.
Walters Art Gallery, Baltimore.
According to the artist, during such crossings there was "a great deal of fun and merriment intermingled with hard swearing in several languages."

has composed the caravan into a great arc, coming toward us from the foot of the mountains, gradually becoming clearer so that details and individual faces can be perceived and scattering into fringes in the foreground.

The expedition continued with *Crossing the Kansas,* an early barrier to the progress of the caravan. Miller described it, as usual in general terms. "In a large company of men, horses, wagons and equipments, the crossing of rivers is quite an undertaking and, if deep, involving considerable risk and damage. The Company's goods and the produce must be kept dry at all hazards. In the first place, guides are sent out to cross and explore the river at different points, in order to find the best places for embarking and landing, and when the river is deep, the goods must all be unladen from about 30 wagons and charettes, transferred to boats and ferried across.

"The horses and mules compelled to swim, and *nolens volens* pitched into the river to take their chances, there is a great deal of fun and merriment intermingled with hard swearing in several languages.—The trappers getting rid of their religion and losing their temper at the same time. Sterne's Capt. Shandy remarked that 'our army swore terribly in Flanders.' In this particular accomplishment, our devil-may-care Trappers have not degenerated."

In depicting the scene thus described, Miller chose as his viewpoint the farther shore, as the men, horses and wagons are coming out of the water with, apparently, a

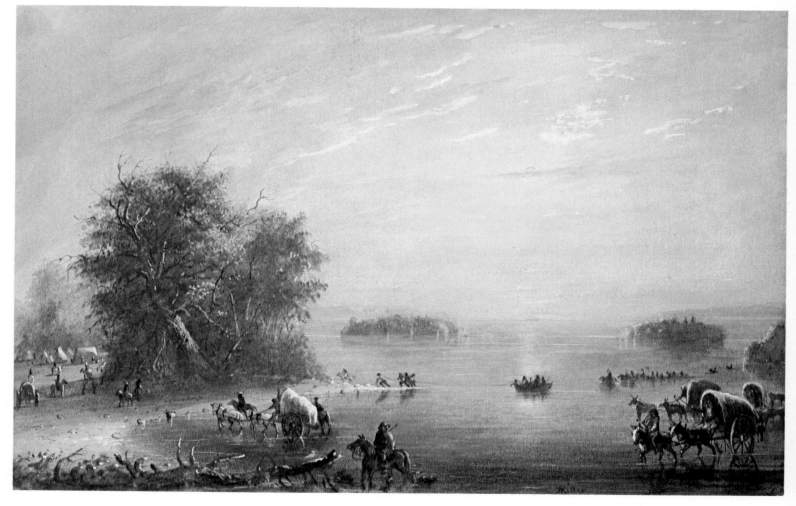

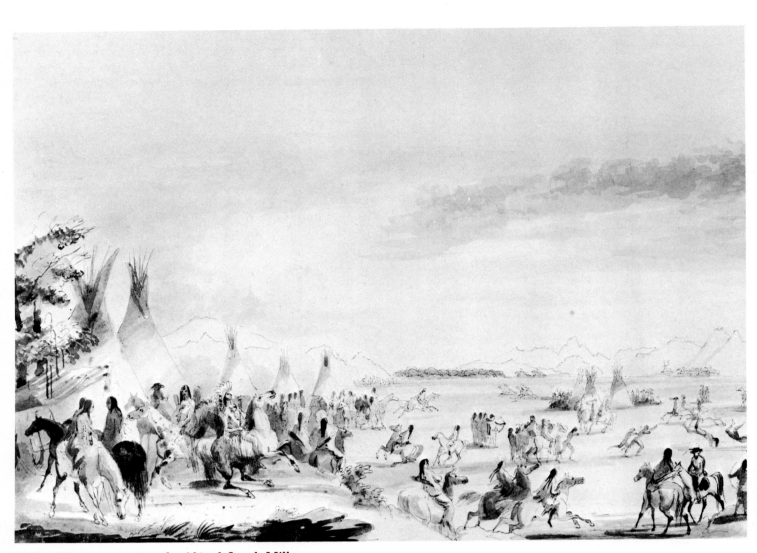

Indian Encampment, n.d., Alfred Jacob Miller.
8-3/8 x 12 1/2 in., wash, pen and ink on paper.
Dr. Carl S. Dentzel, Northridge, California.
The encampment scene is a catalogue out of which Miller
could easily extract dozens of subjects for other paintings.

friendly Indian encampment in the distance on the left. We are made fully cognizant of the various details of the crossing. In the foreground, charettes—the two-wheeled wagons—emerge from the water watched over by a mounted guard at the center of the bottom of the picture. In the middle distance, a group of men and a single horse are tugging at a line attached to a well-laden boat, behind which a string of horses and riders breasts the current. Once again, all of this multitudinous activity is dwarfed and diminished by the surrounding spaces of water, land and sky. The whole caravan, spread out, sweating and swearing, as the painter noted, make scarcely a line or so of punctuation on the calm surface of the Kansas. Even the old ruin of a tree on the new shore towers over the expedition while the morning sky spreads endlessly, the sunlight reflected from scattered clouds adding to the illumination of the scene.

This general theme of the vastness of nature within which man goes about his passionately pursued but miniscule tasks occurs again and again in Miller's sketches and paintings. It was, of course, one of the basic themes of the Romantic Movement in art and poetry. Miller also recorded man's efforts—red men and white men alike—to create shelter and a controllable, if small, environment within the vastness of land and sky.

Indian Encampment is rather "sketchier" than most of his sketches and may be merely a fast effort to get as much as possible down at once. At any rate, on the visual testimony of other Western artists and, for that matter, of Miller himself elswhere in his work, it does seem impossible that all these things could be going on simultaneously in the area encompassed by the sketch, large as that is.

In the lower right, a white trapper arrives in the camp and engages a mounted Indian in conversation. To their right, a small group seems to be engaged in target practice with the bow and arrow, while up from them Indian youths are leaping and diving on the ground. To the left, horses seem to be engaged in races of some kind. Beyond

the scattering of tepees, the Indian shelters made of poles and hides, a band of mounted Indians is in hot pursuit of a herd of racing buffalo. It is a fascinating picture, almost a catalogue out of which Miller could easily extract the subjects for a dozen or so of his more usual paintings.

The tepee was above all portable. A single Indian woman could set one up in twenty minutes, dismantle it in less. Dismantled, its poles and hides were arranged behind a horse to form a kind of dragging burden-bearer called a *travois,* the perfect extension of horsepower for a people who never mastered the wheel.

Indian Lodge shows the interior of the more permanent form of Indian dwelling, of which Miller wrote, "There is considerable ingenuity and taste displayed in the structure of these permanent Lodges—upright posts with crotched ends are first raised supporting bond timbers at different heights to give a sloping, circular roof:—

rafters radiating from the center rest on these, and are secured in their places by transverse pieces leaving narrow interstices—the whole of the framework is now covered with adobe, both roof and sides, which completes the Lodge. The light is admitted through an aperture in the centre and the smoke finds egress through the same. The subject of the sketch presents a favorable specimen of a permanent Lodge, with groups of Indians scattered about; at the upper end are some Indians seated, playing one of their favorite games, the 'games of hand.' It had a strong resemblance of our game of 'hunt the slipper.' Many persons conceive that Indians always carry a grave countenance. We have seen them 'laugh consumedly' while engaged in this favorite pastime."

Miller has probably given the lodge a little more feeling of spaciousness than it actually had, judging from similar pictures by Catlin and Bodmer. The open roof almost

Indian Lodge, ca. 1859, Alfred Jacob Miller.
7-7/8 x 11-7/8 in., watercolor.
Walters Art Gallery, Baltimore.

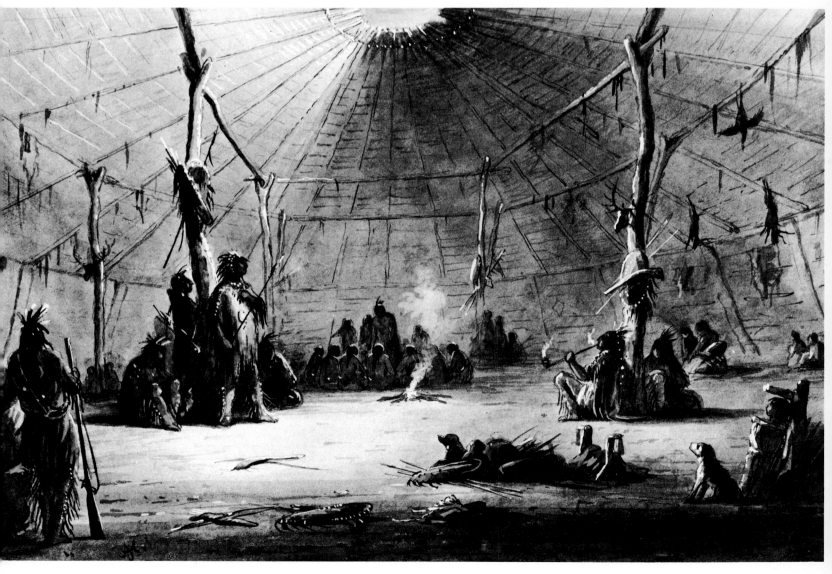

Laramie's Fort, ca. 1859,
Alfred Jacob Miller. 8-1/2 x 11-3/4 in., watercolor.
Walters Art Gallery, Baltimore.
Forts such as these gave clear evidence of the serious
changes occurring in the West, for they were the antitheses of the mobile or easily destroyed Indian structures.

suggests the commodiousness of such antique buildings as the Pantheon, with the "oculus," or eye, open to the heavens. The advantage is that we do get a sense of the distinct groups and occupations of the inhabitants.

Miller also recorded a *Western Log Cabin,* "situated at that time on the Western frontier of the United States, ... the last house we encountered previous to entering the wilderness. It was inhabited by a Shawnee Indian, who for a wonder has been benefited by civilization, for here he cultivated successfully about 100 acres of arable land, and had everything in plenty around him.

"The main building was 50 feet in length, flanked by kitchen and offices, built of logs dovetailed at the corners, with a Hall through the centre about 15 feet wide, and was altogether a most comfortable country residence."

Miller adds that the party camped there for a week, witnessing an Indian wedding and "purchasing mules and making our final preparation for a savage life."

Laramie's Fort shows a more elaborate structure, built by the American Fur Company some eight hundred miles west of St. Louis, in what is now the state of Wyoming at the confluence of the North Platte and the Laramie rivers in the eastern slopes of the Laramie Mountains. Miller described the fort as follows:

"Quadrangular form, with bastions at the diagonal corners to sweep the fronts in case of attack; over the ground entrance is a large block house, or tower, in which is placed a cannon. The interior is possibly 150 feet square,

Western Log Cabin, ca. 1859, Alfred Jacob Miller.
9-3/16 x 14-7/16 in., watercolor.
Walters Art Gallery, Baltimore.

72

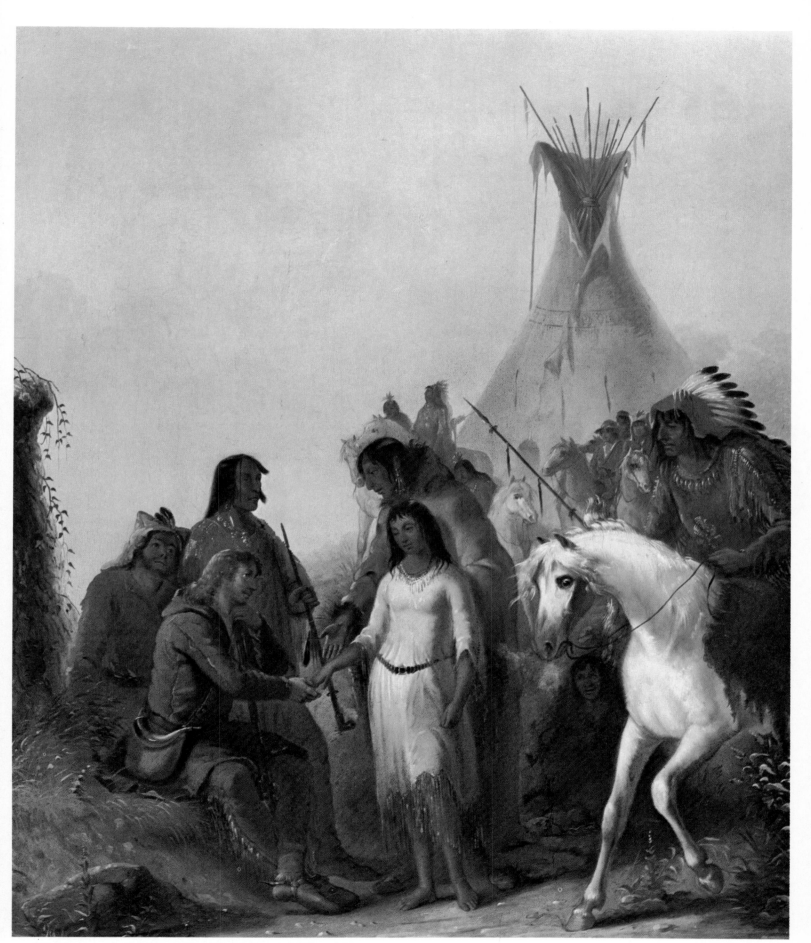

The Trapper's Bride, 1837, Alfred Jacob Miller. 25 x 30 in., oil.
Joslyn Art Museum, Omaha.

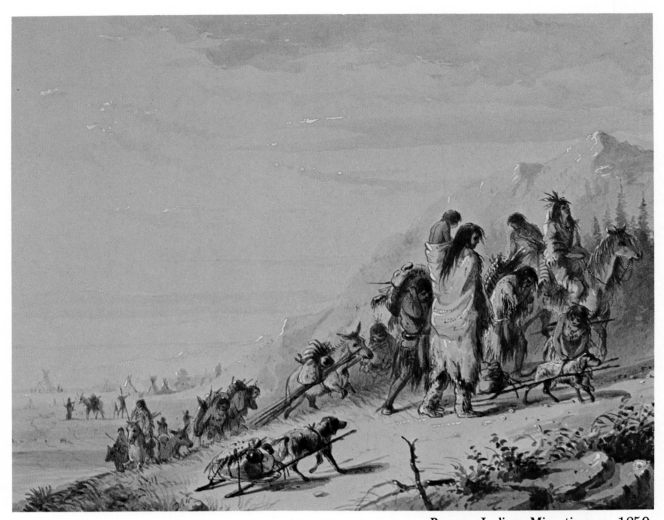

Pawnee Indians Migrating, ca. 1859,
Alfred Jacob Miller. 9-7/16 x 12-3/16 in., watercolor.
Walters Art Gallery, Baltimore.
While not as concerned as Catlin with the coming plight
of the Indians, Miller seems here to have realized
the sad migrations to come.

a range of houses built against the palisades entirely sur-
round it, each apartment having a door and window
overlooking the interior court. Tribes of Indians encamp
here 3 or 4 times a year, bringing with them peltries to be
traded or exchanged for dry goods, tobacco, vermillion,
brass, and diluted alcohol."

The sketch underlines the profound transition already
taking place in the West. The tepees and the little cooking
fires of the Indians, and for that matter the Indians them-
selves, all suggest in every line the temporary nature of
their stay. The tepees have pride of place in the picture.
But we look from them to the fort and the fort is a massive,
solid, structure, built for permanence and dominance. At
the time Miller painted this picture, the white man was
still an intruder in the West, an explorer, an adventurer
who risked his life merely by being there, while the coun-
try belonged to the Indians by immemorial right of
residence and hunting. But already the Indian was chang-
ing his ways to accommodate them to those of the white
man from the East. The quarterly encampment was one
sign of that. The nature of the trade goods was another,
especially the diluted alcohol, which meant that not only

was the Indian introduced to an extremely dangerous
drug, but was cheated in the bargain. From area after
area, the tepees would vanish, eventually to be replaced
by slum housing on reservations. The fort would remain,
as indeed, in altered form, it has. Miller, himself by no
means feeling as secure in Indian country as that contrast
might imply, nevertheless perceived it and per-
fectly rendered it.

He seems to have come closer still to a conscious reali-
zation of the impending plight of the Indians in their own
country in a sketch of *Pawnee Indians Migrating*. The
composition is beautifully unified in the slow, sad diagonal
from lower left upward toward center right. This main
line is reinforced by the mountains, piling up in exactly
the course of the Indian band ascending out of the plain
onto the trail to some new hunting ground. Even the dogs
are fitted with *travois* poles and crosspieces to carry the
"peltries &c." In time-honored artistic fashion, Miller has
compressed a sequence of events into a single moment of

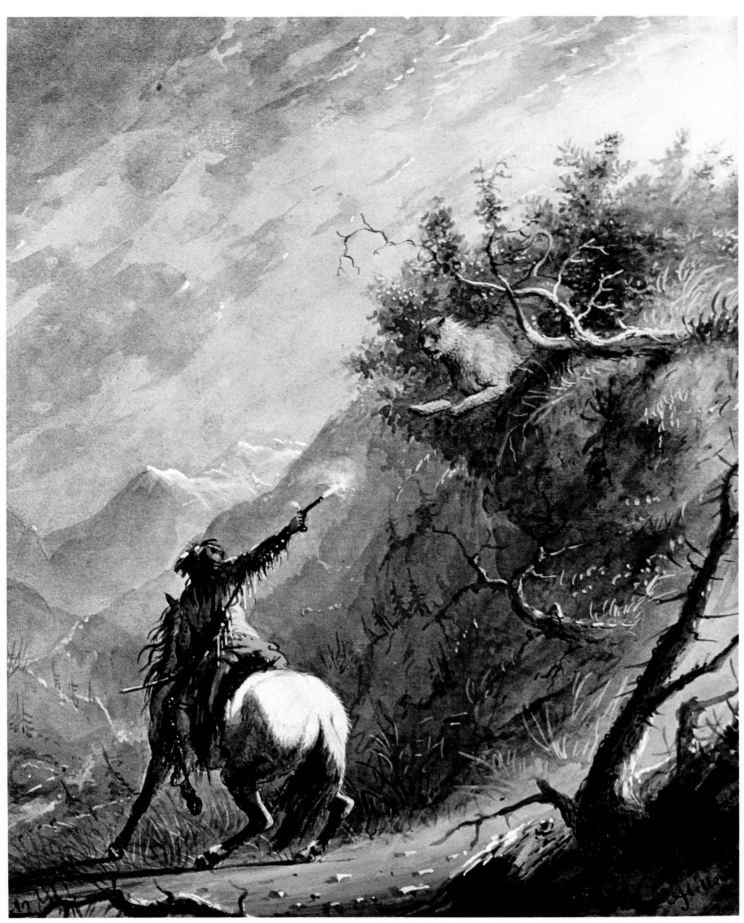

Shooting a Cougar, ca. 1859, Alfred Jacob Miller.
11 x 9-1/8 in., watercolor. Walters Art Gallery, Baltimore.
The encounter between man and beast was a favorite
theme of Romantics like Miller, who found many
opportunities to employ it in his paintings.

view: in the background, tepees are still standing in various stages of dismantlement. Closer to us, a donkey is being loaded for the trip, while in the foreground, up the slopes of the surrounding mountains, the migration is already in progress.

Miller in his notes displays once more his customary casual contempt of Indian ways compared with those of the industrious whites: "When the grass in camp is eaten up by the animals, & the Buffalo all driven off by repeated forays amongst them, the Indian must then perforce break up his encampment. His natural indolence is averse to movement, but stern necessity that rules her children with an iron rod drives into the measure;—nothing short of an Indian yell, that dreadful gage to battle (once heard, never to be forgotten), can rouse him to his wonted activity. Now, however, he must leave his *dolce far niente,* his solacing campfire, pack up his moveables and go."

The basic attitude toward the Indians is standard not only for Miller but for the majority of that generation of white men engaged in cheating the Indian in trade, robbing him of his land and signing treaties with him to be broken before the ink was dry. But Miller's literary background here betrayed an insight unsuspected in most of his notes. After going on to describe how everything is brought together, placed into the column and put in motion, he concluded his note to the migration picture with a classical reference:

"The World was all before them, where to choose
The place of rest, and Providence their guide."

The quotation, of course, is from Milton's *Paradise Lost.* The lines are the next to last two of the whole long poem and refer to the situation of Adam and Eve immediately after their expulsion from Paradise. The comparison is rather lofty, to say the least, to be made for a tribe of Indians setting out from one campground to a new one, a process, after all, to which, for all Miller's imaginings about indolence and *dolce far niente,* the people had long been accustomed. But when Milton's lines, with their dying fall, are set against the overall situation of the American Indian from Miller's time in the West to the end of the nineteenth century, then indeed does the comparison seem justified, for then the Indians were turned out of their earthly Paradise and "with wand'ring steps and slow/ Through Eden took their solitary way."

Encounters between man and the wild animals of the wilderness were a favorite theme of the Romantic era, and Miller had ample opportunity to employ that theme on his journey. *Shooting a Cougar* is the essence of the Romantic encounter. Unlike the hunting of the buffalo or the trapping of the beaver, here the animal not only had a fighting chance but was in mid-attack upon the mounted trapper on a mountain trail. The great cat was leaping from a bluff overlooking the path when the rider heard something, turned in the saddle at the same time drawing his pistol and firing straight at the beast of prey. Light and shadow are managed for the utmost in dramatic effect. The light from the right emphasizes the height of the locale, a fact already quite clear from the distant background of trees, streams and smaller mountains far below. The cougar is depicted in full attack leap. The reined-in horse holds steady as the rider aims and fires in an instant and the moment is preserved.

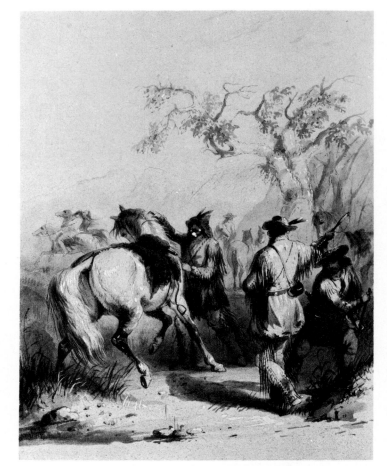

**Preparing for a Buffalo Hunt, ca. 1859,
Alfred Jacob Miller. 12-5/16 x 9-1/2 in., watercolor.
Walters Art Gallery, Baltimore.
Members of Miller's adventure party were
sketched as they geared up for a hunt.**

Some provisions were brought along on such trips as Captain Stewart's, but they were few and of the kind that could not be had on the journey. Water was never hauled West, although its absence was occasionally an inconvenience, even a danger. It could be obtained en route for man and beast if the expedition were properly guided. The same was true of meat for the riders. The Plains were alive with buffalo and the great herds provided meat for the itinerant trapper and adventurer as they had so long for the Indian. *Preparing for a Buffalo Hunt* shows the party gearing up. Auguste, a French-Canadian always distinguishable in Miller's drawings by his animal headdress, holds Captain Stewart's horse. The Captain is seen with his back to us, giving last minute orders to Antoine, his most reliable hunter who, improbably, accompanied him eventually to Scotland and served there as his valet. Miller has caught the stir of interest and anticipation, with the horses in the distance galloping out toward the hunt, and the Captain's steed pawing the ground and turning in a movement abstractly repeated in the overhead branches of the trees.

In the oil painting *Buffalo Hunt,* executed after his return to the East, Miller depicted an Indian hunt of the great beasts of the Plains. In the foreground, a mounted Indian rides close alongside a galloping buffalo and is about to discharge an arrow into the usually fatal spot at the base of the skull. Off to the left, two Indians are between them about to kill and yet playing with their

buffalo. In the distance, the whole vast herd flees from the hunters and will undoubtedly escape, with the possible exception of one or two more. The scene is at Independence Rock with the lofty Sweet Water Mountains in the background.

Occasionally a buffalo would be wounded or exhausted or crippled from falling while racing to escape. It was then that *Killing Buffalo With the Lance* came into play. Miller makes it clear that danger is not entirely past at this point. Indeed, it may even have been greater than earlier in the hunt, for while the buffalo normally fled from the sight of man, when wounded the beast would fight to the death, ripping open horses with its horns and trampling hunters in the dust. Here the stricken beast, cut off from the herd, is set upon by two warriors, one of whom is having some trouble bringing his horse close enough to strike at the buffalo. The rearing horse on the right contrasts with the pawing one of the left and both are tense and lively counterpoints for the dying bison.

An alternative to the buffalo as a meat source was the elk; although the meat was considered inferior to that of the buffalo and the mountain sheep, the Indians valued

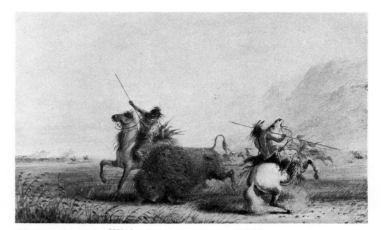

Killing Buffalo With the Lance, ca. 1859,
Alfred Jacob Miller. 8-5/8 x 14-3/16 in., watercolor.
Walters Art Gallery, Baltimore.
In this final play of the hunt, the tense and lively horses are counterpoints for the dying buffalo.

Buffalo Hunt, 1840, Alfred Jacob Miller. 30 x 40 in., oil.
Thomas Gilcrease Institute
of American History and Art, Tulsa.

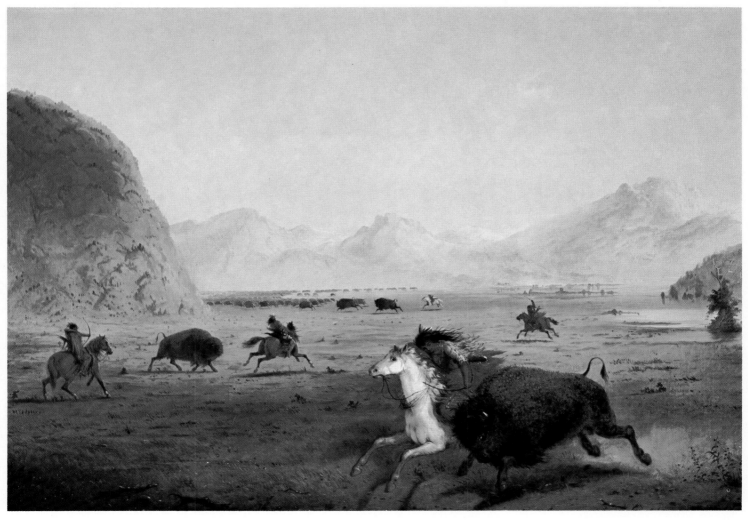

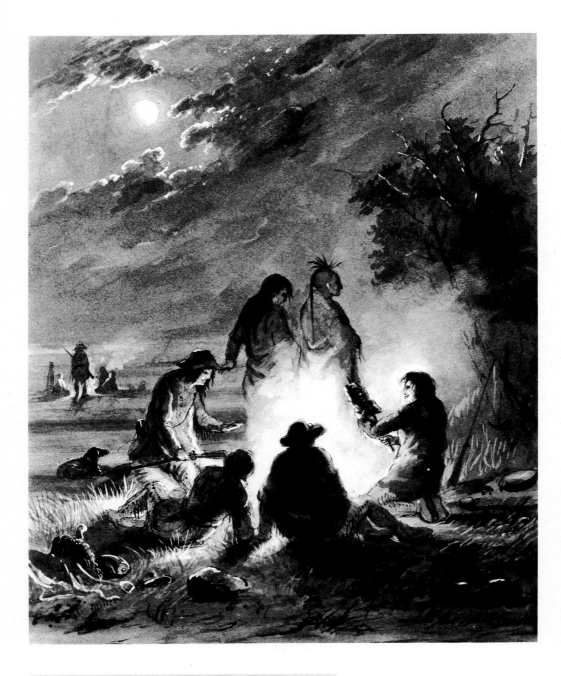

Left:
Hunting Elk Among the Black Hills, ca. 1859,
Alfred Jacob Miller. 11-3/4 x 9-3/8 in., watercolor.
Walters Art Gallery, Baltimore.
Both Indian and white hunters found a most expedient way
to hunt elk was to ambush the fleet-footed animals.

Above left:
Camp Fire, Preparing the Evening Meal, ca. 1859,
Alfred Jacob Miller. 11 x 9 in., watercolor.
Walters Art Gallery, Baltimore.
The tender buffalo hump rib was the
delicacy of this campfire meal.

Above right:
Hunting Elk, n.d., Alfred Jacob Miller.
8-1/2 x 12-5/6 in., watercolor.
Walters Art Gallery, Baltimore.

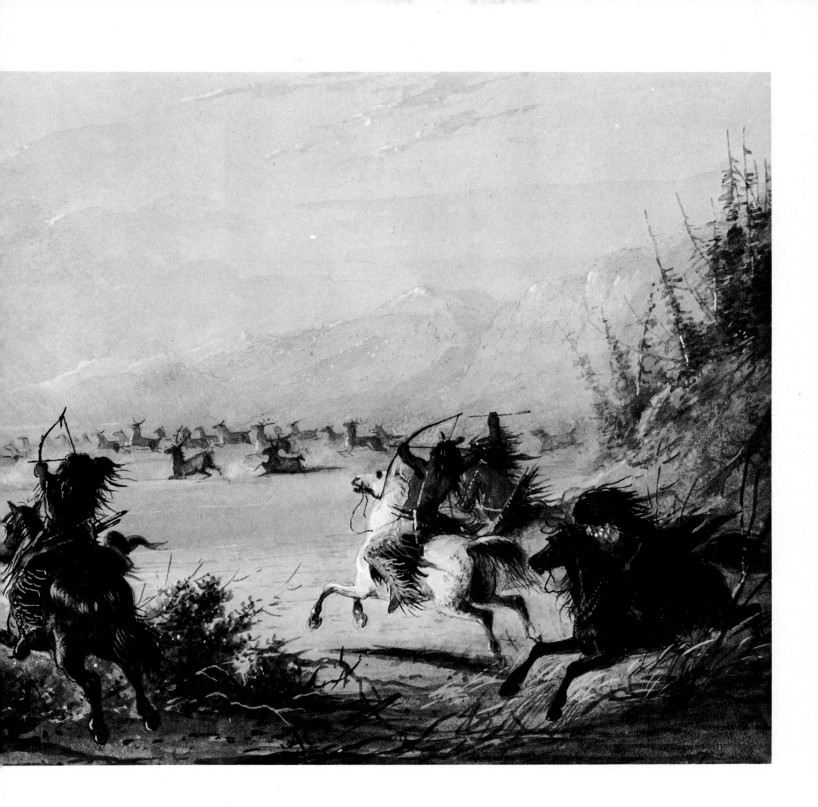

the skin for its superior rawhide and its horns, which at their greatest extent, made excellent bows. In *Hunting Elk,* the party of Indians has ambushed a herd of elk, the only practical way to get close enough to the fleet-footed animals to kill them. Firing their arrows as fast as they can draw them, they make no real effort to chase the elk, only to kill those they can take by surprise. Similarly, the white trappers in *Hunting Elk Among the Black Hills* have ambushed the elk and, having climbed upon the rocks they formerly hid behind, are firing at the fleeing herd.

The rewards of the hunt, whether of buffalo or elk, are shown in *Camp Fire, Preparing the Evening Meal.* In this picture, the reward is that special treat of the prairie, the humb rib of the buffalo. The tenderest part of the animal,

the hump rib was much prized by both Indians and trappers. Miller notes that "The fire is often made from the *bois de Vache* (literally, "wood from Cow," a French-Canadian humorous circumlocution), but as we had the best of all sauces, viz: most ungovernable appetites, and most impatient dispositions for this same roasting operation, the circumstance did not affect us in the least. We found hunger so troublesome that it was quite a common thing to rise again at midnight and roast more meat, if we had any." The picture is nicely balanced with its three sources of light, the cooking fire in the foreground, the one in the middle distance and the pale moon overhead.

Miller, despite his insurmountable feelings of racial superiority took great interest and delight in the Indian life he observed around him as the expedition passed over

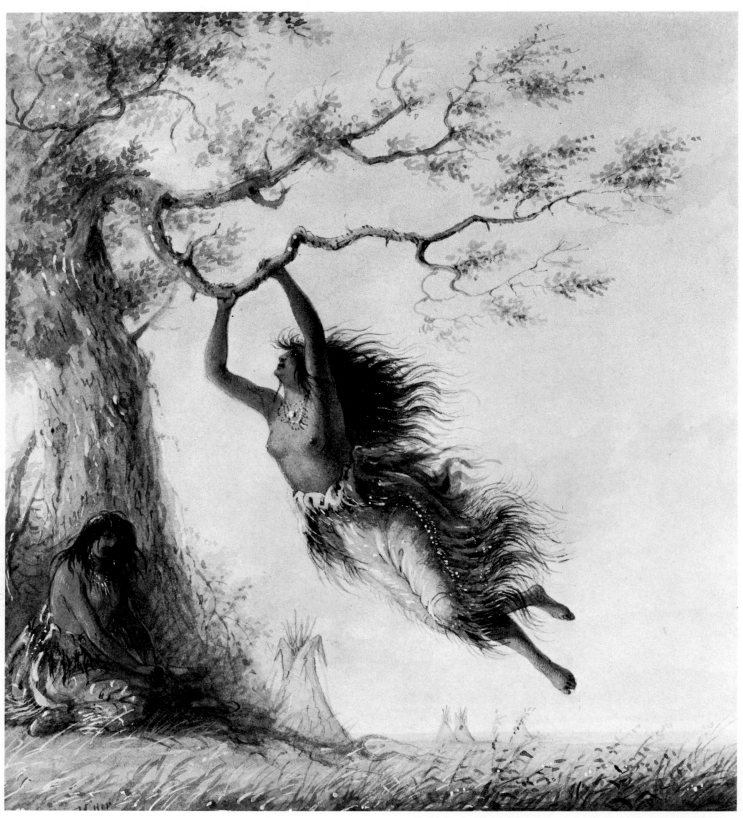

Indian Girls Swinging, ca. 1859, Alfred Jacob Miller.
10-15/16 x 9-1/2 in., watercolor. Walters Art Gallery, Baltimore.
Miller's usual racial bias is nowhere present
in this enchanting vignette of casual Indian life.

Opposite: **Beating a Retreat,** 1842, Alfred Jacob Miller. 29 x 36 in., oil.
Museum of Fine Arts, Boston, M. and M. Karolik Collection.
This became a conventional impression among whites of Indian life.

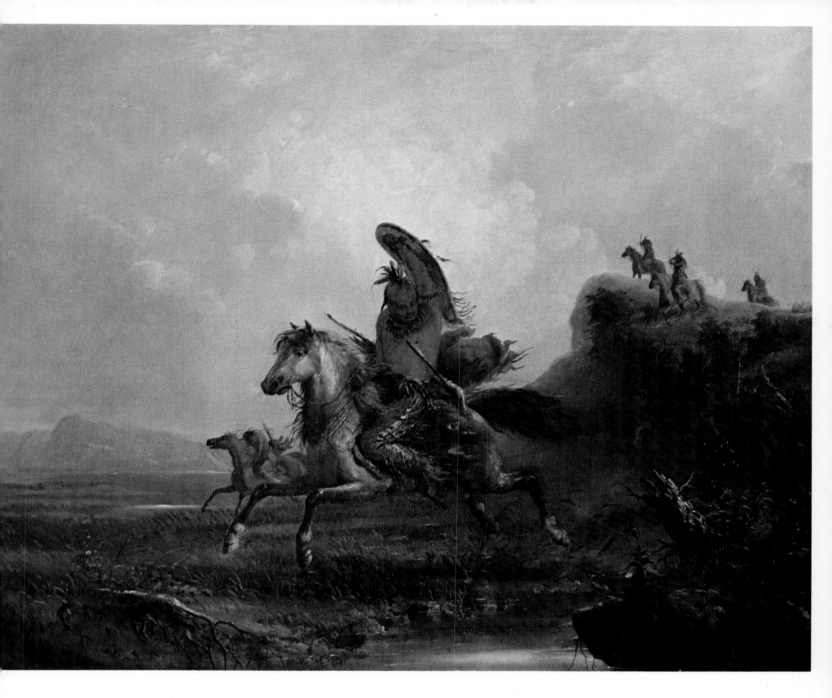

the Plains and through the mountains. *Indian Girls Swinging* is an enchanting vignette of Indian life, a casual moment caught by the artist and immediately transcribed, along with a note especially perceptive in one himself still in his mid-twenties. "She had in truth," he wrote, "almost nothing to wear and with her kith and kin in addition not worth a baubee—yet with these serious drawbacks, one quality she possessed outweighed them all. It was youth."

A view of Indian life that was to become much more conventional among whites was painted by Miller in *Beating a Retreat.* The leading warriors race across the plain off to the left. The one nearest us raises his shield to escape the impending rush of arrows from his galloping enemies, who, from the right, come thundering over the embankment, the leading rider aiming a shot with bow and arrow.

All things considered, Miller's most enduring contribution to the art of the West was his grasp and appreciation of the unique, overwhelming beauty of Western scenery. Bodmer and Catlin were both more concerned with the

ways of the Indians, and the Swiss, in particular, was concerned with the flora and fauna of the newly explored lands. Miller was no scientist nor was he employed by one. His attitude toward the Indians, as his notes make clear, was closer to that later view that said "The only good Indian is a dead Indian"—although Miller would have shrunk from that formulation—than to Catlin's mystical, high regard for the noble savages untainted by civilization yet doomed by its advance. For Miller, therefore, and the more so as a practicing, believing Romantic, the glorious scenery of the West could be and was enjoyed for itself alone. In picture after picture, especially after the expedition got into the Rocky Mountains and passed through them to the Wind River and the Green River of Oregon, Miller recorded breathtaking views.

It is almost possible to watch the effect of the natural grandeur upon the young artist as he made his way west with the expedition. Naturally, he never gave up the lively sketches of Indian customs and trappers' adventures. But in the larger views of scenery, there is a gradual diminution of interest in the activities of the na-

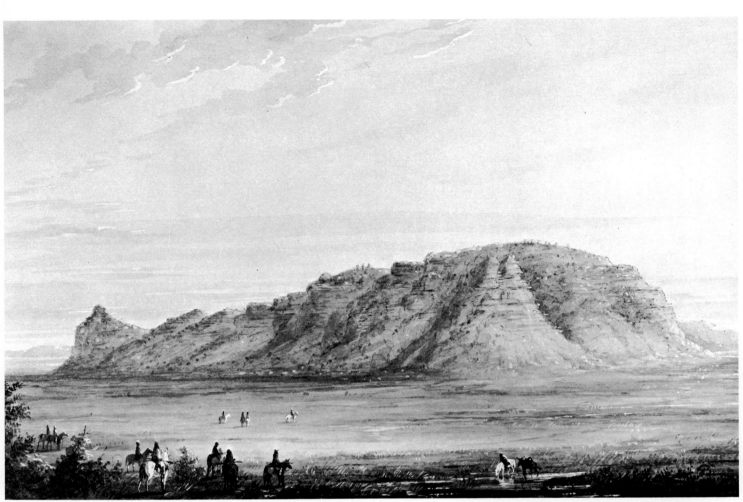

Scott's Bluff, ca. 1859, Alfred Jacob Miller.
9-1/16 x 14-1/4 in., watercolor.
Walters Art Gallery, Baltimore.

tives and the travelers and a corresponding shift of focus to the high skies, the mighty mountains and the broad waters that had, as he says in a note to one such picture, "been waiting . . . thousands of years, and could afford to wait thousands of years longer, for they are now as fresh and beautiful as if just from the hands of the Creator."

Miller concluded that passage prophetically, though he could hardly guess some of the results of his prophecy: "A single Lake and Mont Blanc are the wonders of Europe, but here are mountains and lakes reaching from Tehuantepec to the Frozen Ocean of the North, or upwards of 50 degrees—nearly one seventh part of the globe—ample room and verge enough, one would think, for a legion of tourists."

Scott's Bluff, some seven hundred miles west of the Mississippi, is presented as a single, natural terrain feature of some curiosity. Miller records the origin of its name: A sick man on an earlier party had been left there with one man in attendance. A year later, on its return, the party found Scott's bones and no sign of the other man.

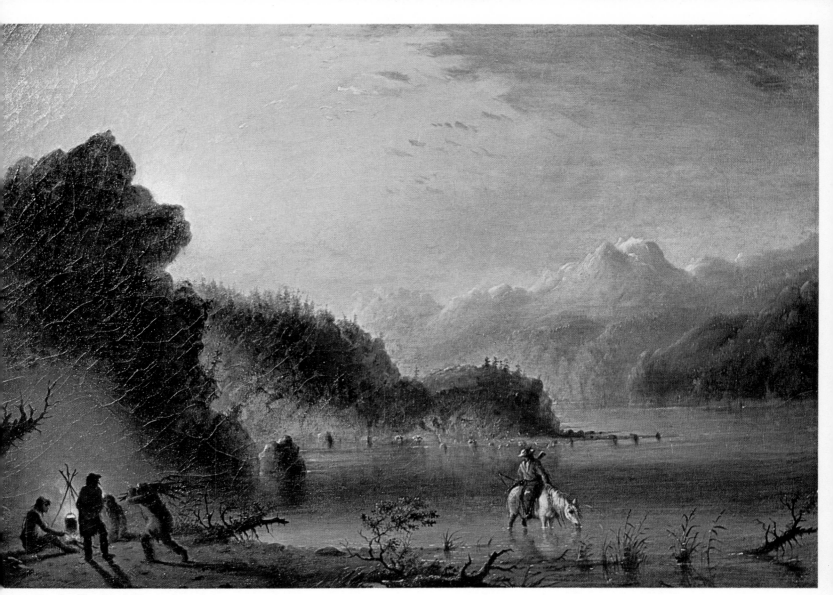

In the Rocky Mountains, n.d.,
Alfred Jacob Miller. 14-3/8 x 20 in., oil.
Joslyn Art Museum, Omaha.
A record of daily camp life is this scene with Captain
Stewart inspecting his camp, a rather unusual painting
in that human efforts supersede the background majesty.

In the Rocky Mountains is still essentially focused on
the doings of the Stewart party: the leader sits on his
white horse ankle-deep in the river while inspecting a
camp set up by the trappers who are cooking their supper
and bringing in a load of dead wood for the fire. The
scenery, spectacular enough in itself, is still a background
for these recorded activities.

In *Lake Scene, Wind River Mountains,* the focus has
changed. There is, as it happens, an exciting chase going
on in what may be called the foreground. But the scale of
the scenery and of the picture has become so large that
the chase—after an elk swimming across the river to es-

cape its pursuers—is a minor motif, useful for revealing
the scope of the river and the mountains but easily dis-
pensed with altogether. Indeed, the usual viewer at first
sight is unaware of the presence of the six or eight horse-
men and the swimming elk. What he sees first and last is
the majesty of the scene.

Likewise in the obviously related *Lake, Wind Riv-
ver, Chain of Mountains,* the central rider, despite his pre-
ferential placement downstage center, is all but invisible
at first glance. Again, when we do discover his presence,
we accept it only as underlining the awe the picture in-
spires at the astounding scope of the spaces along

(continued on page 86)

Overleaf: **Lake Scene, Wind River Mountains,** ca. 1859,
Alfred Jacob Miller. 9-3/8 x 12-3/16 in., watercolor. Walters Art Gallery, Baltimore.
First and last in this painting is the majesty of the scene, and secondary
is the elk chase in the foreground. The theme of humanity's little
ventures among nature's vastness recurs often in Miller's works.

the water, from mountain to mountain and above in the gorgeously colored sky. The picture reveals Miller's familiar competence in composition. The clump of trees in the center, behind that rider, are balanced by the nearer tree on the left and the bluff rising from the river on the right. All of these seem a frame for the mountain range in the distance and especially for the massive formation in the center of that distance.

Finally, in *Green River, Oregon,* the goal of the expedition was reached, the site of the rendezvous, the great annual meeting between traders, trappers and Indians. In this picture, the painter, too, reached, if not a goal, at least a workable and instructive blend of the two approaches to Western landscape he had already explored on the way out. Now, at last, there seems to be a perfect combination of animated human figures going about their business and the glories of the country stretching, it seems, to infinity. Perhaps it is because the human beings in question are Indians, and hence accustomed to

the scenery that, as Miller remarked in a note, possibly as few as twenty white men had ever before this party gazed upon it. The Indians, gathering for the rendezvous, have erected their tepees on the shore of a cove in the river along the far bank from our point of view. Some of them there and nearer are walking their horses in the water, letting the animals drink and looking about as if for additional arrivals; one such arrival is trotting his horse through the bracken above the shore.

Around, beyond and containing this calm group of Indians are the mountains, rising from both banks of the Green River to the serene peaks in the distance, with lesser summits in front of them. Yet, vast as the distances are, they do not dwarf the Indians or their dwellings, which seem small enough, to be sure, but which nevertheless seem purposeful and at home. The light from the sun, veiled in mist above the mountains, is reflected more sharply in the waters and completes the ensemble. In this picture and in others no less striking, Miller discovered

Left: **Green River, Oregon,** ca. 1859,
Alfred Jacob Miller. 9-1/6 x 12-1/4 in., watercolor.
Walters Art Gallery, Baltimore.
The site of the final rendezvous of Miller's expedition is a
serene blend of natural grandeur and purposeful human activity.

Lake, Wind River, Chain of Mountains, n.d.,
Alfred Jacob Miller. 7-3/4 x 11-7/8 in., watercolor. Joslyn Art Museum,
Northern Natural Gas Company Collection, Omaha.

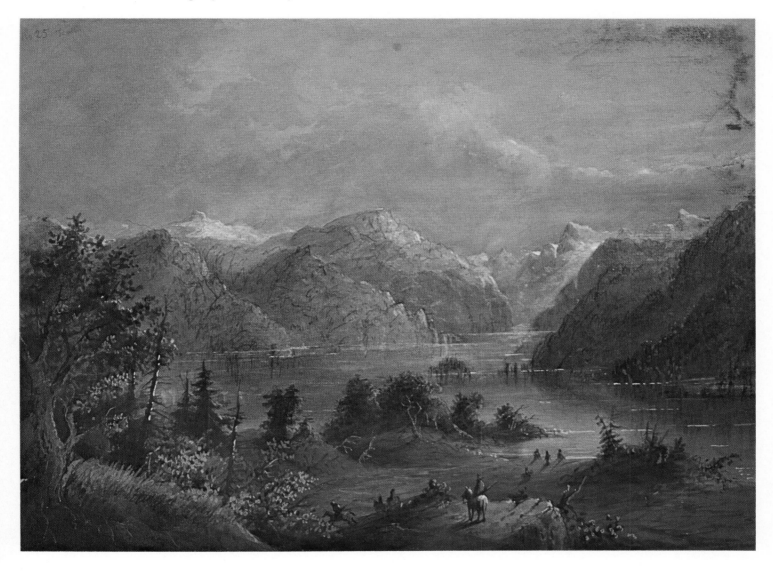

the landscape of the West as an overwhelming subject
for the American artist. His successors would not be long
in following his trail both geographically and artistically
but, though their canvases expanded sometimes as if they
wished to paint life-size pictures of Yellowstone Falls or
Pike's Peak, none of them ever surpassed the feeling of
nature's majesty and beauty achieved by Alfred Miller
in a picture such as this, nine inches high by twelve across.

But though others followed in his footsteps, he himself
never did. Captain Stewart did take one more hurried

trip west the following year and it is conceivable that Miller accompanied him, but there is more evidence that he did not. On his return to St. Louis, Stewart learned that his elder brother, as long expected, had died and he was now the baronet. There would be no more rambles in the wilderness, however much Sir William's heart might be in the American highlands, chasing the elk or the buffalo in lieu of the deer.

In the spring of 1839, just before Stewart sailed for Scotland, he exhibited eighteen of the pictures Miller had painted for him at the Apollo Gallery in New York City, where they attracted favorable popular and critical notice. In 1840, Miller joined Stewart at Murthly Castle, which he was enchanted to discover included in its grounds that famous Birnham Wood, in which Duncan's soldiers had hacked branches to shield their movements as they advanced against the tyrant-usurper, Macbeth. At Murthly, he painted in oils from the water color sketches he had made on the spot and, as noted above, was much gratified that Sir William treated him as a guest and a friend, an equal, in contrast to the captain's military attitude in America.

The winter of 1841–42 Miller spent in London, where he executed three religious pictures for Stewart and where, at last, he met Catlin, then approaching the peak of his success. In the spring he returned to Baltimore, where, all his adventures over, he picked up his old career as a portrait painter. Throughout the next thirty-two years of his life, he never ventured farther west than Cumberland,

Right:
Taking the Hump Rib, n.d., Alfred Jacob Miller.
8-5/16 x 12-5/16 in., watercolor.
Walters Art Gallery, Baltimore.

Below right:
Chimney Rock, Nebraska, 1837, Alfred Jacob Miller.
10-1/4 x 14-1/4 in., watercolor.
Walters Art Gallery, Baltimore.

Below:
Indian Procession in Honor of Captain William Stewart,
1837, Alfred Jacob Miller, watercolor. Thomas Gilcrease
Institute of American History and Art, Tulsa.

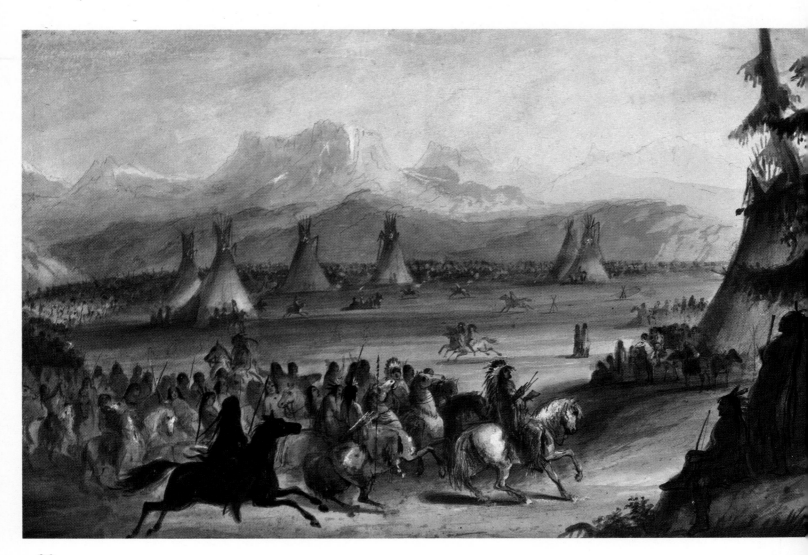

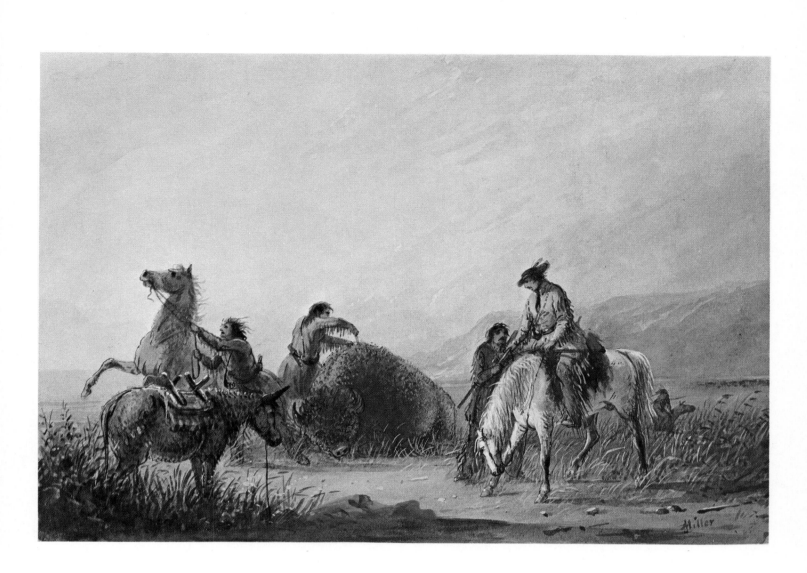

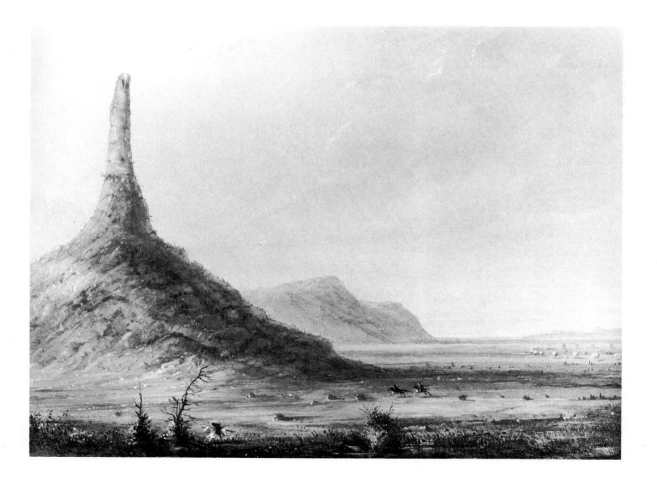

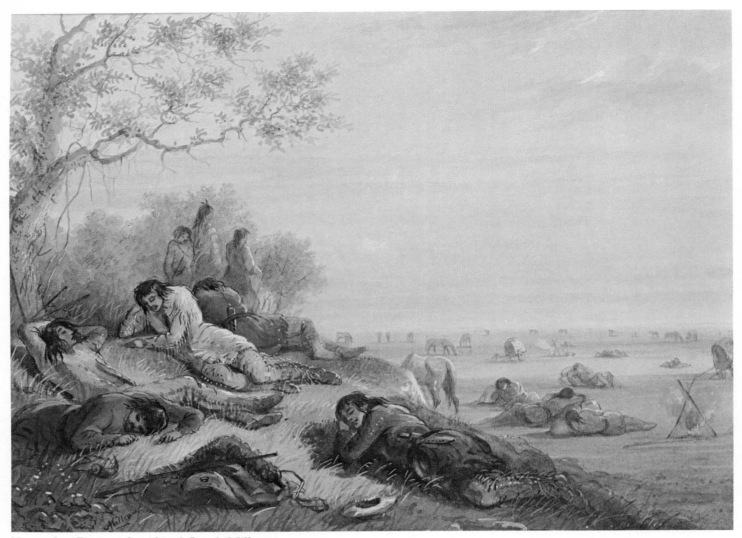

Noon-day Rest, n.d., Alfred Jacob Miller.
9-7/16 x 13-1/8 in., watercolor.
Walters Art Gallery, Baltimore.

Maryland, and Susquehanna, Virginia, long settled and cultivated areas, the former one of the first passages through the eastern mountains to be used by westering Americans. For three decades, then, he made the portraits of people in Baltimore, becoming well established as a provincial portrait artist. Quite regularly he made copies of his Western sketches for people requesting them. Perhaps the best set—in watercolors—was made for the Baltimore collector, William T. Walters, whose collection became the Gallery that bears his name in that city. Executed at twelve dollars each, they totaled two hundred. More complete than the on-the-spot sketches, they nevertheless lack the ponderousness that sometimes weighed down Miller's oils.

Such ventures, however, remained merely a sideline, a source of small additional but regular income, and why this was remains a mystery in the story of American art. The Walters pictures, for example, were delivered to that philanthropist beginning in February 1859 and continuing to August 1860. He executed another set of forty watercolors, now in the Public Archives of Canada at Ottawa, in 1865. He lived until 1874.

Thus, when Miller began delivering Walters his copies of his early work in the West, Albert Bierstadt was on his first Western trip. When Miller completed delivery, Bierstadt was showing what were called the first Rocky Mountain pictures in New York, Miller having, in the intervening twenty years, been forgotten in that metropolis. Bierstadt became a rich man developing the themes Miller had discovered, chiefly the grandeur of the Western landscape, while the discoverer continued in Baltimore as a portrait man.

Partly because of his obdurate practice of portraiture, partly because his no less obdurate fidelity to the city of his birth, Miller sank into an obscurity which only became more profound as the years piled up. Happily, in the last two decades, thanks to an awakening of general interest in the history of the West, Miller at twenty-seven and twenty-eight as copied by Miller of forty to fifty has re-emerged from the shadows of art history as a remarkable artist of the West, clearly the finest between Catlin and Bierstadt and in different ways superior to both. The immediate future, with its predictably increasing concern over the preservation and reconstruction of some of the pre-settlement values of our land and its similarly growing concern over the fate of the American Indian, offers promise that the reputation of Alfred Jacob Miller will grow and that his work will once again instruct Americans in the treasures that are—or once were—theirs.

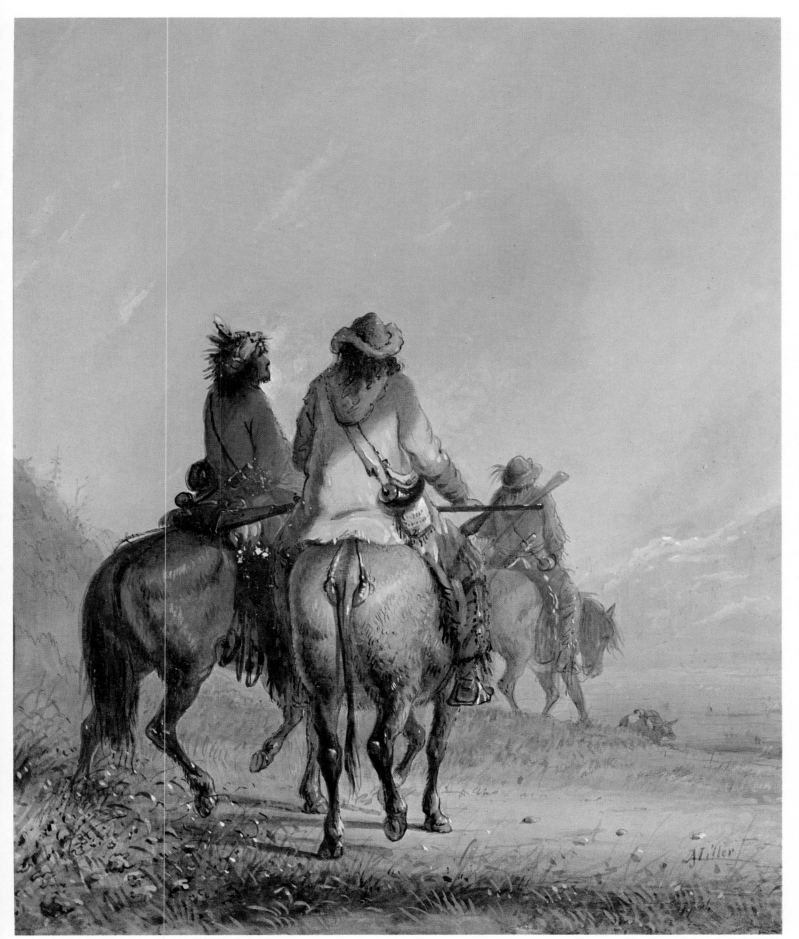

Trappers Starting for the Beaver Hunt, n.d.,
Alfred Jacob Miller. 11-3/16 x 9-3/8 in., watercolor.
Walters Art Gallery, Baltimore.

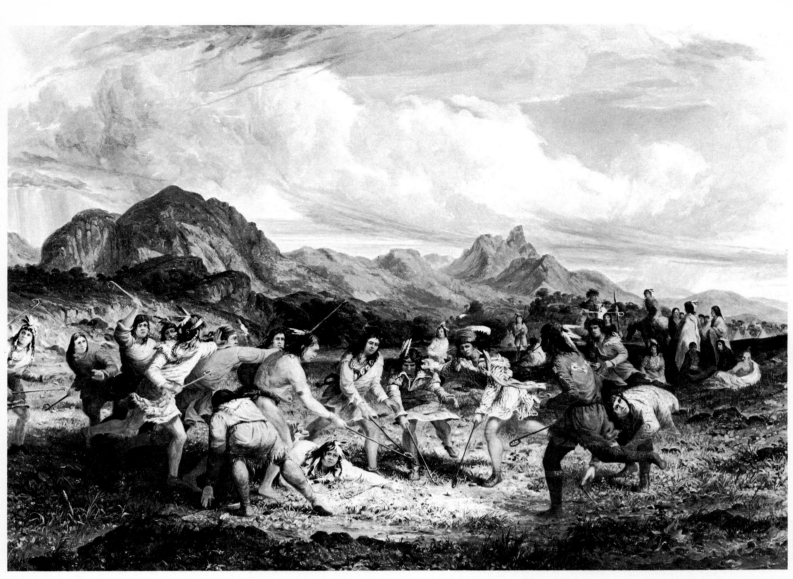

Lacrosse Playing Among the Sioux Indians, 1851,
Seth Eastman. 28-1/4 x 30-3/4 in., oil.
The Corcoran Gallery of Art, Washington, D.C.

SOLDIER AS ARTIST

Seth Eastman
(1808—1875)

Catlin, Bodmer and Miller all dealt, at one time or another, with the United States Army in their explorations of the Great Plains, the mountains and the rivers of the West. Catlin particularly accompanied military expeditions up the rivers and all three painters were aware that the only white authority in the territories they traveled in was provided by the Army. Eastman, the fourth of the early quadrumvirate of Western painters, took the relationship a step further. He was a member of the Army, served in it all his adult life and retired as a brevet brigadier general after the Civil War.

It was in the course of his military service that Eastman did most of his Western painting and drawing. His career is significant for two reasons beyond the quality of his work, which is considerable. In the first place, he was a soldier-artist over the period in which the West stopped being a problem of exploration and trade for the United States and started being a military problem. Eastman was in the Army, along the frontier, during the first major Indian Wars of the United States. Secondly, by the accident of military assignment, Eastman's art career, like his Army career, follows the swing from the time when the West, for Americans, meant chiefly the central Plains and the Rocky Mountains, to the time when the West came to mean the Southwest, including Wyoming and Colorado but concentrating on Texas, New Mexico, Arizona and Nevada. Eastman did not serve throughout those territories, but his significance, from this point of view, is that he began his military-artistic-Western career

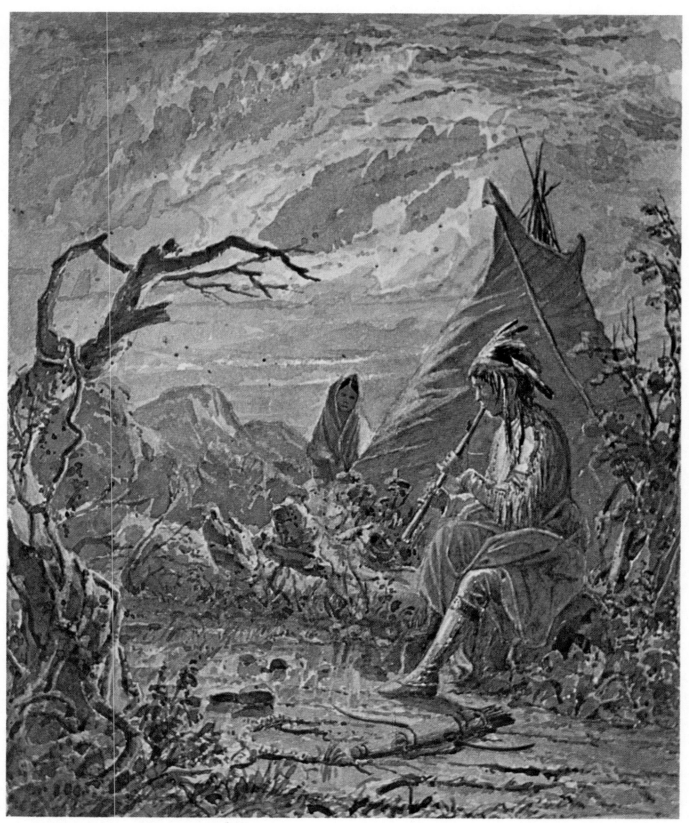

Indian Courting, ca. 1851, Seth Eastman.
5-1/4 x 6-1/4 in., watercolor.
James Jerome Hill Reference Library, St. Paul.

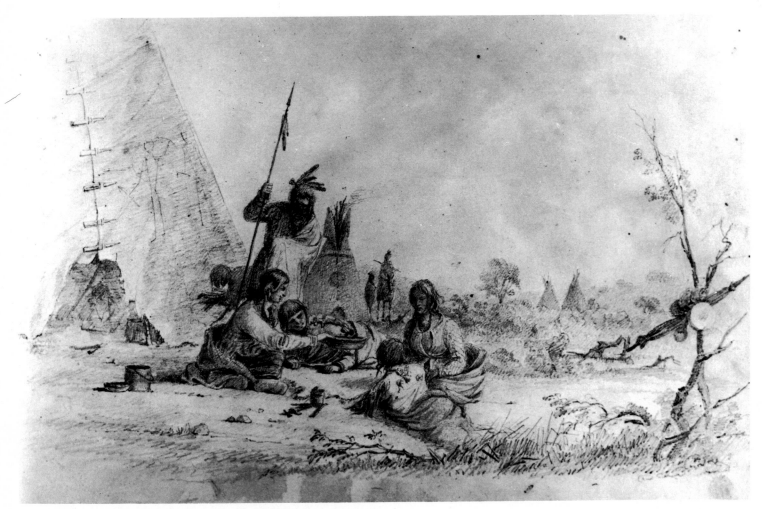

Sioux Indians Playing the Game of Plum Stones, 1841-48,
Seth Eastman. 9-1/4 x 6-1/2 in., pencil.
Peabody Museum of Archaeology and Ethnology,
Harvard University.

along the Upper Mississippi and its tributaries, just as
had Catlin, Bodmer and Miller, but capped that career
with his regiment in Texas, country later memorialized
by Remington and Russell.

Seth Eastman was born in the State of Maine, as far
east as you can get in the continental United States,
although his town, Brunswick, is on the coast a little above
Portland before that coast takes its great curve eastward.
At the age of sixteen he obtained an appointment to the
United States Military Academy at West Point, New York,
graduating with the class of 1828. At the Point, he had
been thoroughly grounded in topographical drawing, at
that time a more vital military skill than it has become
since the perfection of photography. Unlike most young
officers who were taught to draw well enough to represent
the terrain in front of them for purposes of military dis-
position of troops and guns, Eastman realized in his
drawing classes that this was something he liked to do,
had talent for and wished to master.

On graduation, he was posted to duty as a lieutenant of
infantry at Fort Crawford, Wisconsin, and Fort Snelling,
Minnesota. A year or so later he was transferred to spe-

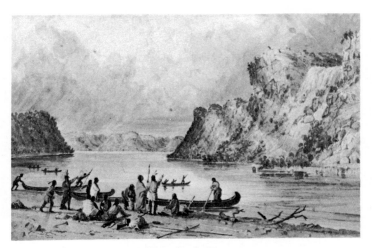

Wenona's Leap, ca. 1851, Seth Eastman.
9-3/4 x 6-1/2 in., watercolor.
James Jerome Hill Reference Library, St. Paul.

94

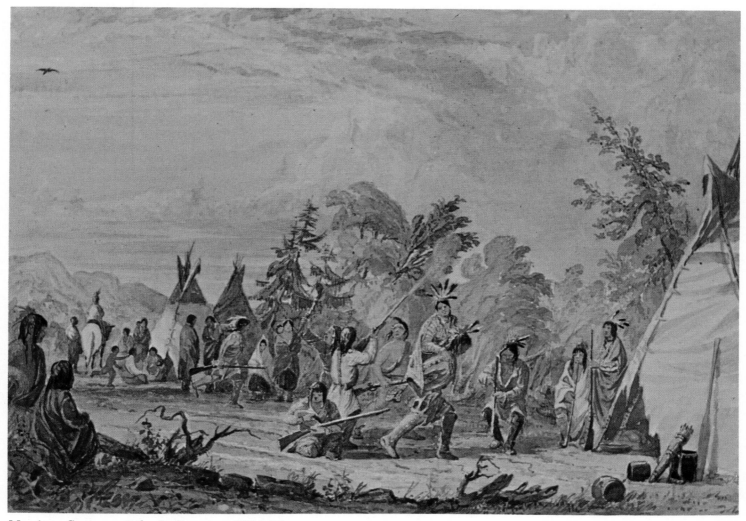

Marriage Custom of the Indians, ca. 1850-55,
Seth Eastman. 8-1/4 x 5-1/2 in., watercolor.
James Jerome Hill Reference Library, St. Paul.

cifically topographical duty first at New Orleans, then in Connecticut. In the academic year of 1833–34, he became assistant drawing master back at West Point, where he resumed his own art studies in private instruction with C. R. Leslie and Robert W. Weir, the last destined to be the patriarch of several generations of American painters. Thus improved, Eastman successfully exhibited in the annual shows of the National Academy of Design, which elected him an "honorary amateur," and at the Apollo Gallery within a few months of the exhibition there of the paintings Miller had created for Captain Stewart's Scottish castle. In 1840, he served with the First Infantry in the war against the Seminole Indians in Florida and the following year he returned to his regiment at Fort Snelling, where he remained through most of the decade. His art career continued, with exhibitions and sales in New York and Cincinnati, which by then was something of a cultural capital for the West.

In 1848-49, Eastman was posted to the First Infantry in Texas, despite his politicking for the choice artistic assignment of preparing illustrations for Henry Rowe Schoolcraft's monumental scientific report on the Indians. To join his regiment, he voyaged down the Mississippi from Minnesota to New Orleans, across the Gulf of Mexico to the Texas port of Indianola, and rode inland to San Antonio. These experiences—fort life in Wisconsin and Minnesota, boating down the Mississippi to Texas, and marching overland to San Antonio and beyond to Comanche country, comprise the source for almost all of Eastland's paintings and drawings of the West.

Despite his personal engagement in combat against the Indians in Florida, along the Upper Mississippi and in Texas, no scenes of fighting are portrayed in any of his work. He sought accurate representations of the Indians and some of their customs and of the new American landscape he was passing through and pacifying. It is worth mentioning that his wife, Mary (née Henderson), while they were at Fort Snelling, wrote a book, one of several, called *Dahcotah; Life and Legends of the Sioux around Fort Snelling,* which is said to be the principal source Henry Wadsworth Longfellow used for his American epic poem, *Hiawatha.*

95

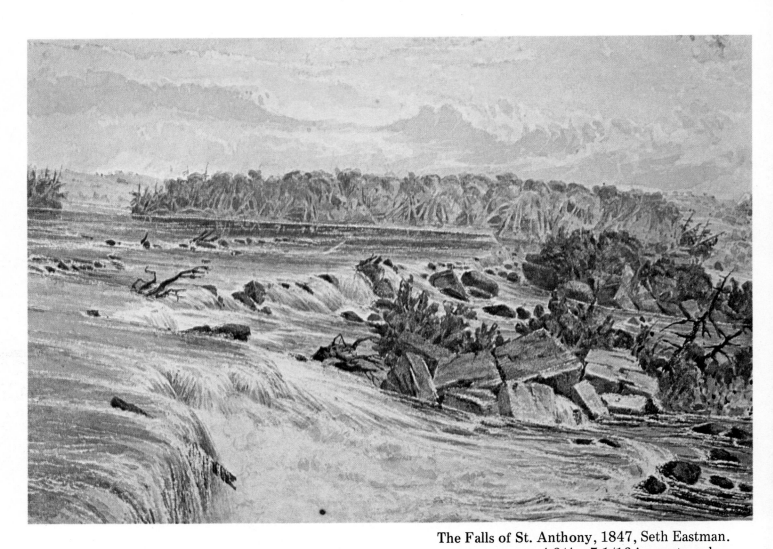

The Falls of St. Anthony, 1847, Seth Eastman.
4-3/4 x 7-1/16 in., watercolor.
The St. Louis Art Museum, purchase funds donated by Mr. and
Mrs. Warren Shapleigh, Mr. and Mrs. G. Gordon Hertslet,
Mr. William Pagenstecker, and the Garden Club of St. Louis.
The power of the great Western river, the Mississippi, is
impressive even at its northern reaches above Ft. Snelling.

He was in Texas just under a year, then applied for a leave, traveled to Washington and at last succeeded in getting the Schoolcraft assignment. Altogether he produced the drawings for almost three hundred plates for Schoolcraft's work, *Indian Tribes of the United States.* He returned to Texas and to Fort Snelling during the 1850's, but by now he had acquired the talent, still to be observed in the military life, of somehow always turning up in Washington, where the real military action took place then as it does now. In the Civil War he served in his native state and in neighboring New Hampshire in recruitment and Army Finance and attained his highest permanent rank, that of lieutenant colonel. He served as military governor of Cincinnati, a particularly sensitive Northern city in the Civil War, subject to attack from roving bands of Confederates across the Ohio River. After commands in New York, Pennsylvania and Kentucky, he was retired as a brevet brigadier in 1866.

Besides his work on the Schoolcraft report, Eastman had helped with the monumental sculpture of the Capitol in Washington by obtaining Indian models for the Italian sculptors to use. He now, with the strong assistance of Congressman Schenck, obtained a Congressional commission of his own. Returned to active duty, he was posted to the service of the Secretary of the Interior, the

Hunting Buffalo in Winter, ca. 1853,
Seth Eastman. 9 x 6-1/2 in., watercolor.
Courtesy, The Newberry Library, Ayer Collection.

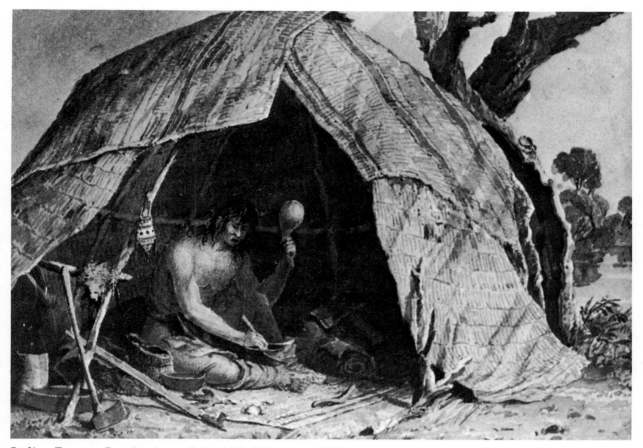

Indian Doctor Concocting a Pot of Medicine, ca. 1854,
Seth Eastman. 8-1/2 x 6-3/4 in., watercolor.
James Jerome Hill Reference Library, St. Paul.

department then responsible for the Capitol, to execute nine paintings for the rooms of the House Committee on Indian Affairs. He followed that with seventeen paintings of the forts of the United States for the rooms of the House Committee on Military Affairs.

The paintings Eastman did for the House of Representatives are not highly regarded. Most likely, the brevet brigadier had been away from both the Indians and the active military life for too many years. *The Rice Gatherers,* for example (not reproduced here), in the Indian Affairs rooms, resembles nothing so much as an early diorama of primitive life in a natural history museum. The three principal Indian women gathering the rice look either stuffed and embalmed or made of wax. The details, we are assured, are accurate, but there is no breath of life stirring in the Minnesota rice field or in the gatherers.

Even so, the contract with Eastman was something of a

landmark. Representative Schwenck, in pressing it upon his colleagues, made its significance clear:

"We have been paying for decorations," Mr. Schwenck said, according to the *Congressional Record,* "some displaying good taste and others of a tawdry character, a great deal of money to Italian artists and others, while we have American talent much more competent for the work."

He then went on to praise Eastman as second only to Catlin or possibly John Mix Stanley as an illustrator of Indian life and capped his plea with the winning argument: it would be cheaper. Thus:

"If assigned to this duty, General Eastman will draw his full pay as Liet. Colonel instead of as on the retired list, making a difference of about $1200. or $1500. a year. For at the most $1500. a year we will secure services for which we have been paying tens of thousands of dollars to foreign artists and we will get better work done. I think under the circumstances a gallant American officer, who

has taste and artistic ability, should be permitted to be assigned to this duty. I invite Members to look at a book I have here of engravings from his paintings, which display everything that is elegant and tasteful in art."

Few American artists have received so strong an ecomium in Congress, and Schwenck's praise, coupled with the promise of saving money, carried the day for American art. The traditional Congressional niggardliness in regard to art aside, the change was important. Up to that moment, it had been assumed by the government of the United States that fine art was an imported product, as witness Catlin's endless and futile efforts to get government sponsorship for his Indian Gallery. With the hiring of Eastman—at only another $1,500 a year—Congress officially decreed that Americans, too, could produce art acceptable to an American government. From that moment on, through the elaborate task of completing the decorations of the Capitol and those of the Library of Congress, the legislative body never again returned to its early practice of employing only European painters and sculptors. The long shadow of Eastman's contract with the Committee on Indian Affairs falls across all the Federal art projects of the New Deal and on to the National Endowment for the Arts today. Eastman himself was still in harness, completing his Congressional commissions, when he died, in 1875.

If the formal, full-stop oil paintings of General Eastman in the halls of Congress are stiff and lifeless, this is never true of the watercolors and pencil sketches of Lieutenant Eastman along the Upper Mississippi and Captain Eastman in Texas.

The Falls of St. Anthony, the location at which, for obvious reasons, navigation of the great river ceased, conveys an immediate sense of the sheer, overwhelming power of the river, even here, before it has been joined by the Missouri and the Ohio, and hundreds of miles above the "great big muddy" of the flood plain and the delta. In addition to the swift-flowing white water itself, the power of the river is manifest in the pileup of trees, debris and even rocks swept from the banks and carried along to this catch place.

View of the Mississippi, 180 Miles Above Prairie du Chien, ca. 1847-49, Seth Eastman. 4-3/8 x 7 in., watercolor. The St. Louis Art Museum, purchase funds donated by Mr. and Mrs. Warren Shapleigh, Mr. and Mrs. G. Gordon Hertslet, Mr. William Pagenstecker, and the Garden Club of St. Louis. The tiny scene at the left, of Indians in combat, is an unobtrusive part in this landscape of unbridled nature.

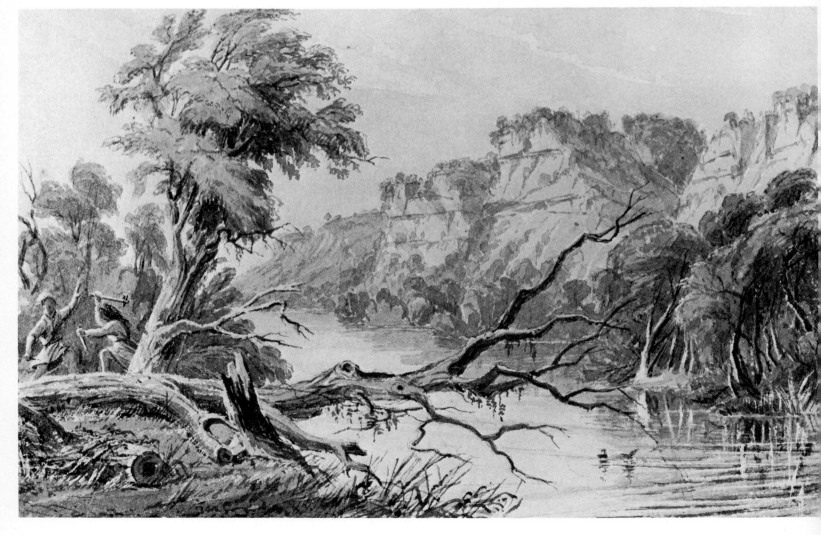

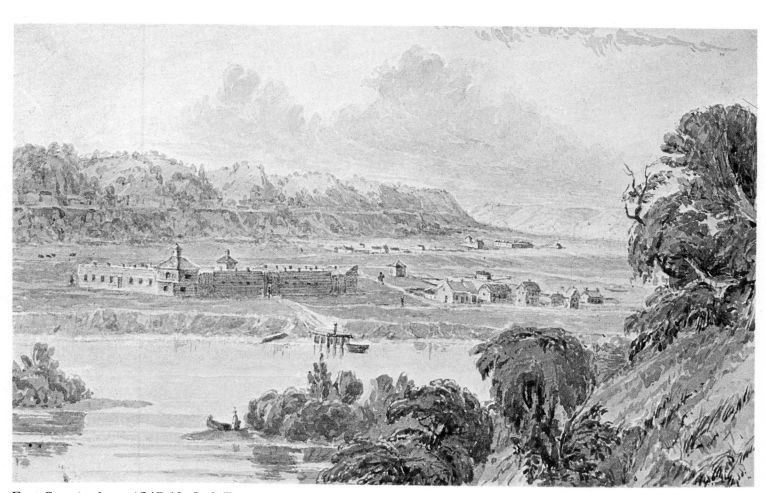

Fort Crawford, ca. 1847-49, Seth Eastman.
4-7/16 x 7-1/16 in., watercolor.
The St. Louis Art Museum, purchase funds donated by
Western Electric Company.
Eastman's talent was to combine the overall, topographical
view with local details like the tiny foreground Indian.

Fort Crawford, on the Upper Mississippi, takes a
commanding view of the river in both directions yet is it-
self dwarfed by the bluffs looming behind. Eastman's great
talent in these watercolor and pencil sketches was to com-
bine the overall, topographical view with local details
such as the Indian in the canoe on the near side of the
river. Into the soft and attractive colors and forms of the
bluffs on both banks and the high piled clouds above, the
angularities of the fort seem to fit peacefully and
naturally,with no hint of the Indian fighting directed and
maintained from the fort.

Well above the site of present day Minneapolis,
Eastman's *View of the Mississippi, 180 Miles Above
Prairie du Chien,* shows the great river narrowing and be-
coming closed in by swamp growth and fallen trees. The
Mississippi bluffs still loom as impressive as farther down-
stream but it is no longer possible for a topograph-
ical artist to find the space in which to view them as the
monuments they are. Here they merely tower up out of
primeval chaos instead of ordering space and the river.

Dutch Church at Fredericksburg, Texas — **70 Miles North
of San Antonio,** January 24, 1849, Seth Eastman.
4-11/16 x 7-3/4 in., pencil on paper.
Marion Koogler McNay Art Institute, San Antonio,
gift of the Pearl Brewing Company.

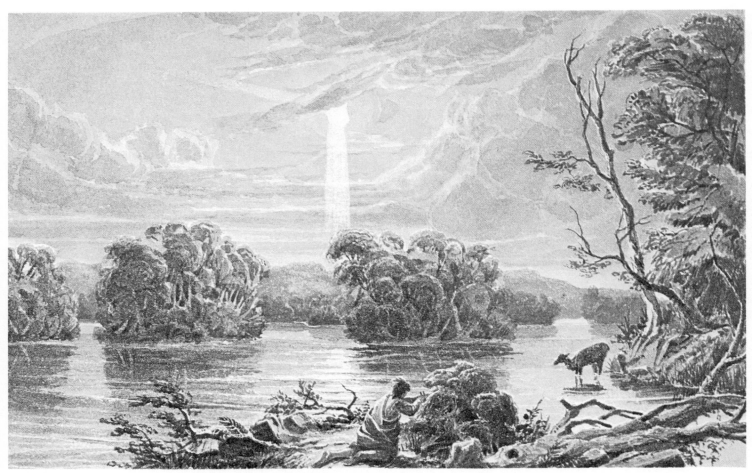

Moonlight View on the Mississippi, 75 Miles Above St. Louis,
ca. 1847-49, Seth Eastman. 4-3/8 x 7 in., watercolor.
The St. Louis Art Museum, purchase funds donated by Mr. and
Mrs. Warren Shapleigh, Mr. and Mrs. G. Gordon Hertslet,
Mr. William Pagenstecker, and the Garden Club of St. Louis.
Under the fantastic, moonlit patterns in the sky, the vignette
of natural violence — Indian hunting a deer —
blends with the overall untamed scene.

Indians Killing Fish, 1848, Seth Eastman.
4-1/4 x 6-1/2 in., pencil.
Peabody Museum of Archaeology and Ethnology,
Harvard University.

As he often did, Eastman includes a vignette of Indian life, in this case woodland combat with knife and axe between two warriors. Taken in itself, the passage at arms is violent enough, yet in Eastman's composition it seems at one with the untamed thrust of nature evident in every direction.

Moonlight View on the Mississippi, 75 Miles Above St. Louis contains the same sort of vignetted natural violence. In the center foreground, a robed Indian kneels behind a bush to fire a rifle at a solitary deer—a young one or a female, at that, without the great antlers of the adult male—as the animal perches on a rock to drink from the river. The axis of this little hunting scene parallels, indeed is part of, the axis of the river itself and therefore the ambush is subsumed into the natural flow of the water. Heavily wooded islands punctuate the Mississippi, while overhead, besides the direct shaft of moonlight that illuminates the trees on the distant shores, the clouds create an elaborate, fantastic pattern of light and shadow.

Church in the Plaza at San Antonio, Texas, March 18, 1849, Seth Eastman. 4-11/16 x 7-3/4 in., pencil on paper. Marion Koogler McNay Art Institute, San Antonio, gift of the Pearl Brewing Company.

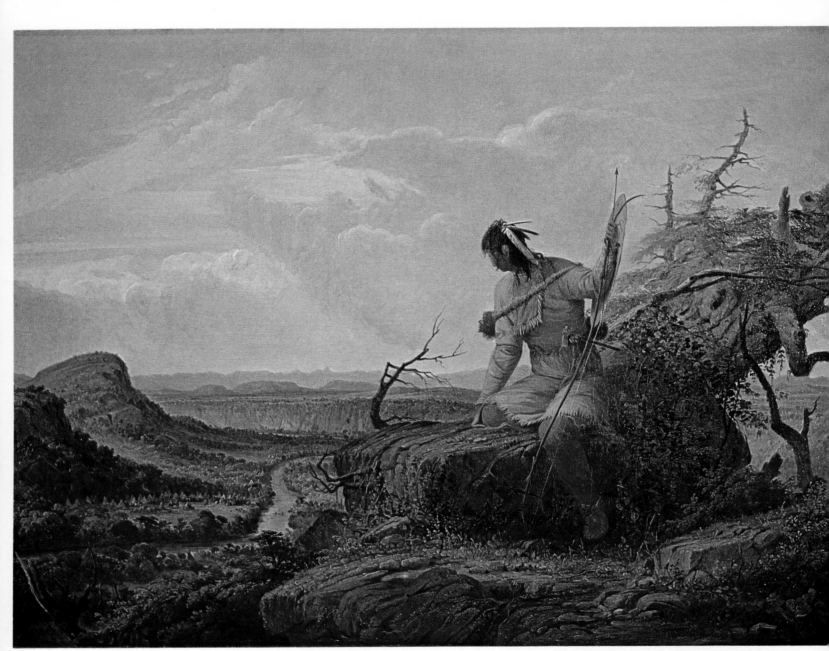

Indian on the Lookout, ca. 1841-48,
Seth Eastman. 22 x 29-3/4 in., oil.
Joslyn Art Museum,
Northern Natural Gas Company Collection, Omaha.
Though this human figure is
more immediately noticeable than in many
Eastman paintings, the Indian and the tepees below
are absorbed into the landscape's forms.

Indian on the Lookout reverses Eastman's usual pattern as seen in the preceding two watercolors. Here the solitary Indian guard is very definitely the focus and center of the painting. Armed for war, with bow and arrows, tomahawk, club, knife and shield, he looks down upon the camp in the clearing on the other side of the river. In the camp, before a ring of tepees, mounted warriors confer. Eastman supports his Indian figure and at same time subtly stresses the Indian's instinctive absorption into the landscape in every way, by the upward tension of the rocky promontory on which he sits, a movement repeated by the bare branches growing out of the rock to the left. Meanwhile, despite the prominence given the lookout, the whole broad country stretches away below in Eastman's familiar implication about the union of the Indians with the land and the overriding containment of all in nature.

Front View of the Mission Chapel of San José, 5 Miles from San Antonio, Texas, Nov. 1848, Seth Eastman.
4-11/16 x 7-3/4 in., pencil on paper.
Marion Koogler McNay Art Institute. San Antonio,
gift of the Pearl Brewing Company.

The captain's sketches of his trip down the Mississippi and march through Texas are less finished, closer, often,

Front View of the Alamo, Texas,
Nov. 1848, Seth Eastman. 4-11/16 x 7-3/4 in.,
pencil on paper. Marion Koogler McNay Art Institute,
San Antonio, gift of the Pearl Brewing Company.

to hurried jottings, especially those done on land, where the military expedition of which he was part was contending with new and unknown kinds of Indians, most notably the Comanches, with the first non-Indian conquered people this country had to deal with, namely the Mexicans, and, at the same time, with cholera, which raged through the area while Eastman was marching against the Comanches.

Yet, the *Front View of the Mission Chapel of San José, 5 Miles from San Antonio, Texas* adequately shows the entrance facade in the rich, provincial version of Spanish platteresque that Eastman must have been totally unfamiliar with until he laid eyes on this structure. Similar architectural decoration survived for Eastman's pencil when he arrived at the *Front View of the Alamo, Texas.* He was familiar with recent Texas history: "It was in this building," he noted, "that Travis with his small band of Texian [sic] were all massacred by the Mexicans during the Texian revolutions—David Crockett was one of the numbers. The entire extent of ground covered by the Alamo must have been about 3 acres—This has been the scene of much bloodshed—It is built of Lime Stone—At present the whole establishment is occupied by the U. S. Qr. Mas. Dept—"

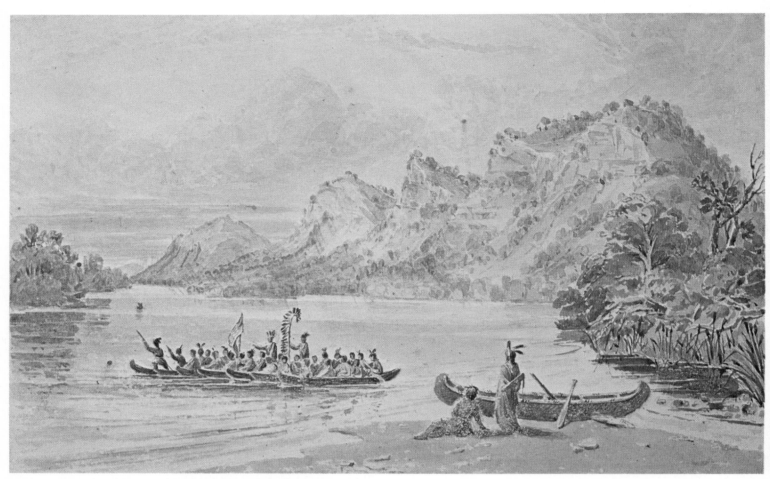

View of the Mississippi, 130 Miles Above the Mouth of the
Wisconsin, Indian Deposition on Their Way to Washington,
ca. 1847-49, Seth Eastman. 4-5/16 x 7 in., watercolor.
The St. Louis Art Museum, purchase funds donated by Mr. and
Mrs. Warren Shapleigh, Mr. and Mrs. G. Gordon Hertslet,
Mr. William Pagenstecker, and the Garden Club of St. Louis.
Although the artist personally engaged in Army combat with
Indians, his paintings almost always show them in non-
military pursuits, as in this scene of treaty delegates heading
proudly toward Washington.

As he had been trained to do as a topographical artist, Eastman recorded both a view of *San Antonio, Texas, from Near the Old Watch Tower Looking North* and, so that the viewer would get the viewpoint as well as the view, a picture with the same date, Nov. 22, 1848, of *Old Mexican Lookout or Watch Tower at San Antonio, Texas, 2 Miles from the Alamo.* Eastman's notes record in the Southwest the same process he and other artists had already witnessed in the central and northern plains: "San Antonio is a Mexican town but rapidly becoming yankee-ized—Flat roofs are giving way to the old fashioned shingled yankee roofs—Most of the houses—or rather many of them—are built of stone cemented with lime—

others of Adobie which are square or rectangular bricks of clay—baked by the sun—These make handsome walls but cannot be very strong."

He faithfully reproduced the "Dutch Houses" in Fredericksburg, but in his *Distant View of Fredericksburg* (not reproduced here) the settlement just about disappears in the sagebrush between the viewpoint and the town and the mountains in the background. His identifying title continues, *Valley of the Pedernales,* thus linking the first American artist to penetrate this great new addition to the Republic with the first American president of the Republic to come from that new land.

San Antonio, Texas, from Near the Old Watch Tower, Looking North, Nov. 22, 1848, Seth Eastman.
4-11/16 x 7-3/4 in., pencil on paper.
Marion Koogler McNay Art Institute, San Antonio,
gift of the Pearl Brewing Company.

Old Mexican Lookout or Watch Tower at San Antonio, Texas, 2 Miles from the Alamo, Nov. 22, 1848, Seth Eastman.
4-11/16 x 7-3/4 in., pencil on paper.
Marion Koogler McNay Art Institute, San Antonio,
gift of the Pearl Brewing Company.

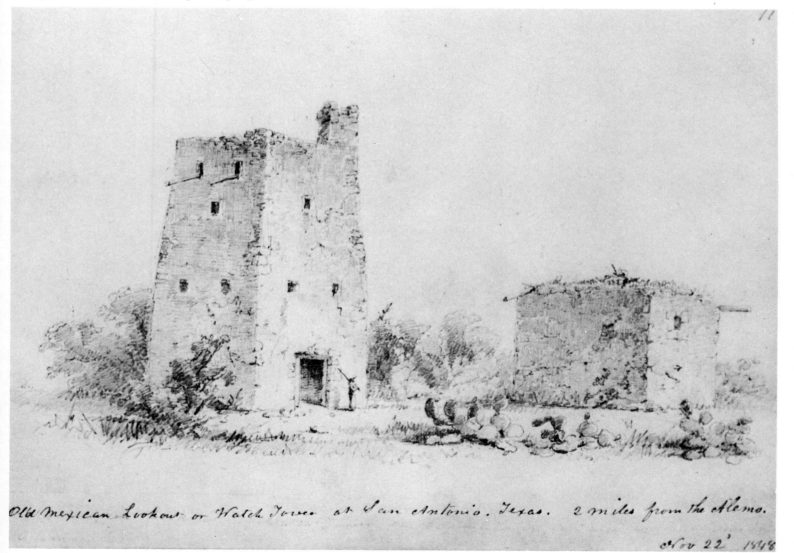

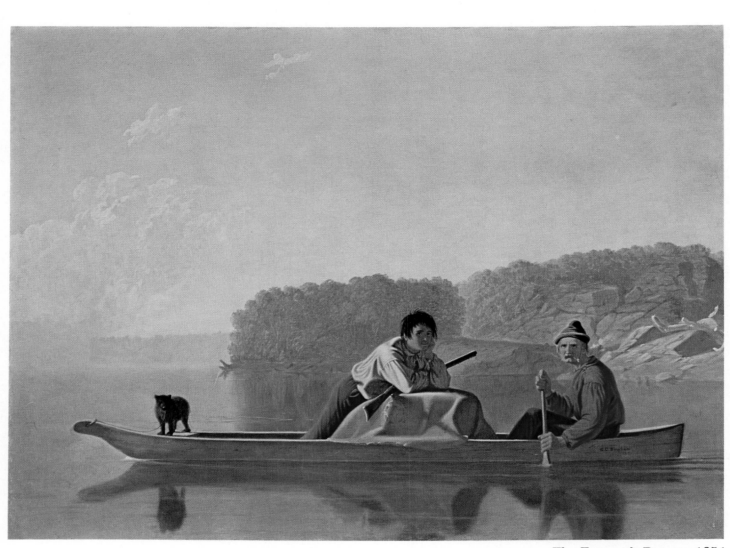

The Trapper's Return, 1851,
George Caleb Bingham. 26-1/8 x 36-1/4 in., oil.
The Detroit Institute of Arts, gift of Dexter M. Ferry, Jr.

THE MELLOW RIVER LIFE

George Caleb Bingham
(1811—1879)

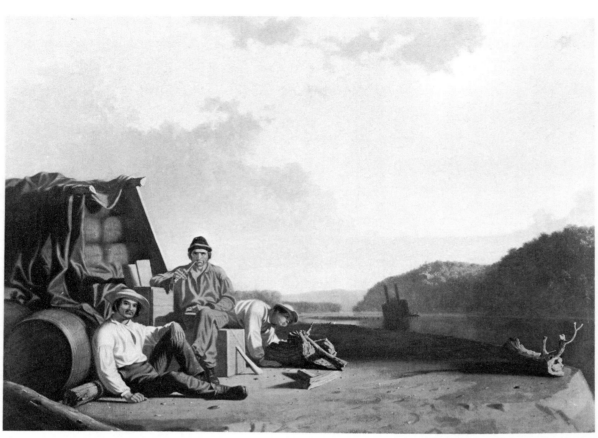

Watching the Cargo, 1849,
George Caleb Bingham. 26 x 36 in., oil.
Courtesy, State Historical Society of Missouri.

Catlin came from Philadelphia, Eastman from Down East, Miller from Baltimore and Bodmer from Switzerland, all to paint the West. In contrast, George Caleb Bingham did not have to come from anywhere to paint the West. He was already there. Bingham was the first painter of the American West to grow up there among the subjects he was to paint, to remember and record details seen in childhood and no longer in existence, to paint from the familiar feel of the landscape, the waters and the people, not from the astonished gaze on things new and unimagined.

He was not born in the West, but he was born in a country not unlike the West in several ways, in the mountains of Virginia, near what would later become the West Virginia border. The area was completely removed, in spirit and in ways of life, from the aristocratic Virginia of Williamsburg and Richmond. Even to this day, the mountainous parts of Virginia are different in spirit, tempo, even language, from the Piedmont and the coastal plain. In the early nineteenth century, they might have been different countries. At any rate, Bingham did not stay in Virginia long. When he was eight, the family moved to Missouri, on the frontier of white settlement. His mother, a schoolteacher, apparently set him to copying European engravings, but the boy was really taken

with art through a chance encounter with the portrait artist, Chester Harding, who came on his solitary way through the wilderness in search of the legendary pioneer and scout, Daniel Boone, whom he wished to paint.

The ensuing early career of Bingham is extraordinary. When he was in his mid-teens his father died and he took on the support of the family through a variety of occupations—farming, cabinet-making, sign-painting and cigar-rolling among them. He also "read"—i.e., served as a starting apprentice in the system of the time—in both theology and law, but never forgot that he wanted to be an artist. After a few years, Harding passed that way again and gave the youth a few simple principles and tricks of the trade, enough for Bingham to set himself up as a frontier portrait painter charging from twenty-five to sixty dollars a head. These early portraits are blazing with intensity and partake of the self-taught or ill-tutored painter's concentration on the desperate effort to catch the likeness. Not surprisingly, young Bingham determined to go east, both to master his craft and to practice in a region where art, as he supposed, was properly appreciated.

In 1837-38 he studied at the Pennsylvania Academy, learning not only from the classes and critiques but also from the mass of American painting by the masters of the country that the Academy was already accumulating.

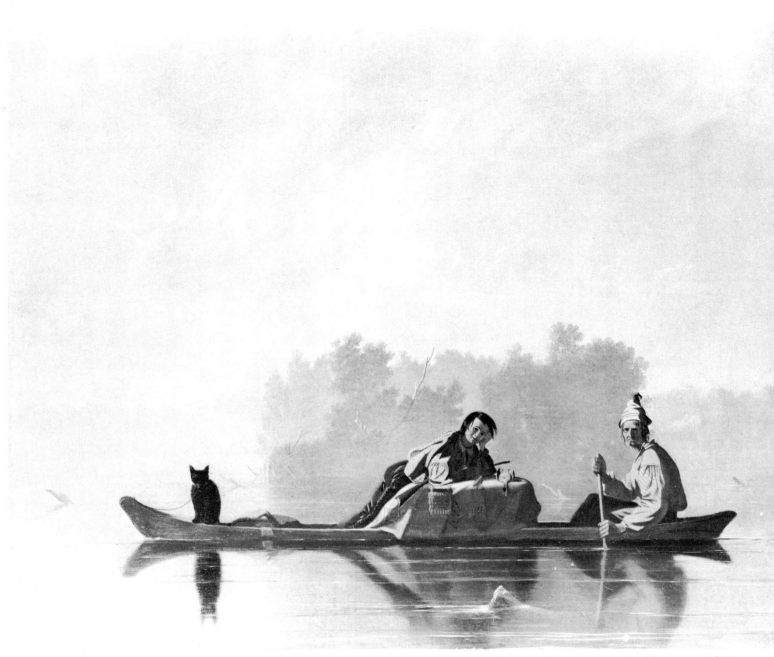

Fur Traders Descending the Missouri, 1845,
George Caleb Bingham. 29 x 36-1/2., oil.
The Metropolitan Museum of Art, Morris K. Jessup Fund.
The end-of-an-era feeling hovers over this Missouri
River boatman and his boy.

From Philadelphia he moved to Washington for a few years, setting up as a portrait painter in a studio he called a "shanty" at the foot of Capitol Hill. Having participated in Missouri politics during the election of William Henry Harrison, Bingham returned to Missouri in 1844 to support Henry Clay against the victorious Polk. His side lost, but the experience put Bingham in touch once more with the subjects that were to produce his best pictures.

For about the next decade, Bingham produced one superb picture after another of life along the Missouri-Mississippi frontier, with the two themes of Jacksonian democracy in the electoral struggles and the life of the flatboatmen on the rivers predominating.

His first picture in that decade was probably his best, for it harks back to a way of life then vanishing and at the same time has an extraodinary air of mystery and halluci-nation in a scene that ought to be common and everyday.

Fur Traders Descending the Missouri is a great painting by any standard. The three figures of the French trader, his half-breed son (we know their relationship from the artist's original title) and that strange black animal in the bow all stare out at us intently, as if the attention of all three had been simultaneously attracted to something happening on the riverbank. The combination of ele-ments—the attention of the three figures within their continuing relaxation, the blurred reflection of the boat and its passengers in the water, the quiet movement of the river, evident in the ripples caused by the sunken log and the paddle, the mist on the water out of which emerge the trees of the island in the background —creates a strange magic, a moment of suspended time, that occurs in very few paintings in America or anywhere else.

Being a fur trader on this scale was not the life of a merchant prince like John Jacob Astor and the breed was

Wood-Boatmen on a River, 1854,
George Caleb Bingham. 29 x 36 in., oil.
Museum of Fine Arts, Boston,
M. and M. Karolik Collection.

passing out of existence even as Bingham painted this surviving example. The original penetrations of inner North America had been made chiefly by French traders and trappers, both interested in the fur of the beaver for its use in making felt hats. The first great white man's system of transportation and communication between the mountain chains and through the mountains had been the rivers. The French came down the St. Lawrence, over the Great Lakes, down the Mississippi and up the numerous tributaries in both directions. From this circumstance it happened that much of the Indians' language, when the

Anglo-Americans first encountered it in any numbers, consisted of French words and phrases. This system of trade and trapping for furs continued to be practiced by French people long after the British victory in the French and Indian War had determined that the continent north of Mexico would be English-speaking. Early in the century, Astor, and others like him only not so extensive in scope, had begun to organize fur trading on a continental scale, the process reaching from St. Louis into the Oregon Territory, erecting forts, concluding private treaties with the Indians and even losing a city, Astoria, to the British. Trappers speedily divided into "Company Trappers" and "Free Trappers," with the former having all the odds in their favor. The Free Trapper, of course, operating with

a boy and boat, had even less chance against such enterprises as Astor's and passed out of existence. In addition, ready to destroy the whole trade, there lurked just ahead in the future, the invention and immediate popularity of the silk hat, which would completely collapse the beaver trade.

Just in time, of course, for between the arrival of the first French trappers and traders in the sixteenth century and the arrival of the silk hat in the mid-nineteenth, the beaver, pursued by Free Trappers and Company Trappers, by John Jacob Astor and the Hudson Bay Company, had been slaughtered in millions. The fur trade, more than any other single factor, taught the Indians the capitalist technique, hitherto unthinkable to them, of killing more animals than they needed for their immediate or short term uses. Capitalists without capital, they joined in the plunder of their land for a pitiful return and helped improverish themselves in the Anglo-American future that lay ahead.

For us today, if not for Bingham, something of that end-of-an-era feeling is also present in the bemused, slightly melancholy air that hovers over the boatman and his boy coming down the Missouri with one of the last such loads of peltries.

The Concealed Enemy is a counterpoint, in a way, to Bingham's formal monument to the opening of the West, *Daniel Boone Escorting Settlers Through the Cumberland Gap*. Chester Harding, the artist who paused in his quest for Boone long enough to give the boy Bingham a few hasty lessons in painting, did in fact find his man. Harding's portrait of Boone, painted around 1820, the year America's most famous pioneer and backwoodsman died at about eighty-six, is the only one known to have been painted from life. Bingham's Boone, painted three decades after the pioneer's death, is amazingly like Harding's man minus perhaps forty years.

In American legend, Daniel Boone is the very epitome of the frontiersman. He served as a blacksmith and

The Concealed Enemy, ca. 1850,
George Caleb Bingham. Peabody Museum of Archaeology and Ethnology,
Harvard University. In contrast to the warmth of his river scenes,
Bingham sometimes touched on the dangers still surrounding the
seemingly carefree boatman's life on frontier waterways.

Daniel Boone Escorting Settlers Through the Cumberland Gap,
1851-52, George Caleb Bingham. 36 x 52 in., oil.
Washington University Gallery of Art, St. Louis.
Pioneer resolution is expressed in the solid characters
and composition of this group.

wagoner in Braddock's campaign against the French and Indians, in which that commander lost his life along with the battle but in which, also, George Washington distinguished himself. After early explorations in Florida, Boone, in 1769, accepted a commission to explore the mountain country that was to become the state of Kentucky. Acting as agent, Boone purchased vast tracts of land from the Cherokees, opened up the Wilderness Road and, as Bingham shows him doing, personally conducted bands of settlers—and land purchasers—into the new region. His efforts worked well for Kentucky and for the settlers, but his own easy-come-easy-go attitude about the excellent sites he had reserved for himself led to defects in their titles and to the effective founder of Kentucky ending up without a place of his own in the Blue Grass State. This condition led him in old age to Missouri, where Harding went seeking him, and where, once more, the pioneer's land titles proved defective after the Louisiana Purchase. But Congress, in recognition of his service to American expansion, confirmed his holdings. Operating out of Missouri, he had led expeditions into unsettled Kansas and as far West as Yellowstone. If he was, in some sense, a land speculator, his very failures prove that his heart was not in that aspect of his work.

Bingham has memorialized the "real" Daniel Boone. In neatly tailored buckskin suit with curled brim hat—he hated coonskin headwear—holding the bridle of a horse on which sits a pioneer mother, Boone marches resolutely through a mountain pass into the wilderness. The wild nature of the new land is symbolized by the blasted tree on the right, another, smaller one on the left surmounted by a stripped, jagged branch that almost seems a lightening stroke against the dark foliage, and by the rugged rocks of the pass. The pioneer's resolution is expressed not only in Boone's firm, easy stride, his ready hold on his rifle and his expression of determination and watchfulness, but also by the composition of the group. This is a solid pyramid set against the rocks of the pass: they open to admit this stabilized form. There is no doubt, in this picture, that the group and especially its leader have the fortitude and dedication needed to make a world out of a wilderness.

It was with *The Jolly Flatboatmen,* however, that Bingham at last made the mark he had been trying to make for so long. He sent the picture, as he had sent *Fur Traders Descending the Missouri,* to the American Art Union, in New York, a highly ambitious form of artists' cooperative plus museum of contemporary art plus dealer plus

The Jolly Flatboatmen, 1846,
George Caleb Bingham. 38 x 48-1/2 in., oil.
From the collection of Herbert and Claiborne Pell.
This painting's great reception and national distribution (as
an engraving) made Bingham's first mark in American art.

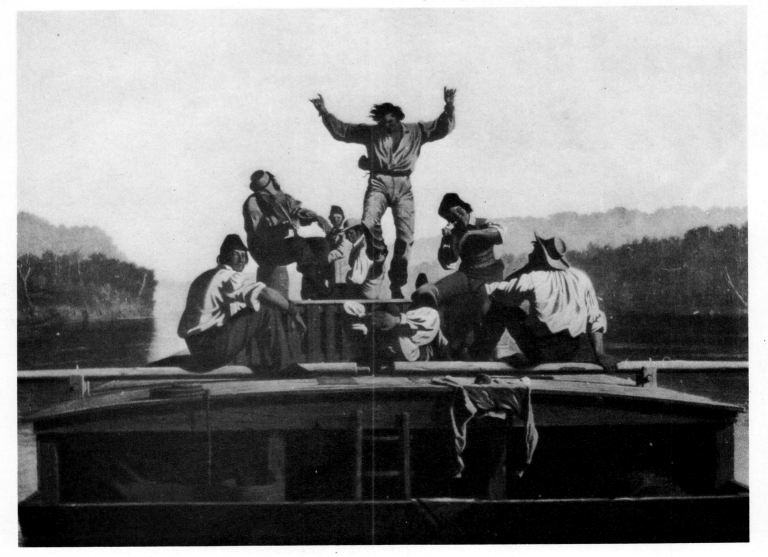

112

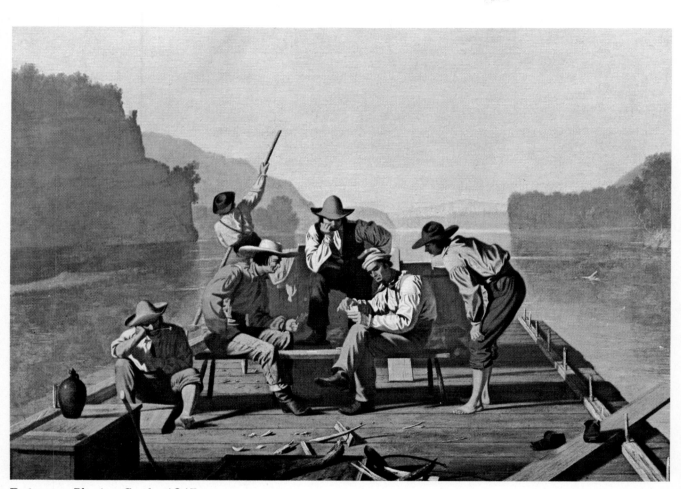

Raftsmen Playing Cards, 1847,
George Caleb Bingham. 28 x 36 in., oil.
The St. Louis Art Museum.
Bingham's theme of easy life on the Missouri
appeals naturally, for it shows the frontier in its
golden time between wilderness and civilization.

art publisher plus mail order art firm. The Union exhibit-
ed the painting, found it very well received as a new,
popular and unexpected form of art from the frontier and
immediately had it engraved and distributed to its large
subscription list all over the country. Almost overnight,
Bingham found himself growing financially comfortable
on the royalties and enjoying the sudden fame that
universal distribution can bring.

The picture itself is the most insistent use of the paint-
er's favorite compositional device, the pyramidal group-
ing, in all his work. The dancer towers above the rest of
the group. The musicians are a single fiddle, the omni-
present instrument of the frontier, and a boy rapping time
on a pan. The two seated boatmen are brought together
by the reclining figure whom we see from the back, his
head cradled in his hands, and his leg foreshortened, a
professional handling of a classical problem that must

have pleased the frontier artist to be able to do. The
pyramid continues not only through the group, but to the
stern gunwales of the shallow boat itself. The pyramid
also served to suggest the basic movement of the boat
between the banks, left and right, which offer a comple-
mentary, somewhat flattened form of container for the
central structure.

Pleased with the success of *The Jolly Flatboatmen,*
Bingham in the following year, 1847, returned to the
theme and created an entirely creditable variation on the
theme. *Raftsmen Playing Cards* poses the action fore
instead of aft, but the essential theme of an easy life on
the Missouri is the same. The central pyramidal group
consists of the two card players and the kibitzer who
rests his foot on their bench, his elbow on his knee and
his chin in his hand as the vertical axis of the pyramid. The
form is extended and disguised to some extent by the

113

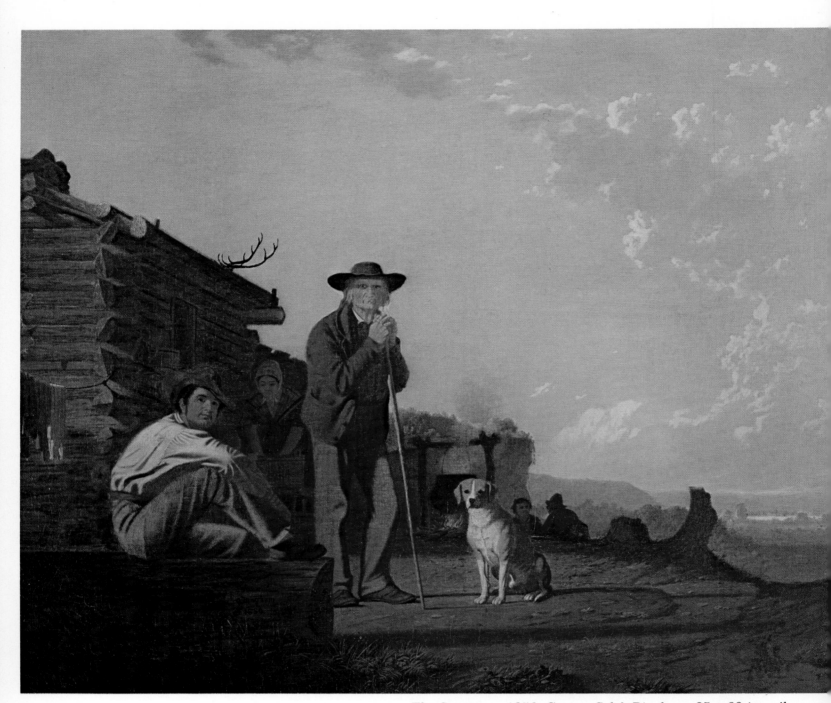

The Squatters, 1850, George Caleb Bingham. 25 x 30 in., oil. Museum of Fine Arts, Boston, bequest of Henry L. Shattuck in memory of the late Ralph W. Gray. A less mellow existence on the frontier is apparent in this picture of squatters that Bingham had seen in the West.

poleman on the left and the leaning watcher on the right, but it is reasserted by the seated smoker, ignoring the game, on the left and it is emphasized by the lines of the boat itself and the gentle opening of the riverbanks, this time with a bluff and a sandbar on one side, a clump of trees and a mountain on the other.

Bingham was criticized in his own day and has been since for showing only the sunny hours, like some artistic sundial. His rivermen, it is objected, are always singing and dancing or playing cards and chatting. They always drift downstream in good weather. But, of course, the flatboatmen and even more the raftsmen did always drift downstream in pleasant weather. A standard opera-

tion for a crew of raftsmen was to get together a consignment of cargo to St. Louis or even to New Orleans, drift downstream, playing music and cards, deliver at their destination and then break up the raft and sell it for lumber, making their way back by foot or steamboat to do it all over again. The kind of total cargo space offered by both the flatboats and the river rafts did not allow the kind of naval architecture needed for sailing and all the downstream critic of Bingham has to do to be convinced is to try to pole or row a raft upstream on the Mississippi or Missouri. Bingham's boatmen floated gently down-

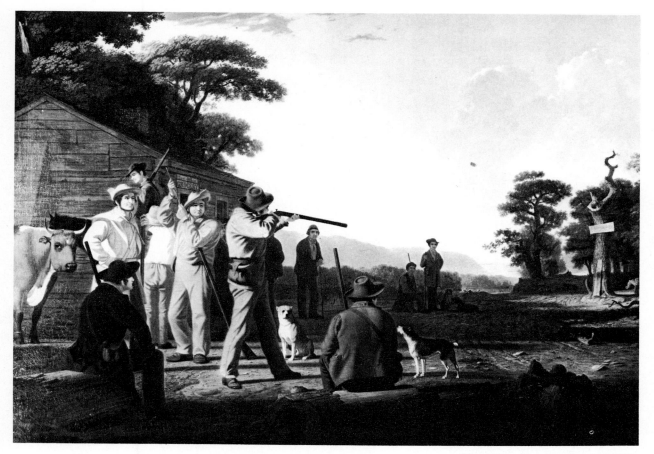

Shooting for the Beef, 1850,
George Caleb Bingham. 33-1/2 x 49-1/4 in., oil.
Courtesy of the Brooklyn Museum. Dick S. Ramsay Fund.

stream in his pictures because that is precisely what they did on the rivers.

The Squatters shows a different aspect of life on the frontier. The father, the son and the family dog stare their defiance at the visitor in front of their sturdily built log cabin, while the daughter-in-law scrubs clothes in the shade of the house. Other clothes dry in the sun and more water boils on the fire. The land is clearly marginal, overlooking the richer bottom land along the distant river, and the two children, in the expression of one and the bulk of the other, are singularly unattractive. The usual pyramid of the three foremost figures is here placed against a sloping diagonal from left to right which reveals scraping poverty against a background of sunlit pasture.

Like so many Western artists who were to succeed him—and indeed like so many American artists in general—Bingham was convinced that there were "secrets" to art that he did not know but could learn if he went to the right place, namely Europe. There were, he believed, techniques of composition he had never heard of, methods of mixing paint and of relating colors on the canvas which, could he but find out about them, would put the final perfection on his art. He had had, after all, only a few months formal instruction at the Pennsylvania Academy, plus the catch-as-catch-can lessons he got from Harding. Thinking thus, he used the money he had made of his success to embark for Europe in 1855, putting an end to a decade of artistic activity as felicitous

in conception and happy in result as that of any artist in our history.

Bingham went first to Paris, where he was only confused by the sheer profusion of painting in the Louvre. In Düsseldorf, then a magnet city for American painters, he found a friendly and comfortable environment and a method of art instruction and a theory of painting that took the frontier life completely out of the frontier artist.

He continued to paint sporadically, but never again approached the excellence he had attained in painting the world he knew with the talent and homespun skill he had in his hands. He grew increasingly involved in Missouri politics, which were from the beginning a very special variety. Even in his days as an artist of life on the river, he had also painted several masterful works— beyond our scope here—of the electoral process. Now he became more and more preoccupied with the process itself. He filled several state offices, with neither distinction nor disgrace, and gradually saw his reputation as an artist dwindle and diminish and, with his own death, die away completely, to be revived only when, in the 1930's, the American Scene Painters, led by another Missourian of political background, Thomas Hart Benton, stimulated a new interest in frontier art.

All things considered, Bingham was the strongest of the actual, born-and-raised frontier artists. That warm sunlight characteristic of his work shines upon a golden moment of the frontier when the worst dangers of the wilderness were past and the worst disasters of civilization were yet to come.

The Scouting Party, 1851, William Ranney. 22 x 36 in., oil. National Cowboy Hall of Fame and Western Heritage Center, Oklahoma City. Ranney's experience in Texas during its war of secession from Mexico nurtured a vision of the West — apparent in this painting of three proto-cowboys in a vast land — far different from Catlin's or Bingham's.

PAINTER OF THE FIRST COWBOYS

William Ranney
(1813–1857)

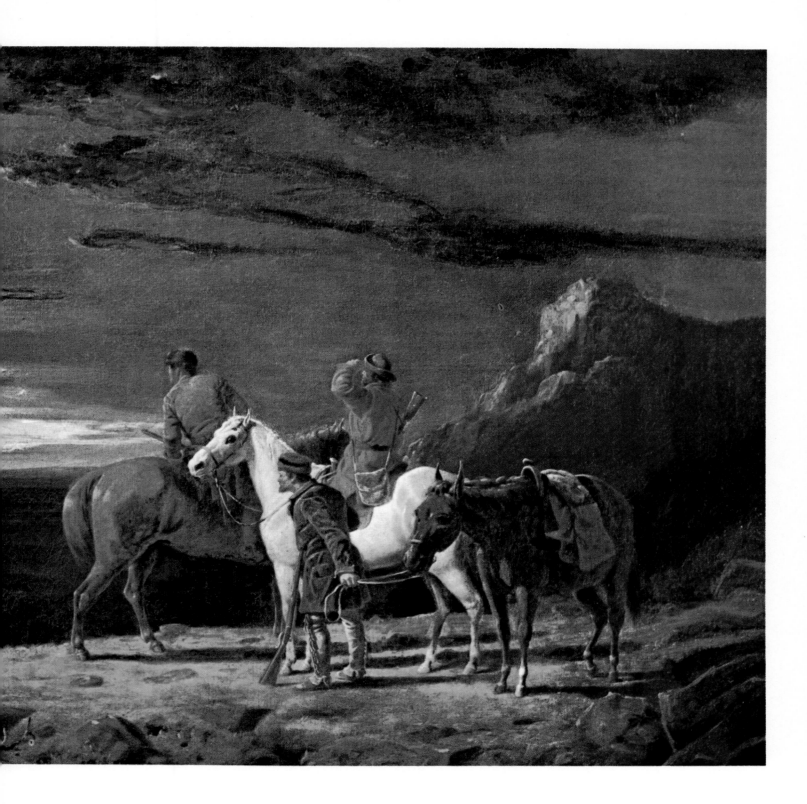

Like Seth Eastman, William Ranney was present at a dramatic shift in the nature of the West for the American mind. The shift was most visible as óne of geography, but it had a hard economic base. It was enormously important in terms of the Anglo-American relationship to the Indians and, most crucial of all but most difficult to document, the shift took place in the American mind in its thoughts about the West.

Geographically, the shift began with the Mexican War and was completed very rapidly in the years after the Civil War; it consisted of a change in focus from the Mississippi-Missouri-Yellowstone West to the Texas-New Mexico-Wyoming West. Economically, the shift was from the West as an entire vast region, several times as big as the thirteen colonies which had declared themselves a Republic, principally devoted to the trapping of the beaver, to the West as a complex economy centered on ranching, the raising of cattle and sheep, on the mining of gold and silver, and on homesteading across the continent. As far as the Indians were concerned, the shift meant that United States policy changed from one of accommodation through treaties, from one of friendship, trade and alliance, to one of warfare, and, without ever so phrasing it, one of open extermination. In the American mind, the shift was simply from the West as the locale of the solitary trapper and explorer, making his way among the Indians

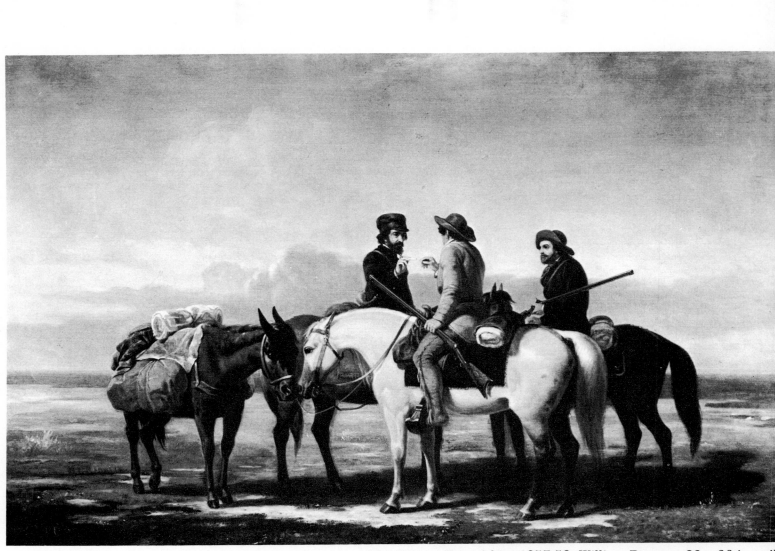

The Pipe of Friendship, 1857-58, William Ranney. 23 x 36 in., oil
Collection of The Newark Museum, gift of J. Ackerman Coles

and the spectacular scenery, to the hard riding, hell-bent-for-leather cowboy, a unique American type only possible after the Mexican War which gave us the geography, the trade and even the language of cattle raising, and with the dynamic post-Civil War explosion of the cities along the Eastern seaboard and the Great Lakes and their constantly growing demands for beef and mutton.

Quite by accident, William Ranney found himself at one of the hinges of that turning point of Western history and managed to get down at least a hint or two of the change in some of his paintings.

Born in Middletown, Connecticut, a quiet, river town so named from its location between the mouth of the Connecticut River in Long Island Sound and the capital of the state, Hartford, Ranney did not participate in the excellent higher education available in his native town at what is now Wesleyan University. Instead, at fourteen, the traditional age for apprenticeship under the old craft system, he was sent to an uncle in Fayetteville, North Carolina, where, although the uncle was a merchant, the boy was apprenticed to a tinsmith, mastering the trade in six years and apparently never working at it again. At twenty or twenty-one he was in Brooklyn studying painting and drawing. In 1836, as news of the Alamo reached the North, he headed for Texas and enlisted in the army of the Anglo-American secession from the republic of Mexico. As a regimental paymaster during that brief campaign, Ranney picked up all the personal experience of life in the West he was to have for his subsequent career in Western art.

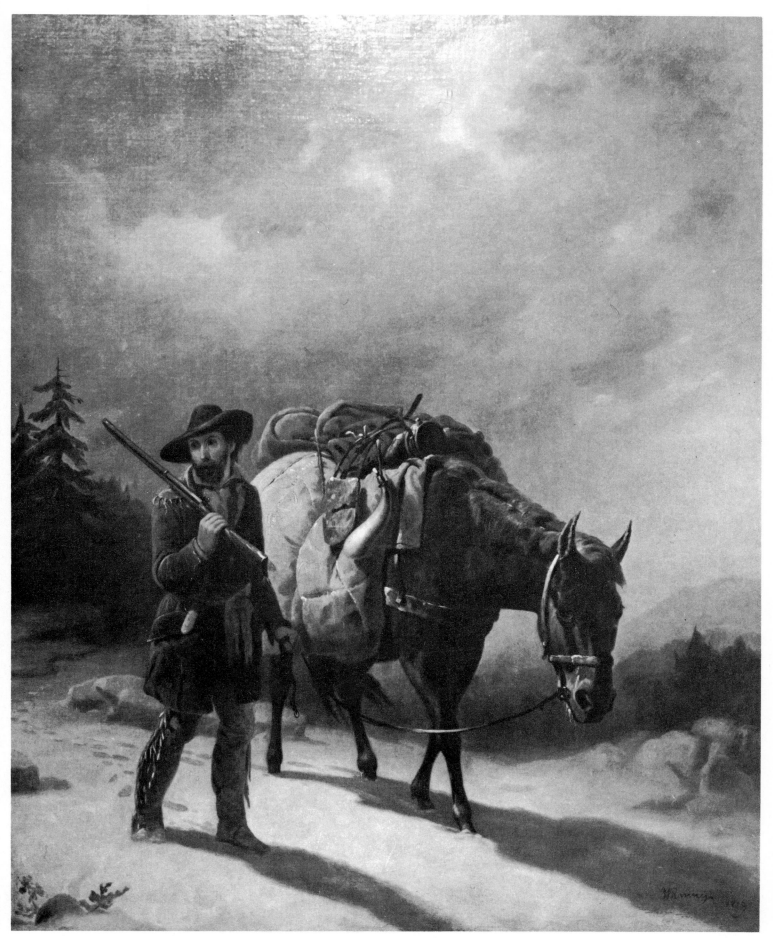

A Trapper Crossing the Mountains, 1853,
William Ranney. 38 x 33 in., oil.
J. B. Speed Art Museum, Louisville.

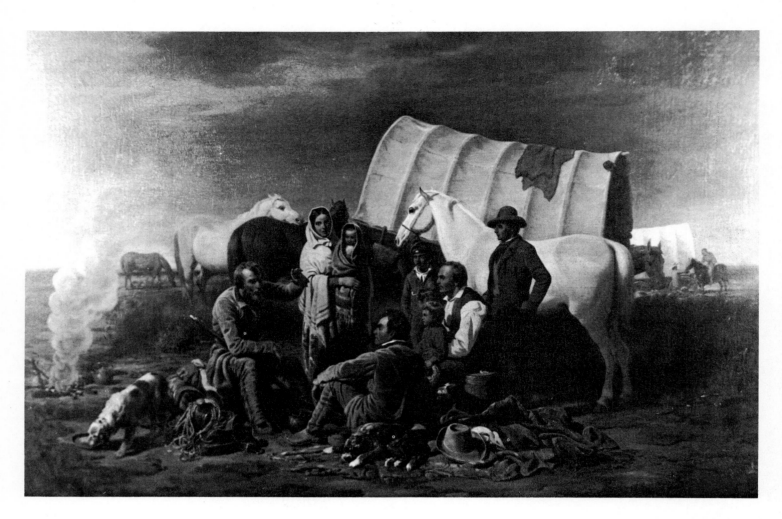

Above: **The Old Scout's Tale (Advice on the Prairie)**, 1853,
William Ranney. 40 x 54 in., oil.
Collection of Elizabeth Ranney Moran,
Paoli, Pennsylvania.

Above right:
Halt on the Prairie, n. d.,
William Ranney. 36-1/4 x 53-1/4 in., oil.
Courtesy, Mr. C. R. Smith, Washington, D. C.
The growing influence of the Texan-style habits of
travel and dress, as the frontier moved from the
Mississippi plains to the Southwest, is evident in these
travelers' head-gear and strictly horse transportation.

Right:
The Prairie Fire, 1848, William Ranney. 38 x 60 in., oil.
Collection of Elizabeth Ranney Moran,
Paoli, Pennsylvania.

It was enough. He saw at first hand, for instance, the
Texans transforming the Spanish-Mexican arts of horse-
manship and cattle-raising into American arts. *The
Scouting Party,* painted after he had been back in New
York for years, is a fully developed picture of the new,
emergent American West. There is a different feel in the
broad land below, in the sky and in the attitudes of the
three Texans—proto-cowboys making their land their
own—from anything seen by Catlin in the northern Plains
or by Bingham on the Western waters. A new life, a new
and lasting variant of the idea of the West was coming
into being before Ranney's eyes in the Texas war for in-
dependence. Whether he was fully conscious of this or
not, he nevertheless recorded it faithfully and today, with
our perspective in time, we can see it as he could not.

That element of transition is clearly present in *Halt on
the Prairie.* The dress of the two riders is much like that of
those earlier Westerners of the northern Plains, even like
that of the trappers, with the fringed buckskins, mocca-
sins and slung rifles. But there are significant differences.
The most obvious one, perhaps, is the hats. These are not
fur hats nor adaptations of military headgear. They are,
instead, an early evolutionary step between the sombrero
—from the Spanish word for shade, or shadow, as in

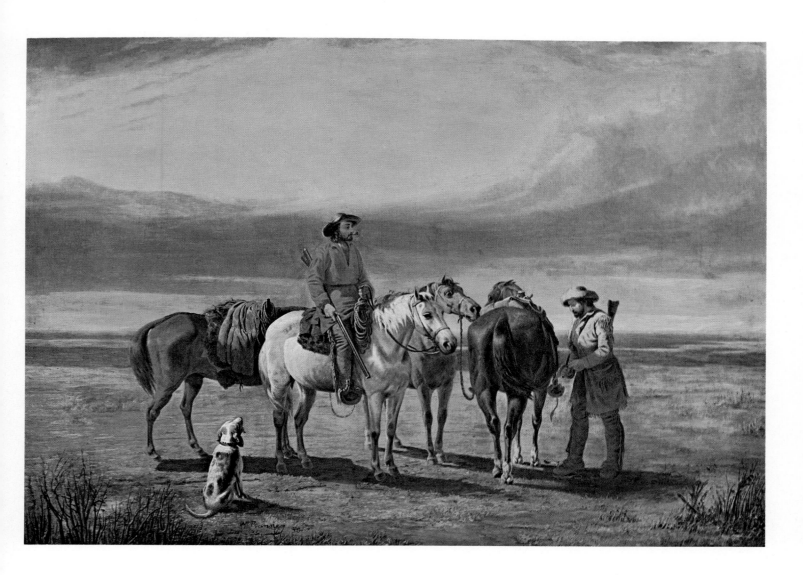

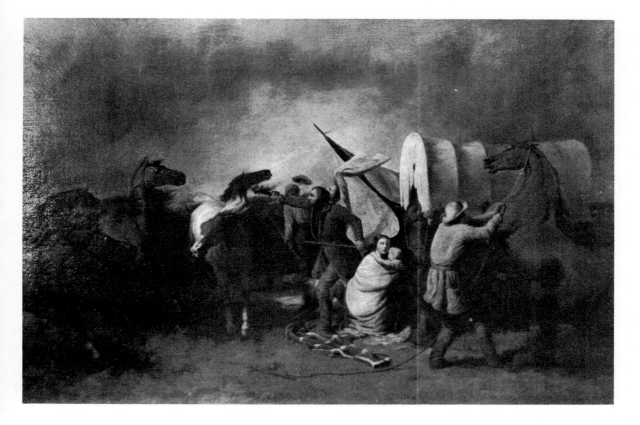

121

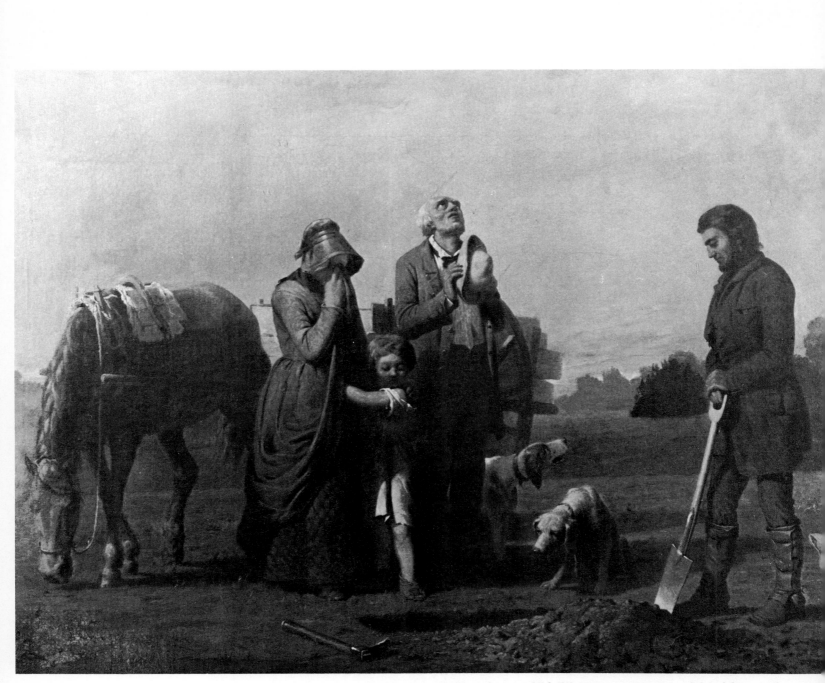

The Prairie Burial, ca. 1850-57, William Ranney. 24 x 36 in., oil.
Collection of Elizabeth Ranney Moran, Paoli, Pennsylvania.

somber—and the proper Western ten-gallon. Also, these riders making their halt are strictly horsemen, so much so that they make their journey with two horses each, one to ride, one not as a pack animal but as a spare. Horses, of course, were used in the **northern** Plains, but they were used about equally with the water and in some trades, locations and periods, they were used hardly at all, the water being so much more suitable. Here, water transport is not even considered as an alternative. The sweep of the lone prairie, the stubble of grass instead of the long blade, the flat distance and the sky itself all betoken that shift of the West to the Southwest.

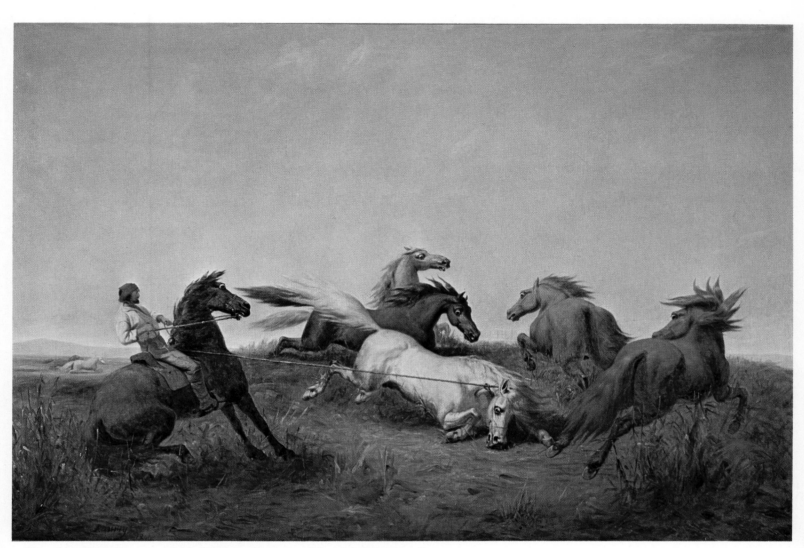

Hunting Wild Horses, 1846, William Ranney. 36 x 54-1/2 in., oil.
Joslyn Art Museum, Northern Natural Gas Company Collection, Omaha.
Ranney documented the Mexican influence on later
American cowboy dress and gear, and this rider's look
is about half-way between old and new styles.

Hunting Wild Horses documents the same transition. The rider-roper is dressed with decidedly Mexican overtones, including not only the scarlet semi-Moorish headgear and sash but also the boot that serves as a part-chap for the leg constantly working the horse's side in such an enterprise. That boot is halfway between the sixteenth-century great boots of the conquistadors and the mid-calf boot of the American cowboy in full development. In addition, the saddle, with its high pommel, is Mexican and will be American cowboy: its usefulness is amply demonstrated in the use the roper makes of it to anchor the captive horse leaving both his hands free to manage his

own mount. The composition is one of Ranney's best, the rider and his horse solid, rocklike, immobile—for this instant, at least—connected by the rope to the panicked, centripetal ring of wild horses.

Back from the West, Ranney settled down to the artist's life in New York, painting portraits, showing at the National Academy. In his life, except for the portraits, he was better known for his sporting scenes than for his Western painting, but when he built a studio in rural West Hoboken, he built it in the style of a cabin in Western America.

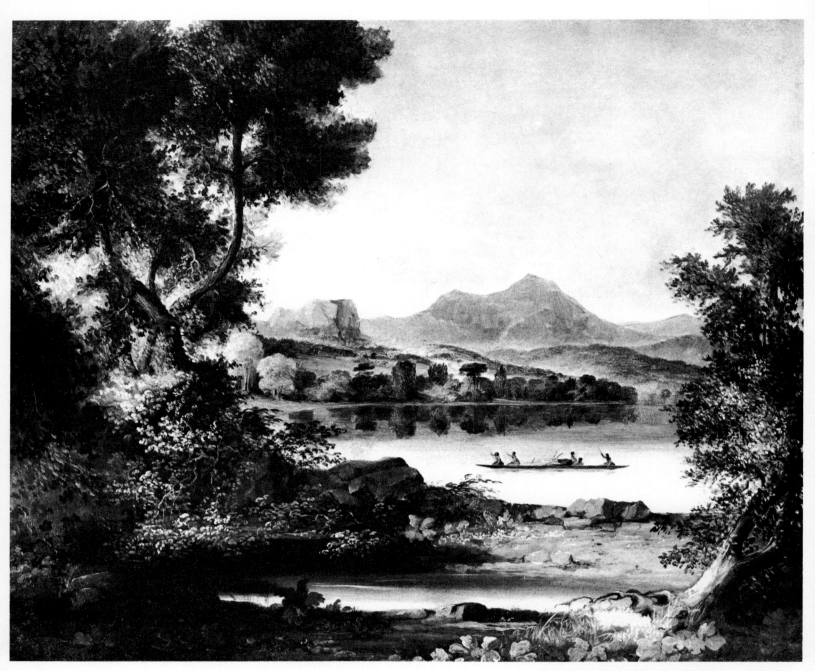

Scene on the Columbia River, ca. 1852,
John Mix Stanley. 17 x 21 in., oil.
Courtesy, Amon Carter Museum of Western Art, Fort Worth.

ON A TURN OF FORTUNE'S WHEEL

John Mix Stanley
(1814—1872)

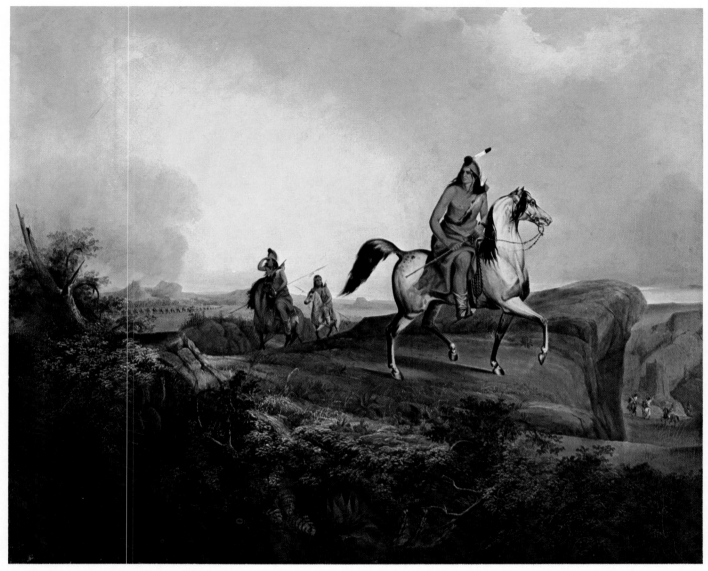

Black Knife, an Apache Chief, 1846,
John Mix Stanley. 51-1/2 x 60-1/2 in., oil.
National Collection of Fine Arts, Smithsonian Institution.
In an advance over earlier Indian portraits, Stanley painted
Black Knife in action, unposed and prepared for battle.

The history of art, like the history of everything else, is full of the stories of might-have-beens, of flaming youthful talents which withered in maturity or, perhaps worse, were struck down by death before they could begin to fulfill what all agreed was their potential. John Mix Stanley is an example of an even more dreadful fate, from an artistic point of view, that of the artist who actually attained the fulfillment of his promise and then had that attainment destroyed. The substantial majority Stanley's best work was destroyed by fire seven years before his death; he was left with neither the time nor, in all probability, the heart, to create such a body of work again. Instead he passed his few remaining years in ransoming such financial compensation as he could from the ruins of his lifework. But enough fragments escaped the blaze to bear out the testimony of his contemporaries that he was a Western artist of the first rank.

He was born in Canadaigua, in the Finger Lakes region of New York State along the route of the Erie Canal, that waterway which, along with the Cumberland Road and the National Road, ranks as one of the great ways west early in the Republic. At fourteen he was apprenticed to a coachmaker, a trade which still, in 1828, involved a certain amount of decorative painting along with the elementary techniques of varnishing wood and canvas for preservation. Moving to Detroit at the age of twenty, he worked as a sign painter and house painter. The following year he went to Philadelphia and learned the art of portrait painting, returning to Detroit to practice that trade. In 1838, in partnership with his Philadelphia teacher, James Bowman, he opened a portrait studio in Chicago. The partners traveled downstate and also north to Green Bay, Wisconsin, painting portraits. In 1839, a decade after Seth Eastman, Stanley arrived at Fort Snelling, Minnesota, where, like so many of his somewhat older contemporaries, he began painting portraits of the Indians, both as part of his regular trade—the Indians, one occasionally feels in reading the history, must have gotten quite used to white artists arriving to paint their portraits—and with some vague ideas of preserving in paint the faces and ways of these fascinating people who soon must

pass from history. Such ambitions, however, were only to be specifically formulated by Stanley much later.

Meanwhile, after a successful season or two plying his trade among the seacoast cities, Stanley headed West. He traveled to the Arkansas Territory and the New Mexico Territory and attended the Cherokee Council in Oklahoma presided over by—or negotiated with— Major Pierce Butler. In 1846, he had enough work accumulated to exhibit, in partnership with his companion of the plains, Sumner Dickerman, a show called "Stanley and Dickerman's North American Indian Gallery." After stands in Cincinnati and Louisville, Kentucky, Stanley rode West and hit the Santa Fe trail to New Mexico again and from there enlisted as a topographical draftsman with the engineers on Major Stephen Kearny's march to San Diego, where he fought against the Mexicans in the liberation, or annexation, of California by the United States as a kind of footnote to the Mexican War.

Stanley next proceeded with his personal exploration of the West, going overland from San Francisco to Fort Walla Walla and coming back by canoe down the Columbia River. In 1848, he capped the entire experience of American artists going West by westering out of the country altogether and painting portraits of King Kamehameha III in Hawaii. By the mid-century he was back in New York and content to exhibit his Indian Gallery in that state and in Connecticut before settling in Washington, D.C., where he, like others before him, conceived the idea of having the government take over his Indian paintings as a boon to students and citizens. He did manage to get his Indian pictures housed and exhibited in the then young Smithsonian Institution and to publish a catalogue of the paintings.

In 1852 he took time off from trying to get official government sponsorship, as distinct from housing, for his Indian Gallery to join the railroad survey expedition from Minnesota to Puget Sound. In Oregon he not only sketched the Indians as before but now made use of the relatively new device—and brand new along the Columbia River–of the daguerreotype. Back in Washington he painted a huge panorama of the railroad expedition, a challenging subject, which he showed in Washington, Baltimore and elsewhere. Meanwhile, the Indian Gallery was exhibited at both Baltimore and Richmond. In 1856, the Senate turned down Stanley's proposal that the government should take on the Indian Gallery and the painter went back to Detroit where, in the middle of the Civil War, he created and showed what he styled a "Polem-orama" of the war, which meant simply a painted argument on the merits of the Union cause, as opposed to the conventional panorama of the time, such as those that still survive at Gettysburg and Atlanta.

Fort Okinakane, Washington, 1853,
John Mix Stanley. 6 x 9 in., lithograph.
Western History Collections, University of Oklahoma Library.

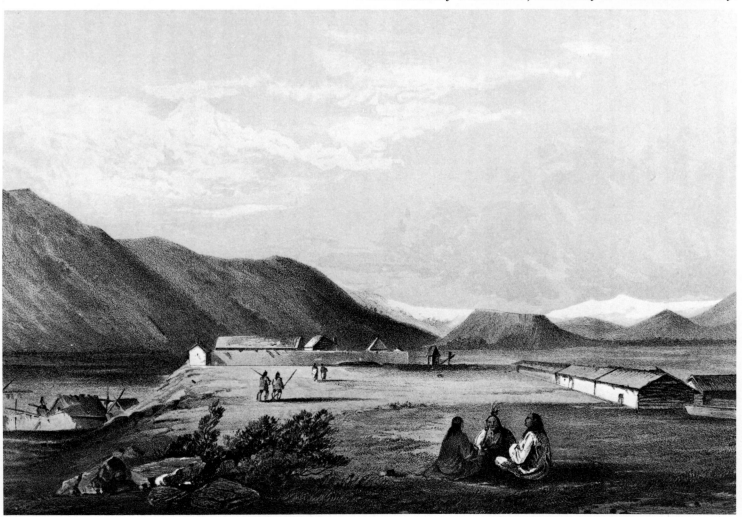

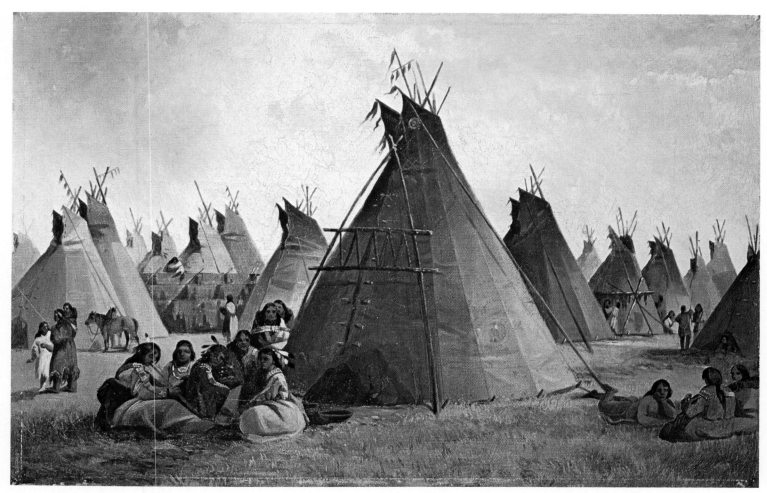

Prairie Indian Encampment, n. d.,
John Mix Stanley. 9-1/8 x 4-1/8 in., oil.
The Detroit Institute of Arts, gift of Mrs. Blanche Ferry Hooker.
This close-up of a village and tepees appears more like a
detail from a larger view than a complete work itself.

In 1865, the year that brought the end of the war, the original Smithsonian building on the Mall was all but destroyed by fire, along with most of the contents including all save five of Stanley's paintings. It was an overwhelming blow, one from which, in the nature of things, his reputation has never recovered. The painter himself apparently weathered this destruction of his life-work, at least to the extent of, first, going to Berlin to have his five paintings reproduced in chromolithography for sale here and, second, obtaining from Congress, as compensation for his loss in the Smithsonian fire, permission to import the chromolithographs, more than 20,000 of them, duty free. He engaged in further chromolithography enterprises in Detroit, perhaps on the theory that if an image is duplicated often enough it cannot be destroyed. He died in that city in 1872, by far the most traveled, industrious and unfortunate Western artist in our history.

Black Knife, an Apache Chief, shows a decided advance in Indian portraiture over the straight on, hold-still, posed pictures of Catlin and Bodmer. Black Knife is seen in action, decidedly prepared for war, stationed on high ground from which he and his aides can survey the surrounding territory. The Apaches were among the most warlike of the Southwest Indians, maintaining fierce and often successful guerilla war against the Americans

and the Mexicans for another forty years after the date of this painting.

Prairie Indian Encampment falls into a compositional trap Catlin always avoided. The point of view is too close to the village of tepees to get any idea of the proper extent of the village itself as a unit. The hide and pole structure go on and on with no center or focus to them, while the group of women and children in the left foreground have no more claim on our attention than any of the others. In the left background, buffalo hides may be seen drying in the sun and the whole ensemble suggests rather one detail from a larger view, appropriately enough for a man who eventually became a panorama painter.

In *Mountain Landscape With Indians,* Stanley shows his fullest development as a painter. The distant volcanic peak dominates the mountainscape. The range nearer at hand is a great protective wall around the lake and its little colony, which gives every evidence of just coming into being. The problem of scale is marvelously handled. On the farther edge of the lake, those great, thrown down boulders loom, even at that distance, so much higher than the human structures being built on the point on the near side. The whole range of human activities, unloading the boats, building the lodges, goes forward serenely against a backdrop on the colossal scale so that we are able to take in both and to enhance our view of each one by the presence of the other. The total command of this painting underlines the loss we all suffered when the Smithsonian's castle burned.

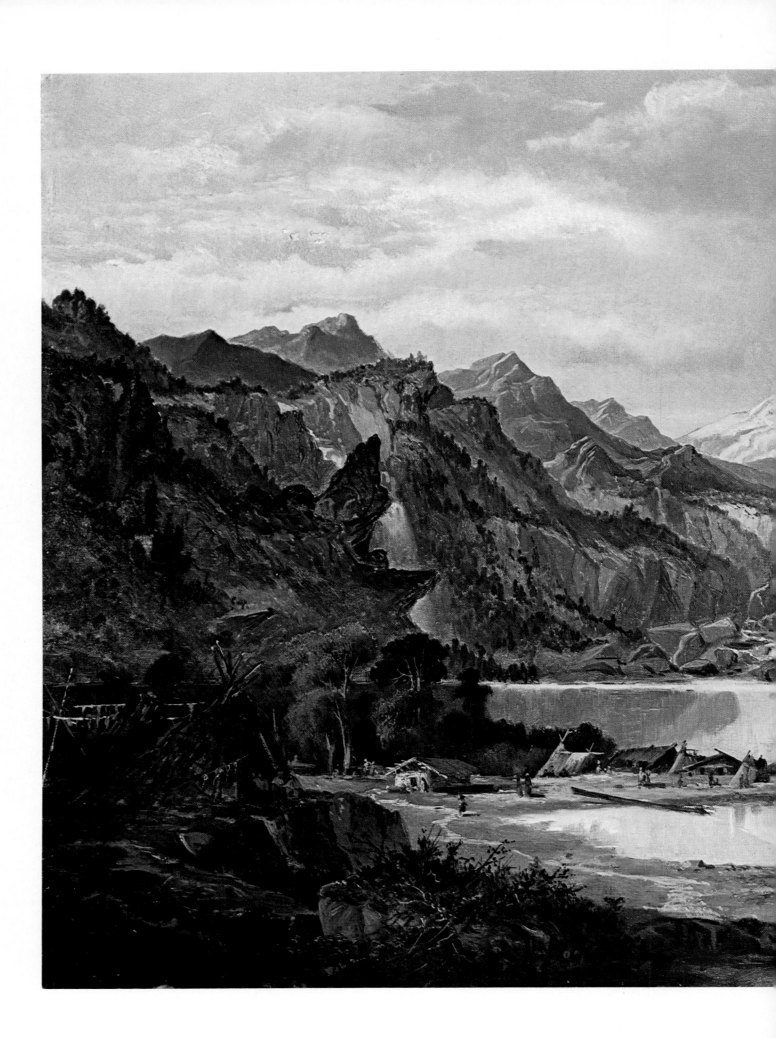

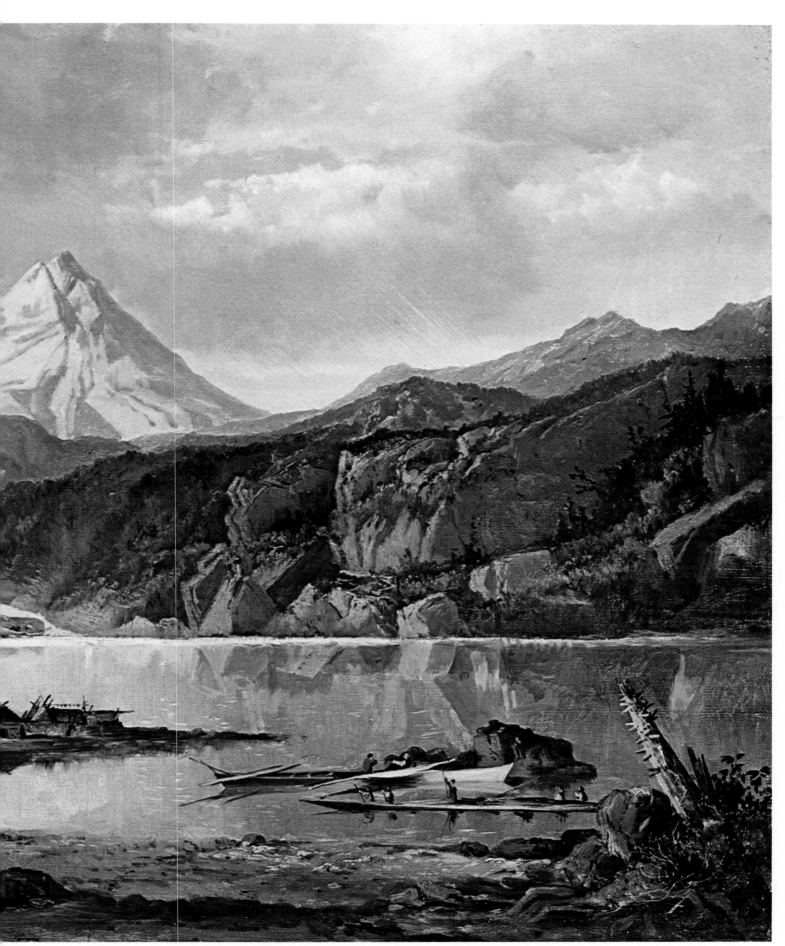

Mountain Landscape with Indians, n. d., John Mix Stanley. 18 x 30-1/2 in., oil.
The Detroit Institute of Arts, gift of the Wayne County Medical Society.
The artist's command of both colossal and human-scale scenes
in one painting shows his full development as a painter.

THEATER OF MELODRAMA

Charles Deas
(1818 — 1867)

The Death Struggle, 1845, Charles Deas. 30 x 25 in., oil. Shelburne Museum, Shelburne, Vermont.
Though melodramatic, this struggle is a believable image of the West and is Deas's masterpiece.

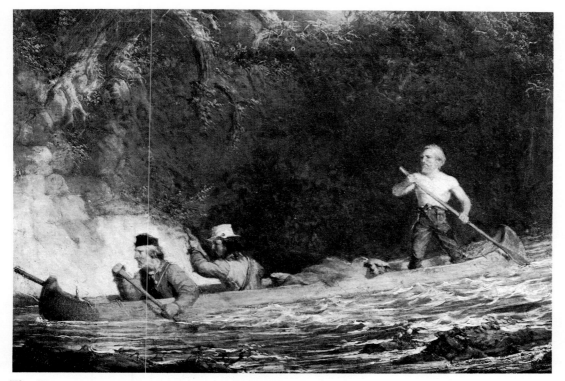

The Voyageurs, 1846, Charles Deas. 13 x 20-1/2 in., oil.
Museum of Fine Arts, Boston, M. and M. Karolik Collection.

Poor Deas was only a one-picture artist, but what a picture!

It was not that he only painted one painting in the course of his career. On the contrary, he was prolific and if he had not gone insane in his mid-thirties, he might have produced a more worthwhile body of work. What he did produce was blood-and-guts melodrama which rarely rises above the level of illustration for the cheapest of cheap adventure fiction.

Born in Philadelphia, Deas tried to get appointed to West Point but failed. He became a producer of sporting pictures and humorous scenes of everyday life. In 1839 he saw Catlin's Indian Gallery, presumably in New York or Washington, where the painter was exhibiting it and trying to get Congress to buy it for the national heritage. Inspired by Catlin's Indians, Deas resolved to follow the example of his fellow-Philadelphian and go West.

He visited a brother who was an infantry officer stationed at Fort Crawford at Prairie du Chien on the Mississippi. Thanks to his brother and to other friends he made in the Army, Deas roamed freely with Army expeditions along the Upper Mississippi, the Missouri and the Platte rivers. Eventually he settled in St. Louis and began painting and exhibiting his paintings of Indian life.

For an artist consciously following in the footsteps of George Catlin, the difference could not be more striking. Catlin painted what he saw and his paintings retained great ethnological value for years. Beyond that, they convey a persuasive sense of Indian life on the prairies and along the great rivers of the Plains.

Deas, although he had obviously exposed himself to the realities of Indian life, at least insofar as those realities could be easily studied from the point of view of Army troops engaged in keeping the Indians peaceful, never seriously considered simply making paintings of the way life was on the frontier for either Indian or white. Instead, he plunged into a phantasmagoria of melodramatic incidents. Nothing is ever calm in his work. Nothing is merely in the state of being itself. Everything is in convulsion of one sort or another, sometimes of several sorts at once. Desperate enemies confront each other in duels to the death. Maddened wild animals attack. The waters of a river close over the lost explorer. Indians make war on white settlers. The prairie bursts into flame and cuts off a party from escape. And all of this was done with the most agonizing consciousness of imminent disaster on the faces of all concerned.

Even so, in this nonstop theater of pure action, Deas did strike off one masterpiece. It has all the super-heap of desperate events and details that he liked so well, but somehow here they all come together and in the ensemble compel that willing suspension of disbelief without which no fiction is possible.

The Death Struggle, painted by Deas in 1845, is absurd in its details, yet persuasive in its totality. The mounted trapper has been attacked at cliff's edge by a knife-wielding redskin who seizes him about the waist. The pioneer's own knife hand is also the hand holding on to a rather flimsy tree branch as both horses are catapulted out into space. If the Indian does not kill him, the fall will, for they are so high that high-flying hawks appear below them in the canyon. If by some concatenation of miracles the harried trapper does win through, there still lurks one more Indian, looking through the foliage and waiting to get in the final, fatal blow if needed.

It is absurd, and yet the solid central group of men and horses comes together in a way that Deas's paintings rarely did. A few years later Deas went mad from melancholia and died in an asylum.

Roping Wild Horses, 1877,
James Walker. 14 x 24-1/2 in., oil.
Thomas Gilcrease Institute
of American History and Art, Tulsa.

Vaqueros Roping Horses in a Corral, 1877,
James Walker. 24 x 40 in., oil.
Thomas Gilcrease Institute
of American History and Art, Tulsa.
Walker shows with great detail the refinements of
technique and equipment which the Mexican *vaqueros*
passed on to their American counterparts, the cowboys.

THE SPANISH SOUTHWEST

James Walker
(1819—1889)

It is almost, not quite, solely due to James Walker that we have memorials in American art to the Spanish horsemen and cattlemen who provided the principal sources for the rise of the central Western figure, the cowboy, and the principal Western way of life, the cattle culture. Walker was well prepared to serve as the artistic mediator between the emerging Anglo-Americans of the Southwest and California, for he had begun his career in just such a transcultural capacity.

Born in Northamptonshire, England, he was brought here at the age of six with his family, who settled on the Hudson River near Albany, New York. In his early twenties, Walker moved to Mexico City after a brief residence at Tampico and was in the Mexican capital when war broke out with the United States. Escaping from the city, he made his way to the American forces, led by General Winfield Scott, which had landed at Vera Cruz and proceeded to execute a brilliant campaign culminating in the battle of Chapultepec and the entry into Mexico City. Walker volunteered to serve as an interpreter and made sketches of the battles and marches he observed between the coast and the capital.

After the war was over, he remained briefly in Mexico and then returned to New York, visited South America, and in the later 1850's arrived in Washington where he won a Congressional commission to paint the Battle of Chapultepec, which he had witnessed, for the Military Affairs Committee Room of the House of Representa-

Roping a Wild Grizzly, 1877, James Walker. 29 x 50 in., oil. Thomas Gilcrease Institute of American History and Art, Tulsa. Although this grizzly looks like a caricature of its species, a great deal of skill was required of the *vaqueros* who preferred to show their prowess with ropes rather than guns.

tives. Presumably because of its size, the painting seems always to have been hung not in the committee room but on the west staircase in the Senate wing of the Capitol. The painting cannot be called a striking success as a figure composition. Americans and Mexicans are seen milling about on a desert plain not so much in the chaos of battle as in the chaos of an unordered filling up of space with men in the two different sets of uniforms. There is an authentic palmetto in the foreground and a view of the viaduct in the distance, while the citadel looms starkly above.

In spite of its stagy mediocrity, or perhaps because of it, the picture, completed and reluctantly paid for by Congress in 1862 in the midst of its continuing deliberations about the Civil War, launched Walker on his principal career as a painter of panoramas, the popular art-and-entertainment form of the period. During the rest of the war, Walker visited various battlefields making sketches of the terrain and of the soldiers and artillery involved as a prudent investment in the future. The investment paid off starting as soon as the war was over with a major commission from General "Fighting Joe" Hooker to paint a panorama of the Battle of Lookout Mountain, also known as the Battle Above the Clouds, which Hooker had won, opening the path to the definitive victory on Missionary Ridge. Walker painted other panoramas, the most notable of which was his expansive view of *The Third Day of Gettysburg*, which is still exhibited, in a building specially constructed for it, at the site of that battlefield.

In 1877 he visited California, supporting himself by painting pictures of the large ranches of the country, still Spanish in origin, style and ownership. All the paintings here reproduced in color are from that visit. Later, after a trip to Europe, he returned to California, where his twin brother owned a ranch, and spent the last five years of his life in a coastal valley leading to Monterey Bay.

Roping Wild Horses shows the immediate ancestors of the American cowboy, the Mexican *vaqueros,* at work among the mustangs which at times seemed more like an infestation to California ranchers of both Mexican and American origin than like the blessing the wild horses were to the Plains Indians. At several times in the nineteenth century the ranchers engaged in a campaign against the mustangs, even driving them over cliffs into the sea, in order to save the grazing grass for their cattle. The situation became even more acute following the Americanization of California and the subsequent discovery of gold, leading to a flood of Anglo-American immigration and skyrocketing demand for beef.

Walker was not the most skillful draftsman in the world, even in the Western world, but there is a sense of pounding flight among the herd of wild horses galloping away from the *vaqueros,* who, for their part, are trying to hold their own mounts steady in the sea of frightened, fleeing horseflesh.

Vaqueros Roping Horses in a Corral shows a calmer version of the same activity. There is less panic among

the animals, more nervous irritation. The details of the work and of the appurtenances of the trade are more clearly rendered. The mounted roper, for example, is playing the white horse by a few turns taken with his rope around the pommel of his saddle, a Spanish-Mexican refinement of technique and equipment which was borrowed directly and further refined by the cowboy. The saddles and leather-enclosed stirrups of the two horses standing on either side of the corral gate survived virtually unchanged among the cowboys and on the standing *vaqueros* at the gate we see the prototype of the cowboy's leather chaps. The ropework of the *vaqueros* became one of the essential tools of the trade of the cowboy.

Roping a Wild Grizzly does not at all depict an outing for sport in the mountains but an essential campaign of protection for the cattle. The grizzly bear was a legendary danger for all those who ventured West from the earliest days. Although the bear, like all bears, lived on nuts, berries, honey and fish when available, he did develop the habit of killing cattle as he had earlier, very occasionally, killed a buffalo. The Americans, typically, when they set out to hunt and kill the grizzly to protect their cattle, did so with guns of the heaviest velocity they could find. The *vaqueros,* proud of their skill with the rope and also, perhaps, aware of their ancient Mediterranean tradition of

man against bear as a trial of strength, endurance and dexterity, attacked the great bear with ropes. Here the riders have three ropes on the bear, with a fourth about to drop around its neck, a sufficient number, usually, to effect the capture. As Walker makes clear in the movements of the horses, the whole process was rendered all the more difficult, and hence a greater challenge, because the horses shied at the first scent of the grizzly.

Californianos at the Horse Roundup is one of the best compositions Walker ever created. The large circular movement of the herd from the dusty distance right across the front of the picture, with the *vaqueros* at once pursuing, leading, steering and, finally roping, is a powerful central movement, given direction and emphasis by the mound in the middle distance on which scattered, individual riders are roping in horses. The lead rider clearly displays the slipknot that gave the lariat its name, while the man on the mount just getting ready to throw his rope could be completely American in the hat, the stance the horse is held in and the position assumed by the roper. The transition, so long in getting started, when one thinks of the centuries the Spanish and Mexicans were engaged with horses and cattle in the New World, moved swiftly once it began and the American cowboy came into being almost in a single act of self-creation out of his Mexican origins.

Californianos at the Horse Roundup, n. d.,
James Walker. 30-1/2 x 50-1/2 in., oil.
Dr. Carl S. Dentzel, Northridge, California.
The excitement of the round-up is captured in the powerful circular movement of the wild-eyed horses.

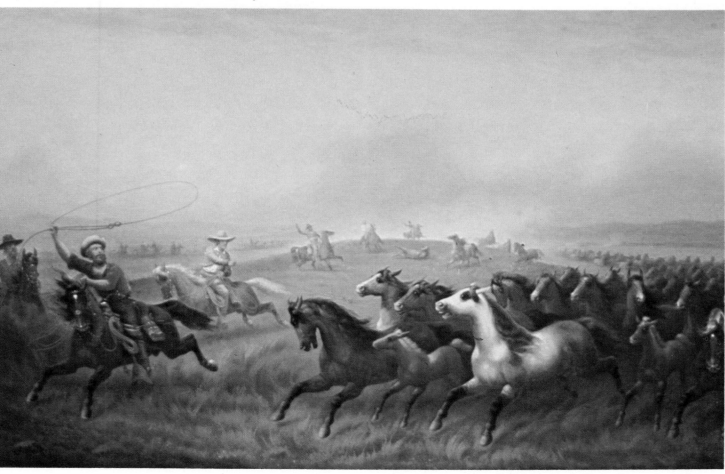

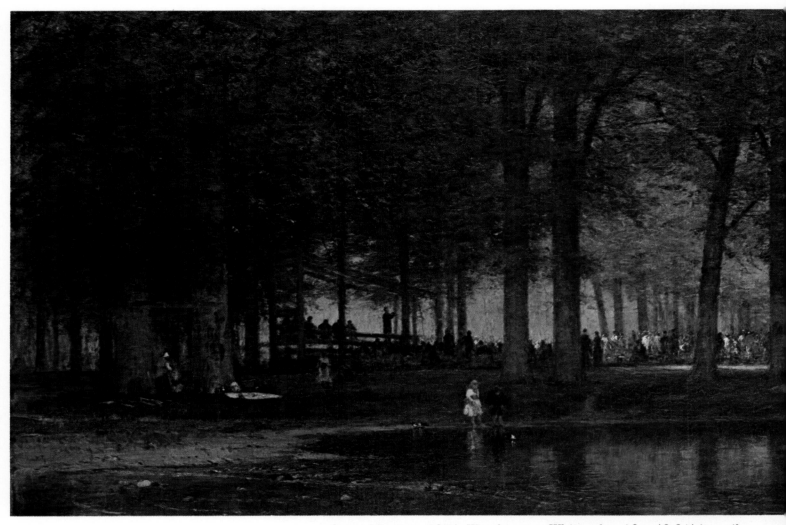

Camp Meeting, 1874, Worthington Whittredge. 16 x 40-3/4 in., oil.
The Metropolitan Museum of Art, New York, Lazarus Fund.
Though the title indicates human activity, the religious feeling
of this painting emanates from the quiet majesty of nature.

A WIDE MEASURE OF GRANDEUR

Worthington Whittredge
(1820—1910)

Worthington Whittredge was one of the most accomplished American painters of the nineteenth century. Though he was born on the frontier in Ohio, son of homesteading farmers still surrounded by wildlife and even Woodland Indians left over from the first of the Indian Wars fought by the Republic, Whittredge is found in our art history chiefly as a member of the Hudson River School. He was a practicing Hudson River painter and indeed the author of some of the most beautiful views of the Eastern forests. Some critics, however, have detected a certain unease in his Hudson River painting and the artist himself confessed that he was not entirely at home in the relatively civilized wilderness of the Catskills.

Whittredge ascribed his slight unease in the East not to his Western origins but to his European training. Although he grew up on a frontier farm without a hint of art about it, he knew from an early age that his vocation lay in painting. At seventeen he left the farm and moved to Cincinnati, where there were plenty of artists engaged in founding a tradition of art in the river city that has endured to this day. The young Whittredge supported himself by painting signs and houses while he studied his

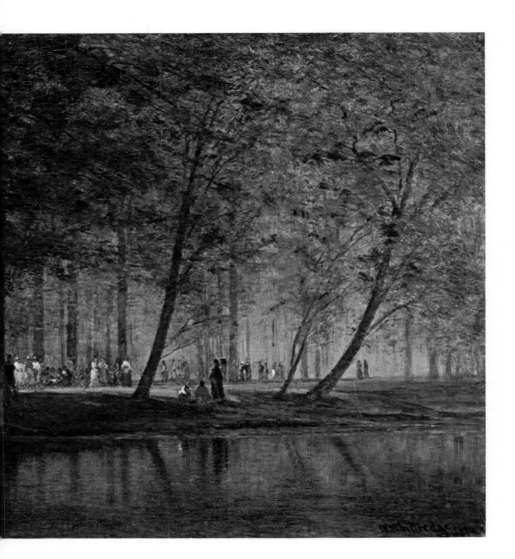

future craft. He also mastered the new art of the daguerreotype, an early form of photograph, and lived in Indianapolis with Henry Ward Beecher, destined to become the greatest preacher of nineteenth-century America. Whittredge painted him at age twenty-seven, in 1840, when he was just on the edge of becoming the national religious figure he was to be for almost half a century.

After continuing this early portrait career in Charleston, Virginia, later in West Virginia, and back in Cincinnati with success and recognition, Whittredge decided he would concentrate on landscape painting instead of portraits, a decision thoroughly in the spirit of the way mainstream American art was developing back along the Eastern seaboard. But that took considerable courage for a Midwest painter making a name in portraits and twenty-three years old. He turned out to be fortunate in his city. Led by Nicholas Longworth, patron of the arts and later a political figure of national importance, a group of Cincinnati businessmen chipped in enough money to send Whittredge to Europe for the study and the professional "finishing" that virtually all American artists and patrons then believed could only be obtained abroad.

Once over there, Whittredge developed a taste for the place that was most curious in view of his later sentiments. He stayed a full decade, starting in 1849, painting in Belgium and France before undertaking formal study in Düsseldorf, Germany, where he posed for several of the figures in *Washington Crossing the Delaware.* He made the classical trip on foot for northern European artists, up the Rhine River, through the Swiss Alps and down into Italy, sketching all the way and following in such footsteps as those of Albrecht Dürer and Pieter Brueghel (the Elder). Having arrived in Italy he stayed there for five years, settling in Rome and becoming friends with the sizeable American artists colony in Italy, including his predecessor as recipient of Nicholas Longworth's patronage, Hiram Powers, the sculptor.

On returning home in 1859, he began voicing his regret almost at once. He declared that it was a great mistake for an American artist to study abroad at all, let alone stay in Europe for ten years, as he had done. He professed to feel less than intimately familiar with the American landscape of the Hudson River Valley, New England and rural New Jersey that a nineteenth-century American painter was called upon to paint. He did, in

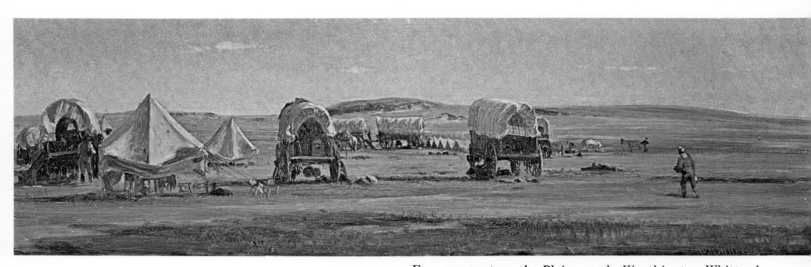

Encampment on the Plains, n. d., Worthington Whittredge.
7-1/2 x 23 in., oil. Joslyn Art Museum,
Northern Natural Gas Company Collection, Omaha.
Whittredge said he never learned to measure grandeur in
a perpendicular line, but his horizontal composition lent
itself to capturing the vast stretch of the Plains.

fact, paint superb examples of Hudson River School land-scapes. He moved into the famous Studio Building on Tenth Street in New York, the artistic headquarters of the city for the rest of the nineteenth century and one that enjoyed a revival in the middle of the twentieth. Back in America three years, he was elected to the National Academy and, despite his reservations about his own fitness for the task, the future looked bright.

Then he departed abruptly from that future. Excused by age from service in the Civil War, when that cataclysm was over, Whittredge joined a military expedition West led by General John Pope. After a promising early career in the Mexican War and as military engineer and explorer, Pope ruined himself in the Civil War by becoming the architect of the disastrous Second Battle of Bull Run. Heading West, he was out to rebuild his career and did indeed do so, becoming one of the leading Indian fighters of the later nineteenth century. Whittredge rode with Pope's command from Fort Leavenworth up the Platte to Denver, down to New Mexico and over the Spanish Peaks to Santa Fe and Albuquerque. Returning on the Santa

Fe Trail and the Cimarron Trail, the expedition ended at Fort Riley.

A few years later, Whittredge took another trip west, this time in the company of two fellow artists of the Hudson River School, Sanford Gifford and John Kensett. Meanwhile, his career flourished. He served as president of the Academy from 1874 to 1877, having already held the post briefly at the end of the Civil War.

The West apparently was a magnet of some strength for Whittredge. He may have made a third trip after his term as academy president, yet Western life and land did not become a major theme in his work, but rather an occasional alternative to the glens and dells of the East that he did so well. Whittredge was also an early exponent of "luminism," a specialty within nineteenth-century American landscape painting which concentrated on the quality of the light on a scene more than on the topography of the scene itself. It is quite possible that his Western experiences reinforced his early knowledge of light as a variable in art. Always a modest and personally attractive artist, Whittredge said of himself in regard to

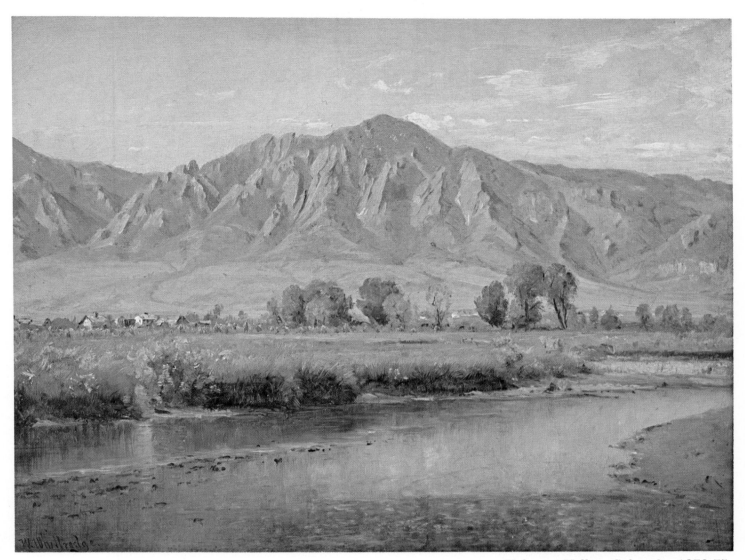

Valmont Valley, Colorado, 1870-75,
Worthington Whittredge. 12 x 16 in., oil.
Courtesy, Mr. and Mrs. Jonathan C. Calvert, San Antonio.
Whittredge's mountains form a strong horizontal
band between the valley and sky.

the Alps something that may well apply to his attitude toward the Rockies as they became, in his lifetime and even during his Western travels, a major focus for American art. "It is altogether unsuitable for me," he said of Alpine scenery. "my thoughts ran upon more simple scenes and simple subjects, or it may be I never got in the way of measuring all grandeur in a perpendicular line."

Encampment on the Plains is certainly a thoroughly horizontal picture. Its proportions, of course, suggest those of the locale and the view of encampment suggests, too, the way in which the Army on a route march accommodated itself to its terrain. The military apparatus, from the wagon half seen on the left edge through the tents with their sides rolled for ventilation, past more wagons without their horses, a small row of pup tents, a few horses being tended in the distance and a soldier entering the scene from the right, all manage to fit comfortably within the basic horizontal band of the picture from the horizon to the scrub grass at the bottom of the painting.

Even in the mountain range pictured in *Valmont Valley, Colorado,* Whittredge perceived a horizontal rather than a vertical dominance. For him, the distinguishing note of the mountains was not so much that they rose up out of the earth toward the sky as that, having done so, they formed a strong horizontal band of their own between those of earth and sky. The stream in the foreground and especially the nondescript foliage along its banks are familiar felicities of Whittredge's work, almost seeming lost here in the bright light and empty space of the West. The distant settlement, too, is lost, at once dwarfed by the mountains and blended into the line of trees and bushes.

In *Camp Meeting,* painted after his return from the trip West with Gifford and Kensett, Whittredge celebrated a subject not often met with in the East, but one that provided the principal religious inspiration for most of the rest of the country for a great part of the nineteenth century. But the artist has shifted the focus from the actual event to the quiet majesty of the trees in the grove and the changing quality of light from near the pond to the shadow of the grove to the brilliant sunlight beyond, all adding up to the feeling of a natural religion that was one of the universal experiences of Western country.

139

A LUMINOUS TOUCH

Sanford Robinson Gifford
(1823—1880)

Like his friend Worthington Whittredge, Sanford Robinson Gifford was essentially a Hudson River School artist, but like Whittredge—indeed in his company—he journeyed west looking for subjects and while he can hardly be called a Western painter, his distinctive style of "luminism"—that branch of American landscape painting particularly concerned with light—added a handful of views of the West that greatly enhance the whole body of work.

Gifford lacked the early training in Europe that Whittredge had so much of, and therefore lacked, too, the incapacities that Whittredge felt his European art training left him with. Gifford was born and raised right in the heart of the Hudson River country, in Saratoga County and at Hudson, New York. After two years at Brown University, he determined to devote himself to landscape painting. After studies in New York, including classes at the National Academy, where he also exhibited and was elected an Associate Member at twenty-eight, Gifford established himself as a landscapist with views of the Catskills, the Hudson River, New England and upstate New York. He went to Europe for a couple of years, but did so as a traveling American, sketching what he saw but not subjecting himself to European art instruction.

In the Wilderness, 1860, Sanford Robinson Gifford.
30 x 54 in., oil. Toledo Museum of Art.
The artist had not yet seen the West when he painted this,
yet the great mountain's form and the feel of space are accurate.

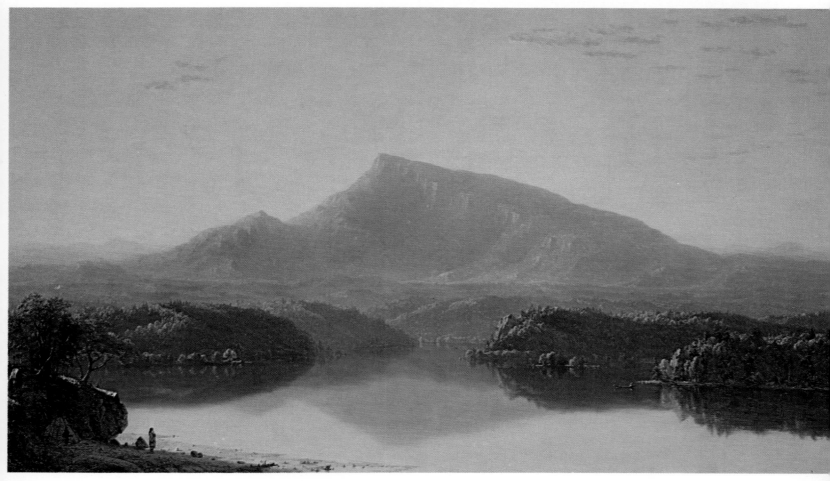

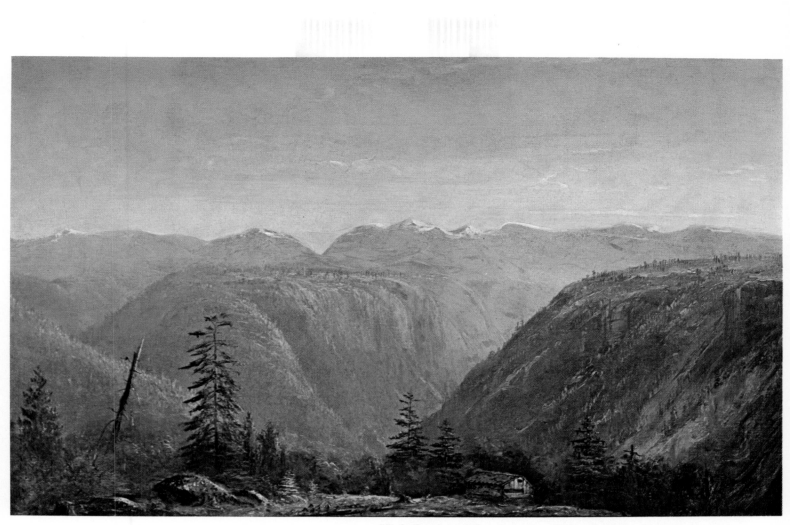

High Banks of the Americas Near Colfax, California, n. d.,
Sanford Robinson Gifford. 18-1/2 x 30 in., oil.
Kennedy Galleries, Inc., New York.
A glow of warm light from above touches the
vast mountain spaces, a Western scene to which
Gifford applied his special luminist vision.

Back in New York, he settled into the Studio Building on Tenth Street, where he kept a studio for the rest of his life. When the Civil War came, he joined the Seventh New York Regiment, was stationed at Washington and served with the regiment for three years. After the war, he spent two years traveling and sketching in the Eastern Mediterranean and the Middle East. It was only after all that, when he was in his late forties, that Gifford, in the company of Whittredge and their friend and fellow luminist, John Kensett, that Gifford went west in his own country, never, until then, having ventured beyond the eastern foothills of the Appalachians. In 1870, the three artists toured the Rocky Mountains and the Great Plains, joining a military expedition to get through Indian country as the wars with the Indians continued to rage. Later, Gifford visited the Pacific Northwest as far as Alaska.

Since all of his Western experience took place only in the last decade of his life, it was natural enough that Gifford should have brought his established way of painting, which includes a way of seeing, to bear on the West rather than, as has happened to so many Western painters, allowing the experience of the West to shape and form his way of painting. Even so, his contributions to the view of the West offered by American art are substantial.

In the Wilderness, actually painted the year Gifford enlisted in the Seventh Regiment, serves as a kind of prevision of his Western experience. The great distant mountain that centers the picture is beautifully balanced in its descent from the peak on both sides: the right runs regularly down, the left is broken by a lesser peak. Both of these supporting features are echoed in the wooded promontories on either side of the water, while the whole geometrical structure is completed by the reflection in the water of the great peak itself. On this side of the lake, a single human figure gives the scale of the terrain, and the whole picture takes on a luminous unity in the overall coloring from the sky.

The *High Banks of the Americas Near Colfax, California,* glows with the same unifying light from above. The river is a tributary of the Sacramento River and the scene is in the northern range of the Sierra Nevada. The exquisitely precise painting of the near plane, the individual trees, the stumps in the clearing, the rocks and the lonely cabin in the pines accentuate the vast spaces encompassed by the distant, misty mountains.

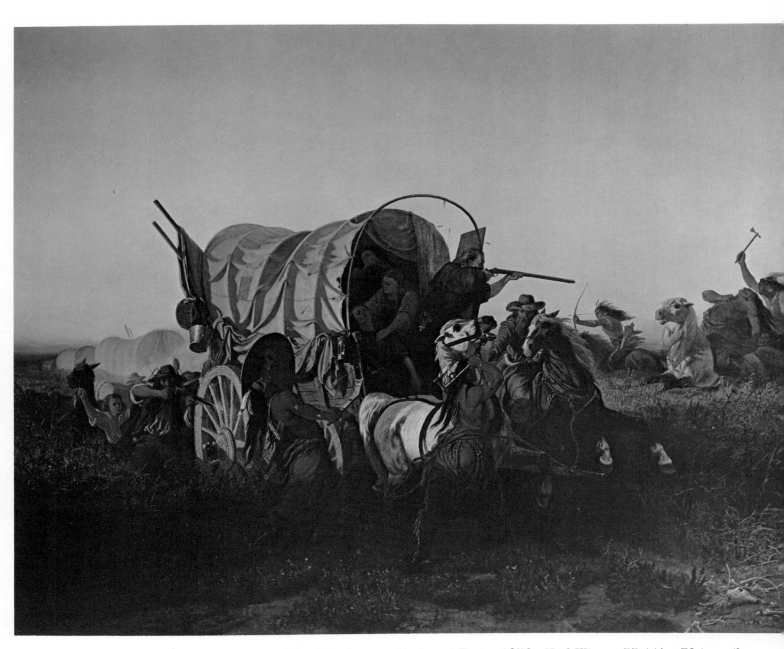

The Attack on an Emigrant Train, 1856, Karl Wimar. 55-1/4 x 79 in., oil.
University of Michigan Museum of Art, bequest of Henry C. Lewis.

THE ORGANIZER

Karl Wimar
(1828—1862)

Karl Wimar, as his dates reveal, had a short life, dying at thirty-four. But it was an extremely influential life, not so much in the effect his pictures had on other artists or even, for that matter in the effect they had on non-artists, for Wimar simply did not live long enough to become an important, influential artist. But he did live long enough to help create the first organization of Western artists. The fact that he did puts all his successors in his debt. The fact that the situation of art in the West seemed ready for it says a great deal about the rapid development of the art in the few decades between, say, Alfred Miller's ride into the mountains with Captain Stewart and Wimar's early death in the first years of the Civil War.

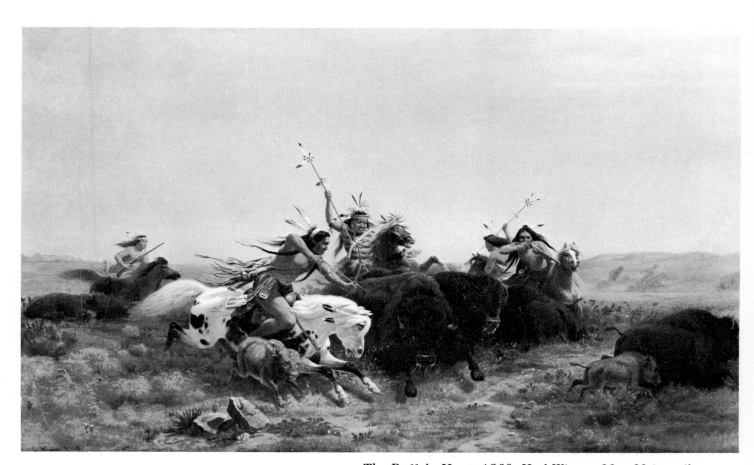

The Buffalo Hunt, 1860, Karl Wimar. 36 x 60 in., oil. Collection, Washington University Gallery of Art, St. Louis. Painted for the opening of the Western Academy's galleries, this work's subject matter is certainly heroic history, and the Indians are larger than life or at least seem to be larger than either their horses or their quarry.

Until this point in our history, almost all the references to art organizations of any kind are located in the East, especially in Philadelphia, the first great center of American art, in New York, which rapidly became a national art exchange as it did a national stock and finance exchange, and in Washington, the capital, where painters and sculptors all through the nineteenth century could hope to gain employment on the public buildings being erected, even if only as apprentices and assistants to the assorted Italians the Congress imported to give the Capitol its authentic Classical air.

Wimar was born near Bonn, Germany, and lived there with his family until he was fifteen, at which point he emigrated to America, coming to St. Louis, which like Cincinnati, already had a sizeable and growing German colony. In St. Louis, the young Wimar apprenticed himself to a painter, Leon de Pomarede, for whom he worked for four years, at one point traveling with him up the Mississippi by steamboat, making sketches all the way as preparation for a projected panorama of the river from the Falls of St. Anthony in Minnesota down to where the Ohio River joins the Mississippi at the southernmost tip of Illinois.

Apparently, the panorama project did not work out. At twenty-four, Wimar, having left Pomarede, returned to his native land to study at, inevitably, Düsseldorf, where he took instruction from Emanuel Leutze while that master was working on his best-known work, *Washington Crossing the Delaware.* Wimar undoubtedly at least made the acquaintance of the corps of American art students then residing in, visiting and returning to the Rhineland city. After two years with Leutze and with Josef Fay, Wimar returned to St. Louis, from where, in 1858, he made an extensive trip by steamboat and overland to a series of the Western forts, and then, in a party of fifty-three men, went three hundred miles up the Yellowstone River to Fort Sarpy. From Fort Union, the hub of his journeys, he rowed down the Missouri with eight other oarsmen, back to St. Louis, making the return trip in forty-two days. The following year he went by steamboat to Fort Union and then on to Fort Benton on the first

Indians Approaching Fort Union, n. d.,
Karl Wimar. 23 x 47-1/2 in., oil.
Collection, Washington University Gallery of Art, St. Louis.
As the artist became increasingly and directly familiar with
nature, his academic training in cultural details took a
lesser importance, and in this painting the human and
natural drama are balanced.

voyage of a Missouri River steamboat to that western Montana outpost.

That was the extent of Wimar's travels into the wilderness but it did him for the few years left of his life and his career. Back in St. Louis, in addition to painting steadily, he helped organize the Western Academy of Art and was elected librarian. His instinct to organize in art may have come from the automatic organization of all things in Germany, but in founding the Western Academy he brought to the West an establishment of art able to validate and understand a range of artistic experiences not always easily accessible to Eastern art dealers and artists.

The Buffalo Hunt was painted for the grand opening of the Western Academy's galleries in 1860. Although undoubtedly based on or at least refined by observation on the Plains, the picture shows the faults of Düsseldorf training that Wimar did not live long enough to rectify in his work. The Indians are all too clearly pictured and they seem to overpower completely both their horses and their quarry. The buffalo and the horses might almost be figures on a merry-go-round; from another point of view, the buffalo seem really to be wild boars, a favorite hunting target in Germany in the middle of the last century.

Turf House on the Plains, on the other hand, is a good example of Wimar's realistic observation and atmospheric rendering, to some extent successful because the subject had no prior equivalent in his Düsseldorf training. The golden haze of the prairie contrasts sharply with the mean dwelling, one of thousands of similar structures in which

people lived and laid the foundations of the grain and cattle empires that today flourish so widely.

Indians Approaching Fort Union is, on balance, perhaps Wimar's most ambitious and most successful picture. Fort Union, which he visited four or five separate times during his two far-ranging expeditions up the rivers of the Great Plains, was located on the eastern border of Montana at the junction of the Yellowstone River and the Missouri River. The broad stretch of country and the coming together of the two rivers is clearly seen beneath the high calm sky of the plains. The fort sits on the river's edge and the Indians announce their arrival with gunfire in the air. This is a trading expedition, as is evident in the *travois* pulled by horses and dogs laden with furs and with other belongings. In the lower right corner, a pack dog rummages among the bones of a dead mountain sheep, the kind of dramatic, distracting detail Wimar mastered at Düsseldorf. But no details can detract from the essential unity of the picture, the band of Indians arrayed above the river's plain and the whole broad land of the Dakotas spread beyond.

In the last year or so of his life, Wimar also brought official patronage to the West, obtaining a commission to decorate the new dome on the old St. Louis Court House. The pictures, on Far Western themes, are undistinguished, but the commission itself, like the foundation of the Western Academy, was a milestone in the art of the West.

Turf House on the Plains, n. d.,
Karl Wimar. 5-3/4 x 12 in., oil on cardboard.
Bancroft Library, University of California, Berkeley.
In this painting, Wimar showed an ability to combine
realistic observation and atmospheric rendering.

The Captive Charger, 1854, Karl Wimar. 30 x 41 in., oil.
The Saint Louis Art Museum, bequest of Miss Lillie B. Randell.

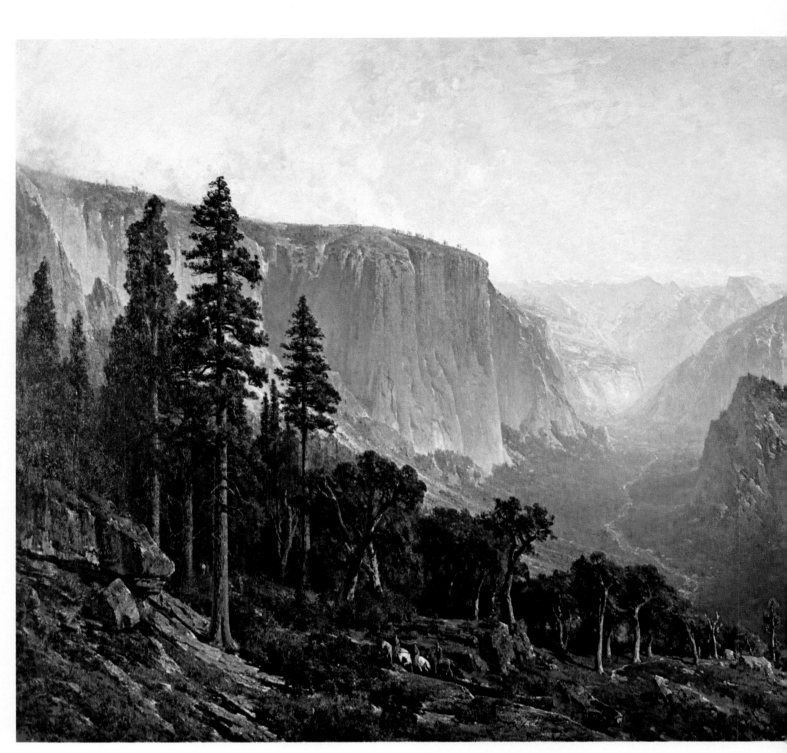

Yosemite Valley, 1889, Thomas Hill. 88 x 72 in., oil.
The Oakland Museum, collection of Dr. Cecil E. Nixon.
Hill became known as the "Artist of Yosemite," for he
had contributed enormously toward popularizing the area
by painting many views of the spectacular valley.

THE ARTIST OF YOSEMITE

Thomas Hill
(1829—1908)

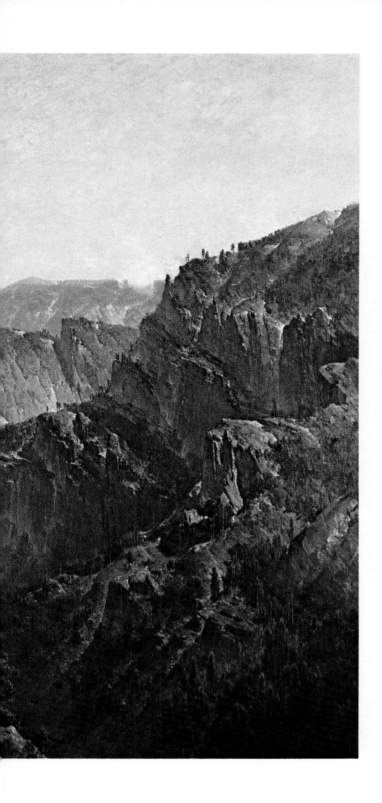

Although Bierstadt was by far the best known of the Rocky Mountain School in his lifetime and still is, he was by no means alone in his artistic appreciation of the beauties of the mountains. Thomas Hill, a year older than Bierstadt, painted some of the same country at about the same time. Hill, however, came to be a specialist, perhaps the first, within the Western mountain landscape tradition. Also, unlike almost all the other artists of the West, Hill eventually moved West, settling in San Francisco and becoming a major force in the planting and nourishing of an artistic community there, one which has survived in excellent health for more than a century.

Hill was born in Birmingham, England, and moved, with his family, to Massachusetts when he was twelve. A few years later he entered an apprenticeship to a coach painter, after which service he was employed as a painter of decorative details valued for his mastery of wood graining and linear scrollwork, both much in demand in Victorian America. In his early twenties, Hill went to Philadelphia, now committed to becoming an artist, and enrolled at the Academy of Fine Arts. He made progress in his chosen profession, winning the gold medal for portraiture of the Maryland Institute.

In addition to portraits, Hill painted some still lifes, but his principal subject was not discovered by the artist until, in 1861, he went to San Francisco, presumably by the overland route. He exhibited Rocky Mountain pictures and won wide approval. In 1866-67 he studied in Paris where his teacher urged him, successfully, henceforth to concentrate on landscapes rather than portraits, which he had supported himself on in San Francisco.

Back in America, he showed some mountain pictures in Boston, thus helping to spread the knowledge of Ameri-

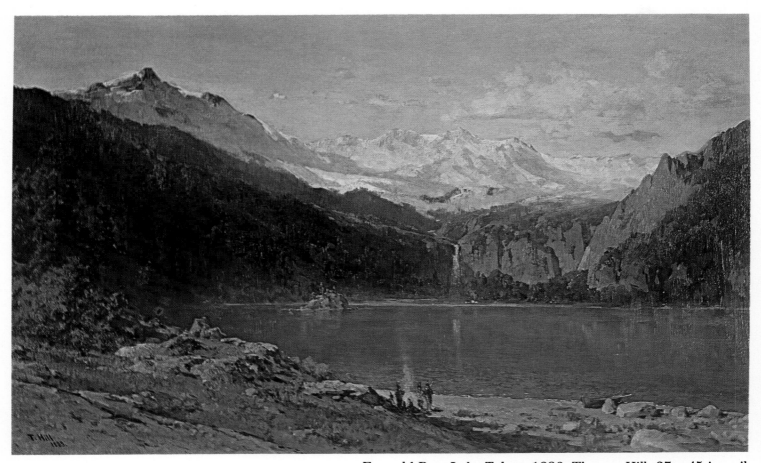

Emerald Bay, Lake Tahoe, 1883, Thomas Hill. 27 x 45 in., oil.
Los Angeles County Museum of Art,
gift of Mr. and Mrs. Robert B. Honeyman, Jr.
The artist perhaps took a cue from the famous painter of mountains, Albert Bierstadt, and let the expanse of water and sky take dominance over the human figures in this composition.

ca's most spectacular scenery. In the early 1870's, he settled permanently in San Francisco, where he became the vice-president of the city's art association in time to confer an honorary membership on Bierstadt when that artist visited the city.

Hill lived in a large house in Oakland, across the bay from San Francisco, and became a moving figure in the art community. He helped set up the California School of Design, the first art school on the West Coast. In the company of Jules Tavernier and Paul Frenzeny, he journeyed to the Monterey Peninsula, which, with adjoining Carmel, has supported a steady and sometimes flourishing artists' colony ever since.

The main thing Hill did in California art, however, was to become "The Artist of Yosemite," as he was called. He visited there every summer and painted view after view of every aspect of the valley. His Yosemite pictures, sent to exhibitions and sold to collectors in all parts of the country, contributed enormously to popularizing Yosemite as one of the natural wonders of the United States and one of the most desired stops for pleasure travelers to the West.

The two views of Yosemite here reproduced were painted twenty-one years apart and show an interesting change in the artist's grasp of his subject and, for that matter, in the status of Yosemite itself in the general American imagination.

Party Touring the Yosemite is just what the title says. The picture seems to center on the group of tourists riding along the trail, taking in the spectacular scenery. The tourists and the trees in the foreground are painted very sharply, with the great, looming landmarks that gave Yosemite its fame, somewhat lost in the ground haze and the mist from the waterfall in the right background. One point the picture was making for the outside world, obviously, was that Yosemite was an excellent place to visit.

Twenty-one years later, in *Yosemite Valley,* painted in 1889, it was clearly no longer necessary to underline the touristical aspect of Yosemite. That spoke for itself, and the painter placed in his foreground not the tourists that such pictures stimulated to come to Yosemite, but the more exotic native inhabitants the tourists might hope to see. Again, the mountains and waterfall—which seem to be in the same general area as the scenery in the earlier

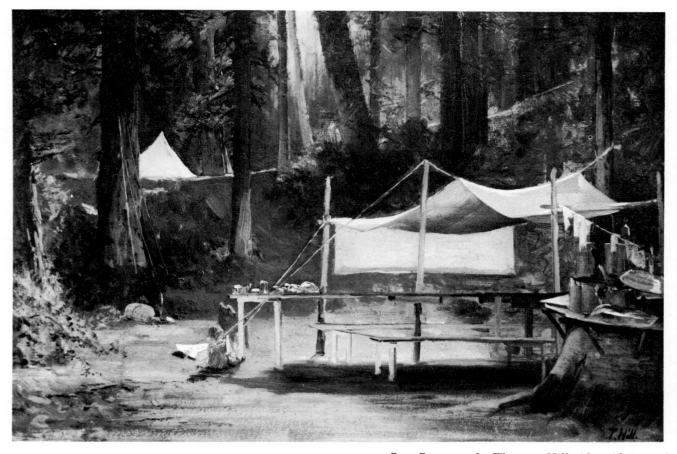

Our Camp, n.d., Thomas Hill. 12 x 18 in., oil.
The Oakland Museum, Kahn Collection.

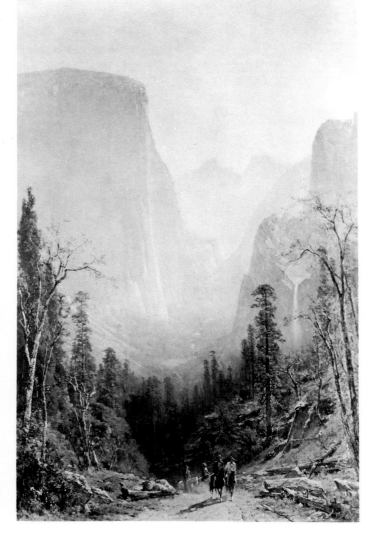

picture, are a slightly diffused backdrop to the foreground scene, a difference which immediately distinguishes Hill from Bierstadt and makes the Englishman a lesser artist of the mountains than the German.

Emerald Bay, Lake Tahoe was painted between the two Yosemite pictures, in 1883, and comes closer than either to the kind of composition that gave Bierstadt his dominance in the field. Again, there are Indians as the foreground figures, but they are subordinated to the majesty of the scene. They stand and sit around a cooking fire on the shore of the lake, half hidden by rocky spur of land and dwarfed by the expanse of water and the soaring, snow-clad peaks in the distance.

Eventually, and inevitably, Hill built himself a permanent studio in Yosemite at Wawona. In 1896, Hill was paralyzed and twelve years later he died near the Yosemite Valley he had done so much to make beloved by the people of his adopted country.

Party Touring the Yosemite, ca. 1868,
Thomas Hill. 56-1/2 x 36 in., oil.
Kennedy Galleries, Inc., New York.

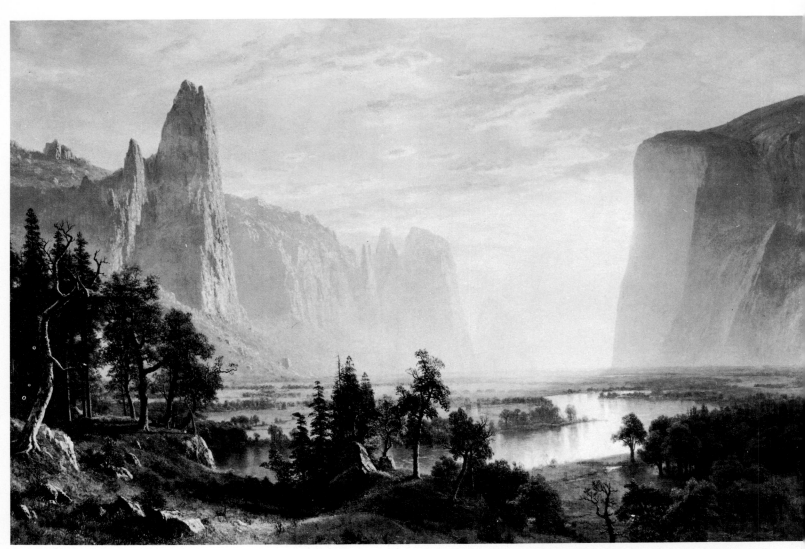

Yosemite Valley, 1868, Albert Bierstadt. 36 x 54 in., oil.
The Oakland Museum, gift of Miss Marguerite Laird.

THE SELLING OF THE WEST

Albert Bierstadt
(1830—1902)

The man who, more than anyone else, finally put Western landscape painting solidly in the center of the national art world was Albert Bierstadt. Until Bierstadt, Western artists had been deprecated as ethnologists or provincials, as unsophisticated and uninstructed. At a stroke, Bierstadt set the subject of Western landscape into the American art world and dazzled that world as much with grandeur of the subject as with the consummate skill and sure eye he brought to the task of rendering the subject. It is also no exaggeration to say that Bierstadt was the first American artist to command the attention of the European art world on grounds other than curiosity or novelty. Despite Baudelaire's perceptive praise, George

Catlin in London and Paris was a nine days wonder, admired for the exotic nature of Indian life at least as much as for his actual painting. The same thing was true of John James Audubon, who cut a fantastic figure in the London of Beau Brummell in his fringed buckskins, moccasins, coonskin hat and hair glistening with bear grease. Benjamin West, to be sure, was totally accepted in England, but after all he was an English artist, a loyal subject of the king who had come "home" to England well before the Revolution.

Albert Bierstadt, recipient of official honors from European governments, widely exhibited, extravagantly admired, and purchased for the highest prices ever paid for American art until then, was the first painter to impress upon the European art community and the general public that American art had something new and of unique value to offer. More important, he was, for a variety of reasons, the first painter to reveal to

the American people the richness, the beauty, the transcendent sublimity of their Western heritage.

Because of the nature of this book, we have been following closely the careers of people passionately concerned with the West, with getting there, seeing it, working it, exploring it, mapping it, pacifying it, settling, painting it. But all of these people together, plus all of those they moved among and are now forgotten, the whole westering population of this country, constituted, at any time in the nineteenth century, a tiny percentage of the American people. The center of American population, as determined by the first census, was a point somewhere between Philadelphia and Baltimore. That point moved West, in succeeding censuses, very slowly.

At the time of the first artistic ventures West, those of Catlin, Eastman, Bodmer and Miller up the Mississippi,

the Missouri, the Platte and the Yellowstone rivers as that country was just being opened up to white settlement, the cities of the Eastern seaboard had been settled and growing for two hundred years. The string of cities from Boston to Charleston, South Carolina, was older then, than Chicago and Omaha are today. Just as each trans-Atlantic migration has brought a very particular kind of European to the New World, so the Western trek attracted a few very clearly defined types. Most people stayed home, as most people always do. To this day you can find in New England citizens who believe that their ancestors' neighbors who went West more than a century ago did so because they lacked the moral gumption necessary to cope with the rocky New England soil.

Staying home, staying East, that vast American majority knew very little about the West and probably cared, most

Yosemite Winter Scene, 1872, Albert Bierstadt. 32-1/8 x 48-1/8 in., oil.
University Art Museum, Berkeley, gift of Henry D. Bacon.

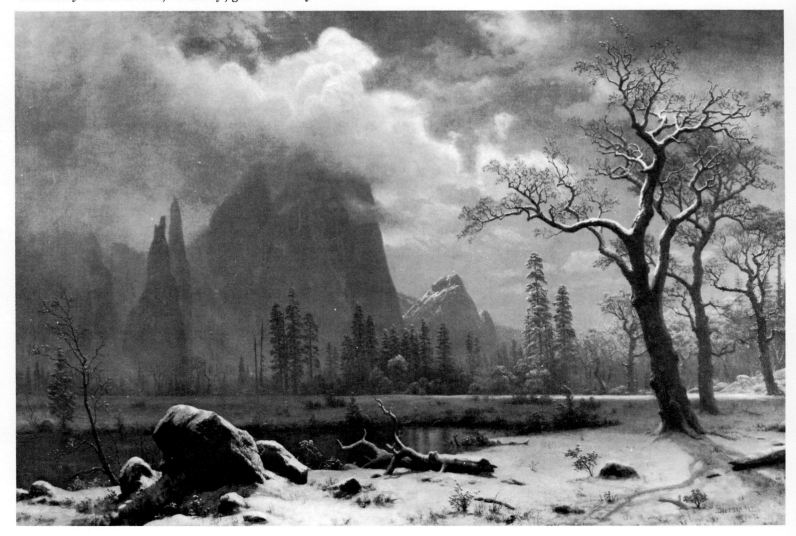

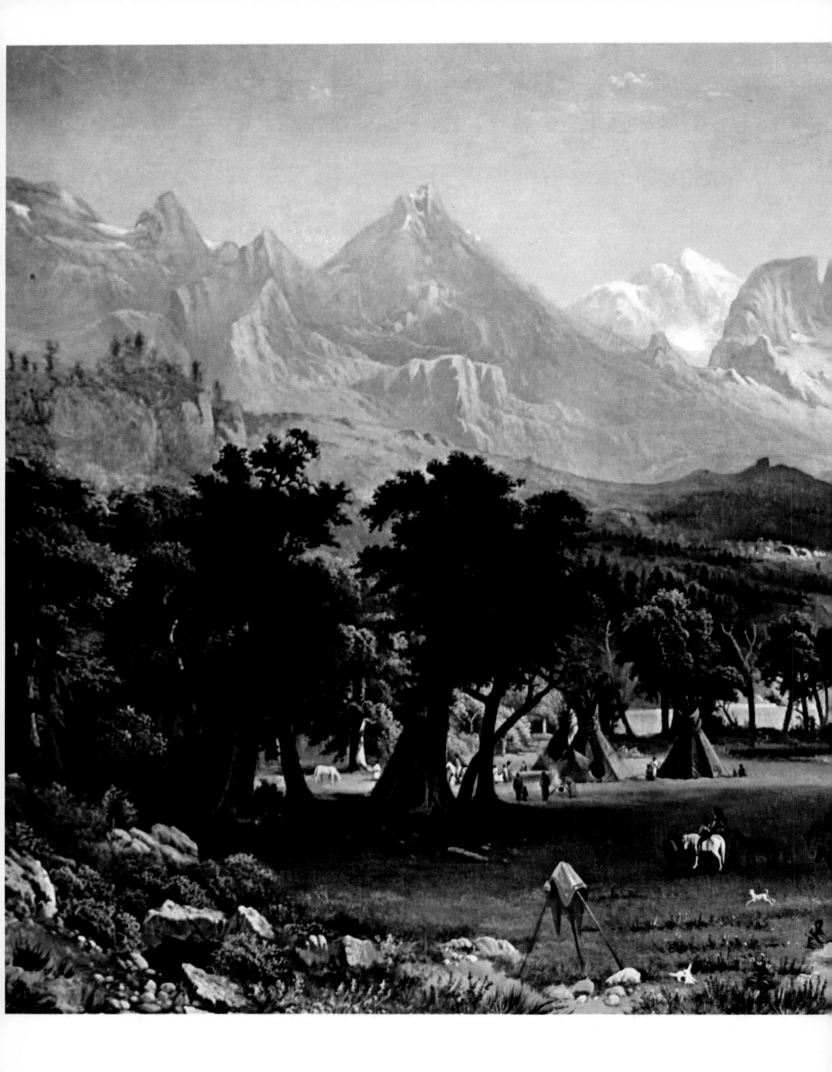

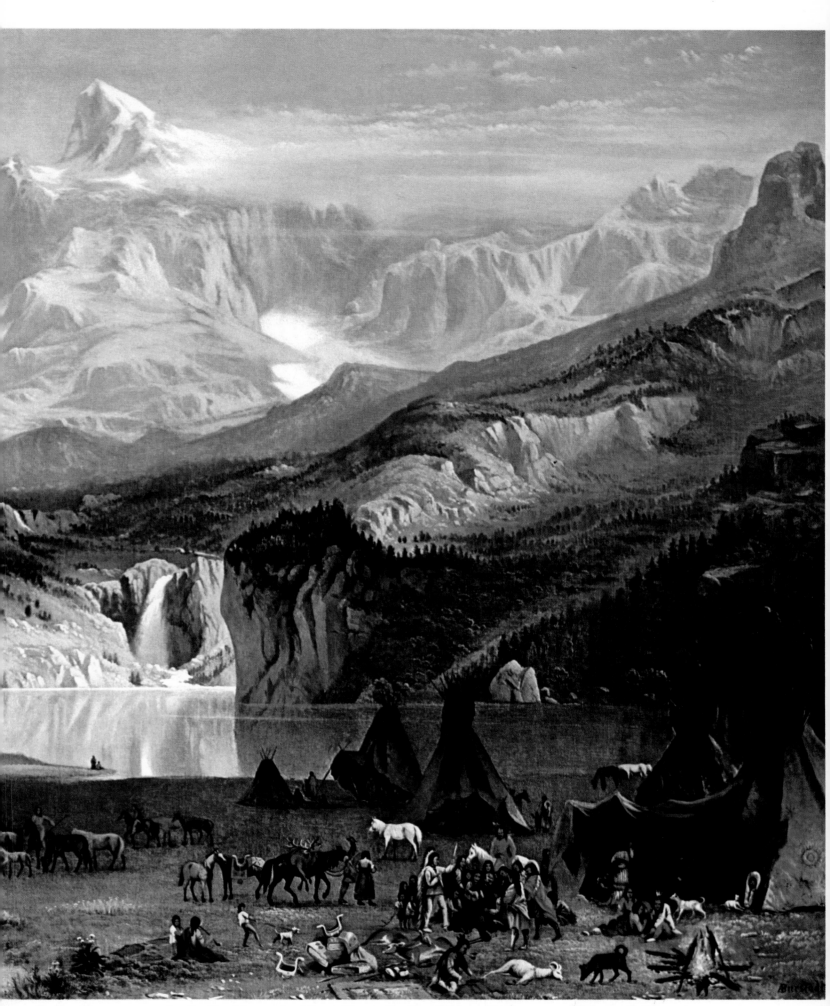

Indian Encampment in the Rockies, n.d., Albert Bierstadt. 48 x 82 in., oil. Courtesy, Whitney Gallery of Western Art, Cody, Wyoming. The artist painted several versions of this grandiose scene and, when one of the versions was exhibited in 1863, he gained a reputation as one of America's two most popular painters of showpieces.

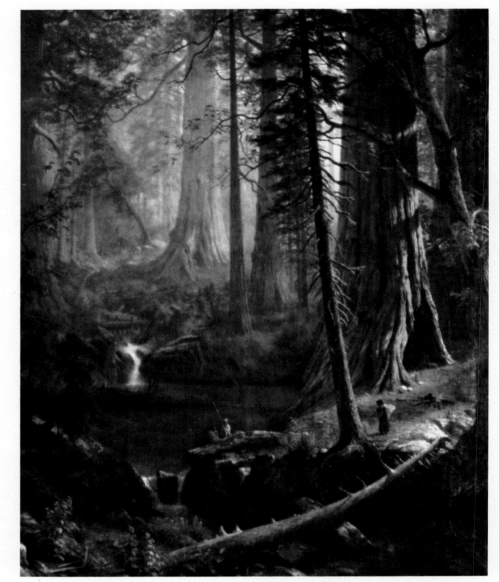

Giant Redwoods of California, n.d.,
Albert Bierstadt. 43 x 52-1/2 in., oil.
Courtesy, Berkshire Museum.

of them, even less. A child might read or hear travelers' tales and dream idly of crossing the broad Missouri, but on reaching man's estate that child would go into the fields or the counting house, or woman's, into the kitchen and nursery right in the old hometown. Occasionally the West became a political issue, or more accurately, was involved in Eastern political issues, just as the French and Indian War, so vital to the future history of the United States, was a kind of sideshow to the center ring of European power politics. The issue of Western lands was an important element in the negotiations that made the thirteen sovereign states into one nation, but the Western lands were an issue the way oil might be an issue in a Persian Gulf sheikdom: They were out there, clearly a source of potential wealth and therefore of immediate quarreling over who got what. The issue was, of course, settled by ceding the Western lands to the new nation for the creation of new states, which made the West politically possible: If it had not been, Chicago and Odgen, Utah, would be in Connecticut, while Alaska would comprise the northernmost counties of Virginia.

Jefferson's brilliant stroke of the Louisiana Purchase was a political issue in the East, chiefly over spending all that money, fifteen million dollars, for what became the states of Louisiana, Missouri, Arkansas, Iowa, the Dakotas, Nebraska and Oklahoma, as well as the major portions of Kansas, Colorado, Wyoming, Minnesota and Montana. But the issue was fought over economy in government and presidential powers, not over the attraction or value of the West. It was Jefferson, too, of course, who commissioned Lewis and Clark to find an overland route to the Pacific. When they did this they not only "nailed down" the Louisiana Purchase by visitation and meeting with various Indian tribes who had never seen white men before, but they also annexed the Oregon Territory to the Purchase, an extremely useful mistake which U.S. maps continued to carry until the twentieth century.

The West next figured in general American thought in the War of 1812, where battles at the northern and south-

154

ern end of the Western territory confirmed American occupation and afforded a people extremely dubious about the war their only solid, ringing victories. One of them, however, the Battle of New Orleans, was essentially Southern, as well as postbellum, the war having ended before Andrew Jackson's shore batteries battered the invading British, while the other, although it gave the country Oliver Perry's immortal command,"Don't give up the ship", took place on Lake Erie a few miles east of Toledo, Ohio.

Jackson himself next brought the West to the general American attention by becoming President and introducing Jacksonian Democracy, the raucous populism of the frontier as the successor to the Jeffersonian Democracy of the philosophical yeoman, the Hamiltonian meritocracy and Aaron Burr's big city machine politics. But the Jacksonian West that alarmed the Easterners, already effete, was only Tennessee in the first place and, in the

second, the Eastern Ascendency reestablished itself in Jackson's successor, Martin Van Buren, from Hudson River Country. The next Western President, also from Tennessee, was the ill-fated Andrew Johnson, Lincoln's vice-president. Hoover was a Californian, but he was more truly a member of the international technocratic bureaucracy which evolved in the wake of World War I. In a meaningful sense, the first President from the West was Lyndon B. Johnson.

The Mexican War and the continuing Indian Wars, both of which opened the West to ever increasing settlement, were also national political issues, but both were most widely regarded as expressions of national honor and power, rather than as essential steps in the creation of a new part of the United States.

From the middle of the century on, the major national issue to involve the West was the Slavery-Freedom issue. As the very language of the time reminds us, the Civil War

Island in Princess Louisa Inlet, B.C., ca. 1880,
Albert Bierstadt. 29 x 43-3/4 in., oil.
Courtesy, The Art Institute of Chicago,
Charles H. and Mary F. S. Worcester Collection.

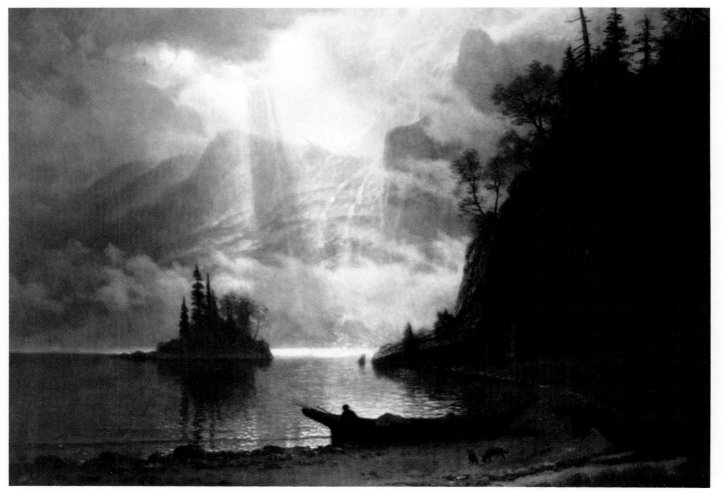

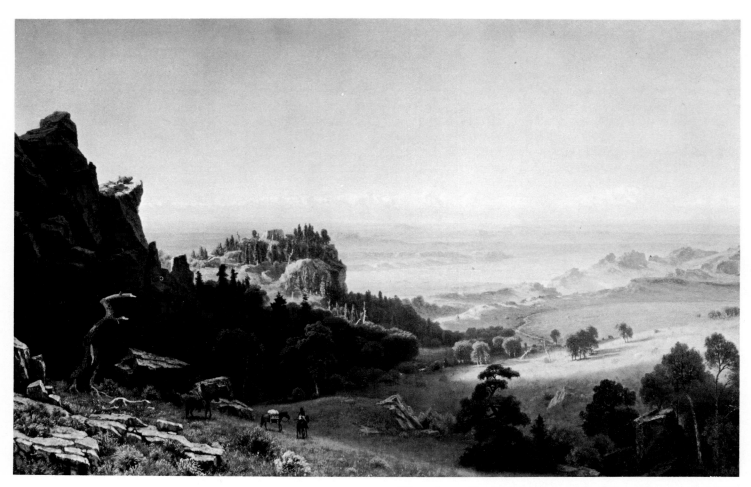

View from the Wind River Mountains, Wyoming, 1860,
Albert Bierstadt. 30-1/4 x 48-1/4 in., oil.
Museum of Fine Arts, Boston, M. and M. Karolik Collection.

was basically an issue between the North and the South, between New England abolitionists and Southern slave owners, between the strictest construction of the Constitution and the Union and the various measures by which Southern states sought to "interpose" themselves between the national government and their citizens, between the rapidly industrializing North and the richly agricultural South. Into that quarrel, the West was inevitably injected as a kind of prize to be fought over by both the major contenders.

There was no Western issue as such in the Civil War. The evolving economy—trapping, grain, cattle and mining—did not lend itself to the economic use of slavery. Western people, insofar as that new breed authentically existed in any numbers, were somewhat above and apart from the North-South quarrel. But both North and South seized upon every new increment to the growing Western Empire, the organization of every new territory, the incorporation of every new state, as an occasion to fight out the issue once again, debating in Congress and through hot-blooded partisans on the scene, the question whether each new entity should be free or slave.

The greatest statesman from beyond the seaboard states in the decades before the Civil War was Henry Clay. Clay's Missouri Compromise successfully put off the question for more than thirty years, but then it erupted with greater fury than before, and the Compromise, which enabled the violently disagreeing parties to live in peace,

was in effect, repealed by the Kansas-Nebraska Act of 1854. For a period, the West was the main battleground of the struggle. The nickname "Bleeding Kansas" testifies to the intensity of the efforts of each side to conquer the other. Before he seized the arsenal at Harper's Ferry, John Brown fought the slavery forces at Osawatomie, Kansas.

These, then, were the things most Americans, the seaboard and Piedmont American, knew about the West. It was a prize. It was an emblem of the Republic's strength against the Old World powers of England, Spain and France. It was battleground in the preliminary maneuvering for what increasing numbers of uneasy citizens were beginning to realize would be either a civil war or the dissolution of the Union. It was a refuge and a magnet for those of their fellow citizens who somehow had never made things work for them. It was a promise, a rather vague one, of a future Republic which should stretch from sea to sea. It was mysterious and perilous, full of savage people like those who had originally lived in Massachusetts and Virginia but obviously grown more dangerous still with the passing of a couple of centuries, the harboring of the memory of wrongs done them by the white men, and the mastery of firearms and horses. The West was all those things, but above all, it was out there someplace. It was beyond the mountains. It was distant. It was not something one had to think about to get through the

daily routine or even the years of one's life. It was comforting to know the United States had the West. Its possession meant that never again, as had been threatened or imagined, could the Spanish, the French or the British mass forces and drive the Americans into the sea, interfere with legitimate American commerce, or exact tolls and duties on American transport and communication.

It was good to have the West, but that formulation defined the limits of the relationship. The West was something America had. New England in contrast, or the Carolinas, were not something the nation had; they were the nation. Until that fundamental difference was resolved, the West would be outside, apart, a lesser thing. Finally, of course, the difference could only be resolved as it was, by the increased flow of people into the Western territories, by the organization of the territories into sovereign and equal states, by the growth of an independent Western economy, one that could trade with North and South but be dependent on neither, by the full development of cattle, grain and mining as opposed to the earlier

economic bases of furs and hunting, by the development of a distinctively Western politics instead of the projection of the North-South animosity upon the West, and by the emergence, in full self-recognition, of the Western person, man and woman, one as knowable and as acknowledged by non-Westerners as the New Yorker was by the Marylander, the Georgian by the Connecticut Yankee.

The natural processes of economics and politics mentioned above proceeded at their own pace throughout the nineteenth century and achieved the goals sketched above early in the twentieth. But before that, as much as any person, Albert Bierstadt changed the idea of the West held by most Americans along the seaboard. For all of those ideas, whether of the West as a lever or hinge used in relation to the other powers on the North American continent, or of the West as a stage for token warfare between North and South, all of them were abstractions. Bierstadt single-handedly moved the West into the realm of living, breathing, glorious, stupendous, overwhelming reality. His paintings of the West, most notably

Pioneers of the Woods, California, n.d., Albert Bierstadt. 19 x 25-3/4 in., oil.
High Museum of Art, Atlanta, gift of the Exposition Foundation.

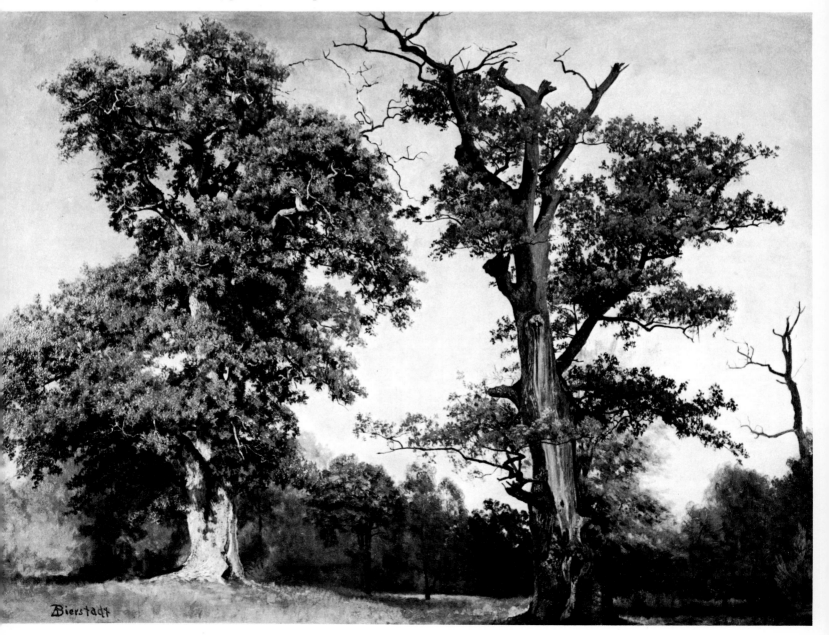

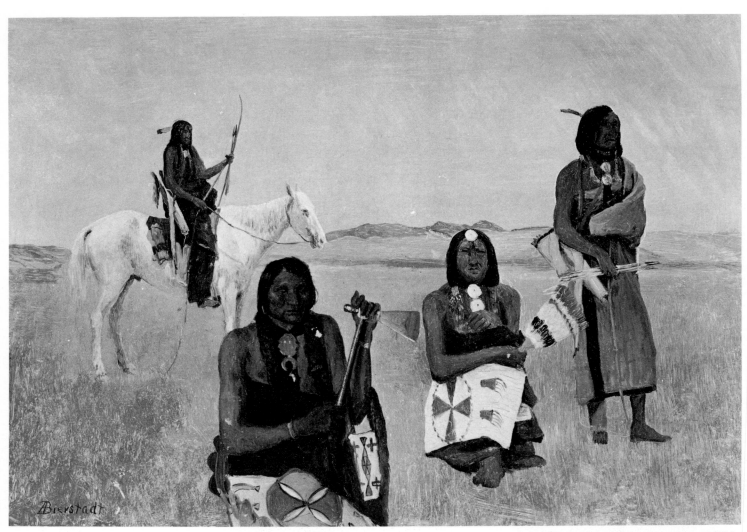

Indians Near Fort Laramie, 1858,
Albert Bierstadt. 13-1/2 x 19-1/2 in., oil.
Museum of Fine Arts, Boston, M. and M. Karolik Collection.

those of the Rocky Mountains, abruptly changed the American idea of what the Americans had out there. Suddenly it was all real and it was all beautiful.

It was also all different. There are mountains in the East from New Hampshire to Alabama, but nothing in that long stretch of land remotely prepares the Easterner for what he will find again and again and again in a trip from Denver, say, to Salt Lake City, or from Helena to Boise. The Eastern mountains, the Appalachians, are ancient mountains, well worn down by time, weather and water so that they seem to rise gradually, in easy stages, from the central Plain to the West and from the littoral and the Piedmont to the East. Moreover, they present no sudden, sharp break in the rise of land that begins almost at the water's edge. There are lovely and striking individual peaks, particularly in New Hampshire, but the Virginia Blue Ridge is more typical. The Blue Ridge, too, is completely charming, but from fifteen or twenty miles away to the east, it simply appears as a rise in the ground the observer is standing on—or sometimes as a long trail of blue haze, evenly distributed and hanging just above that ground.

No such confusion is ever possible with the Rockies. At first glance, from miles away, they announce their pres-

ence as imposing monuments, as formidable obstacles, as terrain objects worthy of and compelling contemplation.

They are "young" mountains, like the Alps, but whereas the Alps are some five hundred miles by one hundred-and-fifty miles at their longest axes, the Rockies measure three hundred miles across by a sweeping 2,200 miles north and south. The Rockies are like the Alps, but like the Alps multiplied by ten.

The Rockies contain a whole collection of spectacular water falls, rare and delightful phenomena like "Old Faithful," the geyser that erupts every hour, and of course the mountains themselves with their great rock faces, flourishing green toward the bottom, crowned by eternal snows. To look is to admire, to dream, to think, to fall into reverie or into contemplation, including religious contemplation.

From the point of view of human history, mountains occupy a rather ambiguous position. For mountain climbers, they are "there," as they say, to be conquered. For the tiny percentage of humanity who actually live in the mountains—most of whom really live along the rivers and lakes and passes, the low places of the high places—the mountains are a normal locale, a place for agriculture, industry and trade, for community, tribal and national organization, for living and learning, for having

158

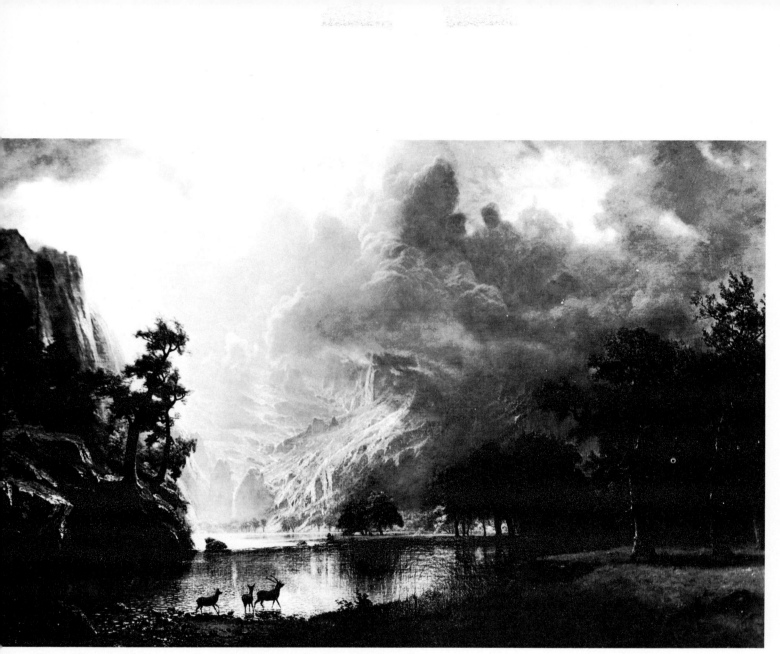

Sierra Nevada Morning, n.d., Albert Bierstadt. 56 x 84 in., oil.
Thomas Gilcrease Institute of American History and Art, Tulsa.

children and for dying, just like other places. But in other places, mountains are mostly ignored. For military leaders, mountains are barriers, the whole history of Switzerland being based in part on that fact, and the mountainous achievements of such captains as Hannibal and Napoleon being precisely that they got over, through or around these barriers, not that they stayed and did anything in them. It is not only civilization that has flourished in ports or at the natural intersections of trade routes, it is human community itself. The Biblical expression, "the cities of the plain," is almost redundant. That is where cities are, at or near water level. It is no accident that the two megalopolitan systems this country has now evolved, from Boston to Norfolk and from Buffalo to Milwaukee, are both rooted firmly in port cities on the water, either the ocean, the inland seas that are the Great Lakes, or on navigable rivers only a few miles from the ocean. The natural unit of the lowlands is the city; the natural unit of the mountains is the village or the extended family, the tribe, the clan.

Yet though the whole history of the human race, in trade, in city-building, in the growth of culture, even in wars and imperial conquest, seems to turn away from mountains, to seek suitable conditions for maximum evolution elsewhere, that appearance is deceptive.

Despite the fact that all the action seems to take place in plains and ports, the mountains, not even specific mountains, just ideas of mountains, have always occupied a special and ineradicable place in the human mind and soul. Before Jewish thought comprehended the idea of a universal God moving in justice and love to create and sustain the world, Jehovah, the God of Jews and Christians, was thought of as a tribal god, like many others in the Middle East, and also as a storm god, a mountain god, living on the awful, solitary peaks and loosening lightening and thunder to show his anger and jealousy.

The other principal source of Western thought about divinity and superhuman power was, of course, the ancient classical world of the Greeks and Romans; in both cultures, the gods were said to dwell on a mountain,

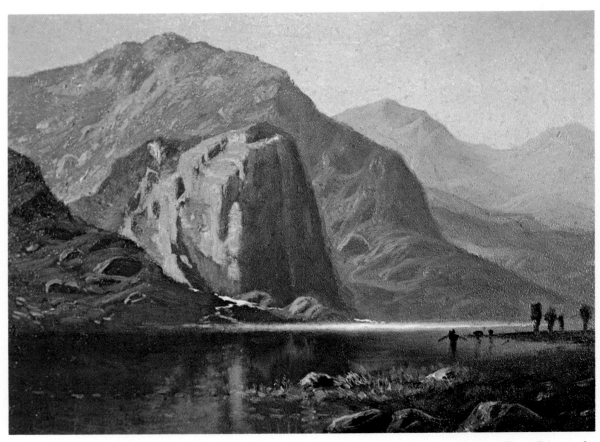

Western Landscape, 1868, Albert Bierstadt.
7-1/4 x 10-1/4 in., oil on hardboard.
Steven Straw Company, Seabrook, New Hampshire.

Olympus. Only lesser deities, nymphs and satyrs, were at home in the lowland countryside and none at all could be found in cities.

Nor were Jupiter and Jehovah alone up there on their mountains. The ziggurats of the Babylonian and related cultures were taken by Jewish observers to be affronts to God, put up to escape His justified wrath expressed in flood, as in the Genesis account of the tower of Babel. Archeology, however, has learned that these tall structures in the flat plain were raised platforms for the tribal god to descend upon and feel somewhat at home: they were artificial mountains, built for gods who naturally dwelled on mountains. The pyramids of Egypt, obviously, are also artificial mountains and they were built precisely to launch and assist the royal soul on its voyage from mortality to divine infinity.

In the New World, the pyramid appears in the high cultures of Mexico as a religious locale. Even in a landscape by no means without mountains of its own, a need was felt to build a mountain on which to offer fitting sacrifice to the gods, just as Abraham, thousands of miles and hundreds of years away from the Maya and Aztecs, led Isaac up the mountain to offer him to God, as the Greeks ascended to Delphi to hear the wisdom of the

gods, as St. Benedict naturally founded his revolutionary monastic order on top of a mountain as imposing as Olympus, as Moses received God's commandments on a mountain, and the spiritual center of the Orthodox Church is on Mouth Athos. The one great, completely original architectural achievement of Christianity is the Romanesque-Gothic cathedral. It is often remarked how like a forest the cathedral interior is, with its columns and piers like tree trunks and its vaulting like branches meeting overhead. This is true enough on the inside, but seen from without, approaching across a plain or up a river, the Gothic cathedral resembles nothing so much as a mountain itself, with uneven heights of the masses and with points and pinnacles shooting up into the sky.

All of these examples taken together at least offer a strong indication that for Europeans and Americans, the mountain is the locus and the source of divine power, the home of gods, and sacred place where men and women fall silent and experience some feeling of oneness with God, with Providence, with Nature, with the Universe, with whatever any given individual believes exists above and beyond humanity.

With this ancient and natural human predeliction for finding in mountains some special contact with divinity,

160

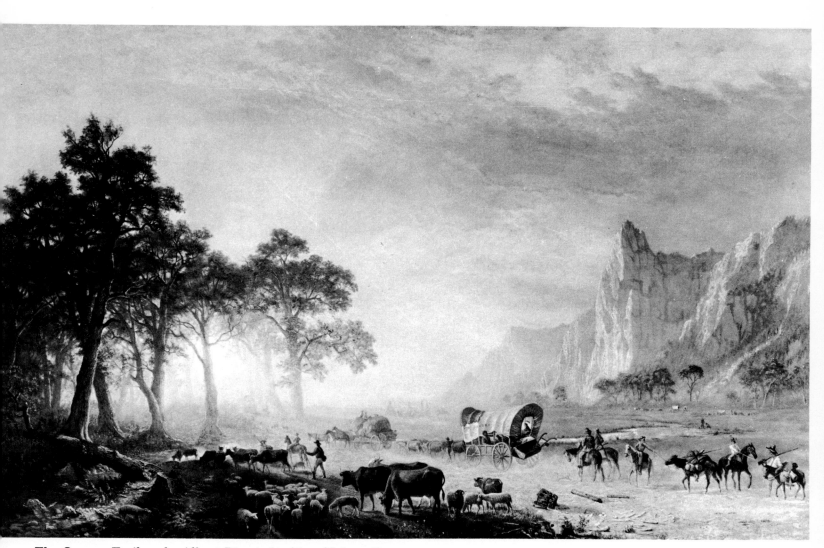

The Oregon Trail, n.d., Albert Bierstadt. 31 x 49 in., oil.
Butler Institute of American Art, Youngstown, Ohio.

it was, perhaps, inevitable that, granted the inexorable expansion of the United States from the East Coast to the West Coast, at some point the Rocky Mountains would be a revelation to the Republic and would become a focal area for those myriad activities of Americans that can best be described as those undertaken while not at work and not at home, ranging from rest and relaxation to the intimations of divinity Graeco-Romano-Judaeo-Christians have always found in mountains. That recognition and that utilization were, no doubt, inevitable, but still, the process had to be begun and there is no question but that Albert Bierstadt began it, that he and he alone first brought the Rockies to the center of American attention, that he preeminently presented this region, these literal landmarks, these monuments of the spirit and of the divine, to the American mind for contemplation in a medium by definition designed for contemplation.

Even as the Rockies were an inevitable discovery in the American march from sea to sea, so they were an inevitable subject for American painting. American painting had been preparing for the Rockies for some thirty-five or forty years when Bierstadt arrived on the scene with his first exhibited picture of the mountains in 1860. Colonial painting was almost entirely portraiture and that

situation continued into the first decades of the new Republic. By common agreement artists and their more cultivated patrons recognized that what was called "historical painting" was the highest and best kind of painting, but only the Revolution inspired a few American artists to try their hands at what was a risky business proposition compared to the steady security of portraiture. Still life became a very minor branch of the art, with emphasis, thanks to the Peales, on "deceptions," or pictures so closely painted the viewer momentarily thought the objects real. Abruptly, in 1825, that whole situation changed. Almost overnight, the dominant, most favored and most practiced form of art became landscape.

There are several widely accepted explanations for this change beyond the sudden appearance on the scene of competent and dedicated landscape painters like Thomas Cole and Asher Durand. The fact that some of the explanations contradict each other does not count against them. In social history, explanations often do contradict each other, yet continue not only to be held but to offer some authentic light on the phenomena they explain.

The principal contradictory theories about the rise of American landscape painting in the second quarter of the

161

nineteenth century apply also to the later rise of Western art. They are these: On the one hand, by 1825 or so, the initial encounter of the Europeans, particularly the Anglo-Saxons and Scotch-Irish, with the coastal plain and the Appalachians was over. The hostility of the wilderness, recorded so poignantly by the early colonists in Virginia and New England, was long tamed, and now the new race, the Americans, could look around at their domain and enjoy it—not only enjoy it but begin to endow it with mystical qualities, as, for example, the first stanza of "America the Beautiful" so strongly implies. Landscape painting flourished in response to those new feelings of Americans for their land and at the same time encouraged those feelings.

On the other hand, that period, the second quarter of the century, was also a period of intensive urbanization in America. Cities grew and new inventions, speedily put into wide use, changed the whole rhythm of life. The cotton gin revolutionized Southern agriculture, while, in the North, the rise of the factory began changing the economy from one of trade, centered on the swift ships that sailed out of New England harbors, to one of manufacture, centered on what would soon be called the dark, Satanic mills. Landscape painting also flourished as a kind of antidote to all that: an escape from the city and the factory to a dream of innocence and nature. For these and other reasons, landscape became the dominant form of American art and remained so throughout the century.

Starting with Cole and Durand, a distinguished roster of American painters saw the American land anew and presented it, freshly seen and and shimmering with mystical intimations, to three or four generations of Ameri-

cans. In the middle of that long dominance came the career of the most popular, and in some ways ambitious, of all the native American landscapers, Frederic Edwin Church. A few years older than Bierstadt, Church certainly opened up the field of the heroic landscape which Bierstadt so thoroughly explored.

Oddly, as Church progressed in size, scope and compass, he just about skipped completely the American West as a subject. Instead, moving from his early modest views of his native Connecticut, he sought heroic subjects in the Andes of South America and in the great icebergs and glaciers of the polar regions. His *Heart of the Andes,* exhibited in New York and surrounded by South American foliage and other accoutrements, caused a tremendous sensation in the city and, later, throughout the American art world. The public marveled at the vast distances in his large canvases, distances combined with meticulous rendering of birds or flowers seen close by. But Americans were soon to see that they had in their own country views and panoramas equally impressive. The man who revealed this to his adopted countrymen was Albert Bierstadt. Beginning in the early 1860's, Bierstadt came to share the fame and wealth that America poured so generously on Church. The vision he presented more than repaid their generosity.

Rainbow Over Jenny Lake offers one of the few overt links between the two painters. Before he discovered the Andes and the ice-packs, Church made his first major impact on American and English art consciousness with what may be the finest painting of Niagara Falls ever made. The observation at every point is superb and the

Ox, n.d., Albert Bierstadt.
11-1/2 x 18-1/4 in., oil on cardboard.
The Oakland Museum, Kahn Collection.

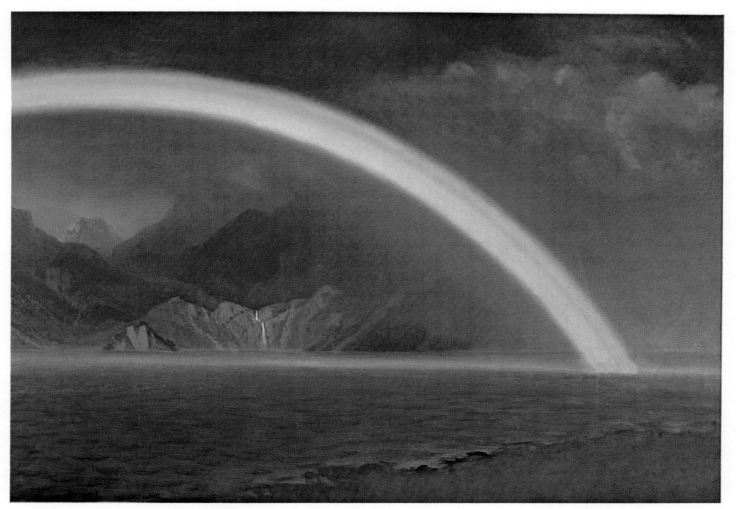

Rainbow Over Jenny Lake, ca. 1870, Albert Bierstadt. 30 x 44 in., oil.
Morton D. May Collection, St. Louis. Americans of the late nineteenth
century had a great taste for heroic landscape, and Bierstadt did much to
satisfy it with this glowing painting of a rainbow over an immense stretch of water.

overall composition dramatic. The distinguishing feature, however, is the rainbow—the Falls are never without a rainbow—which arcs through the sky and into the great chasm and is painted so delicately that it seems to float on the surface of the painting. When he first saw the painting in a London gallery, the great English critic, John Ruskin, wrote that he assumed the rainbow was an effect of actual light in the gallery passing through the beveled edge of a windowpane or the prism of a chandelier.

Rainbow Over Jenny Lake is a graceful acknowledgement of all that Bierstadt owed to Church—not so much as a direct or indirect teacher, but rather as a valuable predecessor who had created the American taste for the heroic landscape, a taste Bierstadt himself was to join Church in satisfying for decades.

In contrast to Church's *Niagara Falls,* in which the rainbow is a subtle and delicate addition to a painting that without it would still be a formidable work, Bierstadt makes the rainbow the glowing center of the whole painting. Boldly and dominantly, it arcs in from the left and plunges to the lake's surface on the right. It divides the

air it passes through: Above it are the brownish pink clouds, opening to reveal dark blue beyond. Below it, the sunlight touches peaks and slopes of red, stone mountains and only gradually reveals the immense space the artist is encompassing. The rainbow itself is bordered by darkness on both sides, as if to suggest the significance of that rainbow God presented to Noah after the flood as a sign of peace between God and man.

Seeing at first the overall view, we do not comprehend the spaces. The distant sunlit peak beneath the rainbow on the left begins to suggest distance, but the detail that brings it home is the white cascade in the sunlit rock wall descending to the lake directly across from our point of view. The diminished size of what we know at once to be a mighty spill of white water sharply tells us that it is a very long distance away. The lake is very wide, we suddenly see; a note of distance is emphasized by the painting of the water itself in the area around the rainbow's end. The space from our shore to the place where the rainbow meets the water to the far shore is so varied in its coloring that it must encompass acres of water.

163

The sense of awe and wonder that was Bierstadt's hallmark in painting the American Western landscape was never more powerful than it is in *Estes Park, Colorado*. The scene is on the edge of land that is now the Rocky Mountain National Park. Its selection as well as its execution reveal the underlying sense of the spiritual that animated Bierstadt's most gradiose visions.

Again, the immensity of mountain spaces is very subtly conveyed. The sheer scope of the painting does not begin to dawn on us until we notice the deer poised on the edge of the bluff overlooking the lake. The tiny size of that sizeable animal makes us grasp not so much the scale of the painting as the distance from our viewpoint to that of the deer. At the same time, we realize that where the deer is is really just the beginning of the adventure in mountain space that the artist has accomplished for us.

From that rise on which the deer poises itself to regard the lake, our gaze travels across the motionless reflecting surface of the water to an intermediary shore with dark trees on the left and then on to the farthest shore, approached through white water indicating a rocky bottom and a powerful current. On that rocky shore, our vision sweeps up and to the left to the mist-shrouded mountains towering above the tree clumps of the halfway shore. The

mountains there almost seem to be turning, as sunlight picks out the rising slope and deep shadow engulfs the shoulder and the peak. Then, in the center distance, with all this as prelude, tower the great peaks, almost immeasurably distant, with a cascade of water, with a permanent mantle of snow and with pearly gold light from the cloud covered sky.

The peculiar pearly light is a great virtue of the painting. It suffuses the entire work, from the seemingly infinite variety of clouds in the sky to the different textures and forms of mountains, across the changing surface of the lake, with its reflections, to the lush greens of the trees and the grassland that seems, deceptively, to be at our feet. The light provides a compositional scheme of its own, superimposed upon, or supported by, that of the lay of the land itself. Its center, in the clouds, is duplicated on those most distant and grandest mountain peaks and again on the white water at the far side of the lake. From this strong vertical flow of light, the pearly gold dimishes as it moves outward, left into the cloud cover, right into the light-absorbing trees. But its reflection illuminates the lake and its farthermost rays pick out the deer on the shore and the grasses in the foreground.

The Estes Park picture makes it abundantly clear that the qualities that captivated Bierstadt in the West and those that, in turn, captivated his audiences in his pictures,

Estes Park, Colorado, 1869, Albert Bierstadt. 33 x 48-7/8 in., oil. Collection of Libbie Moody Thompson, Washington, D.C. A hallmark of Bierstadt's vision of the West was a sense of awe which is powerfully conveyed here by the great spaces and amazing varieties of light pouring from the skies.

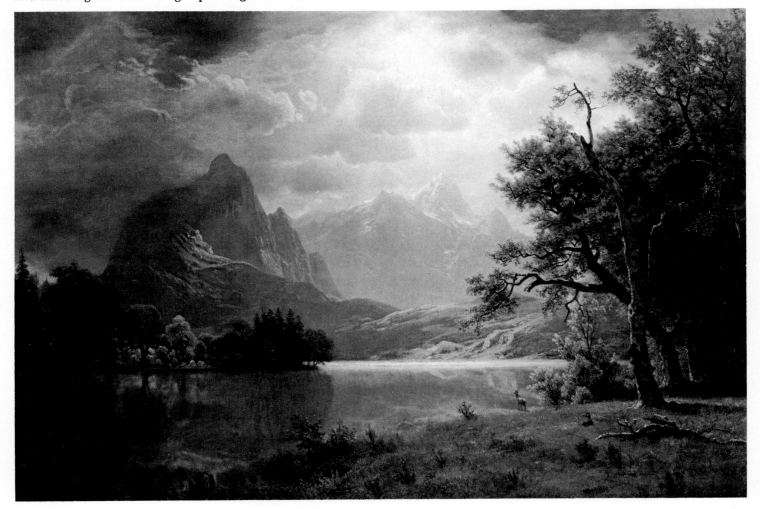

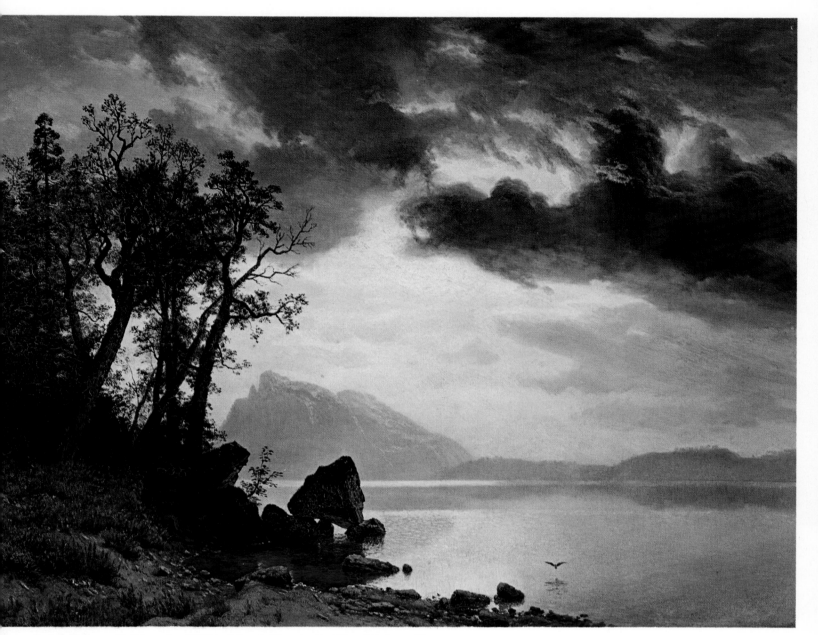

Lake Tahoe, California, 1867, Albert Bierstadt. 22 x 30 in., oil.
Museum of Fine Arts, Boston, M. and M. Karolik Collection.
In this canvas, Bierstadt worked out numerous variations of
the qualities of light as it played over the landscape and sky.

were much more centered on great spaces shaped by
Nature and on the amazing varieties of light pouring down
from the Western skies than they were on the simple and
straightforward grandiosity of the towering moun-
tain peaks.

The primacy of space and light in Bierstadt's world of
Western mountains is inescapable in a picture like *Thun-
derstorm in the Rocky Mountains,* but the point, perhaps,
is even stronger in less spectacular pictures. *Lake Tahoe,
California,* for instance, is a quiet, unpretentious scene.
There are some trees and rocks on the shore of a lake and,
in the distance, some hills and mountains. The day
is slightly overcast. But this apparently modest statement
yields a treatise of Western space and light as these quali-
ties enchanted Albert Bierstadt. On the lake's shore, that
great triangular rock balanced on others is more than just
an interesting trick of nature. We see light reflected from

the water playing on the bottom of the rock and adding
one more variation of light to those represented on the
rock's other faces: the direct, although modified, sunlight
of the right side, the darkness of the side toward us and
the mixture of the two on the side facing the shore, where
the light is reflected from the more absorbant surfaces
of the foliage.

But that little passage beneath the poised rock also
serves to draw our vision beyond the rock and across the
lake, a function similarly served by the bird starting out
from shore and its dim reflection in the water below.
When our eye follows those direction signals, we are made
aware of numerous and subtle nuances of light filling the
air above the water. We become aware that the space,
although vast, is not endless: It is shaped, on a mammoth
scale, by the distant mountains, the flat water and, above
all, so to speak, by the floating clouds.

The Buffalo Trail offers the same virtues within its
calm, pastoral setting. At first glance, the scene could be

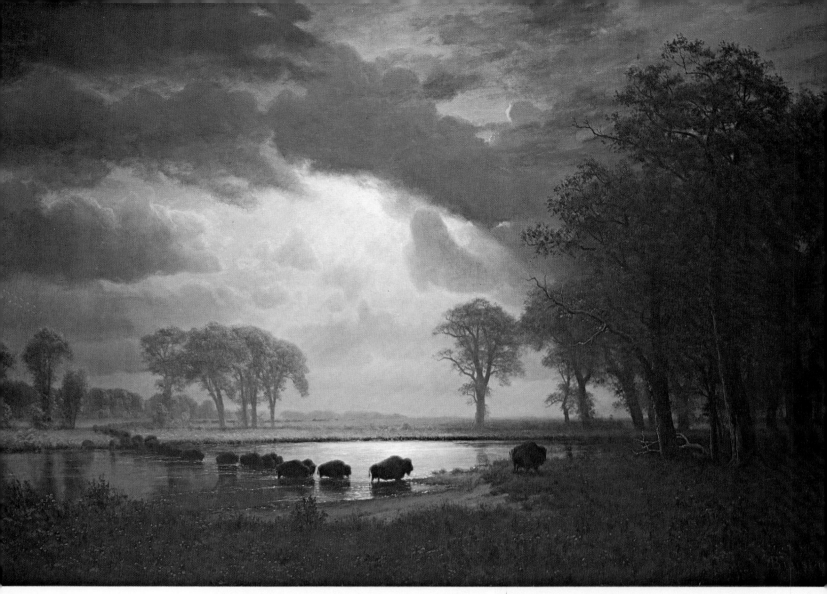

The Buffalo Trail, 1867-68, Albert Bierstadt. 32 x 48 in., oil. Museum of Fine Arts, Boston, M. and M. Karolik Collection. Though at first glance this has the elements of an Eastern scene, the facts of towering trees, giant herds of bison and the wide river confront the viewer with the vast spaces of the American West.

a familiar country landscape from seventeenth- or eighteenth-century Holland. The skies above are quiet, influencing the light, but not dramatically so. The trees tower gracefully in the near right and the more distant left. The herd crosses the gentle stream, peacefully moving from one pasturage to another.

But then something registers, and we gradually experience a total change of scale. These are not, after all, domestic cows of Holland or upstate New York. The shape is different. These are bison, the miscalled buffalo of the western Plains. Moreover, the lead buffalo, so much larger than any cow, as he approaches the grove of trees on the right, is himself diminished, and we realize that these trees are no simple woodland. They are giants, survivals of the original American virgin forest, the trees found in unsettled lands before pioneers arrived to cut them down for heat and shelter. As that great scale gradually dawns on us, we notice, too, that the train of buffalo stretches out much father than any herd of domestic cows; it crosses the stream, which itself turns out to be wider than it seemed at first glance, and winds back across the plain, its ending lost in the dust kicked up by the procession. Again, we are confronted with—initiated into—the vast spaces of the American West.

Domes of the Yosemite shows Bierstadt at the height of his powers, combining a spectacular landscape with all his mastery of enclosed yet open space and of the shifting, changing lights that fall from the sky or are reflected from water within such great space. Always a careful composer of such space, Bierstadt leads the eye into the picture by what seems a natural disposition of the land, establishing scale and distance by the contrast of rocks and trees in the foreground that we know to be reasonably large with the vastness of the enclosed space of Yosemite.

The California valley is one of the few places in America which was recognized at its first discovery for the inestimable values it offered as recreation. Although earlier expeditions possibly passed through the area, the valley did not become known to America until 1851, when a cavalry battalion pursued an Indian raiding party home to its secret refuge, which turned out to be the valley. The doctor with the battalion, Lafayette H. Bunnell, named the site for the Indian word for grizzly bear, corrupted somewhat as almost all such transliterations have been in the New World. Thanks to the work of a number of naturalists, including the great John Muir, the valley became a public park with the collaboration of Congress and the State of California as early as 1864 and a national park in 1906. One minor artist published some lithographs

based on sketches of the valley in the late 1850's, but it was Bierstadt's paintings, more than any single element, that made Yosemite known to the American people as one of their most precious treasures.

The man who revealed Yosemite to the Americans, along with many other American beauties of Western scenery, was not an American by either birth or artistic training.

Albert Bierstadt was born in a suburb of Düsseldorf, Germany, or the Kingdom of Prussia as it was then, in 1830. He was brought to America almost as a babe-in-arms by his parents, who settled in New Bedford, Massachusetts, where Albert was brought up. When, as a young man, he determined to become a painter, he quite naturally returned to Düsseldorf, where the local academy was then one of the leading art schools in the world, rivaling Rome and Paris and commanding a great deal of American attention. While at Düsseldorf, he became acquainted with Worthington Whittredge, George Caleb Bingham and Sanford Gifford, among other American landscape artists. He studied with Emanuel Leutze and traveled through Germany, Switzerland and Italy before returning to the United States in 1857.

Two years later, he made the first of four extensive journeys to the American West as a member of the survey expedition led by General F. W. Lander. Like other American artists, starting with Catlin, Bierstadt was struck by the Indians, whose way of life, he wrote, seemed to have been unchanged for hundreds of years. He wanted to paint them in the knowledge that their way of life would soon vanish completely—as indeed it did. But a much more powerful attraction to his Germanic, romantic soul was the astounding scenery of the Rocky Mountains. The following year, on returning to the East by way of Fort Laramie, Bierstadt exhibited the first of a lifetime of paintings of the Rockies. The same year he was elected a member of the National Academy of Design, the first of a very long list of honors and awards made in recognition of his Rocky Mountain painting.

Bierstadt's painting, well-grounded in the solid, academic training he received at Düsseldorf, did not change much in the course of an active professional career of four decades. As with all Düsseldorf artists, for Bierstadt, drawing was of paramount importance, the scaffolding of a picture. With his first view of the Rockies, he had found the subject for all his life's work and he continued to paint that subject. Despite that subject, Bierstadt spent a great deal more time on the East Coast than he did in the Western mountains. His sketches were accurate and detailed, and he accumulated sheaves of them on his trips West, working out of them for years afterward. He moved his working base first from New Bedford to Boston,

Domes of the Yosemite, 1867, Albert Bierstadt. 116 x 180 in., oil. St. Johnsbury Athenaeum, Vermont. Yosemite Valley has been a favorite place for artists and naturalists ever since its discovery by white Americans in 1851, but it was Bierstadt's paintings which did most to extol the valley's beauty to the nation.

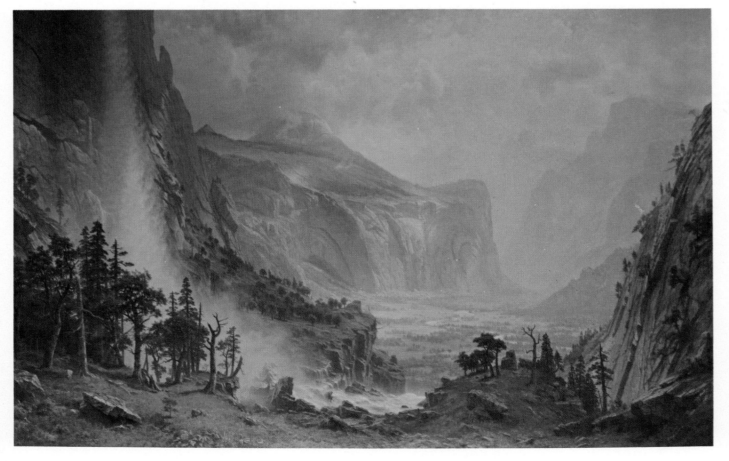

then to New York. He visited Europe with some frequency, collecting, in the process, high awards from Napoleon III and the Turkish Sultan.

In 1889 a terrible blow befell the artist after close to four decades of unwavering success and enthusiastic professional and public acceptance. The New York committee of artists responsible for assembling the American section of the art show at the Paris Exposition rejected his major work, *The Last of the Buffalo*. They reasoned that it was out-of-date, old-fashioned and no longer of interest to an art public beguiled by Impressionism. In terms of fashionable interests, the committee was right. The committee also no doubt felt a certain righteous glow in strking at one of the dominant artists on the American scene. Bierstadt did not accept the decision quietly, but got the picture accepted by the French Salon, a considerably more prestigious institution than the American artists' committee. The rejection, however, clouded and embittered the last dozen years of his life. Four years later, for example, he refused to exhibit his *Landing of Columbus* at the Chicago Exposition held to commemorate the four-hundredth anniversary of Columbus's discovery.

The rejection also affected his prices. Bierstadt had earned enough in his decades ot total success not to have to worry much about current income. He took to spending a few months abroad each year, as if in search of a more congenial climate than the one created by his fellow artists in New York. But there was, of course, no real escape. In 1898 he bought back a picture of his, *The*

Rocky Mountains, the quintessential Bierstadt, for $5,000, one-fifth the price he had sold it for when new. Bierstadt died in New York in the winter of 1902, full of years and honors but also full of the knowledge that he had been rejected by his own trade.

That rejection continued to hang over Bierstadt's posthumous reputation for half a century and more after his death. The explanation is simple enough: From Impressionism on, the American art world has been in the business of importing art revolutions, mostly from France. But a revolution implies something strong and dominant to revolt against, and Bierstadt happened to be a target of convenience when the American Impressionists and Luminists and other late landscapists struck their blow. In the decades since, Bierstadt obviously did not relate to any of the successive revolutions that have marked the twentieth-century history of American art.

Throughout those decades of rejection, it was fashionable, even more or less required, of people of taste to laugh at Bierstadt for his large paintings of extremely attractive scenery. They seemed to have nothing to say of the condition of life as it really was in increasingly urban American and even less to say of current developments in art. The really knowing scholars of American art would admire his draftsmanship, and an occasional collector would exhibit with pride a small oil or watercolor sketch of his. As happened earlier with Rubens, it became re-

The Last of the Buffalo, ca. 1889, Albert Bierstadt. 71-1/4 x 119-1/4 in., oil. In the Collection of the Corcoran Gallery of Art, Washington, D.C., gift of Mrs. Albert Bierstadt. When Bierstadt presented this work to the art world, his meticulous style and immense canvases were judged old-fashioned in the age of Impressionism, but recent attitudes have been receptive to his grand paintings of natural glories that have, in part, disappeared.

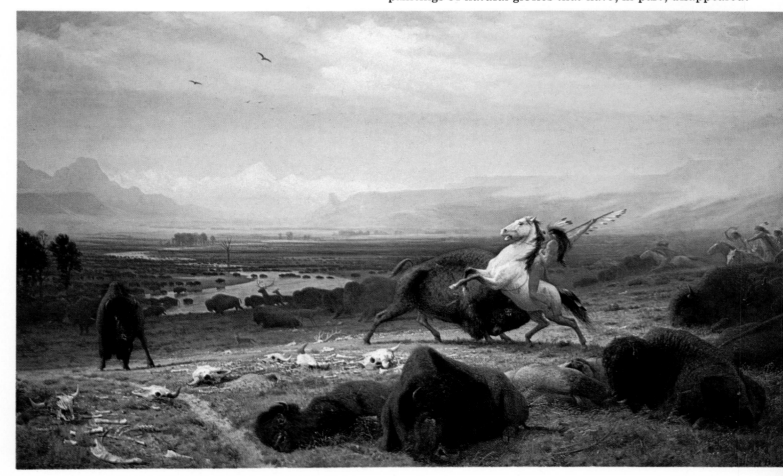

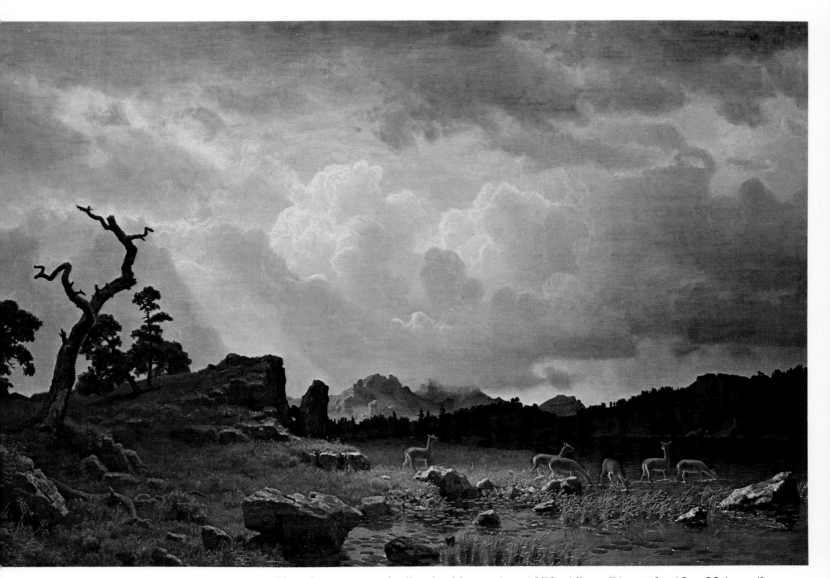

Thunderstorm in the Rocky Mountains, 1859, Albert Bierstadt. 19 x 29 in., oil.
Museum of Fine Arts, Boston, given in memory of Elias T. Milliken by his
daughters, Mrs. E. Hale and Mrs. J. C. Perkins. The grandeur of space
and light is the import of all Bierstadt's Western mountain scenes.

ceived opinion that Bierstadt was quite able in his small, less ambitious sketches, but that when he translated them into the full-scale paintings for which he was best known, a certain stiffness and a great deal of pretension took over and made the work the American equivalent of the French Academic paintings, which the Impressionists had rebelled against in the first place.

In the third quarter of the new century, however, Bierstadt was startlingly and unexpectedly "rediscovered" by a new generation of the same critics and officials who, as it were, "de-discovered" him back in 1889 and throughout the decades since his death. Two profound changes took place in the art world to allow for the accommodation of Bierstadt after half a century of neglect. The Abstract Expressionist revolution of the 1950's had successfully accustomed American eyes and American museums to large paintings once again. Educated by Jackson Pollock and others, Americans found that they could look at large canvases once more without automatically assuming they were inflated and empty. Secondly, the revolution initiated by Pollock—himself a Western painter in one sense, being a native of Wyoming—ran so far, demolished barrier after barrier, or standard after standard, that anything became acceptable, even the

meticulously painted, carefully composed mountain landscapes of Bierstadt. Naturally, once people were permitted to look at his work seriously again, they once more saw the very real artistic virtues that were present.

A profound and even more drastic change in the general thought of America as the last third of the century began was perhaps even more crucially responsible for Bierstadt's "re-discovery." This was the sudden realization that we were on the point of running out of the environment. We had used it up, wastefully disposing of such tangible resources as minerals and forests and even more carelessly using the intangible ones of fresh air and unspoiled land. Even those vast reaches of mountain landscape that had become national parks were in danger of inundation by campers and by their automobiles. The country turned to thoughts of how to save what was left and restore what might be restored of what was already gone. In that situation, Albert Bierstadt provided, as he had to his own generation, a glorious vision of the most spectacular aspects of the American landscape before its erosion by humanity. Bierstadt became again, as he had been for most of his career, a painter who opened America's eyes to some of its most valuable national treasures and to some of the greatest glories of the West.

NATURE IN GENTLE TONES

Samuel Colman
(1832—1920)

The Green River, Wyoming, 1871, Samuel Colman.
16 x 21-3/4 in., watercolor and pencil on paper.
Museum of Fine Arts, Boston, M. and M. Karolik Collection.
The vastness of this scene only becomes clear when one notices
the tiny groups of Indians amid the great walls overlooking the river.

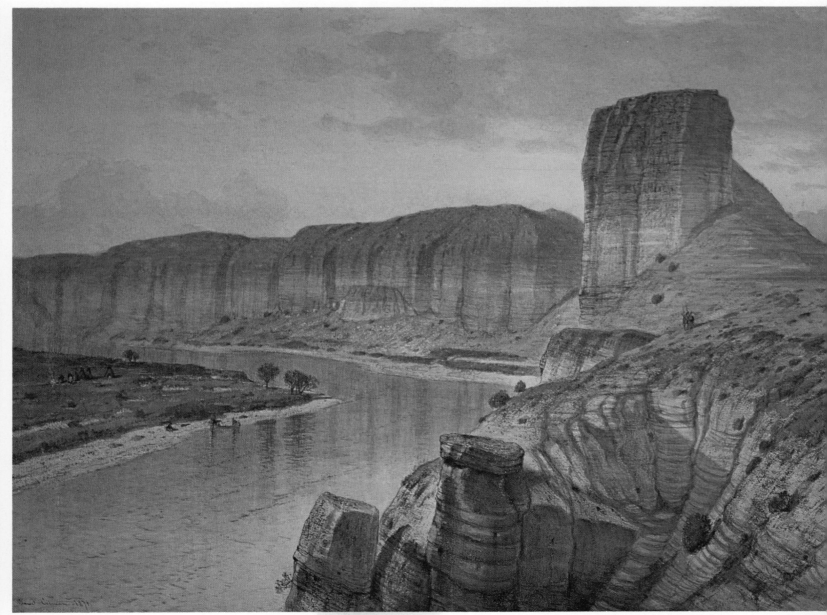

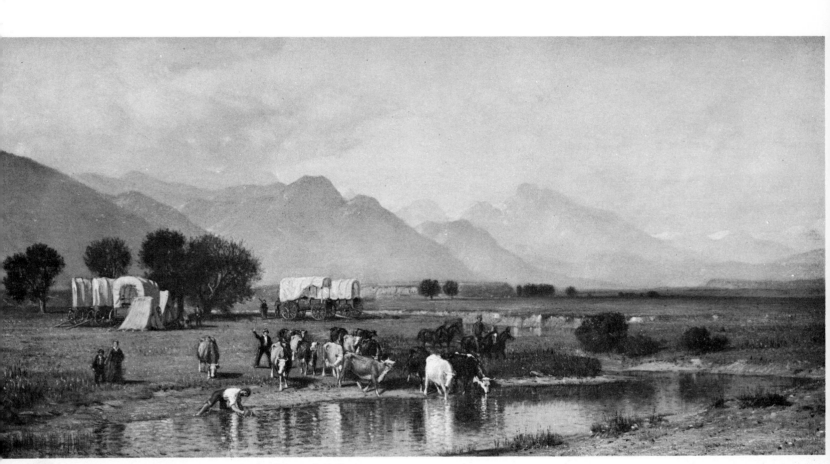

The Emigrant Train, Colorado, 1872, Samuel Colman.
19-1/2 x 40 in., oil. St. Johnsbury Athenaeum, Vermont.
This scene from the great popular adventure —
wagon trains rolling West — is unusual in that it is
entirely peaceful, with not an attacking Indian in sight.

Born in Maine, Colman was soon taken to New York where his father's publishing house employed some of the leading American artists as illustrators. He thus came in contact with Asher Durand, second only to Thomas Cole as founder of the Hudson River School, and under Durand's instruction was exhibiting at the National Academy of Design by the time he was eighteen. He was elected an associate of the Academy when he was twenty-three, becoming a full Academician at thirty. After studies in Paris and Spain, Colman returned to New York where he helped to found and became the first president of the American Watercolor Society.

Colman traveled to the West beginning in or a little before 1870 and kept returning for most of his life. He painted Western scenes off and on throughout those years. *The Green River, Wyoming* was one of his earlier Western subjects, painted in 1871, and amply demonstrates the suitability of watercolor to the sweep and scope of Western landscape.

At first glance we do not really grasp the scale of the painting. It is only when we notice the three groups of tiny figures that we realize how big this scene is. On the great bluff on the right side of the picture, relatively near our own vantage point, two Indians stand, armed with lances. On the other side of the river, two or three more Indians are beaching or launching a boat, and inland from there is a small encampment complete with tepee. The smallness of the figures reveals the vast expanses of land and water encompassed in the scene, the reaches of air contained by the great walls overlooking the river.

The Emigrant Train, Colorado offers a rare bucolic aspect of the great covered wagon trains of the nineteenth century, without the usual drama of the attack by Indians. Here the train has stopped, the animals are being watered, on the left a mother and her son are out for a stroll in the new temporary location. Except for the wagons themselves — and the great looming mountains in the distance — the scene could be from any ordinary pastoral land rather than from the great popular adventure of our history.

171

MASTER OF THE MOUNTAINS

Thomas Moran
(1837—1925)

Moran was second only to Bierstadt as a master of the mountains in terms of popularity and quite possibly not second to anyone in terms of command of his subject. As much as any single person, he, through his paintings, was responsible for the legislation establishing Yellowstone National Park, the Park Service that was created to maintain the park, and thence our own system of such parks and the copying of the practice by many countries in all parts of the world.

Moran was born in Lancashire, England, was brought to the United States at seven and settled in Philadelphia. In his mid-teens he was apprenticed to a Philadelphia printing firm, where he was set to sketching designs on the wood blocks used for printing. In a few years he determined to become an artist and began making etchings. At twenty-one he exhibited a full-fledged, professional-looking oil painting at the Pennsylvania Academy. During

The Teton Range, 1897, Thomas Moran. 30 x 45 in., oil. The Metropolitan Museum of Art, bequest of Moses Tanenbaum. Moran brought to Western landscape art the ability to paint air and space in an incomparable manner.

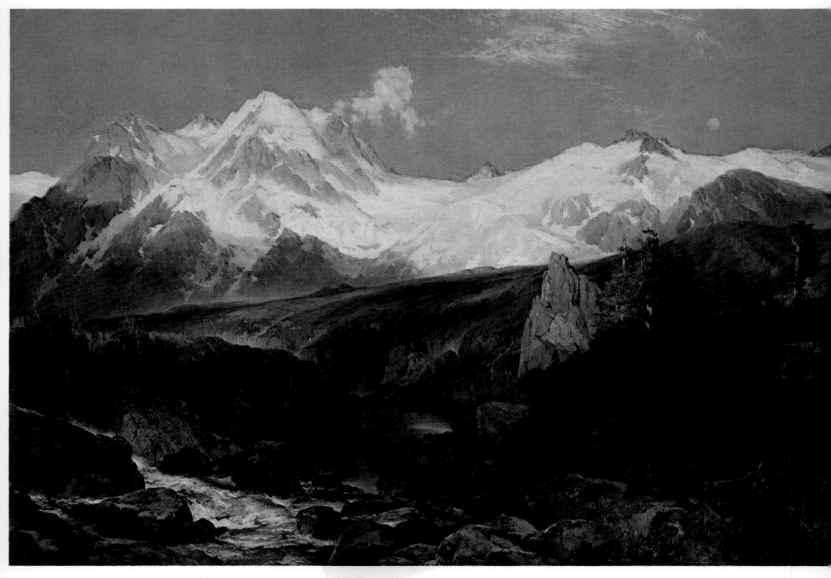

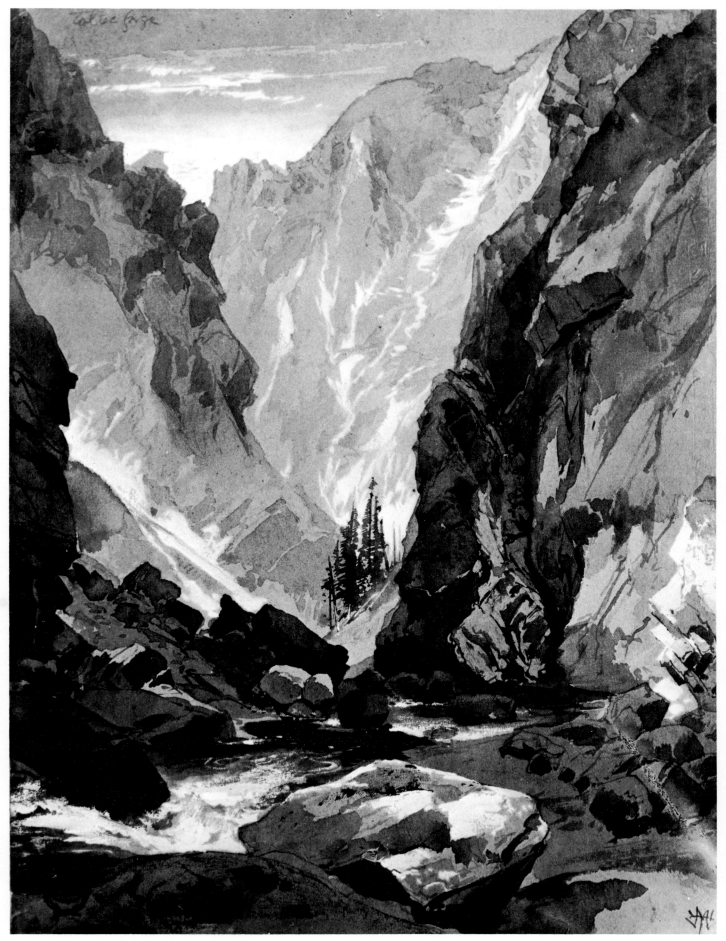

Toltec Gorge, Colorado, 1892, Thomas Moran.
12-1/2 x 9-1/2 in., pencil, watercolor and gouache on paper.
Cooper-Hewitt Museum of Decorative Arts and Design, New York.

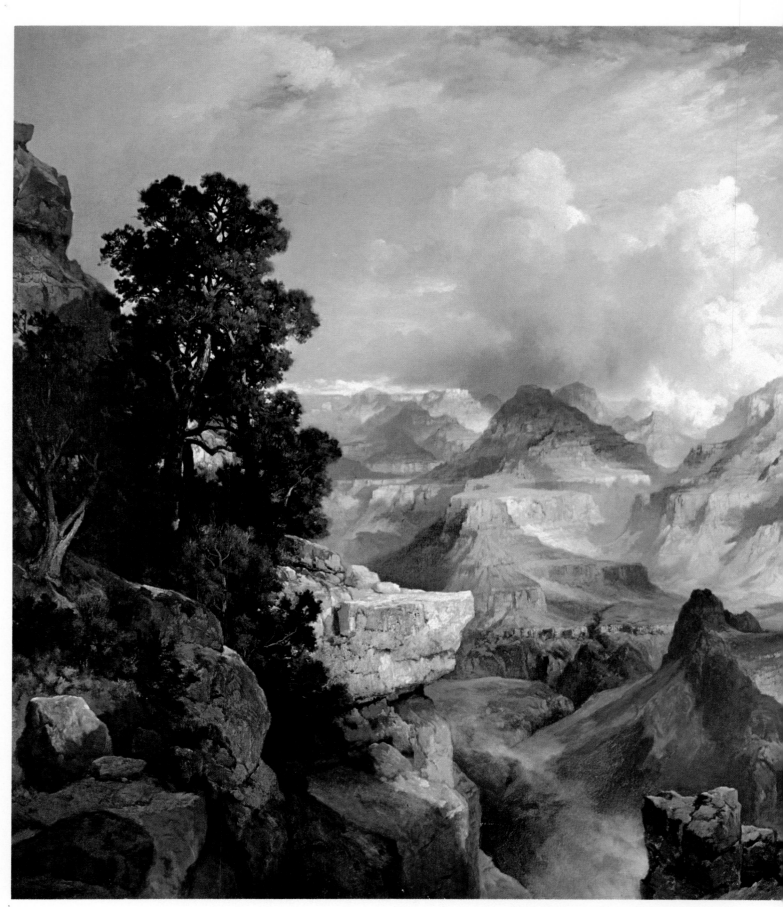

Grand Canyon, 1913, Thomas Moran. 30 x 40 in., oil.
Thomas Gilcrease Institute of American History and Art, Tulsa.
Moran painted this view of the canyon after 40 years'
familiarity with the area's fantastic natural attractions
and rare qualities of light and atmosphere.

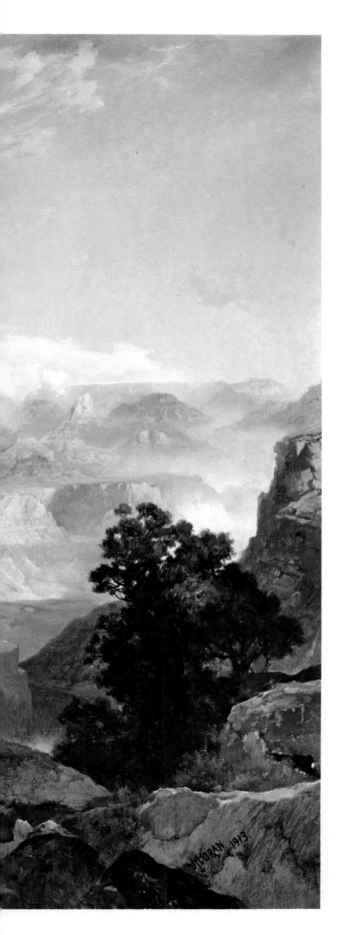

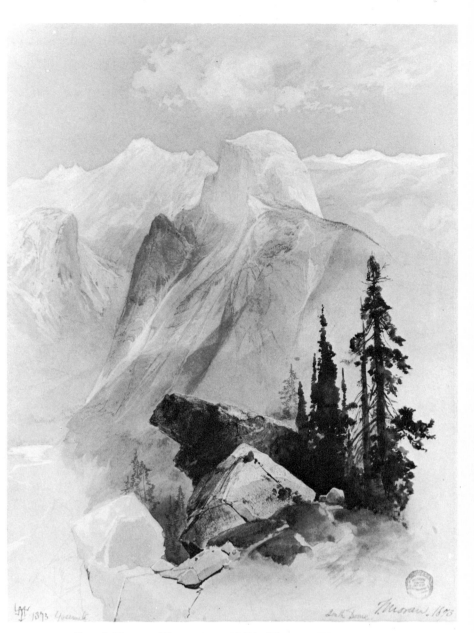

South Dome, Yosemite, 1873, Thomas Moran.
16-1/4 x 12-1/4 in., pencil, watercolor, gouache
on paper. Cooper-Hewitt Museum
of Decorative Arts and Design, New York.

the Civil War he made two trips to his native land and on those trips he came under the influence of two of the most important European landscape painters—his fellow-Englishman, J.M.W. Turner, and the well-known French painter of dawns and sunsets over ports and piers, Claude Le Lorrain.

The fact that Moran was impressed by Turner and Claude led to his bringing a whole new aspect of painting to bear on the Western scene. Claude and Turner were both pioneers in the painting of atmosphere, the feeling of the air that occupied the space between the eye and the object. It seems elementary that a painter cannot paint the air, but the fact is that many of them have done so, beginning with Claude, then later, Turner and finally the whole golden horde of the Impressionists and related movements of open-air painting. The addition of this particular quality of artistic consciousness turned out to be particularly relevant to Moran's chosen subjects in the West.

In 1871, now well established as a Philadelphia artist, with his first portfolio of lithographs published by a Philadelphia firm, Moran joined the surveying expedition of Ferdinand V. Hayden up the Yellowstone. Moran was in the process of acquiring the artistic capital he would paint on most of his life, but he immediately made payment in advance, as it were, to his new country. The spirited, Turneresque watercolors he made on his first trip West were presented by Hayden to the appropriate Congressional committees and were conceded to be the deciding factor in setting up Yellowstone Park.

A couple of years later, Moran served as official artist with the almost legendary expedition through the Grand Canyon, led by Major John Wesley Powell, later founder of the Cosmos Club, Washington, and one of the great latter-day American explorers. Moran also moved around this spectacular country on his own and in the company of William H. Jackson, the photographer whose camera images backed up Moran's painted ones in convincing Congress to save the Yellowstone from exploitation.

As his career blossomed, Moran traveled a good deal, both in this country and abroad, but he always came back to the Grand Canyon, as to the source and origin of his career and of the vision that made his art so highly individual. He was one of the early artists to settle for the summer at East Hampton, Long Island—where many of his smaller works are still to be found. He made his last sketching trip to the West in 1923, when he was eighty-six years old. Two years later he died.

Grand Canyon, one of numerous Moran pictures with similar titles and subject matter, was painted in 1913 and

The Grand Canyon, 1915, Thomas Moran.
Rockwell Gallery, Corning, New York.

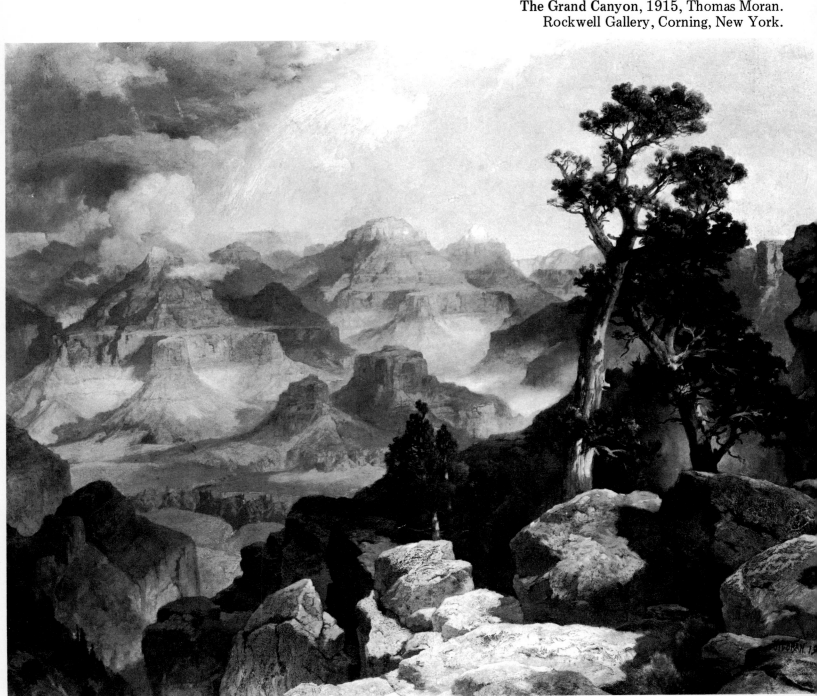

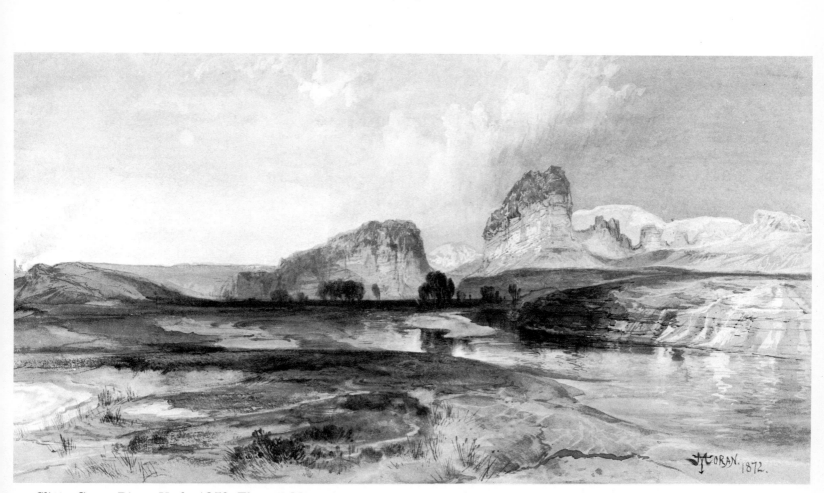

Cliffs, Green River, Utah, 1872, Thomas Moran.
6-3/16 x 11-11/16 in., watercolor.
Museum of Fine Arts, Boston, M. and M. Karolik Collection.

therefore is among other things a summing up of, by then, four decades of familiarity with the territory and its special attractions for the style of painting Moran had perfected so largely under the spell of that country.

There is great space in the picture, of course, but by 1913 Moran seemed to take that for granted. It is there, it is not slighted, it is assuredly part of the scene. But it is not insisted upon, it is not pushed, it is not presented so as to stagger the imagination. Instead, the space is made real by an orderly progress out from the viewer. The nearest rocks and vegetation seem to be right at our feet; then there are others farther away; a gap in the eroded rock sets off a high plateau with its own little mountain and its own plateau, and island in the deep space of the canyon. Beyond that there is a passage that almost seems a plain but in fact is land that was once riverbed, when the river ran higher than it does now. That ends at the distant rock formations, mountains themselves, and bereft of any of the softening greenery encountered nearby.

Throughout all this panoramic spread of a fantastic natural phenomenon, there is inconspicuous but steady and very effective concern with the qualities of light and air. They change, subtly and sometimes not so subtly, from area to area. Between the great gullies cut into the rock by centuries of flowing water and hard wind, the air takes on different degrees of moisture: the lessons of Turner and Claude as far as the painting goes, but also the lessons of years of patient, humble, open-eyed observation of the air and the light in the great canyon. In the distance it almost seems as if the billowy white clouds looming over the mountains are themselves emanations of the thickened air rising up out of the deep crevasses of the earth.

One small point illustrates the special virtues Moran brought to the Western landscape. In the center of the foreground, at our feet, the rocky precipice we almost stand on drops down into a gully out of which is rising white vapor. That almost certainly indicates a tumbling mountain stream, full of white water, rapids, falls, pools and spume. Few other mountain painters, certainly not Bierstadt, would have been able to ignore the lively water. Most would have changed their point of view to get it in as a useful textural contrast with the mountains. Moran contented himself with the spray and the mist rising from the water as an element in his extensive survey of the changing atmosphere in the vast scene before us.

Glory of the Canyon, painted in 1875, or thirty-eight years earlier, is a summing up in a different way. Instead

(continued on page 180)

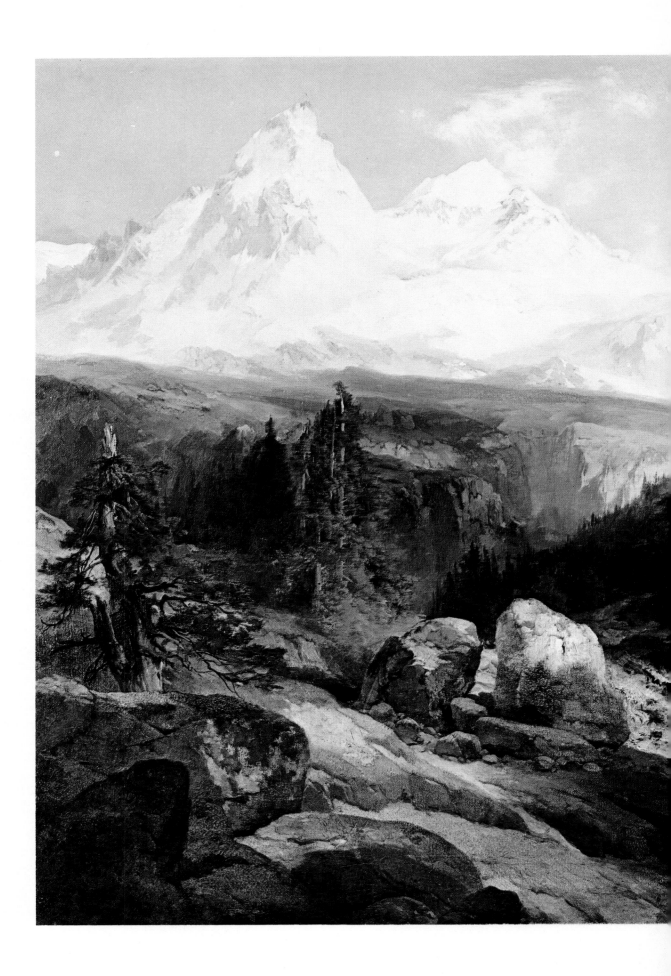

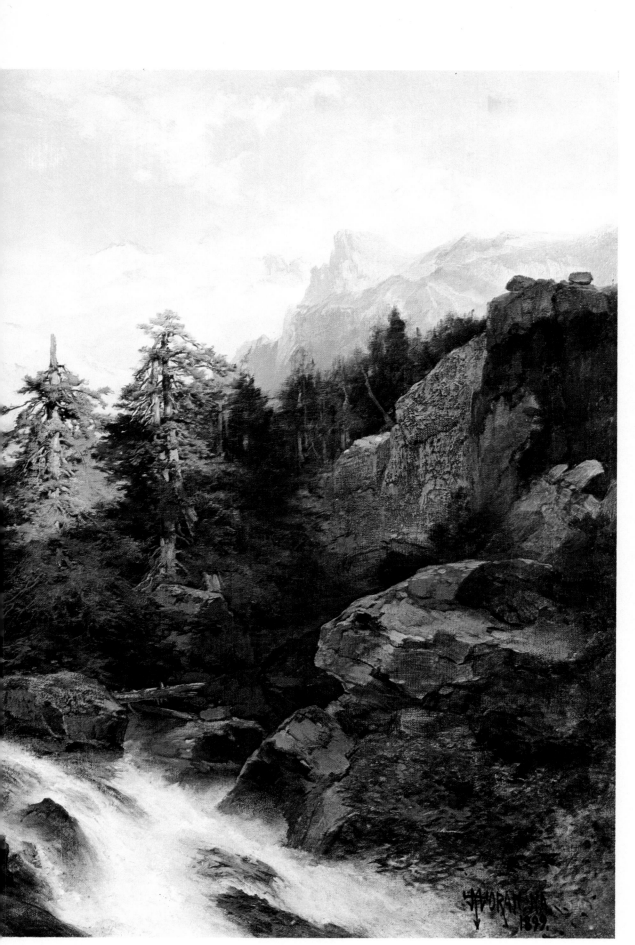

The Teton Range, Idaho, 1899, Thomas Moran.
19-1/2 x 29-7/16 in., oil.
Kimbell Art Foundation, Fort Worth.
Moran was master of painting mountains and did much
toward enlightening the public on the merit of pre-
serving the West's ranges in national parks.

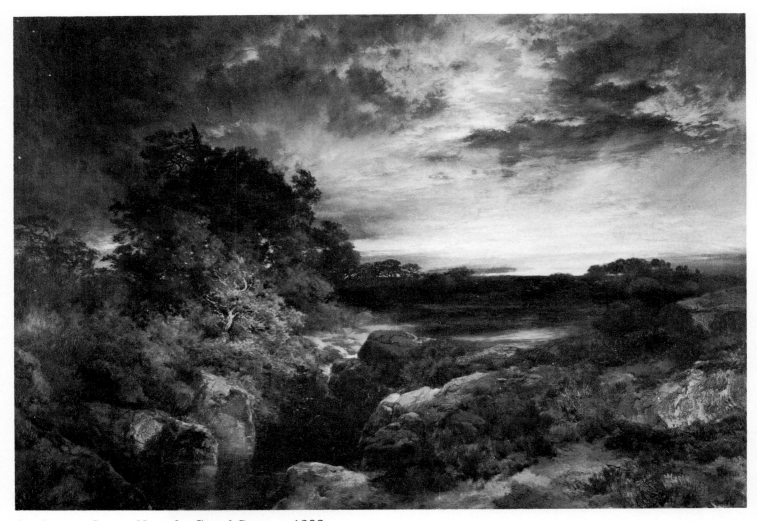

An Arizona Sunset Near the Grand Canyon, 1898,
Thomas Moran. 20 x 30 in., oil.
Butler Institute of American Art, Youngstown, Ohio.

of summing up a long life's looking at the canyon, the earlier picture sums up the artist's overwhelming feelings on first being exposed to the place, with Powell, and his similar but different exposure, just a few years earlier, to Turner and Claude. Both painters are present in the canvas, but the result is powerfully early Moran.

There is a strong, dynamic balance between the warmly lighted promontory in the lower center of the picture and the pale, lofty peaks in the upper center. It is almost a landscape statement of some such contemporary theme as the Real and the Ideal, or Earthly Content and Heavenly Aspiration. The rocky towers clearly suggest a castle, and the swirl of lights and vapors below and behind the form suggest Turner. Beneath both great natural forms, the broad, swift surface of the river links them together, for the water, too, changes its lights and tones, more subtly, to correspond with the differences between

the two central motifs, chill, silvery blue at the base of the cloud-capped towers, warmer, and yellowing as it flows past the sunlit, wooded upthrust.

Moran painted the West for more than half a century, concentrating on the areas of his first exposure to the glorious country, Yellowstone and the Grand Canyon. He never got enough, either in his life or his work, returning at least every other year, sometimes more often, steadily refining his vision, improving his command of the means to embody that vision in paint, to share it with America and the world.

The success of his effort to share his vision may be measured any day from spring to fall by watching the visitors, from America and from all over the world, trooping into Yellowstone Park and trail riding down into the Grand Canyon to follow Moran's own dream that his work did so much to preserve for posterity.

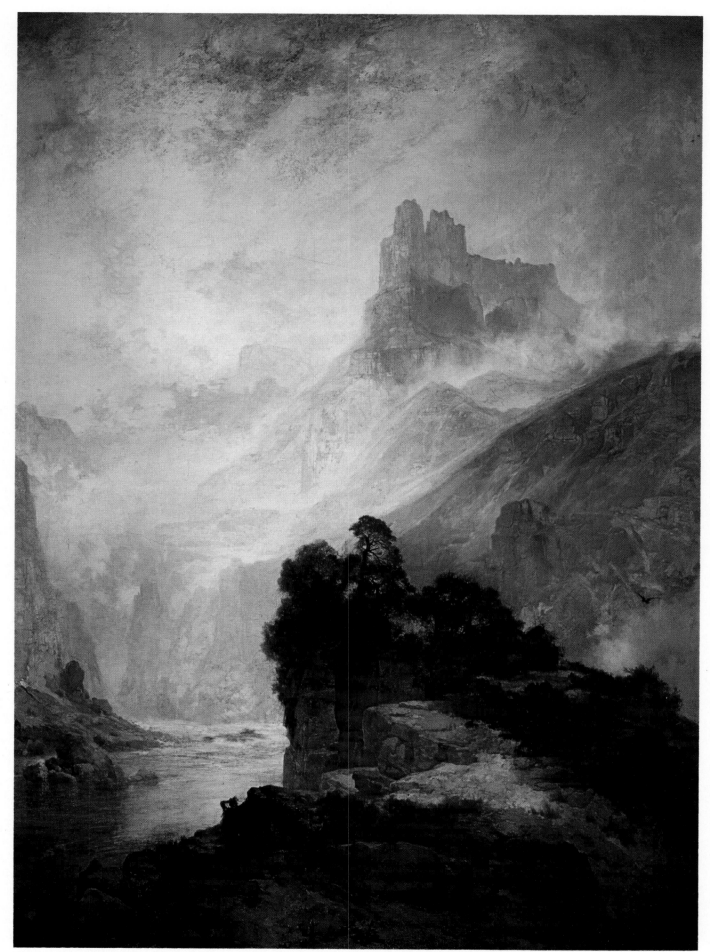

Glory of the Canyon, 1875, Thomas Moran. 52 x 40 in., oil. Thomas Gilcrease Institute of American History and Art, Tulsa. The Grand Canyon was overwhelming and new to the artist when he portrayed it in this powerful work, with its swirl of lights and vapors.

Buffalo Hunt, n.d., Walter Shirlaw. 10 x 15 in., oil. Mr. C. R. Smith, Washington, D. C. Shirlaw's dashing brushstrokes were perfectly suited to capturing the sense of the wild, dusty hunt and violent action.

WITH DASHING STYLE

Walter Shirlaw
(1838–1909)

Shirlaw brought a new and on the whole most appropriate European influence to painting of the West, the style of the Munich school. Featuring broad, slashing brush strokes, the Munich style derived ultimately from Frans Hals. Coming into prominence later than the Düsseldorf manner, it succeeded that of the more northern city as the dominant German style, surviving into twentieth-century German Expressionism, which was undoubtedly influenced by Munich. With a few exceptions, American painting largely missed the Munich influence, our painters shifting their allegiance from Düsseldorf or Rome to Paris, which remained the dominant city for American art until the Second World War.

Though Shirlaw did bring yet another European style into the service of the West and though he did use that style to create many memorable, sketchlike paintings of Western action, Shirlaw gave little enough of himself to the West.

Born in Paisley, Scotland, he was brought to New York by his family when he was two or three. At fifteen or so he was introduced to art in the form of making maps and drawings for a partnership of real estate speculators. From this he moved into a five-year apprenticeship as a bank note engraver, a trade on which he supported himself in Chicago for four or five years after his first efforts to make a living as a painter failed, despite exhibition in shows at the National Academy as well as the Pennsylvania Academy.

Indians and Horses with Travois, 1890,
Walter Shirlaw. 5-1/4 x 9-1/4 in., oil on panel.
Dr. Carl S. Dentzel, Northridge, California.

In 1869 he journeyed West and spent six months in the Rockies, accumulating sheafs of sketches before returning to Chicago to assist in founding the Art Institute. At this point he apparently decided he needed better training than he had been able to give himself, so he spent the next seven years studying in Munich and traveling about Europe. Back in New York he was active in the Art Students League as a teacher and in setting up the Society of American Artists, becoming its first president. At fifty, he was elected to the National Academy, and it was only two years later that he made his second trip to the West. One of six artists commissioned as Special Agents to survey Indian tribes for the 1890 census, he visited two Indian Agencies, one in Custer County, Montana, and one on the Tongue River of Montana and Wyoming.

On that rather slim total of personal exposure to the West, Shirlaw created a highly personal record of things he saw. His pictures are not valuable as documentary, because little detail is given. Instead, following the precept and example of the Munich school, he fused the action of his brush upon the canvas with the action of the Indians he portrayed. Every inch of his painting breathes the sense of the violent action that his subjects are engaged in. His *Buffalo Hunt,* almost alone in the dozens of pictures of that theme, derives much of its drama from the obvious fact that in the hunt, across miles of plain, the air had to be full of dust. Other painters concentrated on what they knew of the hunt, the singling out of a target bull, the chase, the split of the herd and so on. Shirlaw portrayed what he saw, the thick dust rising from the ground, enveloping man and beast in a kind of brown, artificial night for the act of slaughter.

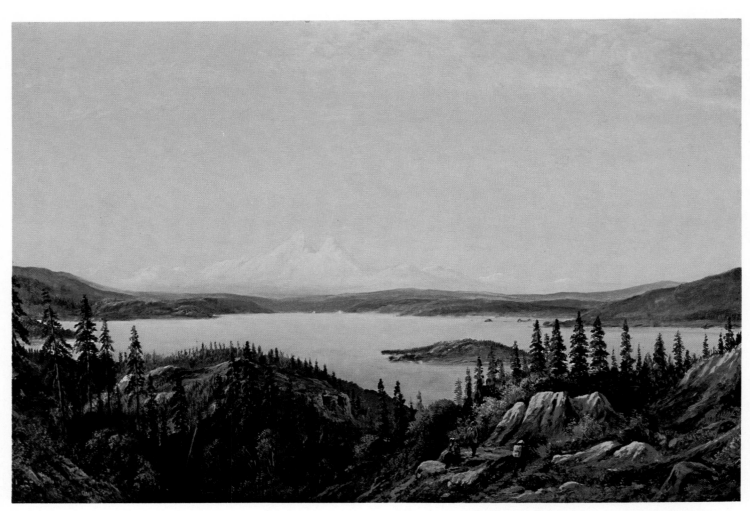

Mount Baker, Washington, 1869, William Keith.
24 x 36 in., oil. E. B. Crocker Art Gallery, Sacramento.
As a young member of the San Francisco art community, Keith
traveled widely along the West Coast, gaining exposure to,
but not intimacy with, the landscape.

WESTERN JET-SETTER

William Keith
(1838—1911)

Keith was one of the stalwarts of the young San Francisco art community in the last third of the nineteenth century and the first decade of the twentieth. He had a keen appreciation of the beauties of Western landscape, and if he never attained the intensity of vision of Bierstadt or Moran or even of his fellow San Franciscan, Thomas Hill, the Yosemite specialist, it may be because he never stayed in one place long enough to absorb all it had to give. His itinerary through life suggests that Keith was really an early jet-setter, about a century ahead of his time.

Born in Aberdeenshire, Scotland, Keith was sent to New York when he was twelve to live with an aunt and uncle and make his way in the New World. He attended school, then worked in a lawyer's office, then became an apprentice to a commercial firm making wood engravings and illustrations. At twenty he made his first trip to California, then returned to Scotland and visited England. Back in San Francisco he worked in an engraving shop, then set up one of his own. After showing some paintings locally, he opened a studio, traveling the while to Oregon and around California. At thirty, he auctioned his works and became one of the tiny minority in those days who took his wife and children across the continent going East.

After a winter in Maine, he went to Düsseldorf for a fast course in painting and was back in San Francisco the following year. At that point he more or less settled in the city of the Golden Gate, but his residence there was regularly punctuated by sketching trips to Monterey and

to Oregon, travels with John Muir, the noted naturalist and early environmentalist, circuits of the California missions, art classes down the coast at Santa Cruz, visits to Eastern cities in the hope of selling paintings, trips to Alaska and Chicago, to Amsterdam and Munich, where he set up a studio and studied portraiture.

Obviously, it was a full life. We cannot really judge Keith's work today because about 2,000 of his paintings and drawings were destroyed in the San Francisco earthquake and fire of 1906.

California Pines faithfully records the look of the landscape, and there is nice painting in the textures—more, ironically, in those of the rocks and earth than those of the pines of the title. *Mount Baker, Washington,* painted almost a decade earlier, in the year Keith was pulling himself together for the trip back East and then on to Düsseldorf, reveals exactly the situation of the artist—a tremendous view caught with something of the excitement of first exposure, but with no serious examination of the scene's full pictorial possibilities.

Evening Glow, n.d., William Keith. 36 x 40 in., oil. Butler Institute of American Art, Youngstown, Ohio.

California Pines, 1878, William Keith. 36-1/4 x 72-1/2 in., oil. Los Angeles County Museum of Art, gift of Museum Patrons Association. Keith often made sketching trips along the California coast, at times with the naturalist, John Muir, and faithfully recorded the look of the land.

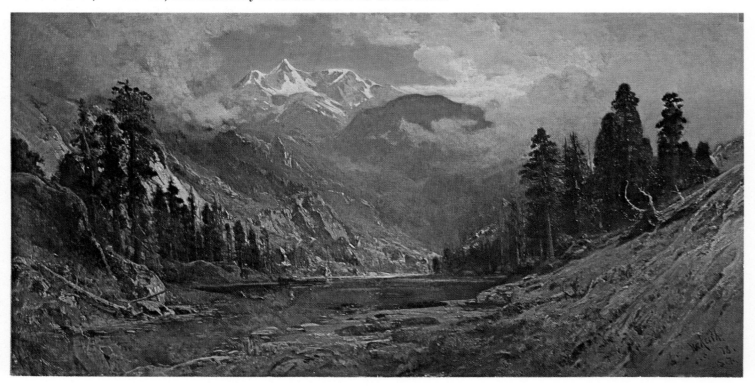

WHEN LEGENDS WERE MADE

William de la Montagne Cary
(1840—1922)

There was a lot about the art of painting that Cary never learned, but he learned enough to make a living as an illustrator for years, working in a New York studio and drawing for magazines and papers.

A great deal of his career and almost his entire interest to people concerned with the West in art today stems from one extraordinary circumstance. In 1860, when he was twenty years old, William Cary and two friends of the same age set out to travel West. They had neither jobs, commissions nor specific destinations. Leaving his birthplace, Tappan, New York, the young Cary and his com-panions went up the wild Missouri, along the, by then, time-honored route of traders and trappers, with stops at Fort Benton and Fort Union, made their way through the mountains and came out into Oregon. Proceeding down the coast to San Francisco, they shipped out of that port to Panama, crossed the Isthmus and sailed through the Caribbean and along the East Coast, arriving home in New York just as the Civil War was starting.

What this meant was that a young, high-spirited and alert young artist in the making got an extended view of the American river-based trading culture among the Indians just before that culture was destroyed forever by settlement, by the Civil War and by the last and bloodiest

Return of the Northern Boundary Survey Party,
n.d., William de la Montagne Cary. 44 x 84 in., oil.
Thomas Gilcrease Institute of American History and Art, Tulsa.

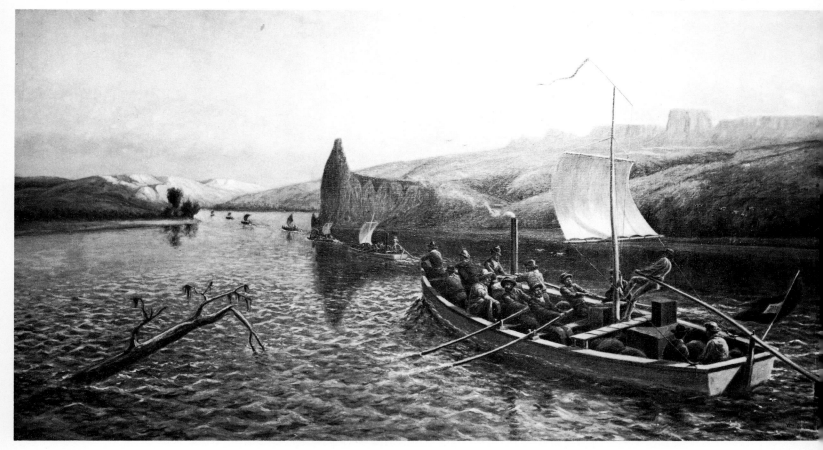

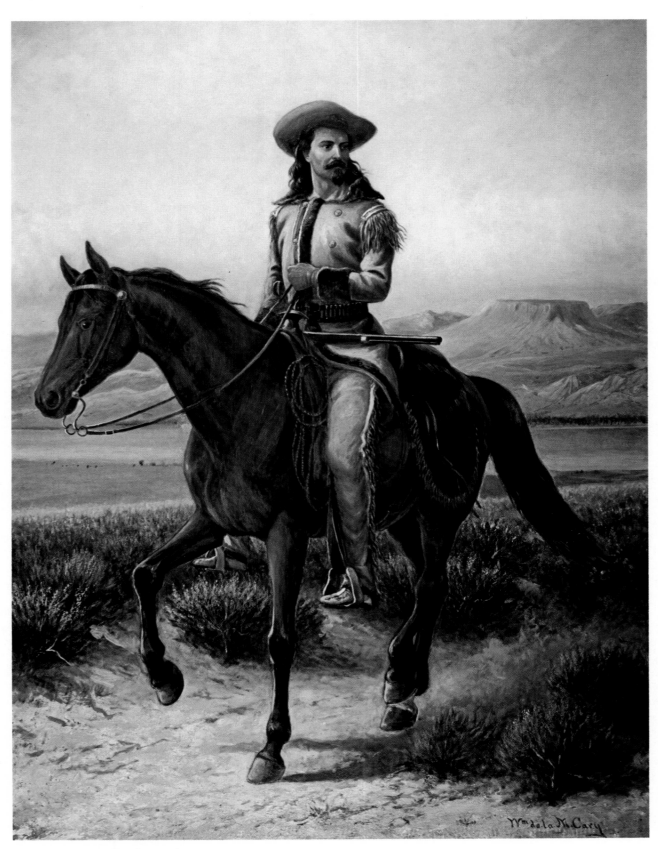

Buffalo Bill on Charlie, n.d.,
William de la Montagne Cary. 52 x 40-1/4 in., oil.
Thomas Gilcrease Institute of American History and Art, Tulsa.
Buffalo Bill Cody did much to become a legend in his time, contributing to the lore of the West with his spectacular Wild West Show.

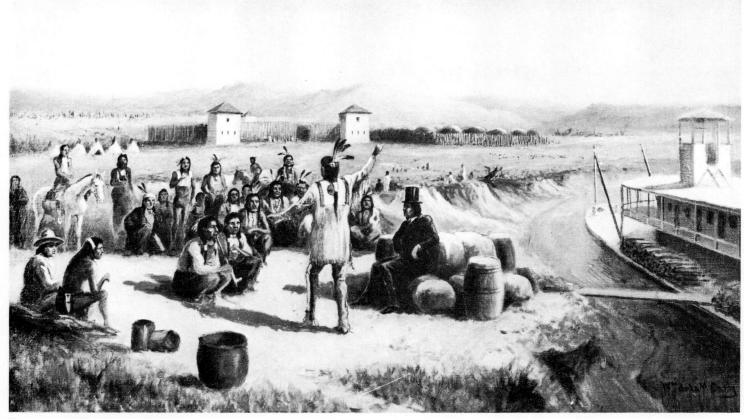

Trading on the Upper Missouri, n.d.,
William de la Montagne Cary. 17 x 30 in., oil.
Thomas Gilcrease Institute of American History and Art, Tulsa.

of the Indian Wars. *Trading on the Upper Missouri* was painted later, obviously, but based closely on the voluminous sketches Cary made en route. The trading agent, himself at least part Indian, sits in his white man's finery of blue suit and top hat, resting on his bales and barrels of trade goods while his interpreter regards the assembled Indians and announces the terms of trade. In the background, the village Indian tepees are clustered before the palisade walls of the fort, one of the chain that controlled the West.

Fourteen years later, Cary was invited to accompany the Northern Boundary Survey Party, the expedition to determine, on the spot, the actual boundary between the United States and Canada as previously agreed by treaty. Cary's view of the *Return of the Northern Boundary Survey Party* is not particularly convincing in its handling of the waters of the river or of the land alongside, compared with what a dozen artists, earlier and later, have done with the same material. But the party itself, sailing and rowing straight as an arrow in a diminishing perspective that is

also not quite right, nevertheless takes on an epic feeling entirely appropriate to the occasion.

Cary also felt he was invoking epic feelings, no doubt, in his portrait of Buffalo Bill Cody, a legendary figure of the frontier who, in the view of many Western contemporaries, invented a good deal of his own legend. Cody served as a scout in the Indian Wars and the Civil War, was an unsuccessful prospector for gold and a Pony Express rider. After the War Between the States, the Iowa-born Cody signed on as a buffalo hunter, the job in which he picked up his famous nickname by slaughtering, according to his own account, over four thousand animals in less than a year and a half, using a fifty-caliber, breech-loading Springfield rifle. Later, again according to his own report, which has been disputed, Cody, while serving as a scout with General Custer, killed and scalped the Sioux chief Yellow Hand.

Whatever the truth of the Buffalo Bill legend, he made his greatest contribution to the lore and the love of the West by organizing, in 1887, the first Wild West Show featuring feats of marksmanship, roping and riding and bringing these highlights of the West to the East and to Europe.

SEER OF TRUTH

Thomas Eakins
(1845-1916)

Eakins was the greatest painter America has ever produced. He was also our greatest portrait artist and our greatest teacher of anatomy to artists. Because of his interest in anatomy, he experimented with serial photography of human beings and animals in motion, thus becoming one of the forerunners of the men who, within his lifetime, perfected the motion picture.

Eakins was born in Philadelphia and died there, having spent most of his life in the same city, indeed in the same house, his father's, where, after returning from studies in Paris, he set up a studio on the top floor.

He lived through a period variously called the Victorian Era and the Gilded Age and noted for a good deal of pomp and pretension, more hypocrisy than most ages have, and in general the desire to have things appear for the best in this best of all possible worlds, regardless of reality. In such a world, Eakins was hopelessly a slave of truth. Not surprisingly, he was never a towering financial success as a portrait artist, yet portraits are the overwhelming majority of his work. He was passionately interested in both the theory and practice of his art. As such, teaching came naturally to him, and when the Pennsylvania Academy of Art—which he had attended as a student—moved into new, enlarged quarters in 1876, he became the teacher of the life classes. Three years later he was running the Academy in all but name and in 1882 he acquired that as well, the title of Director.

The Academy was immediately thrust into a violent break with tradition—or, in Eakins's view, a return to tradition. As a student there himself, he had been drilled in drawing "from the antique." Now, drawing from the antique did not mean drawing pictures of the classical sculpture of Greece and Rome. Instead, it meant drawing pictures of plaster casts of those ancient sculptures, or, more often of plaster casts of the parts of those sculptures: hands, feet, torsos, sometimes even heads. It was only when he got to Paris, in the studio conducted by Jean Léon Gérôme, the academic teacher, that Eakins really came to study the nude for its full value in painting. Meanwhile, as a Philadelphia art student, he managed to augment his limited art education by taking classes in anatomy at Jefferson Medical College, thus reviving for

himself a practice common among Renaissance artists but exceedingly rare in the nineteenth century and, except for Eakins, probably non-existent in America.

Thus, when he came to the Academy's directorship, Eakins had to some extent trained himself and he had done so in such a way as to become extremely conscious of the bad effects of the standard Academy training. He reorganized the school abruptly, so that everything grew out of drawing and painting from the nude. Like the Old Masters, Eakins believed that the most intimate knowledge of the human form was essential to the understanding that the artist must bring to his work. Inevitably, in America's Gilded Age, this belief brought him into trouble with the society which controlled the Academy as surely as it did the banks. Alarmed by protests, especially from the parents of women students, the Academy trustees demanded that Eakins moderate his insistence on the nude as the base of art studies. The painter replied that he would remain as director only if he could be true to his beliefs. His resignation was accepted, and he was succeeded by his assistant, Thomas Anschutz.

In protest against the trustee's action, most of the men students of the Academy, along with many of the women, resigned and founded the Art Students League of Philadelphia, asking Eakins to serve as director. He did, teaching without pay and painting many of his most sensitive portraits of his students at the League. But with no endowment and with no other source of funds than the fee of students, the League did not last long. When it went out of business, some six or seven years after it started, Eakins's formal teaching career ended.

He lived thereafter chiefly on a small legacy from his father. His paintings did not sell well, and he accommodated himself to that fact. Mostly he painted portraits of people he knew—doctors, professionals of one sort or another, giving them the portrait with his thanks for sitting for him. In at least one instance, when a portrait of his was purchased by a museum, he gave the sitter half the sale price. Besides the academics, musicians, mathematicians and relatives he painted, Eakins also did portraits of a surprising number of Roman Catholic prelates. A convinced atheist of Protestant heritage, the artist found unexpected sympathies with the clergy at St. Charles Seminary. He liked Latin, for one thing, and these men were the only group in Philadelphia likely to be in touch with a broader, more central tradition of European culture than the one he grew increasingly alienated from in Philadelphia.

The West played almost no part in Eakins's life and work and it seems a pity. As a man apart from and at odds with the prevailing attitudes and ways of one of the East's oldest cultural capitals, he might well have found a more ready acceptance in the freer atmosphere of the West. He would surely have found the body movements of Indians and cowboys, of horses and cattle of supreme interest—at once an opportunity and a challenge in one of his lifelong preoccupations. In fact, however, he went West only once, spending the summer of 1887 on a ranch in the Dakota Badlands. A few paintings survive from the experience, but the experience itself was not deep enough for Eakins really to feel the West.

The one Western picture that is undoubtedly among his masterpieces is a portrait that brought all of his virtues to the fore. Eakins liked to paint his professionals engaged in their work. His two great clinic pictures show the doctor subjects in the act of operating and lecturing at the same time. Musicians are seen playing, even thinkers seem to be thinking in his portraits.

At the same time, he had a painter's natural affinity for color, and it is undoubtedly true that one attraction the Catholic higher clergy had for him was the scarlet and purple of their ecclesiastical robes. In his full-length, life-size portrait of the anthropologist Frank Hamilton Cushing, Eakins combined his natural tendency to show professionals surrounded by the instruments of their calling, his painter's love of color, and his penetrating gift of seeing beneath the skin—or seeing *in* the skin—the interior life, the dominant mood, the nature of the concerns of his sitters. This last ability was undoubtedly the principal reason for Eakins's lack of financial success in his own calling. He painted what he saw, and what he saw was the usual feeble, decaying heap of human flesh we all possess, lighted, sometimes, by some interior spirit, but even so in the process of dissolution. That vision, to be seen in a wide variety of modulations in Eakins's portraits, takes on an added value in the Cushing picture.

Cushing was a brilliant anthropologist, one of the founders of the modern science through his work on the Zuñi Indians. The Zuñi people were isolated from their fellow Pueblo tribes. When conquered by Coronado in 1540, there were seven Zuñi towns. In Cushing's day there were three, and now there is one, called the Ant Hill of the Navel of the World, near Gallup, New Mexico.

Cushing, obviously, was aware of the slow, inevitable attrition of all the Indians, including the Zuñi people he had come to know so intimately. In addition, the artist may well have sensed and painted the scientist's premonition of his own impending, early death. Twenty-three when he published his first work on the Zuñi, Cushing was thirty-seven when Eakins painted his portrait. The heat and the cold and the hard life of the desert Indians, shared by Cushing, had prematurely aged the scientist so that he looked twenty, perhaps twenty-five, years older than he was. He died five years later.

To paint the portrait, Eakins, guided by Cushing, constructed a corner of a Pueblo interior in his Philadelphia studio. Cushing dressed in the costume of a Zuñi priest of a secret society he had been admitted to in the course of his Southwest studies. Holding fetishes of the tribe, the scholar seems to be contemplating the people's inevitable disappearance and perhaps his own as well. The golden light floods the room and concentrates itself behind the subject's head, providing, along with the highlight on the left side of his face, a kind of contrasting frame for the shadowed front face of his melancholy.

That sympathy for and apprehension about the American Indians which regularly troubled artist after artist who came to know the Indian has never been given so penetrating and somber a statement as it was here by Eakins, who knew them not at all.

Portrait of Frank Hamilton Cushing, 1895, Thomas Eakins. 90 x 60 in., oil. Thomas Gilcrease Institute of American History and Art, Tulsa. The ethnologist Cushing is dressed here in the costume of a Zuñi priest. Both he and the artist Eakins were so concerned with maintaining realism in the picture that they recreated a Zuñi room for the portrait's background.

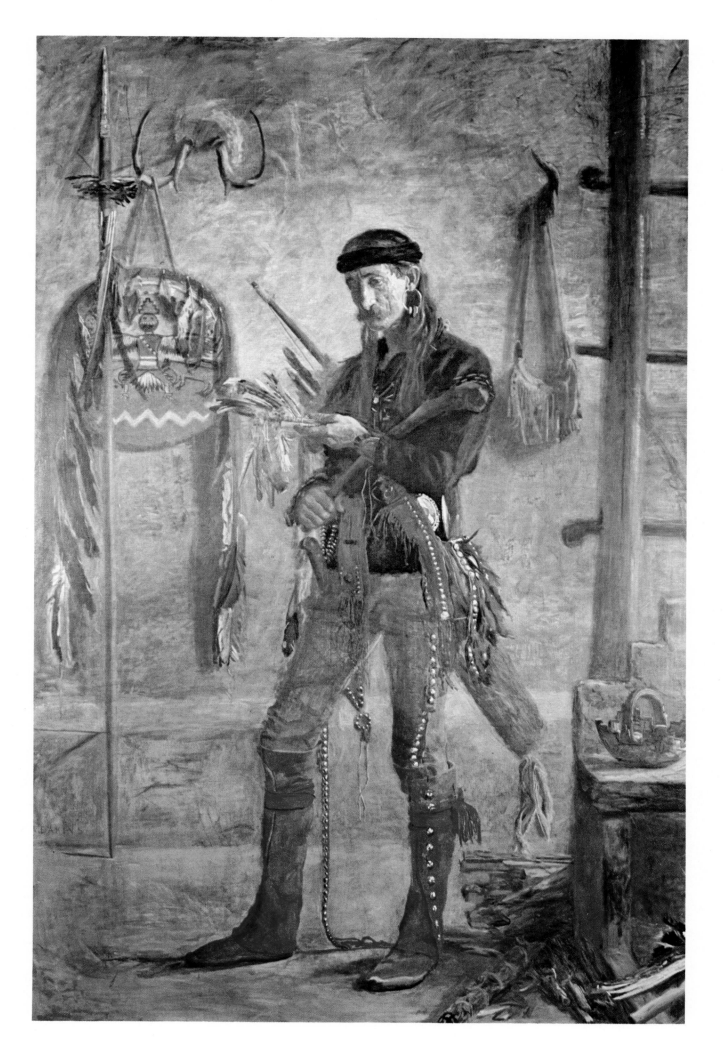

OF EPIC CIRCUMSTANCES

Howard Pyle
(1853—1911)

Howard Pyle was, in his time, the best illustrator America ever produced. He was surpassed, if at all, only by his star pupil, N.C. Wyeth. A leading artist for *Harper's Weekly* and other periodicals in the 1870's and -80's, Pyle was also keenly interested in the education of artists. Teaching at the Drexel Institute, Philadelphia, he decided to start his own school, taking with him to his hometown, Wilmington, Delaware, ten of his best students from Philadelphia. Surprised at their progress when released from the routines of classes and lectures, he expanded his school, operating in his own home winters and the family summer place at Chadds Ford, Pennsylvania, summers. The tradition which he thus founded at Chadds Ford continues to this day, mostly with the Wyeth family and their relatives.

Pyle was chiefly famous for his scenes of colonial life in New England and New Amsterdam and for his illustrations of such children's classics as *Robin Hood.*

He never painted Western life as such, but he belongs in any consideration of art about the West by virtue of this painting of *George Rogers Clark on His Way to Kaskaskia.*

After all, had it not been for Clark and the arduous military campaign he began by marching to Kaskaskia in 1778, there might well have been no American West. His younger brother, William Clark, is perhaps more famous for his expedition with Meriwether Lewis to explore and confirm Thomas Jefferson's bold Louisiana Purchase, a trip that took the explorers from the Mississippi to the Pacific. But a quarter of a century earlier, George Rogers Clark, in practically sole command of operations beyond the Appalachians, secured the Northwest Territory for the new nation—comprising, eventually, the states of Ohio, Indiana, Illinois, Michigan, Wisconsin and much of Minnesota—and thus opened the way West for all who came after, including Clark's younger brother.

Like his fellow Virginian, George Washington, Clark as a young man went over the mountains to work as a surveyor along the frontier in Ohio and Kentucky. When the Revolution started, Clark realized how open to British attack the American West was. He hurried to Williamsburg, then Virginia's capital, persuaded the legislature to join Kentucky to Virginia—a union of convenience that hardly survived the Revolution—obtained an authorization to raise an army and returned to the frontier prepared to wage war against the British. With less than 200 men, Clark marched west from the falls of the Ohio to the Mississippi at Kaskaskia. There he successfully separated French settlements of traders from their nominal allegiance to the British and ended the British threat to the embattled colonies from their western flank. Thanks to Clark's successes at Kaskaskia and Vincennes and his defeat of a British attack against the Spanish settlement at St. Louis, the peace treaty awarded the territory to the new republic, thus opening the way for the entire Western expansion that occupied so central a place in our history.

Pyle pictured Clark at a dramatic moment, the crossing of the Ohio by his little army, the beginning of one of the most audacious expeditions in military history and, in its outcome, one of the most momentous. As the soldiers—less than an infantry company in strength—cross the river, Clark himself mounts guard against any possible enemy incursion by land or water. In the sky, a flight of migratory geese provides an emblem for this military beginning of the great American Western migration.

George Rogers Clark on His Way to Kaskaskia, n.d., Howard Pyle. 35 x 24 in., oil. Thomas Gilcrease Institute of American History and Art, Tulsa. As an illustrator of American history, Pyle paid grand tribute to Clark and his expedition to the old Northwest Territory in this portrayal of the moment when Clark and his little band crossed the Ohio, with their leader standing guard against enemies.

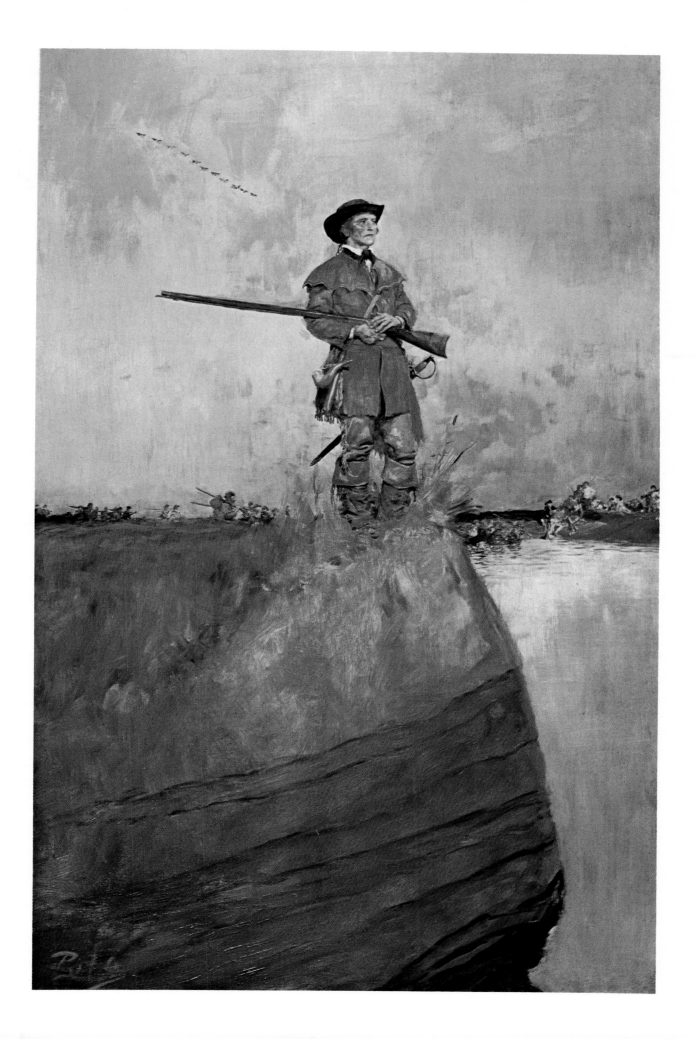

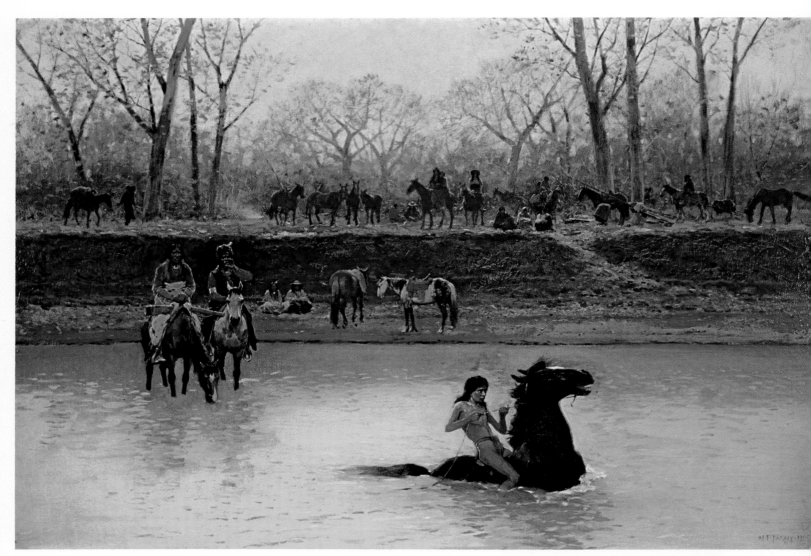

Breaking a Pony, or Fording a Stream, 1905,
Henry F. Farny. 21 x 32 in., oil.
Thomas Gilcrease Institute of American History and Art, Tulsa.
One of the gentler Indian methods of breaking a horse was
to lead it into water, which would hinder and tire the horse
while it became accustomed to a rider and halter.

DAYS OF QUIET BEAUTY

Henry F. Farny
(1847—1916)

Farny's principal contribution to Western painting consisted of simple, low-keyed, carefully observed, non-dramatic scenes of everyday life among the Indians during the period after the Indian Wars, but before the complete imprisonment of the Indians on reservations. He painted at a time when there were still plenty of survivals of the authentic tribal life as it had been lived in its fullness during the long, losing war against the whites.

Farny himself came to his last and best subject matter only after a long career in commercial art of one kind and another. Indeed, he came to America only because of the rise of the preposterous Emperor of the French, Louis-Napoleon III. Farny was born in Alsace. His family had violently opposed the rise of the younger Napoleon, and when the Bonaparte was elected President of the Second

Republic, Farny's parents brought him to America at the age of six, settling in western Pennsylvania. There, Farny later recollected, he first learned Indian customs and ways from the Senecas who still lived in the woodlands.

When the boy was twelve, the family moved on to Cincinnati, where young Farny was apprenticed, in his teens, to the thriving lithography business of that city, specializing in views of the Civil War. After the war, he found work in New York for Harper & Brothers, publishers. He did a good deal of traveling and studying in Europe. An early creator of the colorful circus posters—the "twenty-four sheets"—that decorated the broadsides of so many American barns, Farny exhibited at the Vienna Exposition of 1873 a ninety-foot cartoon he had executed for the Cincinnati Chamber of Commerce. In the company of Frank Duveneck, Cincinnati's best-known artist, Farny visited Munich and then opened a joint studio in Cincinnati.

It was only after all this and more that the West fulfilled for Farny the promise it had tendered him as a boy getting

194

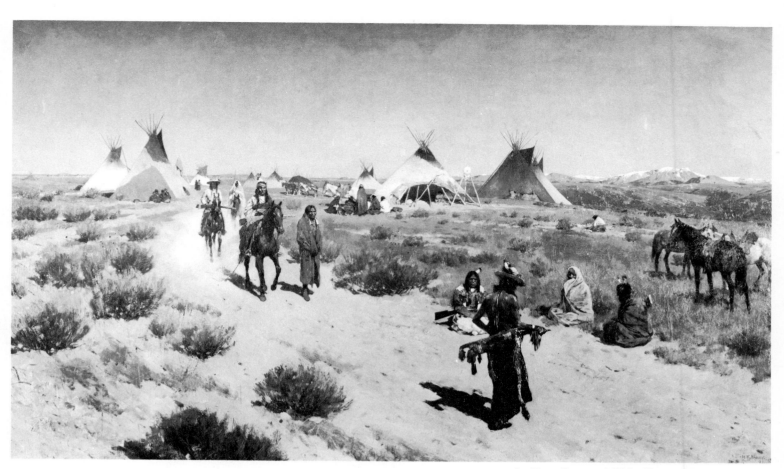

Indian Camp, 1890, Henry F. Farny.
22 x 36-5/8 in., oil.
Cincinnati Art Museum, bequest of Mrs. W. A. Julian.

The Sorcerer, 1903, Henry F. Farny. 22 x 40 in., oil.
Thomas Gilcrease Institute
of American History and Art, Tulsa.

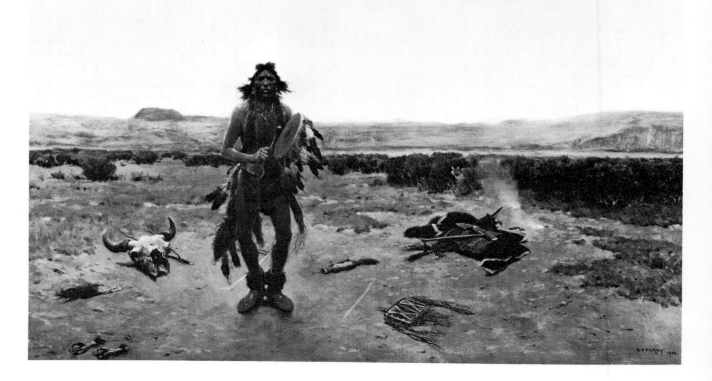

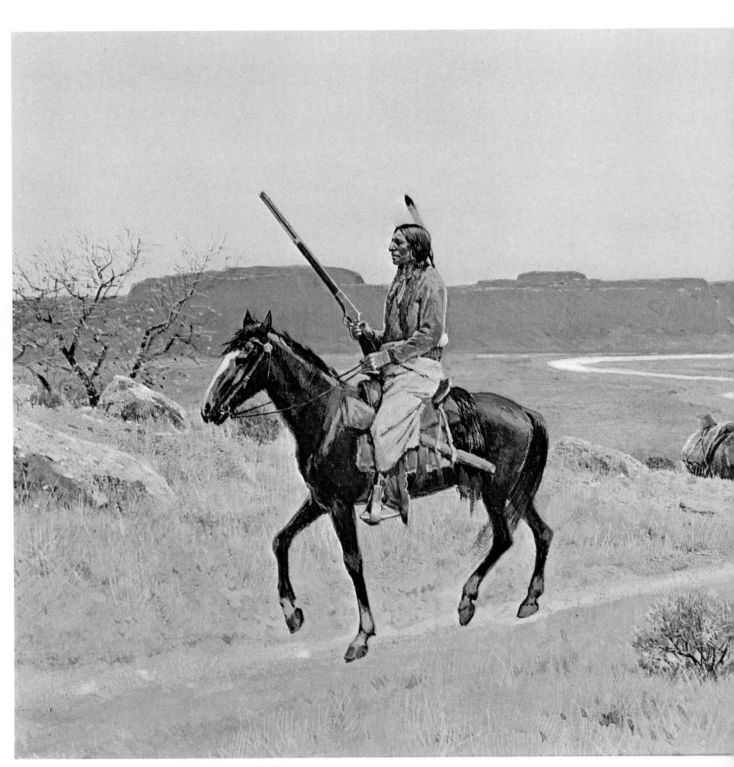

In the Enemy's Country, 1900, Henry F. Farny.
10-1/2 x 17-1/2 in., gouache. Mr. W. J. Williams,
Cincinnati. Farny's paintings of Indians in daily
pursuits have a measured, tender beauty in their
portrayal of native Americans during their last
decades of independent, tribal life.

to know the Senecas in western Pennsylvania. In the
1880's, he made a number of expeditions to the West: He
visited Indian Agencies at Standing Rock and elsewhere;
he accompanied the excursion to celebrate the driving
of the last spike in the transcontinental railroad and
traveled down the Upper Missouri to illustrate an article.
He spent some years in San Francisco and continued to
travel to see American Indians while they could still be
seen living more or less as they had for centuries.

In the Enemy's Country is a good example of Farny's
quiet, matter-of-fact approach to life among the Indians.
The scene is potentially dramatic, but the painter only

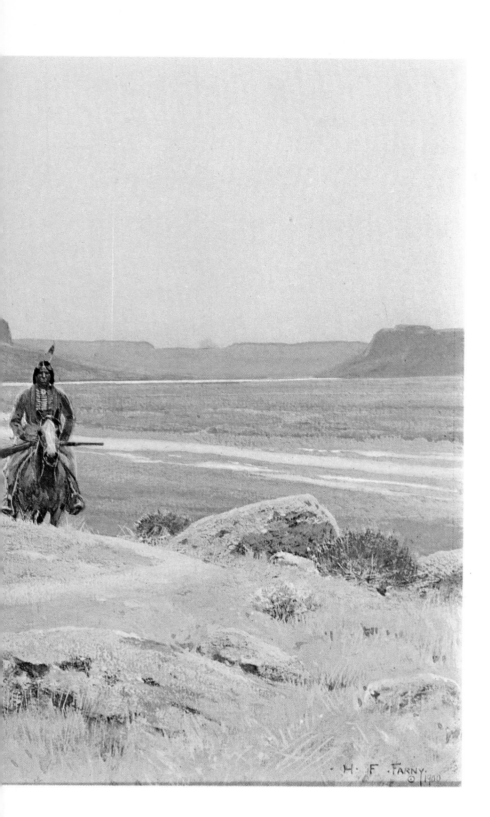

indicates that obliquely, by the calm alertness of the two riders as they proceed up from the broad bottom land into the hills. There is beautiful, measured control of every element in the painting, from the stunted trees to the left of the lead rider and the tender grasses in the foreground to the broad sweep of the winding river and somber majesty of the distant bluffs. The lead horse is a beautiful piece of painting of a beautiful animal, walking so as to duplicate the alert, on-guard condition of the rider.

Breaking a Pony illustrates a remarkably logical method the Indians employed for this regular task of the West, one in sharp contrast to the white cowboy practice of happily bucking around the corral on a bronco. Here a young boy, who is also demonstrating his own growing mastery of adult ways, has led a wild horse into the water to a depth at which he could easily mount the steed. The water, obviously, would prevent most of the bucking and leaping that were so much a part of the whites' method of breaking a horse. Several such dunkings were required usually before the horse was ready to be ridden on land. The whole tone of Farny's scene underlines the quiet purposefulness of the Indians.

The Sorcerer is quiet and melancholy. The solitary medicine man, his time long passed by, performs the ritual hymn to the dawn, surrounded by the amulets and fetishes of his tribe and his profession, a solitary figure against the river cutting through the plain, seen only by the curious coyote in the brush behind.

197

The Herd, 1899, Frank Reaugh. 15 x 36 in., pastel on board.
Thomas Gilcrease Institute of American History and Art, Tulsa.
This portrait of the longhorn cow — the basis of the vast cattle empires
of the West — does justice to the alert, self-possessed and sensitive beasts.

PORTRAIT OF THE LONGHORN

Frank Reaugh
(1860—1945)

The whole central myth of the West, that of the cowboy, was based upon the longhorn steer. There has never been a better, more authentic portrait of that animal than in *The Herd* by Frank Reaugh.

The cattle business was introduced into the land destined to become the United States by the Spanish and Mexicans in California. After a series of drought years in the first half of the nineteenth century, the Spanish cattle of California and the Southwest were gradually abandoned by their owners and went wild, developing into what became known as the "Texas longhorn." The process was similar to that by which the mustang, or wild pony, developed out of Spanish horses turned loose or escaped onto the western Great Plains.

Only after the middle of the century did sufficient American demand for beef develop for some venturesome Texans to begin the task of rounding up the wild cattle and marketing them for Eastern markets. As the reborn cattle business thrived, the longhorn proved to be adaptable to all climates and became the base of the vast cattle empire stretching from Mexico to Canada, from Kansas, the locale of the main railhead, to the Rockies.

The longhorns are long gone and with them the open range and the great trail drives. But they were the beginning of it all, and Reaugh's picture is a remarkable evocation of the alert, self-possessed and sensitive beasts.

Frank Reaugh was born in Illinois. He studied art in St. Louis and in Paris before settling down in Texas and doing for livestock the kind of animal portraiture the English had long done for racehorses and favorite dogs.

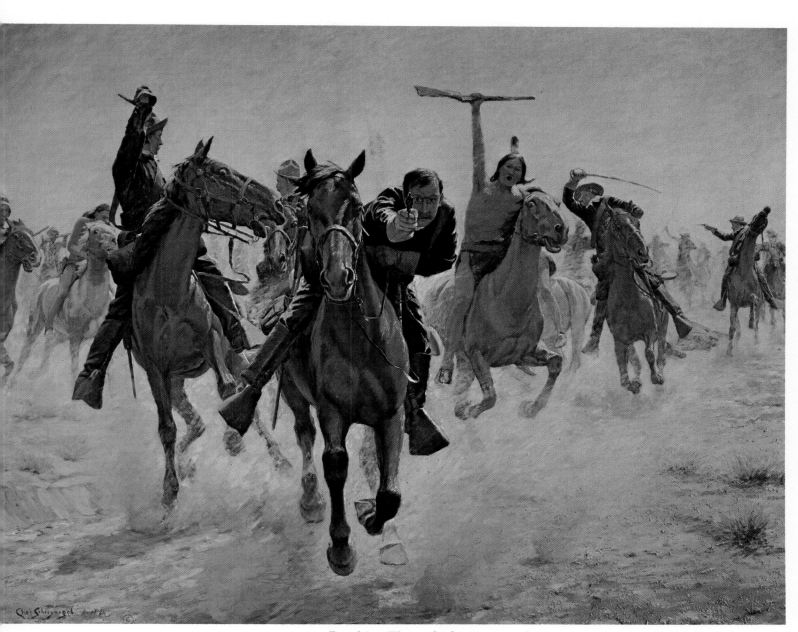

Breaking Through the Lines, n.d., Charles Schreyvogel, 39 x 52 in., oil.
Thomas Gilcrease Institute of American History and Art, Tulsa.
The height of dramatic action is a hallmark of Schreyvogel's cavalry
scenes, and this can hold its own with the most sensational Western movie.

A FLAIR FOR DRAMA

Charles Schreyvogel
(1861—1912)

In an odd kind of way, Schreyvogel established his reputation as a Western painter through a painting loaded with technical errors for which he was called to account by no less an authority than Frederic Remington, then widely considered the leading artistic authority on life in the West and most particularly on life with the Western cavalry fighting the Indians.

The picture was *Custer's Demand.* Schreyvogel painted it in 1902-03, and it was reproduced in the New York Sunday *Herald.* Representing an incident in the campaign against the Indians in 1868-69, the picture was immediately attacked by Remington as being incorrect in many details. Remington proceeded to tick off items of uniform and weapons which did not come into use in the cavalry until years, even decades, after the time of the scene portrayed. Far from being crushed, Schreyvogel managed to

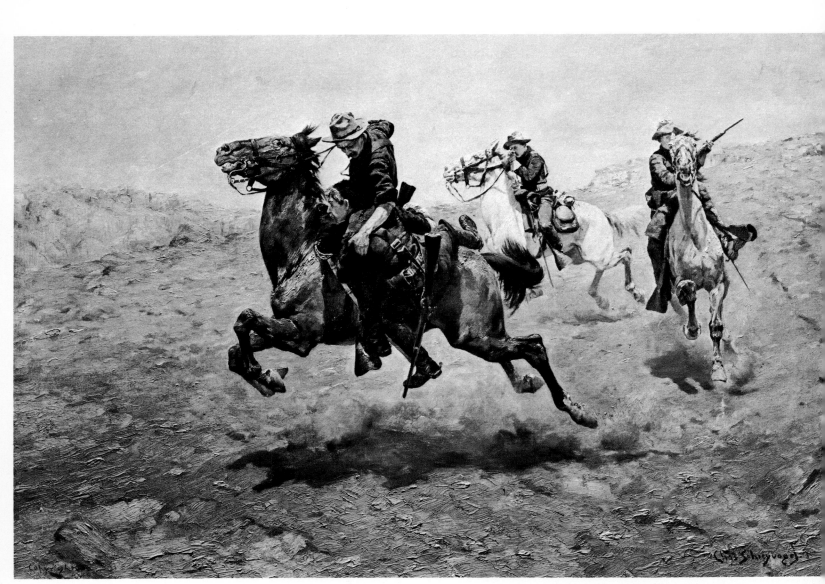

Above: **My Bunkie**, 1889, Charles Schreyvogel.
25-1/4 x 34 in., oil. The Metropolitan Museum of Art,
gift of friends of the artist.

Right: **Custer's Demand**, 1902-03,
Charles Schreyvogel. 54 x 78 in., oil.
Thomas Gilcrease Institute of American History and Art, Tulsa.
In an Indian campaign of 1868-69, General George Custer demanded
that renegade bands return to their reservations.

obtain the defensive words of Custer's widow, who, while she was certainly not present at the scene of the parley prior to battle, was nevertheless highly regarded by her countrymen and women. The mere fact of having been in dispute with Remington and having survived it raised Schreyvogel's reputation several notches.

A similar kind of ambiguity continues to hang over the career of George Custer. A graduate of West Point, he performed brilliantly in the Civil War and was breveted brigadier general at twenty-four, a promotion many older officers regarded as rash and unjustified. He is, of course, best known to history for his celebrated "Last Stand" in which he and his command were slaughtered to the last man by the Sioux on the Little Big Horn River in Montana. The fact that the total defeat took place within ten days of the centennial anniversary of the Declaration of Independence helped enshrine Custer in the hearts of his countrymen, as it ensured that the Western cavalry would grimly hound the Sioux to death, defeat and captivity. But

there is considerable professional difference of opinion as to whether George Custer, as Indian fighter, was a gallant last-stander or a simple fool unable to realize the better part of valor, destroying his men and himself in the hope of achieving glory unshared with the reinforcements on the way, with whose help Custer would surely not have been so ignominiously cut down.

Schreyvogel was, in fact, eminently suited for the kind of mousetrap into which he played himself so that Remington could cut him down like the Sioux cut down Custer. Born in New York City, he studied in Munich but returned to New York to become an engraver and lithographer. He did not go West until it was suggested he do so for health reasons in 1893. He stayed in Colorado and traveled into Arizona, the whole visit not taking more than three months. In 1900 he made another trip West, this time bringing back East pieces of uniform and equipment to be used as models for his paintings of the West.

(continued on page 204)

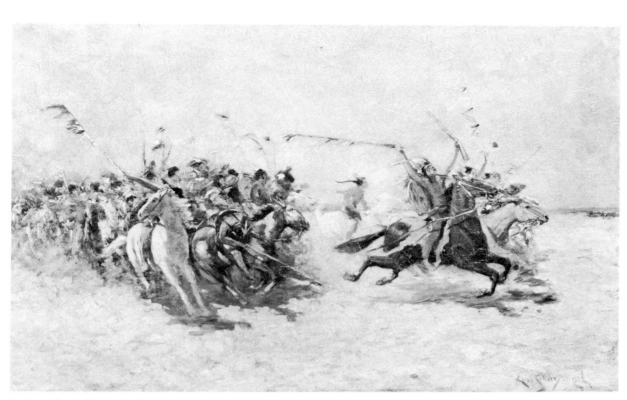

Indian Attack, n.d., Charles Schreyvogel.
20-1/4 x 34-1/4 in., oil.
Courtesy of The R. W. Norton Art Gallery, Shreveport.

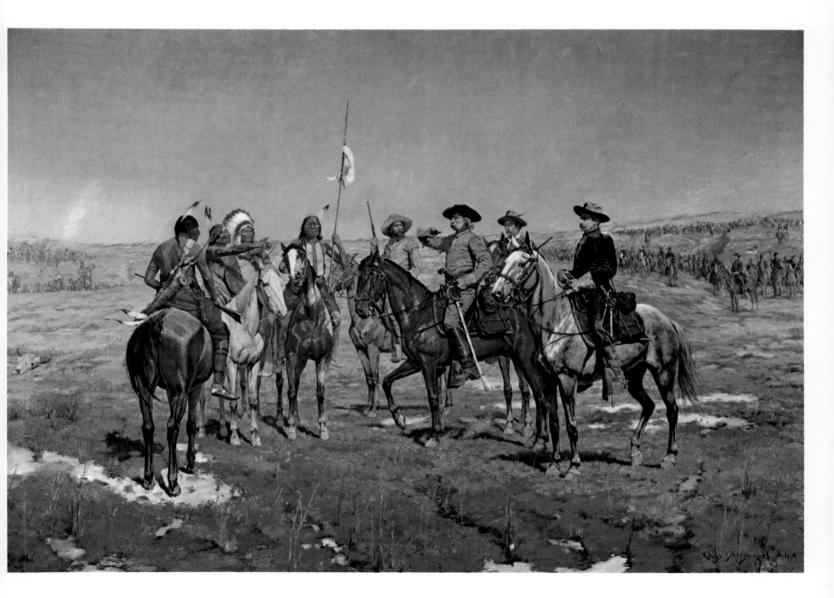

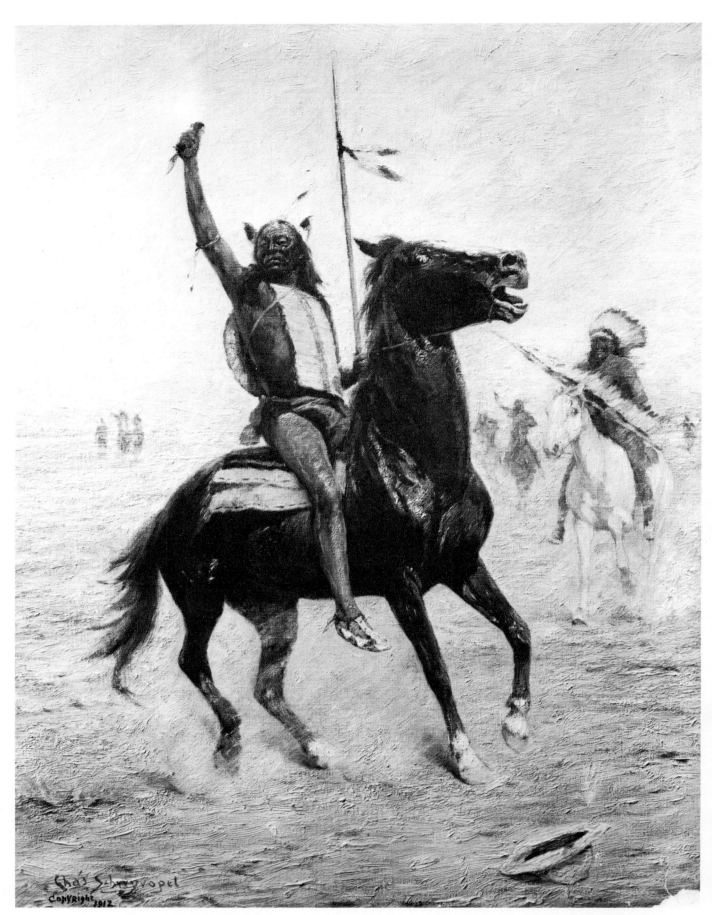

Above: **The Victory,** 1912, Charles Schreyvogel.
14-1/8 x 19-3/8 in., oil. Library of Congress.
Right: **The Summit Springs Rescue — 1869,** 1908,
Charles Schreyvogel. 48 x 68 in., oil.
Whitney Gallery of Western Art, Cody, Wyoming.

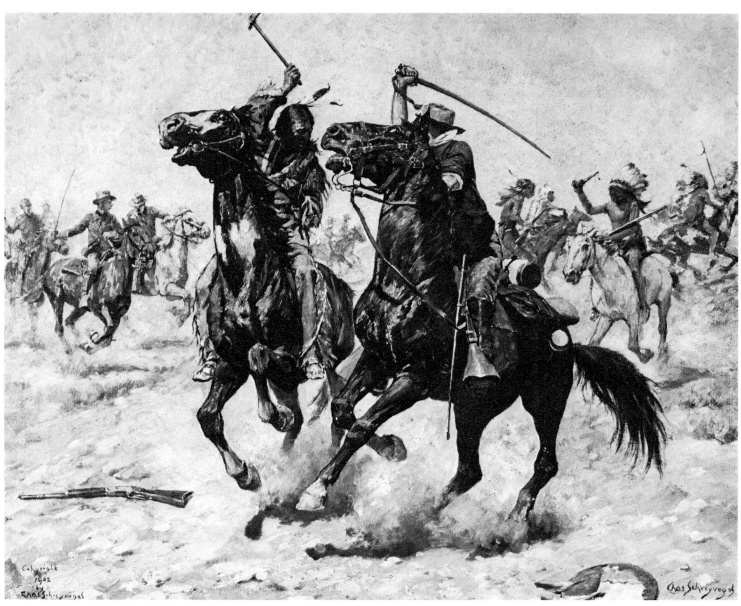

The Duel: Tomahawk and Sabre, 1902,
Charles Schreyvogel. 18 x 24 in., oil.
Thomas Gilcrease Institute
of American History and Art, Tulsa.

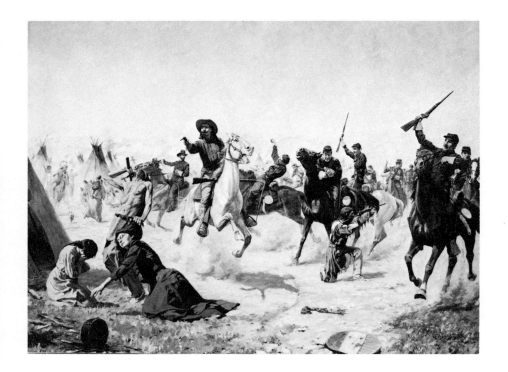

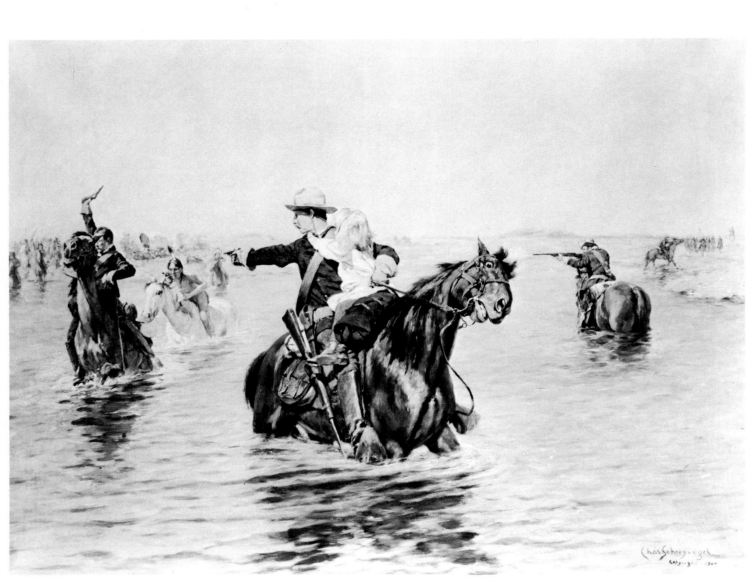

In Safe Hands, n.d., Charles Schreyvogel.
25 x 34 in., oil. Kennedy Galleries, New York.

Never as at home in the West as many painters or as friendly and familiar with the Indian-fighting cavalry as was Remington himself, and with his equipment samples acquired almost a quarter century after the period he wanted to paint, it was no wonder Schreyvogel made a few mistakes.

But he made up in a flair for the dramatic what he lacked in intimate knowledge of the time, the place and the people. Two of his canvases are classics of the Western legend of the cavalry subduing the Indians of the Plains. *Fight for Water* shows three cavalrymen engaged successfully in dealing with three Indians, one down, the second fatally wounded and falling from his horse, the third just about to be shot as he pursues the mounted soldiers. Off in the distance two more Indians are riding hard, but there seems little doubt the cavalry will be able to handle them. Schreyvogel has made the moment of encounter extra-dramatic by centering the picture on the great red, rearing horse of the lead cavalryman; the rider thus can shoot down at the second Indian at the same time his figure contrasts with the fallen Indian and his mount in the foreground.

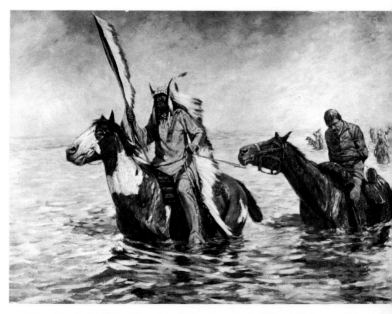

The End, 1912, Charles Schreyvogel. 30 x 40 in., oil.
Thomas Gilcrease Institute
of American History and Art, Tulsa.

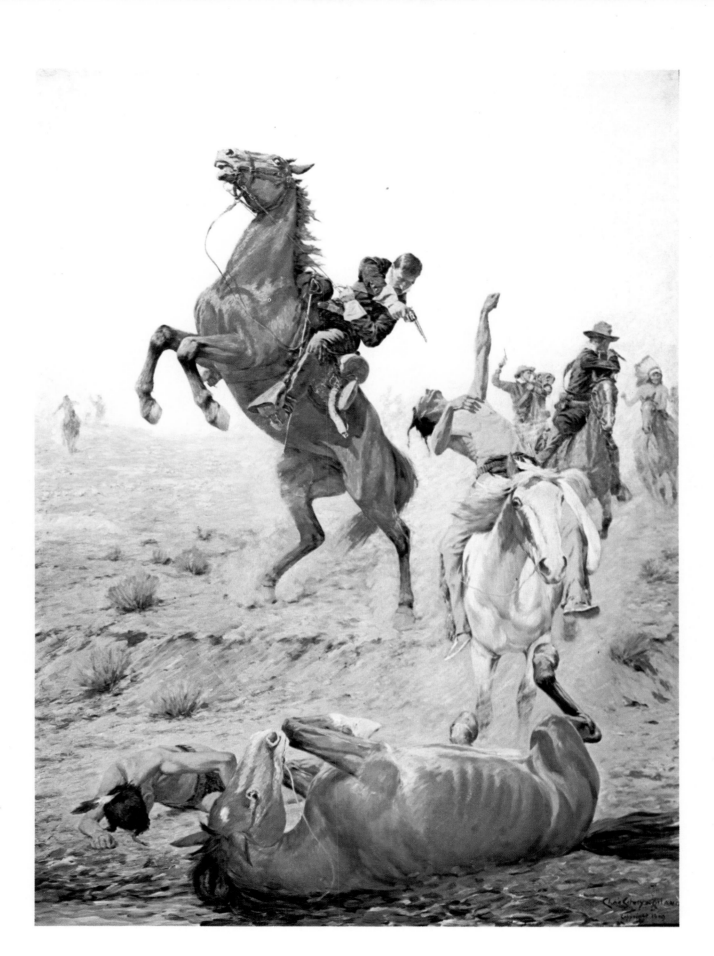

Fight for Water, 1909, Charles Schreyvogel. 53 x 40 in., oil.
Thomas Gilcrease Institute of American History and Art, Tulsa.
Battles between U.S. cavalrymen and Indians did not allow for a stand-off
or surrender: They were usually short, bloody fights to the finish.

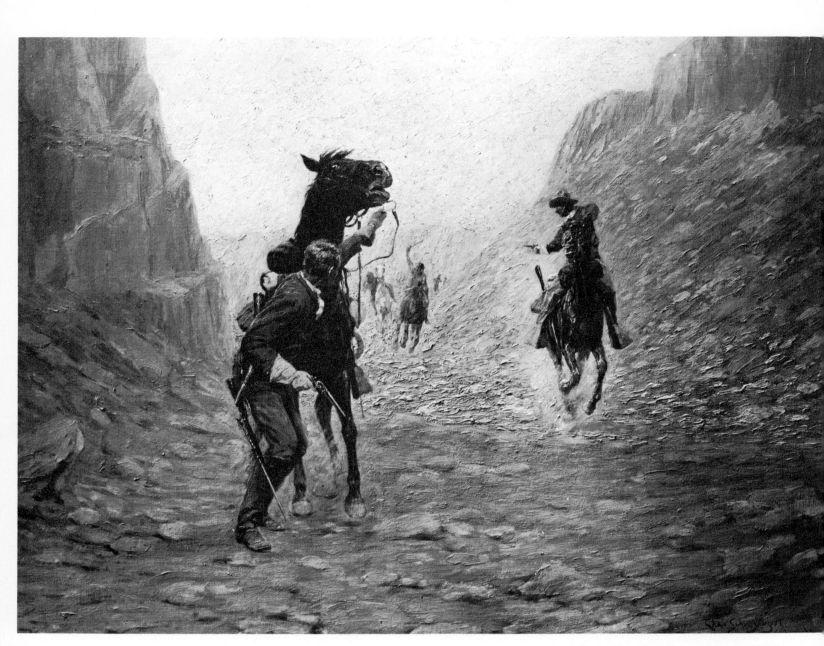

Guarding the Canyon Pass, 1912,
Charles Schreyvogel. 14-1/8 x 19-3/8 in., oil.
Library of Congress.

Even more dramatic is *Breaking Through the Lines,*
with its sharpest focus reserved for the trooper riding
straight at the viewer and aiming his revolver right at our
eye. At first glance the scene to the rear of the intrepid
warrior is pure chaos, but it is a highly ordered chaos,
with the cavalrymen systematically breaking through the
Indian line and thus breaking up an attack.

Shreyvogel always looked for the most dramatic mo-
ment possible in an encounter between Indians and cav-
alry. He was often, no doubt, a shade *too* dramatic. There
is the feeling in such pictures as *Breaking Through the
Lines* that he would have made a better movie director
for battle scenes than he would an historian. Still, matched
against Indian riders professionally regarded as "the best
light cavalry in the history of the world," the U.S. troop-
ers were themselves the immediate product of the most
advanced school of cavalry ever devised, that of Robert
E. Lee in the Civil War. The result was the most pure
cavalry warfare the battlefield has seen in centuries.
Shreyvogel's dramatics emphasize that fact.

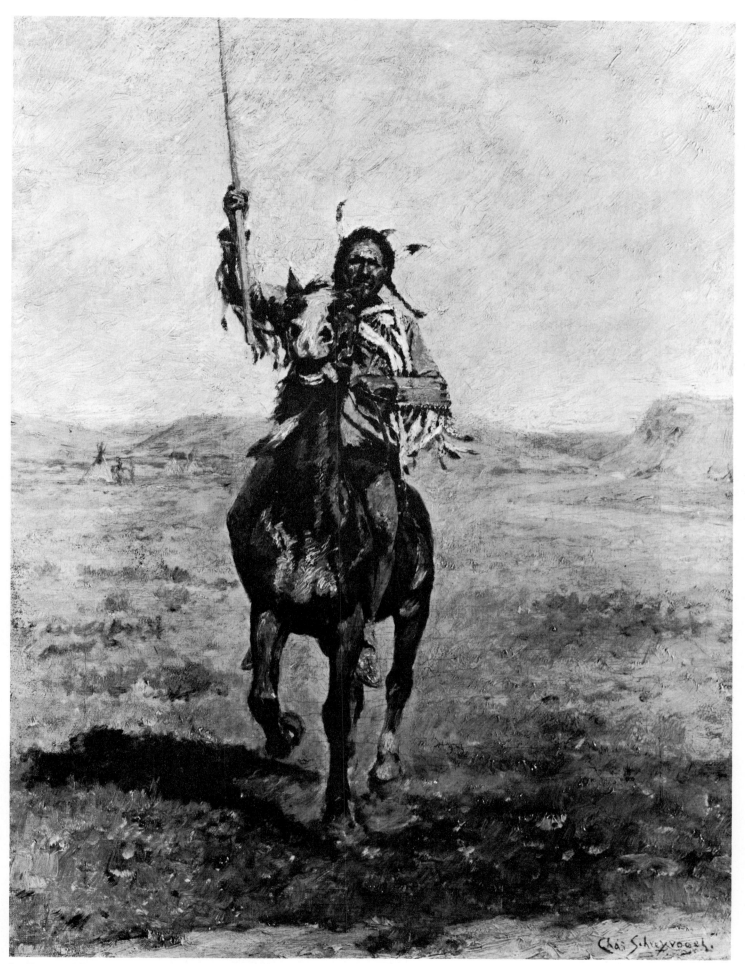

Indian on Horseback, n.d., Charles Schreyvogel.
16 x 20 in., oil. Kennedy Galleries, New York.

HE KNEW THE HORSE

Frederic Remington
(1861—1909)

At his birthplace, in Canton, New York, the stone reads simply, "Remington." This is fair enough, for to this day, more than half a century after his death, Remington remains the most enduring effect on the larger world ever to come out of the small town in upstate New York.

Yet the artist himself had asked for a different epitaph on his tombstone. He wanted it to read, "He Knew the Horse." It sounds like a modest boast, for Frederic Remington, although a poor and reluctant scholar during his shortened days at school, came to know a great many things before his no less shortened days on earth had come to an end.

He did know the horse. He never thought of the animal as simply a type, an accoutrement or a prop for a scene of action in the West. A horse was as individual a person to Remington as a man or woman is to most of us. He had his country studio equipped with sliding barn doors so that horses - individual horses – could be walked in, posed and painted as they actually were. He was also involved, early on, in that classic dispute of the nineteenth century,

Aiding a Comrade, n.d.,
Frederic Remington. 34 x 48 in., oil.
The Museum of Fine Arts, Houston, The Hogg Brothers Collection.

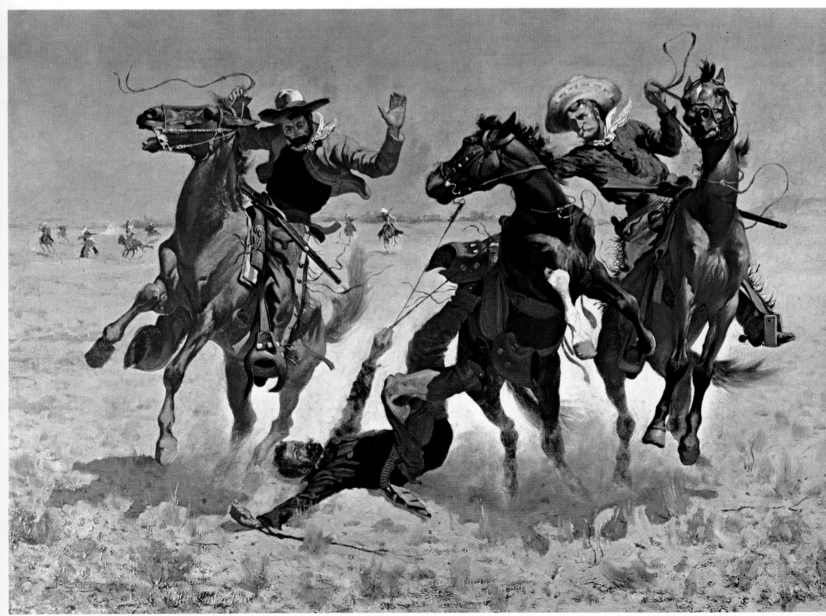

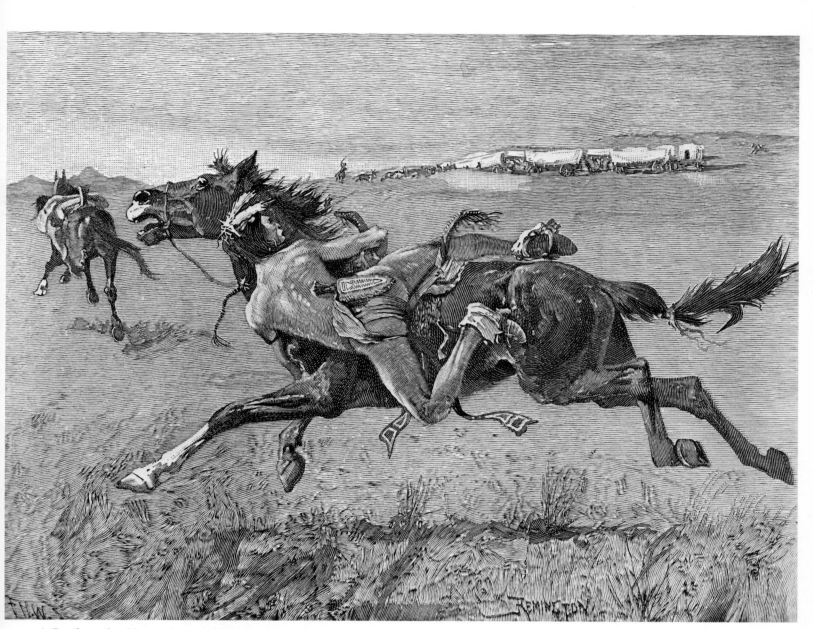

A **Peril of the Plains**, Nov. 1890, *Century Magazine*, Frederic Remington. Library of Congress.

one settled eventually by applied science, as to whether a running horse always had at least one foot on the ground or whether, at full gallop, all four feet were in the air. Remington said they were in the air and most people who hung around horses a lot laughed at him. Then, in a series of photographic experiments involving, at one time or another, the early photographer of motion, Eadweard Muybridge, the greatest American painter of the nineteenth and perhaps the twentieth centuries, Thomas Eakins, and the governor of and senator from California, Leland Stanford, a running horse was actually photographed by a series of synchronized cameras in a kind of prototype of the movies. The prints were developed and Remington had been right all along. In regular, rhythmical repetition, all four feet left the ground together, just as the painter had said. He knew the horse.

He also knew the men who rode on, worked on, fought on, lived on, horses. For Remington, these were three principal categories, the cowhands of the West, the Indians of the West, and the United States Cavalry of the West, with special emphasis on the last. In late prehistoric and semi-historic times, cavalry emerged as the peculiar method of warfare in Asia, while Europe relied always on infantry. It was the genius of Philip of Macedon – which enabled his son, Alexander the Great, to conquer "the world" as then known in the Eastern Mediterranean – to combine cavalry and infantry in efficient proportions, roughly one to six, in a manner that was followed for almost twenty-five hundred years.

It was the fate of Frederic Remington to be present at and to preserve in paint the last phases of that immemorial mode of combat. It was in the American West, in the closing decades of the nineteenth century, that the last great confrontation of cavalry took place between military professionals, whose whole art rested on all that had been learned of the horse in war since Philip of Macedon, and self-tutored, uncivilized men of a hunting culture who had had the horse at most a century and who developed their tactics as had their Asiatic forebears, by pure instinct and sympathetic union with their mounts. It was an epic, and

an epochal, end to the conquest of the continental United States by the Anglo-Americans, to the free, untrammeled ways of the American Indians, and to the long history of mounted warfare. Frederic Remington was there to see it and to preserve it for us in pencil, paint and bronze.

Remington was born in Canton in 1861 with a certain appropriateness about both the time and the place. As to the place, Canton is not far removed from the James Fenimore Cooper country a bit to the south and it was there, surprisingly enough in strict geographical terms, that the West began for most Americans. Even though, at the time Fenimore Cooper was working, Catlin, Bodmer and Miller were all, each in turn, traveling through the real West and bringing back authentic pictures of the peoples of the plains and the mountains, it was Cooper more than any American who first made his countrymen aware of the Indians as a continuing force in our national life, one at once strangely attractive, in some sense morally superior to people living in cities, and at the same time a vague menace to the ambitions of the Anglo-Americans to make this land their own. Earlier, Canton and Coopersville had shared the same tribes of Woodland Indians, the Iroquois, the Mohawks, the Onondagas, the tribes that had given Cooper his inspiration and given Americans their first widely shared image of the Indians.

As to the time, Remington was born on October 1, 1861, when the Civil War was less than six months old. When the child was two months old, his father, a country editor, left the family to recruit, train and serve with a cavalry company, spending four years in the war. But there was more to the Civil War connection than Remington's father's voluntary service in just the arm that Remington himself was to grow to love and know so well.

The Civil War was a paradoxical event in the long history of cavalry. The war was not decided by soldiers on horseback. It was decided by the growing industrial strength of the North, the sheer, almost prodigal, production that the mills and factories proved capable of, and the astounding new ease of transportation and communication provided by the still relatively new railroads. The war was won by iron and coal and they were overwhelmingly Northern resources.

In the South, however, Robert E. Lee managed to fend off that inevitable fate for four long years and he did so by the final refinement of the use of cavalry as an instru-

An Old Times Plains Fight, 1904,
Frederic Remington. 27 x 40 in., oil.
Remington Art Museum, Ogdensburg, New York.

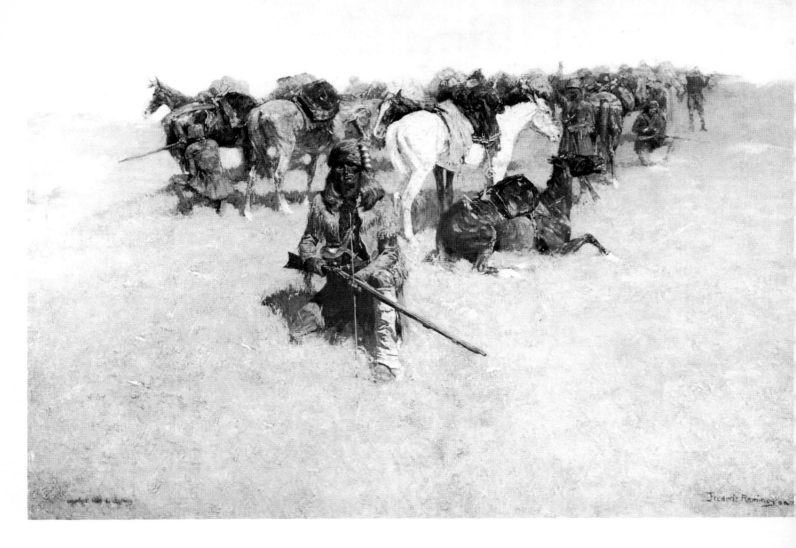

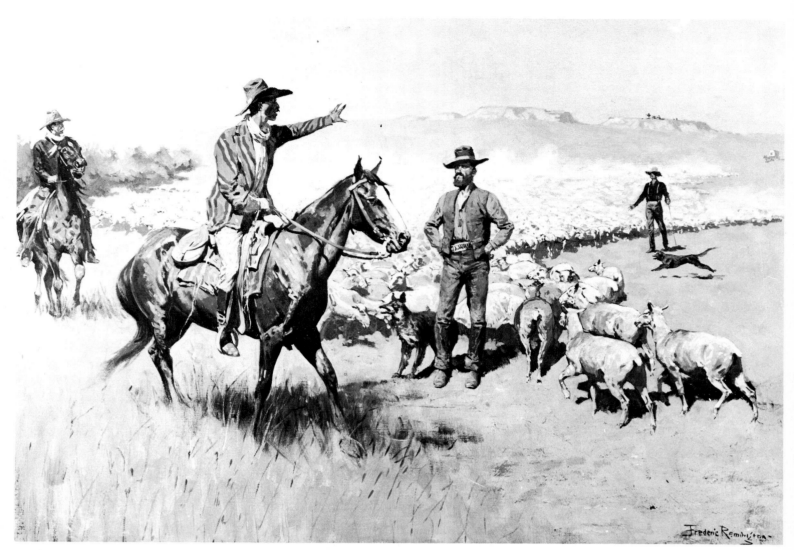

Cattlemen Warning Sheepmen Away From Their Water, n.d.,
Frederic Remington. 27 x 40 in., oil.
The University of Arizona Museum of Art,
gift of Mr. and Mrs. Harry L. Bell.

ment of warfare. Given the one great resource of the South, mounted manpower accustomed almost from birth to life in the saddle, Lee created what military historians have called the "mounted rifleman," a new development in cavalry. It was the only possible intelligent use to make of what the South had to offer: Jefferson Davis's reliance on "King Cotton" to create strong European support swiftly proved to be a fatal delusion. The "mounted rifleman" was, at the same time, the only possible method by which the hopelessly outnumbered and out-industrialized South could hope to initiate and prolong the contest.

A man, a horse and a rifle are speedily brought together, more so if all three have been intimate, familiar partners in work and sport for two decades. A system of war production and a system of war transportation are very different things—irresistible in the end but, in the beginning, very slow to be brought into effective existence. In that gap, the military genius of Robert E. Lee flourished. When the gap closed, Lee—and the Southern cause—were finished. But the general, the second greatest the Americans have produced, left his original and reunited

nation the legacy of a new kind of cavalry, the last effective variation in the long line from the Mongols and the Macedonians to the end of the art, and the subtle, mobile, infinitely adaptable instrument of the final winning of the West—as seen and recorded by Frederic Remington, then an infant in upstate New York bereft of a father off fighting Lee.

The father returned. The boy was four. In a few years more, the family moved to Ogdensburg, not very far away but a larger town; a river town on the St. Lawrence fifty miles downstream from Lake Ontario—a mile by water from Canada—which had been captured and seriously damaged by fire at the hands of the British in the War of 1812.

The boy never cared for formal education much, although he was able to endure it. He was exposed to the best available, but it never really took. Appropriately for the son of an editor who was also a captain of cavalry, Frederic was sent to a good private school, then to a military school and then, at sixteen, he enrolled at Yale, where he became one of the university's first two art students. The training was traditional and Frederic could not stand it. Set to drawing plaster casts of the feet, the

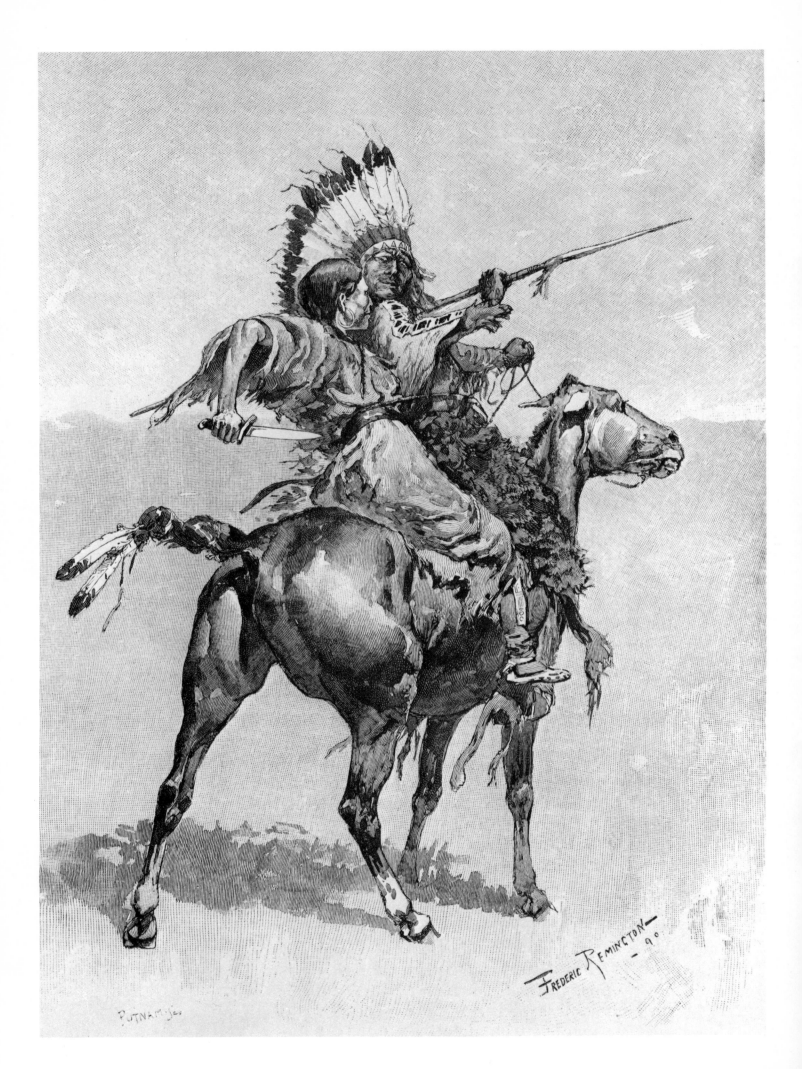

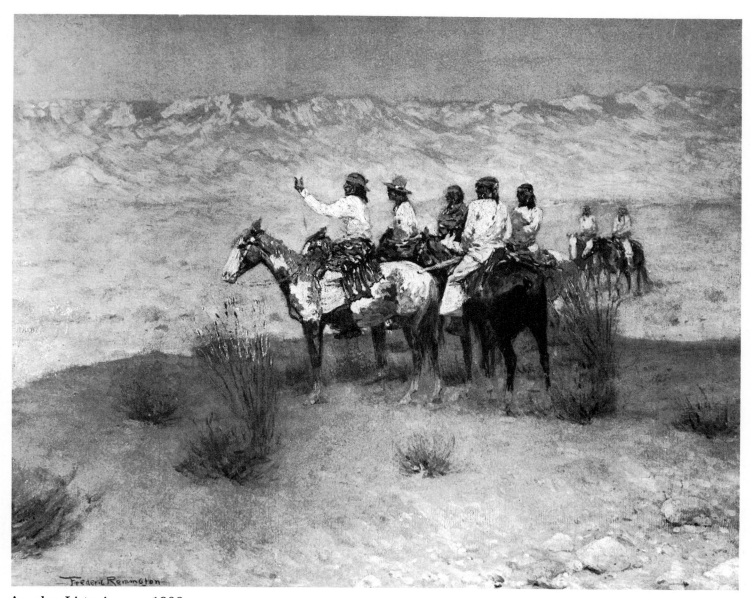

Apaches Listening, ca. 1908,
Frederic Remington. 20 x 26 in., oil.
Remington Art Museum, Ogdensburg, New York.

hands and the heads of antique sculpture, he poured his real, awakening artistic impulses into casual sketches of whatever he saw wherever he happened to be. A no less urgent desire for physical action he poured into football—which, in the late 1870's at Yale, was a lot closer to mortal combat than it has since become.

Yale could not hold him, however, and as soon as he had the chance he lit out, like Huckleberry Finn, for the "territory," that vast part of the United States not yet made a part of the country and still contested by the Indians who, having been pushed westward and westward and westward for two and a half centuries, were preparing to make their last, desperate stand. The opportunity came with the death of his father—not because he was no longer able to attend Yale but because he was now able to leave

The Romantic Adventure of Old Sun's Wife, Dec. 1891,
Harper's Monthly, Frederic Remington.
Library of Congress.

it. The editor-cavalryman left his student son a small legacy, and the boy, to the deep disappointment of his mother, used the money to clear out of New Haven and head west well before the end of his sophomore year.

With money in his pocket and a horse under him, Remington, still not twenty, roamed the West from Canada to Mexico, from the Mississippi to the mountains, meeting various representatives of the Indian tribes, the assorted, hard-bitten types who managed to scrape a living in that dangerous country, and the United States Cavalry fighting to subdue the Indians and open the whole land for peaceful settlement by emigrants from back East.

The emigrants were coming, he knew that, learned it early. He also knew the railroads were coming. The transportation system that had done so much to defeat the South was already embarked on the more extensive task of encompassing the West. In later years, the artist recalled his reactions as these changes began to bore into his consciousness: "I knew the wild riders and the vacant land were about to vanish forever and the more I considered the subject, the bigger the *forever* loomed. . . . I began to try to record some facts around me, and the more I looked, the more the panorama unfolded."

213

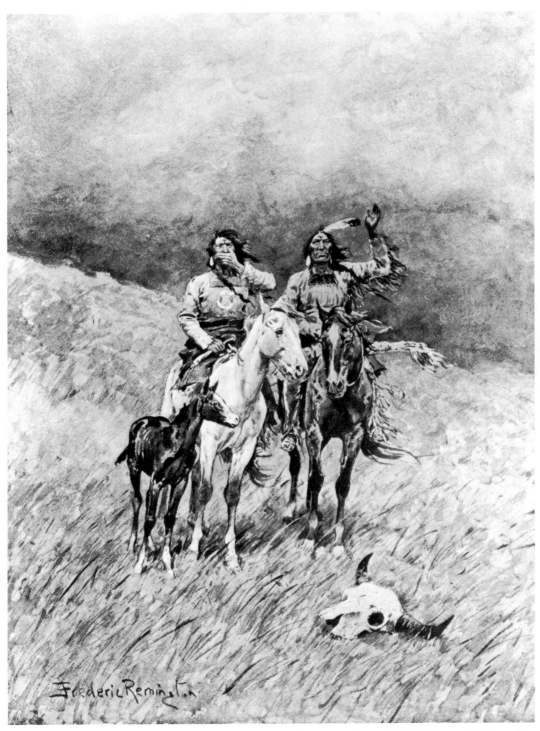

The Mystery of Thunder, Sept. 1897, *Harper's Monthly*,
Frederic Remington. Library of Congress.

His motive, then, was basically the same as Catlin's, to record the image of a way of life he sensed, suddenly and deeply, was about to vanish. This drive, common in the writing of history, biography and anthropology, is, in art, almost unique to the painters of the American West. At just about the time Remington was forming this resolve, for instance, the French Impressionists were coming to the peak of their achievement, but even they, profoundly concerned with things that, by definition, were passing, transitory, ephemeral, seem never to have had a thought that they were recording things that would pass. Perhaps

this was because the things they painted would not pass— or rather, would indeed pass but would regularly return: the bouquet of flowers, the lily ponds in Monet's garden, the cypress trees, the sunlight at a certain hour on the facade of an ancient cathedral.

Earlier artists seem to have taken it for granted that what they were painting or modeling for bronze would exist under the species of eternity if only because they were painting or sculpting it. Michelangelo's famous reply to a patron who complained of the lack of a likeness in two sculptured figures indicates as much: In fifty years, the Florentine said proudly, no one will know or care what the originals looked like, but centuries from now, people will see these figures and know their thoughts. Only in the West, apparently, from Catlin to Remington and Russell, did a whole tradition of painters come to a new land, be tremendously impressed by the life and the land they saw around them, be stricken with the thought that, in the nature of things, such life could not last much longer, and determine to record it for the future while it was there to be recorded.

This unique, or all but unique, phenomenon is the more remarkable because—again all but uniquely in art history—the giants of Western art worked essentially as independent, largely self-taught, solitary spirits. There is no

A New Year on the Cimarron, 1903,
Frederic Remington. 27 x 40 in., oil.
The Museum of Fine Arts, Houston,
The Hogg Brothers Collection.

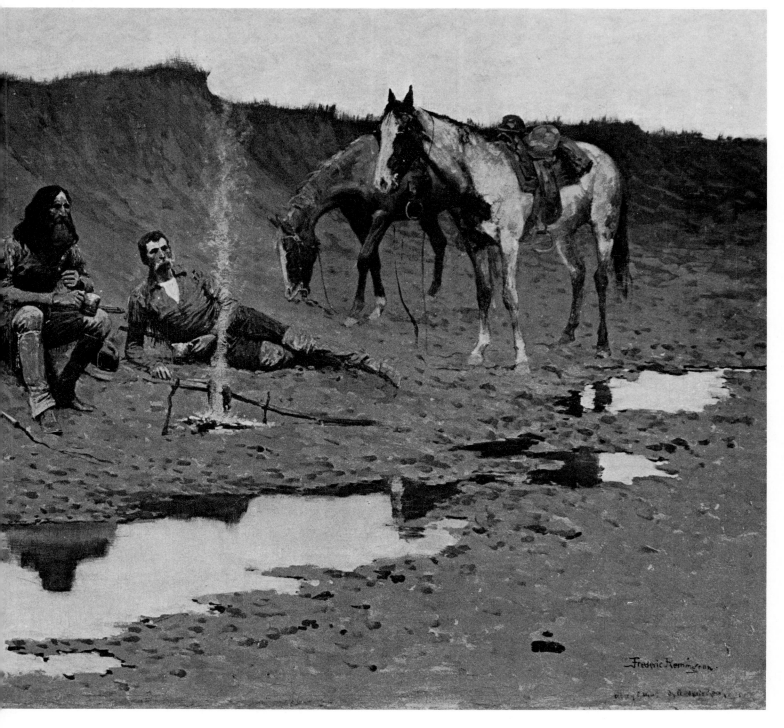

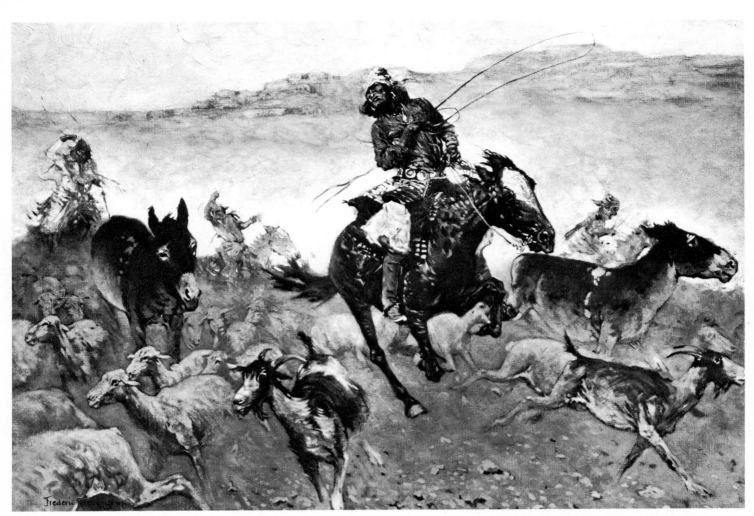

The Navaho Raid, n.d., Frederic Remington, oil.
Mrs. Libbie Moody Thompson, Washington, D.C.

"school" of Western painting, no handing on of the tradition from Catlin, who invented it, to Russell, who was the last of the giants to work from on-the-spot observation of a way of life now gone. On the contrary, each one of them had to invent it all over again for himself.

Remington certainly did. Talented while at prep school, he went to Yale already determined to study art, although he also had an early prediliction for his father's trade of journalism. Learning little at Yale, he lit out for the territory and sketched constantly, even as his determination to record the Western life he fell in love with was forming. In the midst of a helter-skelter, drifting life, in which he was in and out of saloons, attached to and detached from cattle outfits, riding with the cavalry, cooking for cowboys, guiding a wagon train through the Rockies, anything that would earn a dollar and offer some sport, Remington drew and drew and finally sent off one drawing, on a wrinkled old piece of brown paper, to the leading magazine in the country, *Harper's Weekly*, the journal which had employed Winslow Homer as an artist correspondent during the Civil War. *Harper's* bought it and it appeared in the issue for February 25, 1882, when Remington was still on the short side of twenty-one. It was called "Cow-boys of Arizona: Roused by a Scout" and the magazine credited it as "Drawn by W. A. Rogers from a Sketch by Frederic Remington,"

indicating that the editors turned it over to a staff artist for finishing. But it was still recognition.

Abruptly, Remington dropped the pursuit of that promising start and instead bought a mule ranch outside Kansas City. It was not his line of work. He sold out, losing money, and took another sketching trip out among the Indians. Back in Kansas City, his resolution now fully formed, he bought a small house and set himself up as an artist there, working furiously to develop his sketches into paintings. Among his first sales were some to William W. Findlay, a Kansas City merchant who included pictures among his merchandise and whose descendants today run art galleries in Chicago, Palm Beach and on both 57th Street and Madison Avenue in Manhattan. Again, however, the young Remington was tempted by get-rich-quick schemes and went into partnership in a saloon, a business, after all, that he knew from personal experience ought to be a sure thing among the Westerners. For Remington, it was not. He lost the last of his inheritance.

In spite of his poverty, he persuaded the father of his childhood sweetheart, Eva Caten, to approve their marriage, which took place in Canton, and the young couple settled in Kansas City and sank swiftly into ever deeper poverty.

216

With family help, they got back to New York, lived with friends in Brooklyn and Frederic attended classes at the Art Students League. As at Yale, he probably did not learn much in the classes, but he sharpened his professional attitude simply by having the company of professionals, both teachers and fellow students. Drawing on his large supply of Western sketches, he sold a picture to *Harper's* again, this time published solely over his own name. He illustrated a story in *St. Nicholas,* the famous nineteenth-century children's magazine and then came his great stroke of good fortune, a renewal of acquaintence with an old Yale classmate and friend, Poultney Bigelow, editor of *Outing* magazine, who asked him to illustrate a whole series of stories.

From that moment on, in 1886 at the age of twenty-four, Remington's reputation climbed steadily. He had all the work as an illustrator that he could handle. His paintings were shown in the exhibitions of the American Watercolor Society and the National Academy of Design and won prizes in both institutions. He began publishing his written accounts of his Western travels as well as his pictures. With a few lessons from a professional friend, he took up sculpture in bronze and immediately proved himself a master at it. His illustrations began appearing on a large scale in magazines just as technical advances made color printing cheaper and easier, and Remington moved happily from charcoal and pencil sketches into full-scale oils—sometimes in black and white oil only—for that work. The sheer quantity of paintings, sculptures, drawings and writings that Remington produced in his short life make him one of the great makers of art in history. When he died there were almost 3,000 pictures, including illustrations for almost 150 books, eight of which he wrote himself, twenty-five major sculptures in bronze and no one knows how many sketches.

It was as if the youthful experience in the West so stuffed his imagination and his memory with unforgettable images that once he achieved the leisure, the studio, the tools and the skills, the images came pouring forth in a stream of paintings and sculptures, an output which fixed in the minds of Americans the picture of the last years of the Old West that most of them carry about to this day.

Yet Remington did not depend by any means solely on the compressed experience of the West between his leaving Yale and his arrival in New York and meeting with Poultney Bigelow. On the contrary, he continued to roam the West, almost every year, gathering material for the winter's work at studios he maintained in Manhattan and

The Mule Pack (Ore-Wagon Going into Silver Mines), 1901, Frederic Remington. 27 x 40 in., black and white oil. The Museum of Fine Arts, Houston, The Hogg Brothers Collection.

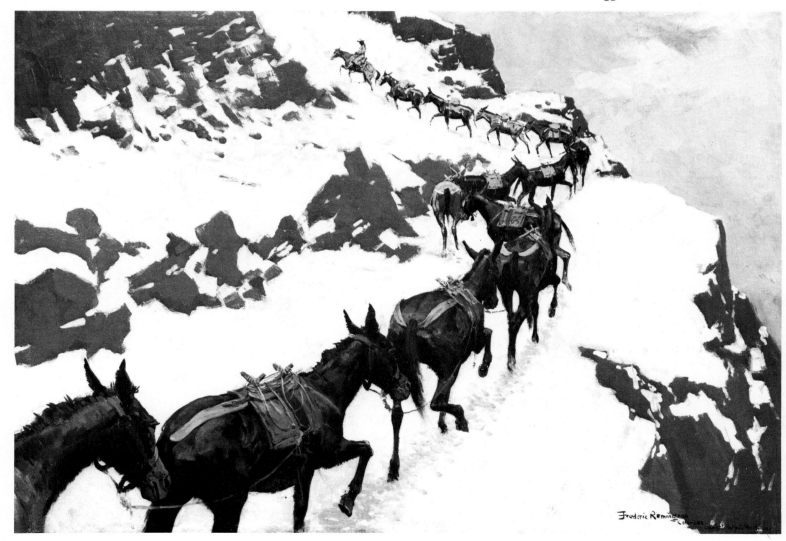

in New Rochelle, then a pleasant country town on Long Island Sound, later to be celebrated by George M. Cohan as only "Forty-Five Minutes From Broadway."

One summer he rode out of Fort Grant, Arizona, with the Tenth Cavalry. He joined an expedition into the Badlands and he was at Wounded Knee a day or so after that climactic battle in the Indian Wars, recognizing at once, with extremely mixed feelings, that the long wars were over, that the Indian was now completely the captive of the white man, that the West, while safer for whites, had lost one of its most vital elements.

He traveled extensively abroad, as well as in the Western United States. With Bigelow he went to North Africa, where he was intensely interested in the Arabian horses, the blood cousins, he never doubted, of those the Spaniards brought to Mexico and which escaped to become the wild herds which, tamed by the Indians, made them the best light cavalry in history. With Bigelow, too, Remington journeyed to Germany and Russia. He went frequently to Mexico as a source for material for his pictures.

By far, however, Remington's most famous trip out of the country was a voyage to Cuba he made during the Spanish-American War. Remington's pictures, printed in William Randolph Hearst's *New York Journal*, made their own contribution to bringing America into war with Spain, or at any rate toward influencing public opinion overwhelmingly against Spain and in favor of the Cuban insurgents. Remington, in Cuba a year before the blowing up of the American battleship *Maine*, was the recipient of that famous telegram from Hearst which the publisher's enemies ever since have taken as evidence that Hearst started the war virtually single-handedly, with the help of his hired artist, Remington, and his brilliant international war correspondent, Richard Harding Davis.

In recent years, there has been a good deal of changing of minds about the United States and the Spanish-American War. This revised thinking started well before the Vietnam War—some of it, indeed, started with the famed Battle of San Juan Hill and some more with the successful completion of the Panama Canal. But Vietnam and the widespread American uneasiness over our role in the Indochina Wars has led to a much more general reversal of formerly accepted attitudes about the war with Spain. American participation in the Indochina fighting has been so ambiguous, shadowed by doubts and

"Don't Nobody Hurt Anybody" said Specimen Jones, 1895, Frederic Remington. 25 x 35 in., oil. Courtesy of The R. W. Norton Art Gallery, Shreveport.

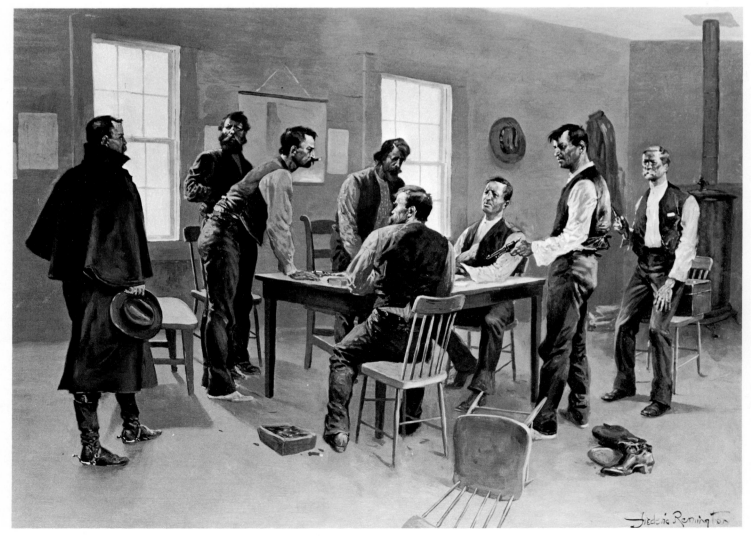

unclear in intention or result, that many Americans, projecting their doubts backwards, have concluded, somewhat glibly, that the Spanish-American War was another instance of American might being used to crush a smaller nation, Spain, and to rearrange the disposition of power in the Caribbean Sea so as to secure the approaches to the Canal and to render the entire area an American dependency.

The parallel is seductive to many Americans disillusioned with the uses of American military power, but it is misleading in many ways. A little examination of the Cuban situation is called for in order to understand the ready, even enthusiastic, acceptance of the war by Frederic Remington and his entire generation of Americans.

In the first place, the comparison between the two nations is extremely misleading. The Spanish-American War did indeed reveal the final bankruptcy of the Spanish military power, a power which had, in its time, created an empire more extensive than any in history, including the British and the Roman. In the early years of the New World under European dominance, Spain ruled, besides its peninsular base, a great deal of central Europe plus the Lowlands; perhaps two-thirds of the American hemisphere and a much higher percentage of that part of the hemisphere effectively ruled by Europeans, a rich and varied domain that included California, Texas and Florida, most of the Caribbean islands, Mexico and Central America and, except for Brazil, all of South America from the Caribbean to the edge of the Antarctic regions; the Philippine Islands; and assorted bits and pieces of the world in North Africa and elsewhere.

The defeat of the Spanish Armada, sent against the English in Elizabeth's reign, was a serious blow to Spanish ambitions, but the empire survived it very well and continued to fight English pirates and privateers in the Caribbean if unable to crush their home base. The nineteenth century saw the gradual independence of many of the Spanish New World possessions, but the general acceptance of Spain as a mighty empire survived until the Spanish-American War, much as Great Britain and France are now still regarded as important powers, though the two empires that created those powers have been gone for almost a generation.

In contrast, in the general world view and in the view of most Americans, the United States was not, prior to the war of 1898, regarded as any kind of world power at all.

Bringing Home the New Cook, Nov. 2, 1907,
Collier's Magazine, Frederic Remington.
Library of Congress.

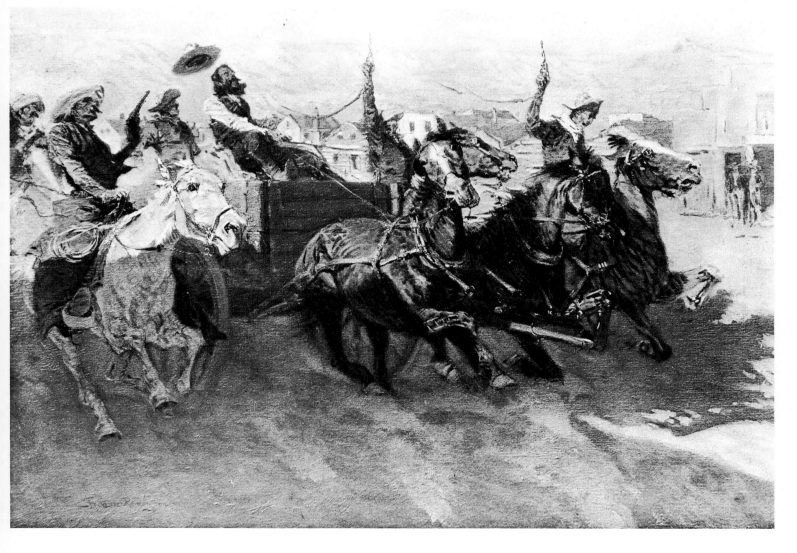

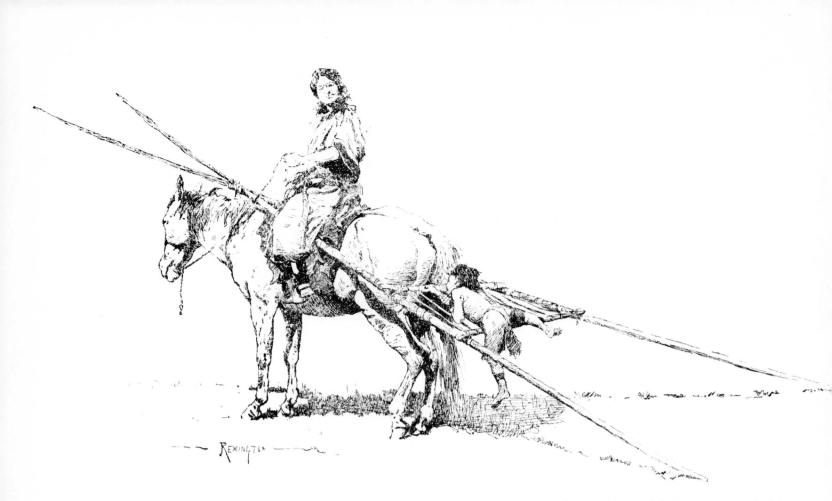

Indian Mother and Boy—Blackfoot, Dec. 1891,
Harper's Monthly, Frederic Remington.
Library of Congress.

And rightly so. We had fought England—twice—in wars we considered essential to the fundamental purpose of establishing our independence. We had fought Mexico for, from our point of view, the same sort of essential purpose, that of filling out and completing what seemed to most Americans the natural, logical, "God-given" boundaries of the continental United States. Out biggest war had been with ourselves, between North and South. And of course, as Remington knew better than most Americans in 1898, we had been fighting the Indians in a finally successful effort to make all the land that had been theirs our own. Thus, from an American point of view, as well as from a European, we had really been engaged in no foreign wars at all in the conventional sense.

Moreover, the great drive of the great powers in the nineteenth century had been the conquest of colonies all over the world. Spain still had the remnants of her empire; now she was joined by the Italians and Germans in Africa, by the French in Africa, the Middle East and Southeast Asia, by the Dutch and the Belgians in Southeast Asia and Africa and by the English everywhere. The United States had engaged in none of these expansions and dominations of distant peoples and the exploitation of their lands and other resources including their labor. From our point of view, this abstention from empire was a point of pride; from the European point of view, it meant simply that the United States was not a great power, not a force to be reckoned with in the divvying up of the world that was the concern of the true great powers.

To be sure, there were a few perspicacious European statesmen and historians who regarded both the United States and Russia as the "sleeping giants" of the world, capable, when they were ready, of moving easily and naturally into positions of world dominance, but their perception was not widely shared. A mere twenty years after the Spanish-American War, this country was to become the pivotal power in Europe and would remain so at least until the early 1970's, but that situation was generally unimaginable on the eve of 1898.

Thus, the currently popular revised version of the war of 1898, in which a mighty United States ruthlessly crushed a weak Spain, is oversimplified to say the least. It is a telling point that, as the two nations drifted toward war in the spring of 1898, one of Remington's most satisfying assignments was a tour of our Atlantic coastal forts, a mission undertaken in what seemed the logical anticipation that if war came the Spanish fleet—whereabouts at first unknown—might very well materialize off New York and attack the mainland. This anticipation of the artist and his employer was also shared by the government, and our coastal defenses were tightened considerably in those months.

Beyond that consideration of relative size, might and military prospects is a further consideration, that of American support for what today would be called a war of national liberation. This country did not attack Spain simply for the sake of attacking Spain, not even solely as a direct response to the sinking of the battleship *Maine*.

Conjuring Back the Buffalo,
Aug. 1892, *Century Magazine*,
Frederic Remington. Library of Congress.

220

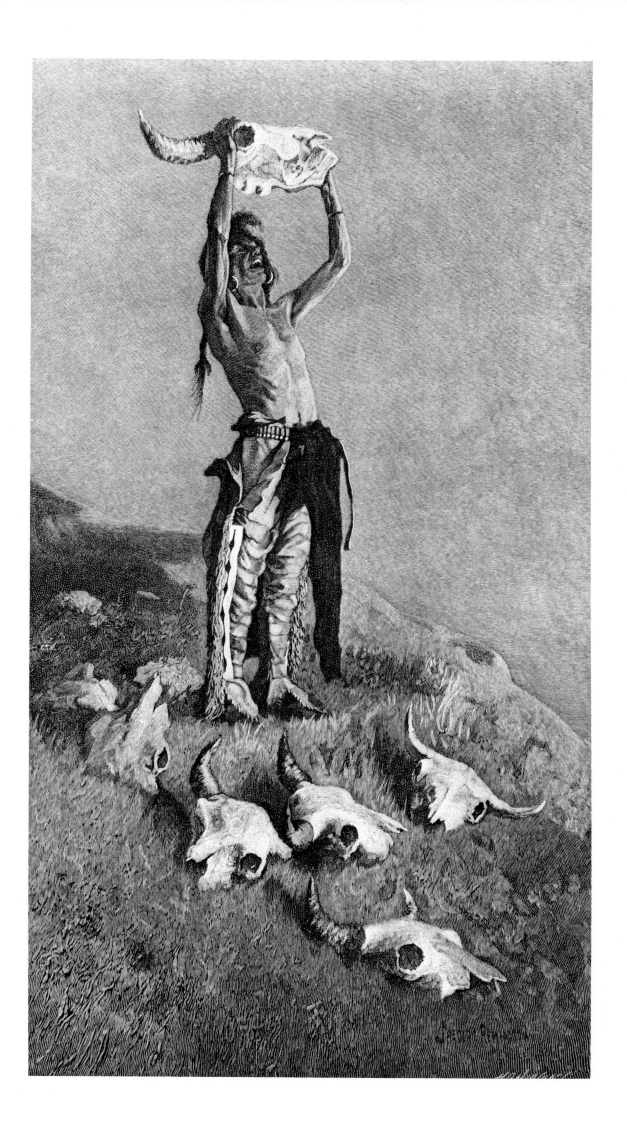

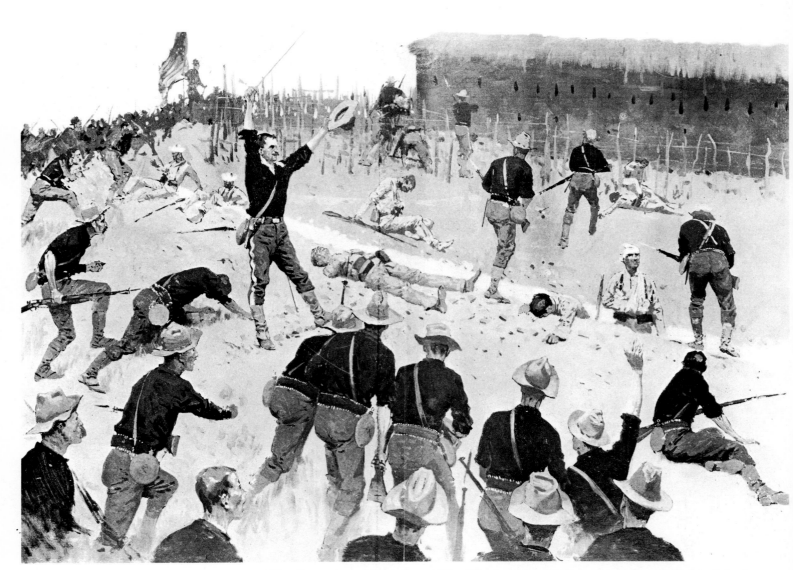

The Storming of San Juan: The Head of the Charge, Santiago de Cuba, July 1, *Harper's Monthly*, August 6, 1898, by Frederic Remington. Library of Congress.

On the contrary, for several years there had existed on the island of Cuba a persistent and hopeful movement dedicated to throwing off the Spanish yoke and establishing a free and independent nation—*Cuba libre,* as the name still survives in bars everywhere.

Now, this movement for national liberation from the thrall of a European power fit precisely into the whole history and dedication of the American people. We believed in a hemisphere free of the meddling and exploitation of the European powers. Earlier in the nineteenth century, Americans had followed the career of Simón Bolívar in liberating the new nations of South America with great enthusiasm. Statues erected to that liberator may be found in New York and Washington and elsewhere in the United States as evidence of the country's instinctive support of the liberation movement. The Monroe Doctrine supported the states liberated by Bolívar and any others that, in the future, might obtain their liberation. Specifically in the case of the French supported and imposed "empire" of Mexico, brought into existence when the United States was preoccupied with the Civil

War, vigorous American diplomatic representations, once that war was over, led to the French withdrawal, the collapse of the "empire," and the execution of the "emperor" by a Mexican firing squad.

There was, then, plenty of precedent for United States support of any movement for liberation and self-determination anywhere in the hemisphere.

Finally, and this is especially true of most of Remington's actual drawings and paintings from Cuba, once hostilities were begun, the focus of the American people—and of Remington—concentrated not on any legal niceties about the Spanish colony but on the fate and fortune of the American "boys" – that is, the men fighting the war – on that tropical island. This, of course, has been true for most wars conducted by most countries in modern times. It was only with Vietnam that large numbers of Americans were able to view a war as a separate problem from that of support for American soldiers wherever they might be. Certainly Frederic

Patrolling the Yellowstone (Getting a Grub), n.d.,
Frederic Remington. 17-1/2 x 16-1/2 in., watercolor, monochrome.
Collection of Mr. and Mrs. James Ryan Williams, Cincinnati.

Remington never separated the two things in either his mind or his work.

It was as early as the last few days of 1896 that Remington first sailed for Cuba as an artist-correspondent for Hearst. He and Davis established themselves in Key West and paid the captain of a Cuban vessel to sail them over. Weather forced the boat, the *Vamoose,* to turn back, to the extreme disappointment of the two journalists, even though, during a fierce storm, they had clung to the rail to keep from getting washed overboard and discussed what measures they should take when the vessel capsized.

Frustrated in their efforts to enter the embattled island clandestinely, they got a friend in Key West to fabricate a pair of passports for them and had no difficulties obtaining

regular passage to Havana, where the American consul-general arranged an audience with the Spanish general in charge of the military occupation and the counter-insurgency action against the guerillas.

Remington drew constantly, as always, and sent back sheets of sketches of the Spanish army on patrol and of prisoners being marched to jail. In spite of the rising ill-feeling between Spain and the United States, Texas broncos were being sold to the Spanish army in Cuba, and Remington took particular pleasure in drawing a Spanish cavalryman with rifle over sword in the air as he was bucked off by the American horse.

All the same, he felt a certain lack of critical quality in the actions of both Spanish and guerrillas. He wired

223

Hearst: EVERYTHING IS QUIET. THERE IS NO TROUBLE HERE. THERE WILL BE NO WAR. I WISH TO RETURN."

He received the classic answer: PLEASE REMAIN. YOU FURNISH THE PICTURES. I'LL FURNISH THE WAR.

The war was duly furnished, but it came more than a year later. Augustus Thomas, the turn-of-the-century playwright, recalled that he heard about the sinking of the *Maine* in Havana harbor and immediately telephoned his friend Remington, who he knew would be interested. For his pains, he received a terse reply: "Ring off!" said Remington, already planning his departure and eager to get through to Hearst.

War preparations dragged along, so much so that at one point a war-hawk Congress seemed likely to impeach President McKinley for dragging his feet. Remington used the interval to tour the forts that would defend the East Coast and the staging areas at Tampa, Florida, from which the expedition would depart. At last, in April, war was declared to have already been in existence for some days and Remington was off with the expeditionary force.

For the American public, the war was over before it began, so long had it been in coming. It produced a short-lived generation of heroes, soon superceded by the greater numbers of World War I veterans. But from a public

Arizona Cowboy, 1901, Frederic Remington, pastel. Rockwell Gallery, Corning, New York.

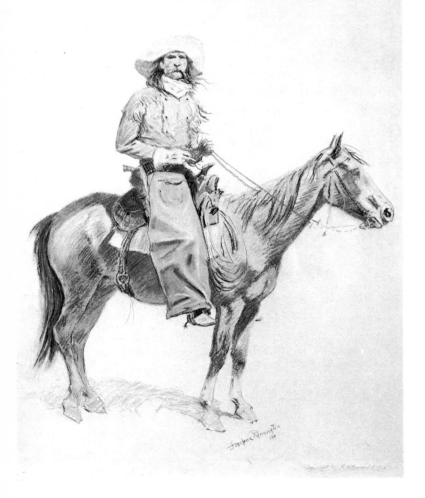

point of view, the war was thoroughly satisfactory: short, decisive, thoroughly in the American tradition of fighting for freedom against tyranny, and productive of a group of heroes, chief among them Theodore Roosevelt, hero of San Juan Hill, governor of New York within a few months of his mustering out, President of the United States—by succession from the Vice-Presidency—three years almost to the day after the disbanding of his Rough Riders.

The student of American history is hardly surprised to learn that T.R. was a friend and a great admirer of the work of Remington, particularly of the sculpture. Beyond the president's aesthetic interests, Remington's bronzes of hard-riding, hard-fighting Americans touched a chord within Roosevelt, one manifest in his vigorous approach to problems foreign and domestic, in his preaching to his fellow citizens on behalf of the rugged life, in so much of his history, from the charge up San Juan Hill through his audacious challenge to custom in seeking a third term by way of the Bull Moose Party, to his post-Presidential big-game hunting in Africa. Something of the spirit of the man is caught in almost any of Remington's oils or bronzes of action along the frontier. The Rough Riders knew exactly what they were doing when, during their mustering out period on Long Island, they called their colonel from his tent, escorted him to the center of the regiment drawn up in hollow square and there presented him with a cast of Remington's first bronze, the *Bronco Buster.*

In a way, of course, the end of the trail had already been reached for the way of life Remington extolled above all others, the life of the United States cavalryman. Although Roosevelt's charge up San Juan Hill exists foggily in the American mind as a cavalry charge and although, indeed, Remington contributed more than anyone else to that impression by his later picture of the Rough Riders in full gallop, their leader at the center of the first line, the truth is that San Juan Hill was taken by the New Yorker's troops dismounted. The battle was essentially an infantry battle with more casualties sustained from enemy artillery fire than from hand to hand combat. The wounded horses got their wounds where they were picketed, at the bottom of hill, before the charge began.

After the Spanish War, things did not go any better for the cavalry. The tank, or armored vehicle, was originally invented by Leonardo da Vinci, but the internal combustion engine made it both practical and militarily profitable. General George Patton of World War II and most of his generation of tankers thought of themselves as cavalrymen. This explains Patton's boots and riding pants which were a little odd for either a mechanic or a chauffeur. But except for Rommel's romantic battles in the desert, the tank in World War II was really a form of artillery giving enhanced support to infantry because of its mobility.

Cavalry in America in general has never played the role it sometimes has in the much longer history of European warfare. In the Revolution, the raiders of Francis Marion, the "Swamp Fox," were mounted men, but the war was much more decisively waged and won by foot soldiers. Lee's cavalry, perfected for the Civil War, was the high point of cavalry in America as a formal mode of fighting wars, and it was on Lee's innovations that Remington's Western cavalry was based. Yet the Indian Wars were essentially guerrilla actions according to definitions from authorities as different as Napoleon and Mao Tse-tung. Given the terrain and the nature of the enemy, the United States Cavalry proved to be the ideal instrument

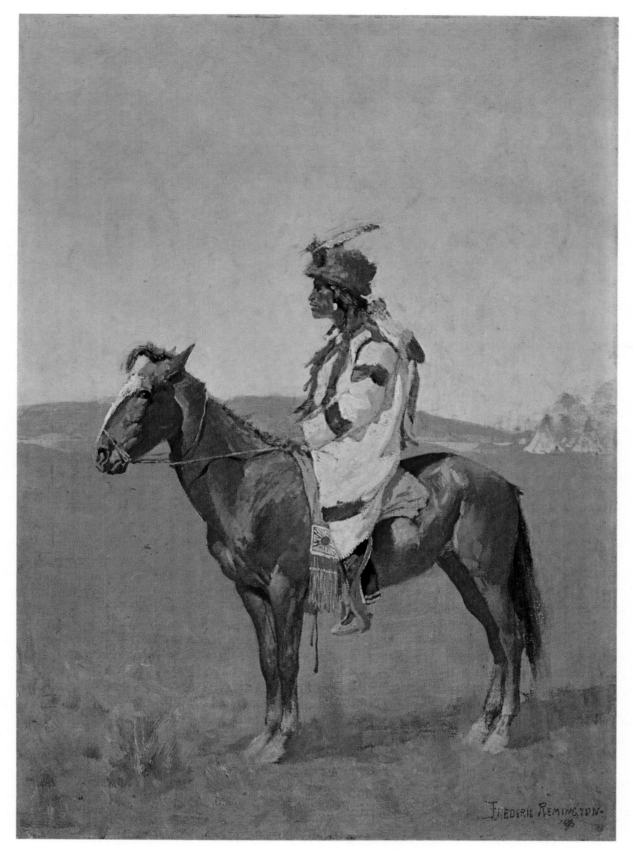

A Blackfoot Indian, 1888, Frederic Remington.
21-15/16 x 16 in., oil on board.
Kimbell Art Foundation, Fort Worth.

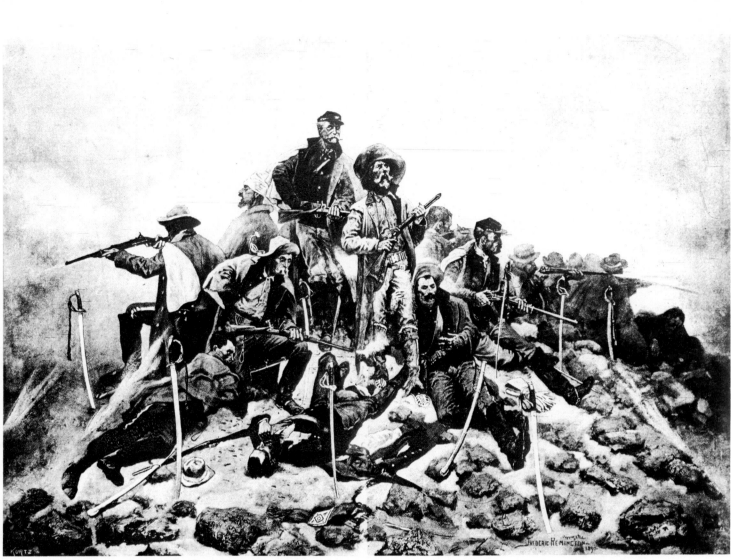

The Last Stand, Jan. 10, 1891, *Harper's Monthly*,
Frederic Remington. Library of Congress.

with which to fight the Indian Wars. The cavalry, in the old saying, would have had to be invented—if Lee had not already done so.

Remington thus came upon the scene just as the cavalry reached its peak of technical perfection and at the same time its peak of military value to the nation. In his art he celebrated a special kind of fighting man eminently worth celebrating at the time.

If the Spanish War requires a word of explanation to the modern mind, the Indians Wars—the ones portrayed by Remington—require even more. As recently as half a generation ago, most white and black Americans grew up in the inherited belief that our "manifest destiny" had obviously been to occupy the entire ocean-to-ocean stretch that has become the continental United States. To do this required a series of wars or treaties to acquire those parts of that land held by various European or other American powers, the English preeminently, but also the French, the Spanish and the Mexicans. In addition, the following of the Course of Empire along its Western Way required making the land safe from Indian attacks, the

Indians being regarded, in this view, as savages to be policed, perhaps exterminated, much as the sources of natural disasters are eliminated if possible. Rivers liable to flood are levied; forests likely to burn are given fire-brake lanes and constant watching; in cyclone country, farmhouses are routinely equipped with special cellars in which the residents retire to wait out the storm. In just that spirit, generations of Americans were taught, the maurading Indians of the western Plains, had to be subdued so that Americans could get on with their manifest destiny of crossing the Plains in safety, later, of settling down on the Plains and raising grains and cattle, and still later of prospecting below the Plains for oil and natural gas. To all of these manifestations of the American destiny, the Indian was at best an obstacle, at worst a menace.

Although there has always been a tiny group of dedicated white or black Americans agitating for some measure of social justice to the Indians, it is only recently, quite recently, that any substantial number of non-Indian Americans began to recognize that the Indians had been

forcibly ejected from land that was theirs all the way from the Atlantic to the Pacific, that treaty after treaty made with tribe after tribe of Indians was unilaterally abrogated by the United States and finally that living conditions for the American Indians on reservations or elsewhere were often miserable and rarely remotely in line with the promises of the treaties whereby the Indians had been moved off their land in the first place.

At the time of the Indian Wars, of course, that future of betrayal and exploitation was not known; moreover, that shameful future was not the work of the men Remington celebrated in paint and bronze, the United States Cavalry as Indian fighters.

And that should be the governing consideration of our own attitude toward those men as they appear in Remington's art. They were, it now seems unavoidable, instruments of a monstrous injustice perpetrated against the Indians. But the injustice was not theirs and it would have been almost impossible, granted the popular patriotic thought of the time, for any one of them to have perceived what they were doing as injustice. In their own eyes, they were making America safe for Americans and, as professionals, fighting against warriors whose courage and skills they came quickly and lastingly to appreciate.

Remington, too, like the cavalry, had a deep appreciation of the Indian virtues, even while he took for granted the essential virtue, or at least historical inevitability, of the American wars to end the Indians' freedom and possession of their own land.

The Scout: Friends or Enemies?, painted in the last years of the artist's life, depicts a single Indian warrior on the northern Plains in the deep of winter. Crystal stars faintly punctuate the blue night; the folds of the land are even more faintly discernible beneath the blue-white snow. Within this vague and generalized setting, two definite objects stand out, the mounted Indian, poised, straining, alert, looking and listening for any clue as to the nature of the second object, a distant darkening against the snow, a procession of mounted men, perhaps, or an encampment: but a march or a bivouac of what men? The troopers or a possible allied tribe? It is the scout's strained attention that brings that distant line into sharper focus for us than it has in reality. The scout, alone in the moonlit snow, is, at this moment, the closest link between the resisting Indian tribes and the determination of the United States to crush them. Remington's picture loses nothing of the cold and solitude and evokes a kind of low-key, stoic sympathy for the solitary rider against the army in the distance.

(continued on page 230)

Prospecting for Cattle Range, n.d.,
Frederic Remington. 29 x 50 in., oil.
Whitney Gallery of Western Art, Cody, Wyoming.

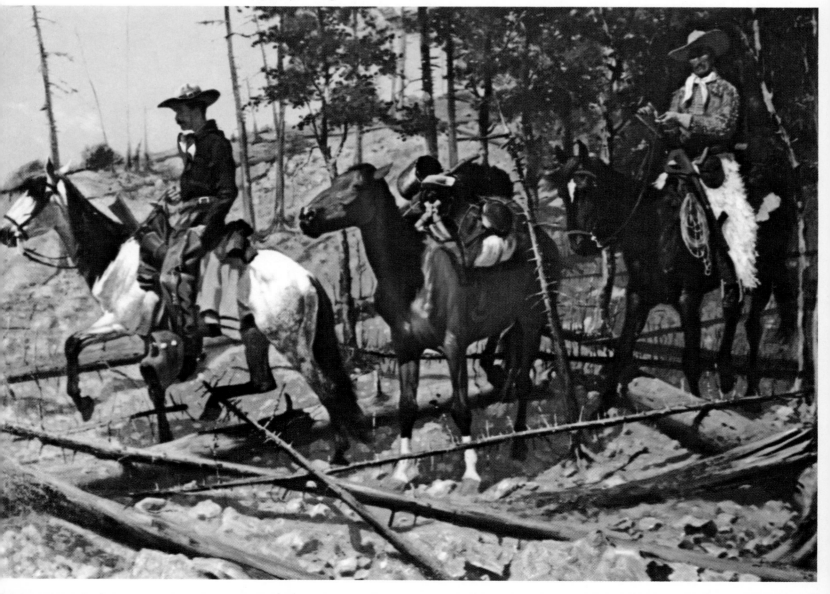

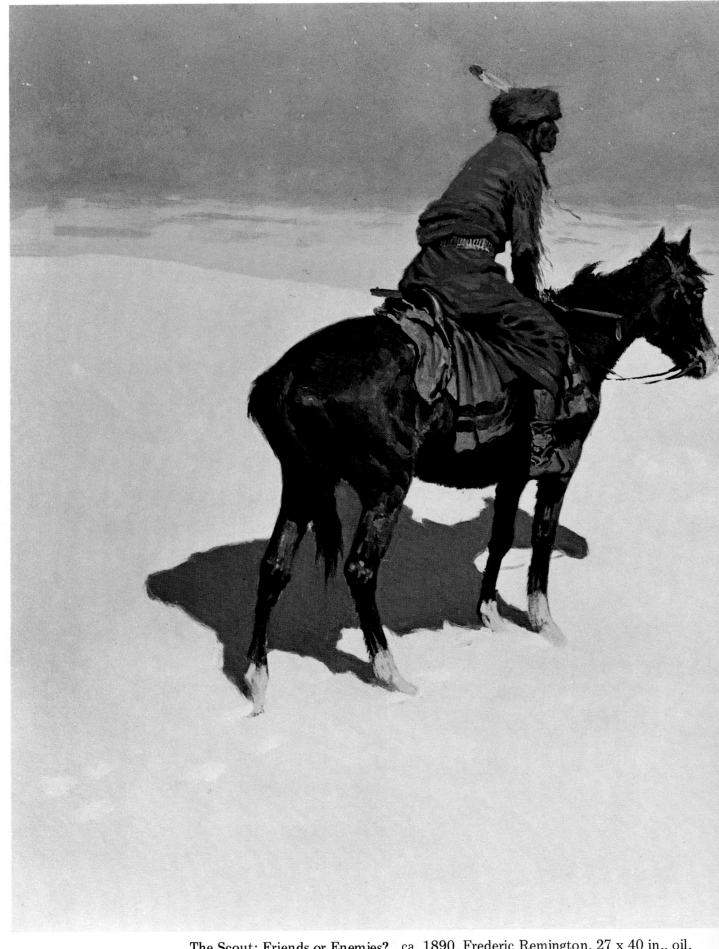

The Scout: Friends or Enemies?, ca. 1890, Frederic Remington. 27 x 40 in., oil.
Sterling and Francine Clark Art Institute, Williamstown, Massachusetts.
Remington's picture of a solitary Indian warrior evokes a kind of stoic sympathy
for the lone rider facing the unknown army in the distance.

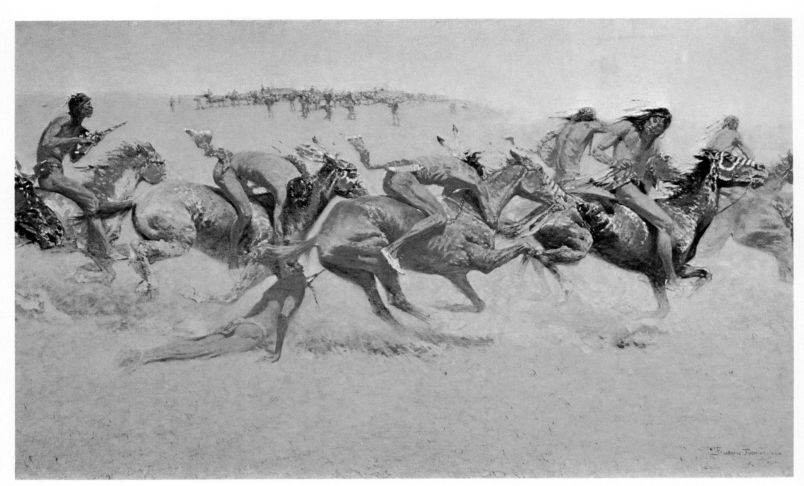

Indian Warfare, 1908, Frederic Remington. 29-1/2 x 50 in., oil.
Thomas Gilcrease Institute of American History and Art, Tulsa.
Remington often glorified the cavalry, but this painting is a whole-
hearted acknowledgment of magnificent Indian horsemanship.

Indian Warfare similarly is presented from the Indians' point of view, or, more accurately, from a point of view just the other side of the Indians, with the Americans beyond them in the distance. The infantry column has fallen into its customary position of defense when it is unexpectedly attacked. The wagons are drawn into a cluster on top of a rise in the ground. The troopers are deployed out from that center in a 360-degree perimeter, firing from standing or kneeling positions. The Indian tactic, familiar from a thousand movies and television shows, is to ride furiously around the defenders, shooting at them as the opportunity suggests and relying on their sheer speed to evade most of the counter fire.

The attacking Indians are also shown by Remington in the execution of a basic warrior's duty: Two of them are recovering, at top speed, the fallen body of a comrade killed in battle. From childhood, Indian warriors were instructed in this sacred obligation and they always ful-filled it when at all possible. Here two riders, assisted by a third, while all three are covered by the rifles of their comrades, are leaning from their mounts to secure the body from the ground by means of a rawhide rope.

The picture incidentally is a magnificent example of what Remington meant when he modestly boasted that "He knew the horse." The animals stretched and bunched across the foreground of the painting comprise a small encyclopedia of the movements and muscles of the horse.

They are as much a part of the execution of this com-plicated and difficult maneuver as their riders. Legs, flanks, necks, heads, manes and torsos are shown in the instant of greatest confusion, yet the penetrating vision of the artist, as well as his mastery of the subject, have or-ganized the confusion so that we undoubtedly can see it more clearly than the distant infantry or even the participants. Minor felicities appear everywhere in the powerful charge of horses. Between the leading horse that we see fully – the one whose rider holds the rescue lines with his right hand – and the next in line – the one whose rider leans over the far side of his mount to main-tain the lines – between those two there is a little, casual, momentary structure of space and form that is baroque in its conception, almost like the decorations on an Austrian church's altar or cupola.

Similarly, that second horse, the central one of the overall picture, is placed in the reverse of the movements of the horses directly ahead and directly behind, while at the extreme right and left of the picture, horses less vividly depicted carry on the normal running gallop. The rescue operation thus becomes visually what it was in fact, a daring interruption of the mighty flow of the group by three of its members for the sake of a fourth and for the basic, protective law of the tribe.

While this furious and precisely coordinated activity goes on the foreground, in the background the Federal

230

infantry, although engaged in a fire-fight, the essential event of ground combat, seems an island of calm repose in the midst of the Indian fury. The soldiers stand or kneel in the classical positions of the rifleman and take their shots as opportunity presents itself. The very wagons, looming behind the marksmen, add an air of stability and permanence utterly absent from the incredible Indian horsemanship being demonstrated at close view. And this, no doubt, is the final meaning of the painting. It is why Remington chose the infantry for the scene, rather than his beloved cavalry. The infantry's historic mission is to take and hold the ground, the cavalry's being to seek out and engage the enemy. The two arms work together – or rather, *did* work together, when cavalry was still a useful component of an army – and the two goals are often indistinguishable. But they are different goals and different types of soldiers. In classical warfare from Caesar to Eisenhower, the infantry stays.

Remington has made the point with great economy and with a wholehearted acknowledgement of the magnificent horsemanship of the passing foe.

The artist paid tribute to the cavalry in another work, one that eloquently shows the difference between Indians on horseback and the American cavalry, and this again makes the larger point that organization will normally win out over impetuous enthusiasm. Although working together in an intricate movement, the recovery of their dead comrade, the Indians of *Indian Warfare* were really individual warriors, incredibly skilled at what they did and brave beyond accounting, but still basically single fighters carrying on their single fights in company. In contrast, Remington's *Cavalry Charge Across the Southern Plains* shows the United States Cavalry in regular, steady, totally coordinated and disciplined advance.

The riders have not only mastered their assorted trades of riding and shooting and sabre-wielding, they have also mastered the more complex art of conducting themselves as a unit rather than as a collection of individuals. Here they are riding into battle at full gallop, but they are holding their fire, pistols cocked and held aloft, until they shall be close enough to their targets to be reasonably sure of hitting what they aim at. Here there is less virtuosity on the part of the horses and therefore the horsepainter, since the steeds, like their riders, are parts of an integrated unit, moving forward at an accelerating but always controlled pace. At a certain point in the approaching distance, we know, the pistols will be levelled and fired, cocked and fired again. A little later on, sabres will be drawn and slashed with. Casualties will be given and taken, but the discipline will hold, the unit will continue to advance, attack, regroup, perhaps withdraw, as a single being. Like the infantry's quality of taking and holding ground, so the cavalry's coherence contributed mightily to the winning of the West.

Cavalry Charge Across the Southern Plains, 1907,
Frederic Remington. 30-1/8 x 51-1/8 in., oil.
The Metropolitan Museum of Art, gift of several gentlemen.
This charge shows the U.S. Cavalry in wholly coordinated, disciplined advance.

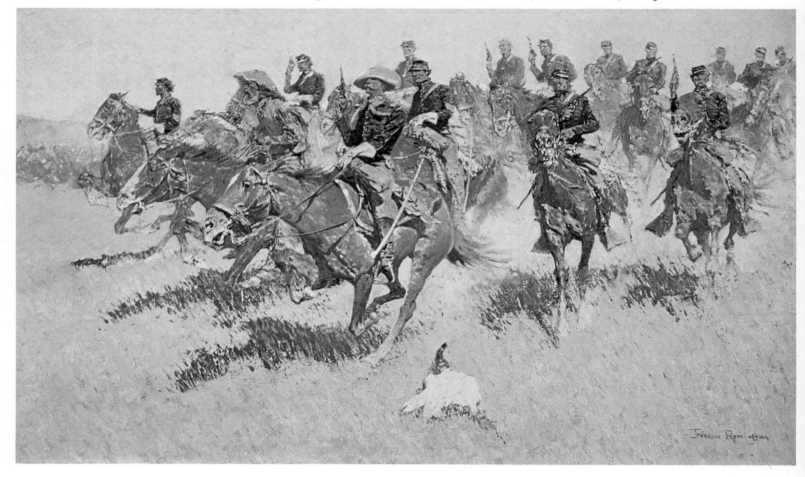

231

The end of all these gallant enterprises is shown in *The Battle of War Bonnet Creek*. The blue-clad soldiers remain in command of the field. There are dead soldiers, to be sure, but all the Indians in sight are dead and the line of troops is still alert. All are looking off to the right and while some are attending to fallen friends, most are watching the presumably retreating foe, prepared for a regrouping and a new assault. The scene, with its litter of corpses and wounded, puts us in touch with the grim reality of the wars on the Plains, a reality Remington wrote about constantly in stories, dispatches and private journals. The rock exposed in the foreground contrasts sharply with the soft textiles and flesh of the fallen. The rock is hard and enduring, like the winter, like the quality of life suffered by both the soldiers and their enemies. The winter sunlight through the clouds behind the group seems to hover over the standing soldiers like some sort of common halo, or perhaps simply a brightening of the dismal day as the battle ends or at least offers some brief respite.

Remington documented every aspect of life in the West that came to his attention and he did not fail to paint subjects that justified his country's campaigns against the Indians, even though he himself felt that no justification was needed, the containment of the "savages," as he often called them, being a self-evident good.

Immigrants is such a picture. With his instinct for drama, Remington chose for the moment of attack the entry of the lead wagon in the train into the waters of a river to be forded. The lead wagon is thus immobilized, unable to turn back, to join in a circle or in other measures of common defense. Clearly the attack has come on suddenly, for no such measures have been taken. Two files of mounted Indians have overtaken the slow-moving train, one on each side. The driver, already knee deep in water as he becomes aware of the threat, turns to face it with the only weapon available, the long prod he was using to move his oxen forward into the water. Attacked by lance and arrow, he seems to have little chance, but he makes his stand anyway and lifts his pole in opposition. It is this kind of situation that could only be saved by the arrival of the cavalry and it is this kind of ambush that led, in the years after the Civil War, to the spreading of cavalry posts all over the northern and southern Plains, complete with systems of keeping tabs on the progress of wagon trains, sometimes even offering them armed escort through particularly dangerous country.

The Battle of War Bonnet Creek, n.d.,
Frederic Remington. 26-1/2 x 39 in., oil.
Thomas Gilcrease Institute of American History and Art, Tulsa.
The grim reality of wars on the Plains was a constant theme
in Remington's writings and art.

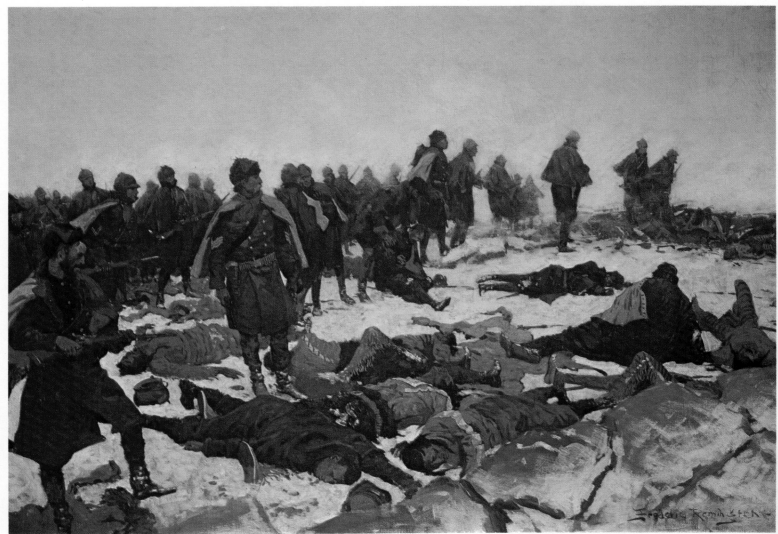

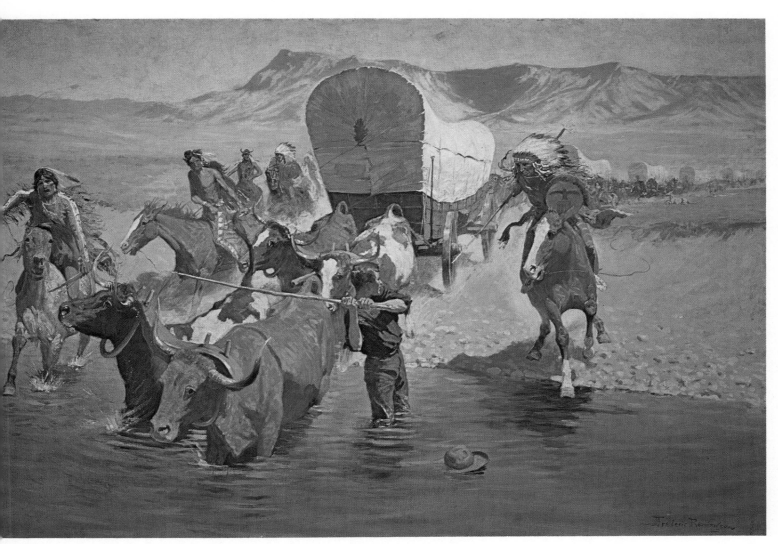

Immigrants, 1904, Frederic Remington. 30 x 45 in., oil.
The Museum of Fine Arts, Houston, The Hogg Brothers Collection.
This dramatic moment of attack leaves one to believe that only the
arrival of the cavalry can save the day.

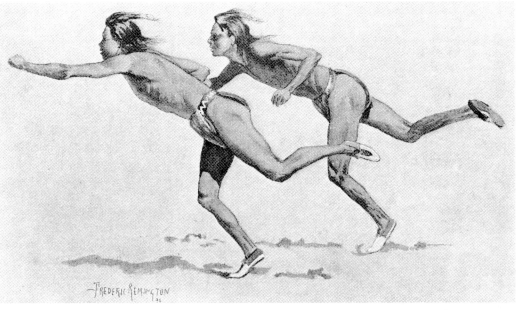

Indian Boys Running a Foot-Race, Dec. 1891,
Harper's Monthly, Frederic Remington.
Library of Congress.

233

The Fight for the Water Hole records another such incident of explanation of the Indian Wars carried on by this country against the native inhabitants of the Plains. Here five civilian men – cattlemen or buffalo hunters by the look of them – have retreated from Indians and set themselves up in defense around the rim of a sunken water hole. The attacking Indians seem spread out enough and few enough to pose no serious threat to the defenders barring a series of lucky shots. The defenders, for their part, enjoy the advantage of earth shelter. The Indians on horseback are fully exposed to the fire of the men in the hole; they, in contrast, have only their heads and shoulders open to Indian fire and are in a position to draw back completely from any sudden perceived threat of a direct aim.

Remington composes the action as well as the terrain into his overall arrangement. The cowboy lying at what would be eleven o'clock is firing, or has just fired, as we see from the cloud of pale smoke floating away from the muzzle of his rifle. The others are in various stages of getting ready to fire. The Indians have taken one visible loss, as we see from the riderless horse lying off to the right. A shot has just been taken at the defender closest to us, but it plugged harmlessly into the dirt a few feet

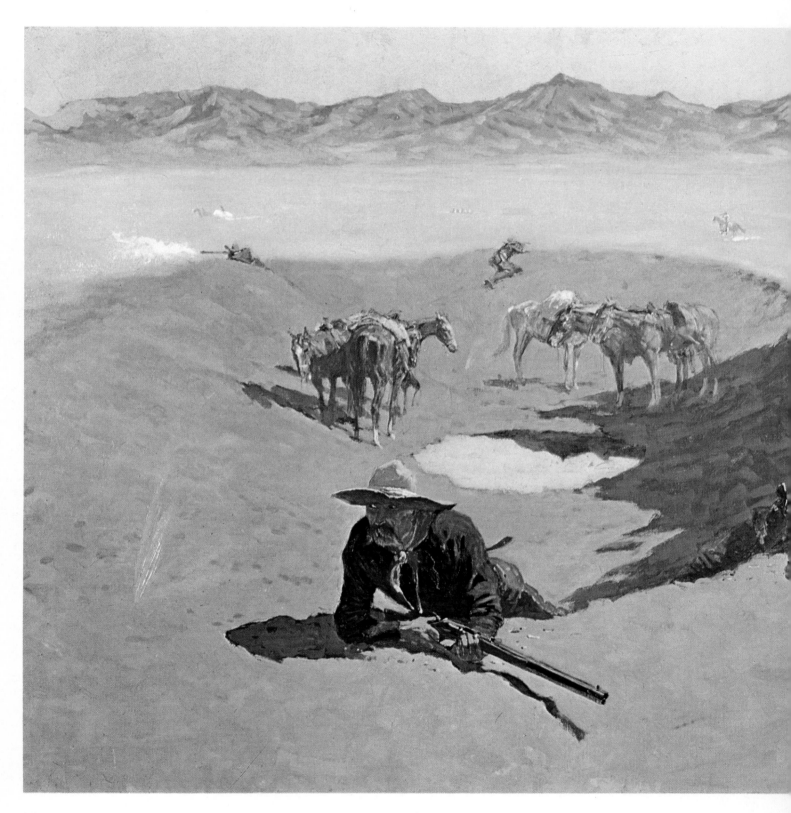

from his right elbow, kicking up the dust but not hurting him. As a result, he stares out into that hostile space with gimlet eyes. Meanwhile, at the center of this varied action, the horses, protected by the depth of the hole, stand about in good order until the fight shall be decided. The spreading khaki color of the Plain is interrupted by the cooler, slightly damp earth around the water itself, which, reflecting the blue sky, is the center of the composition. Almost like a backdrop, the impassive and rugged mountains rise majestically behind the small skirmish. Fighting off an Indian attack, their imposing presence implies, is a hazard of life in the West but the country itself is so big that such encounters are minor incidents.

As if to balance the long wars against the Indians that he followed and chronicled, Remington in *Howl of the Weather* recalled those earlier Indians of the American imagination and indeed of the American land. The rising winds and waters suggest the voyagers are fighting the mighty St. Lawrence, the great river of Remington's boyhood and the country of the Indians of James Fenimore Cooper. The bark canoe is propelled through the water with strength and sureness. The very qualities that make the craft so vulnerable to tipping when handled by ama-

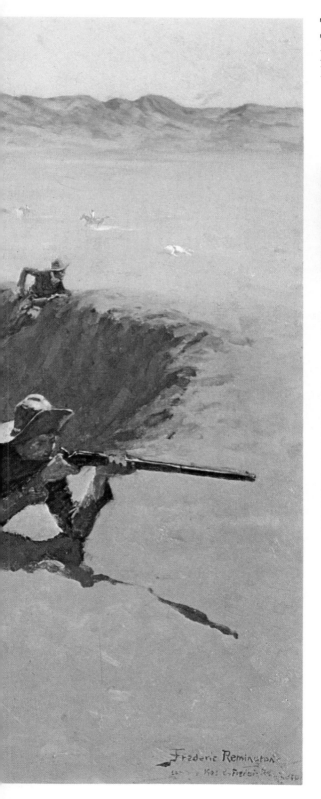

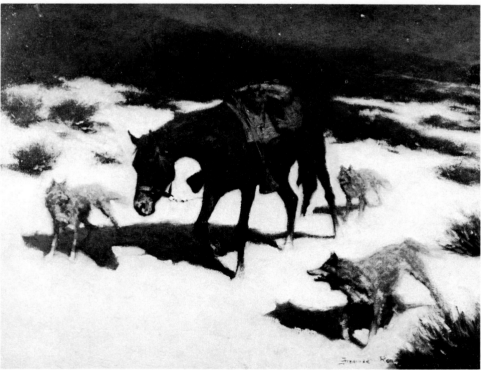

The Fight for the Water Hole, 1901, Frederic Remington. 27 x 40 in., oil.
The Museum of Fine Arts, Houston, The Hogg Brothers Collection.
Remington records one of the many incidents in the long
Indian Wars between white settlers and native inhabitants.

The Last March, 1906,
Frederic Remington. 22 x 30 in., oil.
Remington Art Museum, Ogdensburg, New York.

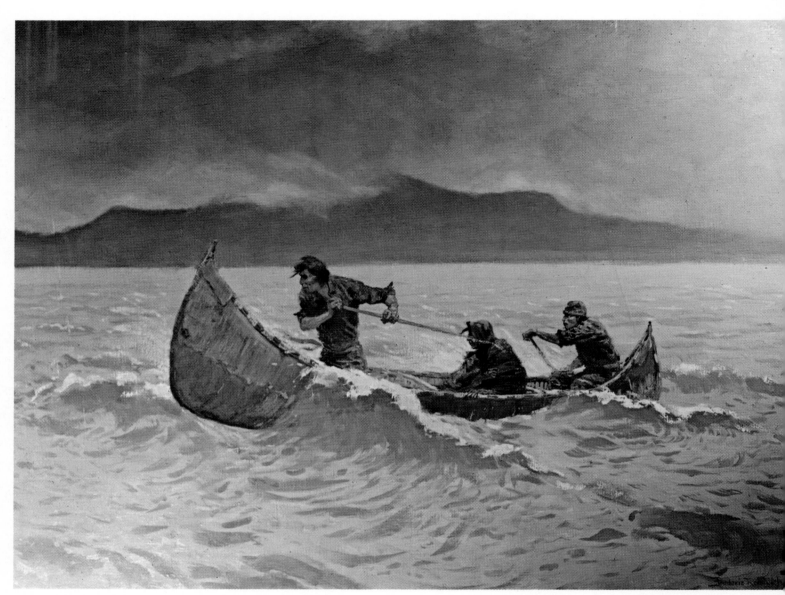

Howl of the Weather, ca. 1907,
Frederic Remington. 27 x 40 in., oil.
Remington Art Museum, Ogdensburg, New York.
These are the Indians of American imagination, before
their popular image changed during the fierce Plains wars.

teurs in wooded or aluminum vessels make it swift and reliable when paddled and steered by the Indians who invented it and who made it out of bark.

Interestingly, there is a similar relationship between the men at work, the flat surface that surrounds them and the distant mountains in this picture and the same relationship in *The Fight for the Water Hole,* but here the values seem reversed. The mountains here do not loom eternal, above the concerns of the gunfighters in the foreground and their Indian enemies riding around them. Instead, they are soft, relatively low and already blurred by the fog moving in with the bad weather. And the voyagers are not sheltering in their flat-surfaced environment, as the cowboys are in the other picture: They are mastering it. Straining at the paddles, eyes ahead for

changes in wind or current, the two men are, through their boat, a part of the force of the great river and at the same time the users, the rulers of that force—although they clearly know very well that the force, if turned against them, could destroy them. In the middle of the canoe the mother and daughter do not so much huddle together as hold themselves close to maintain the balance of the volatile vessel.

The subject of Western painting, like the subject of Western fiction, Western movies and Western television shows is, in the popular imagination, "Cowboys and Indians." The easy juxtaposition is annoying to people who know the literature and the art because in fact those two kinds of people only occasionally figure prominently in the same work. Catlin, for example,

A Fantasy From the Pony War Dance, Dec. 1891,
Harper's Monthly, Frederic Remington.
Library of Congress.

**The Ghost Dance of the Oglala Sioux at Pine Ridge Agency,
Dakota, Dec. 6, 1890,** *Harper's Monthly*, Frederic Remington.
Library of Congress.

The Coming and Going of the Pony Express, 1900,
Frederic Remington. 26 x 39 in., oil.
Thomas Gilcrease Institute of American History and Art, Tulsa.
Though it only lasted a year and a half, the Pony Express
commands a notable place in American historical imagination.

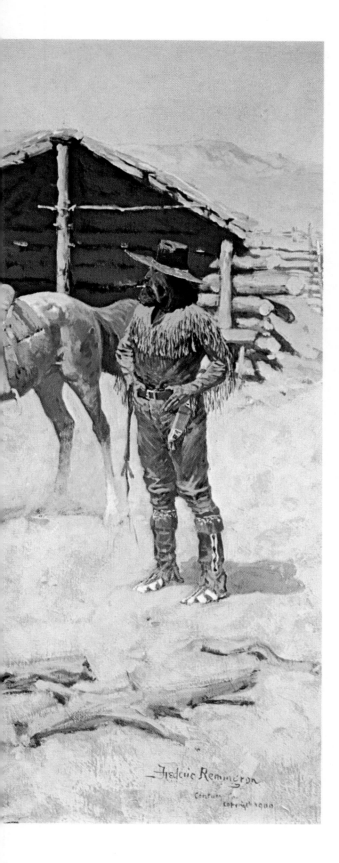

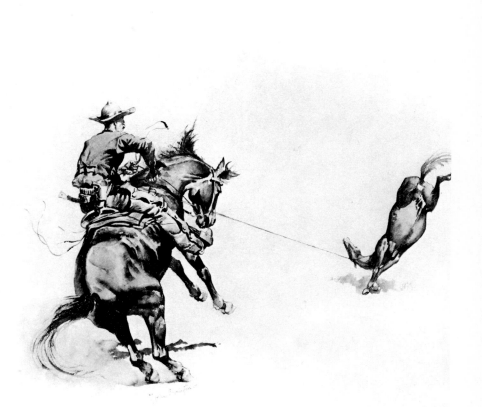

Reaction Equals Action, n.d., Frederic Remington, wash drawing. Rockwell Gallery, Corning, New York.

painted Indians long before there were any cowboys—although the cowboy's predecessor and model, the *vaquero,* was long established to the south of Catlin's territory.

Even in fiction of the cheapest kind in any of the forms—print, film or cathode ray—the cowboy is normally engaged in competition of one sort or another with other cowboys: Rivals for a girl's love, for range land, for a herd of horses or whatever. The Indians, on the other hand, in the same sort of fiction, are engaged in a losing fight for their land against the immigrants, as in Remington's painting of that title, or against the United States Cavalry, as in any number of his paintings.

In accord with the reality of the situation, Remington normally kept the two breeds apart, but he certainly painted plenty of pictures and fashioned some first-rate sculpture on the theme of the cowboy.

The kind of rider who made a good cowboy is depicted in his painting, *The Coming and Going of the Pony Express.* The Pony Express is remarkable for the place it still commands in the American historical imagination despite the fact that its total lifetime was just a shade over a year and a half. The runs began in April, 1860, and the

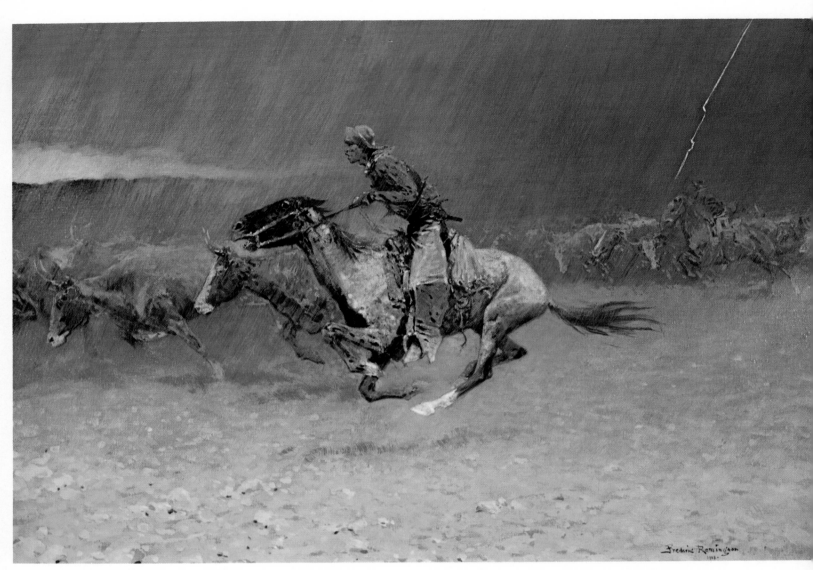

Stampeded by Lightning, 1908,
Frederic Remington. 27 x 40 in., oil.
Thomas Gilcrease Institute of American History and Art, Tulsa.
The cowboys' expert riding is the theme of this famous work.

service was discontinued in October, 1861, with the completion of the transcontinental telegraph. The idea, of course, was to get mail from the fringe of established settlement, namely St. Joseph, Missouri, to the equally established American settlements in California, especially San Francisco. After six years or so of careful planning, a series of posts or stations was set up, most of them like the one shown by Remington, a crude cabin and a sturdy corral, in which were kept the ponies between riders. The stations were as close as fifteen or twenty miles. At the stations, the rider normally kept going, the horse, or pony, was exchanged. An express rider was expected to bring his mount to a halt, leap to the ground, take his saddlebags of mail, throw them on a fresh steed, get into the saddle and race out of the station, all in a maximum of two minutes.

The express service, a private enterprise with some government subsidy, although brief, was an important link in the chain that Western expansion was forging to bind the growing country together. Stage coach service had existed prior to the Pony Express and continued afterward to be the principal transportation until the railroads

were completed. But the express concentrated on communication and for a brief eighteen months created a service that ranks in memory with the couriers of the Roman Empire, the road-runners with their knotted strings in the Inca Empire and the intrepid flyers, who, a mere sixty years or so later, followed the Pony Express in carrying the U.S. Mail.

Remington obviously never saw a Pony Express post in operation, since the telegraph link was completed about three weeks after the artist was born. Some scholars of Western history have taken mild issue with his details, notably the fore-and-aft saddle bags. But Remington quite likely met up with older cowhands or cavalrymen who had ridden the route in that hard-riding year and a half. The original advertisement for riders, appearing in San Francisco a month before the service started, is one of the most famous ads of all time: "WANTED: Young skinny wiry fellows, not over eighteen. Must be expert riders willing to risk death daily. Orphans preferred. Wages $25.00 per week. Apply, Central Overland Express." The job qualification specifics pretty well fit the cavalry of Remington's day, except for the age limit, and the same men, grown older, could easily have become cowhands.

At any rate, Remington has perfectly captured the sheer speed of the service. Typically, he has picked on the one moment better calculated to show that speed than any number of views of the riders racing through desert or along mountain trails. The rider is changed and mounted and goading his horse to leap forward out of the post, back on the trail, before his earlier mount has even begun to be stripped of its saddle and bridle to be watered, fed and rested for its next run. Against the sandy dust of the whole landscape, including the roof of the station, the riders and the rest of the employees, the men stand out in darker tones of the same brown-gold. They appear almost like the platform of a rocket launching, all their attention turned toward the departing rider, who springs from the post like a projectile—young, skinny, wiry, an expert rider.

Expert riding of a more complicated kind is the theme of one of Remington's most famous cowboy pictures, *Stampeded By Lightning.* The scene is one of the great trail drives, already passing out of existence when Remington roamed the West. The drives followed round-ups on a vast scale and took thousands of head of cattle from the range and the ranch to railheads for shipment or, in the earlier years, all the way to the slaughterhouse cities.

The artist wrote of this picture, "Man was never called on to do a more desperate deed than running in the night with longhorns taking the country as it came and with the cattle splitting out behind him, all as mad as the thunder and lightning above him, while the cut banks and dog holes wait below."

The composition is at once subtle and powerful. The only conventional device in the arrangement is the play of the three principal lights: the thin, intense bolt of lightning in the rear right, the murky opening of a still distant dawn off to the left and the green and golden light of the immediate foreground. These three lights give the picture the only formal organization it has.

The thundering herd is a great mass stretching out to the background, without any limits even suggested. Two cowhands are working the herd and the one in the center is the focal point of the picture. Although his comrade to the rear seems to be more actively engaged in turning a part of the herd, the center figure is riding as fast as he can, presumably to get to the head of the charging, panicked animals, the only place it is possible to begin

to control a stampede. Yet the cowboy himself is not painted as the center of the picture; his upper body is a somewhat darker green than the same green of the rain and the sky. He is part of that rain. The most juicy painting and the most sparkling lights are reserved for the flanks of the galloping horse, with some of it reflected on the creases of the cowboy's chaps. The horse is also portrayed as Remington stubbornly insisted was the truth—in full flight with all four feet off the ground simultaneously.

At the moment of stampede, the cowhand combined many of the skills of the Pony Express rider and the cavalryman, as well as those of the Indian warriors on horseback, and Remington had blended them all in this lasting image of the cowboy at work.

The cowboy at play was also a natural subject for Remington. The artist was perhaps the most convivial painter since Frans Hals. He liked nothing better than eating and drinking in the rough company of a crowd of cowboys or cavalrymen off duty. At times he sipped whisky gently all through the day, maintaining an easy balance between the brush and the bottle. At others, he was capable of swearing off and measuring his progress as the dry days passed, writing to a friend that his next drink would come only when the doctor assured him his end was at hand: At that point, said Remington, he would take one dry Martini and prepare to mount the Golden Stairs.

The Misdeal, Barroom Scene portrays the end of one session of cowboy conviviality, an end not at all unusual, according to the painter. He wrote:

"It is more than likely that in Montana, Arizona and New Mexico, where cards are played for money by ranchmen, horse rustlers, teamsters and cowboys, kites and hawks are numerous, while pigeons to be plucked are comparatively rare birds. . . . Apart from the skill of the professional and his perfect knowledge of the ways of playing the game, long practice has enabled him to increase his chances by the cleverest tricks of legerdemain. . . . Nimble fingers pass the cards, and flushes and straights upset all the calculations of chances. A hidden card, produced at the exact nick of time, makes 'four of a kind' and the pot is raked in. . . . Sometimes, however, there comes a player who . . . knows all those ways which are crooked, . . . is quite prepared for the double stake—his life and his dollars. . . . Before he went into

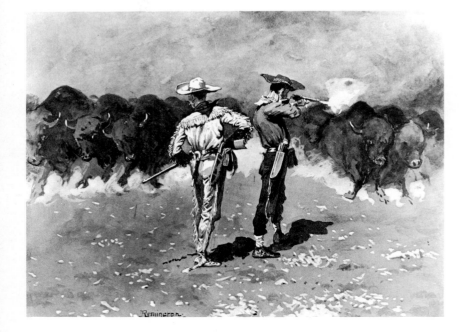

Splitting the Herd, 1889,
Frederic Remington, wash drawing.
Rockwell Gallery, Corning, New York.

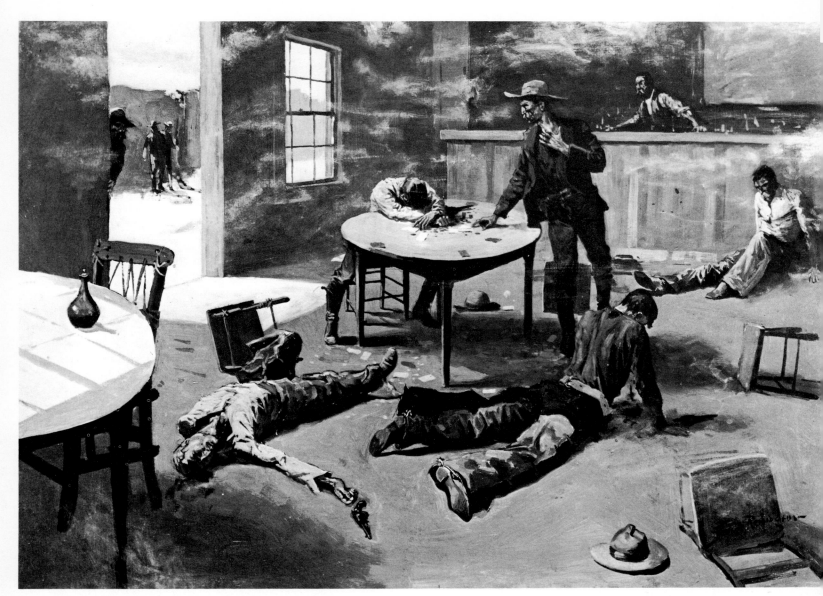

The Misdeal, Barroom Scene, n.d.,
Frederic Remington. 24 x 36 in., grisaille.
Collection of Mr. and Mrs. Hal Wallis.
This work is representative of the many black and white oil
paintings Remington made throughout his career.

that nest of thieves, he saw that his revolver was in prime
order, sweet of pull, and with no hitch about it."

He concluded: "The papers tell of it briefly: 'A team-
ster killed a gambler over a game of draw.' Or it may be:
'A gambler shot a cowboy dead at poker.' You can pack
in a whole drama and the end of a life easily enough
in eight or ten words."

This remarkable picture, painted entirely in blacks,
whites and grays, shows the end of such a game of cards.
There have been two sudden deaths, two seriously
wounded men. The bartender, back on his feet, has just
started around the bar to clean up the mess. From the
street a few passersby, attracted by the shots, are begin-
ning to have look at the scene. At the table the winner of
both the game and the shooting match points to the
cards that support his winnings and justify his actions—
although such actions mostly justified themselves.
Around this central figure, Remington has composed an
ellipse of the dead and the dying and an outer arc of the
bartender and the people still on the street. The sun-
light of the street contrasts with the gunsmoke hanging
in the air of the saloon. That contrast is heightened by
the bright light from an unseen window casting its squares
across the round table in the left foreground.

The picture is as laconic in its statement as the news-
paper clippings cited by the painter: eight or ten words,
or a few tones of black and gray against a few
more of white.

It may be that Remington's very conviviality led to his
early death. As a jolly fat man he ate everything that
came within grasp and sent out for more. His final illness
was sudden and short and he died the day after Christmas,
1909, at the age of forty-eight.

Had he had the score of working years more he might
reasonably have expected, he would certainly have
expanded his picture of the West in paint and in bronze.
Yet the time was ripe for his going, early as it was. The
West of the open range and the trail drives was finished
by 1909 and Remington knew it and regretted it. Five
years after his death, in the beginning of World War I,
it became clear that his other great love, the cavalry,
was finished, too. He was spared that knowledge.

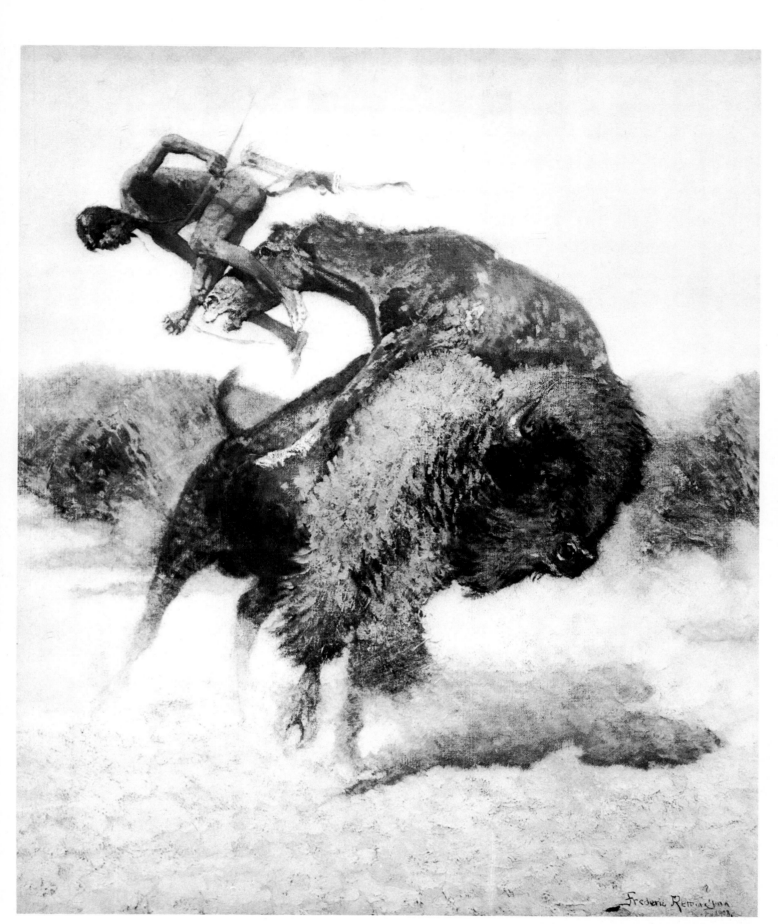

An Episode of the Buffalo Hunt, 1908,
Frederic Remington. 28-1/2 x 26-1/2 in., oil.
Thomas Gilcrease Institute of American History and Art, Tulsa.

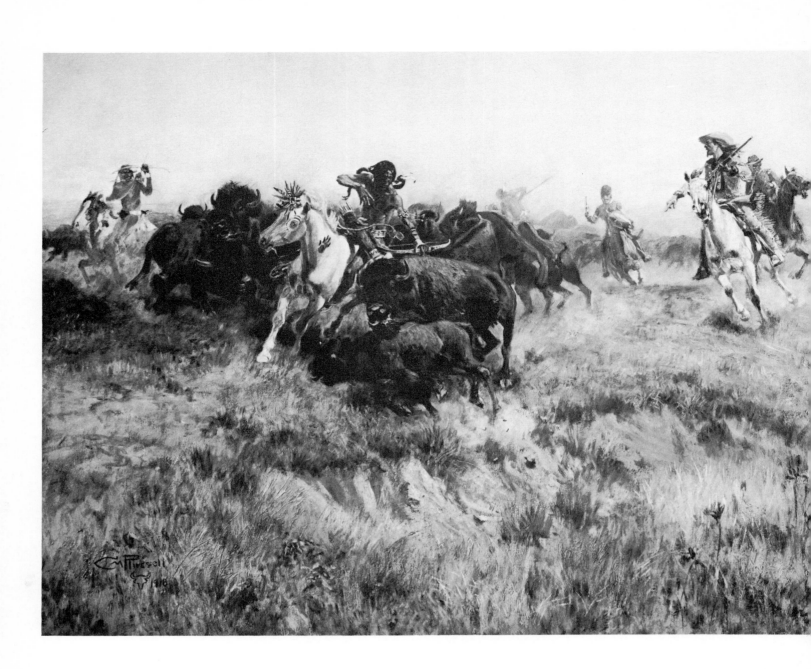

THE BEST OF THE COMPANY

Charles Marion Russell

(1864—1926)

Charley Russell stands all alone on the roster of Western artists on a couple of counts. The first is simply that, by almost universal acknowledgement, he was the best of the company. Remington is often cited as a near equal, and for many the classification of Western art means only a kind of hybrid, Remington-and-Russell, spoken as one word and thought of as essentially a single painter or sculptor. But except for Remington, no one in the field approaches Russell on the score of either quality of portrayal or inclusiveness of the world of the West portrayed.

His second distinction relates to the first because it serves to explain it. This is that Charley Russell is the only Western artist who was an authentic Westerner, a practicing, working, livelihood-gaining cowboy long before he seriously thought of himself as an artist of any sort at all.

From Catlin to Remington, the artists of the West were artists who went West with the specific purpose of painting that land and its people. Some, like Bierstadt, were drawn West because the grandeur of the land corresponded to the heights of their own artistic ambitions. A more pervasive purpose, again from Catlin to Remington, was to preserve a way of life that seemingly had the seeds of its dissolution apparent almost from its beginnings. Catlin in the streets of Philadelphia saw that Indian delegation and knew, at sight, that they represented something bound to vanish from the earth, something worth preserving in art. Remington expressed the same feelings and so did many of the artists in between. For that reason, they went West, to experience and to record an experience they knew to be unique, valuable and passing.

Russell lived through the ending of the Old West, the open range and the great cattle drives. He saw the prairie

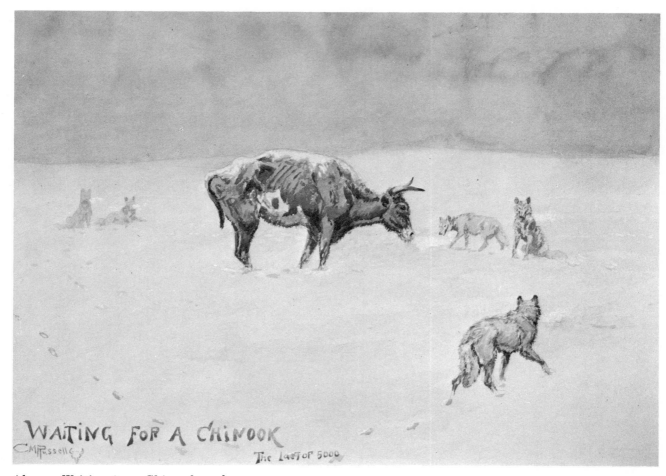

WAITING FOR A CHINOOK

The Last of 5000

Above: Waiting for a Chinook, n.d.,
Charles Russell. 20 x 29 in., watercolor.
Whitney Gallery of Western Art, Cody, Wyoming.

Left: Running Buffalo, The Buffalo Runner, 1918,
Charles Russell. Thomas Gilcrease Institute
of American History and Art, Tulsa.

grass nibbled down to its roots by sheep. He saw the prairie itself fenced in by homesteaders. He saw the whole cattle industry, for its own unavoidable reasons, change away from the free and wild toward the orderly and planned. Raising cattle had always been a business, of course, from the Spaniards on down. But in Russell's lifetime it became a big business, with less and less room for the maverick, the loner, the man who went on his own way on horseback over half a continent.

Like all the Western artists, therefore, Russell always lived with the sense that something precious, something that he loved, was steadily passing out of existence, being replaced by new ways and new people he didn't much care for. But while for most of the others, what was passing was an attractive and exotic way of life "out there," something one would go to see as one went to see Venice or Vesuvius, for Charley Russell, what was passing was his own life, his people and his places.

Russell was born and brought up in Oak Hill, Missouri, about seventy miles southwest of St. Louis. With his four brothers and one sister, the boy attended the local schools and didn't like them. He liked sketching and drawing and modeling in mud, the only material available. His grades at school were so alarming that in 1879, just after Christmas, he was sent East to military school, a course then and for decades afterwards resorted to by desperate parents in the belief that the discipline of the mini-military life might straighten out a wayward boy. No doubt it did for many. On Charley Russell it had no discernible effect at all. He spent most of his time at Burlington College, New Jersey, walking guard duty as punishment for pranks and all-around lack of attention to his work. He was there for one term and that was the end of his schooling.

Back home, he wrangled permission to travel to Montana in the company of Wallis Miller, a friend of the

245

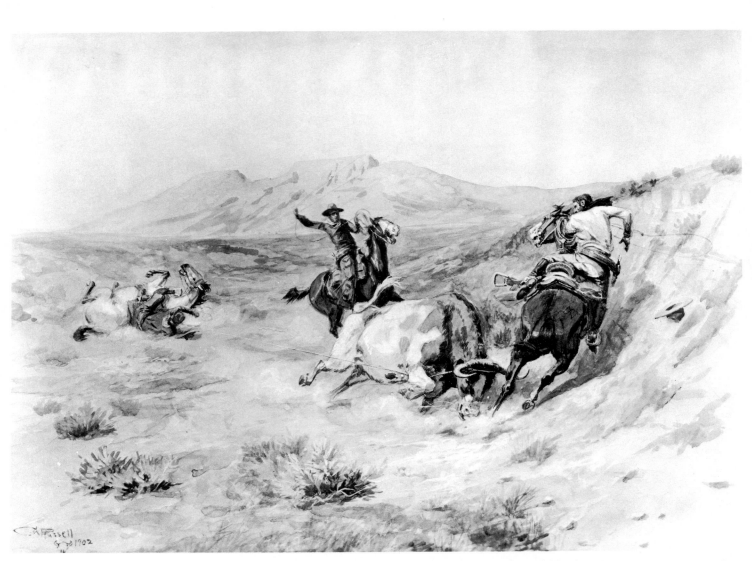

One Down and Two to Go, 1902, Charles Russell, watercolor.
Rockwell Gallery, Corning, New York.

family. The theory apparently was that a summer in the West would relieve the boy of his urge to roam and, with the coming of autumn, he would settle down to serious work at his studies.

He was never to sit in a school room again. The pull to the West was not the "wanderlust" his parents thought. Indeed he had inherited that pull through them from earlier members of the family. In 1828 four great-uncles of his, Charles, William, George and Robert Bent had built a fort on the Arkansas River that became famous in the history of the region; for some time before that they had been successful trappers and traders in the region, thus participating in the first entreprenurial penetration of the West by the Anglo-American young Republic. Something about the family tales had caught the youngster at an early age. When he went to Montana, he was not going out to the edge of civilization: He was coming home.

And home he went, reliving the family experience. His partner on the trip out was half-owner of a sheep ranch, and the sixteen-year-old Russell's first job in the West was working the sheep. He did not like them, instinctively adopting the cowboy's attitude toward the wool-bearers and their owners. The boy moved on to a kind of appren-

ticeship to Jake Hoover, a trapper in the tradition of his great-uncles, the Bent brothers. He worked for Jake for two years, absorbing in the process the techniques, the life, the suspicions and manners of the earliest form of Anglo-Western man.

Russell then returned to St. Louis for a visit and headed back for Montana with a cousin who contracted mountain fever and died two weeks after their arrival in Montana. Russell headed out of Billings hoping to find Hoover. Instead, he encountered an outfit of cowboys picking up a thousand head of cattle to drive back to their ranch. Charley signed on as a nightherder "and," he says in some autobiographical notes, "for the next eleven years I sung to the horses and cattle."

In the course of those eleven years, Russell learned all there was to learn about punching cattle and the assorted trades associated with punching cattle. He rode in the big round-ups and he drove herds to market. He participated in the peculiar folk art form of the cowboy, the rodeo. He knew how to brand a steer, to search out and minister to a sick or wounded animal, to cook out of a kitchen you carried in your bedroll, to work hard for long hours over extended periods and then to pick up the

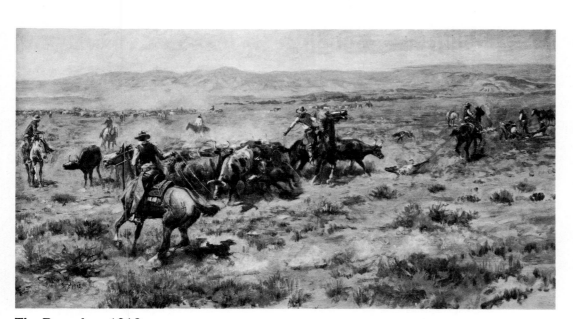

The Roundup, 1913,
Charles Russell. 25 x 37 in., oil.
Montana Historical Society, MacKay Collection.

Idaho Oxen Team, n.d., Charles Russell, pen and ink drawing.
Rockwell Gallery, Corning, New York.

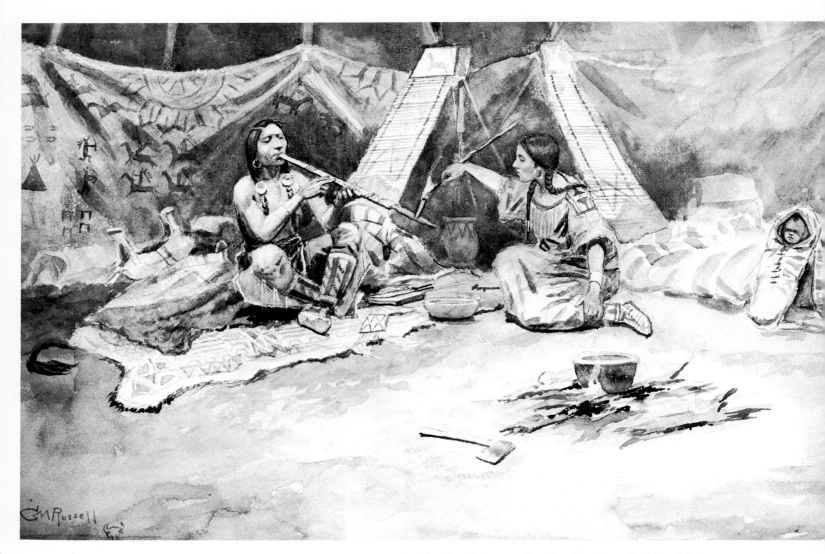

Inside the Tepee, n.d., Charles Russell. 16 x 24 in., watercolor.
Thomas Gilcrease Institute of American History and Art, Tulsa.

pay, hit the town, and play cards and drink whiskey until dawn.

It was a pleasant life for a young fellow in the West and hundreds followed it. Charley Russell, however, had already begun to make himself a second life alongside the first. From his earliest days as a cowboy he continued his boyhood habit of modeling figures in clay and he added the practice of painting the country he loved, the life he lived and the folks he knew. As nightherder, which was his most steady occupation as a cowboy, he had his days pretty much to himself not only because his own work was done, but more importantly because everybody else was out doing the daytime work on the herd. With the time and the solitude, his natural bent for art came out and dominated his days throughout that period, even despite the lack of any kind of instruction, any kind of other art to study and even any reliable source of the proper materials. He drew on cheap paper, he painted on wood and some of his earliest works were executed in housepaint—a use of materials hailed as a "breakthrough" when it was done by New York Abstract Expressionist artists some sixty to seventy years later, but which, for Charley Russell, was simply the logical thing to do when nothing better was available.

The youth also added one other experience of the West to his store of images and movements out of which all his art was to come. In the spring of 1888, Charley headed north with a friend, "Long Green" Stillwell, who got his nickname from his prowess at dealing faro, an ancient European card game that became briefly "the American national game" in the West. They rode into Canada, visited old friends and made new ones among the settlers along the High River. In September, with the advent of the first chill winds, they headed back to the States. In crossing the reserve—as the Canadians call their reservations—of the Blood Indians, Charley accepted the invitation of the chief, Black Eagle, to spend the winter with the tribe. Stillwell went on back to Montana, but Russell spent the winter with the Bloods. Those six months—he left in March—gave Russell an experience that no American artist of the West had had since Catlin traveled by canoe and on horseback half a century earlier, several hundred miles to the south. He lived with the Indians through the sparse winter, sharing with them the unique American life closest to earth and to nature. There is little doubt that his half year with the Bloods made

Russell permanently more sympathetic to the Indians—even when depicting them as horse-stealers and attackers of wagon trains—than any American Western artist except Catlin.

When he came back from Canada in the spring of 1889, the year Montana gained statehood, Russell found himself mildly famous in the new state. For some years he had been exhibiting his paintings in the windows of saloons in many parts of the territory and now it began paying off. The sense of identity conferred by statehood may have had something to do with it, but at any rate Montanans began to be proud of having their own state artist, as many of them had for some time been intrigued by the portrait of the new state emerging in Charley Russell's work.

Montana had been a very mixed bag politically when Russell first arrived there. It had been legally part of the Spanish territories in the New World, but as far as is known, no Spanish explorer, conquistador or missionary ever made it north of Great Salt Lake or what was later named Pike's Peak. Napoleon picked up the eastern three-fifths of Montana from Spain but held it a very short time, selling it to President Thomas Jefferson in 1803 as the northwesternmost part of the Louisiana Purchase. The rest of the future state was part of the Oregon territory, disputed between the United States and Britain, then part of the Washington Territory, then part of the Dakota Territory, then part of the Idaho Territory before becoming the state of Montana.

The state was also and still is extraordinarily beautiful. As the name implies, the state has its mountains and they appear in the purple distance of many a painting by Charley Russell. But Montana's mountains are, taken all in all, lower and gentler than those of Wyoming, Colorado and Utah, for the Rockies decline as they approach Canada, despite formidable individual peaks in Montana, such as Mount Evans and Mount Jackson. They thus do not form the impenetrable barrier of the Rockies to the South. The Pacific winds, soft and warm, flow easily across these rises and into Montana, moderating the climate almost to the eastern border of the state. The eastern edge of the Rockies and the western end of the Great Plains combine in Montana to create the most equable and pleasant climate of all the mountain states.

The Ambush, ca. 1897, Charles Russell. 24 x 36 in., oil. Courtesy of The R. W. Norton Art Gallery, Shreveport.

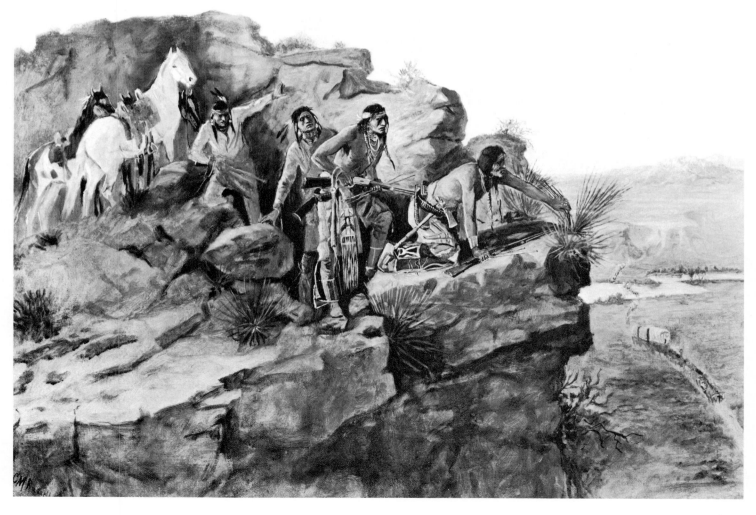

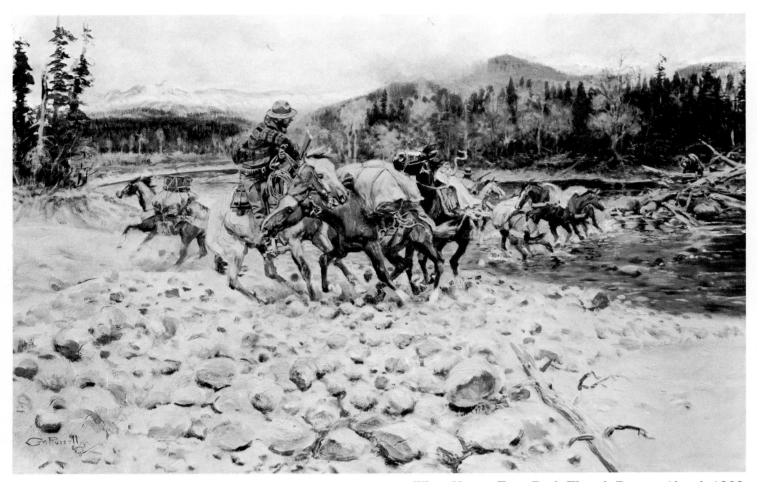

When Horses Turn Back There's Danger Ahead, 1922,
Charles Russell. 30 x 48 in., oil.
Courtesy of The R. W. Norton Art Gallery, Shreveport.

Winters in Montana can be severe, but there is always the possibility that they will be broken at any time by the chinook, the warming western wind which melts the snow and reveals the grass to cattle.

Montana's motto is "the treasure state," and that proud title refers to an aspect of the state's life that Russell, the state's artist, hardly took notice of in his paintings and sculpture, the mines and the metals underground that caused the mines.

Like much of the West, Montana began its life in the Anglo-American union as a fur-trading region. Fur-traders are solitary people, traveling by foot, by horse and, most often, by water, dealing quietly with the native residents, causing no trouble, taking their profit and passing on. Settlement in the Bitterroot Valley became more extensive in the decade before the Civil War, but it was during the war that a series of gold strikes really attracted settlers in large numbers. Toward the end of the war the future capital, Helena, then known as Last Chance Gulch, was founded as a mining camp around a rich vein of gold.

It was because of the gold strikes and consequent settlements that stock-raising and agriculture began in western Montana, where the mines were, and gradually moved to the east. Two other developments gave great impetus to the rise of the cattle business in the state: the successful "pacification" of the Indians, which was complete by 1877, and the completion of the railroad that ran all the way across the state and that linked the West Coast and Chicago.

The Indians made their last big stand in 1876 against General Custer's cavalry on the Little Big Horn River. At issue was a clear violation of treaty-protected territory by the invading miners. The Sioux won a devastating victory over Custer, but in the process lost so many braves that they were never again a serious threat to Anglo-American settlement in Montana. The last gasp, in the following year, was led by Chief Joseph of the Nez Percé Indians. He managed one all-out battle in the Big Hole country of southwest Montana, led a masterfully organized retreat across a thousand miles, but, outnumbered and outgunned, was surrounded and captured in the Bear Paw mountains before he could escape to Canada.

The first great trail drive of cattle from Texas to Montana took place as late as 1869. Montana cattlemen made their first use of the railroad by trail driving cattle to railheads at Ogden, Utah, and Cheyenne, Wyoming. The completion of the Montana stretch of the Northern Pacific, which was accomplished from 1879 to 1883, made Montana a factor in the national beef market, as it has been ever since.

Such, then, were the cataclysmic changes in Montana life and particularly in Montana cattlemen's life that were going on during Charley Russell's early years as a cowboy. Arriving in the territory early enough—1880—

to work with one of the last of the trappers, Jake Hoover, an original "mountain man," Russell worked as a cowboy through the years of that trade's most spectacular growth in Montana. In his writings and certainly in his art, he appears hardly aware of these monumental changes. His attitude seems to be that herding cattle was always the main business in Montana, one threatened by homesteaders and their agriculture and by sheepherders with their small animals cropping the growth right down to the dirt. Actually, sheepherding was established and flourishing in Montana well before the first cattle arrived. The railroad hardly exists in Russell's art, though the explosive growth of the cattle business during his first ten years in Montana stemmed directly from the steel rails laid across the Great Plains and curving through the mountains. Although mining occasioned the first important settlement of Montana as well as the first ventures in cattle-raising, and although mining today ranks second only to agriculture and stock-raising in the state's economy, it, too, is barely perceptible in Russell's view of Montana. The mines get in only at second- or thirdhand in the various activities of card sharks, saloon hands and highwaymen.

In a way this is fair enough. The gold in Montana mines was quickly exhausted in the course of bringing great and sudden wealth to the territory. Silver went much the same way, leaving mining represented chiefly by the great copper deposits in the Anaconda range. Copper mining, from the earliest days of history, has been a useful and necessary business but never a wild and romantic one, like gold and silver. Copper in Montana as elsewhere was an industry and Russell was not painting industries. He was painting a way of life that he lived himself and found to be challenging, exhilarating, dangerous and immensely rewarding.

That life stayed in him and in his work far longer than he stayed in the life, although throughout his career he considered himself a cowboy who painted and sculpted rather than the other way around. What happened to Russell was that he fell into the hands of a good woman. She was probably the making of him as an artist, but in the process she inevitably curtailed his cowboy style,

Where Fools Build Fires, 1919, Charles Russell. 30 x 50 in., oil.
Courtesy of The R. W. Norton Art Gallery, Shreveport.

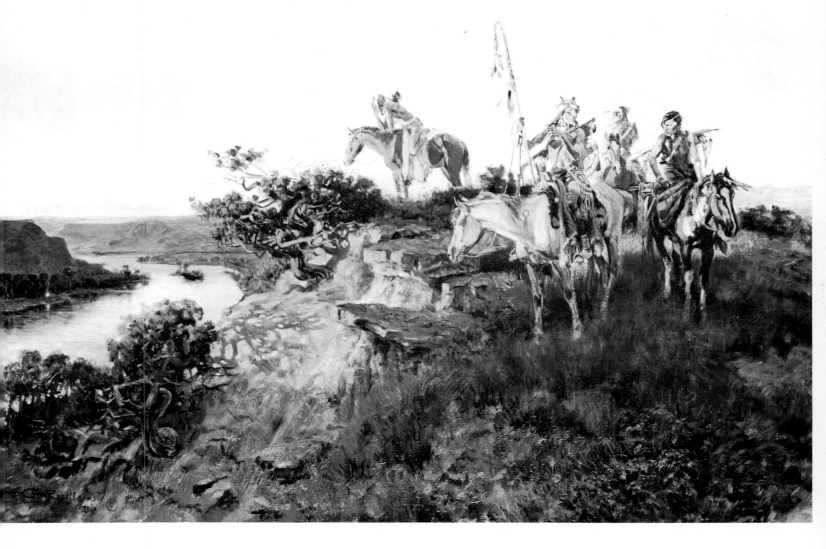

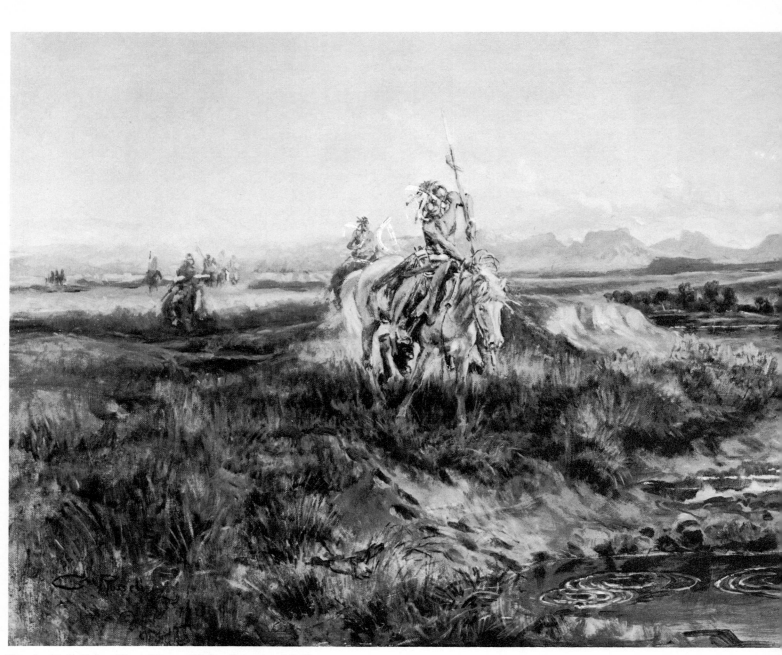

Tracks Tell Tales That Rivers Make Secrets, 1926,
Charles Russell. 18 x 30 in., oil.
Courtesy of The R. W. Norton Art Gallery, Shreveport.

keeping him off the range, largely off his horse and to an astonishing extent, off the bottle.

Returning from Canada to find himself something of a regional celebrity as "the cowboy artist" due to his exposure in saloon windows and on saloon walls, he pursued his art more determinedly than before. He was still cowpunching along the Milk River, but in 1890 he published *Studies of Western Life,* a portfolio of a dozen reproductions of his paintings. He also spent some time with his old trapper friend, Jake Hoover, in Jake's cabin. At the end of the 1893 round-up, Russell was one of his outfit's cowboys selected to ride with the stock train to Chicago. He took in the World's Fair and went on to St. Louis to visit his parents. While there he also visited a St. Louis hardware and kitchenware manufacturer, William Niedringhaus, who had invested heavily in Montana cattle and on whose ranch, the N Bar N, Russell had occasionally worked. The hardware man, aware of Russell's reputation as an artist, commissioned him to paint a series of paintings on cowboy life, leaving the specific subjects up to the artist and leaving the price open.

That commission marked the end of Russell's life as a cowboy. He was twenty-nine years old and ready to take up life as a professional artist specializing in Western subjects. He had sold paintings before this, but had done so irregularly and haphazardly, regarding the money received as a kind of windfall, like finding a goldpiece in the street. On occasion he even felt slightly ashamed, it would seem, for taking money for doing what he liked so much. Years later he recalled an early sale of two pictures to a stranger in a saloon: "I thought I'd hit him good and hard, because none of the boys had any money. Grass hadn't even started on the ranges and our saddles were in soak, so I said, 'Fifty dollars,' and I'm a common liar if the fellow didn't dig out a hundred dollars and hand 'em over. He thought I meant fifty dollars apiece, you see. I got crooked as a coyote's hind leg right away. I just bought the fellow a drink and kept the rest. He don't know to this day how bad he beat himself."

252

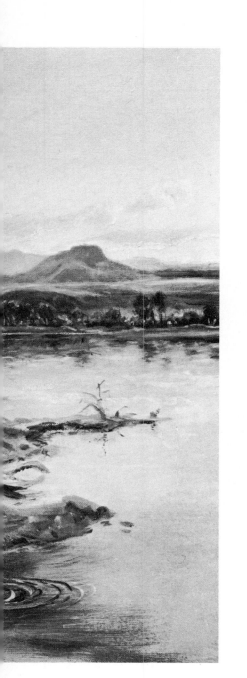

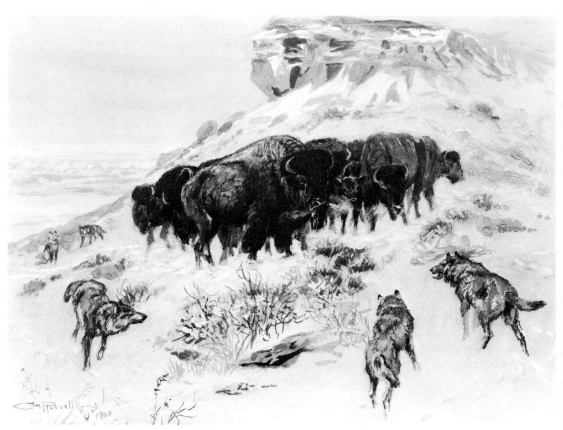

Above: **Time Running Out** — **Buffaloes**, 1903, Charles Russell.
13 x 9-1/2 in., black and white oil.
Rockwell Gallery, Corning, New York.

With the Niedringhaus commission, however, Russell felt no such compunction, possibly because he had worked for the man already as a cowhand and was used to getting paid by him.

Back in Great Falls, he found very quickly that the temptations and companionship of the town's saloons were too much for his high artistic resolve. Greatly to his credit, because he dearly loved the easy carousing and the cheerful company of his cowboy friends, he moved for the winter to Cascade, a smaller town some twenty miles up the Missouri River. There he set up a studio in an unused courtroom and got to work on the Niedringhaus commission, painting, over the years, more than fifteen paintings for that family.

After the winter and the successful completion of the first part of the continuing commission from the St. Louis rancher, the new professional artist moved back to Great Falls, now established in the habit of working for himself on his painting as conscientiously as he had always worked for men like Niedringhaus as a cowhand.

Or so he thought. Another close observer was not to agree with his satisfactory estimate of his work habits in his new life. A couple of years later, he paid a visit in autumn to a Cascade friend and found there, as a fellow house guest, a seventeen-year-old girl named Nancy Cooper. They were married a year later, moved into a kind of shack on the property of their mutual former host and hostess and a year later moved back to Great Falls, which was to be the artist's headquarters for the rest of his life. A couple of years after that, Charley received a small legacy from his mother's estate and they used it to build a modest home in a better residential section of developing Great Falls. Nancy Cooper Russell had a total faith in the abilities of her husband and from then until his death moved in numerous ways to insure his success as an artist.

The first of these was to get him to keep regular working hours. Thanks to Nancy's insistence, Charley took to spending the entire morning at the easel in the studio. After the noonday meal, he rode into town but, it

Indian Woman Carrying Water, n.d.,
Charles Russell. 31-5/8 x 26 in., watercolor.
Collection of Glenn E. Nielson.

was said by those who saw it, on his departure for town Nancy held up two fingers, counting out the number of drinks the cowboy-artist could allow himself. Surprisingly for anyone familiar with the general drinking habits of cowhands when work was over, Charley adhered to Nancy's rationing. Some of his old friends grumbled, but there is no question that her firm insistence gave Charley the discipline and productivity that made his career as an artist.

From then on, Charley Russell was an artist, a cowboy artist, in time *the* cowboy artist. At Nancy's insistence he took to writing pieces about his cowboy days as vehicles to sell his pictures to magazines. From 1903 on, he made annual trips to New York—which city he didn't much like: For one thing, he noted, the bartenders won't drink with you and therefore you can't be sure you are not being poisoned. But that's where the art market was and is. He rapidly built up a following among magazine editors and made some dents in the market for pictures. In 1907 a Brooklyn church, the pastor of which had seen the paintings in a Great Falls saloon, arranged a show of his paintings. Nancy quickly followed the event by exploring

all conceivable outlets—large, regional expositions, Montana state fairs—attaining finally, in 1911, his first one-man show at a New York art dealer's, the Folsom Galleries on Fifth Avenue.

There followed a career of steady production of the images of Charley Russell's Wild West and steadily increasing national and international recognition. His first "foreign" show was, appropriately enough, at the Calgary annual Stampede across the border in Canada. Exhibitions of his work shortly took place in London, where Charley himself, in the boots and red sash he never abandoned, inspired as much curiosity and interest as had Audubon and Catlin before him. He became friends with a number of personalities of the day, most notably humorists Irvin Cobb and Will Rogers. From 1919 on, the Russells spent each winter in southern California, where his work found a very good market in the growing movie colony. His work was immensely popular and admired by art professionals as well as by the general public. The year before he died, he was given an exhibi-

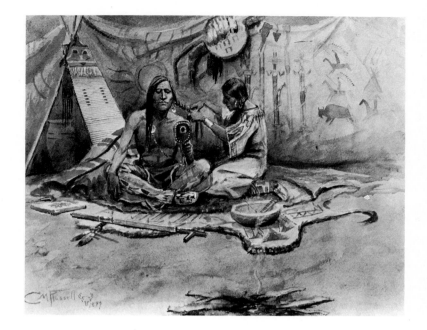

Indian Beauty Parlor, 1899, Charles Russell.
14-1/4 x 18-1/2 in., watercolor.
Courtesy of The R. W. Norton Art Gallery, Shreveport.

Attack on the Plains, 1899, Charles Russell. 48 x 72 in., oil.
Courtesy of The R. W. Norton Art Gallery, Shreveport.

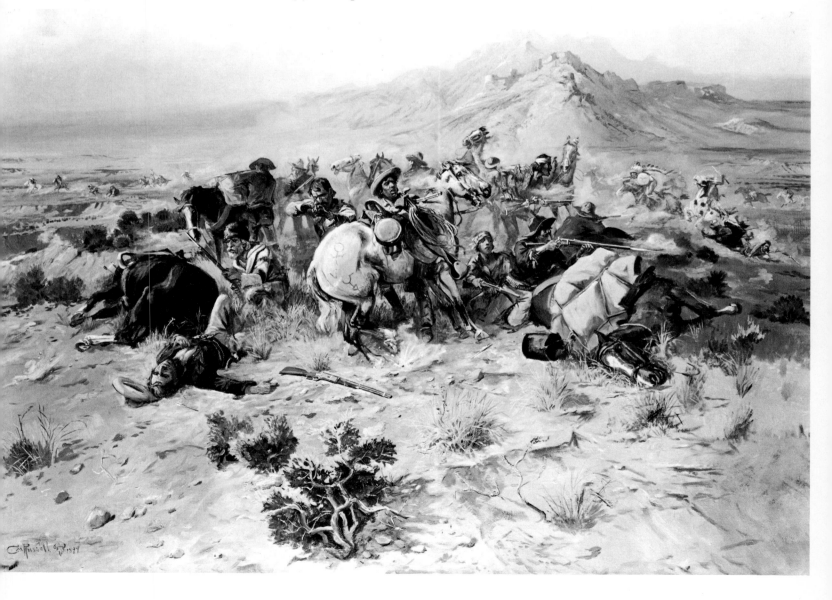

tion at the oldest big art museum in the country, the Corcoran Gallery of Art in Washington.

Montana appreciated its adopted son. One mark of that appreciation is the fact that, although each state is entitled to place statues of two of its citizens in the rotunda of the U.S. Capitol, Montana has so far placed only one, a full-length, life-size marble of Charley Russell, palette in hand.

Another mark of the state's appreciation came earlier, in 1911, when the state legislature commissioned him to paint a mural for a wall in the house of representatives. He chose as his theme, *Lewis and Clark Meeting the Indians at Ross' Hole.* Installed the following year, the mural commemorates the first moment of Montana as an American land, its formal possession, following its purchase from Napoleon, by an American citizen, the official representative of President Jefferson.

Jefferson had begun to plan an expedition to the West Coast even before the Louisiana Purchase. As anyone who has read the Declaration of Independence or seen the University of Virginia knows, Thomas Jefferson had very large dreams for the Republic he had helped bring into existence. One of those dreams was the stretch of land from sea to shining sea. To blaze a trail into that West, Jefferson chose his private secretary, Meriwether Lewis. After wintering near St. Louis, the party of about forty men set out in the spring of 1804 up the Missouri. By the time winter closed in they had made the difficult ascent of the river into the Dakotas where they spent the winter among the Mandan Indians near the site of Bismarck. In the spring they pushed into Montana for the historic meeting commemorated in Russell's painting. From the Montana Indians, Lewis and Clark procured horses and their near legendary woman guide, Sacajawea, who was an invaluable interpreter as they proceeded through the Rockies and, again by water, down the Columbia River to the Western Sea.

The painting, on that large scale, is also dramatic

York in the Lodge of the Mandans, 1908, Charles Russell. 19 x 25 in., watercolor. Montana Historical Society.

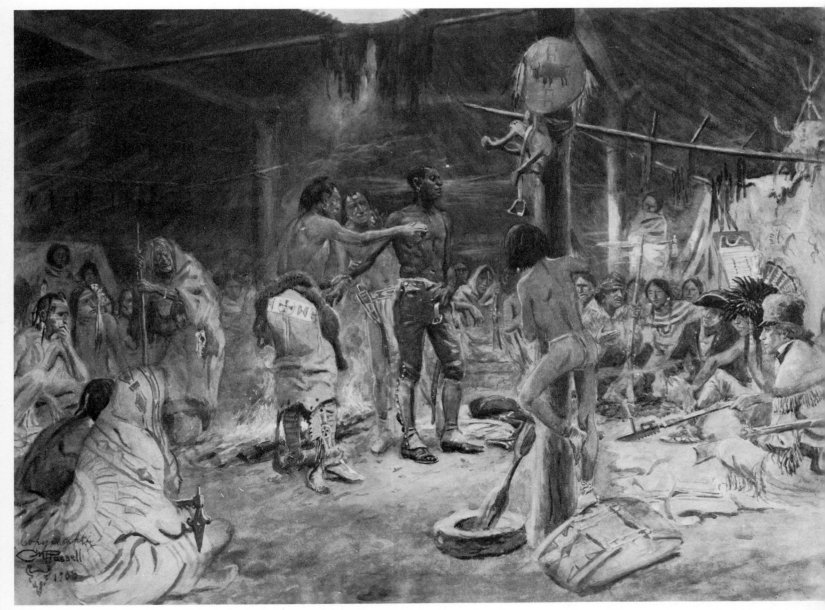

evidence of what consummate mastery Russell had obtained over his art. The sheer space of the country is marvelously rendered. The edge of the Great Plain gives way in the near distance to foothills and, in the distance, to mountains, several ranges, the eastern slopes of the Rockies. The eye travels from the plains grasses to the trees and then to the snows and treeless rocks, some of them lost in great swirls of smoke and cloud, the latter taking on a pink light suggesting the dawn of a new day for the young Republic pushing West. The space conveyed by all this is centrally important to the theme of the painting. It implies both the magnitude of Lewis and Clark's exploit and breadth of Jefferson's dream for his country.

Against that space, the Indians are shown in the act of riding out from the distant village of tepees, their horses arrayed in a tight, breaking curve, one that builds pressure like a coiled spring. Spreading out from the curve as if by centrifugal force are the skull of a dead mountain goat

half hidden in the grass and three camp dogs, each in a different pose. The three dogs suggest the same thing the mounted Indians suggest, the fluid movement of a whole series of moments compressed into the single moment that is all a single painting can contain. The Lewis and Clark group is off in the middle distance toward the right. Pictorially, the Anglo-Americans balance the Indian village on the left. As in history, the explorers have already acquired their "girl guide"—when she joined the expedition, Sacajawea was seventeen years old, though much of the journey was accomplished by her with a papoose on her back—and she is opening negotiations with the Flatheads, while Lewis and Clark stand behind her.

Now, this is, on the face of it, an extraordinary choice for Russell or any other painter to make while creating a work commissioned by an offical Anglo-American government body to celebrate the arrival of the Anglo-Americans in the territory governed by that body. At first sight, it appears similar to, let us say, a painting of the

The Scout, 1894, Charles Russell. 22-5/8 x 34-9/16 in., oil. Kimbell Art Foundation, Fort Worth.

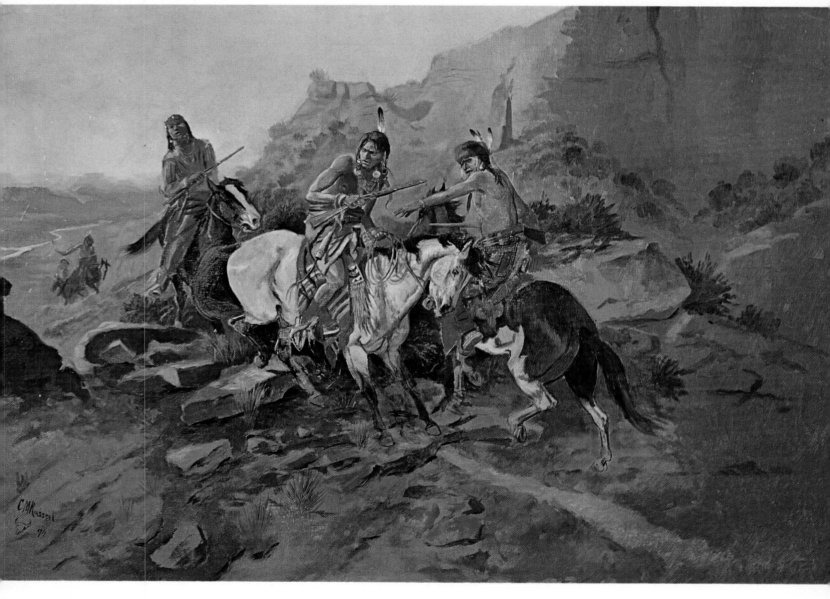

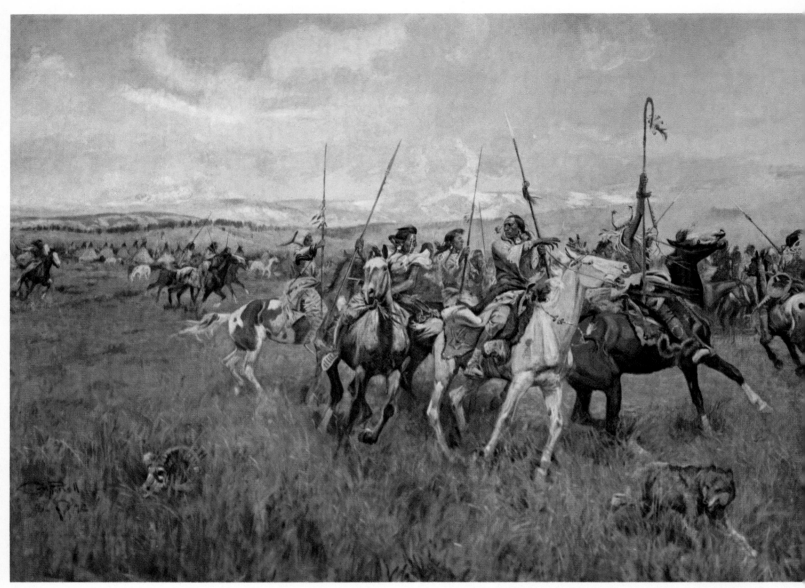

Above: **Lewis and Clark Meeting the Indians at Ross' Hole,** 1912,
Charles Russell. 297 x 137-1/4 in., oil.
State Capitol, Helena, Montana; Courtesy, Montana Historical Society.
Although painted for the white man's government, this work is a tribute
to the dignity of the Indian and his prior claims to the land.

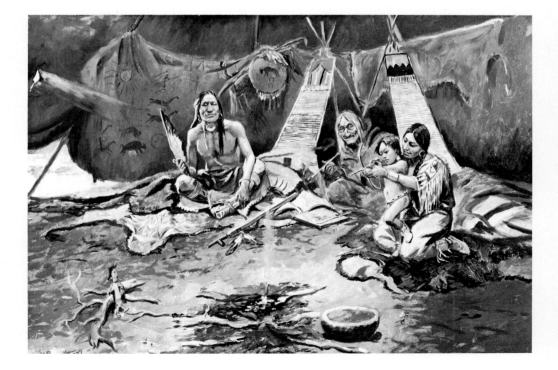

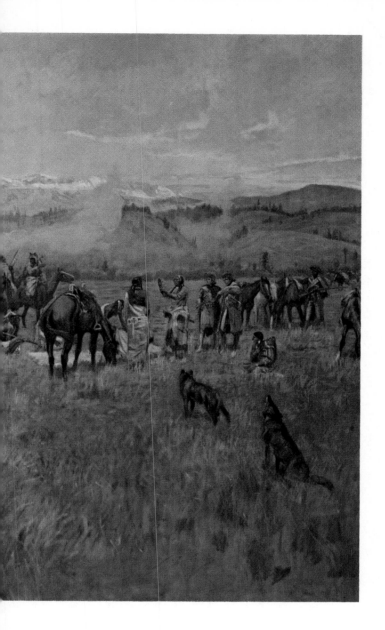

Overleaf: **Lewis and Clark on the Lower Columbia,** 1905, Charles Russell. 18-1/2 x 23-1/2 in., watercolor. Amon Carter Museum of Western Art, Fort Worth. In this scene of Anglo-American history, Russell gives prominence to the Chinook Indians and the near-legendary Sacajawea, the woman interpreter-guide.

character, the Indian woman guide involved in sign language with the Flatheads. What the painter clearly meant was that this—Montana—was Indian country. Into this Indian country, Lewis and Clark and their party had come as strangers and as guests. The Anglo-American future here was as broad as the prairies, as high as the distant peaks, as roseate as the drifting clouds touched by sunlight. But at this time and for more than half a century ahead, Montana was and would be a place in which what the Indians did loomed much larger than the comings and goings of this small band of white men—and one black man—from the east. And so Russell painted.

He may also have had in mind something else to bring to the attention of his state's legislators assembled in deliberation about the fortunes of the people they represented. He may have had in mind to call to their attention, every day, that the Indians were human beings just like white people and that Montana was Indian for a much longer time than it had been white. The dominant American attitude toward Indians had changed drastically as the nineteenth century progressed and especially toward the end of that century. The early, romantic view of the noble Redman in some sort of prelapsarian paradise, living a life in union with Nature and with Nature's God, had lasted only so long as the Indian fell back docilely, surrendering his lands to the eastern strangers. Once the Indians of the Plains realized the probable extinction they faced from the great migration of Anglo-Americans and began to resist it, white America's opinion of the Indian changed.

The Indian became, for example, a "varmint," a word encountered constantly in letters and literature of the period. Now, a varmint is not just an expression of contempt or dislike. The word is a nineteenth-century, or late eighteenth-century, strictly American variation on the word vermin. Vermin, in the days before most people understood much about ecology and the interdependent links in the cycle of nature, were animals or insects considered not only useless but detrimental to the process of making a living on the land. They were beasts that preyed upon crops or stock. Field rabbits and mice were vermin, foxes were vermin; in the West, coyotes were vermin. By the end of the nineteenth century, the Indians were vermin. This meant that they were considered utterly a menace to the construction of orderly, fruitful life. Their logical destiny was simple: They were to be destroyed.

In his monumental mural for the Montana Legislature, Charley Russell, who had lived with Indians and had come throughout his life to respect them, reminded the lawmakers of the dignity of the Indian and of his prior claims to the land being legislated about.

Crucifixion which would focus on the Roman soldiers rolling dice for the garments of the condemned man while the agony and death appeared only as a couple of crossed lines, slightly filled out, punctuating the horizon.

Well, in fact, such a painting of the Crucifixion could have a special meaning of its own, as indeed Anatole France demonstrated in his short story of Pontius Pilate as an old man only dimly recalling the minor event in his career in Palestine which involved the execution of some sort of local troublemaker. The point of Anatole France was the irony of history: He was making clear the obvious fact—when you think of it—that what for later generations has been the central event in the history of the world was, for officials on the scene, a small disturbance, handled with some difficulty, but handled, and almost automatically forgotten as a civil servant moved on to his next, more important, post in the bureaucracy of empire.

That easy historical irony is not at all what Russell had in mind when he painted his Lewis and Clark picture and put Lewis and Clark in the background as secondary characters—even as secondary characters to a secondary

Left: **Three Generations,** 1899, Charles Russell. 15-1/2 x 24 in., oil. Courtesy of The R. W. Norton Art Foundation, Shreveport.

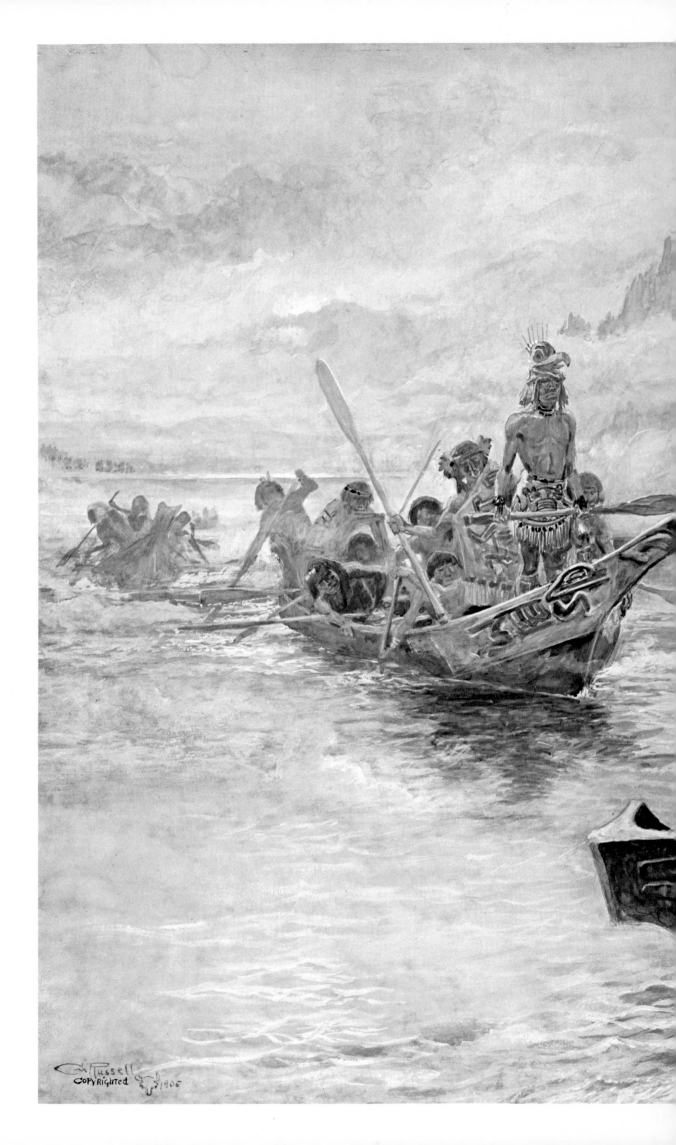

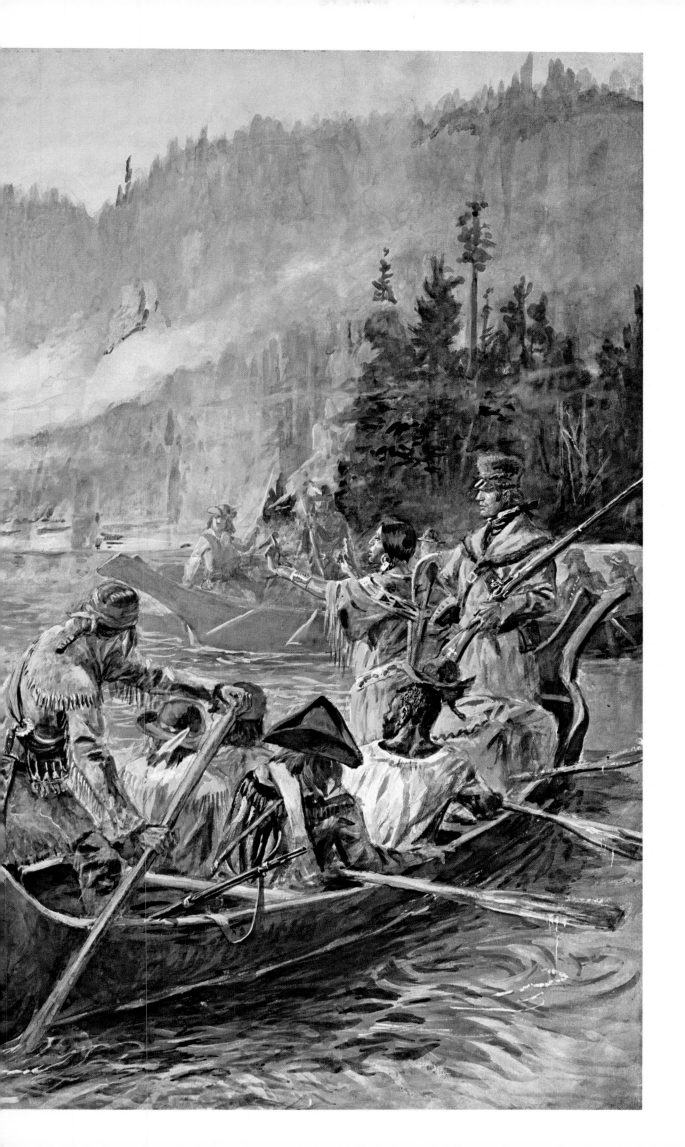

The extraordinary sense of space composition and the same instinct for combining individuals in various stages of the same movement that distinguish the Lewis and Clark mural are also the strength of *Preparing for a Buffalo Hunt,* painted a few years earlier. The space is more complex because the land is centered on a rise, around which the hunters are approaching their prey by stealth. We see the arrival of the hunters behind the shielding outcrop of rock, their preparing of mounts and weapons and their gathering at the best point of vantage just before their furious descent and assault. Off to the right, in the middle distance, the herd peacefully grazes, oblivious of its hunters.

The main motif of the painting is thus a great, easy curve, from the horses and hunters preparing on the left, in the shelter of the rock, to the herd itself, farther away, with the apex of the curve occupied by the lead hunting party, reinforced by the harsh outcrop of rocks behind them. That curve, of course, suggests the curve of the hunt, the curve of the herd fleeing in panic, of the riders in hot pursuit, of the splitting of the herd, a standard strategy, and the curve of death as the individual beast, chosen on the run, pierced by the arrow, falls out of the race and into the dust.

All those curves of the chase are dramatically seen in *The Buffalo Hunt.* As he invariably did, Russell chose the climactic moment of supreme action. In this and in several other ways, this picture powerfully demonstrates his superiority to earlier painters of the subject. Compare, for instance, this action-packed scene with Catlin's quiet, almost stage-set composition. Russell has chosen the crucial moment of splitting the herd. Put to panicky flight by the appearance of the hunters, the great beasts have been overtaken and the riders have caught up with the head of the herd. Their attack from both sides has already begun the split, with the leading group of animals heading straight at us, those behind the split continuing their charge to the right. Again, Russell has successfully created this highly dramatic instant as part of the longer process. In the distance on the left we see, first, a single mounted hunter coming up fast and closing in on the herd, just as the foremost hunters must have done moments earlier, and, second, in the far distance, another main branch of the herd being similarly harrassed by other hunters, only one of whom is visible.

Preparing for a Buffalo Hunt, 1903,
Charles Russell. 36 x 24 in., oil.
Collection of Lyle S. and Aileen E. Woodcock, St. Louis.
Russell's extraordinary sense of space composition is evident in his ability to show the hunters in various stages of preparation for assault.

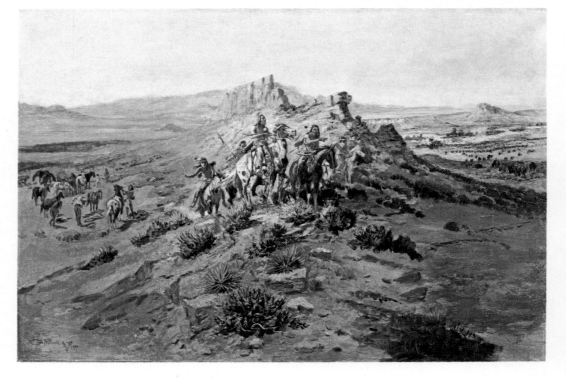

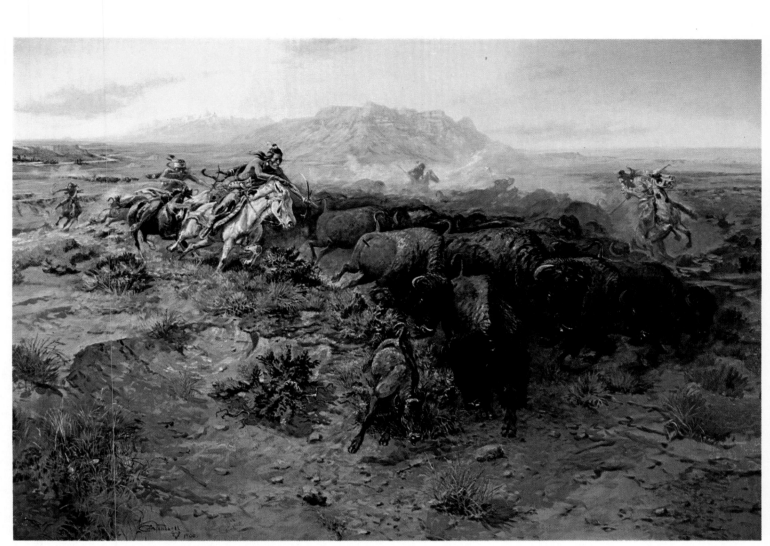

The Buffalo Hunt, 1900, Charles Russell. 47 x 70 in., oil.
Thomas Gilcrease Institute of American History and Art, Tulsa.
A sweeping composition, this climax of the buffalo hunt shows the herd
overtaken, split and a few animals singled out of the multitude.

Again, too, Russell displays his deep feeling for Western space. The sweep of the prairie goes off deep into the distance on both left and right, the left being measured by a river reflecting the high pale sky.

It is impossible to overestimate the importance of the buffalo in the life of the Plains Indians. They lived off the herds, of course, buffalo meat being the staple in their diet, both fresh and preserved for winter by a primitive process of drying. The hide of the buffalo provided robes and the walls of the tepee as well as a cord for tying many things together, including the ends of the bow.

Considered from a purely economic point of view, the buffalo hunt was an extravagantly wasteful method of food gathering. All hunting is, of course, which is why the primitive cultures are the hunting cultures, why agriculture is the great step up from savagery to civilization, from the nomadic, roaming life of following the herds and living in fragile, collapsible homes to the stable life of planting and harvesting and living nearby in more permanent structures which, through their permanence, become ever more elaborate, more comfortable, more convenient and more crucial in modifying the lives, even the thoughts, of the people living in them.

But the buffalo hunt was particularly prodigal of energy, especially that of the animals. A herd could have as many as a thousand or more beasts, even several thousand on occasion. All of them were put into violent, agitated motion, chased across the prairie, separated out into smaller groups and then dissipated altogether to assemble elsewhere for the sake of a handful of Indians intent on killing perhaps six or a dozen of the multitude. In terms of energy expenditure, it was like using a sledge hammer to crack walnuts.

But until the coming of white man, the Indians were really pre-economic. There was a great deal more trading than is generally appreciated, but the profession of trading did not exist, and the items traded tended to be peripheral to the life of the tribe. At the center of that life roamed the buffalo. The whole process of following the herd, hunting, stripping the hides and curing them, cutting the meat and preserving it, sewing together the hides into house coverings and body coverings—these activities occupied the tribe and supported it. The buffalo was much more than economic. It was a spiritual presence in the life of the tribe, at once sustaining the tribe and offering each brave a chance to test himself in danger and in doing so contribute to the life of the tribe.

The Anglo-Americans changed all that. No one really knows how many buffalo there were on the Plains in the nineteenth century. One reasoned estimate says there were sixty million in the middle of the century. If so, it

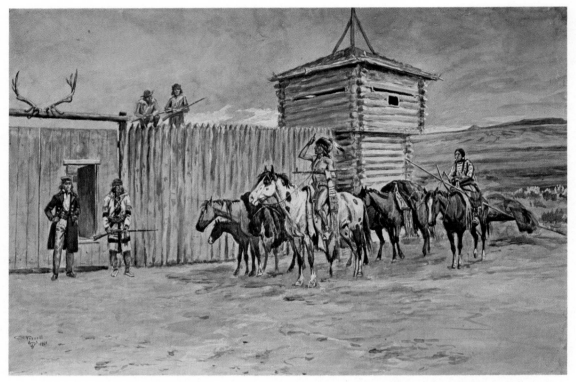

The Robe Traders, 1901, Charles Russell. 20 x 30 in., watercolor.
Thomas Gilcrease Institute of American History and Art, Tulsa.
Suspense is the mood in this parley between the unarmed
Indian traders and the alert men in the stockade.

was extraordinary for the whites to eliminate them in a generation or so. The Indians had lived with and lived off the buffalo for centuries and would have gone on doing so indefinitely. The whites, when they got around to hunting the great beasts, all but wiped them out in a matter of some thirty-five or forty years.

Buffalo hunting as an American industry did not get under way on a large scale until after the Civil War, when a lot of men proficient with arms headed West to improve their fortunes devastated by the war. For them, buffalo hunting was like gold prospecting: free wealth there for the taking and a lot more certain of result than panning streams for the yellow glitter.

The buffalo, or bison, as the animal really is, offers illuminating contrasts between the whites and the Indians, quite as illuminating as gold did between the Aztecs and Incas and the Spaniards. For those Central and South American Indians, their vast treasure of gold was important because the fine metal could be made into skillfully designed objects to enhance life and to offer worthy homage to the gods. For the Spanish, gold had an abstract, economic value. They cheerfully melted down hundreds of beautifully fashioned objects and swiftly worked out the mines because they were interested passionately and solely in the economic abstraction.

Precisely the same motivation led the white buffalo hunters—as many as 20,000 a decade after Appomattox—to destroy the great herds. There had been a certain amount of sporting interest—more among visiting foreigners than among the Anglo-Americans—in following the buffalo chase in the Indian manner, using rifles, of course, rather than bows and arrows and lances. But after the Civil War, the business got going in earnest. The white

hunter, using a long rifle that had to be supported at the end like the early muskets, fired from a distance of as much as three hundred yards. Whereas the Indians' strategy involved stampeding the herd and then overtaking it, the whites' was to kill as many individual species as possible before the herd stampeded and to kill them as close together as possible to save time and effort for the skinning crews which moved in with the marksman. Since there was neither an adequate method of meat preservation nor the transportation needed to get meat to market, the carcasses were simply left on the plain to be picked over by coyotes, wolves and carrion birds. Later there came to be some brief market in the bleached bones, which made good fertilizer, but the focus was on the hides which, made into "American leather," were a popular commodity as far away as Russia.

It would not have been difficult for people with foresight to raise buffalo exactly as the ranchers were already raising cattle, following the Mexican example. The destruction of the buffalo came about through the historically rare combination of an advanced technology and a primitive, hunting culture. The same combination has brought the whales of the sea to within sight of extinction, as earlier it completely destroyed the passenger pigeon. Ironically, the movement to protect the environment from such mechanized hunting and fishing has brought with it a sudden and belated appreciation of the pre-economic attitude of the Indians toward their fish and game.

That development has been a reversal of the historic process, for in that process the Indian was swiftly swept up—briefly but intensely—into the white man's economy. That moment of involvement is the subject of *The Robe Traders*.

The picture is very thinly painted. There is complete mastery of watercolor delicacy in the ground and the distant plains and mountains. The two media—oil and watercolor—are very different from each other, and Russell in this picture amply demonstrates his authority with the lighter medium. The fresh sketch quality of watercolor is, in a way, ironic in this subject. The image, after all, of a stockade wall and a standing moment of parley is stable. The movements are few. The tone is one of confrontation. Russell was probably constitutionally incapable of conceiving a picture in which everything had been resolved. So here, suspense is the mood, but it is quiet suspense, manifested chiefly in the alertness of the three armed men and their commander. The trading Indian, however, is unarmed and is holding his pipe of peace and parley at the ready. His wife, who has actually produced the "robes," or cured hides he has come to trade, sits stolidly on her horse, which is harnessed with a travois, or dragging poles, to carry more robes in addition to those on the Indian's horses of burden. Trading with the Indians was normally conducted by the whites outside the forts they had set up across the trading territories, an early indication of the complex attitude of the whites toward the Indians, a mixture of mistrust and the desire to exploit.

Although, obviously, Russell admired the Indian and accepted him as equally a human being—an increasingly rare attitude among Western whites as the nineteenth century approached its end—he never slipped into the sentimentality of the eighteenth-century Europeans who regarded Indians—without knowing any—as noble savages. To Russell Indians were men and women, the same as white people. That meant that they were also subject to sins and crimes like everybody else.

Among the whites in the West, horse stealing was just about the unforgivable sin, and lynching was the automatic result of a horse thief's being captured. Among Indians, it was rather a different thing. It was, apparently, a form of warfare without all the killing. Horses were wealth, of course, but there was much more to it than that. Stolen horses represented a successful foray against tribal enemies. Whether the theft was accomplished by stealth

Stolen Horses, 1898, Charles Russell.
12-1/4 x 18-1/2 in., oil.
The Rockwell Foundation, Corning, New York.
One of Russell's few nocturnal scenes shows the successful thieves moving away across the desolate, moonlit plains.

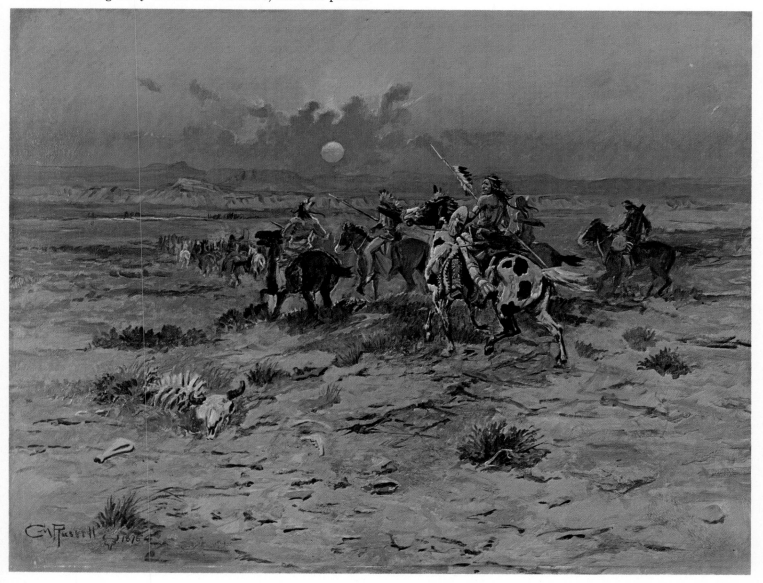

or by force or, more usual, by a combination of the two, the deed was an act of war, a battle won. Indians, Russell makes clear, stole horses chiefly from other Indians. It was almost always a nocturnal operation, complete with bird and animal cries, expertly reproduced, as signals, the silent murder of the sentry, the very quiet removal of the enemy tribe's horses from their night stand and the triumphant leading of them back to the home place.

Russell painted very few nocturnal scenes, but here are two, *Stolen Horses* done in 1898, and *The Horse Thieves,* 1901. The points of view are opposite in the two paintings. In the earlier we watch the successful thieves moving away from us across the prairie under the full moon. The same full moon shines down on the scene in the later picture, but in this one we are ahead of the expedition, watching it come toward us, just as successfully, leading a troop of stolen steeds.

Both pictures beautifully capture the lonely desolation of the Great Plains at night, when the land seems, even

more than in daylight, to stretch to some mysterious infinity, within which an Indian band of horse thieves gives focus and location to an otherwise endless vista.

The later picture has both historical and personal value in the career of Charley Russell. The Indian leading the run of stolen horses is White Quiver, one of the great Indian horse stealers, who conceived and executed one of the most famous raids of the time and the place. He is shown returning from a successful raid against the Crows, the enemies of his own Piegan tribe. The marks painted on his horse's neck are like those painted on bomber and fighter planes in the wars of our recent past, each one signifying a raid against the enemy.

White Quiver rode against the Crows at night, overpowered the sentries and rode away with some fifty ponies, including the horse of the Crow Chief Plenty Coups favored for chasing buffalo. By that time, of course, the white man's law was thoroughly mixed up in all the doings of the Indians. White Quiver was captured by the law near

The Horse Thieves, 1901, Charles Russell. 24-1/8 x 30-1/8 in., oil.
Courtesy, Amon Carter Museum of Western Art, Fort Worth.
The lead Indian of this band, White Quiver, was one of the greatest horse thieves, and among these stolen Crow horses is one pinto pony which Russell eventually acquired and rode for over 15 years.

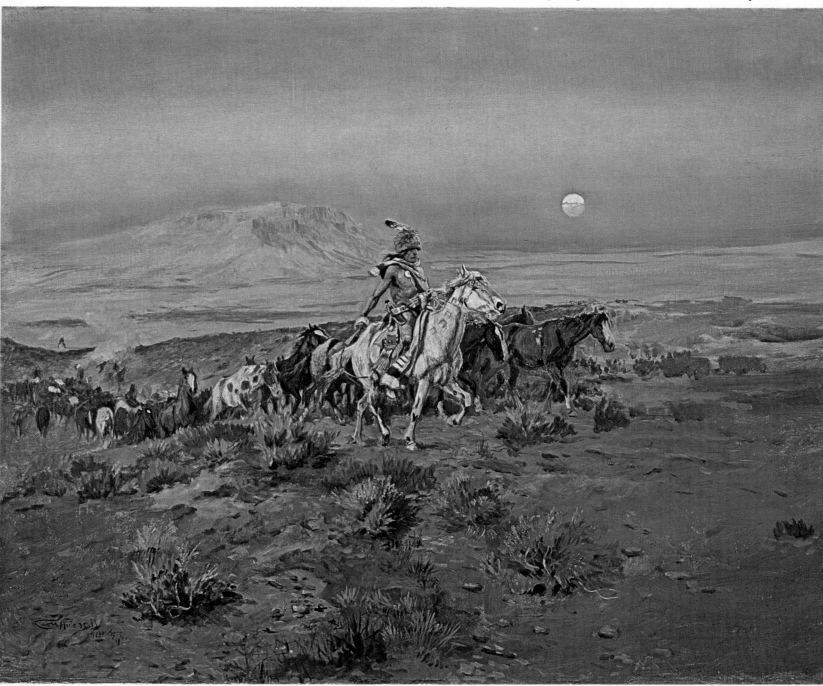

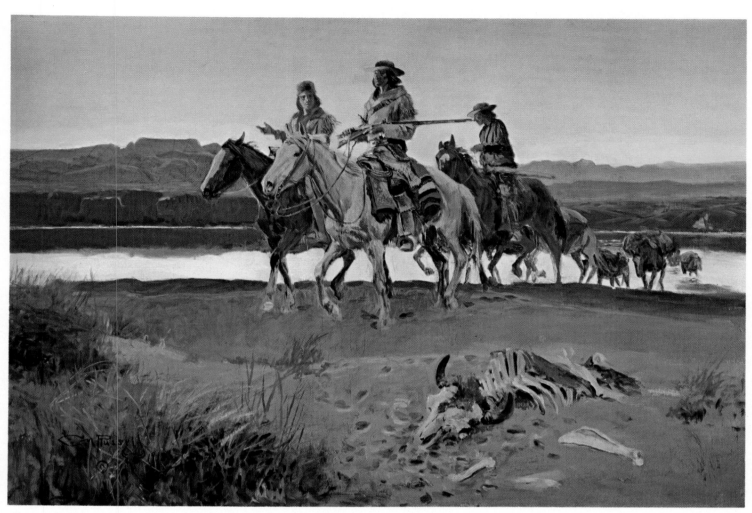

Carson's Men, 1913, Charles Russell. 24 x 35 in., oil.
Thomas Gilcrease Institute of American History and Art, Tulsa.
Kit Carson was commissioned by the government to keep peace
along the Santa Fe Trail, and Russell gives tribute to a Carson patrol
that endeavored to keep settlers and Apaches from conflict.

Fort Benton and thrown into jail, the stolen horses confiscated to await the arrival of their owner, Plenty Coups. Before the Crow chief got to Benton, White Quiver had escaped from jail, recaptured the hostage horses and ridden north, across the border and safe from the authority of the United States. In an early version of Interpol, however, the Royal Canadian Mounted Police were informed of his crime and his direction of flight. They captured him without difficulty and once more impounded the horses. Once again, White Quiver broke out of imprisonment, once again he stole the Crow horses and this time he headed back for the Blackfoot Reservation in Montana. Among the horses thus persistently preserved was one pinto pony which he later sold to another Indian, Bad Wound, who in turn sold the mount to Charley Russell, who rode it for the last quarter century of his life.

Kit Carson, born in Kentucky in 1809, was a kind of reincarnation of Daniel Boone, the Pennsylvanian credited with founding Kentucky and with creating the legend and the archetype of the American pioneer. Raised in Missouri when that was frontier territory, by his mid-teens Carson was a professional trapper, guide, scout and hunter, a wilderness man. He rode with Fremont on his explorations of the West and California. He fought in the war with Mexico and in 1854 became the Indian agent at Taos, New Mexico, where he managed, through his working knowledge of Apache language and customs, to restrain the Indians from taking precipitate action against the incursions that were becoming all too regular a feature of the white man's westering.

President Polk commissioned him to keep the peace along the Santa Fe Trail, and it is in that period that Russell pictured him in *Carson's Men*. The small, three-man patrol, followed by baggage animals, has forded a stream and is pushing toward the sunset. The bleaching bones of a dead shorthorn steer lie in the foreground. The lay of the land is all horizontal: the stream reflecting the sky, the sky itself, the opposite banks, the mountain range, low and following the horizon, the near bank. Against this collection of horizontals, emphasized by the low angle the artist chose, the riders cross as both vertical on the picture plane and far-to-near movement against the horizontals. The leader, his flintlock cradled in his arm ready for use but safe from accidental discharge, stares professionally ahead for any sign of trouble, listening the while to the remarks of his comrade while the third man brings up the rear, gazing upstream and keeping an eye on the pack animals. The picture is a noble, restrained tribute to those few men like Carson who dedicated themselves to the opening of the West at no particular profit to themselves but simply because they shared something of Jefferson's dream in sending out Lewis and Clark.

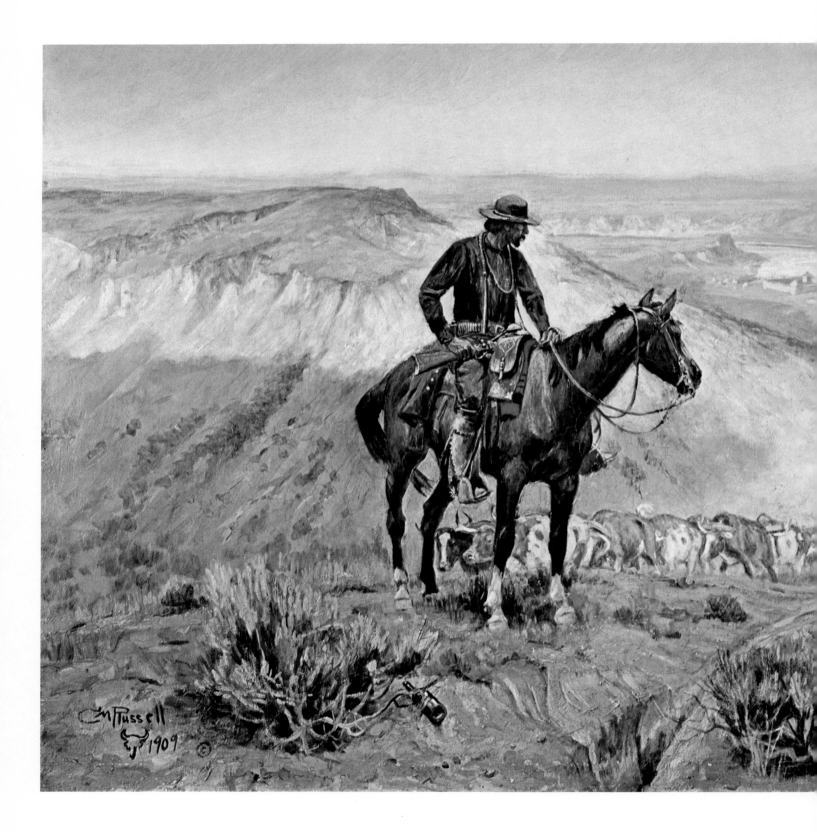

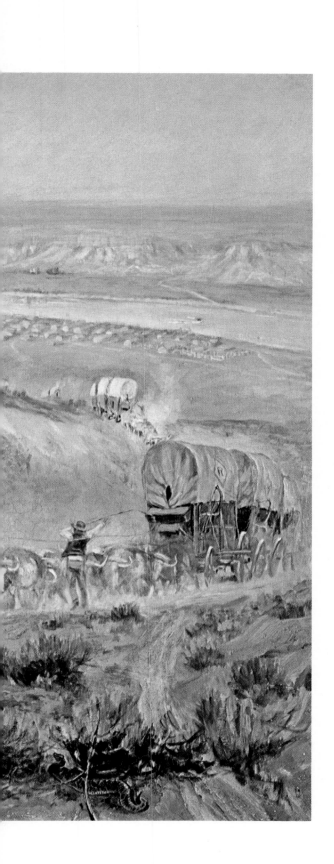

Succeeding Carson in his effort to keep the trails open and the passage of settlers free was the frontier figure of the *Wagon Boss*. The automobile today has certainly changed the face of America, bringing with it such assorted advantages and disadvantages as the super-highway, air pollution, the distant suburb, parking lot banditry and the drive-in movie. Yet it may still be doubted if the motor car has changed America as profoundly as did the Conestoga wagon of the nineteenth century and its several rivals and imitations. The car has made possible Upper Montclair, Shaker Heights, Whitefish Bay, Silver Spring and the San Fernando Valley as, respectively, parts of New York City, Cleveland, Milwaukee, Washington and Los Angeles. But the wagon made possible all the West as part of the United States.

Territories and trading are one thing; settlement is another. The trappers and the buffalo hunters could have continued in the West forever—had not their unthinking greed wiped out the source of their livelihoods—and it would have had no effect on the political status of the land. But when the wagons began to roll, bringing women and children, bringing families and schools and churches and the desire for orderly municipal government—that is when the West was won.

Russell's *Wagon Boss* appears almost silhouetted at the head of his line of beasts and wagons, the wagons closed and piled high with goods, a drover on foot flicking the cattle with a drover's whip to keep them climbing the steep incline up from the river. The implied curve of the river repeats the decided curve of the wagon train, surveyed by the boss from the height he has attained. This was a freight train—the term was taken over intact by the new railroads—out of Fort Benton, Montana, where the goods were delivered by Missouri River steamer and then put into wagons for the overland trek.

Wagon Boss, 1909, Charles Russell. 23 x 36 in., oil.
Thomas Gilcrease Institute of American History and Art, Tulsa.
The wagon boss was a frontier figure upon whose efforts
the winning of the West depended, for he directed
the maneuvers and defenses of the train.

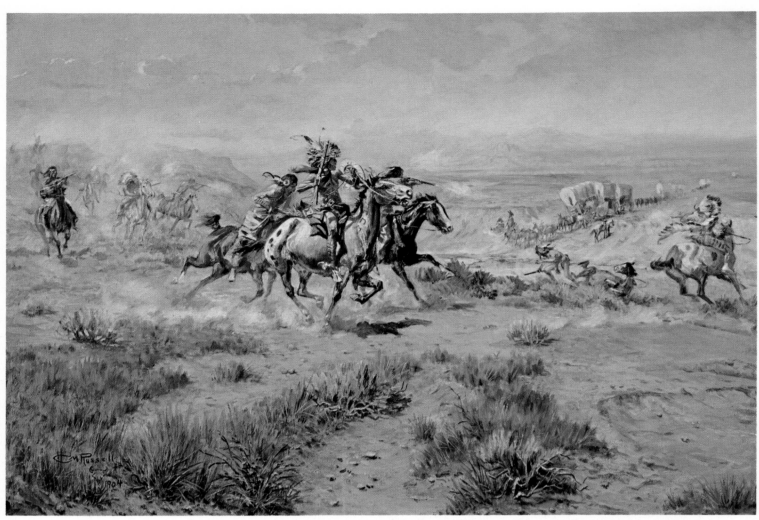

Attack **On** the Wagon Train, 1904, Charles Russell. 23 x 35 in., oil.
Thomas Gilcrease Institute of American History and Art, Tulsa.
The issue of who wins the fight is undecided in this moment of action,
for the battle will continue later as the wagons proceed.

Attack On the Wagon Train depicts such a train hit by the Indians just as it drew up to a small stream to be forded. The ford was a natural and easy place to ambush a train: The water ensured that the travelers could not easily drive on through, and there was usually high ground nearby from which to launch the attack. Russell portrays the attack as the intersection of two lines, the wagon train itself, coming from the distant upper right toward the center of the picture, and the line of firing Indians coming from the middle distance left toward the right and intersecting the progress of the train. As in the Lewis and Clark mural, we get a much closer and clearer view of the Indians than we do of the wagon train. The horse closest to us, we note, has the mark of honor of having participated in raids against enemy Indian tribes. The fighting has begun. The train goes on into the distance and the issue, it is clear, will be fought for some time without a clear decision.

Intercepted Wagon Train shows what was by far the more usual encounter between westering whites and affronted Indians. As the migration increased, the migrants organized themselves into larger and larger parties able to support heavier weapons of defense. Such trains could not be attacked without serious damage to the attackers, and the change in the travelers brought about a change in the Indians' strategy. Instead of the all-out attack on the trains in an effort to destroy them and thus preserve their lands free from white incursion, the Indians took, in effect, to charging a toll for passage through their domains.

In this lively watercolor, Russell shows a command group waiting on a knoll while an emissary, bearing the white flag of truce, goes forward to meet the wagon train and present the tribe's demands for payment. Almost invariably, the wagon bosses preferred to hand over what was asked—or possibly to haggle it down a bit—rather than risking an attack. The diamond shape composition is only implied: the group from the left riding hard toward the center, the scout with the flag charging away to the right to meet the train, the scrub vegetation in the foreground balanced by the snow-dappled peak in the distance, with the chief and his aides right in the center. The group of command Indians is, as it should be, the most vividly painted thing in the picture, everything else being toned down from that intensity.

270

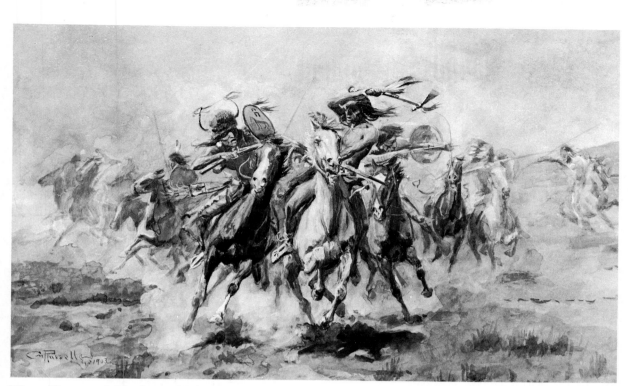

When Sioux and Blackfeet Meet, 1903,
Charles Russell. 16 x 27 in., watercolor.
Thomas Gilcrease Institute of American History and Art, Tulsa.

Intercepted Wagon Train, 1898, Charles Russell. 19-5/8 x 27-3/4 in., watercolor.
Courtesy, Amon Carter Museum of Western Art, Fort Worth.
As the white settlers' migration increased, the Indians found they could
demand a toll from the wagon bosses, who naturally preferred it to an all-out attack.

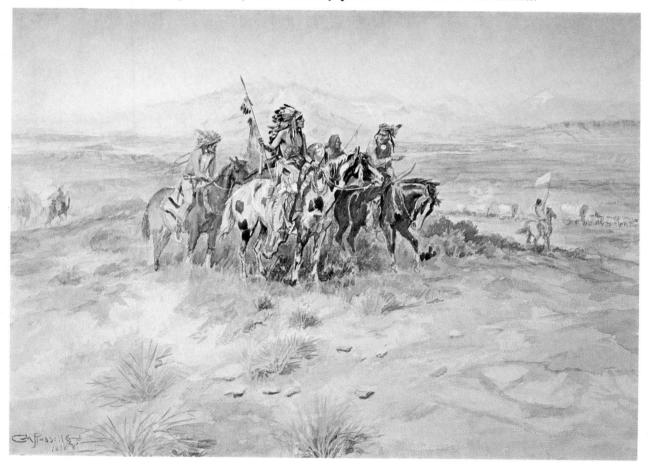

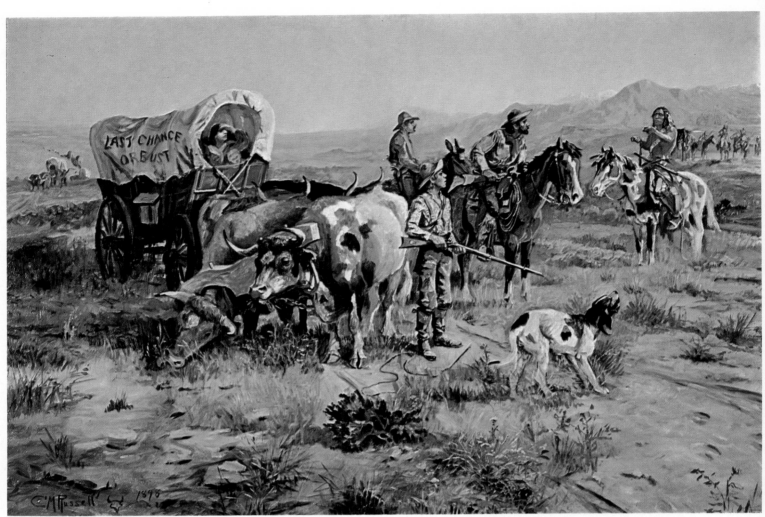

A **Doubtful Visitor**, 1898, Charles Russell. 29 x 35 in., oil.
Thomas Gilcrease Institute of American History and Art, Tulsa.
The Indian is attempting to tell the pioneers that passage through
the land is not free, as most settlers assumed.

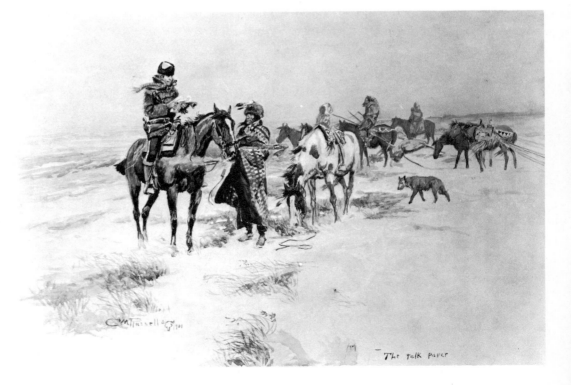

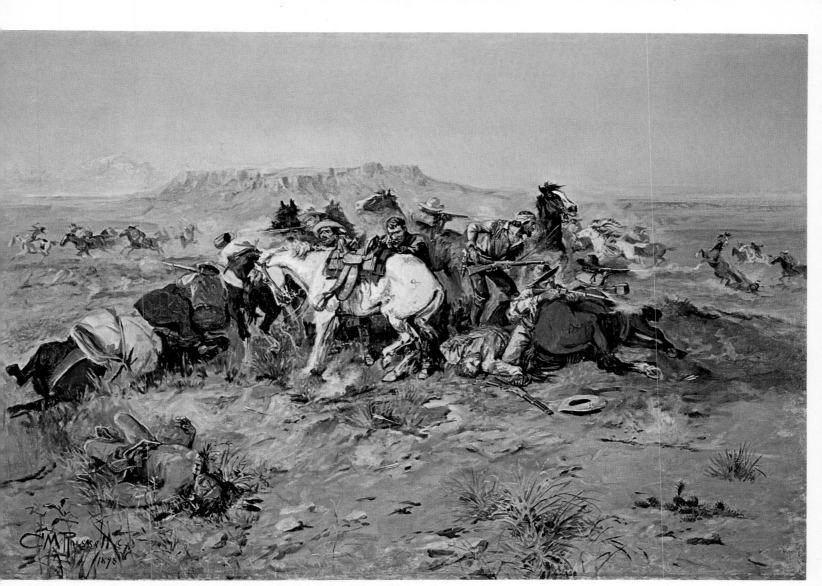

A Desperate Stand, 1898, Charles Russell. 24-1/8 x 36-1/8 in., oil.
Courtesy, Amon Carter Museum of Western Art, Fort Worth.
The line of this tight circle of defense is repeated in the rocky butte
in the background and serves to emphasize the tense mood of the trapped men.

A Doubtful Visitor represents a similar encounter seen close to the head of the wagon train. The hopeful sign painted on the canvas of the covered wagon, "Last Chance or Bust," has a double meaning, one part of which refers to the early name, Last Chance Gulch, for the location that later became Helena, the capital of Montana.

The pioneers and their dog stand alert as the Indian, with others behind him, tries to convey in sign language what his people demand for the freedom of passage the travelers are taking for granted.

Even without the added burden of wagons and women and children, travelers in the West often found spirited opposition from the Indians. In *A Desperate Stand,* Russell depicts the final scene in such an encounter. The white horsemen, presumably trappers lingering on into an era in which the balance had changed so much that the formerly friendly Indians were hostile to all whites, are gathered in the classic circle to defend themselves against the attacking Indians. The Indians, riding in constantly closer circles, fire at the whites who return the fire over the live or dead bodies of their mounts. In the left foreground we note that one Indian, at least, got fairly close to the target before being killed. We note, too, that there are different brands on the two horses on which brands are visible, a D-plus and a Running-Eight or an S-returned. As always, or almost always, Russell has backed up his central group with an outcropping of rock, in this case a truncated mountain, or butte, as it was called in Montana. Here, as in many other paintings, the group of white riders, closed in and fighting to survive against the free-riding Indians, echoes, in its form, the form of the rocky outcrop behind it. Russell has pointed the guns of his hardpressed little party in as close to three hundred and sixty degrees as it is possible to depict in a painting more or less at eye level. On the right, as a minor bonus, he shows the one advantage of the long, trailing Indian bridle: When a rider was thrown or when he had fallen, he could reach out and have one chance to grab the trailing bridle and be dragged to safety.

Left: **The Talk Paper**, 1901, Charles Russell.
13-3/4 x 20-1/4 in., watercolor.
Courtesy of The R. W. Norton Art Gallery, Shreveport.

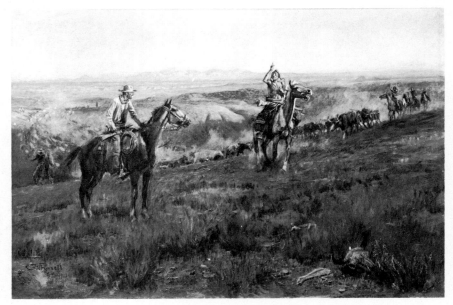

Toll Collectors (Deadline on the Range), 1913,
Charles Russell. 24 x 35 in., oil.
Montana Historical Society, MacKay Collection.

Below: When Horseflesh Comes High, 1909,
Charles Russell. 24-1/4 x 36-1/4 in., oil.
Courtesy, Amon Carter Museum of Western Art, Fort Worth.
A doomed horse thief's fight to the finish is depicted here
as his partner takes off and the owners or posse arrive.

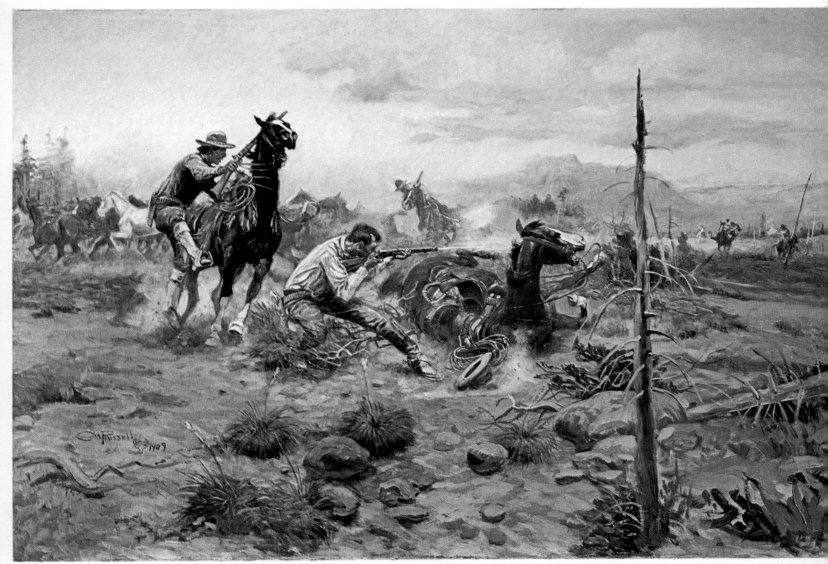

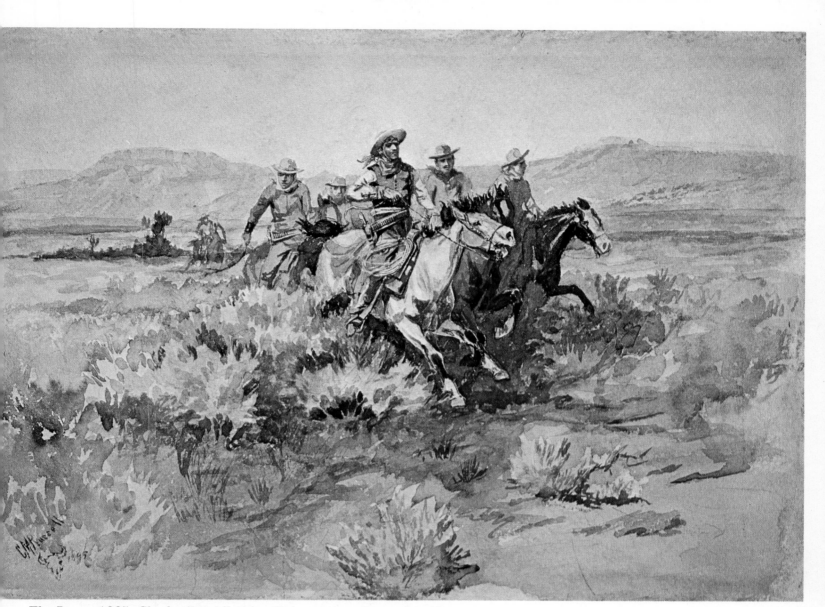

The Posse, 1895, Charles Russell. 14 x 20 in., watercolor on board.
Courtesy, Amon Carter Museum of Western Art, Fort Worth.
Posses were often sent in pursuit of horse thieves, who were common in
border states, and Russell shows "the law" as a solid, determined group.

The Indians were not the only horse thieves in the West, and Russell was well aware of the others. *When Horseflesh Comes High* depicts the end of a white man's effort to make off with a whole string of horses, those shown on the left milling around in the confusion created by the arrival of the original owners and their friends out to recapture the stolen mounts.

The principal thief fires a rifle from the relative shelter of his horse, taking the squatting position, about the most difficult pose from which to fire a weapon, although one making for accuracy because of the support it offers. Meanwhile, his presumed partner or hired hand—more likely the latter—a half-breed in white man's clothing, has already estimated the odds against the pair and is taking off: He uses the standard Indian mounting approach, the opposite of the European-American. In contrast to so many scenes of Russell's West, where the scope of the spread-out Plains is matched by the sky, here there is a huddled in, cooped-up quality exactly right for the theme. This is achieved almost entirely by the low angle

of view combined with clouds of dust and smoke in the background behind the central figure. The great sweeping vistas of life on the plains have been closed off, not really by the circumstances of dust and gunsmoke, but by the choice made by the young—and doomed—horse thief firing futilely at the approaching posse.

The Posse, a watercolor of 1895, shows such a group riding out through the sage on the trail of horse thieves or other malefactors. Montana was peculiarly subject to horse stealing during Charley Russell's years as a working cowboy. The Canadian border was just too tempting a "privileged sanctuary." The more successful horse thieves would round up a group of stolen American mounts, drive them into Canada, sell them with no questions asked, then steal a group of Canadian horses and reverse the process. Ranchers on both sides of the border formed into mutual protective associations and sent posses in pursuit. Russell's watercolor technique is particularly appropriate to this picutre: The riders and their horses stand out in solid strength against the relatively sketchy sage and distant mountains which the posse rides past.

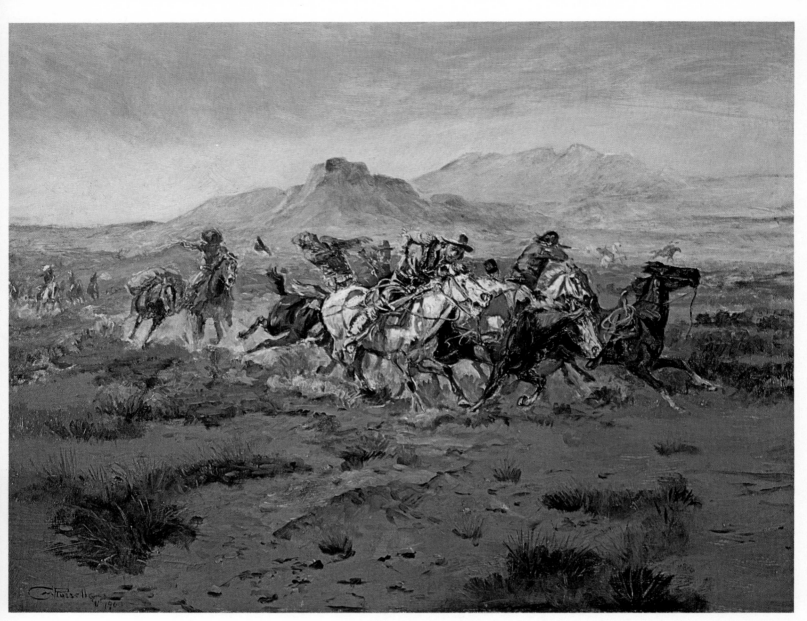

The Attack, 1900, Charles Russell. 18-1/2 x 24-3/8 in., oil on board.
Courtesy, Amon Carter Museum of Western Art, Fort Worth.
The blur of the landscape provides contrast to the sharp lines in which
Russell has rendered the determined but scared riders fleeing an attack.

Interestingly, the artist got the same effect in an oil of five years later, *The Attack.* Here, the situation is reversed. The riders are the hunted, not the hunters, and the people in pursuit are the Indians, attacking a roving band of Anglo-Americans, presumably trappers working Indian territory they had no right to be in. The whole feeling of the riding group of whites is the opposite of that in *The Posse,* which it should be. Here the men are looking back rather than ahead and, except when firing at their pursuers, are crouching down on their horses instead of sitting high so as to see more. Yet the same relationship of the hard, solid group of riders to the misty, almost blurred landscape sets the tone of the picture. Partly this is realism. After all, the riders are kicking up a good deal of dust. But it also conveys that the riders in both pictures are intent on their actions and ignoring their surroundings except in terms of those actions. Our attention is skillfully directed in exactly the same way.

The Hold Up shows another popular variety of crime in the Old West and another one that frequently brought a posse in pursuit. Painted in 1899, the picture depicts an actual incident, the last holdup of a famous stagecoach robber of some fifteen years earlier, Big Nose George. George may be seen holding the rifle to keep the passengers covered while one confederate does the same for the driver and his presumed protection, and another lifts the booty from the victims.

The passengers make up the kind of mixed bag that was to become standard in movie stagecoach groups twenty years later. Left to right, we find a clergyman, a prospector, a schoolma'am new to the territory, a widow, Mrs. Flannagan, keeper of a popular boarding house in Miles City, a gambler, a Chinaman, by all odds either a ranch cook or the proprietor of a laundry, and, separated from the others and about to be separated from several thousand dollars, Isaac Katz, a merchant. Katz had recently arrived in Miles City to open a gents' clothing store. Until his goods arrived from New York, he had been passing his time at faro, the regional sport, and doing very well at it. He was known to carry his winnings sewn into the lining of his clothes, and it was his presence on the coach that brought Big Nose George and his buddies into

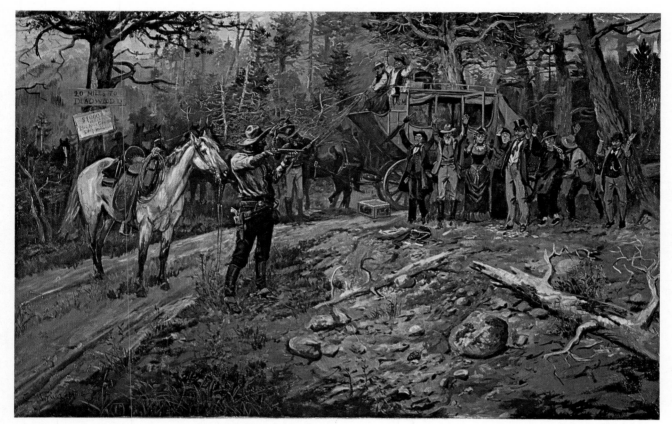

The Hold Up, 1899, Charles Russell. 30 x 48 in., oil.
Courtesy, Amon Carter Museum of Western Art, Fort Worth.
This was an actual event—the last holdup of the infamous robber, Big Nose George,
who is pictured keeping rifle cover over the mixed bag of passengers
while his partner lifts the booty from the victims.

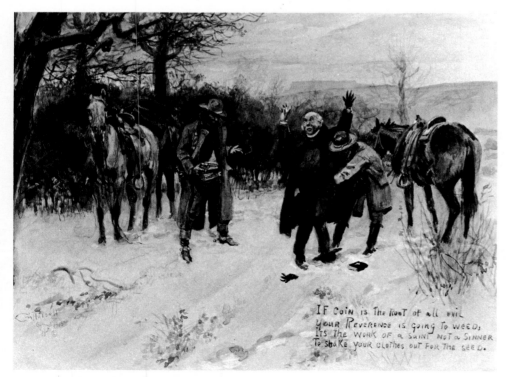

Fleecing the Priest, 1915, Charles Russell.
9-1/2 x 12-3/4 in., watercolor.
Courtesy of The R. W. Norton Art Foundation, Shreveport.

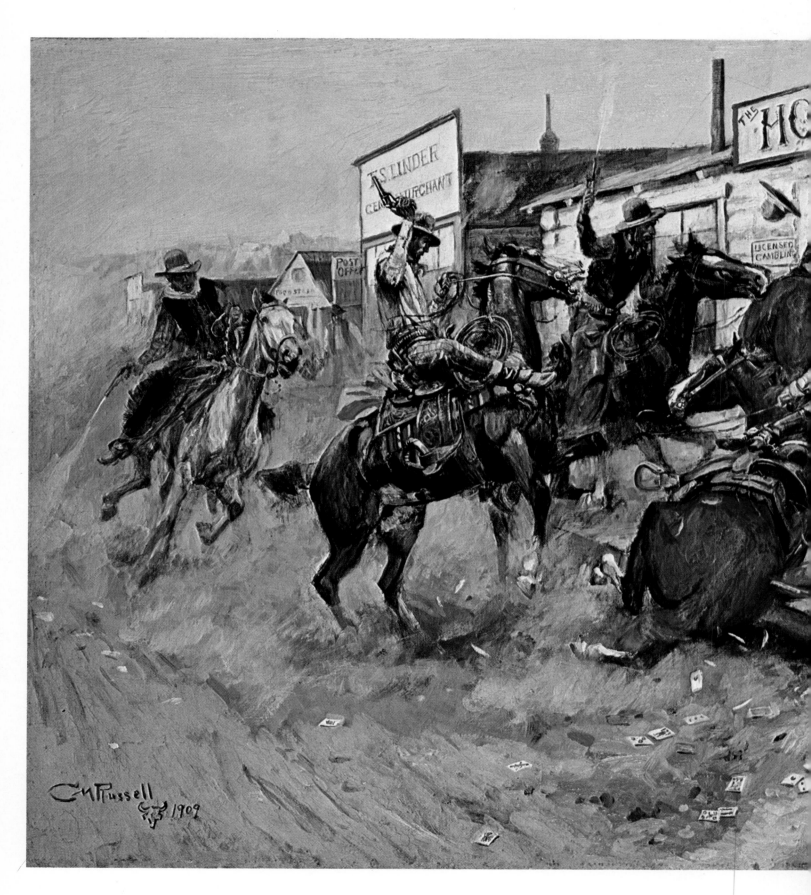

In Without Knocking, 1909, Charles Russell. 20-1/8 x 29-7/8 in., oil.
Courtesy, Amon Carter Museum of Western Art, Fort Worth.
Russell recorded an actual event when his fellow ranch hands, the night
before a long drive, whooped it up in this unorthodox entry into Hoffman Bar
and showed off their remarkable control over their mounts.

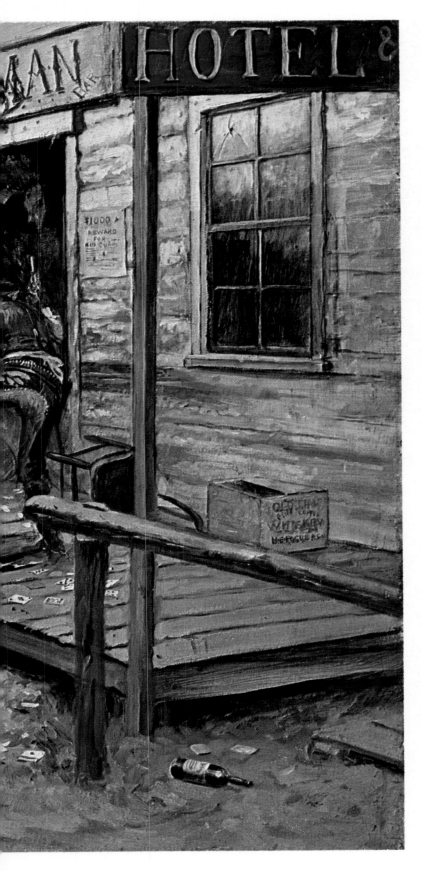

action as the coach passed through a wooded area between Miles City and Bismarck.

As the letters on the panel of the driver's bench indicate, the coach was also carrying the U.S. mail, and so Big Nose George was committing a Federal offense. He was captured in Miles City and taken to Wyoming to be tried. As happened more than occasionally in the West, the citizens were outraged that, once captured, Big Nose George should still be alive. They broke into the jail, overpowered the guards and hanged the outlaw from the nearest telegraph pole, a suitable tree apparently being too far away. Almost incredibly to a modern mind, Big Nose George was skinned by the local doctor the night of his death and the skin used to make up a riding quirt and a pair of lady's shoes.

In sharp contrast to the vast majority of his paintings, with their wonderful feeling of the vastness of land and sky, here Russell portrays a closed-in, hidden scene that is exactly right for the subject. The curve of the road leads to the halted coach and everything is closed in by the surrounding trees.

In Without Knocking is also the record of an actual event. The riders crashing their way into the local gambling hall were Charley Russell's fellow ranch hands in the Judith Basin. After the round-up of 1881, ranchers in the area decided to stage an overland drive to the railhead of the Northern Pacific, scheduled to be in Glendive before the snow flew. The night before the drive began, the crew rode into nearby Stanford for a night of whooping it up. This unorthodox entry into the Hoffman Bar was a highpoint of the expedition. Russell, on his usual job of night watch with the herd, was not on the trip to town, but those who were testified that the picture captured the incident just as they remembered it. At a moment like this of carefree hell-raising, the remarkable command the cowboys exercised over their horses is even more evident than in pictures of them at work. Each of the riders, including the one who has taken a fall on the wooden sidewalk, expresses in a slightly different way his complete and confident control over his mount.

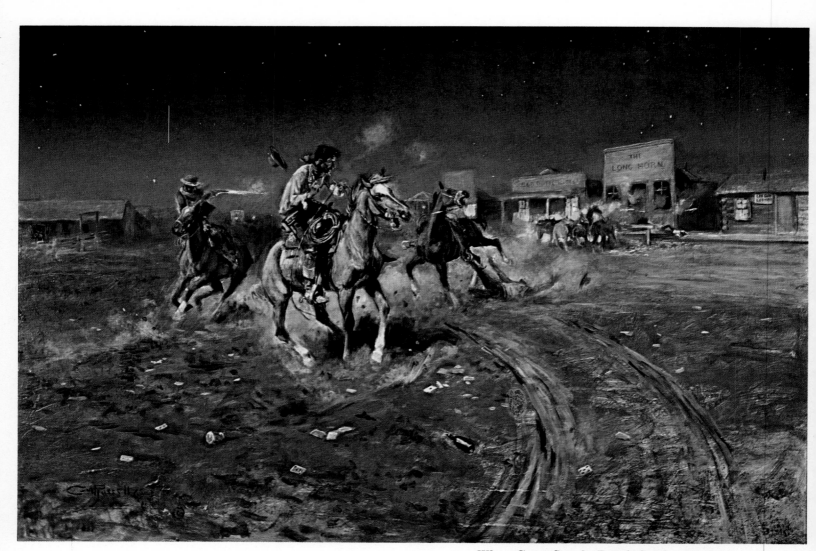

When Guns Speak, Death Settles Disputes, n.d.,
Charles Russell. 24 x 36 in., oil.
Thomas Gilcrease Institute of American History and Art, Tulsa.
Gunshots were not unusual night sounds in the streets of cow towns;
here, card players shoot it out under the indifferent, starry sky.

Another kind of barroom altercation is shown in the dramatic picture *When Guns Speak, Death Settles Disputes.* A night piece, which is relatively rare in Russell's work, the painting portrays the end of a dispute over cards. Russell's great gifts for variety and reality are evident in every detail. The three men fleeing the fire from the Long Horn bar are each in vividly different stages of flight. The rider nearest us has just had his hat shot off and is preparing to return fire while he reins in to help his companion who has apparently been shot and fallen from his horse. The third man in motion is curving fast around the other rider and firing straight back at the saloon door. Although the lights of other establishments are burning brightly on the little main street, those of the Long Horn have been shot out, either in the original dispute or as a common sense measure of defense when the shooting started. Shots come from the doorway and a man lies dead on the walk in front. Meanwhile, overhead, the stars twinkle brightly and imperviously, implying that the incident is really a very small one easily contained in the great spaces of the West.

But it is as the chronicler of the daily life of the cowboy that Russell is best known. In that role he has given his greatest gift to his fellow Montanans and indeed to all Americans, making live again for them a unique and important way of life in this country, a life now all but gone in most of its oldtime manners, a life constantly in danger of being made frivolous in movies, television and fiction. Russell painted the West as it was and the cowboy's life as it was.

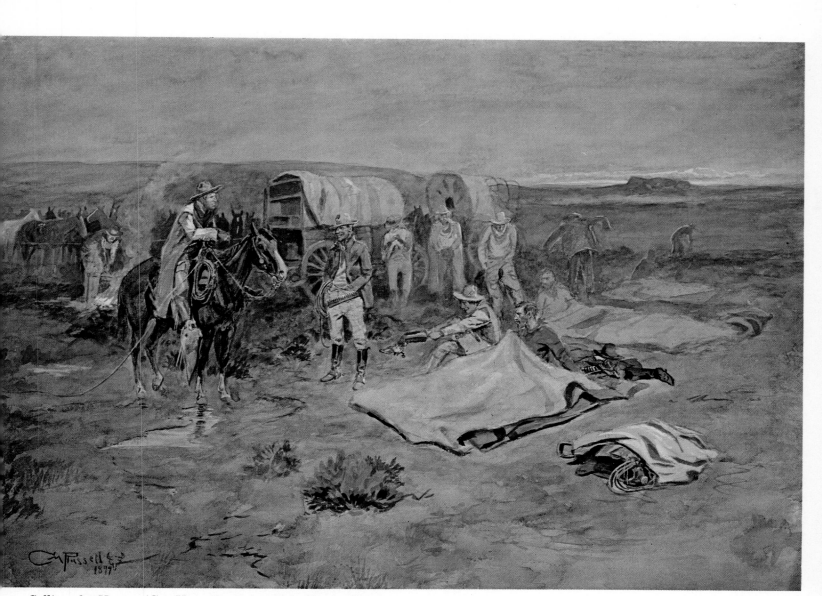

Calling the Horses (Get Your Ropes), 1899, Charles Russell.
19-15/16 x 29-1/4 in., watercolor and gouache on paper.
Kimbell Art Foundation, Fort Worth.
"Get your ropes" was the nightherder's call to wake the cow camp,
which is shown in various stages of readiness for the day's work.

One way it was is shown in *Calling the Horses (Get Your Ropes)*. The nightherder, who bears a remarkable resemblance to Charley Russell, nightherder, is awakening the camp with the laconic command of the title. In the distance a cloud of dust indicates the presence of part of the herd on the loose and needing to be rounded up before the trail drive or branding, depending on the time of year, can continue. As he often did, Russell here placed his cowboys in a variety of stages of waking up and getting into working gear, from the fully dressed cowboy nearest the nightherder to a couple of them just struggling into conciousness, while others already pull on a boot, buckle on chaps, shake into a jacket or light the first cigarette of the day.

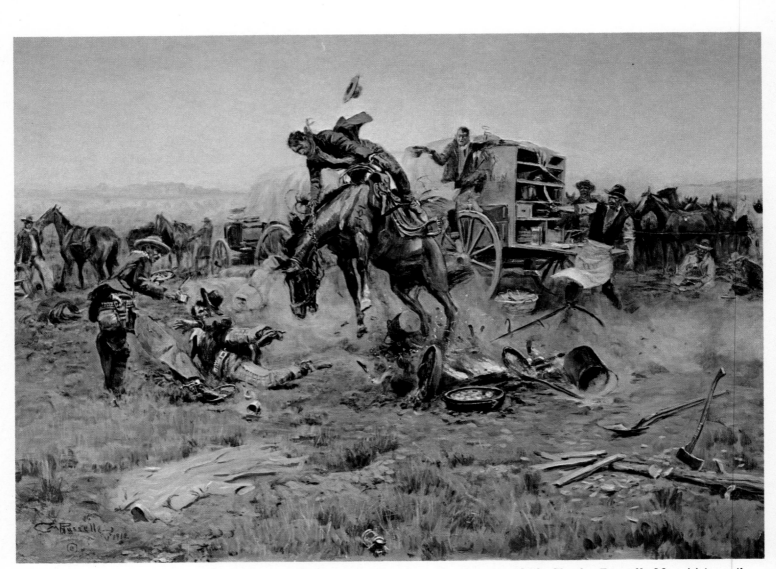

Camp Cook's Troubles (Bronc to Breakfast), 1912, Charles Russell. 30 x 44 in., oil.
Thomas Gilcrease Institute of American History and Art, Tulsa.
Russell had an uncanny ability to stop the action just at the peak of movement.

Yet another cook and his troubles are the subject of *Bronc in Cow Camp.* Russell liked this theme and painted it a number of times. It is interesting to contrast this picture with *Camp Cook's Troubles.* In the former picture, Russell employed a fairly tight composition to reproduce the tension such an incident obviously would create in a camp. Here, the moment of the painting is a touch later—the cook, for example, has had time to take arms against the intruder and the standing cowboy time to register and laugh—and the composition is more spread out, underlining the extent and the quality of the bronc's spasmodic ride through the range hands' breakfast.

The trouble of another cook—a different kind of cook and a very different kind of trouble—is portrayed in *Meat's Not Meat Till It's in the Pan.* Here the solitary rider in the mountains, probably a prospector, a hunter or a trapper, has hit his day's food supply just as the day be-

gins but he is at least momentarily unable to collect. The tracks in the snow beside his own indicate that the mountain goat was hit at a higher and more accessible part of the slope, then staggered down to the ledge on which it now rests. Although badly wounded, it is still alive enough to make it extremely dangerous to try to take it by hand, while another shot might well blast it off the ledge altogether. The hunter waits, the horses wait and the soaring eagle waits, confident that the meat will end up in its own gullet rather than in the hunter's.

Camp Cook's Troubles is remarkable for Russell's uncanny ability to stop the action just at the peak of every possible movement. A moment later, the maverick mount will be out of the fire, the cowboys interrupted at breakfast will be out of the way, the cook will be actively trying to retrieve his gear and the rider, no doubt, will be on his way to a salty-tongued, angry dressing-down by the boss.

(continued on page 287)

282

A Bronc to Breakfast, 1908,
Charles Russell. 19 x 25 in., watercolor.
Montana Historical Society, MacKay Collection.

Meat's Not Meat Till It's in the Pan, 1915,
Charles Russell. 23 x 35 in., oil.
Thomas Gilcrease Institute of American History and Art, Tulsa.
In this famous painting, hunter, horses, eagle and goat wait for
fate, perhaps, to settle the question of who will collect the meat.

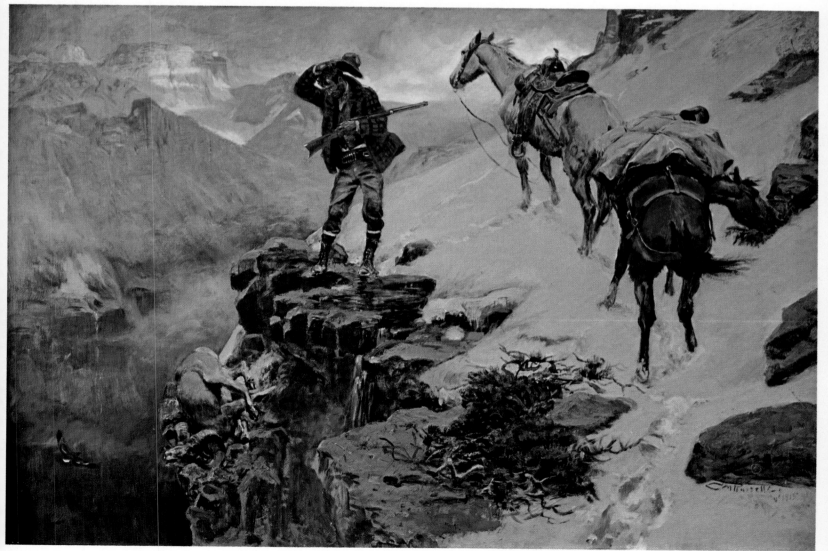

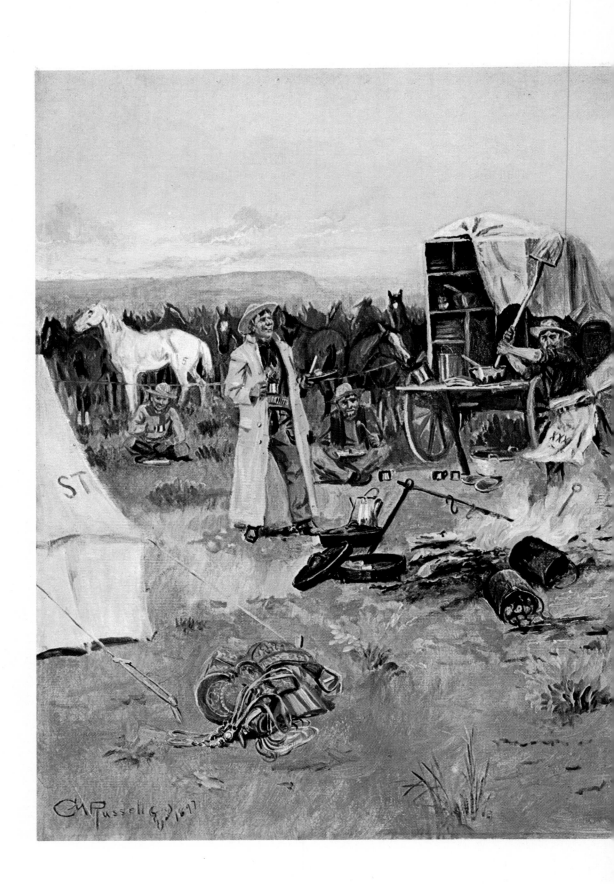

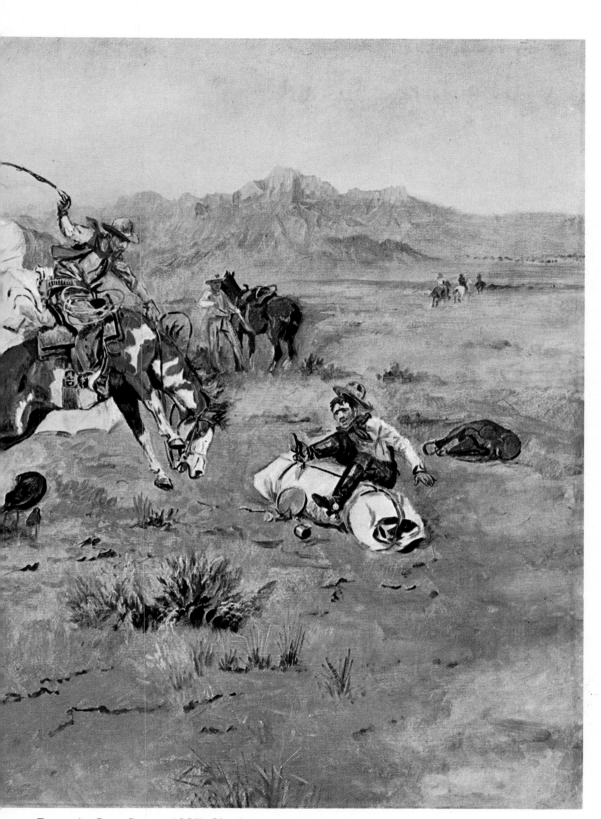

Bronc in Cow Camp, 1897, Charles Russell. 20-1/8 x 31-1/4 in., oil.
Courtesy, Amon Carter Museum of Western Art, Fort Worth.
This scene of a camp cook's morning shows the action after the
bronc is out of the fire and the incident is already laughable.

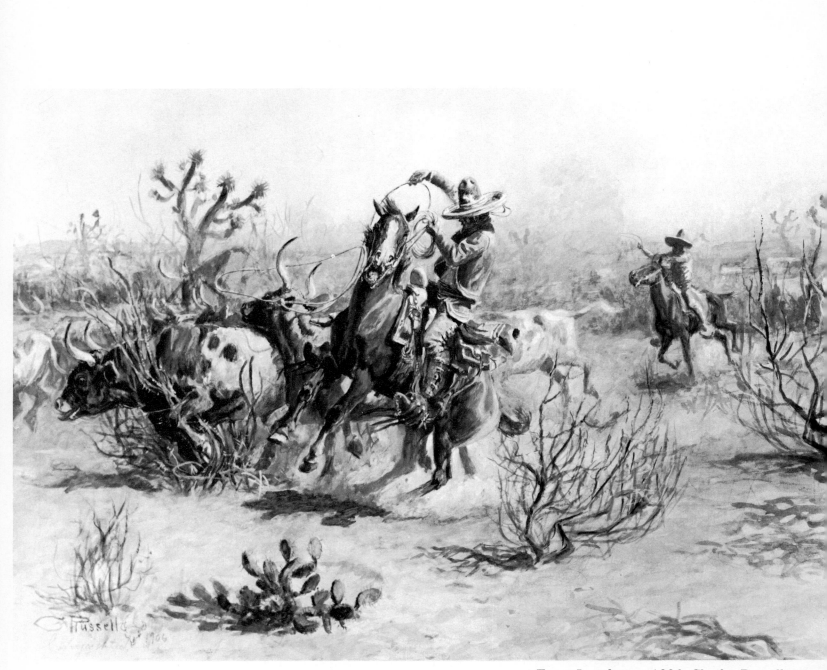

Texas Longhorns, 1906, Charles Russell.
14-1/2 x 20-1/2 in., watercolor.
Courtesy of The R. W. Norton Art Gallery, Shreveport.

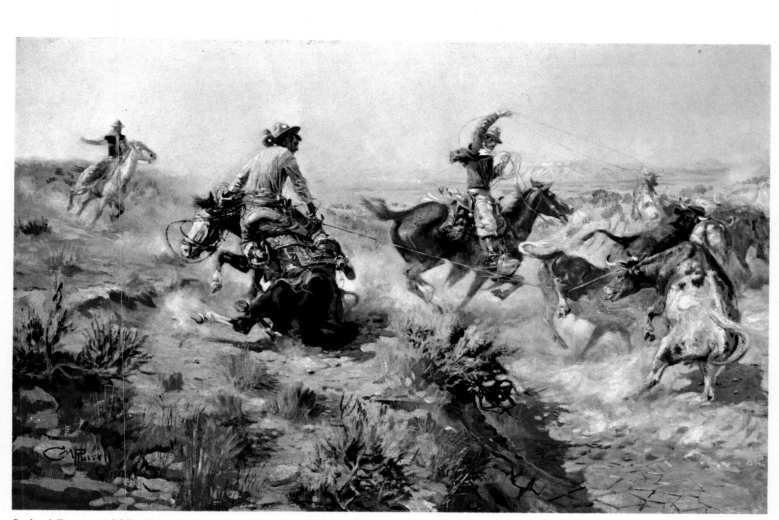

Jerked Down, 1907, Charles Russell. 36 x 22-1/2 in., oil.
Thomas Gilcrease Institute of American History and Art, Tulsa.
The skill of cowboys at work is authentically detailed in this
painting of unexpected trouble when a steer becomes entangled in a line.

One of Russell's most famous pictures of cowboys at work is *Jerked Down*. One range hand at work has roped a steer only to have another get entangled in the line. The sudden, unexpected weight has pulled his horse to the ground, but by shifting his position the roper is trying to help the mount get back on its feet. Another cowboy swings his lasso to drop it over the horns of the roped steer, thus enabling the first to cut loose. The basic trouble arose from the "hard-and-fast" method of roping, which was universally employed in Montana as opposed to the "dally" of the Southwest. The dallyman so tied his rope to the saddle that it could be drawn in or let out, as on a pulley. The hard-and-fast ropers just tied the line to the saddle horn and relied on the strength and skill of themselves and their horses. In the gear of the first roper, Russell has created a small masterpiece of absolutely authentic detail which nevertheless does not leap out from the overall painting. Here, on the contrary, the sharp focus is justified by the composition of the painting: Where man, horse and rope meet is the focus of the painting and that's where our eyes are compelled by the sharpness of detail.

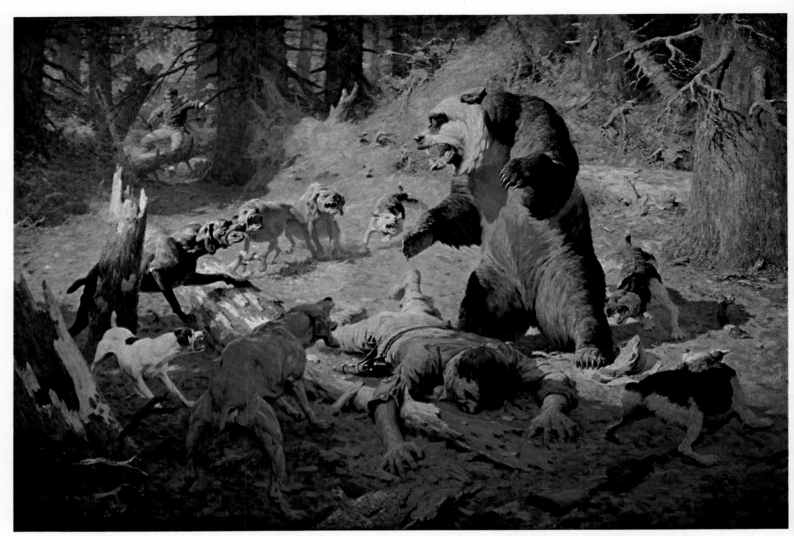

A Close Call, 1914, William Robinson Leigh. 40 x 60 in., oil.
Thomas Gilcrease Institute of American History and Art, Tulsa.
Leigh is supposed to have based this work on an actual incident during a bear
hunt in Wyoming in 1912 when trailing bears with dogs was legal.

A LATE BUT LIVELY ARRIVAL

William Robinson Leigh
(1866—1955)

Leigh was lucky to live as long as he did, for as a young man he wanted nothing so much as to paint the West, but for years nothing seemed more unlikely. Born in West Virginia, he studied art in Baltimore, then went on to Munich for twelve years of rigorous training. Back in New York, he sought and found work as an illustrator, turning out scenes of American history for Scribner's. It was not until he was forty years old—perhaps because he was forty years old—that Leigh pulled himself together and headed West. He got to Chicago on his own, there went to see an officer of the Santa Fe Railroad, showed his samples and proposed a trade: one first-rate painting of the Grand Canyon in exchange for one passage to New Mexico. Once out there, Leigh delivered value for value, and the company ordered five more pictures, enabling the new Westerner to roam about his new country for some

months. He had to return to New York to continue living, but, "Hereafter," he recollected in his autobiography, "I was in the West as often as I could earn enough money to take me there."

That was often enough, and fortunately he had almost a whole half century ahead of him once he made his delayed contact with the West. He painted the Indians, he painted the cowboys, he painted the cavalry, he painted the plains and mountains. He loved every moment of his intermittant life in the West, and that love and curiosity animated his work.

Fleeing Bandit is only slightly melodramatic. The outlaw has fled along the wall of a canyon, outdistancing his pursuers but by no means yet free of them. He turns in the saddle to take a shot at them, at the same time keeping the bridle loose to encourage his horse to the greatest speed possible. The details of kerchief still wrapped around the lower part of his face, the rope, the gun and the eyes of the horse are all painted in sharp focus to stand out against

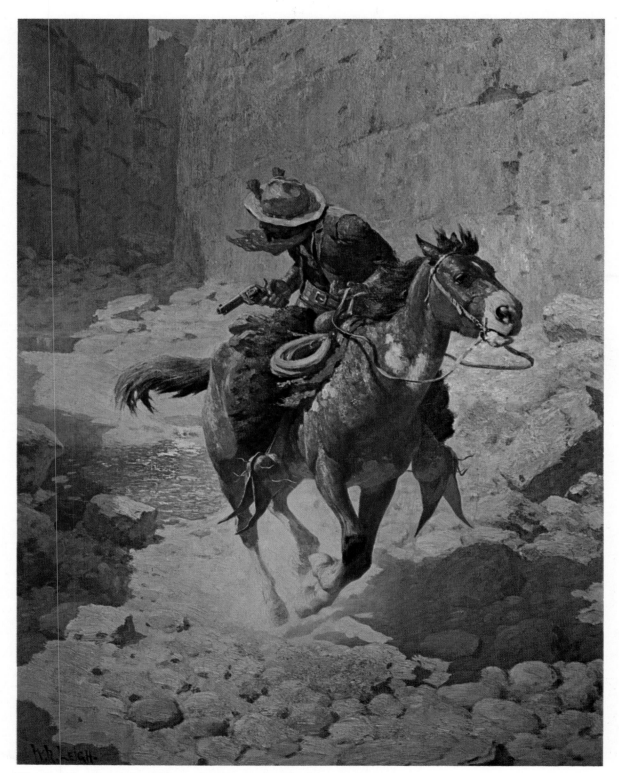

Fleeing Bandit, n.d., William Robinson Leigh. 28 x 22 in., oil.
Paine Art Center and Arboretum, Oshkosh, Wisconsin, gift of Nathan Paine.
Arriving in the West after the turn of the century and the heyday
of the old legends, Leigh nevertheless carried a heartfelt love for
his new country and its unsurpassed drama.

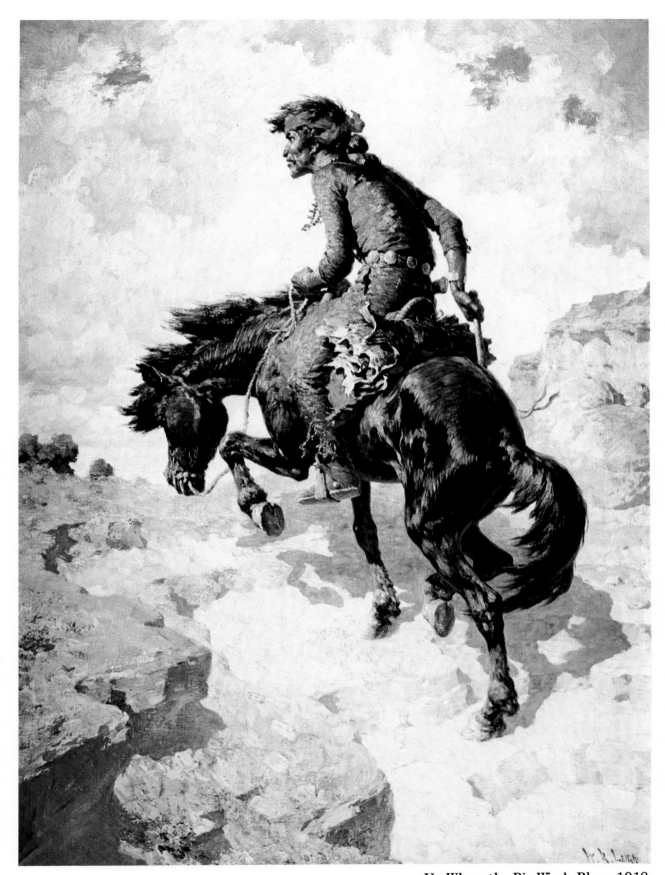

Up Where the Big Winds Blow, 1918,
William Robinson Leigh. 50 x 38 in., oil.
Thomas Gilcrease Institute of American History and Art, Tulsa.
Leigh was an incomparable draftsman, and although he considered his work
entirely documentary, his impressions are personal and romantic.

the overall contrast of glaring sunlight and deep canyon shadow that lends drama to the flight.

A Close Call is drama of a different kind and calls to mind a different, and earlier, peril of the West. The grizzly bear was an object of both sport and dread from the earliest days in the West, but once the white hunters had killed off the buffalo and the great bears began attacking cattle, they were declared a public menace and were ruthlessly hunted down in a combination of dangerous sport and dedicated public spirit. Leigh shows the moment when the hunt has failed, the bear has turned on its attackers and has felled with a blow one of the hunters. The dogs have surrounded the great beast and their yelping is perhaps preventing the final and fatal attack, one that would be over in a moment. In the meantime, leaping over fallen trees, the hunter's companions are breaking through the underbrush to come to the rescue, deliberately and desperately getting as close as they can to increase the odds on their accuracy before firing. The question of the encounter is thus an open one. Leigh based his painting on an actual incident during a bear hunt near Cody, Wyoming, in 1912.

Up Where the Big Winds Blow is less overtly dramatic than either of the other pictures, but in some ways it is stronger. The great height of the mountain being crossed is only implied, but it is inescapable—both from the position of the sky, the ridge and the point of view and from the way in which the small pony bends to the task of getting over the last ridge. Horse and rider are remarkably united, both bending forward, both whipped by the wind from behind, both sharing the blue-black hair that blows in the big winds.

THE PEOPLE, ABOVE ALL

John Sloan
(1871—1951)

Sloan was a Western artist more or less by accident and, as it were, on the side from his main line of work, which was the city.

It is not at all fanciful to suggest that for Sloan, and perhaps in common reality as well, there are similarities between the city in art, as it was discovered by Sloan and his friends around the beginning of the twentieth century, and the West as it was discovered by a whole series of American artists, beginning, say, with Catlin in the 1830's and continuing up to Sloan himself from 1919 on.

Sloan and his friends—The Eight, they were called, from their number, and the Ash-Can School, from their subjects—began, in nucleus, as newspaper artists in Philadelphia. In those days, the nineties of the last century, artist-journalists covered news events the way photographers do today, or the way artists still do cover courtroom trials and other places not admitting cameras.

Sloan and his newspaper pals studied at the Pennsylvania Academy under Thomas Anschutz, assistant and successor to Thomas Eakins, probably the greatest painter and teacher of painting in American art history.

In the first years of the new century, the Philadelphians filtered into New York, Sloan arriving in 1904, after earlier trials in the big town.

In those years, official art was based on French academic art and consisted of meticulous drawing and correct coloring of scenes of historical anecdotes or happy and sanitized peasant life. Unofficial art, the avant-garde of American painting, concentrated on variants of Impressionism, none of them retaining the understanding and drive of the French artists. To that split scene, the Ash-Can School—a term applied in derision—brought something entirely new. Instead of either weary imitations of French official art or pale imitations of French revolutionary art, Sloan and his friends, out of their vast experience of the city gained as artist-journalists, gave to the city art world the city itself.

The art world looked at the city as seen by the Ash-Can School and didn't much like what it saw. The city in these new paintings was rough and vital, raw and powerful. That was the way the city was in life, of course, but those characteristics had been absent from fashionable art almost since the Renaissance. The art world rejected the Ash-Can School, calling the artists "The Black Gang" and keeping their work firmly out of the large, institutional exhibitions which could make an artist's reputation or condemn him to obscurity. In 1908, The Eight struck back. At a commercial gallery, they staged an exhibition of their own—and changed the course of American art and American art institutions forever. The show was praised and it was condemned, but it was talked about and it was sold to new collectors. The iron grip of the Academy of Design on the art life of New York and, to some extent, the country was broken forever. Sloan and his friends had found a new and steadily increasing audience in the newly urbanized Americans who recognized and rejoiced in the views of city life that were suddenly up there on the gallery wall in genuine oil paint, the same as great moments from Roman history or springtime in a

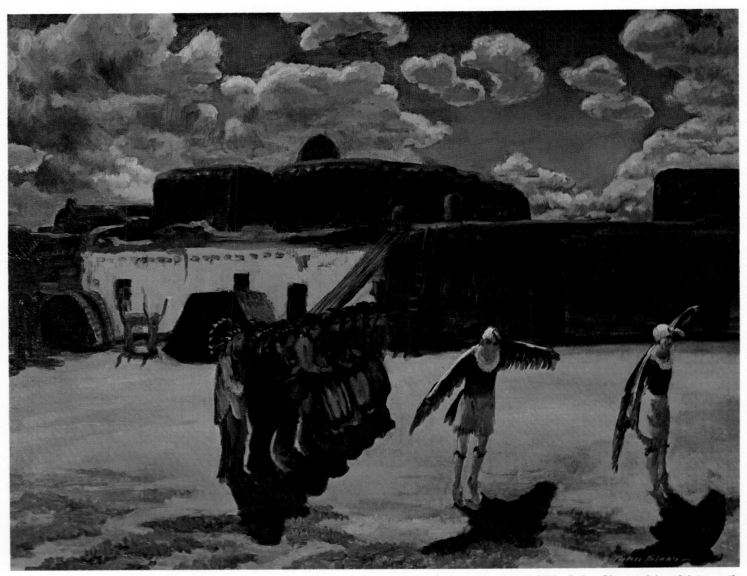

Eagles of Tesuque, 1921, John Sloan. 26 x 34 in., oil.
Taylor Museum of the Colorado Springs Fine Arts Center.
The eagle dance of the Pueblo Indians living at
Tesuque, which the artist saw in the 1920's, had
survived for centuries, though tribal dances often
became mixed with Christian rituals.

New England that most city-dwellers would see, if at all, only on a brief vacation, while surrounded by hundreds of other city-dwellers on holiday.

Sloan became art editor of *The Masses,* a Socialist paper, for which he drew scathing cartoons of the injustices inflicted on the poor by the rich. He taught art for years. He exhibited regularly. With his friends in and around the Washington Square neighborhood of Greenwich Village, he created the very archtype of the semi-Bohemian artist's life, giving parties, staging theatricals and masked balls, entertaining visiting artists from abroad or from outside the city.

But above all, first, last and all the time he painted. His subject and his love were the same: New York in a period that remains the golden memory of the city, the image of the Big Town when the going was good. It was not that

there was no crime or no corruption, no inconveniences, no poverty in Sloan's half century of New York. But there was among most of the residents the assumption of optimism that such things could be dealth with, if not eliminated, or at least contained, so that they interfered as little as possible with the rich, various, stimulating life the city offered on many levels and in many areas. It is that sense of hope and confidence that enlivens Sloan's pictures of lowlife on the sidewalks of New York.

As artists in New York have always done and still do, Sloan, as soon as he could afford it, got out of town for the summer. During World War I, the Sloans and some friends summered in Gloucester, Massachusetts, where Sloan conducted art classes and painted some notable pictures of the New England popular resort and fishing town. In 1919, however, he took a trip to Santa Fe with a

friend and was so struck by the Southwest that he returned there every year except two for the rest of his life. Thus, rather surprisingly, the artist who is, more than any other artist in our history, the painter of New York City, is also a bona fide regional artist, a painter of the Southwest.

It is easy to see what captivated cityman John Sloan about the Southwest's climate and landscape. Those things continue to captivate city people to this day, the high blue sky, the purity of the air, the dry distances the eye can see, the heat that seems purgative but never oppressive. Sloan loved all those things, as he loved the

waves breaking on the rocks at Gloucester and the snow blanketing Washington Square. But his Southwest paintings underline an important fact that is sometimes lost in thinking about Sloan as a painter of New York. This is simply that Sloan was above all a painter of people. It was not New York the place that fascinated him and gave him a subject for half a century; it was the city's people. He painted the streets, but his streets were people flagging a taxi, coming down the stairs from the 'el' or going into a saloon. He painted some of the best "roofscapes" ever painted, but his roofscapes were women drying their hair

The Eve of St. Francis, Santa Fe, 1925,
John Sloan. 30 x 40 in., oil.
The Wichita Art Museum, Roland P. Murdock Collection.
As an artist of the Southwest, Sloan was, as he had
been in the city, most interested in people's activities.
Here, the figures take on more import than the
architecture, desert sky and the religious exoticism.

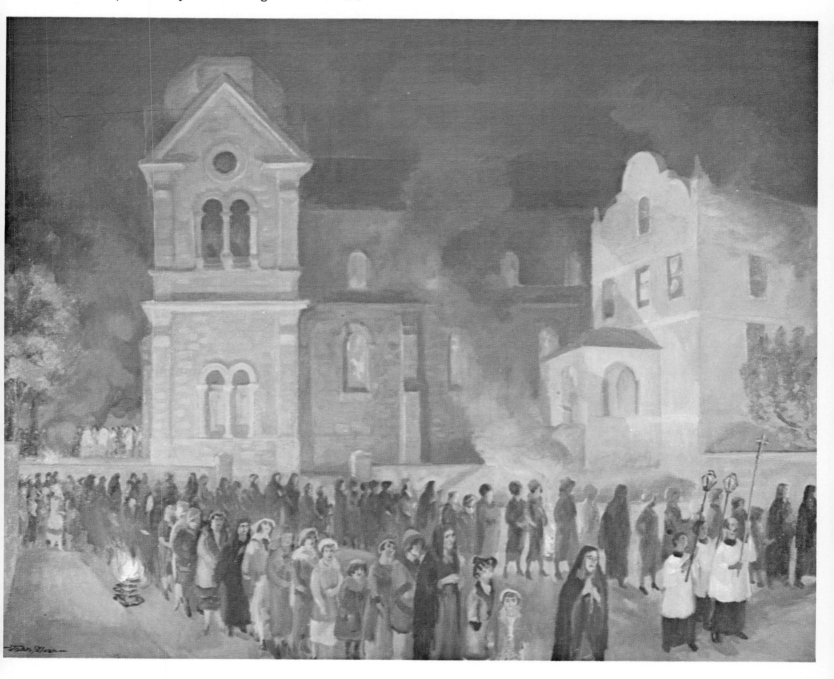

in the spring sun, people sleeping as in a dormitory in the sweltering, pre-air-conditioning nights, men and boys attending to their racing pigeons. So it was when the Southwest revealed itself to Sloan in his late forties. He loved the weather and the climate and the skies and the, to him, exotic landscapes. But he painted the people, and these, for Sloan, came in two principal varieties in the Southwest: the Mexican-Americans and the American Indians.

Sloan was Scotch Presbyterian by birth, and though, as an adult, he made Socialism his religious faith, the Socialism of Sloan's early years in New York had a lot in common with the Puritanism of his ancestors: the pursuit of righteousness, the strong condemnation of evil, the belief in a kingdom to come of justice and brotherhood. The Roman Catholicism of the Southwest must have seemed exotic to him, although his Greenwich Village bordered on the Italian Catholic world of New York, with its street festivals and other public manifestations.

The Eve of St. Francis shows one side of Sloan's Santa Fe. The church and the rectory next to it loom up large and strong in the smoky light of the celebratory bonfires making an enclave of changing light against the blue-black vastness of the desert sky. But clearly, what interests Sloan more than these necessary elements of setting are the people themselves, the long procession of women, led by two acolytes bearing candles and one carrying the cross. The procession has left the church, following services, wound loosely around the grounds and seems to have arrived at an outdoor shrine, there to honor the saint with prayers and hymns.

But the religious exoticism, like the architecture and the starry night, is for Sloan primarily a setting for the people. The head acolyte reveals his character in the intensity of his gaze and also in the proud, sturdy way he stands and holds the cross aloft. The stream of women in the line nearest us presents a suite of variations on the theme of feminine devotion, ranging from boredom to introspection of piety and reverence, while the other line, more subtly, offers the same sort of suite of variations seen in terms of human posture.

Contrary to his lifelong practice, Sloan painted *Eagles of Tesuque* from memory, with neither sketches nor notes to assist. Having seen the extreme sensitivity of the Pueblo Indians to the cameras that tourists brought to their ceremonial dances, Sloan willingly forewent his usual custom of either painting directly on the spot when possible or, if it was not, of making copious sketches and working from them in the studio. However he did study intently the details of costume and face, and this picture, like others he painted of Pueblo ceremonies, may be taken as documentary in addition to its obvious value as art.

Sloan greatly admired the Indians. He wrote of them: "Within nine miles of a Europeanized city, for three hundred years the little Pueblo of Tesuque has made a noble fight against combined poverty and civilization. The population is small and on the day we saw this ceremony a mere handful appeared as spectators."

In contrast to the St. Francis picture, the ceremony here seems almost part of the landscape and its bright sky. The pueblo architecture seems a natural terrain feature, and the painter took full advantage of the stark contrasts of light and dark in the adobe buildings under the desert sun. Within, rather than against, that background, the two "eagles" lead the dance of the tribe, piously maintaining a tradition that long antedated the coming of the white man.

Indian religious customs were much mixed up with Catholic ones. Sloan occasionally attended a mass celebrated before a tribal dance was performed. Yet, in the 1920's, there arose considerable local opposition to the "pagan" ceremonial practices on Indian reservations, and an organized effort was made to stop them and make Indian Christianity pure. Sloan gladly joined this fight on the Indians' side and contributed solidly to the preservation of the old values in the old rituals.

Sloan was also one of the first American artists truly to appreciate Indian art and to help bring it to the attention of his countryman. He organized an exhibition in New York and acknowledged that his own thoughts about tradition in the arts had been deeply affected by his experience of the Southwest Indians.

He had an odd career in terms of public acceptance, one which demonstrates some rather disquieting things about the American art world, things which have not changed much since. A working journalist who transformed himself into an artist and brought with him to art the curiosity and affection for men and women of his first trade, Sloan had made himself famous by the time he was forty. He was widely known—and not entirely correctly—as the leader of a revolutionary movement in art. His paintings had wide appeal. He lived modestly. Yet he never did achieve financial security. He always taught, partly, to be sure, because he believed in passing on what had been given to him, but partly, too, just to support himself and his wife. In the Depression he sent out a letter that remains one of the most moving in our artistic history: Noting that he was sixty-two years old and would probably die in the next few years, he asked, "In the event of his passing, is it likely that the trustees of your museum would consider it desirable to acquire one of his pictures?" He pointed out that "after a painter of repute dies, the prices of his works are at once more than doubled. John Sloan is alive and hereby offers these works at *one-half* the prices brought during the last five years." The letter went to sixty institutions and brought one sale.

Nevertheless, he had a happy life, in the company of people he liked, painting the things he liked and joining, in his observant eye and in his work, the bustling world of New York and the older, quieter traditions he found so fruitful in the American Southwest.

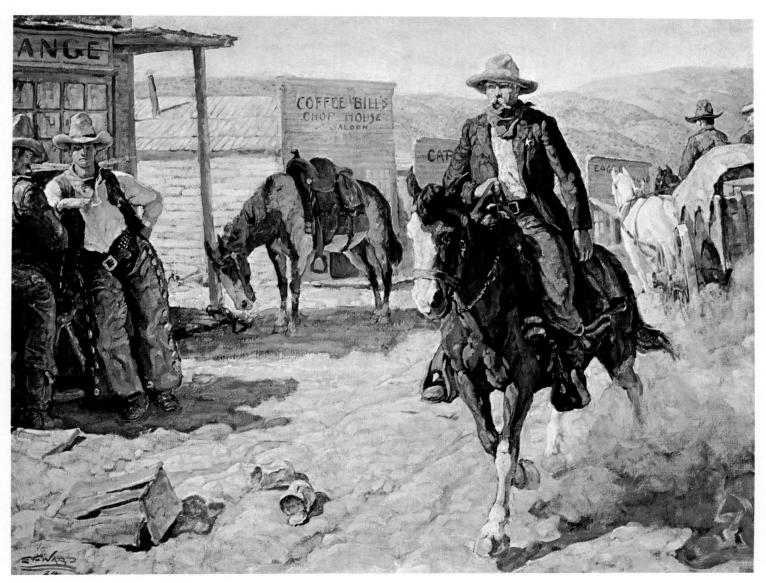

Enter the Law, 1924, E. C. Ward. 21 x 28 in., oil.
Thomas Gilcrease Institute of American History and Art, Tulsa.
As "the Law" — in the form of a rugged, steely-eyed
sheriff — enters town, which looks much like a movie
stage, one can almost sense an impending confrontation.

A CONVINCING SCENE

E.C. Ward
(no dates)

Of E.C. Ward, almost nothing is known—although a whole biography and body of work may turn up at any time. He is represented in the Gilcrease Institute, Tulsa, by a single painting, but it is enough to convince any one at sight that the artist was thoroughly accomplished, technically sophisticated and endowed with familiarity with the West.

Enter the Law is almost monochromatic, a rare kind of painting at any time and extremely so in Western art.

The scene is beautifully put together. To the left a couple of cowboys lean against a hitching rail and talk, the one facing our way catching the light of the sun to reveal a serious face, a glance up the road and a cigarette smoking in his hand. The tied horse takes a nice reflected light on the belly. "The law," the grizzled old sheriff, canters up the street as a two-horse wagon going the other way passes and adds to his dust.

The only clue besides the name is the number "24." If that refers to 1924 as the year of composition is would be worth risking a small bet that the artist and the subject had something to do with the Western movies that were just reaching their first prime. The composition is that calculated and that expertly carried out.

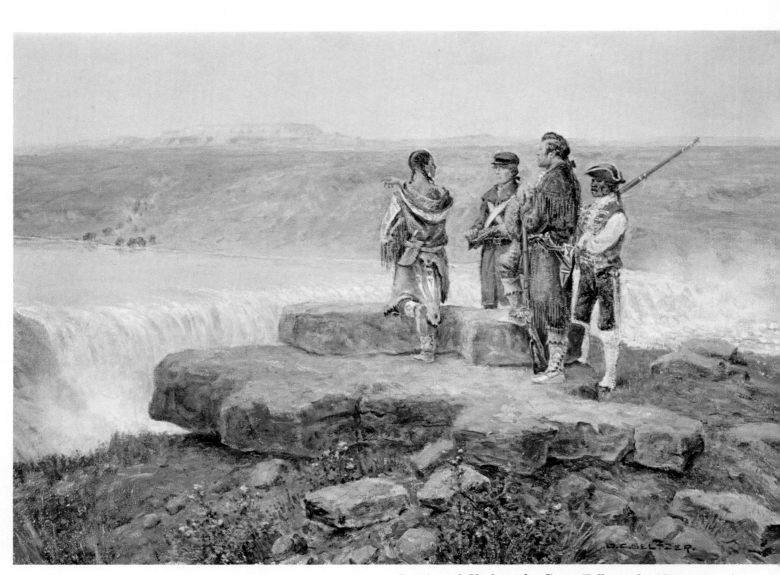

Lewis and Clark at the Great Falls of the Missouri, n.d.,
Olaf Carl Seltzer. 4-1/2 x 6 in., oil on board.
Thomas Gilcrease Institute of American History and Art, Tulsa.
The falls of the Missouri at this point in Montana
are a mighty and impressive scene, though Seltzer
painted them and their landscape in delicate colors.

WESTERN LIFE IN MINIATURE

Olaf Carl Seltzer
(1877—1957)

Olaf Carl Seltzer was almost a painter of miniatures. Not quite. But he came as close to that status as anyone who ever painted Western subjects, closer than most.

He got into painting more or less by accident, the accident of meeting and becoming friends with Charley Russell, the great painter of cowboys and Indians in and around his adopted state of Montana. Seltzer, thirteen years younger than Russell, was born in Copenhagen but came to the United States at fifteen and got a job as a machinist's apprentice with the Great Northern Railroad. He was stationed in Great Falls, Montana, arriving there at just about the time Russell gave up the cowboy's life for good and took up painting as a full-time profession. They got on well, and the older man undoubtedly taught the younger how to handle paints and, especially, how to look at Western life. When Russell died, in 1926, his

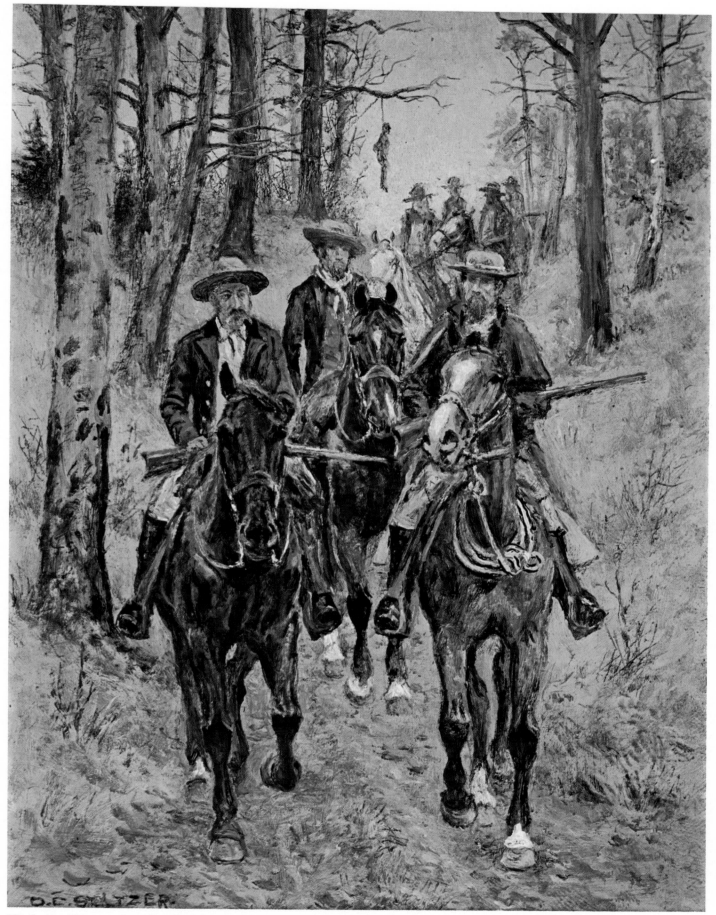

Vigilante Ways, n.d., Olaf Carl Seltzer. 6 x 4-1/2 in., oil on board.
Thomas Gilcrease Institute of American History and Art, Tulsa.
"Necktie parties" of organized citizens often proved to be effective in
dealing with lawless characters until official agencies could be strengthened.

friend went out to New York to complete a couple of commissions the artist had going in the city. Then, in the thirties, he did a whole series of small paintings of Western life and people for a collector in Tarrytown, New York, Dr. Philip C. Cole. These are now in the Gilcrease Institute and they are remarkable for the amount of painting space they manage to encompass within a very small actual space.

Lewis and Clark at the Great Falls of the Missouri, for instance, is six inches across by four-and-a-half inches high. Yet it amply represents the great falls that gave their name to Russell's and Seltzer's town when it was erected on the site. Undoubtedly inspired by Russell's mural on the Lewis and Clark theme, the painting takes a high vantage point on a bluff overlooking the river. We see the falls themselves and, small by comparison, the voyagers coming to shore and preparing to get around the beautiful obstacle.

Vigilante Ways is much closer to the times in Montana that Charley Russell lived through, remembered and undoubtedly related to young Seltzer. Justice was always rough and ready on the frontier—not that the location of a city makes it necessarily more certain or easier to come by. When the outlaws simply overpowered the forces of law and order—either the sheriff and his deputies or, in some areas, the cavalry—the citizens often formed Vigilante Societies. As the name implies, the idea was to be vigilant in preventing, or, if that proved impossible, in the swift punishment of such crimes as cattle rustling and holding up stagecoaches. The term has taken on unpleasant overtones in our own time, but on the frontier it was often a question of vigilante justice or no justice at all, vigilante action or surrender of a whole district to determined and ruthless outlaws.

Vigilante Ways tells the complete story in Selzer's favorite size illustration board, six inches by four-and-a-half. Back along the road through the woods rides the vigilante party after a successful pursuit, judgement and execution, doubtless accomplished in one single expedition. In the distance the outlaw swings in silhouette from a tree branch overhanging the road and thus handy for the traditional commencement of the event, with the presumed criminal astride a horse which was then led out from under him.

Holdup Man, n.d., Olaf Carl Seltzer.
12 x 7 in., watercolor on paper.
Thomas Gilcrease Institute of
American History and Art, Tulsa.

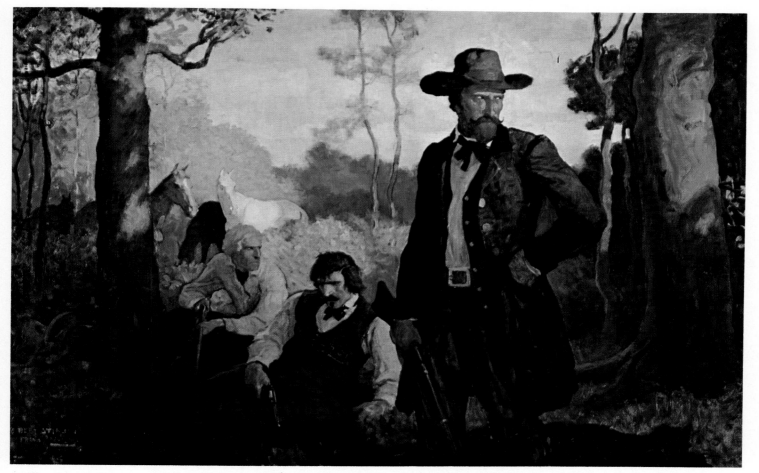

The James Gang, n.d., Newell Convers Wyeth. 25 x 42 in., oil. Thomas Gilcrease
Institute of American History and Art, Tulsa. The James brothers, Jesse and Frank,
notorious bank robbers, kept several branches of law officers in pursuit for 16 years.
Finally, one of Jesse's men killed him, and Frank surrendered soon after.

N.C. Wyeth
(1882—1945)

WHOM AMERICA LOVED

Like his teacher, Howard Pyle, N. C. (Newell Convers) Wyeth became America's best-loved illustrator, especially of children's classics, such as *Treasure Island,* a book which, for Americans, is as inseparably linked with his pictures as *Alice in Wonderland* is with Tenniell's or Dickens is with Cruikshank's. And like Pyle, Wyeth had little to do with the West except for a few pictures which, because he was a great illustrator, perfectly illustrate something of the complex spirit of the West.

Wyeth did make a trip to Kansas City once to look at the cattle arriving in the great stockyards, but he hated the place and canceled a scheduled continuation to Montana. Endowed with substantial and perceptible talent, from an early age he knew what he wanted to do in life and, with his parents' blessing, proceeded to do it, guiding himself into art lessons, then in Pyle's highly personal school. This brought Wyeth to Chadds Ford, Pennsylvania, and he spent most of the rest of his life there, save for summers in Maine.

The James Gang portrays the West's most famous band of outlaws: Jesse James, his brother Frank, and their comrades in arms. The Jameses specialized in robbing banks at a time when banks were in generally low repute among Americans and especially among Western Americans, due to foreclosures of mortgages and similar standard practices that seemed unfair to people unfamiliar with banking. Wyeth portrayed the gang hiding in the woods, apparently having successfully eluded their pursuers but still not entirely sure they will not be discovered and forced to fight or run. The alert, vigilant stares of the outlaws off to our right is echoed by their horses and underlined by the shooting irons they hold in their hands.

The Ore Wagon is a very different scene, a different mood, a different composition, but reveals the same instinctive understanding of the illustrative possibilities of a way of life the painter only understood—insofar as he did—at second, third or fourth hand.

It is a shame that Pyle and Wyeth did not paint more Western pictures, but what illustrators do is to illustrate—from the earliest Renaissance masters to some of the latest Pop artists— literature of one kind or another. Their peculiar sensitivity is to a story about life rather than to life perceived directly in painterly terms. This is their genius and, of course, their limitation. The problem was that when Pyle was painting and to some extent when Wyeth was painting, the outstanding literature of life in the West had yet to be written.

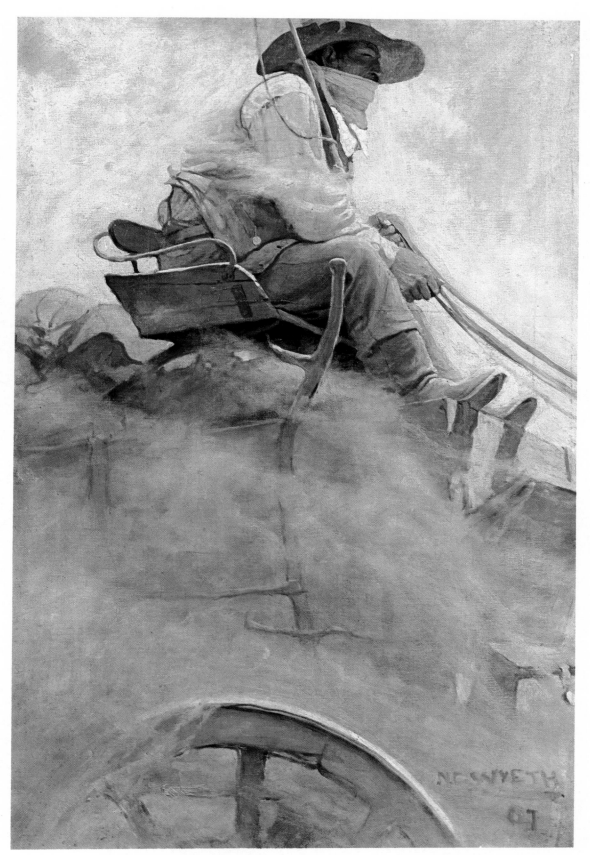

The Ore Wagon, 1908, Newell Convers Wyeth. 38 x 25 in., oil.
Courtesy, Southern Arizona Bank and Trust Company, Tucson.
America's best-loved illustrator, N. C. Wyeth, spent little time
in the West, yet his instinctive understanding of how to illustrate
an adventurous life stood him well in this picture of action.

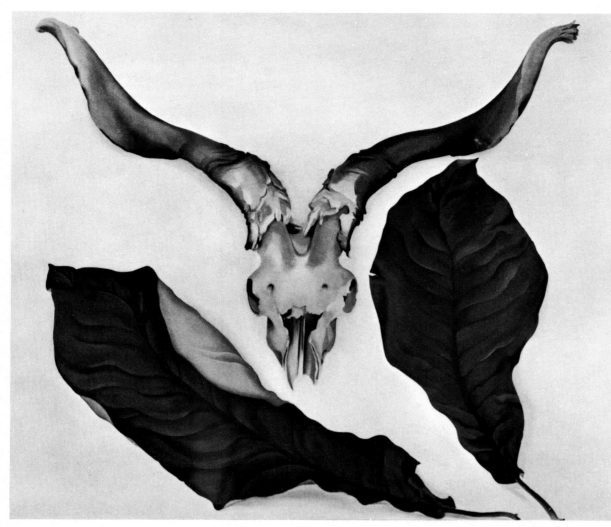

Ram's Skull with Brown Leaves, 1936,
Georgia O'Keeffe. 30 x 36 in., oil.
Roswell Museum and Art Center, New Mexico.

FROM INSIDE
THE ETERNAL WEST

Georgia O'Keeffe
(b.1887)

When, in nineteenth-century Paris, Edgar Degas first saw the work of the great American artist, Mary Cassatt, he said, "At last, a woman who can draw!"

When, in twentieth-century New York, Alfred Stieglitz first saw the work of Georgia O'Keeffe, he said, "Finally, a woman on paper!"

Both men were right about both women, but Stieglitz was the more perceptive of the two. Mary Cassatt, like her successor as America's best woman artist, in addition to being able to draw, did indeed put woman on paper — and on canvas — and did so more unmistakably than O'Keeffe. But Degas, self-trained into a kind of super-

301

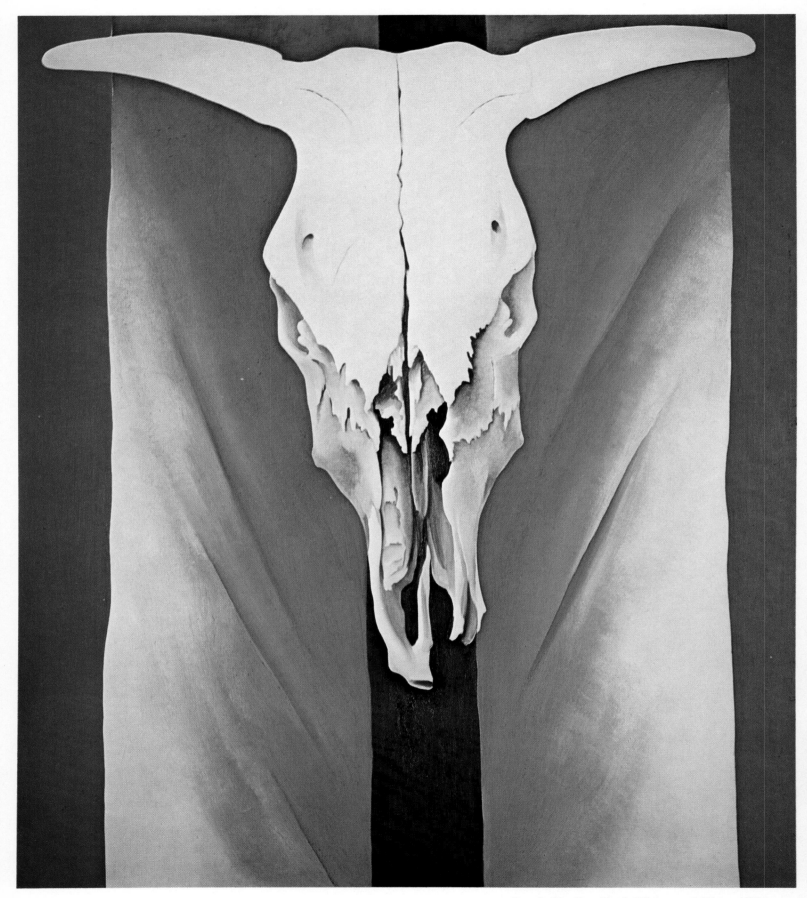

Cow's Skull — Red, White and Blue, 1931,
Georgia O'Keeffe. 40 x 36 in., oil.
The Metropolitan Museum of Art, the Alfred Stieglitz Collection.
These bleached bones have become symbols of the desert
to the artist, who makes them, in their dry beauty, truer
than live desert creatures are to the desert's essence.

objectivity, was on principle uninterested in such aspects of art as the essence of the feminine, which Stieglitz seems to imply in his comment. For Degas such an essence, if it could be imagined to exist at all, existed in the accurately drawn lines depicting the shoulders, back and bottom of a woman stepping out of one of the large, low, flat basins used for bathing in those days.

Like Cassatt, O'Keeffe has been much more than the best woman artist of her time. She has been an artist capable of being ranked with the best of her fellow-American artists and capable, too, of being seen as better than most a great deal of the time. By the accident of meeting Stieglitz she entered the world of American art as a member of a modernist group, but her art was so direct, so personal—and has remained so—that the critical attempts of half a century have failed to fit her conclusively into any of the pigeonholes museums and magazines are always constructing for the convenient categorization of their commodities.

Among other things, O'Keeffe has been an authentic Western artist for more than a quarter of a century, and this aspect of her art has been habitually ignored by individuals and institutions who decided long ago that her place in art was in a certain moment—the twenties—in a certain art world—New York—in the rapid evolution of modern art from the French Impressionists to the American Abstract Expressionists and their successors, the Minimalists, the Conceptualists, the Oppers and Poppers, the Color Painters and what you will.

She was, in the view of such categorizers, an "Immaculatist," which refers neither to a theological specialist nor to a graduate of a certain Catholic high school, but to a small group of American painters thought to be one key to the beginnings of abstract art in this country. The best-known members of this group, except for O'Keeffe, were Charles Sheeler and Charles Demuth, neither of whom knew he was an Immaculatist until informed by the art press.

What both of them did that delighted the instant historian was to discover in such various native American shapes as Shaker furniture and country barns, grain elevators and industrial plants, the same clean, spare lines and volumes as certain European painters were creating in their imaginations and in the abstract.

For one brief period, while she was living in New York and looking out her thirtieth-story window, O'Keeffe seemed to be on the same general track, but in the light of her whole career that can be seen to a case of mistaken identity.

She began as that most unpromising of artists, a young lady making watercolors of flowers. But these were very unusual watercolors and very unusual flowers.

O'Keeffe's flower paintings were entirely new in their approach to the subject. She did not paint bouquets or arrangements and she did not paint small. She painted single blossoms, seen straight on, and magnified on the order of a hundred to five hundred times in size.

"A flower is relatively small," she once wrote. "Everyone has many associations with a flower—the idea of flowers. You put out your hand to touch the flower—lean forward to smell it—maybe touch it with your lips almost without thinking—or give it to someone to please them. Still—in a way—nobody sees a flower—really—it is so small—we haven't time—to see takes time like to have a friend takes time. If I could paint the flower exactly as I see it no one would see what I see because I would paint it small like the flower is small.

"So I said to myself—I'll paint what I see—what the flower is to me but I'll paint it big and they will be surprised into taking time to look at it—I will make even busy New Yorkers take time to see what I see of flowers."

That passage does much more than explain why Georgia O'Keeffe painted single flowers in large pictures. It reveals an exquisite sensitivity and a well-thought-out knowledge of exactly what she wanted to do in art. Born in Wisconsin, O'Keeffe spent her childhood on a farm there. At ten she knew she wanted to become an artist and immediately set about doing so. She took weekly drawing lessons in private, then joined regular classes at convent school in Madison and in high school in Virginia, where the family moved in 1902. In her late teens she studied at the Art Institute of Chicago, then, after a long illness which she recovered from back in Williamsburg, the eighteenth-century capital of Virginia, she also studied at the Art Students League in New York.

Teaching at Columbia College in South Carolina, O'Keeffe rigorously scrutinized her own work, showed it to no one, worked tirelessly to find what she was looking for. Pleased at last with what she was doing, she sent some samples to a friend in New York, instructing her to show them to no one. The friend, instead, showed them to Stieglitz, the photographer then running a modernist art gallery called 291, from its number on Fifth Avenue. Stieglitz was impressed, kept the works and exhibited them along with the paintings of two other artists. Hearing of the show, O'Keeffe went to the gallery to make him take them down, but they stayed up another two months. The painter and the photographer began a friendship and a business relationship and were married in 1924.

Five years later O'Keeffe spent the summer in New Mexico and was so impressed that she spent every summer there, and when Steiglitz died, she moved there permanently, spending summers on an isolated ranch she bought, winters in the town of Abiquiu, where she bought and rebuilt a ruined one-story adobe house. A friend, Mabel Dodge Luhan, who was with the artist on her first visit to New Mexico, reported that she kept saying "Wonderful!" and "No one told me it was like *this.*" To friends and rare visitors since then, she has said, in simple appreciation, "This is the place for me."

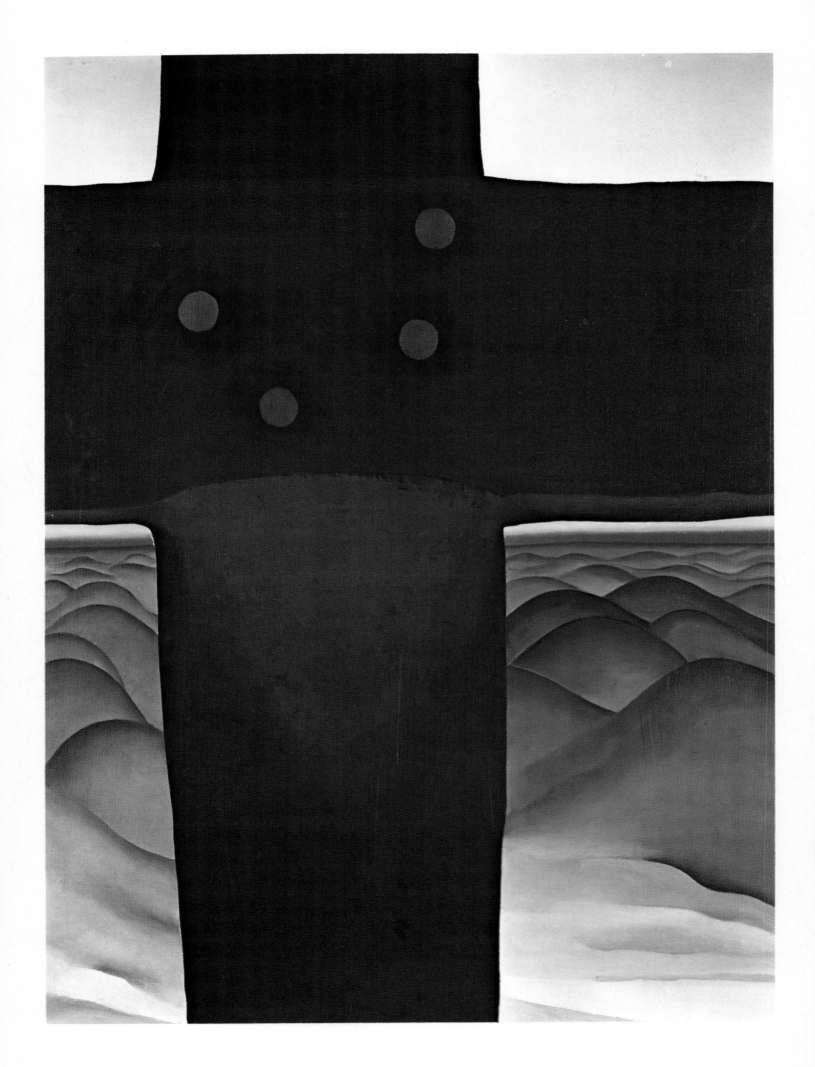

304

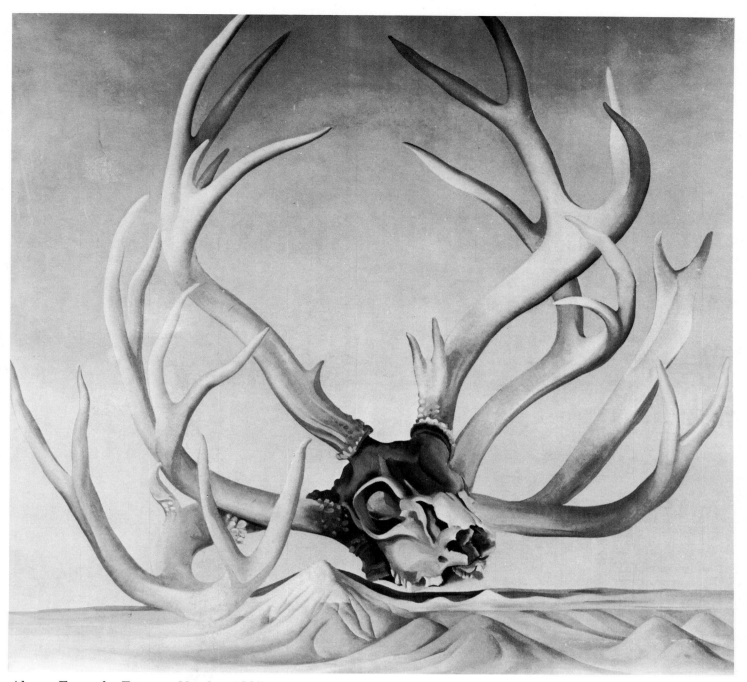

Above: **From the Faraway Nearby, 1937,**
Georgia O'Keeffe. 36 x 40-1/8 in., oil.
The Metropolitan Museum of Art,
the Alfred Stieglitz Collection.

Left: **Black Cross, New Mexico, 1929,**
Georgia O'Keeffe. 39 x 30-1/16 in., oil.
Courtesy, The Art Institute of Chicago.
Throughout the American Southwest
and Mexico, roadside crosses con-
tinually remind the traveler of the
dominance of death in the midst
of life, especially pronounced in this
amazing part of the West.

O'Keeffe has translated the spaces and the subtle col-
ors of the Southwest into space-filled pictures. She has
held everyday objects of the desert up to intense, con-
centrated scrutiny and painted them with penetrating
understanding. She has made abstractions of adobe houses
in the sun and of the distances of the desert at twilight.
She has juxtaposed a blossom and a skull and resented the
implication that this was Surrealism. It was merely a pair
of things common to life in the desert. Her skull paintings
offered a new kind of still-life painting, one in which the
conventional name takes on a shade of irony, but one
which also goes beyond irony to reveal the pulsing life to
be found in dead bones bleached white in the South-
west sun.

O'Keeffe wrote about her skull pictures: "I have wanted
to paint the desert and I haven't known how. I always
think that I can not stay with it long enough. So I brought
home the bleached bones as my symbols of the desert. To

305

me they are as beautiful as anything I know. To me they are strangely more living than the animals walking around —hair, eyes and all with their tails switching. The bones seem to cut sharply to the center of something that is keenly alive on the desert even tho' it is vast and empty and untouchable—and knows no kindness with all its beauty."

Cow's Skull—Red, White and Blue was painted early in O'Keeffe's long acquaintance with New Mexico, but the picture itself is the product of a series of related pictures of the skulls she brought home to look at and to paint. The skull floats in space against the red, white and blue of the title—and the black of the central bar. The white skull could be thought of as nailed to a fence post, but the picture makes all such speculation irrelevant. The skull is simply there—like Mount Everest for a mountain climber, or like death in the midst of life.

The condition of the skull enabled the artist to execute a bravura juxtaposition of the flat, smooth surfaces of the horns and the upper part of the bony head with the layered, intricate, almost membrane-thin structures of the jaw bones and related areas. The red stripes compose a formal border. The blue shadings into the white suggest the infinite skies of New Mexico, while the stark contrast of black and white is austere and Spanish, somehow, reminding us of death in the afternoon in the bullring and on so many battlefields. Yet for all those mortal reminders, the picture lives, the skull lives. The picture is an emblem, almost a flag, commanding attention and communicating its meaning in the language of a heraldry which goes beyond words and is immediately and eternally right.

Black Cross, New Mexico has much of the same mysterious, emblematic quality. Painted in 1929, it is one of O'Keeffe's first attempts to come to grips with the mysterious, attractive new country she had discovered, to get on canvas some part of the wonder the country was daily revealing to her.

The composition of the picture is a combination O'Keeffe has done frequently, though rarely in quite this way, that of a close-up with a distant scene. The close-up object here, the cross, is so close that it goes beyond the borders of the edge of the canvas. It occupies the entire space of the picture and still keeps going off all four sides. The cross appears to be that of a roadside shrine, the two members, horizontal and vertical, unsmoothly shaped and held together by four unevenly placed pegs. Against the light of the sky, the dark cross reveals, despite its title, greens, blues and red-browns within its blackness.

The great, dominating cruciform cuts the landscape and the sky in the distance. We see an infinite of blue and red hills, colored by the setting sun, which also sends the pulsating waves of red and yellow across the far horizon. Above the cross bar, the sky is blue, but also white and with hints of faint violet. The varied colors of the land and sky below the horizontal member are present also in the sky above that member, but they are more subtle.

Light Coming on the Plains, II, 1917, Georgia O'Keeffe. 12 x 9 in., watercolor. Courtesy, Amon Carter Museum of Western Art, Fort Worth.

In the foreground a great drift of snow, perhaps, or white sand, possibly even cloud, slides slowly downward from left to right, forming a kind of threshold before the amazing landscape of hills going off to the sky.

The cross itself is thus slammed up against the spectator's vision. We can only see what is around it, beneath it, above it. The central range of our vision is occupied by the cross, both horizontally and vertically, that being the nature of crosses. Moreover, the cross is so close to our eyes, with the light behind it somewhere, that we cannot really see the cross itself, only its massive, dominating shape.

Taken together, both pictures give an abrupt and highly personal view of the nature of the Southwest, with its Spanish Catholic origins and its necessary acceptance of death in the midst of life.

Georgia O'Keeffe is so well known as an abstract or near-abstract artist that it will still take some time for Americans generally to recognize her as also one of the great painters of the Western part of their country. But these two pictures provide as good a starting place for that recognition as any of her work.

Cliffs Beyond Abiquiu, Dry Waterfall, 1943,
Georgia O'Keeffe. 30 x 16 in., oil.
Collection of the Artist.

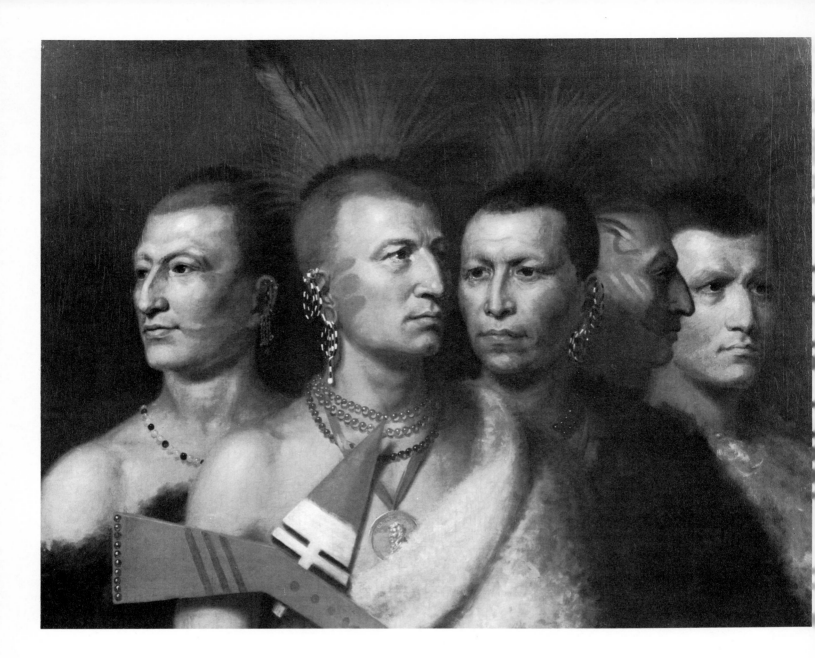

THEY ALSO SERVED

There were, of course, platoons, regiments, of Western painters. Many of them never left the East but were uninhibited by this geographical limitation from painting what they thought, or had heard, or had seen in other people's paintings, about the West. Others, in exactly the opposite situation, never left the West: Gone there or born there, they also painted there, sold or gave away their art to fellow Westerners or to local institutions and hence never got themselves listed in the Domesday Book of American Art which, then as now, tends to be kept strictly along the East Coast—even the Archives of American Art, a Detroit-originated institution, having moved fairly swiftly to a split headquarters in New York and Washington.

Were there mute inglorious Miltons among the native painters of the West? There were. Art scholarship continues to dig up their bones and their pictures. Paintings come on the market as the last member of a family dies

and suddenly a whole lifetime's body of work becomes available. Or a small town museum brings out a group of paintings banished, a generation or more ago, to the basement or the attic. Or an enterprising dealer-scholar links picture to picture to picture to establish an identity for a previously anonymous Western artist. By these and by other means our knowledge of painters beyond the Mississippi grows steadily, and through their work our knowledge of our beginnings, of our continuings and therefore of ourselves grows apace.

Naturally enough, the first impulse to paint the West came to artists in the East, because that's where artists tended to be in the earliest days of the Republic, along with most other citizens of the new nation. When Catlin saw that delegation of Indians passing through Philadelphia on their way to visit Washington for treaty-negotiating purposes, his impulse was to record those noble, savage faces for posterity, in the belief that the

Opposite: Young Omawhaw War Eagle,
Little Missouri and Pawnees,
1821, Charles Bird King (1785-1862).
27-3/4 x 25-3/4 in., oil.
Courtesy, National Collection of Fine Arts,
Smithsonian Institution.
When Indian delegations first visited Washington, D.C.,
they were treated as foreign dignitaries and given medals,
one of which is worn by the prominent Omaha warrior
in this portrait commissioned by the U.S. Government.

Buffalo Hunter, n.d., Unknown American.
40 x 51-1/8 in., oil. Courtesy,
The Santa Barbara Museum of Art,
Buell Hammet Memorial Fund. The buffalo hunt
was a subject that captured the interest of nearly every
Western artist, and although this is an amateurish work,
the grace of hunter, horse and beast is attractive.

Indians were not long for survival, at least in their then independent state. To carry out that ambition, Catlin journeyed into the West, at first attached to military expeditions, then by himself, on foot or in a canoe, making friends with many Indian tribes and returning East with an extraordinary gallery of Indian portraits and scenes of Indian life.

Other artists, however, dealt differently with the same suggestion arising from the arrival in Eastern cities of Indian delegations. One obvious approach was to portray the delegations themselves, and this was pursued outstandingly by Charles Bird King.

Charles Bird King

King (1785-1862) was a serious artist who never prospered particularly. Born in Newport, Rhode Island, where an art colony of sorts survived from the eighteenth to the twentieth centuries, King studied with Benjamin West in London for some seven years before settling down in the new city of Washington at about the age of thirty. A comment on his professional success exists in two of his best know works: *The Itinerant Artist,* which shows a poor dauber toiling away on a portrait of the mistress of a household while the other members regard him with suspicion and contempt and one old crone points out his mistakes; and *The Poor Artist's Cupboard,* a wry still life featuring bills and a notice of a sheriff's sale of the artist's belongings, along with such edifying books as *The Pleasures of Hope* and *The Advantages of Poverty.*

Taos Valley, n.d., Oscar E. Berninghaus (1874-1952).
Collections in the Museum of New Mexico.

In 1824, thanks largely to the efforts of this country's first Superintendent for Indian Affairs, Thomas L. McKenney, a peaceable Quaker, the government established a National Indian Portrait Gallery. The name sounds like the realization of what Catlin tried to effect so long in vain, but the gallery was planned on quite different principles. The idea was not for artists to go out among the Indians, as Catlin had done, but rather for them to stay in Washington and paint the portraits of the Indian members of such tribal delegations as might arrive in the capital for treaty signings and negotiations. King became the artist most completely associated with the gallery, although half a dozen painters worked on the project, including Henry Inman, who was and remains more highly regarded than any of the others.

King and his companions at the easel were thus roughly in the position of White House photographers today specializing in photographs of visiting ambassadors, heads of state and other foreign dignitaries. King was a competent portrait artist as can be seen in *Young Omawhaw War Eagle, Little Missouri and Pawnees,* now in the Smithsonian Institution, which did not exist when it was painted. The heads of the five Indians are superbly painted. Their decorative face painting is carefully observed and there is the feeling of the skull beneath the skin in every man. The two leaders, War Eagle and Little Missouri, are wearing medals bestowed upon them to commemorate their visit. Yet, expert as the painting is, it is impossible to look at it without feeling eventually that these five men are really white men made up and dressed up to look like Indians.

With no experience of the West at firsthand, King was simply unable to look at the Indians and see anything but what he was artistically trained to see, namely heads

An Inquest on the Plains, 1890,
A. D. M. Cooper (1856-1924). 42 x 70 in., oil.
Courtesy of The R. W. Norton Art Gallery, Shreveport.

of a certain bone structure, with a certain way of directing the eyes. Both the structure and the eye-direction were characteristic of white men, but for King they were simply universal: That is the way all people looked and that is how he saw and painted the Indians sent to his studio by the Indian superintendency. This inability to make the cross-cultural, or indeed, cross-ethnic, leap is a common phenomenon, having produced such delights as Japanese popular woodcuts of Commodore Perry and his entourage in Tokyo Bay looking like Samaurai warriors unaccountably dressed in Victorian military uniforms. It was only as the nineteenth century wore on that American artists were able, at last, to see the Indians as they really were rather than as white men with red skins and exotic costumes.

The central effort of King's artistic life was, of course, embodied in the Indian Gallery and it was about ninety percent destroyed by fire. Some portraits survive, and King's colleague, Inman, had made copies of all the works, which may be seen in the Peabody Museum, Cambridge, Massachusetts.

Meeting of United States Commissioners and Indians
(or View of the Great Treaty)
at Prairie du Chien, Wisconsin, September 1825,
James Otto Lewis (1799-1858). 7-1/8 x 11-7/8 in., colored lithograph.
Thomas Gilcrease Institute of American History and Art, Tulsa.
The meeting recorded here formalized peaceful relations between
whites and the various Indian tribes of the Upper Midwest.

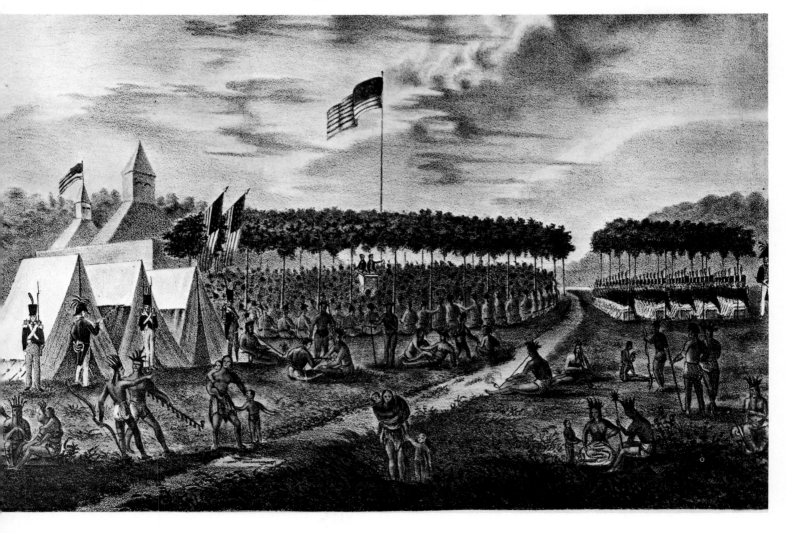

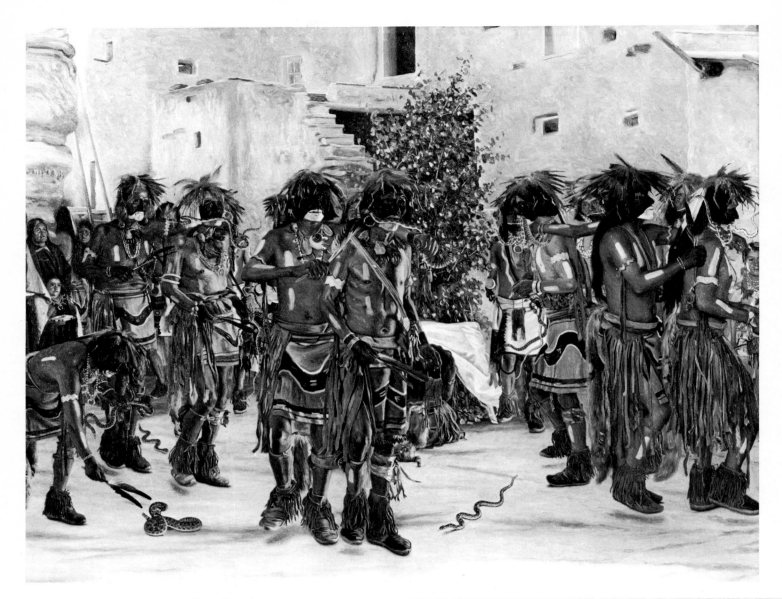

James Otto Lewis

Another colleague of King's on the Indian portrait project was James Otto Lewis. Unlike King, however, Lewis, who lived from 1799 to 1858, had the advantage of some actual contact with Indians. When he was twenty years old, he accompanied Governor Cass of Michigan on journeys around the Great Lakes with a government commission to paint portraits of leading Indians. During the next decade he was present at various councils of Indian tribes in the Upper Midwest. Later, after working with King, he published an *Aboriginal Portfolio,* consisting of printed copies of his paintings. His *Meeting of United States Commissioners and Indians at Prairie du Chien* records an historic treaty gathering at a site, named by French traders, now a Wisconsin city. The Sauk, Potawatomie, Winnebago and Sioux tribes were represented at the meeting, which formalized peaceful relations among the various tribes as well as between them and the white newcomers to the area.

Lewis presents the American soldiers seated in ranks in one grove of trees, the Indians seated on the ground in another across the road. The buildings of Fort Crawford are in the background, while the foreground is devoted to what the artist apparently regarded as typical poses and groups of the "aboriginals": holding bows, smoking pipes and, in one instance it would seem, engaging in amorous dalliance. The assembled Indians 'are being addressed by two men in whites' clothing, one presumably a translator.

312

Lewis was aware of and a little nervous about his own artistic inadequacies, reminding the public for his portfolio of "the great and recurring disadvantages to which the artist is necessarily subject, while traveling through a wilderness, far removed from the abodes of civilization, and in 'penciling by the way' with the rude materials he may be able to pick up in the course of his progress." In relation to such pictures as this, he added, "When it is recollected that the time for holding Indian treaties is generally very limited, that the deepfelt anxieties of the artist to possess a large collection must be no small impediment in the way of his bestowing any considerable share of his time or attention on any one production, together with the rapidity with which he is obliged to labor . . . whatever imperfections may be discoverable, will be kindly ascribed to the proper and inevitable cause."

Opposite: **Hopi Snake Dance, 1909,**
Elbridge A. Burbank (1858-1949). 30 x 40 in., oil.
Butler Institute of American Art, Youngstown, Ohio.
The cultural function of Hopi architecture,
pictured here at the pueblo at Walpi,
Arizona, was to use buildings to frame
a plaza where ritual dances, like the snake dance,
could be ideally performed and watched.

Below: **Conquest of the Prairie, 1908,**
Irving R. Bacon (1875-1962?).
Courtesy, Whitney Gallery of Western Art, Cody.

Unknown American

Lewis was right. His picture of the great treaty gathering at Prairie du Chien does have discoverable imperfections, but he was far from being the least perfectly prepared artist to attempt pictures of Indians. *Buffalo Hunter,* by an unknown American, is much more amateurish from the point of view of understanding of muscles and anatomy of man and beast alike. Yet the vision of the artist presents an extremely attractive, rhythmical picture, full of curves and linear echoes from horse to bison to Indian's bow and arrow.

A.D.M. Cooper

Better painting and a stark composition that rises above the implied visual pun of the title distinguish *An Inquest on the Plains* by A.D.M. Cooper. The seven buffalo do indeed stand about the slain Indian so as to suggest some sort of court convened. Yet the very starkness of the painting turns it into a moving statement with poignant overtones both for the individual lying dead before us and the doomed nations represented both by the dead man and by his "judges," the buffalo.

Cooper's ironic and poignant comment on the situation of the Indian and the corresponding situation of the buffalo, both man and beast so long dominant across the Great Plains, was, it would seem, more or less made by accident in a picture aiming at a fairly easy response, almost a gag, that got out of the control of the artist and rose to a very different, superior quality of human response to the human condition.

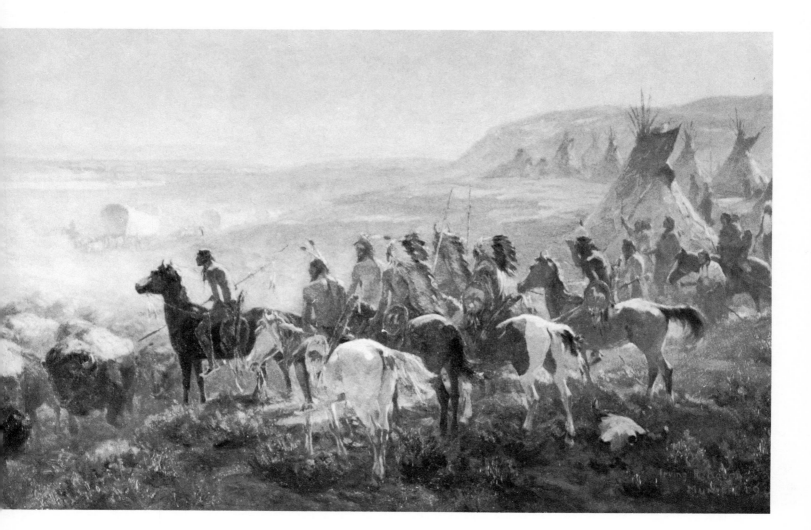

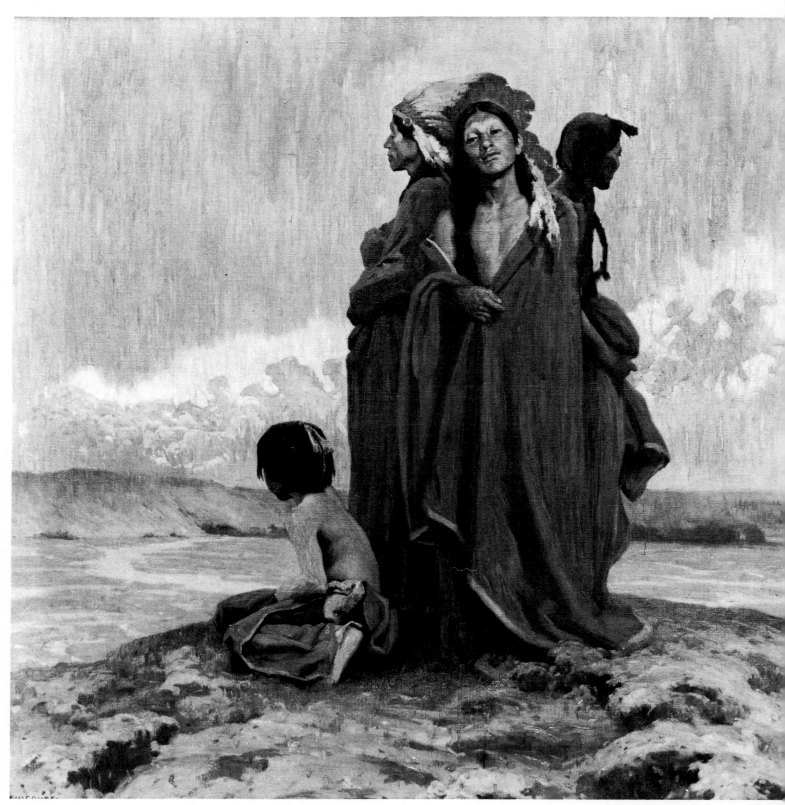

A Vision of the Past, 1913,
Eanger Irving Couse (1866-1936). 59 x 59 in., oil.
Butler Institute of American Art, Youngstown, Ohio.

Elbridge A. Burbank

Other artists who concerned themselves with the Indians aimed more directly at similar statements related to the decline of the tribes. E.A. Burbank's *Hopi Snake Dance,* for example, records the performance of an ancient ritual within the enclosed courtyard of the Pueblo dwellings surrounded by an attentive audience of women and children. We see the snakes and the dancing Indians. But we also see the spectators who are, some-

how, exactly that, rather than vicarious participants in an efficacious religious ritual. Most of all, perhaps, we see the smooth, academic style of the painting and realize at once that enormous changes have taken place since Catlin's day, when any artist concerned about Indians and devoted to recording them was most unlikely to have mastered the best techniques of painting. Catlin would

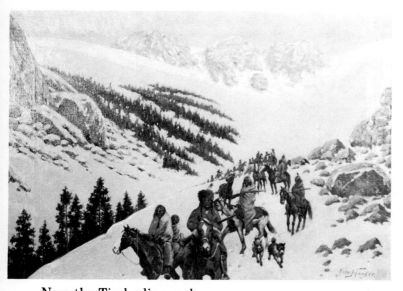

Near the Timberline, n.d.,
by John Hauser (1858-1918), oil.
Rockwell Gallery, Corning, New York.

have been overjoyed if he could have painted as well as Burbank, but in order for him to have been able to, he would have had to have gone to London or Rome at just about the time he headed for St. Louis and points West.

I. R. Bacon

I.R. Bacon's *Conquest of the Prairie* almost seems a staged contrast to underline history rather than an event that actually took place. The whiteman rides all alone across the left side of the picture, while on the right the Indians and the buffalo between them occupy all the space which, on the left, is devoted to prairie grass. The tepees, the mounted warriors and the great beasts of the Plains are all drawn up like sheep led to the slaughter as the new masters of the Western Creation ride confidently in to take possession of their inheritance.

Eanger Irving Couse

A Vision of the Past, by E.I. Couse, is emotionally more explicit than most paintings on such general themes. The three standing adult Indians gaze out in all directions on the wasteland that once had been their own. The seated child has the slump of despondency in the decline of the shoulder, the listless arms, the all too patient pos-

Sioux Hunting Camp, n.d.,
John Hauser (1858-1918), oil.
Rockwell Gallery, Corning, New York.

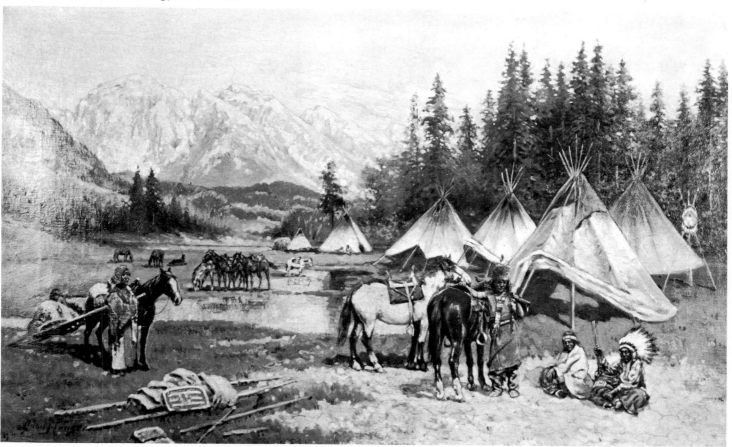

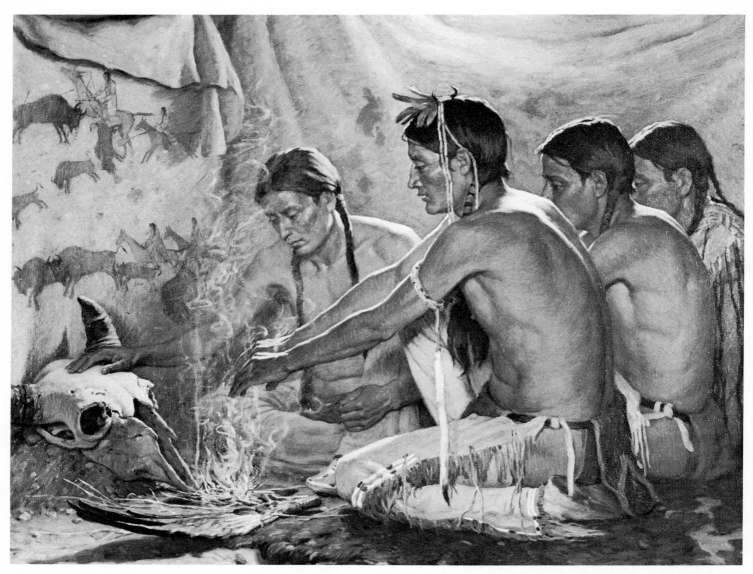

Prayer to the Spirit of the Buffalo, n.d.,
Joseph H. Sharp (1859-1953), oil.
Rockwell Gallery, Corning, New York.

ture. The whole ensemble could so easily be translated into stone or bronze, a single carved or cast monument not so much to a vanished way of life as to the paint and the loss of the vanishing. At the apex of the monument the face of the central figure says it all, the suffering endured, the insults borne, the compensation sought in vain, the acceptance of total desolation.

John Hauser

In contrast to such emotionally loaded pictures, two scenes of Indian life by Hauser, *Sioux Hunting Camp* and *Near the Timberline,* seem noncommittal, almost photographic statements of record. Some measure of symbolic undertone can be read into the *Timberline* picture for the simple reason that that is where the Indians have dwelled in America, to one degree or another, ever since the white man began extending his dominion inland from the East Coast early in the nineteenth century—"near the timberline," that is, near the line at which the earth stops supporting life at all, where vegetation ceases except for certain rare mosses, where there is not quite enough air, quite enough heat for life as we all know it in the lowlands and uplands below. There is a fine sense of great height in the picture, achieved without such obvious indications as precipices and peaks. We just know we are very high up.

Sioux Hunting Camp is a more ordinary scene on the face of it. The tepees have been set up in a sheltered valley. The braves sit taking the sun in the right foreground until the time for hunting arrives. In the middle distance pack horses and riding horses graze quietly; at the left, a squaw stands by with the *travois,* the dragging poles by which the Indians, lacking the wheel, moved their baggage about. Yet even in this calm scene there is a sense of containment, a feeling that the Sioux are not quite as free in their hunting as once they were. The feeling is reinforced by such small details as the double-barreled shotgun held by the seated chief and the decidedly white man's stirrups on the horses next to the seated men, and by the overall impression of a picture posed for by people

willing, perhaps even needing to pick up the odd bit of change available from a passing artist in return for placid cooperation.

Joseph Henry Sharp

A similar air of sadness for things passed beyond recall permeates *Prayer to the Spirit of the Buffalo* by Joseph Henry Sharp (1859-1953). Born in Ohio, Sharp studied in Europe and in his mid-twenties made his first trip West to study the life of the Indians. Works of his exhibited at the Paris Exposition of 1900 attracted a U.S. Government contract to paint a series of views of Indian life for the Smithsonian's trouble-plagued collection on that theme. He set up a studio on the site of the Battle of the Little Big Horn in Montana, later moved to Taos, New Mexico.

Issuing Government Beef, n.d.,
William Gilbert Gaul (1855-1919). 30 x 42 in., oil.
Thomas Gilcrease Institute
of American History and Art, Tulsa.
A sad ending to the Plains Indians' hunting life
is recorded here as descendants of once proud war-
riors, unable to roam their former country,
accept free beef from the Government.

He traveled extensively in the West as well as to Hawaii and the Far East. Technically superb, Sharp had the secret of soft, warm colors and was obviously immersed in the mixed feelings all share who become aware of the glorious, independent past of the Indians underlining their present dependency. That feeling pulses through *Prayer to the Spirit of the Buffalo,* with the animal's skull invoked, on the site of ancient tribal incised painting on the theme, by Indians not yet ready to acknowledge that the age of the buffalo—and all the great beast meant to the tribes—is over forever.

William Gilbert Gaul

Perhaps the most impressive single painting on the theme of the vanishing Indian way of life is William Gilbert Gaul's *Issuing Government Beef.* Gaul (1855-1919) was born in Jersey City, New Jersey, and never stayed long away from the New York area. Educated in art at the National Academy of Design and the Art Students League, he journeyed to the West in the 1880's to pursue a study of military action against the Indians, for the sake of his career as an illustrator of magazine articles. He exhibited in the East, won a gold medal at

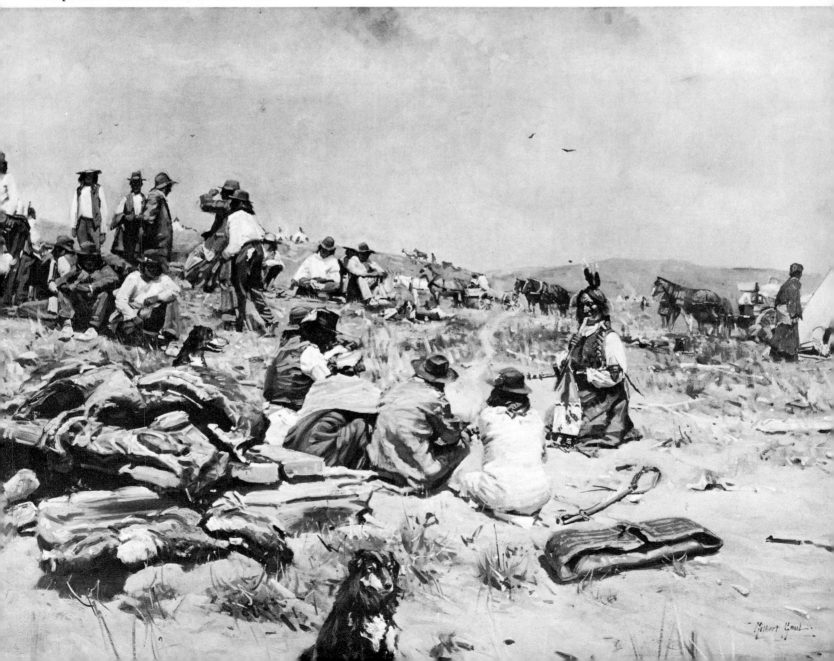

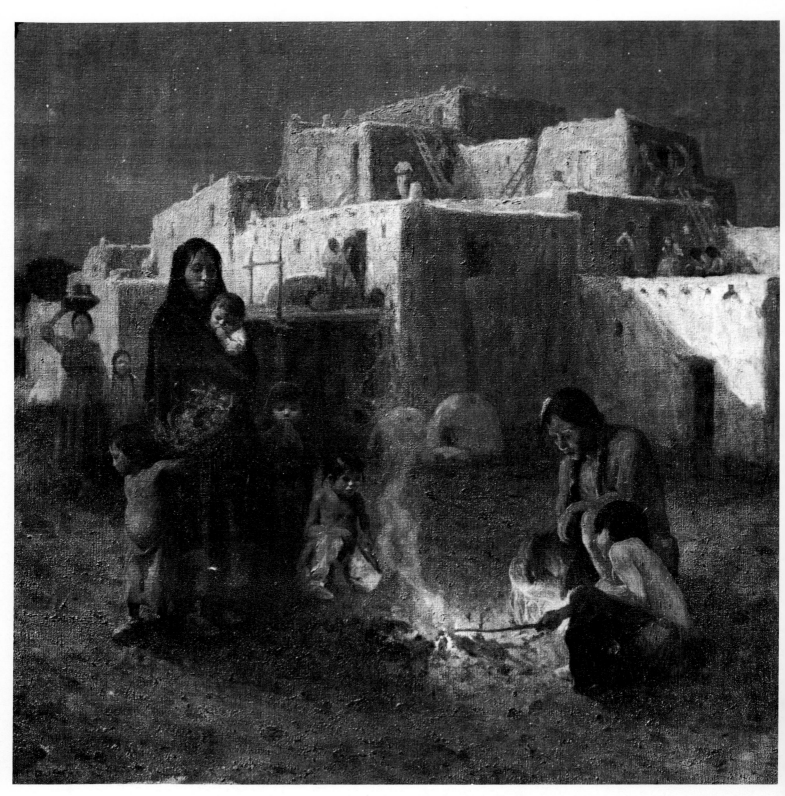

Evening in Taos Pueblo, n.d., E. Irving Couse(1866-1918).
Collections in the Museum of New Mexico.

the Paris Exposition of 1889 and died in New York. Yet, at one moment in this professionally oriented career, W. Gilbert Gaul, as he signed himself, saw one laconically bitter sight and was able to re-create it on canvas and so sum up the plight of the Indian in formerly Indian country. *Issuing Government Beef* is quietly despondent. There is no direct evocation of a vanished past, as in Sharp's picture, no memorial to the past as in Couse's. The Indians, dressed in the secondhand clothes of their conquerors, stand stolidly around as the distribution of free beef proceeds. There is no dramatic center, no single overt act that sums up the predicament of the descendants of free and proud warriors. But there they are, drained of initiative as if by the bright sunlight, the sides of beef heaped up in orderly cuts, so different from the buffalo chase of years gone by, a single squaw recalling the hazardous but noble past by chewing the beef into pemmican, the distribution wagon itself a mere detail of the middle

318

distance, the whole infused with a dry and dying feeling that is more interior than merely the product of the heat and the desert.

Henry H. Cross

Born a full two generations after Charles Bird King, Henry H. Cross (1837-1918) embarked on a similar enterprise of making Indian portraits. He did so, however, in very different circumstances from King's life as an adjunct to diplomacy. Born in upstate New York, Cross was early recognized as a talented youngster and sent off while still in his teens to study in Paris with Rosa Bonheur, the best known member of a whole family of animal painters. In his mid-twenties, already settled in Chicago, he journeyed to Minnesota to observe the Sioux uprising going on there. From that firsthand experience of Indian warfare, Cross joined the decidedly tame Indians of the circus. He worked for Phineas T. Barnum, traveling with "the greatest show on earth" and painting wild animals on the sides of circus wagons. After some time at this branch of art, he tossed it all up and launched forth in the spirit of Catlin, determined to paint Indian portraits while there were still Indians around to paint. Among his subjects in this self-chosen career were Geronimo and the

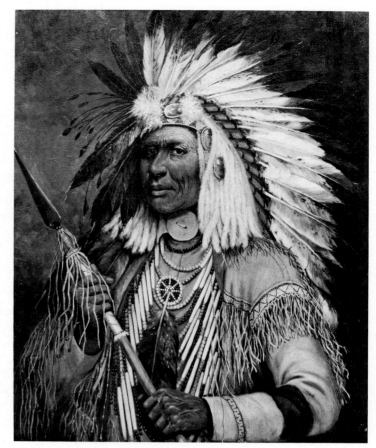

Spotted Elk, Sioux, 1879,
Henry H. Cross (1837-1918). 35 x 29 in., oil.
Butler Institute of American Art, Youngstown, Ohio.

Sitting Bull (Tatanka Yotanka), 1877,
Henry H. Cross (1837-1918). 14 x 11 in., oil on leather.
Butler Institute of American Art, Youngstown, Ohio.
This portrait of Sitting Bull, named in the Sioux
language *Tatanka Yotanka*, was done the year after
he successfully fought General George Custer
at Little Big Horn River in Montana.

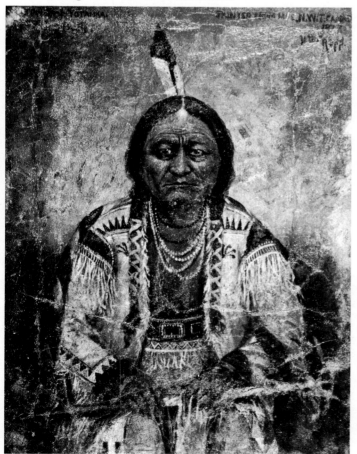

Sioux chief Sitting Bull, both of whom had made considerable trouble for the United States Cavalry in their day.

The portrait of Wild Bill Hickok was painted almost a quarter of a century earlier than most of Cross's Indian portraits, in 1874, and shows that now legendary Western figure alert and intent, gun at the ready. As marshal of Abilene, Kansas, during that town's wildest days, Hickok was the immediate successor of a marshal who tried to run the job with no firearms at all and was shot for his pains. Hickok took no such chances and operated on the theory of shoot first, ask questions afterwards. Nevertheless, he was killed by gunfire—from behind—while playing poker in a Deadwood saloon.

William Henry Jackson

It seems almost incredible that an artist in part responsible for the discovery of the great Western parklands by the American people could have survived into the first year of World War II, but William Henry Jackson did so, living to be ninety-nine years old. He was best known as a photographer and it was his photographs, along with the paintings of Thomas Moran, both made on the Hayden expedition of 1871, that led to the Congressional creation of Yellowstone National Park as the first of the series of such reservations of land from the usual exploitation. Jackson (1843-1942) was the first of a long succession of distinguished Western photographers. He shared with some of his professional descendants the feeling

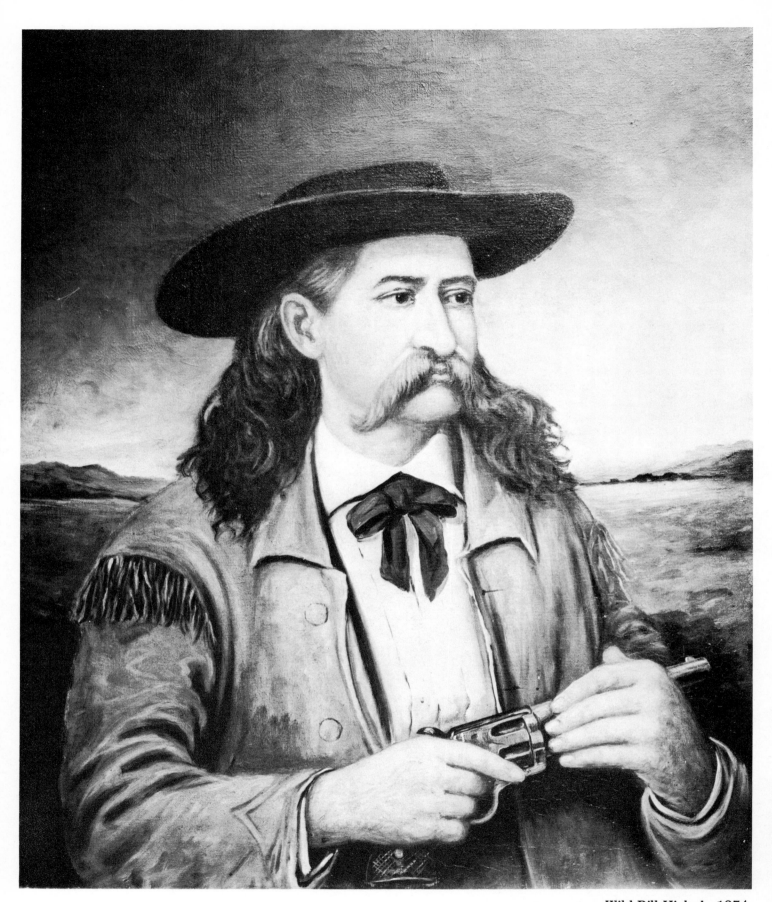

Wild Bill Hickok, 1874,
Henry H. Cross (1837-1918). 30 x 25 in., oil.
Thomas Gilcrease Institute of American History and Art, Tulsa.
Hickok, the famous marshall of Abilene, Kansas, ran the town smoothly for many years on the
theory of "Shoot first, ask questions later," though living by the gun finally paid him
his dues when he was shot from behind in a Deadwood saloon.

that some things about the West just could not be captured by the lens and the wet plate. To have a better try at such challenging subjects, Jackson took to painting. One such challenge was a crossing of the Platte River he witnessed five years or so before he served with the Hayden expedition.

California Crossing, with no melodramatic incident of Indian attack or broken wheel or birth in a wagon train, gives an astonishing picture of the whole westering enterprise. Jackson himself, in a letter to his parents from Salt Lake City, described the crossing in part as follows:

"The river at this place is more than half a mile wide and not more than four feet deep where the current runs the deepest and strongest. There were a number of other trains. . . .The river was filled from bank to bank with teams, a dozen drivers to each . . . to each single wagon the teams were double; sometimes even eighteen yoke were used. . . . The cattle were excited and reluctant to enter the water . . . it was difficult to make them string out and pull as they should In the midst of all this hurly-burly came a band of about fifty Sioux Indians, making the crossing at the same time "

California Crossing, 1867,
William Henry Jackson (1843-1942). 22 x 34 in., oil.
Thomas Gilcrease Institute
of American History and Art, Tulsa.

Everything Jackson wrote to his folks back in Keesville, New York, is present in the painting and then some. The breadth of the river, the stretch of land, combine to make the crowded scene of the foreground. When reproduced on the far shore, it seems to spread out and start to get lost in the sheer space of the West— an effect Jackson would be the first to admit was beyond the compass of the camera then or now.

William Hahn

William Hahn was born near Dresden, Germany, studied in Düsseldorf, Paris and Naples and arrived in New York at about the age of thirty in 1871. With his friend William Keith, the Western artist, Hahn journeyed across the continent to San Francisco, where, during the seventies and eighties, he was a member in good standing of the growing art community of that city. He visited Yosemite and various mining and old Spanish communities around the state, painting scenes from all of them. He is best known, no doubt, for his everyday life scenes of San Francisco, but *Return From the Bear Hunt* chronicles another aspect of life in California in the last cen-

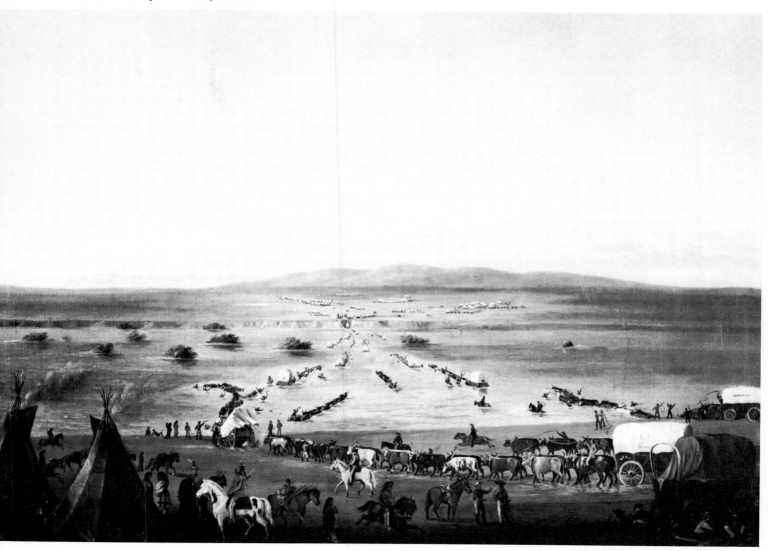

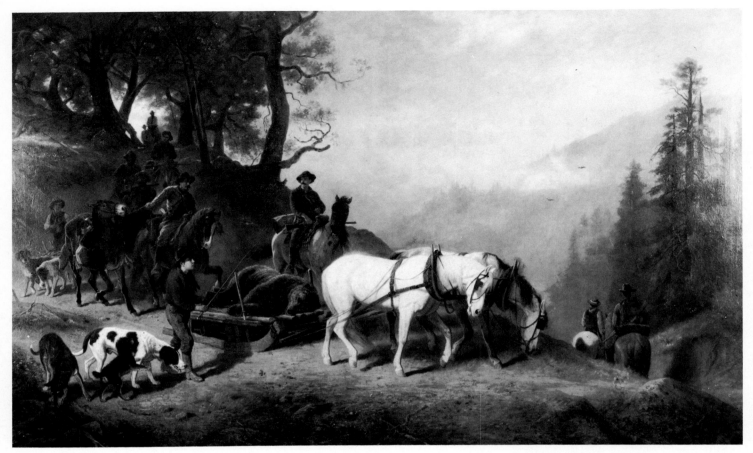

Return From the Bear Hunt, 1882,
William Hahn (ca. 1840-1890/91). 55 x 89 in., oil.
The Oakland Museum, Kahn Collection.

tury. We pick up the procession just at the right spot, the turning from one downhill run to the next. The center is occupied, as it should be, by the great dead animal roped to the sledge, attended by the dogs that tracked him to his lair and the mounted hunters who killed him. The picture is elegantly composed, almost a baroque grand staircase in design, the open masses on the left perfectly and surprisingly balanced by the pinnacle of trees on the right.

In 1848 a complex German immigrant to California named John Augustus Sutter decided that his expanding and very successful industrial and trading operation on the Sacramento River needed a new mill. While he and his men were digging the mill race, the water suddenly sparkled with golden gleams that did not come from the California sun. Sutter tried to keep his discovery quiet but failed and soon the California Gold Rush was on, bringing a whole new breed of immigrant from the East, the forty-niners who headed West to try their luck. The Gold Rush ruined Sutter, injected a new element into the composition of California and added an important, but little celebrated, ingredient to the world of the West.

It is surprising when you think of it that mining is not more celebrated, as part of the legend of the West. It figures as the source of gold shipments that are conveyed by cavalry in that legend and stolen by bandits. But mining itself rarely appears in the art, the literature or the movies of the West. A guess would be that the individual gold-seekers, the forty-niners, were so transparently covetous and greedy almost by definition that they lack the gener-

osity and openness, the easy-going acceptance of other people on their own terms that characterize the West-erner in the legend. In addition, mining that amounted to something rapidly turned into huge corporations—like the aptly named Anaconda—which have a romance of their own, no doubt, but a quite different one from that of the West.

Charles Christian Nahl

At any rate, among the good men and bad that the Gold Rush attracted to California was another young German immigrant artist, Charles Christian Nahl, who did paint a scene of the mines that is a remarkable summation of its subject. *Sunday Morning in the Mines* is more than just a summation, it is practically an inventory of the things the miners did on their day of rest.

There was, of course, no church to attend; the only miners in any sort of contemplative mood befitting that aspect of the sabbath are the two at the center of the composition: one inside the cabin writing home, the other standing outside, smoking and gazing into the distance. These two figures are both in shadow, thus establishing a quiet center and an ironic reminder of Sabbath doings back East with which to contrast the brightly lighted shenanigans going on elsewhere. On the right a couple of miners are doing their weekly wash and joking about the

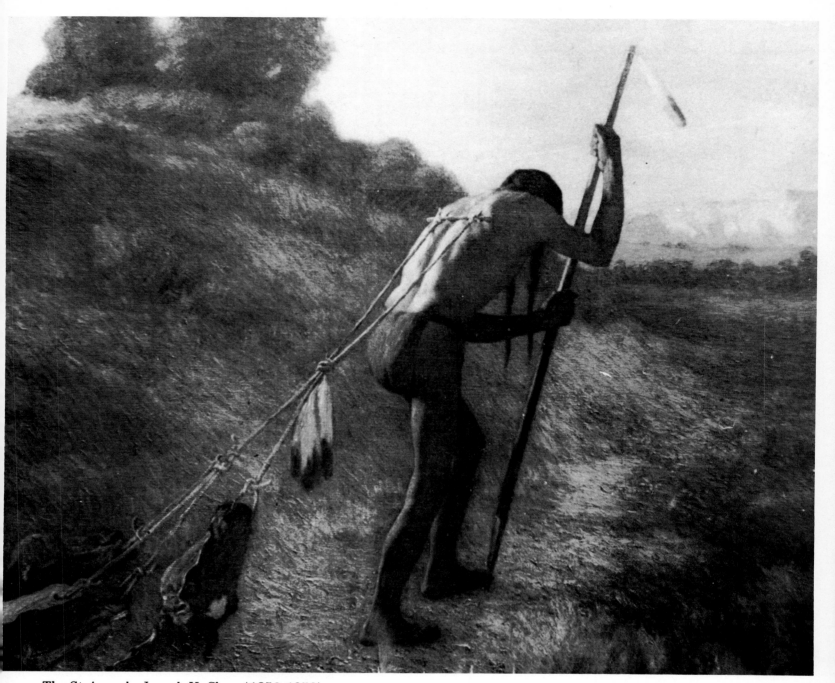

The Stoic, n.d., Joseph H. Sharp (1859-1953).
Collections in the Museum of New Mexico.

long-handled underwear—obviously right off the limbs of the owner—in need of more than washing. Settled against the side of the cabin and sitting on a box, three miners are talking with something less than rapt attention to each other. On the other side of the central plaza of the camp, a free-for-all is in progress outside what seems to be a primitive saloon. Up from the steep trail in the left foreground four riders erupt into the picture racing, while between the horsemen and the cabin, three miners, perhaps after drinking, are engaged in a rustic burlesque of the ballroom dancing of the day. At the very bottom of the picture, the painter has spread out the tools of the miner's trade, most notably the rocking wooden basin used for collecting gold in water.

In the far distance, beyond all the horseplay and the greed now taking a day off, the eternal mountains ascend in majesty, offering assurance that they will remain when those who scrape and scramble for the mountains' wealth are gone forever.

Nahl also addressed himself to the "other California," the one that was there first, that got shoved aside by the goldseekers and that survives today principally in the names of the cities, the Spanish-Mexican California.

The first thought that comes to mind on seeing *The Fandango* is Act II, Scene iii, Afternoon at the Hacienda. Like *Sunday Morning in the Mines, The Fandango* seems to contain everything Nahl knew or thought he knew about the Spanish Californians, most of it operatic. From left to right, the picture contains: a group of servants holding back a knife-weilding rejected suitor or rejected dance partner (choose one); a preacher or padre—Nahl couldn't quite distinguish—restraining another bravo from some other violent act; a mixed couple, white and black, semi-embracing and keeping an eye on the weather; a pair of menacing types; a violinist and a banjo-

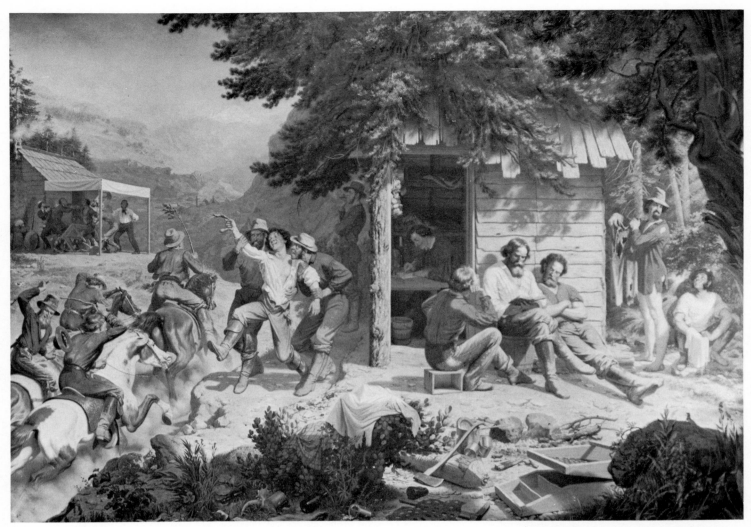

Sunday Morning in the Mines, n.d.,
Charles C. Nahl (1819-1878). 72 x 108 in., oil.
E. B. Crocker Art Gallery, Sacramento.
The miners' Sundays, according to this artist,
appear to be as full of action as any workday.

player grinding the tune out; a pair of donkeys being affectionate; a little girl smiling at her pussy cat; two aged haciendderos engaged in either philosophical conversation or shooting dice, it's hard to tell; the happy fandangoists themselves executing the three-quarter time dance with elegance, ruffles and tight trousers under the admiring gaze of another woman, herself the object of romantic attention from a face barely visible in the aperture of the dancers' arms and shoulders; yet another maiden and a standing, bearded gent waving farewell and godspeed to a romantic couple dashing off on a horse related to the one Napoleon rode over the Alps to Italy; and, at the bottom of the work, an astonishing miniature adult tugging at the leash of a rolling hound. And that's just the foreground: in the background, some sort of equestrian chase is going on.

What on earth does it all mean? Don't even guess. The odds are that scholarly research will eventually demonstrate that there actually was an operetta called "The Fandango" playing in San Francisco in the early 1870's and this scene really is Act II, scene iii. In the meantime, the painter has composed a lively panorama of a kind of dream of life among the Latins. Opera aside, Nahl painted *The Fandango* for the same reason the Germans keep

vacationing in Sorrento: romantically speaking, that's where the action is. Similarly, the new Californians—the gold rushers, the orange growers, the moviemakers, the geriatric Fascists and sunshine Socialists—know in their bones and to their chagrin that the Californianos had something the Californians did not in Nahl's time and do not now. It is hard to express exactly what that Latin something was, but Nahl's picture is a good attempt.

Jules Tavernier

Jules Tavernier (1844-1889) was another European who found his way to the American West. In the brief flight of his forty-five years, his career is almost a travesty on the excesses of the artist and of the Westerner in the view of nineteenth-century home folks on either side of the North Atlantic. Obviously possessed of real talent, Tavernier, born in France, came to America as a young man and was fortunate in obtaining employment as an illustrator for *Harper's* magazine, the the rough equivalent of being a *Life* photographer or a CBS cameraman. In 1873 he embarked with a friend and fellow artist, Paul

(continued on page328)

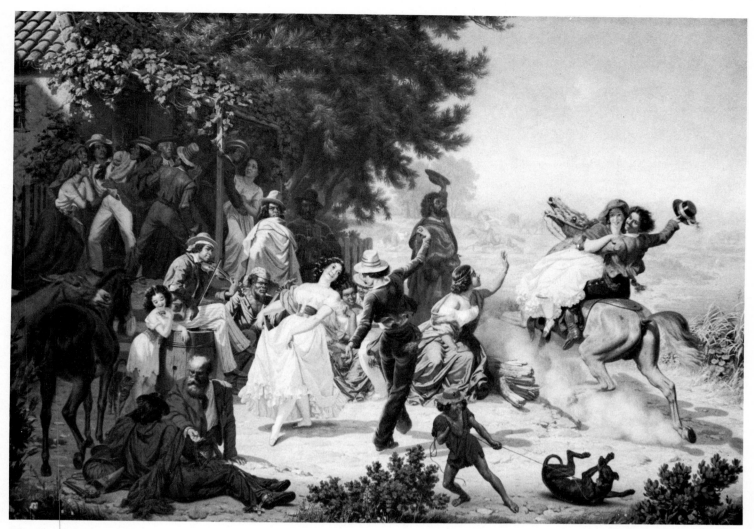

The Fandango, 1873,
Charles C. Nahl (1819-1878). 72 x 108 in., oil.
E. B. Crocker Art Gallery, Sacramento.

Indian Camp at Dawn, n.d.,
Jules Tavernier (1844-1889).
24 x 34 in., oil.
Thomas Gilcrease Institute
of American History and Art, Tulsa.
Once in history, the Indians appear to have
had all the time and space in the world.

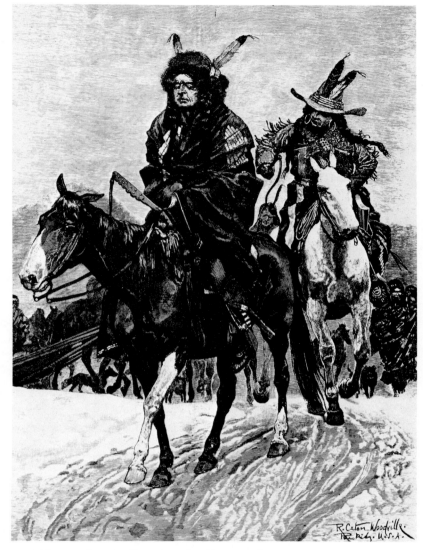

Above: Braves Leaving the Reservation,
from *Illustrated London News*, January 17, 1891,
Richard Caton Woodville, Jr. (1855-1927), wood engraving.
Woodville became the most prolific illustrator in
Europe of the wild West, producing hundreds of
pictures for adventure books and periodicals.

Taos Dance, n.d., Ernest Blumenschein (1874-1960).
Collections in the Museum of New Mexico.

Frenzeny, on a sketching tour right across the continent. He was, perhaps, an early exemplar of the American folk saying that if you tilt the country, everything that is loose naturally rolls to California. Tavernier rolled to San Francisco, where he must have been an adornment of the growing artists' colony there. He and Frenzeny were both companions of Thomas Hill on his early painting trips to the Monterey Peninsula. Tavernier rolled on west, however, ending his days in Hawaii, where, living up to the implications of his name, he died at forty-five of acute alcoholism.

Due to the nature of his way of living, most of Tavernier's paintings survive only as reproductions in the files of *Harper's*. One of the few still extant, however, shows him as a master of space and light.

Indian Camp at Dawn has that rare quality that distinguishes many of Rembrandt's landscape etchings, the ability to present, in a few inches of vertical picture space what seems to be measurable miles of horizontal terrain space. It is not a trick, or anyone could do it. When it is done it invariably raises the picture to a new level of perception. In *Indian Camp,* the land seems to go on forever. There is no abrupt jump from foreground to distance, covered by bushes or trees or a canyon. The eye walks every step of the way from the stream at the bottom of the picture all the way across the sun-dappled grassland to the distant butte and even to the horizon. Within that astounding space, the Indians seem to have all the space and therefore all the time in the world. This proved to be a delusion but it must have been the basic assumption of Indian life right up to the moment the picture was painted.

Right:
Prospecting for Gold in British Columbia: A Portage,
from *Illustrated London News*, January 16, 1897,
Richard Caton Woodville, Jr. (1855-1927),
engraving after a gouache drawing.

Below:
Trail Herd Across Wyoming, 1923,
W. H. D. Koerner (1878-1938).
Courtesy, Whitney Gallery
of Western Art, Cody, Wyoming.
Portraits of the longhorn cow
were done in all seriousness
by Western painters,
and the lead animal of a herd was
valued for its intelligence and sensibility.

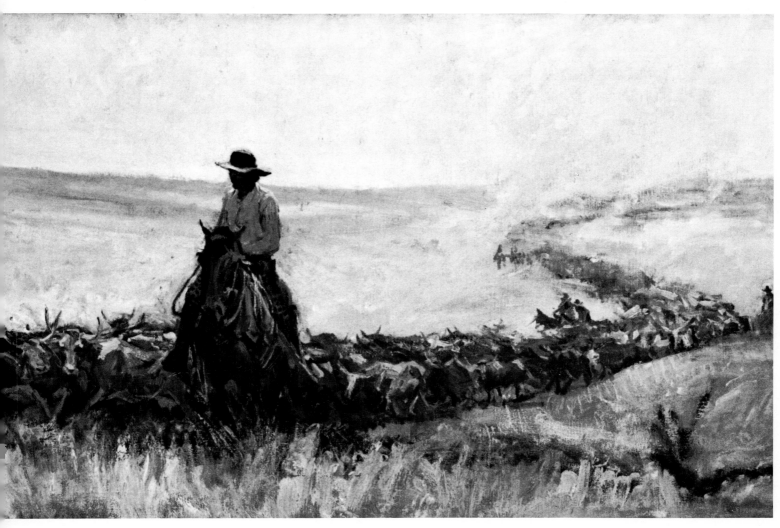

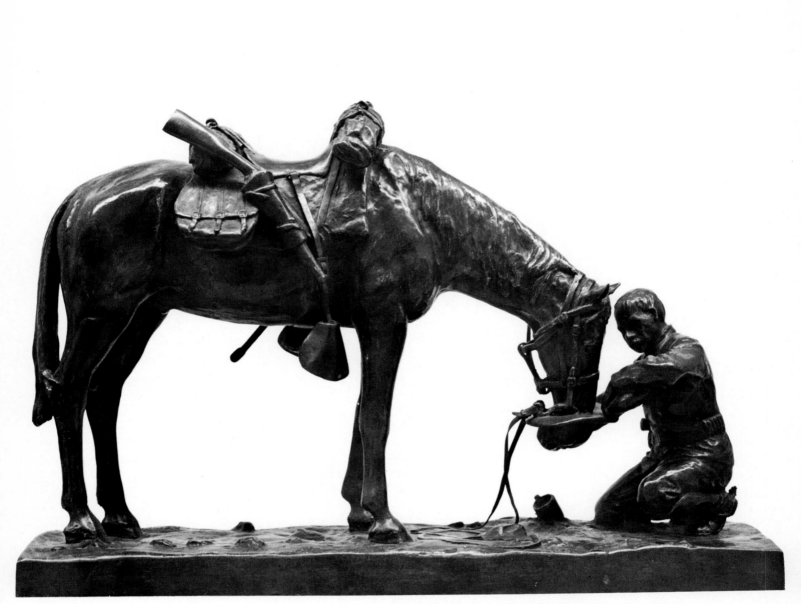

The Last Drop, 1903, Charles Schreyvogel, h. 12 in., bronze.
Thomas Gilcrease Institute of American History and Art, Tulsa. As the title indicates,
a cowboy's loyalty to a favorite horse — perhaps his closest companion
— entitled the animal to the best treatment.

THE WEST
IN THREE DIMENSIONS

The earliest extended work of classical antique sculpture is essentially a horse show. The Elgin Marbles, by far the principal public attraction in the British Museum, came from the Parthenon, in Athens. That great temple was built in the middle of the fifth century B.C., the peak of Athenian culture. The central figures are those of Athena, the city's protectress and patroness, her priests and attendants, but the bulk of the magnificent frieze now in the museum is a long essay on men and horses. Part of this takes the form of a battle between men and centaurs, in which horses are raised to human level; part takes the form of a mounted procession, with infinite variety of poses and views of men paying homage to the gods in the company of their horses.

It does not take a great deal of translation to see that both those themes are implicit in the life of the West, where the horse has been intimately associated with the life and death of whites and Indians ever since the Spanish horses went wild and were recaptured by the tribes. The great migrations across the Plains, the long wars between the Anglo-Americans and the Indians, the rise of the ranches, the whole way of life of the American cowboy, all these essential elements of Western history would have been unthinkable without the horse.

Thus, it is not surprising that, in addition to the many painters and draftsmen who have worked on Western themes, that life, those men and horses, have also attracted the interest of sculptors. For various reasons, most Western sculpture has been in bronze rather than in stone. While everyone understands at least the basic idea of painting and equally the basic idea of carving an image out of a piece of stone, most people are somewhat confused about how it is that bronze sculpture comes into existence. It is a complicated process not only to perform but even to understand.

First of all, except in very rare instances, the sculptor does not work in bronze at all until his essential image is realized in some other material. This material is usually clay, plaster or wax, each of which has different properties of its own. Plaster, for example, is most like direct

The Cheyenne, n.d.,
Frederic Remington, bronze.
Rockwell Gallery, Corning, New York.
The way of Western life would have been unthinkable without the horse, which, along with its rider, formed a natural subject to which sculptors were most attracted.

The Sun Vow, 1919,
Hermon Atkins MacNeil
(1866-1947), bronze.
The Metropolitan Museum of Art,
Rogers Fund.
Among initiation rites
for young Sioux boys was this
demonstration of their mastery of
the bow and arrow.

Indian Hunter, 1860,
John Quincy Adams Ward (1830-1910), h. 8 ft., bronze.
Central Park, Courtesy, New York City Parks,
Recreation and Cultural Affairs Administration.
While the United States and the Plains
Indians fought a long war over native
independence, in much 19th-century art, the Indian was
idealized as a human living in a state of nature.

Methods have been developed—centuries ago—to make several castings of the same figure, each of which is the original work of art, just as each impression of a lithograph or etching is an original. The modeled wax figure is not the original anymore than the drawing upon stone or the etched copper plate are the originals for a lithograph or etching. All three are merely initial steps in the making of the work of art, which is the impression on paper for the prints, or the finished bronze for the sculpture.

Because of the difficulties of the process, editions of bronze sculpture are often limited to six or twelve, in contrast to the several hundred impressions of many print editions, but there is no theoretical reason why a sculptor could not make much larger editions, and some sculptors have, especially those in command of their own casting facilities or foundries.

An aspect of sculpture that does not exist in the same way or to the same degree for painting is the artist's dependence on monumental commissions. This is less a controlling factor than it was in the last century, but in the last half of that century and in the first quarter of this, the sculptor lived by, for and on monumental commissions. Even if the bulk of his work was portrait busts, his reputation was made by large, public works. Interestingly enough, this was true of all the sculptors of Western subjects we shall meet here except the two most prolific, who, as it happened, were also the two most highly regarded Western painters, Remington and Russell.

John Quincy Adams Ward

The problem may be seen in one of the established sculptors of the nineteenth century, John Quincy Adams Ward. Born in 1830 on an Ohio farm, he began modeling figures when he was still a child. Through the help of an older sister living in New York, he came to the city at nineteen and was accepted as a student of Henry Kirke Brown, a near neighbor of Ward's sister in Brooklyn. He soon progressed to the rank of assistant to Brown, working on the older artist's equestrian statue of Washington which still stands in Union Square and upon which Brown generously added Ward's name to his own. After seven years, Ward struck out on his own, living in Washington and modeling heads of many of the politicians involved in the long legislative struggles that preceded the Civil War. Determined to make his name, Ward decided to execute a statue of an Indian hunter. To do so, in sharp contrast to many later sculptors of such themes, the young artist felt bound to travel West and observe the Indians in their own environment. He did so, staying for several months and returning with sheaves of sketches. From them he fashioned his first significant figure piece, *Indian Hunter,* working on it long and carefully to combine accuracy of observed detail with great feeling for weight, movement and psychological state of man and dog approaching their quarry.

A group of prominent New Yorkers contributed $10,000 to purchase the eight-foot bronze work and presented it to the city, erected on a stone base in Central Park, where it may still be seen. Ward's reputation was immediately made by the piece, and commissions for portrait heads and portrait monuments came steadily for the rest of his life, particularly during the great period

carving in stone or wood; clay is built up rather than carved down, as is wax, both of them usually on a metal armature, a kind of skeleton for the work. Most Western sculpture and indeed most bronze sculpture has been made by the "lost wax" process. In this technique the figure to be cast is modeled in wax and then invested, inside and out (or just outside to produce a solid bronze), with a heat resistant material called in Italian *anima,* because like the soul, it dwelt within the visible form. The two layers of *anima* are joined by pins and surrounded by elaborate systems of channels, formed by wax tubes, designed to convey bronze as swiftly as possible to all parts of the form. The wax is then melted away—hence the name—and molten bronze poured into the spaces left between the core and the shell of *anima.* After cooling, the block of *anima* is cracked open and the bronze figure removed, to be cleaned, polished, have the core removed, and finished by the sculptor or assistants.

COMING ... HE ... MAN

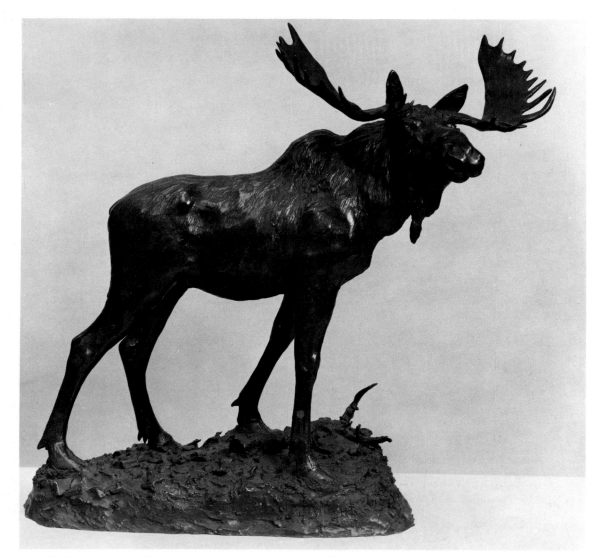

A Bull Moose, © 1900, Henry Merwin Shrady (1871-1922), h. 19-1/2 in., bronze. The Metropolitan Museum of Art, bequest of George Dupont Pratt, 1935.

for American sculpture following the Civil War. He never worked significantly on Western themes again, but with that one statue he at once made his own career and pointed the way for a large number of American sculptors who followed him in creating tributes to the Indians, the cowboys and cavalrymen, and the horses, wild and in service, of the West.

Indian Hunter shows its subject lightly balanced on both feet, tense and expectant, advancing with care, one hand holding his bow, the other placed on the dog's throat to still any growl that might announce their presence to a yet unsuspecting prey. The hair of the dog relates to that of the loincloth of hide worn by his master,

and the two heads of man and beast are remarkably alike in their shared alertness and the grim lines of the mouths.

The social significance of the stunning and immediate success of the *Indian Hunter* and its legion of followers is slightly baffling, for it came about, in the decades following the Civil War, just as the United States and the Plains Indians raised to a series of bloody climaxes their long war against each other. The white Americans were now officially embarked on a war which, if it was not deliberate genocide, was certainly an effort to end the degree of Indian independence that still survived and to bring all the Indian nations under direct and constant American supervision and surveillance. Yet at the same time these same Americans found, in the work of Ward and others, some gratification in seeing the Indian as an idealized human living in the state of nature. The contrast of attitude noted between Vanderlyn's picture of the Indian murder of Jane McCrea (pages 26-27) and Hicks's vision of the peaceable kingdom with Quakers and Indians in harmony (pages 24-25), had, by this time, become permanent, universal and highly intensified.

The Coming of the White Man, 1904,
Hermon Atkins MacNeil (1866-1947),
h. 8 ft. 9 in., bronze.
Courtesy, City of Portland,
Bureau of Parks and Public Recreation.

335

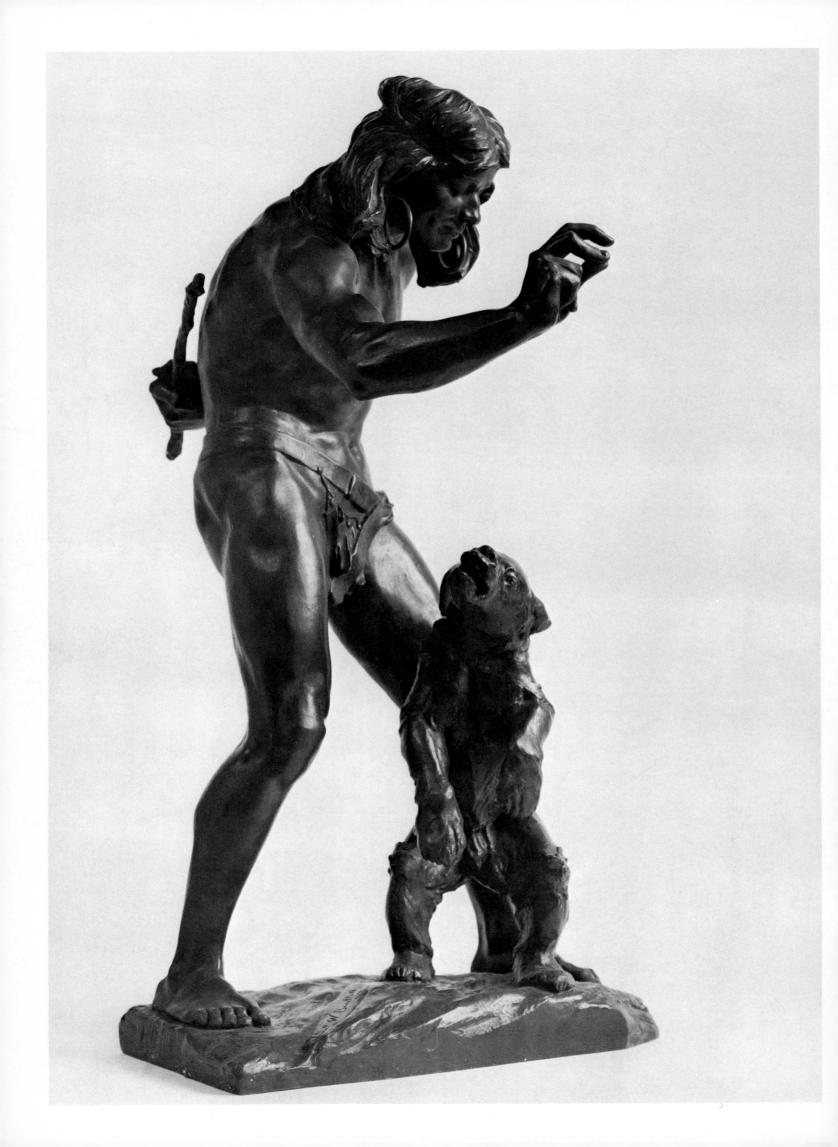

Hermon Atkins MacNeil

Hermon Atkins MacNeil (1866-1947), born two years after Ward's hunter was erected in Central Park, was one who picked up that lead and one of many who, in the later years of the century and the early ones of the new century, brought a new finish to Ward's vision of the noble redman.

Born in Massachusetts, MacNeil studied art in Boston and taught it for three years at Cornell University before embarking, in 1888, for some three years of study at the École des Beaux-Arts in Paris. He returned in time to become an architectural sculptor in the elaborate layout of buildings, waterways, walks and parks that was the World's Columbian Exposition in Chicago in 1892, the four-hundredth anniversary of the Discovery of the New World. The idealized Indian became part of his decorative sculptural language as he moved along a regular circuit of unfolding expositions: Paris, 1900, Charleston, 1903, St. Louis, 1904, and San Francisco, 1915. Meanwhile he excuted numerous individual commissions for monumental sculpture.

The Beaux-Arts style brought to MacNeil's Indian sculpture a degree of finish not present in Ward's hunter and his dog. There is an easy flow to the surfaces and to the compositions of spaces and volumes. It is, in fact, a little *too* easily flowing for most modern taste, but there is an assured command in his work which still deserves recognition and which did produce some of the most convincing images of idealized Indians.

The Sun Vow, for example, was based, according to the artist, on an initiation ceremony among the Sioux, in which young boys demonstrated their mastery of the bow and became braves. The figures of the boy and the elder of the tribe seem in their bearing somehow to be closer in spirit to Greek or Renaissance sculpture than to actual Indians. For one thing, of course, no Indian, young or old, and for that matter, no one else, ever willingly shot an arrow from a bow under the extreme handicap of having to twist the bowstring arm in the manner this boy's has been twisted in order to conform to the entirely too close presence of the elder. On the other hand, the closeness does convey the artist's notion of how essential skills were passed from one generation to another in a primitive society.

Opposite: **The Bear Tamer,** n.d.,
Paul Bartlett (1865-1925), bronze.
In the Collection of the Corcoran Gallery of Art,
gift of Mrs. Paul Wayland Bartlett.

Below: **Sioux Indian Buffalo Dance,** n.d.,
Solon Borglum (1868-1922), h. 38 in., bronze.
Kennedy Galleries, New York.
The Buffalo Dance was a ritual performed
to bring the buffalo within hunting range
of a Sioux village of the Plains.

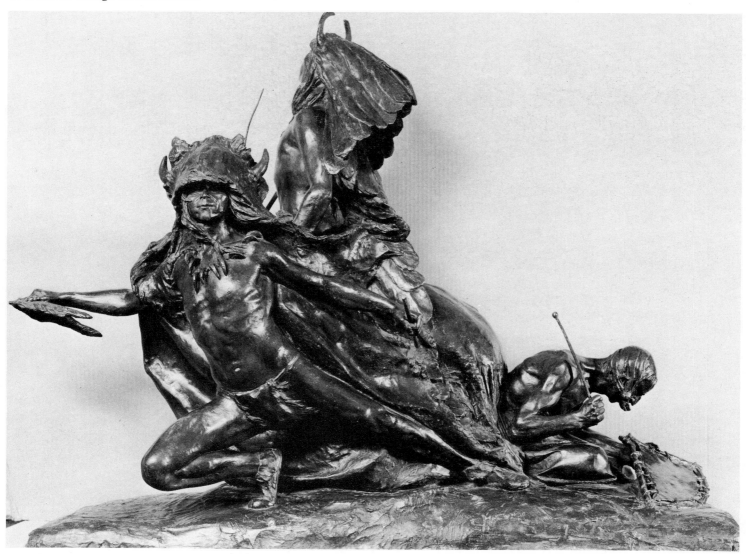

The Coming of the White Man, the Indian figures placed on a rough-hewn rock against a leafy background in a Portland, Oregon, park, conveys even more strongly the sense of virtue in the Indians and more specifically the impending destruction of that virtue by the whites. The two Indians offer contrasting but complementary attitudes. The younger one, on the left , steps toward the unseen white man, holding aloft a leafy branch as a symbol of peace and friendship—a symbol, it should be noted, strictly of the Graeco-Romano-European world, not of the Indians. The older and taller Indian stands proudly erect, clearly fascinated by the offstage whites but nevertheless maintaining his own dignity, self-sufficiency and pride. Not aloof, certainly not hostile, he nevertheless forms an interesting other side to the presumed eagerness to see the new people and learn their ways that is implied in the shorter figure.

Paul Bartlett

Paul Bartlett made the French connection more pronounced than any of the other Beaux-Arts Americans. The child of a moderately successful sculptor and teacher, Bartlett (1865-1925) spent much time in his early years in his father's studio and so grew up accustomed to the ways of sculpture. The father, however, a professor at the Massachuetts Institute of Technology, was determined to save his son from an American education. When Paul was nine, he was sent to Paris with his mother. At fourteen he exhibited his first work, a bust of his grandmother, at the Salon of 1879. He then enrolled at the Beaux-Arts and became, while still in his teens, a self-supporting sculptor of animal figures to serve as parts of other

Mares of Diomedes, 19th century, Gutzon Borglum(1867-1941), h. 62 in., bronze. The Metropolitan Museum of Art, gift of James Stillman.

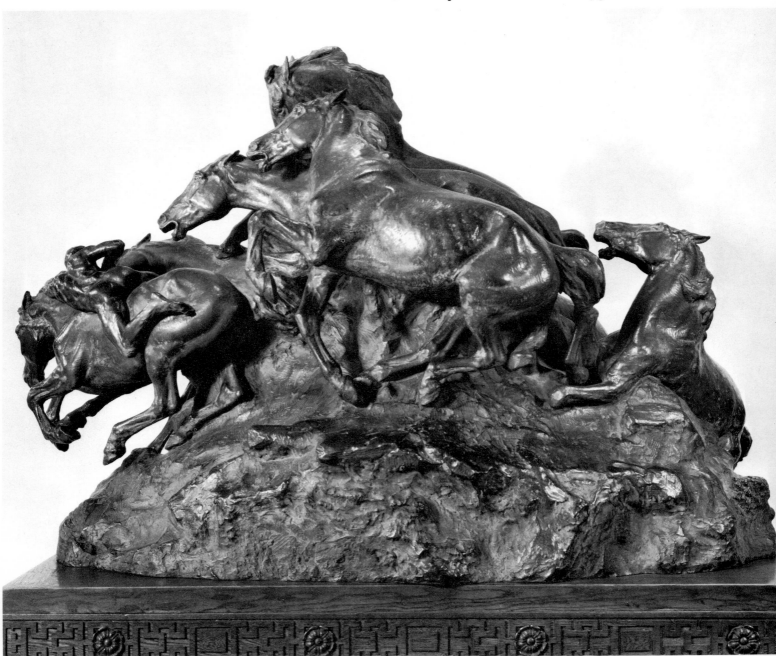

Secrets of the Night, 1926,
Charles Russell, h. 13-1/4 in., bronze.
Thomas Gilcrease Institute
of American History and Art, Tulsa.

sculptors' monumental groups. When he was twenty-two he first attracted widespread critical attention in Paris—and later in America—with the bronze, *The Bear Tamer.* Like J.Q.A. Ward a quarter of a century earlier, Bartlett announced his arrival at sculptural maturity and independence with a life-size bronze image of an Indian of his native land.

Bartlett, as an American in Paris, perhaps had an extra reason to turn to America for the subject of his first major work. It should be noted, of course, that whereas Ward, when he first conceived *Indian Hunter,* immediately made a conscientious and efficacious trip West to see Indians in their native habitat, Bartlett had certainly never seen such an environment and most likely had his only personal experience of Indians in the flesh with those of the Buffalo Bill Wild West Show during its Paris engagement. Even so, the piece at once convinces. It may be doubted if many Indians went in for training bears in the ancient European style, but if any did, we believe on sight, they must have looked a great deal like Bartlett's. The obvious contrast of all training, the combination of the snapped finger in front, the hidden stick behind, is the immediate point of interest, but that anecdotal contrast is superficial compared to the superb modeling of the musculature of the Indian's body and the brilliantly conceived and rendered confluence of conflicting emotions in this face: determination to proceed with the training, amusement at the cub's responses, and variations on these attitudes.

Bartlett went on to the distinguished career that could be prophesied from his talent and training, including a great deal of monumental work in the Capitol complex in Washington, especially the Library of Congress, with figures of American and cultural history, but it may be doubted that he ever surpassed the youthful mastery he showed in *The Bear Tamer.*

Henry Merwin Shrady

Henry Merwin Shrady (1871-1922) does not strictly belong in a collection of Western art, but he is worth introducing for two reasons. First, his statue of *A Bull Moose* is interesting in itself and the moose was after all a Western beast; and second, he is the artist who created the absolute greatest equestrian sculpture group in American history, one of the greatest in art history, and he is relatively unknown for this supreme achievement.

Shrady was born and died in New York and was largely brought to his early grave by the Congress of the United States. Child of a well-to-do New York physician, he took a law degree at Columbia University, but apparently never practiced. In sculpture he was entirely self-educated, but for once such an education proved to be the best. Self-apprenticed to an academic sculptor in New York, Shrady became an *animalier,* as the French called the specialty. His *Moose* is from that period and that aspect of his career. The moose was designed originally to decorate the numerous bridges at the Pan American Exposition in Buffalo in 1901. The smaller bronze version is closer to the sculptor's hand and shows a remarkable grasp of the inherent grace in a beast that seems, like the giraffe, clumsy and awkward, but is really a creature of complex beauty in motion.

339

Shrady had the good fortune, which turned out to be extremely mixed fortune, of winning, at an early age, a major commission from the United States Government. The Congress had voted a quarter of a million dollars for a major memorial, to be placed at the foot of Washington's Capitol Hill and the east end of the Mall, to General Ulysses S. Grant, the man who, once Lincoln discovered him, was as responsible as the Emancipator himself for winning the War Between the States. This was, of course, a prize of a commission; moreover, it was awarded Shrady by a most distinguished jury, the country's two leading sculptors of the time, Augustus Saint-Gaudens and Daniel Chester French, and one of America's all-time great architects, Charles F. McKim.

Furthermore, Shrady produced a masterpiece in the assignment. The group is set on a plaza overlooking a shallow pool—a fairly recent addition. On either side of the plaza is a complex, agitated group of men and horses, one of artillery, dragging a fieldpiece through the mud, the other of cavalry, dragging themselves and their weapons through the same sticky, Southern clay. Both groups powerfully suggest the urgency in the face of great odds, the determination to conquer the climate itself, the dedi-

Above: **Smoking Up,** ca. 1904, Charles Russell, h. 12-5/8 in., bronze. Courtesy, Amon Carter Museum of Western Art, Fort Worth.

Below: **Counting Coup,** n.d., Charles Russell, h. 9 in., bronze. Thomas Gilcrease Institute of American History and Art, Tulsa. Counting coup, or striking a blow to one's enemy, was a measure of how many foes a brave had beaten in war, and Russell's sculpture captures double action just as two enemy braves strike.

340

cation not so much to abstract cause like union or independence as to the obvious unity of a group of men and horses linked together by companionship. In the center of the plaza, on a high plinth of stone, stands the bronze figure of U. S. Grant. Shoulders and hat brim down, he sits on his horse as if watching his troops struggle up a particularly difficult mountain pass or shape up to charge across a predictably bloody meadow. Sad and wise, the figure of Grant, even in the most glorious sunshine of Washington in June, always convinces the viewer that cold rain is falling all around.

Shrady discovered, as have so many before him and since in so many fields of endeavor, that the Congress of the United States is a very difficult customer. Awarded the commission out of a field of fifty-two contestants, Shrady naturally assumed that meant the money was available. It wasn't: Separate acts of Congress were needed for each installment. The sculptor contracted debts for materials and labor which he could not discharge without Congressional acceptance of its obligations, which was not forthcoming. The commission occupied virtually Shrady's entire professional life, filling him with frustration and despair as it became clear that he was responsible to people working for him, whereas the people he was working for were responsible to no one, least of all to him. The Grant Memorial was completed and unveiled shortly after the sculptor's early death at fifty-one, a death undoubtedly hastened by the customary contra-

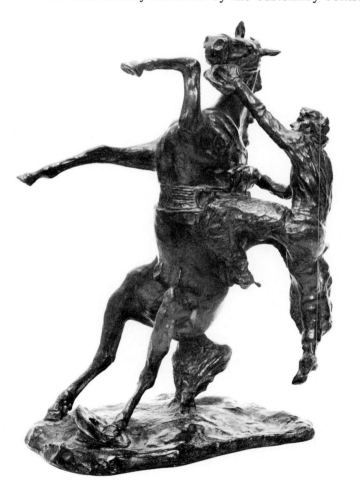

Where the Best of Riders Quit, n.d.,
Charles Russell, h. 14-3/8 in., bronze.
Courtesy, Amon Carter Museum
of Western Art, Fort Worth.

dictions of Congress. But the assemblage of one great individual equestrian figure, Grant, with the two energetic, realistic groups of cavalry and artillery, make the Memorial the supreme achievement in a field in which the West provided the essential experience for Americans.

Solon and Gutzon Borglum

The West provided its experience most directly to American sculptors in the lives and works of the Borglum brothers, Solon (1868-1922) and Gutzon (1867-1941). They were born in the West, Gutzon in the Idaho Territory at Bear Lake, Solon in Ogden, Utah, and grew up surrounded by cowboys and Indians and the knowledge that both wanted nothing else than to be sculptors. Both studied at more metropolitan centers than were available in their home country: Gutzon in San Francisco, Solon in Cincinnati. Both went on to Paris and to steadily growing acclaim at home and abroad. Well over military age, Solon served in World War I as a YMCA representative attached to the AEF in France. He won medals at the great expositions around the turn of the century, including the gold medal at the Louisiana Purchase Exposition of 1904. His principal work for St. Louis was the *Sioux Indian Buffalo Dance,* a dynamic composition in which the two dancing figures, one standing, one in a vigorous squat, back to back, create, as the viewer moves around the piece, the illusion of one dancer in sequential movements. Both figures rise from a mass in spiral ellipse that begins with the end form of the bent over drummer giving the dancers the rhythm.

Gutzon was by far the more spectacular of the two brothers, in his style of public utterance and in his work as well. At one point, long after he was thoroughly established as a successful monumental sculptor himself, he declared that most American public monuments should be dynamited—and added a list of those that should go first and most urgently, especially the best known memorials in New York and Washington. Naturally, he was commissioned to work on the great unfinished Cathedral of St. John the Divine in New York. When some of its resident theologians criticized him for making angels females in clear contradiction of scripture, Gutzon entered the cathedral with a sledgehammer and began breaking up his own work.

As the first American sculptor to advocate the mixture of sculpture and dynamite—a mixture that attained a modest artistic popularity a couple of decades after his death—Gutzon appropriately became the first sculptor actually to use dynamite as a method, at the same time attaining his widest and most enduring fame and creating work on a colossal scale unapproached since antiquity. This, of course, was in his audacious project of carving four presidential heads into the top of Mount Rushmore: Washington, Jefferson, Lincoln and Theodore Roosevelt. In an untypical gesture of offering equal time—or space— to a contrasting opinion, Gutzon went on to carve the Confederate leaders into Stone Mountain, Georgia, a work best appreciated when seen from the roof gardens of certain Atlanta hotels.

It was early in his career, however, that Gutzon Borglum's Western childhood showed itself most powerfully in his work. Again, as with Ward and Bartlett, this early

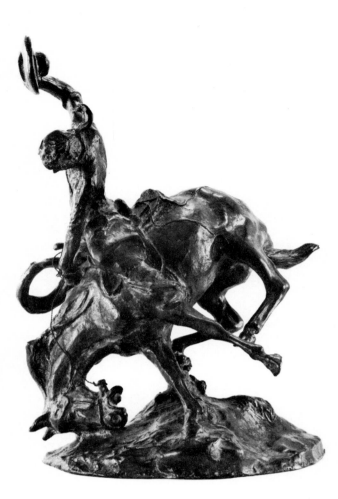

The Weaver, n.d., Charles Russell,
h. 12-1/2 in., bronze.
Courtesy, Amon Carter Museum
of Western Art, Fort Worth.

Charley Russell was the most beloved Western painter of his time or since. He was also a sculptor, although this was but vaguely recognized during his lifetime. His sculpting began at the same time his drawing did, in early childhood. Family legend had it that the boy was missing from home one day for a frighteningly long time. He was found to have followed an itinerant showman with a performing bear. Hauled home, the child took the mud from his shoes and modeled the bear. From time to time he seems to have modeled figures for his own amusement or—in an ancient artist's practice—to help visualize the composition of a painting.

The first time Russell actually modeled a piece for the conscious purpose of having it cast in bronze was in 1904 in New York, where he was with his wife Nancy on a selling trip and feeling lonely, as he often did, in a town where he did not know anyone, let alone everyone, as he did in Great Falls and on many a Montana ranch. In his hotel room, Russell modeled *Smoking Up,* just over one foot high, a lively figure of a cowboy arriving in town to have a good time and announcing his arrival by firing his revolver and rearing up his horse with a short rein. The modeling is superb, especially of the horse, and the spirit is authentic of a scene Russell witnessed many times and actively participated in before his domestication by Nancy.

On his second trip to New York, the following year, Russell successfully modeled three more bronzes, including *Counting Coup,* a scene within an Indian battle.

The name reminds us of the many French words that entered the Indian dialects from the traders who were, all

strain of the West gave the sculptor his first public following in his own country. The *Mares of Diomedes* was by far the most talked about sculpture at the St. Louis exposition, allowing Gutzon for the first time to catch up with Solon in terms of popular acclaim. Gutzon also used the occasion to combine his Western background with the classical allusions that were still expected in high class painting and sculpture. This was not lost on visitors to the exposition, nor on viewers of the work since. An early critic pointed out that although the subject purported to be the Eighth Labor of Hercules, the capture of the wild mares of Diomedes in Thrace, the subject was actually a stampede of Western wild horses, one of them ridden by a cowboy trying to stop the stampede, with the classical allusion obviously an afterthought.

The piece itself is one of great power. Standing over five feet high, the bronze depicts six wild horses breaking like a huge wave over a rise in the land. The nude figure of Hercules/cowboy clings to the mane of the lead horse, the man's muscles as taut and as tense as those of the horses. The early critics were right; this is how a cowboy would go about trying to bring a charging herd under control. But it is also how a classical hero would approach the same task and it was that same task to which Hercules was set in Thrace. As with the Elgin Marbles, the *Mares of Diomedes* reveals the link in horsemanship between classical antiquity and the modern West.

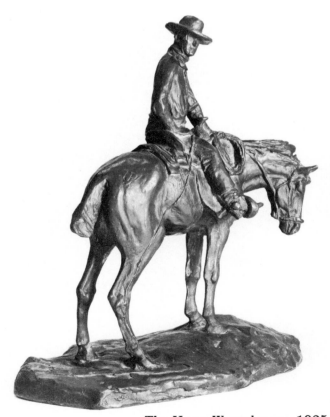

The Horse Wrangler, ca. 1925,
Charles Russell, h. 13-3/4 in., bronze.
Courtesy, Amon Carter Museum
of Western Art, Fort Worth.

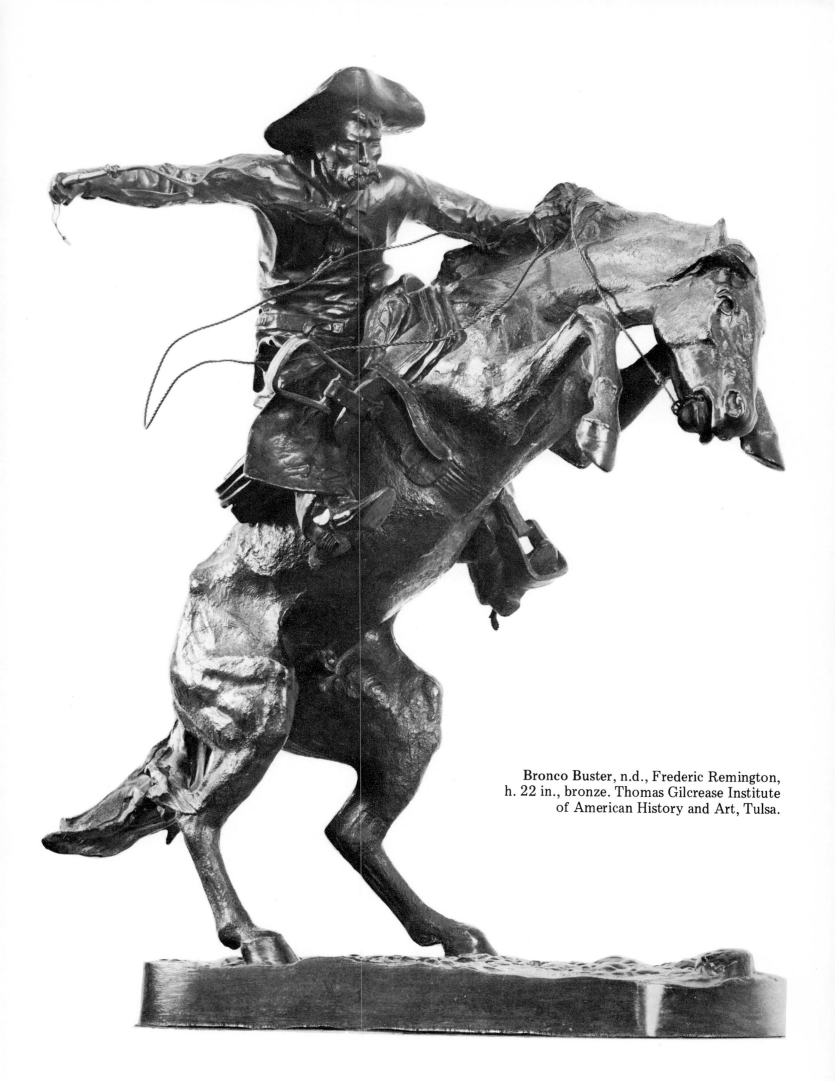

Bronco Buster, n.d., Frederic Remington,
h. 22 in., bronze. Thomas Gilcrease Institute
of American History and Art, Tulsa.

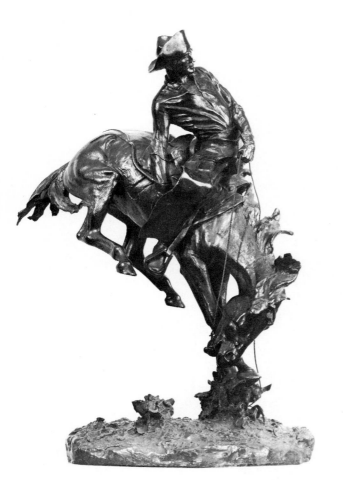

The Outlaw, 1906, Frederic Remington, h. 23-1/2 in., bronze. Thomas Gilcrease Institute of American History and Art, Tulsa.

through the Great Lakes country and the central river system, the first white men the Plains Indians of the North ever saw. The piece itself reminds us that Charley Russell was realistic in his view of Indians as he was in everything else. The salon sculptors gradually created a misty, sentimental view of the American Indian. Based on the historical truth, not to be gainsaid, that the Anglo-Americans did indeed commit grave wrongs against the Indians almost from the day they landed at Plymouth and at Jamestown, culminating in what was almost a war of extinction toward the end of the nineteenth century, those sculptors created the image of the Indian as a peace-loving person wanting only to be left alone. The truth was more complicated. The Indians were assuredly more closely in touch with nature than the whites, one measure of the difference being simply that between the thickness of a buffalo hide and the thickness of logs or stones or bricks as barriers against the weather. Assuredly, too, the Indians in their long occupation of this continent did no damage at all to the land, the water and the air, compared with what the whites have wrought in a few centuries, most especially the last one. But the war-peace contrast is something else again. There may have been in the history or prehistory of the world, or in remote island cultures, primitive peoples who lived and still live at peace with their neighbors and with all mankind, but the Plains Indians of North America were not such people. They had a long tradition of inter-tribal warfare long before the whites arrived on the scene.

It is true that in some inter-tribal situations, "war" consisted usually in the clever stealing of horses, but it also meant mortal combat between the fighting men of two tribes or two sometimes quite extensive sets of tribal alliances. Since the Plains Indians had no real property, these wars tended to be waged as relatively pure exercises in warriorship. They afforded young braves the opportunity to prove or to discover their "manhood" in the act of killing other men. This motive has been inseparable from white man's war, also, of course, but it has usually been subsumed in presumably higher purposes, such as pride, honor, the defense of the fatherland or the preservation of one religion as against others.

Within that convention, counting coup—the French word means blow or strike—was simply a method adding up how many enemies the brave had beaten in war. This was the real significance of scalping. The scalps, hung on a belt or diplayed emblematically in the village, were indisputable proof of the brave's warlike competence and courage. We follow much the same system among our aviators, who decorate their machines with the number of enemy symbols to stand for the number of enemy machines they have shot down, or with bomb silhouettes to indicate the number of strikes—or coups—they have carried out against enemy soldiers, cities or rice paddies.

Russell's sculpture, less than a foot high, is a deliberately complex version of the practice. The Indian on foot is being wounded by the lance of the Indian leaning out from his mount while the latter in turn is about to be tomahawked by the other mounted Indian who rears up on his horse to wield his war axe. The whole encounter is taking place at breakneck speed and will be over in a moment, one way or another. The work successfully translates into three dimensions the great virtue that distinguishes Russell in two: his infallable instinct for the moment of peak dramatic intensity, the split second just *before* the climax of the action.

The Rattlesnake, 1905, Frederic Remington, h. 22 in., bronze. Paine Art Center and Arboretum, Oshkosh, Wisconsin.

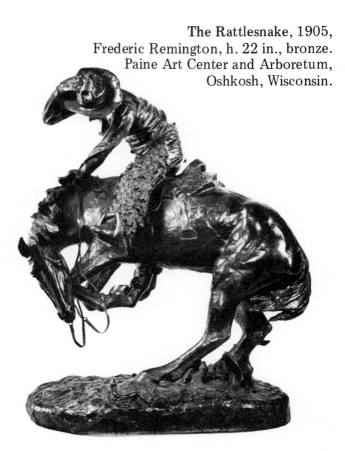

Although he had no illusions about the pacific nature of the Plains Indians, Russell had great respect for them having lived one winter with a tribe just over the Canadian border and having been friendly with them all his life. In the last year of his life, 1926, Russell expressed something of what he felt about the Indians he had known so long in *Secrets of the Night*. The brave seated on a pile of rocks may be doing sentry duty while the tribe sleeps, but more likely he is undergoing part of the rites of initiation, during which he keeps himself awake unnaturally long hours and is visited, in the night, by the totem animals of the tribe who impart to him the tribal wisdom. The intent glance of the youth, the poised perch of the totem bird sum up the union of the Plains Indians with the natural life of the land they loved. The piece, solidly built around its vertical axis, is as close as Russell ever permitted himself to come to an idealization of the Indians or of anything else. Typically, his idealization is based on authentic Indian practices.

But the grand theme of Russell's art was the American cowboy, and he celebrated that theme in bronze as he did on canvas, with close observation, attention to detail, the perception of coherent composition within natural arrangements and, above all, with understanding and great affection.

The two small bronzes, each about ten inches high, *The Weaver* and *Where the Best of Riders Quit*, present what might be called equal and opposite views of a favorite aspect of Charley Russell's cowboys, their relationship, in action, to their horses. One horse is crashing down, rubbing the earth with its head in order to unseat the rider; the other is rearing back with the same purpose in view and pursuing it more successfully. The cowboy in *The Weaver* is holding his own against the equine tactics described by the title; the other rider has chosen the better part of valor.

Russell's most eloquent statement in bronze about the cowboy, however, is also the quietest. *The Horse Wrangler* memorializes a job Russell held himself in his ranch hand days. An outfit on the range usually had two wranglers, a night wrangler and a day wrangler. Night or day, the wrangler was in charge of the horses. The wrangler had a touch of the veternarian, perhaps a touch of the blacksmith, though that was a specialized job, but his prime responsibility was simply to have the horses available when needed. Any cowboy automatically knew the condition of his own horse, but the wrangler knew the condition of the whole herd. Russell portrays him astride and watchful, easy in the saddle, posted in position but ready to move himself and his horse at any moment to wherever he might be required. With dignity and a sense of the trust placed in him by his employer and by his fellow-cowboys, Russell's wrangler is alertly and confidently in charge.

The Stampede, 1910,
Frederic Remington, h. 21-1/4 in., bronze.
Thomas Gilcrease Institute of American
History and Art, Tulsa.
Controlling a stampeded herd
was one of the most dangerous
yet essential duties of the cowboy.

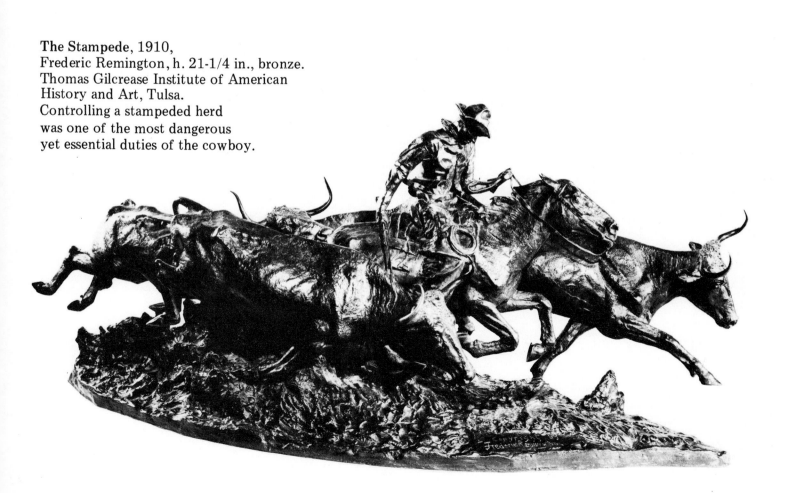

Federic Remington

Frederic Remington, too, the other great artist of the West, expanded from drawings and paintings into bronze sculpture. The basic ability was always there, apparently. A friend, at any rate, recalled in later years that he had been with Remington in his New Rochelle studio while the artist was working on a saloon-poker-playing picture. Something about the composition was not working out, and Remington, starting over again, simply reversed the whole arrangement, moving his own point of view one hundred and eighty degrees, leaving the figures and the setting as it had been. The point was that he had always imagined the scene in three dimensional terms—an arrangement he could walk all the way around and look at from the other side, just as you do with sculpture in the round, rather than as a two-dimensional representation on a flat canvas. He had a sculptor's eye and feel for solid forms.

Remington was also a much more technically sophisticated sculptor than Russell, as is testified to by the fact that the Metropolitan Museum of Art, the country's leading art institution, owns fourteen sculptures and a major painting by Remington, nothing at all by Russell.

It is easy to see the qualities of dash and finish that had immediate appeal to the museum eye right from the first piece Remington did: *Bronco Buster,* which he modeled with the tools and materials of a friendly neighbor who was a sculptor. The horse is rearing and about to plunge down with forefeet and, no doubt, kick out behind, but the bronco-buster holds his seat, keeping a short rein for control and holding a quirt in his free hand to remind the animal from time to time that the rider is the one in command. It is a great ensemble of man and beast, the latter doing his best to unseat the rider, the rider perfectly adapting himself to any change in the horse's wild movement. The officers and men of Teddy Roosevelt's Rough Riders presented a copy of this piece to their commander when the unit was disbanded.

Like Russell, Remington did a pair of bronzes that seem to be equal and opposite versions of cowhand and the cow pony in exhilarating mutual movement. *The Outlaw*

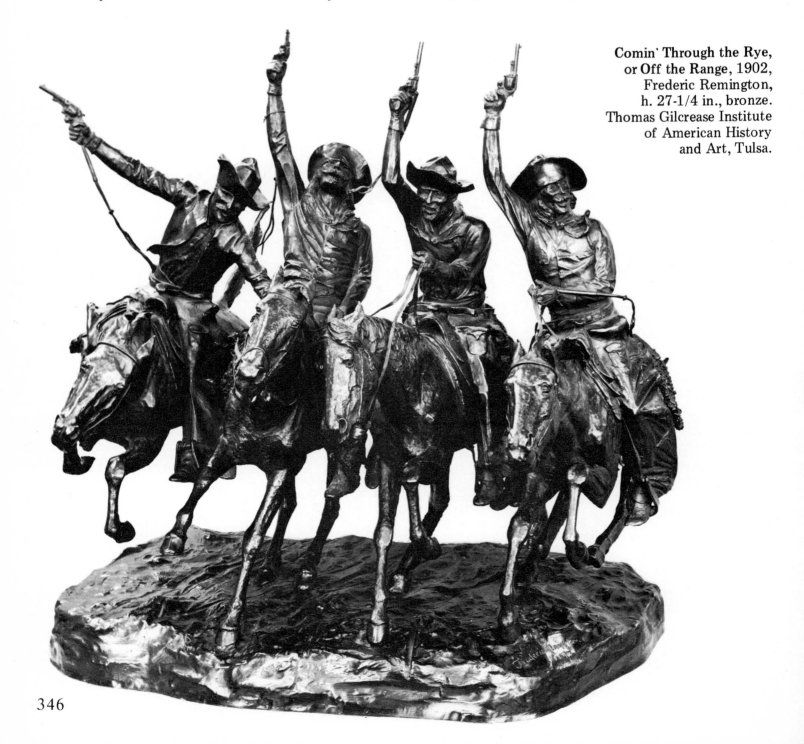

Comin' Through the Rye, or Off the Range, 1902, Frederic Remington, h. 27-1/4 in., bronze. Thomas Gilcrease Institute of American History and Art, Tulsa.

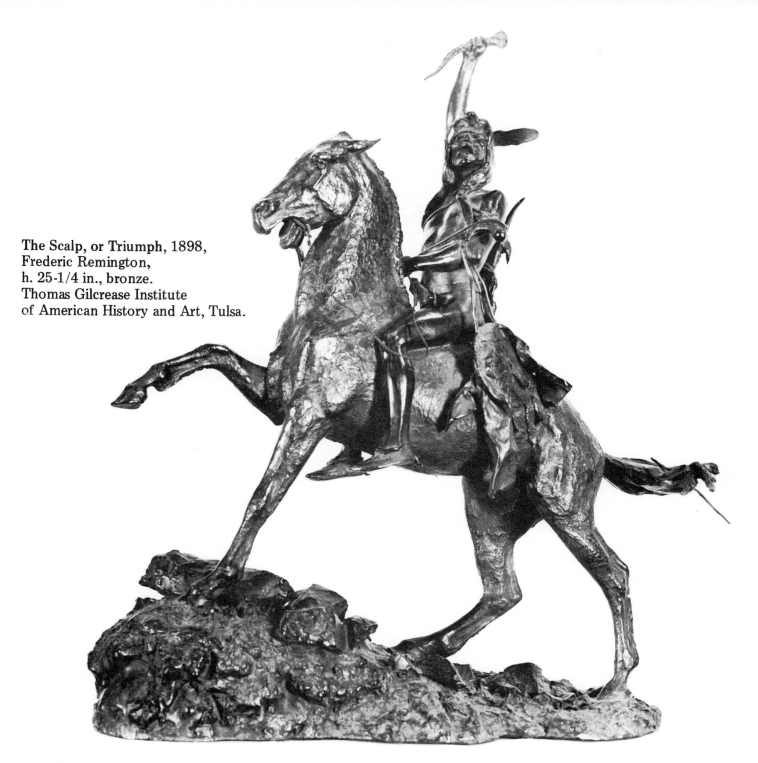

The Scalp, or Triumph, 1898,
Frederic Remington,
h. 25-1/4 in., bronze.
Thomas Gilcrease Institute
of American History and Art, Tulsa.

and *The Rattlesnake* present a panicky horse front end up and front end down, in each case an intrepid and skillful cowboy managing to keep his seat. The rider in *The Rattlesnake* is less securely seated at the moment of the sculpture, obviously because his horse's frightened rearing up from the deadly serpent was unexpected, while any cowboy who got onto a bucking bronco knew exactly what to expect — the worst.

The Stampede is probably Remington's highest tribute in bronze to the cowboy. The rush of longhorn steers is neither as monumental nor as spectacular as the mares of Gutzon Borglum's treatment of the same theme, but the man is much more on top of his situation than Borglum's "Hercules" clinging to the mane of the lead mare. The cowboy is rapidly overtaking the longhorn out in front, having cut his way through the herd to that vital point of control. He rides swiftly but easily, clearly ready to try to save his life if it should come in critical danger through a misstep of the horse or a wound from one of the

horns that surround him. Man and horse work together with complete mutual confidence and shared competence in one of the most dangerous, and, when it happened, most absolutely essential, tasks on the range.

If such a moment of crisis had an "equal and opposite" moment in the cowboys' life, it was the one masterfully depicted by Remington in what is probably his best known bronze, *Comin' Through The Rye*, a title that almost certainly does not mean that the horsemen are riding across a meadow planted with the well-known grain. The piece has been immensely popular ever since it was first cast. Theodore Roosevelt, a friend and fan of Remington's, bought one for the White House, and the piece was reproduced life-size in plaster at the Louisiana Purchase Exposition in St. Louis, where, appropriately, it marked the entrance to the amusements and diversions of the great fair.

The roistering, rollicking cowboys seem to roll in the saddle like drunken sailors, and their horses are affected

by their manner, seeming to be drunk themselves. On all four faces are looks of simple pleasure and solid self-satisfaction. Scenes like this took place at the end of the trail drives and on arrival in the cow towns of Kansas, pay in pocket, the natural reaction to the weeks of hard, tense and expert labor across the Plains.

Remington saw plenty of Indians on his trips West, and his sharp eye noted all details that could be of use in his work, but he had never lived with the Indians, as Russell had done. In general, his attitude was shaped by his many friends among the U. S. Cavalry. He respected the Indians as "the best light cavalry in history," but they remained foreign, suspicious and dangerous. *The Scalp* is a marvelously melodramatic embodiment of an Indian seen through just such predispositions, a wild creature, crying out his savage triumph and waving aloft the scalp lock of his freshly killed foe.

Much more instinctively sympathetic is Remington's treatment of the man who was the first of the Anglo-Americans across the Plains and into the Rockies, who preceded both the cowboys and the cavalry, *The Mountain Man.* The mountain men, or mountainy men, as they were also called, came to trap and to trade, with more of the former than the latter. Remington's model has the look of a "free trapper," that is, one working for himself rather than for the big outfits, like Hudson's Bay or John Jacob Astor, and trading his pelts to those firms as the Indians did. Rangy and spare, he leans back toward his horse's haunches as the animal descends a steep path that might cause many a rider to get off and walk. In a different way from both the cowboys and cavalry, the mountainy man was completely in union with his horse. Remington's piece exemplifies perfectly the faint praise with which Lorado Taft, a sculptor of academic, idealized subjects, once damned him: "his dashing compositions . . . occasionally suggest somewhat of the spirit of the centaur life of the West."

But the cavalry above all was the heart of Frederic Remington's West. Its troopers were the "centaurs" he knew best, admired most and celebrated supremely in bronze as in paint.

The Wounded Bunkie was Remington's second effort at modeling. This immediate move into the cavalry as sculpture subject was accompanied by an astonishing acceptance of greatly increased problems. He did two riders and two horses instead of one each; he linked all four together in various ways, including those of composition; and he balanced the whole group on only two feet, one from each horse, touching the ground. The skull on the ground helps establish the Western scene, but it is not really needed for that purpose: The horsemanship itself would do the job. The wounded bunkie—short for bunkmate—maintains his seat despite his wound, an automatic reaction. His comrade supports him with one arm, holds his own reins in the other hand and keeps a close watch on the action off to their left. They are by no means out of danger yet. The horses work together as easily and expertly as do their masters. The whole complex unity of masses and movements is enhanced by the meticulous detail, down to the US brand on the horses.

Among other things, *Trooper of the Plains* embodies Remington's theory—proved by high-speed, sequential photography—that at full gallop the horses of the Plains

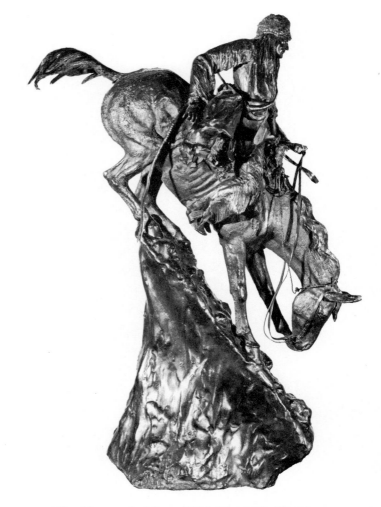

The Mountain Man, 1903, Frederic Remington, h. 28-1/2 in., bronze. Thomas Gilcrease Institute of American History and Art, Tulsa. The trapper and trader of the Rockies had to be in complete union with his horse on the steep Western trails.

The Wounded Bunkie, 1898,
Frederic Remington, h. 20-1/4 in., bronze.
Thomas Gilcrease Institute
of American History and Art, Tulsa.

definitely had all four feet off the ground at the same time, whatever might be the case with their cousins in the Central Park livery stables. Remington achieved this in bronze by a highly individual variation of an ancient expedient. The classical marble carvers and bronze casters would very often place their nude figures alongside a bush or a tree stump or a bit of masonry ruins in order to provide needed support beyond the figure's narrow ankles. Remington supported three of his galloping horse's hooves in a scrub bush of the Plains, probably sage brush. In profile there is a lovely cutting up of spaces by the legs of the animal and the whole pieces has a certain insouciance implying absolute control of the situation.

The impression was purely internal, for this is a post-Civil War trooper, before he and his kind ruled the West. The cavalry of the Plains began as the First Dragoons in the early 1830's. What control it had established over the Indians and, for that matter, what tradition and morale it had accumulated like money in the bank, were both spent freely during the Civil War, and the postwar years were a hasty rush to get back to the situation as before—the status quo before war and diplomacy.

But the jaunty style of the trooper, which he communicates to his horse, marks him as the conqueror and future ruler of the Plains. In a few short years, he was both.

The cavalry defeated the Indians, but in a few swift years the cavalry was itself defeated by time itself, by a new age and new machines brought forth by the culture for the sake of which the cavalry rode the Plains and fought fiercely from border to border, from the great river to the great mountains. Yet, by the time of the Spanish-American War, the cavalry proved that its brief day was over: The charge up San Juan Hill was done by the Rough Riders, but they were not riding. The same inexorable forces have overtaken other aspects of the West. Trapping is long gone, worked out by the same excess of enthusiasm that killed the buffalo. Cattle remain a prime business in the West, but increasingly cattle are big business and only big business. The open range is hardly a memory, the trail drive only a subject for movies. The Indian was

349

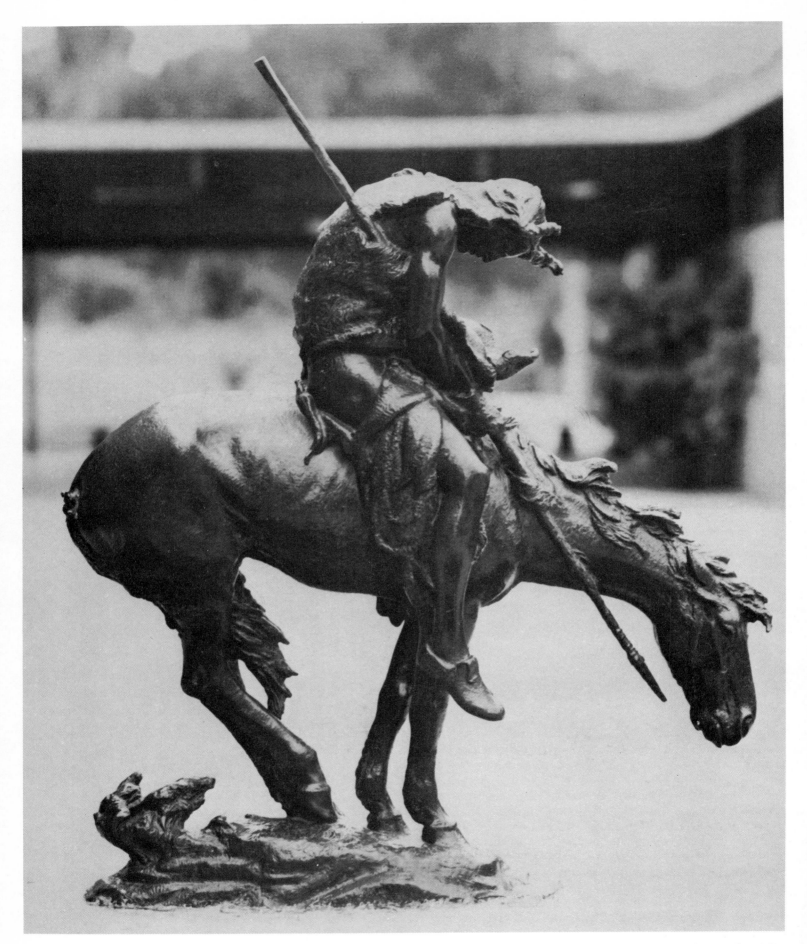

End of the Trail, 1915,
James Earle Fraser(1876-1953),
h. 40 in., bronze. Brookgreen Gardens,
Murrells Inlet, South Carolina.
Seneca Chief Johnny Big Tree who modeled for
this famous sculpture was also the model for the
Indian Head nickel, or Buffalo nickel, which James
Earle Fraser made for the Government.

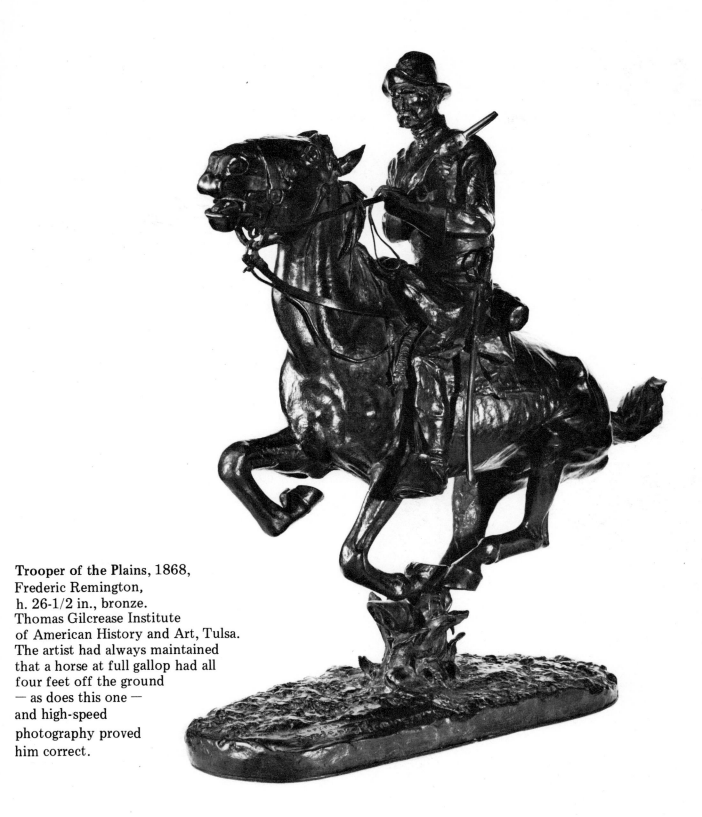

Trooper of the Plains, 1868,
Frederic Remington,
h. 26-1/2 in., bronze.
Thomas Gilcrease Institute
of American History and Art, Tulsa.
The artist had always maintained
that a horse at full gallop had all
four feet off the ground
— as does this one —
and high-speed
photography proved
him correct.

merely the first of the Western people to go, and in some ways the Indian has lingered longer than the others and makes a strong case for a rehabilitation that may or may not come for Indians but will assuredly never come for the cavalry.

Thus, James Earle Fraser's *End of the Trail,* which, in the year of its creation, 1915, seemed a beautiful, poignant, deeply felt and deeply moving tribute to a noble race utterly defeated, now speaks for the whole vanished and vanishing way of life that was the West. A full generation ago and more, a cowboy song told of riding the range in a Ford V-8. The pick-up truck, the light plane and the helicopter are today's version. The

lofty mountains and their valleys, lakes and falls of water have been pressed into the service of all the people, as Bierstadt and Thomas Moran advocated, and all the people have covered the West with empty beer cans, initials carved in rocks, the litter of the deluxe camping life, the hideous noise of the portable radio and the poisonous fumes of the internal combustion engine.

Yet, the West lives on. In the century and a half or so that it survived with cowboys, cavalry, Indians and trappers in various combinations, it shaped forever some part of the American soul. The West lives in that soul and always will. The West lives, too, in the work of the artists who were lured there by the eternal promise of the land and the life.

Index of Names